Die
phantastischen
Köpfe
des
Franz Xaver
Messerschmidt

The
Fantastic
Heads
of
Franz Xaver
Messerschmidt

Tucson 2007

To Derek and Lilian

Thank you for your passion in collecting
wonderful artefacts in stone and jewellery
Just discovered a wonderful artist from
Rokkoko to Klassizism. Have fun to
study the marvellous face and character
expressions of a great mastersculptor.
I sometimes find myself mirrored
in these images and hope you
enjoy it and our work together

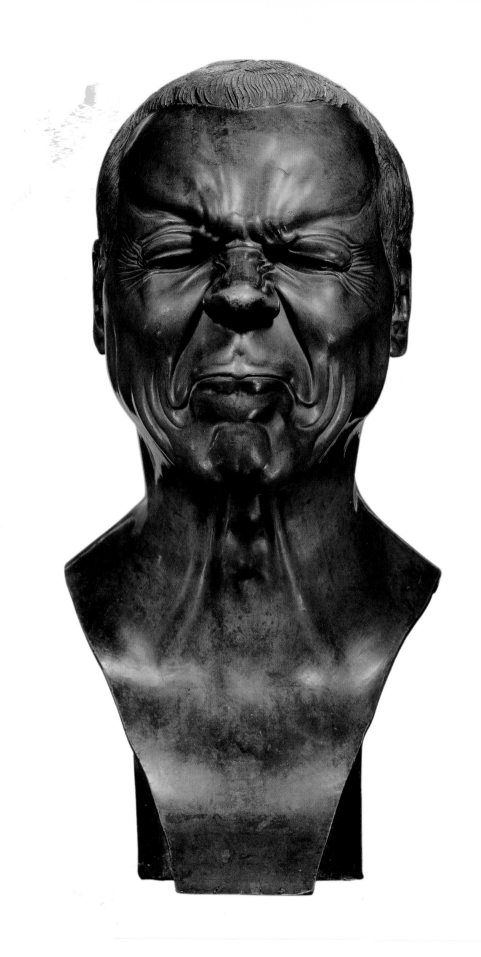

Die phantastischen Köpfe des Franz Xaver Messerschmidt

The Fantastic Heads of Franz Xaver Messerschmidt

Katalog
zur Ausstellung
im Liebieghaus
Skulpturensammlung
Frankfurt am Main

15. November 2006
bis
11. März 2007

Herausgegeben von
Maraike Bückling

Catalogue
of the exhibition
at the Liebieghaus
Skulpturensammlung
Frankfurt am Main

15 November 2006
until
11 March 2007

Edited by
Maraike Bückling

Liebieghaus
SKULPTUREN
SAMMLUNG

Inhalt / *Contents*

Essays / *Essays*

Anhang / *Appendix*

Gefördert durch

 Škoda

 Stadt Frankfurt am Main

Mit zusätzlicher Unterstützung von

 FAZIT-STIFTUNG

Medienpartner

 hr2
kultur

Grußwort

Gefühle und Leidenschaften bestimmen unsere menschliche Existenz und unsere Handlungen. Sie sind der Impulsgeber für Innovationen und Entdeckungen, zudem der Grundstock für die Vielfalt in allen Bereichen der Gesellschaft, in der Kultur genau so wie in der Wirtschaft. Sie festzuhalten und zu erklären, haben unterschiedliche Disziplinen und Wissenschaften in den letzten Jahrhunderten versucht.

Einer der großen Meister der Darstellung menschlicher Empfindungen ist sicherlich der österreichische Bildhauer Franz Xaver Messerschmidt. Noch heute faszinieren und bewegen uns die künstlerische Perfektion und Ausdruckskraft seiner Köpfe.

Mit der Ausstellung »Die phantastischen Köpfe des Franz Xaver Messerschmidt« ist es dem Liebieghaus gelungen, viele bedeutende Werke Messerschmidts erstmalig nach Deutschland zu holen. Ich freue mich, dass Škoda Auto Deutschland als Partner dieses Projekt mit begleiten kann. Mit Überzeugung suchen und fördern wir die Auseinandersetzung mit den Künsten und unterstützen Initiativen, die wie diese Ausstellung wichtige Impulse an die Gesellschaft weitergeben. Denn schließlich waren es Leidenschaft und innovativer Geist, die in der Frühphase der individuellen Mobilisierung 1895 zur Gründung der Fahrradmanufaktur von Laurin und Klement in Mladá Boleslav geführt haben – eine Pioniertat reger Köpfe, auf die die Geschichte von Škoda Auto zurückgeht. Als einer der ältesten produzierenden Autohersteller der Welt will Škoda Auto daher auch heute Enthusiasmus nicht nur in unseren Disziplinen Design und Mobilität erlebbar machen.

Ich wünsche allen Besuchern eine anregende Begegnung mit dem außergewöhnlichen Werk von Franz Xaver Messerschmidt.

Nikolaus Reichert
Leiter Unternehmenskommunikation
Škoda Auto Deutschland GmbH

P.S. Für Škoda besteht übrigens eine ganz besondere Beziehung zum Frankfurter Liebieghaus: Theodor Liebieg, der Neffe des Kunstmäzens Heinrich Baron von Liebieg, hatte 1907 die Reichenberger Automobilfabrik (RAF) gegründet. 1912 übernahmen Laurin und Klement den Automobilhersteller, der damals als einer der wenigen Autobauer neben Mercedes die hoch geschätzten Knight-Motoren in Lizenz fertigen durfte. Wie Heinrich von Liebieg interessierte sich Theodor gleichfalls für Architektur. In Liberec, das damals noch Reichenberg hieß (hier wurde 1875 Ferdinand Porsche geboren), ließ er auf Anregung seines Onkels Heinrich ein ähnliches Haus wie in Frankfurt erstellen.

Sponsor's Foreword

Feelings and passions determine human existence and our behaviour. They are the stimuli for innovation and discoveries as well as the foundation of diversity in all areas of society, in cultural affairs as well as business. Various disciplines and sciences have attempted to identify and explain them over the past centuries.

The Austrian sculptor Franz Xaver Messerschmidt is undisputedly one of the great masters of representing human feelings. Even today the artistic brilliance and expressive powers of his Character Heads continue to fascinate and move us.

The Liebieghaus has indeed landed a coup in bringing together for the first time so many important works by Messerschmidt for the exhibition "The Fantastic Heads of Franz Xaver Messerschmidt". I am delighted that Škoda Auto Deutschland can accompany this project as a partner. We are committed to seeking and promoting a dialogue with the arts and support projects which, like this exhibition, give such important impulses to society. It was, after all passion and the spirit of innovation which led in the early phase of individual transportation to the founding of the Laurin and Klement Bicycle Factory in Mladá Boleslav in 1895. As one of the world's oldest car manufacturers, Škoda Auto wants, therefore, to make enthusiasm not just in our disciplines, design and mobility an enriching experience.

I wish all visitors a stimulating encounter with the extraordinary work of Franz Xaver Messerschmidt.

Nikolaus Reichert
Director, Business Communications
Škoda Auto Deutschland GmbH

P.S. Škoda already has a very special link with the Liebieghaus in Frankfurt: Theodor Liebieg, the nephew of the art patron Heinrich Baron von Liebieg, founded a car factory, the Reichenberger Automobilfabrik (RAF) in 1907. In 1912 Laurin and Klement took over the works, which, alongside Mercedes was one of the very few manufacturers allowed to build the renowned Knight engines under licence. Like Heinrich von Liebieg, Theodor also took an interest in architecture. On his Uncle Heinrich's suggestion, he had a similar house to the one in Frankfurt built in Liberec in northern Bohemia, then known as Reichenberg (it was the birthplace of Ferdinand Porsche in 1875).

Vorwort

Zu den besonderen Privilegien eines neuen Direktors zählen unerwartete Entdeckungen und die Realisation von lange gehegten Träumen. Ich bin in Wien aufgewachsen in einer Wohnung ganz nahe beim Belvedere. Nur zu oft ging ich damals – nicht immer freiwillig – mit meinen Eltern in die dort beheimatete Sammlung der Österreichischen Galerie. Einen nachhaltigen Eindruck, eine immerwährende Faszination erwirkte in Kindesjahren insbesondere ein, vielleicht gar nur dieser Raum des Unteren Belvederes: der Saal mit den faszinierenden Charakterköpfen von Franz Xaver Messerschmidt. Viel später unternahm ich mehrmals zaghafte Versuche, ein Messerschmidt-Ausstellungsprojekt zu realisieren, Versuche, welche sich aber als nicht wirklich tragend herausstellten. Nun endlich, nach einem dreiviertel Jahr Amtszeit als Direktor des Liebieghauses bereits eine Ausstellung zu seinen Charakterköpfen in so kurzer Zeit präsentieren zu können, beruht auf drei ganz wesentlichen, glücklichen Faktoren: das Liebieghaus besitzt eine bedeutende Arbeit Messerschmidts, in dieser Institution arbeitet eine Sammlungsleiterin, die eine ausgewiesene Spezialistin für die Kunst dieses außergewöhnlichen, exzentrischen Bildhauers ist und Frankfurt hat durchaus auch eine Beziehung zu diesem insbesondere in Wien hoch gefeierten Bildhauer der Aufklärung.

Im Jahr 1988 erwarb das Liebieghaus ein Werk Franz Xaver Messerschmidts, die »Büste eines bärtigen, alten Mannes«. Unter anderem aus der Beschäftigung mit diesem Werk erwuchs elf Jahre später im Städel Museum aus Anlass des Goethe-Jahres die Ausstellung »Mehr Licht. Europa um 1770 – Die bildende Kunst der Aufklärung«. Das erste Werk Messerschmidts hatte Frankfurt allerdings bereits knapp 190 Jahre früher, im Jahr 1799, erreicht: Von dem 1768 geschaffenen Grabmal des aus Frankfurt gebürtigen Wiener Reichshofrats Heinrich Christian von Senckenberg hat sich nach mehrfachem Standortwechsel heute jedoch nur noch die Grabinschrift im Innenhof des Bürgerhospitals erhalten; von dem zugehörigen Porträtmedaillon fehlt jede Spur.

Messerschmidt, 1736 im schwäbischen Wiesensteig geboren, Neffe des bedeutenden Rokokobildhauers Johann Baptist Straub,

Foreword

The special privileges of a new director include unexpected discoveries and the fulfilment of long cherished dreams. I grew up in Vienna in a flat very near the Belvedere. How many times I used to accompany – not always of my own volition – my parents to the collection of the Österreichische Galerie housed there. Only one room made a lasting impression on me: the room with Franz Xaver Messerschmidt's Character Heads. Much later I made several tentative attempts at realising a Messerschmidt exhibition but they did not prove viable. Now finally, after nine months as director of the Liebieghaus, my being in a position to mount an exhibition of the Character Heads rests on three serendipitous factors: the Liebieghaus possesses an important work by Messerschmidt; a curator here is a distinguished specialist in the work of that extraordinary sculptor and, finally, Frankfurt also has links with him.

In 1988 the Liebieghaus acquired a work of Franz Xaver Messerschmidt's, his "Bust of A Bearded Old Man". Eleven years later, an exhibition at the Städel Museum grew out of a preoccupation with that work on the occasion of the Goethe Year: "Mehr Licht. Europa um 1770 – Die bildende Kunst der Aufklärung". The work by Messerschmidt in fact reached Frankfurt about 190 years earlier, in 1799: the tombstone, dating from c. 1768, of the Viennese Reichshofrat Heinrich Christian von Senckenberg, a native of Frankfurt, having been moved about several times, all that remains is the epitaph in the inner courtyard of the Bürgerhospital; all trace of the portrait medallion has vanished.

Messerschmidt, born in Wiesensteig, Swabia, in 1736 and nephew of the important Rococo sculptor Johann Baptist Straub, learned the basics of his craft in Munich under his uncle before moving to Vienna in about 1755 to complete his training at the Academy there. He lost no time in receiving commissions from the court. For a decade, since completion of his portraits of the Emperor and Empress in 1760, Messerschmidt was also greatly admired by the imperial family. Then, however, he failed in his career as an academician; even his attempt at establishing himself in Munich was unsuccessful. Finally, in 1777, he

erlernte in München bei seinem Onkel die Anfangsgründe der Bild-
hauerei, ehe er sich um 1755 nach Wien wandte, um an der dortigen
Akademie seine Ausbildung zu vollenden. Schnell erhielt der junge
Bildhauer Aufträge für den Hof. Ein Jahrzehnt lang, seit den 1760
entstandenen Porträts des kaiserlichen Paars, war Messerschmidt
auch vom Kaiserhaus hoch geschätzt. Dann aber scheiterte seine
akademische Karriere in Wien; auch der Versuch, in München Fuß
zu fassen, war erfolglos. Schließlich ließ er sich 1777 in Preßburg,
bis 1780 habsburgischer Regierungssitz in Ungarn, nieder, wo er
1783 im Alter von 47 Jahren starb.

Zu den berühmtesten Werken Messerschmidts zählen die
Charakterköpfe, die der Bildhauer selbst nur »Köpfe« oder »Köpf-
Stückhe« nannte. Die Konfrontation mit den grimassierenden,
clownesken, schreienden, lachenden, starrenden, schnüffelnden
Köpfen und ihre kraftvolle, gelegentlich nahezu gewalttätige Aus-
strahlung ist bis heute ein einzigartiges Erlebnis. Ihre Mimik, die
gleichzeitig irreal und natürlich ist, löst Befremden und zugleich
Faszination aus.

Unsere Ausstellung unternimmt nun den Versuch, die um
1770 geschaffenen Porträts bedeutender Aufklärer, in denen Messer-
schmidt mit dem traditionellen Formenkanon bricht, mit den Cha-
rakterköpfen zu verbinden. Eine neu aufgefundene und Messer-
schmidt zugeschriebene Büste stellt dabei das bisher fehlende
Verbindungsglied zwischen den Porträts beispielsweise eines Gerard
van Swieten und den Charakterköpfen dar. Ferner soll der Versuch
unternommen werden, den Intentionen des Künstlers durch eine
genaue Analyse der Werke und durch Fragen nach ihrer Position im
zeitgenössischen Diskurs zu Antike, Leidenschaftsdarstellungen und
der Seele des Menschen näher zu kommen.

Ohne die großzügige Bereitschaft von Privatsammlern und
Museen, uns bedeutende Meisterwerke auszuleihen, hätte sich unser
Vorhaben nicht verwirklichen lassen. Von Beginn versicherten uns
bedeutende Sammlungen ihre Unterstützung. Wir danken sehr der
Österreichischen Galerie Belvedere Wien, der Kunstkammer des
Kunsthistorischen Museums Wien und dem Wien Museum ebenso
wie der Galéria mesta Bratislavy in Bratislava, dem Szépmüvészeti
Múzeum in Budapest, dem Bayerischen Nationalmuseum, Mün-
chen, dem Germanische Nationalmuseum, Nürnberg, dem
Landesmuseum Württemberg, Stuttgart, und dem Liechtenstein
Museum. Die Fürstlichen Sammlungen, Wien. Größter Dank ge-
bührt auch den Privatsammlern, die ungenannt bleiben möchten,
für ihre Bereitschaft, sich von ihren Büsten Messerschmidts zu tren-
nen und sie für kurze Zeit in unsere Obhut zu geben.

Dr. Agnes Husslein und Dr. Michael Krapf vermittelten den
Kontakt zu Privatbesitzern, die uns bereitwillig Zugang zu ihren

settled in Pressburg (Bratislava), which until 1780 was
the seat of the Habsburg government in Hungary,
where he died in 1783 at the age of 47.

Messerschmidt's most celebrated works are the
Character Heads, which the sculptor himself only
called "Heads" or "Head Pieces". Being confronted
with those grimacing, clownish, screaming, laughing,
glaring, sniffing Heads and their powerful, occasion-
ally even overwhelming, aura is still a uniquely stag-
gering experience. Their facial expression, at once
unreal and natural, is both disconcerting and fasci-
nating.

The present exhibition represents an attempt at
linking the portraits, executed c. 1770, of important
exponents of the Enlightenment, in which Messer-
schmidt had broken with the traditional canon of
forms, with the Character Heads. A newly discovered
bust attributed to Messerschmidt represents the hith-
erto missing link between the portraits, such as that
of Gerard van Swieten, and the Character Heads. A
further aim of the exhibition is to approach more
closely the artist's intentions through precise analysis
of the works and through study of their position in
the discourse of their day on Antiquity, representa-
tions of the passions and the human soul.

Without those private collections and museums
who have so generously loaned important master-
pieces, our project could not have been realised. From
the outset, important collections assured us of their
support. We are very grateful indeed to the Österrei-
chische Galerie Belvedere, Vienna, the Kunstkammer
at the Kunsthistorisches Museum Vienna and the
Wien Museum as well as Galéria mesta Bratislavy in
Bratislava, the Szépmüvészeti Múzeum in Budapest,
the Bayerisches Nationalmuseum, Munich, the Ger-
manische Nationalmuseum, Nuremberg, the Landes-
museum Württemberg, Stuttgart, and the Liechten-
stein Museum. Die Fürstlichen Sammlungen, Vienna.
We are also greatly indebted to private collections
whose owners wish to remain anonymous.

Dr. Agnes Husslein and Dr. Michael Krapf
arranged the contacts to collectors, who unhesitating-
ly granted us access to their collections. We wish to
thank them for their services in ensuring these con-
tacts. Dr. Heike Höcherl placed all her competence

Sammlungen gewährten. Auch ihnen sei vielmals gedankt. Dr. Heike Höcherl unterstützte uns kompetent und engagiert bei der Vorbereitung und Gesamtredaktion des Katalogs. Sie bereicherte ebenso wie PD Dr. Axel Christoph Gampp, Dr. Frank Matthias Kammel, Prof. Dr. Thomas Kirchner und Dr. Ulrich Pfarr unseren Katalog um Essays, in denen neue Erkenntnisse über die Charakterköpfe und Messerschmidts bildhauerische Intentionen festgehalten sind.

Zur erfolgreichen Realisierung dieses aufwendigen Ausstellungsvorhabens haben auch unsere Partner aus der Wirtschaft entscheidend beigetragen. Unser besonderer Dank gilt der Škoda Auto Deutschland GmbH, die wir als Hauptsponsor gewinnen konnten. Im Besonderen danke ich hierbei Alfred E. Rieck, Nikolaus Reichert und Christoph Ludewig für ihr konsequentes Engagement für die Kunst – ein Engagement, das weit über eine ausschließlich finanzielle Unterstützung hinausgeht. Die Stadt Frankfurt hat diese Ausstellung wesentlich gefördert, hierfür gilt unser Dank insbesondere dem Kulturdezernenten Prof. Dr. Felix Semmelroth. Auch freue ich mich, dass die Ausstellung dieses großen österreichischen Künstlers von der Europäischen Zentralbank und der Nationalbank Österreich innerhalb der »Kulturtage der Europäischen Zentralbank – Österreich 2006« mit gefördert wird. Dafür danke ich Dr. Klaus Liebscher, Schirmherr der »Kulturtage der EZB« und Gouverneur der Österreichischen Nationalbank, sowie Helga Meister und Gerald Grisse von der EZB. Für das Liebieghaus ist es auch eine große Freude, dass S. E. Dr. Christian Prosl, Botschafter der Republik Österreich in Berlin, »Die phantastischen Köpfe des Franz Xaver Messerschmidt« mit eröffnet und begleitet. Danken möchte ich auch der Fazit-Stiftung für die finanzielle Unterstützung des umfangreichen Kataloges. Als Medienpartner der Ausstellung konnten wir hr2-Kultur gewinnen.

Danken möchte ich insbesondere natürlich Dr. Maraike Bückling, Sammlungsleiterin für Renaissance bis Rokoko am Liebieghaus, Messerschmidt-Expertin und Kuratorin dieser wichtigen Ausstellung. Sie hat mit außerordentlichem Einsatz, ihrem Wissen und ihrer großen Überzeugungskraft sowohl das Konzept der Ausstellung als auch des Katalogs entwickelt. Dank gebührt auch zahlreichen anderen Mitarbeitern, die sich mit Enthusiasmus, Können und Kreativität um die Ausstellung kümmerten: Cordula Kähler nahm sich aller restauratorischen Belange an; Katja Hilbig und Mirga Nekvedavicius betreuten zuverlässig den Leihverkehr und überwachten den Transport der Leihgaben, der von der Firma Schenker durchgeführt wurde. Dr. Heike Höcherl und Mirga Nekvedavicius kümmerten sich unter Mithilfe von Stefanie Adam, Susanne Katzer und Hanna Martin um die Photoredaktion. Caroline Gabbert verfasste das Schülerheft und organisierte zusammen

and commitment at our disposal in the preparation and editing of the catalogue. She, in company with PD Dr. Axel Christoph Gampp, Dr. Frank Matthias Kammel, Prof. Dr. Thomas Kirchner and Dr. Ulrich Pfarr, enriched our catalogue with essays dealing with new knowledge of the Character Heads and Messerschmidt's intentions with regard to sculpture.

Our business partners have made a crucial contribution to the successful realisation of this complex exhibition project. Our special thanks to Škoda Auto Deutschland GmbH, who agreed to being our main sponsor. Here I should like to thank Alfred E. Rieck, Nikolaus Reichert and Christoph Ludewig in particular for the staunch commitment they have shown to art – commitment above and beyond financial backing. The city of Frankfurt has made a substantial contribution to this exhibition, for which we should like to express our special thanks, in particular to Prof. Dr. Felix Semmelroth, the head of the Cultural Affairs Department. And I am also delighted that the exhibition devoted to this great Austrian artist has been supported by the European Central Bank and the Austrian Central Bank under the auspices of the "Kulturtage der Europäischen Zentralbank – Österreich 2006". For this I thank Dr. Klaus Liebscher, patron of "Kulturtage der EZB" and governor of the Austrian Central Bank, as well as Helga Meister and Gerald Grisse of the European Central Bank. The Liebieghaus is also delighted that His Excellency Dr. Christian Prosl, Ambassador of the Republic of Austria to Berlin, will be helping to inaugurate and accompany "The Fantastic Heads of Franz Xaver Messerschmidt". I am also grateful to the Fazit Foundation for providing financial support for this comprehensive catalogue. We have been fortunate in enlisting hr2-Kultur as media partners of the exhibition.

I should also like to express my particular thanks to Dr. Maraike Bückling, Head Curator of the Renaissance to Rococo Collection at the Liebieghaus, Messerschmidt expert and curator of this important exhibition. With extraordinary dedication, knowledge and persuasiveness, she has developed the concept of both the exhibition and the catalogue. We also thank all those others who have been involved with the exhibition with such enthusiasm, expertise and cre-

mit Anne Sulzbach begleitende Veranstaltungen. Eine Ausstellung braucht zudem Öffentlichkeit, die von Dorothea Apovnik und Eva Ehninger, die den Kontakt zur Presse betreuten, und von Dr. Melanie Damm, die sich unter Mithilfe von Bernadette Seidler des Marketings annahm, hergestellt wurde. Inka Drögemüller hielt, zusammen mit Julia Lange und Katharina Simon, den Kontakt zu den Sponsoren. Ihnen allen sei sehr herzlich gedankt.

Großer Dank gebührt gleichfalls allen, die der Ausstellung gestalterisch ein Gesicht gaben: den Architekten Nikolaus Hirsch, Michel Müller und Daniel Dolder, dem Grafikbüro Heine / Lenz / Zizka, das den Katalog und die Werbemittel für die Ausstellung gestaltete. Hinter den Kulissen wirkte Stephan Zimmermann und rückte die Ausstellung ins rechte Licht. Milorad Petrovic, Alfons Pfeiffer, Peter Pludra und Heinz Urban kümmerten sich um alle handwerklichen Belange. In der Verwaltung unterstützten uns Heinz-Jürgen Bokler, Brigitte Gaebe, Adelheid Felsing, Ursula Körner und Doris Rösch-Becker. Bettina Schmitt sei für Korrekturlesen, PD Dr. Norbert Eschbach für die Unterstützung bei der Herstellung von photographischen Vorlagen und die Hilfe bei der Bildbearbeitung gedankt. Schließlich ist der Hirmer Verlag und hier insbesondere Albert Hirmer, Kerstin Ludolph, Karen Angne, Ines Dickmann, Sabine Golde, Arne Laub und Michael Scuffil zu nennen, deren Professionalität und Engagement ganz wesentlich zum Gelingen des Katalogs beitrugen.

Max Hollein
Direktor

ativity: Cordula Kähler has dealt with all restoration-related issues; Katja Hilbig and Mirga Nekvedavicius dependably supervised the loan of objects and the logistics of transport, which was carried out by Schenker Deutschland AG. Supported by Susanne Orth, Stefanie Adam and Hanna Martin, Dr. Heike Höcherl and Mirga Nekvedavicius were responsible for editing the photographic material. Caroline Gabbert wrote the school brochure and, with Anne Sulzbach, has co-organised accompanying events. An exhibition needs public relations, which in the present instance have been capably handled by Dorothea Apovnik and Eva Ehninger as our press liaison team, and by Dr. Melanie Damm, who, aided by Bernadette Seidler, has been responsible for marketing. Inka Drögemüller, with Julia Lange and Katharina Simon, has been in charge of liaison with our sponsors. Our heartfelt thanks to all of you.

We are also grateful to all those who have had a hand in designing the exhibition: architects Nikolaus Hirsch, Michel Müller and Daniel Dolder, the graphic design practice Heine / Lenz / Zizka responsible for designing the catalogue and the advertising for the exhibition. Stephan Zimmermann worked behind the scenes to ensure public awareness of the exhibition. Milorad Petrovic, Alfons Pfeiffer, Peter Pludra and Heinz Urban were responsible for the hands-on side of setting up the exhibition. From the administration side, we have been unswervingly supported by Heinz-Jürgen Bokler, Brigitte Gaebe, Adelheid Felsing, Ursula Körner and Doris Rösch-Becker. We should like to thank Bettina Schmitt for reading the proofs and PD Dr. Norbert Eschbach for his support in preparing the photographs for printing and his help in processing them. Finally, we thank Hirmer Verlag, and here we should like to mention in particular Albert Hirmer, Kerstin Ludolph, Karen Angne, Ines Dickmann, Sabine Golde, Arne Laub and Michael Scuffil, whose professionalism and commitment have contributed so substantially to making this catalogue a success.

Max Hollein
Director

Heike Höcherl

Der »Hogarth der Plastik« [1]

Vita und Werk des Bildhauers
Franz Xaver Messerschmidt

Als »Ungarns Koustou« wurde Messerschmidt kurz nach seinem Tod im Jahre 1783 geehrt. Bereits zuvor hatte einer der bedeutendsten Aufklärer Wiens, Franz Christoph von Scheyb (1704–1777), ihn als einzigartigen Bildhauer und als »Deutschlands Quesnoy« hervorgehoben.[2] Die Verknüpfung mit dem Werk herausragender Künstler Frankreichs, mit den Bildhauern François Duquesnoy (1597–1643) und Guillaume Coustou (1677–1746), verleiht einer hohen Anerkennung Ausdruck, die Messerschmidt mit seinem von der Kunst der Antike und dem Studium der menschlichen Natur inspirierten Œuvre erlangte.

Seine Vereinnahmung sowohl von deutscher als auch von ungarischer Seite verweist auf die Eckdaten seines Lebens. 1736 wurde er im churbayerischen Wiesensteig nahe Ulm geboren, im Jahre 1783 verstarb er in Preßburg, dem heutigen Bratislava, bis 1780 Regierungssitz der Habsburger in Ungarn. Hier wirkte er die letzten sechs Jahre seines Lebens. Den größten Teil seiner Schaffenszeit verbrachte Messerschmidt indes in Wien (1755–1775), wo er eine akademische Laufbahn einschlug und die Habsburger Kaiserfamilie in Bildnissen und Statuen verewigte, wobei er schließlich die höfische Porträttradition unterlief und neue Bildnistypen mit den Porträts bedeutender Gelehrter und Aufklärer prägte.

The "Hogarth of Sculpture" [1]

The Life and Work of the Sculptor
Franz Xaver Messerschmidt

Shortly after his death in 1783, Messerschmidt was honoured as "Hungary's Koustou". Even before that date, a leading exponent of the Enlightenment in Vienna, Franz Christoph von Scheyb (1704–1777), had identified Messerschmidt as a unique sculptor and "Germany's Quesnoy".[2] Linking Messerschmidt with the work of outstanding French artists, the sculptors François Duquesnoy (1597–1643) and Guillaume Coustou (1677–1746), expresses the high degree of recognition Messerschmidt had attained with his œuvre, which was inspired by the art of Antiquity and his studies of human nature.

His being claimed by both Germany and Hungary relates to the key facts of his life. Born in Wiesensteig near Ulm in the Electorate of Bavaria in 1736, he died in Pressburg, now Bratislava in Slovakia, but then the seat of the Habsburg government in Hungary, in 1783. There he spent the last six years of his life. For most of his active career (1755–1774), however, Messerschmidt lived in Vienna, where he embarked on a career at the Academy and immortalised the imperial Habsburgs in portrait busts and statues. In so doing, he subverted the court portrait tradition to coin new portrait types with likenesses of important scholars and exponents of the Enlightenment.

Apprenticeship years and success with earliest works from his own hand

Messerschmidt (fig. 1), scion of the widely ramified Straub family of artists, learned the profession of sculpting in Munich (1746–1752), at times in company with Ignaz Günther (1725–1775), from his uncle, the important court sculptor Johann Baptist Straub (1704–1784). After spending the next two years (1752–1754) in Graz in the sculpture workshop of Philipp Jakob Straub (1706–1774), a brother of Johann Baptist Straub's, Messerschmidt went to

Die Lehrjahre und der Erfolg mit ersten eigenen Werken

Messerschmidt (Abb. 1), Sprössling der weit verzweigten Künstlerfamilie Straub, erlernte den Bildhauerberuf in München (1746–1752), zeitweise gemeinsam mit Ignaz Günther (1725–1775), bei seinem Onkel, dem bedeutenden Hofbildhauer Johann Baptist Straub (1704–1784). Nach weiteren Jahren (1752–1754) in Graz in der Bildhauerwerkstatt von Philipp Jakob Straub (1706–1774), einem Bruder von Johann Baptist Straub, wandte er sich im Jahr 1755 nach Wien, um seine Ausbildung an der dortigen Akademie als Schüler von Balthasar Ferdinand Moll (1717–1785) und Jakob Christoph Schletterer (1699–1774) zu vervollständigen.[3] Seine außergewöhnliche Begabung erkannte Martin van Meytens (1695–1770), Hofmaler und Direktor der kaiserlichen Bildhauer- und Maler-Akademie. Als Mentor vermittelte er Messerschmidt um 1760 seine erste Anstellung als »Stuckverschneider« im kaiserlichen Zeughaus in Wien unter der Leitung von David Chapelle, der für seine Fertigkeit in der Gusstechnik bekannt war.[4] Im Auftrag des Feldmarschalls Joseph Wenzel I. Fürst von Liechtenstein fertigte Messerschmidt 1760 seine ersten offiziellen Bildnisse des Herrscherpaares

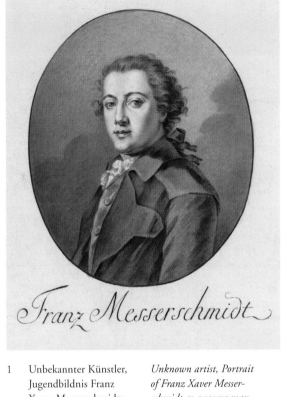

1 Unbekannter Künstler, Jugendbildnis Franz Xaver Messerschmidts, Tuschzeichnung, Österreichische Nationalbibliothek, Wien, Inv.-Nr. NB 501.617-C

Unknown artist, Portrait of Franz Xaver Messerschmidt as a young man, India ink drawing, Österreichische Nationalbibliothek, Vienna, Inv. no. NB 501.617-C

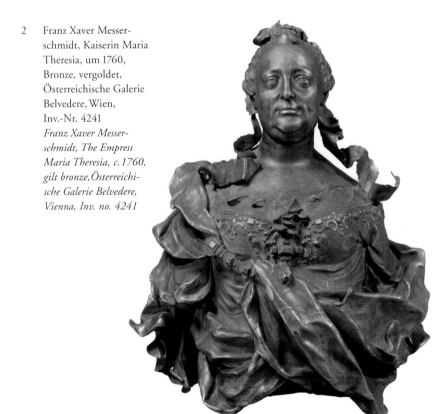

2 Franz Xaver Messerschmidt, Kaiserin Maria Theresia, um 1760, Bronze, vergoldet, Österreichische Galerie Belvedere, Wien, Inv.-Nr. 4241
Franz Xaver Messerschmidt, The Empress Maria Theresia, c. 1760, gilt bronze, Österreichische Galerie Belvedere, Vienna, Inv. no. 4241

Vienna in 1755 to complete his training at the Academy there as a pupil of Balthasar Ferdinand Moll (1717–1785) and Jakob Christoph Schletterer (1699–1774).[3] Messerschmidt's exceptional talent was recognised by Martin van Meytens (1695–1770), painter to the court and director of the Imperial Sculpture and Painting Academy. As his mentor, van Meytens arranged a first exhibition for Messerschmidt in about 1760 as a "stucco cutter" in the Imperial Armoury in Vienna under the supervision of David Chapelle, who was known for his skill in casting techniques.[4] Commissioned by Field Marshal Joseph Wenceslas I, Prince of Liechtenstein, Messerschmidt executed in 1760 his first official portraits of the Emperor and Empress for the Kaisersaal in the Armoury. The colossal bronze busts of Maria Theresia (fig. 2) and her consort Francis Stephen of Lorraine

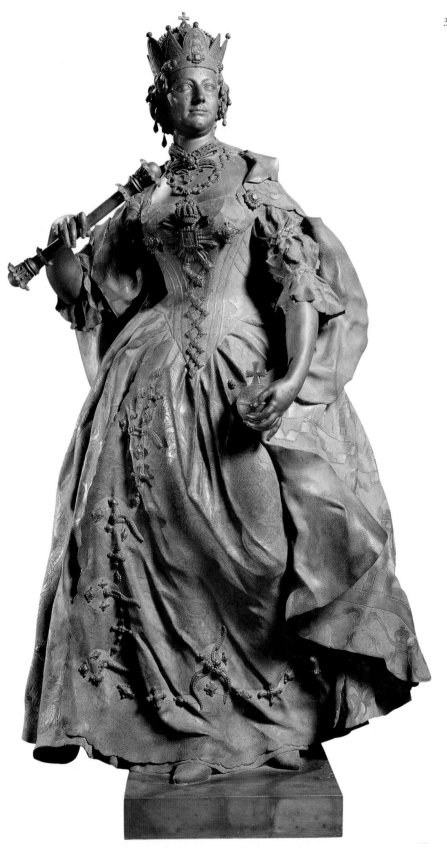

3 Franz Xaver Messer-
schmidt, Maria Theresia
als Königin von Ungarn,
um 1765, Zinn-Kupfer-
Legierung, Österrei-
chische Galerie Belvede-
re, Wien, Inv.-Nr. 2239
*Franz Xaver Messer-
schmidt, Maria Theresia
as Queen of Hungary,
c. 1765, tin-copper alloy,
Österreichische Galerie
Belvedere, Vienna,
Inv. no. 2239*

für den Kaisersaal im Zeughaus. Die kolossalen Bronzebüsten von Maria Theresia (Abb. 2) und Franz I. Stephan von Lothringen mit ihrer ausladend-üppigen Draperie und den Krönungsinsignien am Sockel[5] sind noch weitgehend dem barocken Pathos des Repräsentationsporträts verpflichtet. Im Bildnis der im Gegensatz zu ihrem Gatten eher zwanglos als herrschaftlich posierenden Kaiserin kontrastieren glatte und graphisch aufgelöste Oberflächenpartien, welche einen Eindruck von der individuellen und natürlichen Erscheinung der Herrscherin vermitteln.[6] In dieser Büste Maria Theresias zeichnet sich bereits eine neue, in der Gegenwart verankerte und zugleich zeitlose Porträtform ab, die Messerschmidt im Folgenden weiterentwickelt.

Die Anerkennung des Hofes sicherte sich der Künstler mit den beiden überlebensgroßen Porträtstatuen des Kaiserpaares. Um 1765 entwarf Messerschmidt im Auftrag der Kaiserin selbst eine Statue Maria Theresias (Abb. 3), die sie als Königin von Ungarn gleichermaßen jugendlich wie majestätisch, lebhaft-bewegt und starr zeigt. Mit der kontrastreich-komplexen Darstellung distanzierte sich der Künstler von den tradierten, auf Autorität und Repräsentation zielenden Herrscherporträts und fand zugleich zu einer neuen Form höfischer Bildnisse. Dieses einen »Hauch von Aufklärung«[7] versprühende Werk stieß auf Bewunderung bei der Dargestellten. Die Kaiserin beschenkte den Künstler »mit einem Gnadenpfennige und einer großen goldenen Medaille zu mehrerer Ermunterung aller Künstler«.[8]

Neben der Kaiserin fand Messerschmidt in Maria Theresia Felicitas Herzogin von Savoyen-Carignan, geborene Liechtenstein, die als Auftraggeberin bedeutender Kunstwerke zur kulturellen Blüte Wiens beitrug, eine Mäzenin. Nach Georg Raphael Donner (1693–1741) avancierte Messerschmidt zu ihrem bevorzugten Bildhauer. Sie beauftragte ihn 1766 zunächst mit der Anfertigung einer Statue der »Maria Immaculata«, die sich in einer Nische an der Fassade ihres Wiener Stadtpalais über einer von Putten getragenen Weltkugel befindet.[9] Kurze Zeit später verpflichtete sie Messerschmidt, zwei überlebensgroße Marmorstatuen der Heiligen Maria (Abb. 4) und des Heiligen Johannes (Abb. 5) für den Stephansdom umzuarbeiten. 1770 schuf Messerschmidt für den Innenhof ihres Palais, dem heutigen Savoyschen Damenstift, eine von zwei Löwen eingerahmte Brunnengruppe, deren Mittelpunkt, in Anspielung auf eine Bibelszene, die Figuren einer jungen Frau und zweier Kinder mit Wasserkrügen bilden. Neben religiöser Plastik für die Herzogin von Savoyen-Carignan wurde Messerschmidt von anderen Auftraggebern mit der Fertigung allegorischer Figuren[10] und Grabmälern betraut. Das heute nur noch unvollständig erhaltene Wandepitaph des aus Frankfurt stammenden Wiener Rechtsgelehrten Heinrich

(Emperor Francis I), with their flaring, lavish draperies and coronation insignia on the pedestal[5] are still largely indebted to the Baroque bathos which informed official Baroque state portraits. In the portrait of the Empress, who, unlike her spouse, has been portrayed in a pose more casual than regal, smooth surfaces contrast with areas that have been resolved in line, a graphic solution which conveys an impression of the natural appearance of the Empress as an individual.[6] A new approach to portraiture, at once timeless and anchored in the present, a form that Messerschmidt would further develop in the years that followed, is already revealed in this bust of Maria Theresia.

With these two larger than life-size portraits of the Emperor and Empress, the artist secured the recognition of the court. About 1765 Messerschmidt was commissioned by the Empress herself to execute a statue of her (fig. 3), which depicts her as Queen of Hungary, both youthful and majestic, vivacious yet rigid. In this sophisticated representation built on the tension of sharp contrasts, the artist has distanced himself from the traditional official portraits of rulers aimed at conveying the authority and ostentation of state. This work, emanating a "whiff of Enlightenment",[7] met with the sitter's admiration. The Empress presented the artist "with a gratuity and a large gold medal to further encourage all artists".[8]

Apart from the Empress, Messerschmidt found a patroness in Maria Theresia Felicitas, Duchess of Savoy-Carignan, née Liechtenstein, who contributed to the cultural flowering of Vienna by commissioning important works of art. After Georg Raphael Donner (1693–1741), Messerschmidt advanced to the status of her favourite sculptor. In 1766 she gave him his first commission, to make a statue of the "Maria Immaculata", which is in the alcove on the façade of her Viennese palace above an orb of the world carried by putti.[9] Not long afterwards she commissioned Messerschmidt to work over two larger than life-size statues of the Virgin (fig. 4) and St John (fig. 5) for St Stephen's Cathedral. In 1770 Messerschmidt created a fountain group consisting of the figures of a young woman and two children with oil-pitchers at the centre, alluding to a biblical scene, and framed by two

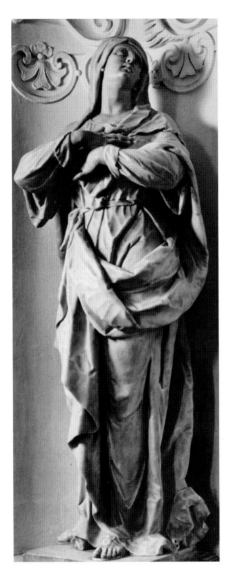

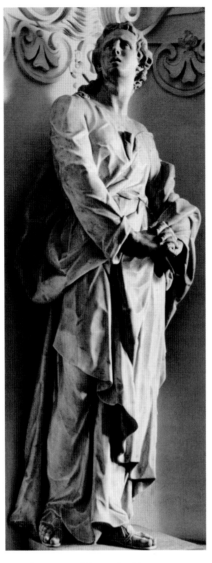

4 Franz Xaver Messerschmidt,
 Heilige Maria, 1768,
 Marmor, St. Stephan, Wien
 Franz Xaver Messerschmidt,
 The Virgin Mary, 1768,
 marble, St Stephen's, Vienna

5 Franz Xaver Messerschmidt,
 Heiliger Johannes, 1768,
 Marmor, St. Stephan, Wien
 Franz Xaver Messerschmidt,
 St John, 1768, marble,
 St Stephen's, Vienna

lions for the inner courtyard of her palace, which is now the Savoyscher Damenstift. Beside devotional sculpture for the Duchess of Savoy-Carignan, Messerschmidt received commissions from other patrons for making allegorical figures[10] and gravestones. The wall epitaph of Heinrich Christian von Senckenberg (fig. 6), a Viennese legal scholar born in Frankfurt, dating from c.1768/69 has only partly survived but shows a relief medallion with the likeness of the deceased carried by two winged putti, which rested on a high pedestal with an inscription plaque and the Senckenberg coat of arms.[11]

Sojourn in Rome

Not long after finishing the prize-winning statue of the Empress and, as a result, basking in his first early successes with independently conceived works for the Viennese court and nobility, Messerschmidt went to Rome for some months,[12] probably early in 1765, on his own initiative and at his own expense – there were not yet any travel and study bourses for Rome in Austria; they were not officially introduced until 1772 at the Viennese Academy to put the seal on artists' training.[13] Scarcely more than anecdotal evidence has come down to us on the seven months or so he spent in Rome; they honed Messerschmidt's skills by enabling him to practise making copies from ancient works.[14] Which specific works his study of Antiquity involved[15] and in which media he worked[16] must remain just as much unresolved questions as what contacts he may have made with local artists or artists visiting from Austria, France and England (fig. 7). Several sources report that Messerschmidt was greatly admired by the Roman sculptor Filippo della Valle (1697–1768), erstwhile head of the Accademia di San Luca.[17] A contact like this would make it seem plausible that Messerschmidt may have encountered the French sculptors Claude Michel, called Clodion (1738–1814), and Jean-Antoine Houdon (1741–1828), who were working at that time as holders of bourses at the Académie de France in Rome, or that he at least received some impression of their sculpture.[18] Messerschmidt may also have met the English sculptor Joseph Nollekens (1737–1823), who was active in Rome between 1762 and 1770 and belonged to the

Christian von Senckenberg (Abb. 6) aus der Zeit um 1768/69 zeigte das von zwei Puttengenien getragene Reliefmedaillon mit dem Bildnis des Verstorbenen, das auf einem hohen Sockel mit Inschrifttafel und dem Senckenberg-Wappen ruhte.[11]

Der Rom-Aufenthalt

Kurz nach Beendigung der prämierten Statue der Kaiserin und damit eingebettet in seine ersten Erfolge mit selbständig konzipierten Werken für den kaiserlichen Hof und Hochadel in Wien, reiste

Messerschmidt wahrscheinlich Anfang 1765 auf eigene Initiative und Kosten für einige Monate nach Rom[12] – noch gab es in Österreich keine Romstipendien, diese wurden zur Besiegelung der Künstlerausbildung erst 1772 offiziell an der Wiener Akademie eingeführt.[13] Über seinen nur etwa siebenmonatigen Rom-Aufenthalt sind kaum mehr als Anekdoten überliefert; sie schmücken Messerschmidts handwerkliche Fertigkeit beim Kopieren von Antiken aus.[14] Auf welche Werke sich sein Antikenstudium konkret bezog,[15] und in welchen Medien er arbeitete,[16] muss genauso offen bleiben wie seine möglichen Kontakte zu den dort ansässigen oder aus Österreich, Frankreich und England angereisten Künstlern (Abb. 7). Mehrere Quellen berichten, dass Messerschmidt von dem römischen Bildhauer Filippo della Valle (1697–1768), der zeitweilig Princeps der Accademia di San Luca war, hoch geschätzt wurde.[17] Ein solcher Kontakt würde es durchaus plausibel machen, dass der Künstler mit den zeitgleich als Stipendiaten an der Académie de France arbeitenden französischen Bildhauern Claude Michel, genannt Clodion (1738–1814), und Jean-Antoine Houdon (1741–1828) zusammentraf oder zumindest einen Eindruck von ihrer bildhauerischen Arbeit erhielt.[18] Auch der englische Bildhauer Joseph Nollekens (1737–1823), der von 1762–1770 in Rom wirkte und

circle of artists working for Cardinal Albani.[19] It is equally conceivable that Messerschmidt and Johann Joachim Winckelmann (1717–1768) may have run across each other there.

In autumn 1766 Messerschmidt left Rome and journeyed back to Vienna.[20] First he finished the statue of the Emperor Francis I, which was set up as the companion piece to his statue of the Empress in the imperial painting gallery in the Stallburg and, from 1773, in the Unterer Belvedere.[21] Another commission from the court followed in 1767, to execute a life-sized bust of the crown prince, Joseph II (fig. 8), for which the artist's study of Greco-Roman as well as French sculpture may well have given the impetus.[22]

Breakthrough as an artist

The statue of the Empress and the bust of her son represented a new direction in court portraiture. In any case, Messerschmidt's subsequent development as an artist by the late 1760s and early 1770s can be traced mainly in the portraits he executed of scholarly contemporaries, who had left the court ideals far behind them and espoused the thinking of the Enlightenment. The important men of the Enlightenment and scholars who had Messerschmidt take their portraits included not only Franz Anton Mesmer, Gerard van Swieten and Friedrich Nicolai but also the art theorist Franz von Scheyb. In the 1769 bust of von Scheyb (fig. 9), Messerschmidt made his first clean break with the traditional portrait formula to depict the scholar, devoid of all embellishments alluding to the sitter's age or status, as a self-confident individual, looking straight ahead in full frontal pose.[23]

The portrait bust of Franz von Scheyb, a lead bust of Martin van Meytens (now lost) and a plaster relief of "Ulysses Discovering Achilles amidst the Women" (also lost) enabled Messerschmidt to become a member of the Viennese Academy of the Arts on 30 January 1769.[24] Two months later, in March 1769, Messerschmidt submitted a "bustum" of clay to the rival institution, the Royal and Imperial Copperplate Engravers' Academy, which the assessors, Jakob Schmutzer and Joseph von Sonnenfels, praised as a work by an artist of "exceptional skill and refined taste" and requested a cast of it "in soft material […]

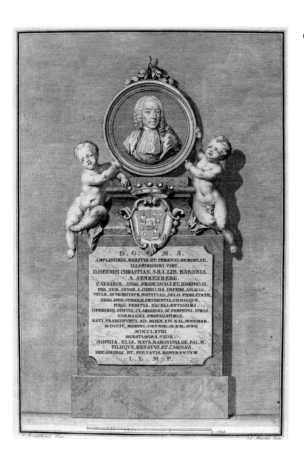

6 Johann Ernst Mansfeld, Grabmal für den Reichshofrat Heinrich Christian von Senckenberg, 1782, Kupferstich, Dr. Senckenbergische Stiftung, Frankfurt am Main (in: Renatus de Senckenberg, »Vita Henrici Christiani L. B. de Senckenberg«, Franckfurt. A. M. 1782, Beiblatt)
Johann Ernst Mansfeld, tomb for Reichshofrat Christian von Senckenberg, 1782, copperplate engraving, Dr. Senckenbergische Stiftung, Frankfurt am Main (in: Renatus de Senckenberg, "Vita Henrici Christiani L. B. de Senckenberg", Frankfurt. A. M. 1782, supplement)

17

7 Giovanni Domenico
 Campiglia, Kunststu-
 denten beim Zeichnen
 und Modellieren nach
 der Antike im Kapitol,
 Stich, Bibliothèque
 nationale, Paris, Inv.-Nr.
 Musei Capitolini – tome
 3/Ab 3 pet fol/fol. 5
 Giovanni Domenico
 Campiglia, Art Students
 Drawing and Modelling
 after Antiquity on the
 Capitol, engraving,
 Bibliothèque nationale,
 Paris, Inv. no. Musei
 Capitolini – Vol. 3/Ab 3
 pet fol / fol. 5

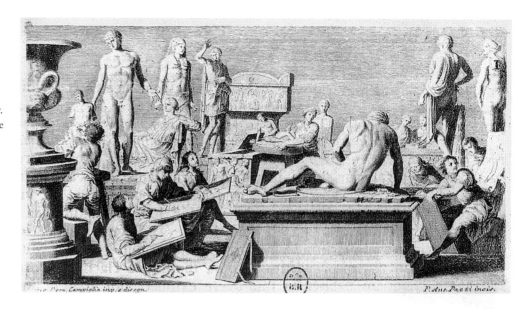

zum Kreis der für den Kardinal Albani arbeitenden Künstler gehör-te,[19] könnte Messerschmidt begegnet sein. Vorstellbar ist ebenso ein Zusammentreffen von Messerschmidt und Johann Joachim Winckelmann (1717–1768).

Im Herbst 1766 verließ Messerschmidt Rom und reiste zurück nach Wien.[20] Dort stellte er zunächst die Statue des Kaisers Franz Stephan von Lothringen fertig, die als Pendant zum Standbild der Kaiserin in der kaiserlichen Gemäldegalerie in der Stallburg und ab 1773 im Unteren Belvedere aufgestellt wurde.[21] Als weiterer Auftrag des Hofes schloss sich im Jahre 1767 die Gestaltung der lebens-großen Büste des Thronfolgers Joseph II. (Abb. 8) an, für die mög-licherweise die Auseinandersetzung des Künstlers mit der Skulptur der Antike wie auch mit französischen Vorbildern impulsgebend gewirkt hat.[22]

Der künstlerische Durchbruch

Stellten bereits die Statue der Kaiserin und auch das Bildnis ihres Sohnes ein Novum in der höfischen Porträtkunst dar, so wird Messerschmidts künstlerische Entwicklung Ende der 1760er und zu Beginn der 1770er Jahre vor allem in Bildwerken gelehrter Zeit-genossen, die die Ideale des Hofes zugunsten aufklärerischer Gedan-ken weit hinter sich ließen, evident. Unter den bedeutenden Aufklä-rern und Wissenschaftlern, die sich vom Künstler porträtieren ließen, befand sich neben Franz Anton Mesmer, Gerard van Swieten und Friedrich Nicolai auch der Kunstschriftsteller Franz von Scheyb. In seiner Büste von 1769 (Abb. 9) brach Messerschmidt erstmals konsequent mit der traditionellen Porträtformel und zeigte den

in order to increase the admirable works in their col-lection."[25] The bust of Franz von Scheyb and the now unknown "bustum" can be compared to the portraits of the two physicians and enlightened thinkers Franz Anton Mesmer (1770, fig. 10) and Gerard van Swie-ten (1770–1772, cat. no. 1). The features all these works have in common are a simple pedestal and a reduced chest section of an unclothed man, in whose face the individual is recognisable and depicted in a manner that is at once candid, contemporary and timeless.[26]

Messerschmidt was lauded in enlightened circles in Vienna for his reformulation of the portrait bust. On 1 September 1769, he was appointed "substitute professor" of sculpture, that is, assistant to the profes-sor, by court painter Martin van Meytens. At the same time, he was offered the prospect of being appointed to the next professorship to become vacant.[27] More-over, his teaching at the Academy authorised him to train pupils, among them Anton Grassi (1755–1807).[28] Messerschmidt probably also taught in the workshop of the house in Vienna he had acquired in 1770 at what is now no. 5, Ungargasse (fig. 11). There Messer-schmidt lived very close to the home of the physician Franz Anton Mesmer, for whose garden he made a fountain group.[29] On this last, the "Wienerisches Diarium" newspaper commented in 1770 that the

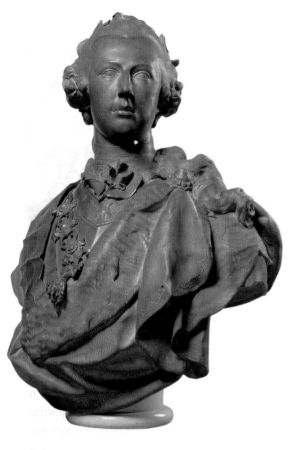

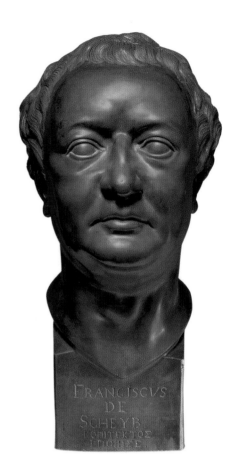

8 Franz Xaver Messer-
schmidt, Joseph II.,
1767, Zinn-Kupfer-
Legierung, Kunsthisto-
risches Museum, Wien,
Kunstkammer,
Inv.-Nr. 5476
*Franz Xaver Messer-
schmidt, Joseph II, 1767,
tin-copper alloy, Kunst-
historisches Museum,
Vienna, Kunstkammer,
Inv. no. 5476*

9 Franz Xaver Messer-
schmidt, Franz von
Scheyb, 1769, Blei,
Wien Museum,
Wien, Inv.-Nr. 95477
*Franz Xaver Messer-
schmidt, Franz von
Scheyb, 1769, lead,
Wien Museum, Vienna,
Inv. no. 95477*

Gelehrten, entledigt von jeglichem zeit- und statusbezogenen Bei-
werk, als selbstbewusstes Individuum frontal nach vorne blickend.[23]

Das Bildnis des Franz von Scheyb gehörte mit einer heute ver-
schollenen Bleibüste des Martin van Meytens und dem gleichfalls
verschollenen Gipsrelief »Wie Ulysses den Achilles unter den Frau-
enzimmern entdecket« zu den Aufnahmestücken, mit denen Mes-
serschmidt am 30. Januar 1769 die Mitgliedschaft der Akademie der
bildenden Künste in Wien erwarb.[24] Zwei Monate später, im März
1769, reichte der Bildhauer bei der Konkurrenzinstitution, der k. k.
Kupferstecherakademie, ein »Bustum« aus Ton ein, das die Juroren
Jakob Schmutzer und Joseph von Sonnenfels als Werk eines Künst-
lers von »unterscheidender Geschicklichkeit und geläuterten
Geschmack« lobten und seinen Guss »in weichem Material« forder-
ten, »um damit die schätzbaren Werke ihrer Samlung zu vermeh-
ren«.[25] An die Seite der Büste Franz von Scheybs und dem heute
unbekannten »Bustum« lassen sich die Bildnisse der beiden Aufklä-
rer und Mediziner Franz Anton Mesmer (1770, Abb. 10) und
Gerard van Swieten (1770–1772, Kat.-Nr. 1) stellen. Sie alle verbin-
det ein einfacher Sockel und reduzierter Büstenabschnitt eines ent-
kleideten Mannes, in dessen Gesicht das Individuum erkennbar
und ehrlich, gegenwärtig und zeitlos zugleich geschildert wird.[26]

thinking behind the work derived from nature, that it
was grounded in "simplicity and truth" and "in short,
the entire work attests to the artist's high intelligence
and just understanding of beauty."[30]

From the highest academic honours to loss of favour

The recognition Messerschmidt enjoyed as an artist,
both from the Academy and the Empress, was at its
height in the early 1770s. However, in November
1772 Messerschmidt was not appointed professor
when the merger, initiated by Kaunitz, of the three
existing academies to form the Royal and Imperial
Academy of the Fine Arts went through and new
instructors were hired.[31] Nor did his justified hopes of
succeeding Jakob Christoph Schletterer, a professor of
sculpture who died in 1774, come to anything.[32] The
reasons for the failure of Messerschmidt's academic
career seem, in the first place, to have begun with the
artist's becoming ill.[33] In statements written by Chan-
cellor Kaunitz in 1774, Messerschmidt's exclusion

10 Franz Xaver Messer-
 schmidt, Franz Anton
 Mesmer, 1770, Blei,
 Leihgabe aus Privatbesitz
 in der Österreichischen
 Galerie Belvedere, Wien,
 Inv.-Nr. Lg 1150
 Franz Xaver Messer-
 schmidt, Franz Anton
 Mesmer, 1770, lead,
 loaned by a private collec-
 tion to the Österreichische
 Galerie Belvedere,
 Vienna, Inv. no. Lg 1150

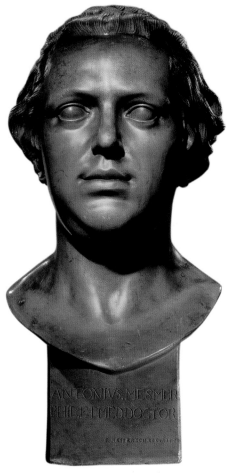

from university activity is justified by the artist's "ambivalent state of health" and "confusion of mind".[34] Whether these "peculiar quirks of the imagination" can be interpreted as symptoms of a serious mental illness which at times made the artist incapable of work can today no longer be reconstructed beyond doubt.

No commissions are recorded for the years 1770 and 1771. A contributing factor must certainly be the deaths of several of his most important patrons between 1770 and 1772: Martin van Meytens (1695–1770), Maria Theresia Felicitas, Duchess of Savoy-Carignan, née Liechtenstein (1694–1772) and Joseph I Wenceslas, Prince of Liechtenstein (1696–1772). This dearth of commissions coincides with the onset of work on what are called the Character Heads, which would dominate Messerschmidt's creative activity for the rest of his life. Into them is probably distilled the explanation for the artist's involuntary departure from the official art scene. So unsparing and so far from idealisation are these heads that they transgress all principles of style known up to then in the art of portraiture.[35] This must have disgusted Kaunitz, who entertained a conception of art, due to Winckelmann, as the epitome of "physical and moral perfection".[36] Messerschmidt infringed the academy guidelines with his Character Heads so that Kaunitz was able to exploit the mental disorder described, but still not unequivocally proved, to shut out the non-conformist artist.

Withdrawal from Vienna and final years in Bratislava

In 1774 Messerschmidt not only gave up his house; he also offered for sale in the "Wienerisches Diarium" of 6 April his "works of sculpture done both from Antiquity and from nature."[37] His feelings were so hurt that he rejected a pension and employment at the Imperial Building Office (Hochbauamt) offered in compensation for a teaching appointment.[38] In 1775 Messerschmidt turned his back on Vienna for good. After spending a few months in Wiesensteig, his birthplace, the artist went to Munich at the invitation of the court painter Johann Jakob Dorner (1741–1813) to become a sculptor to the Electoral

Für die Neuformulierung der Porträtbüste erfuhr der Bildhauer in den aufgeklärten Kreisen Wiens höchste Zustimmung. Am 1. September 1769 wurde er vom Hofmaler Martin van Meytens zum so genannten Substitutsprofessor, das heißt zum Assistenten des Professors, für Skulptur ernannt. Gleichzeitig wurde ihm die nächste freiwerdende Professorenstelle in Aussicht gestellt.[27] Seine Lehrtätigkeit an der Akademie autorisierte ihn zudem, Schüler auszubilden, darunter Anton Grassi (1755–1807).[28] Der Unterricht erfolgte wohl auch in der Werkstatt seines 1770 erworbenen Hauses in der heutigen Ungargasse 5 in Wien (Abb. 11). Messerschmidt wohnte damit in unmittelbarer Nähe zum Wohndomizil des Arztes Mesmer, für dessen Garten er eine Brunnengruppe schuf.[29] Zu dieser hieß es 1770 im »Wienerischen Diarium«, ihr Gedanke sei aus der Natur genommen, sie gründe sich auf »Simplicität und Wahrheit« und »Kurz: das ganze Werk zeugt von des Künstlers hohen Verstande und richtigem Begriffe von der Schönheit.«[30]

Von höchsten akademischen Ehren
zum Gunstverlust

Messerschmidts Anerkennung als Künstler sowohl seitens der Akademie als auch von der Kaiserin erreichte zu Beginn der 1770er Jahre einen Höhepunkt. Im November 1772 erhielt Messerschmidt jedoch keine Berufung als Professor, als die von Kaunitz initiierte Zusammenlegung der drei bestehenden Akademien zur k. k. vereinigten Akademie der bildenden Künste umgesetzt und neue Lehrkräfte verpflichtet wurden.[31] Auch seine berechtigte Erwartung, die Nachfolge des 1774 verstorbenen Bildhauerprofessors Jakob Christoph Schletterer antreten zu können, erfüllte sich nicht.[32] Die Gründe für Messerschmidts gescheiterte akademische Laufbahn scheinen zunächst in einer Erkrankung des Künstlers zu liegen.[33] In den von Staatskanzler Kaunitz verfassten Schriftstücken aus dem Jahre 1774 wird Messerschmidts Ausschluss aus dem Universitätsbetrieb mit seiner »zweydeutigen Gesundheit«, »einer zuweilen irrescheinenden Vernunft« und »Verwirrung im Kopfe« gerechtfertigt.[34] Ob diese »seltsamen Grillen in der Einbildung« als Symptome einer schwerwiegenden psychischen Krankheit zu verstehen sind, die den

11 J. D. von Huber, Messerschmidts Haus in Wien, Landstraße 93 (heute Ungargasse 5), aus der Luftperspektive, 1776, Kupferstich aus: »Scenographie« (Blatt W), Wien 1776, Wiener Stadt- und Landesarchiv, Wien

J. D. von Huber, Messerschmidt's House in Vienna, 93 Landstrasse (now 5 Ungargasse), bird's-eye view, 1776; copperplate engraving from: "Scenographie" (Sheet W), Vienna 1776, Wiener Stadt-und Landesarchiv, Vienna

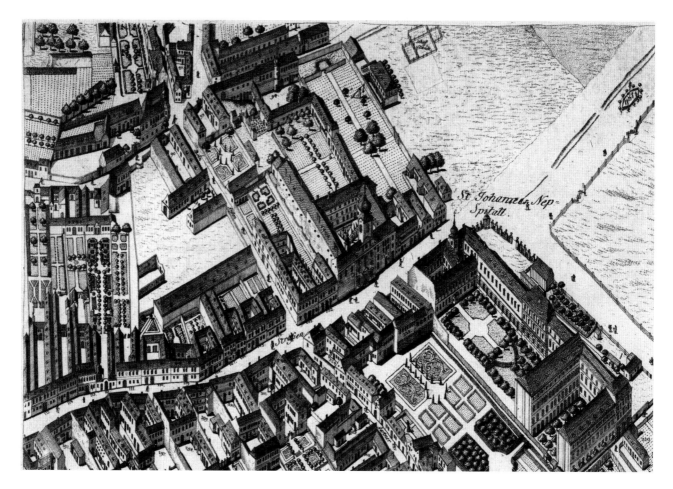

Künstler zeitweise arbeitsunfähig machten, kann heute nicht mehr zweifelsfrei rekonstruiert werden.

Für die Jahre 1770/71 sind keine Aufträge überliefert. Dieses lag sicherlich auch daran, dass mehrere seiner Gönner zwischen 1770 und 1772 starben: Martin van Meytens (1695–1770), Maria Theresia Felicitas Herzogin von Savoyen-Carignan, geborene Liechtenstein (1694–1772), und Fürst Joseph I. Wenzel von Liechtenstein (1696–1772). In dieses Auftragsvakuum fällt der Arbeitsbeginn an den so genannten Charakterköpfen, die Messerschmidts Schaffen bis zu seinem Tod dominierten. In ihnen kristallisiert sich wohl auch die Erklärung für das ungewollte Ausscheiden des Künstlers aus dem offiziellen Kunstbetrieb. In ihrer schonungslosen und unidealisierten Schilderung menschlicher Ausdrucksmöglichkeiten sprengten sie sämtliche Stilprinzipien einer bis dahin bekannten Bildniskunst.[35] Dieses musste den an Winckelmann orientierten Vorstellungen Kaunitz' von einer Kunst als Inbegriff »körperlicher und sittlicher Vollkommenheit« zuwiderlaufen.[36] Messerschmidt konterkarierte mit den Charakterköpfen die akademischen Richtlinien, so dass Kaunitz die beschriebene, aber bis heute nicht eindeutig nachweisbare Geistesverwirrtheit nutzte, um den nonkonformen Künstler auszuschließen.

12 Messerschmidts Haus *Messerschmidt's House*
 »Zum Hirschen« im *"Zum Hirschen" in the*
 Vorort Zuckermandel *Zuckermandel suburb*
 in Preßburg *of Bratislava*

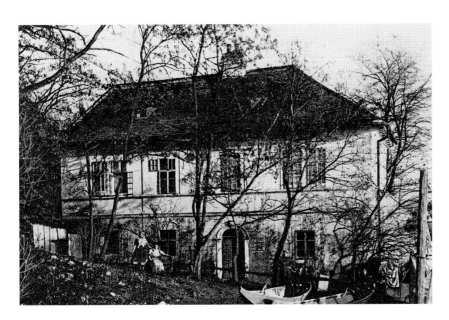

court of Bavaria. But these hopes, too, were dashed.[39] In 1777 Messerschmidt settled for the last six years of his life in Bratislava, known in german as Pressburg and then the capital of Hungary, where its kings were crowned, which was undergoing an economic and cultural upswing under Albert, Duke of Saxe-Teschen, the governor.[40] Messerschmidt profited from this state affairs on a modest scale and received commissions from persons of high rank, including busts of Count Batthyány and his wife and for a number of alabaster medallions.[41] The governor himself admired Messerschmidt, commissioning him to do a portrait of him in 1780 and even, it is recorded, trying to acquire the sequence of Character Heads from the artist.[42] Apart from the portrait busts of the Duke of Saxe-Teschen, probably the most important commission Messerschmidt received in the last phase of his active career, Messerschmidt made the busts of the Capuchin (cat. no. 3) and of the historian Martin Georg Kovachich (fig. 13) in the early 1780s. The portrait of Kovachich, which summarises the librarian's features and personality clearly, stringently and recognisably, links up where Messerschmidt left off with the portraits of his Viennese days, such as that of Franz von Scheyb (fig. 9).[43]

Messerschmidt's legacy

The focal point of the Bratislava phase of his career is the sequence of Character Heads which Messerschmidt worked tirelessly to complete for the rest of his life. This is attested to by numerous contemporaries who sought out the artist in the house he acquired in 1780 in Zuckermandel, a suburb of the city (fig. 12, 14). The roll of contemporaries who were so attracted by Messerschmidt's personality and work that they journeyed to Bratislava from all over Europe ranges from Christoph Ludwig Seipp, Messerschmidt's first biographer, and his fellow student Hans Rudolph Füessli through Heinrich Sebastian Hüssgen, a native of Frankfurt, and the Basel copperplate engraver Christian von Mechel to the Berlin Enlightenment figure Friedrich Nicolai.[44] The literary records of visits contradicts the social isolation which even today is imputed by numerous authors to the artist in his Bratislava years.[45] The picture of a recluse

Der Rückzug aus Wien und die letzten Lebensjahre in Preßburg

Im Jahr 1774 trennte sich Messerschmidt nicht nur von seinem Haus, er bot zudem im »Wienerischen Diarium« vom 6. April seine »sowohl antique als auch nach der Natur verfertigte Bildhauerarbeit« zum Verkauf an.[37] Die ihm anstelle des Lehramts angebotene Pension und Beschäftigung am Hochbauamt lehnte er gekränkt ab.[38] 1775 kehrte Messerschmidt Wien für immer den Rücken. Nachdem er mehrere Monate in seinem Geburtsort Wiesensteig verbrachte, reiste der Künstler auf ein Angebot des Hofmalers Johann Jakob Dorner (1741–1813) hin nach München, um churbayerischer Bildhauer zu werden. Doch auch diese Hoffnung erfüllte sich nicht.[39] 1777 ließ sich Messerschmidt für seine letzten sechs Lebensjahre in Preßburg, der damaligen Haupt- und Krönungsstadt Ungarns, nieder, die unter dem Statthalter Herzog Albert von Sachsen-Teschen eine wirtschaftliche und kulturelle Blüte erlebte.[40] Messerschmidt profitierte in bescheidenem Ausmaß davon und erhielt Aufträge hochrangiger Persönlichkeiten, sei es für Büsten des Grafen Batthyány und seiner Frau oder für eine Reihe von Alabastermedaillons.[41] Der Statthalter selbst schätzte Messerschmidt, er gab sein Bildnis bei ihm vor 1780 in Auftrag und versuchte angeblich, vom Künstler die Serie der Charakterköpfe zu erwerben.[42] Neben den Porträtbüsten des Herzogs von Sachsen-Teschen als wohl prominenteste Auftragsarbeiten der letzten Werkphase entstanden Anfang der achtziger Jahre die Büsten des Kapuziners (Kat.-Nr. 3) und des Historikers Martin Georg Kovachich (Abb. 13). Mit dem Bildnis des Kovachich, das die physiognomischen Eigenschaften des Bibliothekars klar, nüchtern und wiedererkennbar zusammenfasst, knüpfte Messerschmidt an seine Porträts aus der Wiener Zeit, wie etwa dem des Franz von Scheyb (Abb. 9), an.[43]

Messerschmidts Vermächtnis

Den Mittelpunkt seiner Preßburger Schaffenszeit bildete die Serie der Charakterköpfe, an deren Vervollständigung Messerschmidt bis zuletzt unermüdlich arbeitete. Davon berichteten zahlreiche Zeitgenossen, die den Künstler in seinem 1780 erworbenen Haus im Preßburger Vorort Zuckermandel (Abb. 12, 14) aufsuchten. Von Christoph Ludwig Seipp, dem ersten Biographen Messerschmidts, und seinem Studienkollegen Hans Rudolph Füeßli über den aus Frankfurt stammenden Heinrich Sebastian Hüssgen und dem Baseler Kupferstecher Christian von Mechel bis hin zum Berliner Aufklärer Friedrich Nicolai reichte das Spektrum der Zeitgenossen, die von Messerschmidts Persönlichkeit und Werk angezogen aus ganz Europa nach Preßburg reisten.[44] Die literarisch überlieferten Besuche widersprechen der gesellschaftlichen Isolierung, die dem Künst-

must be modified today and so must the notion of Messerschmidt as an impoverished artist leading a humble life and careless of money matters. He not only had a spacious house and an employee;[46] his estate also mentions some valuables. The 1783 inventory of his possessions, known as the "Specification deren Messerschmidischen Mobilien",[47] includes not only the hood Messerschmidt is wearing in his self-portrait as a laughing artist (cat. no. 4) but also a gold watch and several gold rings as well as a silver cane set with precious stones and quite a few silver-mounted pipes, pistols, clothing and furniture. This goes to show that the life Messerschmidt led was not as Spartan as his earliest biographers and interpreters represented it.[48] Like the "Specification", his will, which involved a considerable legacy, supports the idea of an artist who lived an ordered life and was certainly able to "earn his livelihood" from his art, as he put it himself on refusing the pension offered when he left the Academy.[49] Messerschmidt died quite suddenly on 21 August 1783, at the age of only forty-seven, probably of pneumonia.[50] The obituaries honour the artist and his "exceptional skills"; they dwell on his industry and his brilliance as fed by his study of Antiquity.[51] The "Wiener Zeitung" of 27 August 1783 concentrated on the "heads, which express in the most lively manner all sorts of passions and emotions and are admired by all connoisseurs." Messerschmidt's artistic legacy ranges from his portraits of the imperial family through the portrait busts of important 18th-century proponents of the Enlightenment to the "Head Pieces".[52] These fantastic heads with faces distorted by violent grimaces, which through the "immediacy of facial expression" and Messerschmidt's virtuoso ability to convince through "the face as the soul's field of expression"[53] have kept scholars in particular busy down to the present day. The 19th century perceived in them primarily what was odd and caricature-like, calling Messerschmidt the "Hogarth of sculpture".[54]

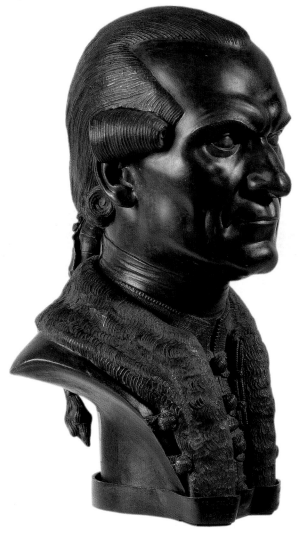

13 Franz Xaver Messer-
 schmidt, Martin Georg
 Kovachich, 1782, Zinn-
 Blei-Legierung, Szépmü-
 vészeti Múzeum, Buda-
 pest, Inv.-Nr. 8336
 *Franz Xaver Messer-
 schmidt, Marin Georg
 Kovachich, 1782,
 tin-lead alloy,
 Szépmüvészeti Múzeum,
 Budapest, Inv. no. 8336*

ler für seine Preßburger Jahre von zahlreichen Autoren bis heute
zugedacht wird.[45] Das Bild des in sich gekehrten Eremiten muss
heute genauso relativiert werden wie die Vorstellung von Messer-
schmidt als materiell anspruchs- und mittellosen sowie in Geld-
dingen unbedarften Künstler. Nicht nur, dass er über ein geräumi-
ges Haus verfügte und einen Mitarbeiter beschäftigte,[46] auch einige
wertvolle Dinge befanden sich in seinem Nachlass. Im Inventar
seiner Besitztümer, der so genannten »Specification deren Meßer-
schmidischen Mobilien«, von 1783[47] sind neben der Haube, die
Messerschmidt in seinem Selbstbildnis als lachender Künstler trägt
(Kat.-Nr. 4), eine goldene Uhr und mehrere Goldringe aufgeführt
ebenso ein mit Edelstein besetzter silberner Stock sowie Pfeiffen
mit Silberbeschlag, Pistolen, Kleidung und Möbel in größerem
Umfang. Messerschmidts Lebenssituation war damit nicht so spar-
tanisch, wie es von seinen ersten Biographen und Interpreten dar-
gestellt wurde.[48] Sein Testament, das ein beträchtliches Erbe um-
fasste, stützt wie die »Specification« das Bild eines Künstlers, der in

1 Wurzbach 1867, p. 447.
2 On "Hungary's Koustou" in Messerschmidt's obituary
 from the "Pressburger Musenalmanach auf das Jahr 1785"
 see Pötzl-Malíková 1982, p. 6. See Scheyb 1770, Vol. 2,
 pp. 93f. For Scheyb's writings on art theory see Scheyb
 1770, Scheyb 1774.
3 On the artist's apprenticeship years in Munich and Graz
 see Pötzl-Malíková 1982, p. 12, and Krapf, Leben und
 Werk 2002, p. 18. Messerschmidt's immatriculation in the
 Viennese Academy on 4 November 1755 is documented in
 Pötzl-Malíková 1982, p. 125 (Document II). It is question-
 able whether Messerschmidt also studied under Matthäus
 Donner (1704–1756), who, in addition to Moll and
 Schletterer, also taught at the Academy (Krapf, Leben und
 Werk 2002, p. 19).
4 See for instance Pötzl-Malíková 1982, pp. 19f.; Fanta
 2002, p. 130, and Krapf, Auftraggeber und Freundeskreis
 2002, p. 65.
5 See Krapf, Katalog 2002, pp. 140ff. (cat. nos. 1 and 2).
6 In the 1767 bust of Joseph II, the artist refined this excit-
 ing design by combining an entirely smoothed "surface
 contour" with an elaborate, finely chiselled rendering of
 intricate detail; see Bückling 1999b, p. 103.

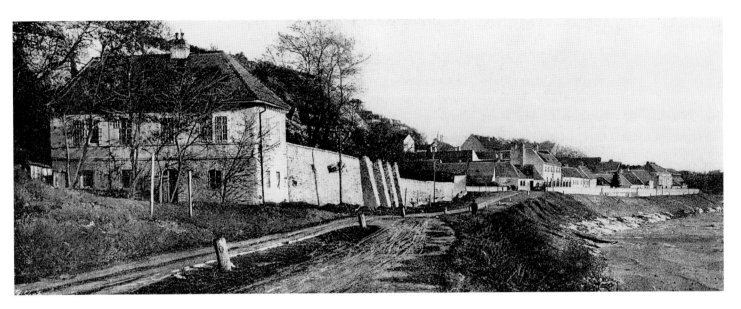

14 Messerschmidts Haus
»Zum Hirschen« im
Vorort Zuckermandel
und Umgebung
*Messerschmidt's House
"Zum Hirschen" in
Zuckermandel and
surrounding*

geordneten Verhältnissen lebte und sich von seiner Kunst durchaus
»ernähren« konnte, wie er es selbst formulierte, als er nach dem
Ausscheiden aus der Akademie eine Pension ablehnte.[49] Am 21. Au-
gust 1783 starb der 47-jährige Messerschmidt überraschend, wahr-
scheinlich an einer Lungenentzündung.[50] Die Nachrufe ehren den
Künstler und dessen »ausnehmenden Kunstfertigkeiten«, sie beto-
nen den Fleiß und seine sich aus dem Studium der Antike speisende
Genialität.[51] Die Wiener Zeitung vom 27. August 1783 fokussierte
die »Köpfe, die alle Arten von Leidenschaften und Rührungen auf
das Lebhafteste ausdrücken und von allen Kennern bewundert wer-
den«. Messerschmidts künstlerisches Vermächtnis spannt sich von
den Bildnissen der Kaiserfamilie über die Porträtbüsten bedeuten-
der Aufklärer des 18. Jahrhunderts bis zu den »Köpf-Stückhen«.[52]
Diese phantastischen Köpfe mit ihren von heftigen Grimassen ver-
zerrten Gesichtern, die durch »die Unmittelbarkeit des mimischen
Ausdrucks und durch die virtuose Fähigkeit Messerschmidts, ›das
Gesicht als Ausdrucksfeld der Seele‹ zu formen«[53] überzeugen, be-
schäftigen vor allem die Forschung bis heute. Das 19. Jahrhundert
hat in ihnen besonders das Kuriose und Karikaturhafte wahrgenom-
men und Messerschmidt als »Hogarth der Plastik« bezeichnet.[54]

7 On this and the new portrait formula see Bückling 2002,
 pp. 78f. and Beck 1989, p. 210.
8 Pötzl-Malíková 1982, pp. 221f. (cat. no. 8).
9 Pötzl-Malíková 1993, pp. 214f. On this and the other
 works by the artist mentioned as having been commis-
 sioned by the Duchess of Savoy-Carignan, see Pötzl-
 Malíková 1982, "Maria Immaculata", p. 225 (cat. no. 18),
 "The Holy Virgin", pp. 226f. (cat. no. 21), "St John",
 p. 227 (cat. no. 22), fountain group, "Elisha and the Mira-
 cle of the Widow's Pot of Oil", p. 231 (cat. no. 32) and on
 pp. 125ff. (Documents V, VI, VIII, X). See also Ronzoni
 1997, pp. 38f.
10 On the now lost Caritas group, which Messerschmidt exe-
 cuted and was probably commissioned by Countess Daun
 for her summer palace in Döbling, see Pötzl-Malíková
 1982, p. 221 (cat. no. 6).
11 Pötzl-Malíková 1982, pp. 227f. (cat. no. 24). On the 1770
 gravestone of Martin van Meytens see ibid., p. 232 (cat.
 no. 37). For the tombstone of Johann Baptist Straub's sec-
 ond wife, the artist made a bust in "Religion" 1775 (fig. 71);
 see Pfarr 2003b, p. 27. On the "Religion" bust see also
 Pötzl-Malíková 1982, p. 233 (cat. no. 44).
12 In his Annals of 1802, Hans Rudolph Füeßli assumes the
 artist spent seven months in Rome; cf. Krapf, Leben und
 Werk 2002, p. 21.

1 Wurzbach 1867, S. 447.

2 Zu »Ungarns Koustou« in Messerschmidts Grabschrift aus dem »Preßburger Musenalmanach auf das Jahr 1785« siehe Pötzl-Malíková 1982, S. 6. Siehe Scheyb 1770, Bd. 2, S. 93–94. Zu den kunsttheoretischen Schriften von Scheybs siehe Scheyb 1770, Scheyb 1774.

3 Zur Lehrzeit des Künstlers in München und Graz siehe Pötzl-Malíková 1982, S. 12, und Krapf, Leben und Werk 2002, S. 18. Die Immatrikulation von Messerschmidt am 4. November 1755 an der Wiener Akademie dokumentiert Pötzl-Malíková 1982, S. 125 (Dokument II). Ob Messerschmidt auch bei Matthäus Donner (1704–1756) studierte, der neben Moll und Schletterer ebenfalls an der Akademie lehrte (Krapf, Leben und Werk 2002, S. 19), ist fraglich.

4 Dazu siehe etwa Pötzl-Malíková 1982, S. 19–20; Fanta 2002, S. 130, und Krapf, Auftraggeber und Freundeskreis 2002, S. 65.

5 Dazu siehe Krapf, Katalog 2002, S. 140–143 (Kat.-Nr. 1 und 2).

6 In der Büste Josephs II. von 1767 verfeinert der Künstler diese spannungsvolle Gestaltung, indem er eine vollkommen geglättete »Oberflächenkontur« mit einer feinteilig ziselierten Detailbehandlung kombiniert; siehe Bückling 1999b, S. 103.

7 Dazu und zur neuen Porträtformel siehe Bückling 2002, S. 78–79, und Beck 1989, S. 210.

8 Pötzl-Malíková 1982, S. 221–222 (Kat.-Nr. 8).

9 Pötzl-Malíková 1993, S. 214–215. Zu dieser und den im Weiteren genannten Werken des Künstlers, die im Auftrag der Herzogin Savoyen-Carignan entstanden, siehe Pötzl-Malíková 1982: »Maria Immaculata«, S. 225 (Kat.-Nr. 18), »Heilige Maria«, S. 226–227 (Kat.-Nr. 21), »Heiliger Johannes«, S. 227 (Kat.-Nr. 22), Brunnengruppe, »Elisäus und das Wunder des Ölkrugs der Witwe«, S. 231 (Kat.-Nr. 32) sowie auf S. 125–127 (Dokumente V, VI, VIII, X). Siehe auch Ronzoni 1997, S. 38–39.

10 Zur heute verschollenen Gruppe der Caritas, die Messerschmidt wahrscheinlich im Auftrag des Grafen Daun für dessen Sommerpalais in Döbling schuf, siehe Pötzl-Malíková 1982, S. 221 (Kat.-Nr. 6).

11 Pötzl-Malíková 1982, S. 227–228 (Kat.-Nr. 24). Zum Grabmal Martin van Meytens von 1770 siehe ebd., S. 232 (Kat.-Nr. 37). Für das Grabmal der zweiten Frau von Johann Baptist Straub fertigte der Künstler 1775 eine Büste der Religion (Abb. 71); siehe Pfarr 2003b, S. 27. Zur Büste der Religion siehe auch Pötzl-Malíková 1982, S. 233 (Kat.-Nr. 44).

12 Hans Rudolph Füeßli geht in seinen Annalen von 1802 von einem siebenmonatigen Aufenthalt des Künstlers in Rom aus; dazu siehe Krapf, Leben und Werk 2002, S. 21.

13 Pötzl-Malíková 1982, S. 30–31. Zur Geschichte der Wiener Akademie siehe Wagner 1967, S. 45.

14 Nicolai berichtet, dass Messerschmidt in Rom große Aufmerksamkeit durch sein robustes Auftreten und seine Fertigkeit im Schnitzen auf sich zog; siehe Nicolai 1785, S. 403. Siehe auch Wurzbach 1867, S. 443–444.

15 Nach Ignaz de Luca (1778, S. 333) schnitzte Messerschmidt in Rom »etliche der besten Antiken in der Proportion eines Schuhes in Holz«. Der Katalogteil der grundlegenden Messerschmidt-Monographie von Pötzl-Malíková 1982 (S. 223–224, Kat.-Nr. 11–15) führt mehrere Holzkopien antiker Werke auf, u. a. des »Herkules Farnese« und eines »Apoll«. Die Autorin stützt sich dabei auf Nicolai 1785 und Hevesi 1909, wobei sie in der Kopie des »Sterbenden Galliers« die für den Künstler typische Schnitztechnik erkennt und sie daher Messerschmidt zuschreibt. Zu ihren Zu- bzw. Abschreibungen zweier Holzkopien des »Borghesischen Fechters« in Wien und Nürnberg siehe Pötzl-Malíková 2003, S. 259–260, Abb. 300.

13 Pötzl-Malíková 1982, pp. 30f. On the history of the Viennese Academy see Wagner 1967, p. 45.

14 Nicolai reports that Messerschmidt attracted a great deal of attention in Rome because of his assertive manner in public and his skill at carving; see Nicolai 1785, p. 403. See also Wurzbach 1867, pp. 443f.

15 According to Ignaz de Luca (1778, p. 333) Messerschmidt carved "some of the best antiques [replicas of ancient works] in the proportion [size] of a shoe in wood" in Rome. The annotated catalogue section of the standard Messerschmidt monograph, Pötzl-Malíková 1982 (pp. 223f., cat. nos. 11–15), lists several wooden copies of ancient works, including the "Farnese Hercules" and an "Apollo". In this, the author draws on Nicolai 1785 and Hevesi 1909; recognising in the copy of the "Dying Gaul" the carving technique typical of Messerschmidt, she attributes this work to him. On the works the author attributes to him or does not attribute to him, including two wooden copies of the "Borghese Swordsman" in Vienna and Nuremberg, see Pötzl-Malíková 2003, pp. 259f., fig. 300.

16 That the artist may also have drawn nudes from life and done studies of ancient works is certainly plausible but can ultimately not be proved. A drawing of a nude attributed to Messerschmidt is reproduced in Pötzl-Malíková 2003, p. 255, fig. 298.

17 Reported in the "Wienerisches Diarium", 6 May 1767, and Seipp 1793, p. 502. See also Thieme-Becker, Vol. 34, pp. 77f.

18 Clodion was active in Rome 1762–1771. On his prolonging his stay in Rome several times and his studies of Antiquity, see Scherf 1992, pp. 77f., and Poulet 1992, pp. 15–34. Houdon studied in Rome from 1764 until 1768. For the work he did there, a St Bruno, see exhib. cat. Houdon 2003, cat. no. 4.

19 See exhib. cat. Art in Rome 2000, p. 269.

20 According to the author of the "Merkwürdige Lebensgeschichte", Messerschmidt returned to Vienna via Florence and London; see Anonymous 1794, pp. 17f. Although these conjectured stops along the way crop up repeatedly in scholarly publications, there is no basis for believing they occcured; the same holds for an alleged appointment to the Paris Academy offered to Messerschmidt (ibid., p. 17).

21 See Krapf, Katalog 2002, pp. 152–155 (cat. no. 6).

22 In this portrait, references to Messerschmidt's reception of classical art are evident in the detailed solutions arrived at for hair and apparel contrasting with the smoothness of the face; see Bückling 1999b, p. 103. The influence of the type of portrait developed by Lemoyne around the turn of the century can be read in the circumstance that the chest section is by now reduced and the facial features have been rendered in a more sensuous way and that both are linked with the Late Baroque pathos formula of the head looking to the side. Extensively on this see Ronzoni 1997, p. 40.

16 Dass der Künstler auch der Tätigkeit des Akt- und Antikenzeichnens in Rom nachgegangen sein könnte, ist naheliegend, aber letztendlich nicht nachweisbar. Eine Aktzeichnung, die Messerschmidt zugeschrieben wird, findet sich abgebildet bei Pötzl-Malíková 2003, S. 255, Abb. 298.

17 Davon berichten das »Wienerische Diarium«, 6. Mai 1767, und Seipp 1793, S. 502. Siehe auch Thieme-Becker, Bd. 34, S. 77–78.

18 Clodion war von 1762–1771 in Rom tätig. Zu seinem mehrfach verlängerten Rom-Aufenthalt und Antikenstudium siehe Scherf 1992, S. 77–78, sowie Poulet 1992, S. 15–34. Houdon studierte von 1764 bis 1768 in Rom. Zu seinem dort geschaffenen Werk des Heiligen Bruno siehe Ausst.-Kat. Houdon 2003, Kat.-Nr. 4.

19 Siehe Ausst.-Kat. Art in Rome 2000, S. 269.

20 Dem Verfasser der »Merkwürdigen Lebensgeschichte« zufolge gelangte Messerschmidt über Florenz und London nach Wien zurück; siehe Anonymus 1794, S. 17–18. Diese in der Literatur immer wieder auftauchenden vermeintlichen Zwischenstationen entbehren ebenso wie ein angeblicher Ruf Messerschmidts an die Akademie in Paris (ebd., S. 17) einer Grundlage.

21 Siehe Krapf, Katalog 2002, S. 152–155 (Kat.-Nr. 6).

22 Auf Messerschmidts Rezeption antiker Kunst verweist bei diesem Bildnis etwa die feinteilige Auflösung von Haar und Gewand, die mit der Ebenmäßigkeit des Gesichts kontrastiert; siehe Bückling 1999b, S. 103. Eine Beeinflussung durch Jean-Baptiste Lemoynes um die Jahrhundertmitte entwickelten Bildnistypus lässt sich darin ablesen, dass der Büstenabschnitt bereits reduzierter und die Gesichtszüge sensualisierter gestaltet sind und sich mit der spätbarocken Pathosformel des erhobenen, zur Seite blickenden Kopfes verbinden. Ausführlich dazu siehe Ronzoni 1997, S. 40.

23 Dazu siehe Bückling 1999b, S. 104–105 (Kat.-Nr. 62). Zu von Scheybs Porträt als erstes Zeugnis einer Neuorientierung des Künstlers und als früheste Büste des Klassizismus in Wien siehe Gampp 1998, S. 20.

24 Pötzl-Malíková 1982, S. 229 (Kat.-Nr. 26–28).

25 Siehe dazu das Protokoll der k. k. Kupferstecherakademie in Wien vom 11. März 1769, abgedruckt in Pötzl-Malíková 1982, S. 127 (Dokument VII).

26 Zu Messerschmidts Bruch mit der Bildnistradition und seiner Entwicklung einer neuartigen Porträtformel anhand der genannten Werkbeispiele siehe Bückling 2002, S. 79; siehe auch Bückling 1999a, S. 72–74, und Bückling 1999b, S. 102. Zur wieder aufgetauchten Büste von Mesmer siehe Pötzl-Malíková 1987. Ausgestellt wurde sie erstmals 2002 in Wien; siehe Krapf, Katalog 2002, S. 162–163 (Kat.-Nr. 10).

27 Den offiziellen Eintrag zur Übergabe des Ernennungsdekrets dokumentiert Pötzl-Malíková 1982, S. 127. Zur Geschichte der Wiener Akademie siehe Wagner 1967.

28 Von 1768 bis 1774 soll Grassi Schüler von Messerschmidt gewesen sein; siehe Baum 1980, S. 207. Zu Johann Martin Fischer als Lehrling des Künstlers, der bei der Ausarbeitung der Brunnengruppe für das Savoysche Wohnhaus mithalf, siehe Pötzl-Malíková 1982, S. 45.

29 Siehe den Grundbucheintrag vom 9. November 1770 zum Erwerb des Hauses in Pötzl-Malíková 1982, S. 129 (Dokument XII). Die von Krapf aus Albert Ilgs Monographie übernommene Behauptung, Messerschmidt habe nach der Rückkehr aus Rom eine gewisse Zeit im Mesmer'schen Haus gewohnt, widerlegt überzeugend Pötzl-Malíková 2003, S. 263. Siehe auch die Dokumente im Wiener Stadt- und Landesarchiv, die Auskunft über die unterschiedlichen Adressen von Messerschmidt und Mesmer geben, die zwar beide im Bezirk »Wien 3« wohnten, jedoch Messerschmidt in der Landstrasse 93, heute Ungargasse 5, und Mesmer in der Landstrasse 261, heute Rasumofskygasse 29. Für die Angaben danke ich Frau Dr. Susanne Fritsch, Wiener Stadt- und Landesarchiv, siehe Brief vom 25. August 2006.

23 Cf. Bückling 1999b, pp. 104f. (cat. no. 62). On the portrait of Scheyb as the earliest witness to Messerschmidt's re-orientation and as the earliest Neo-Classical bust in Vienna, see Gampp 1998, p. 20.

24 Pötzl-Malíková 1982, p. 229 (cat. no. 26–28).

25 Cf. "Protokoll der k. k. Kupferstecherakademie in Wien" of 11 March 1769, reproduced in Pötzl-Malíková 1982, p. 127 (Document VII).

26 On Messerschmidt's break with portrait tradition and his development of a new type of portrait formula as evinced by the works listed as examples see Bückling 2002, p. 79; see also Bückling 1999a, pp. 72–74, and Bückling 1999b, p. 102. On the re-appearance of the Mesmer bust see Pötzl-Malíková 1987. It was first publicly exhibited in Vienna in 2002; see Krapf, Katalog 2002, pp. 162f. (cat. no. 10).

27 The official application for the handing over of letters of appointment is documented in Pötzl-Malíková 1982, p. 127. On the history of the Viennese Academy, see Wagner 1967.

28 Grassi is said to have been a pupil of Messerschmidt's from 1768 until 1774; see Baum 1980, p. 207. On Johann Martin Fischer as an apprentice of Messerschmidt's, who also helped out in the execution of the fountain group for the Savoy private dwelling, see Pötzl-Malíková 1982, p. 45.

29 See the land-registry entry of 9 November 1770 for the acquisition of the house in Pötzl-Malíková 1982, p. 129 (Document XII). The assertion, taken over by Krapf from Albert Ilg's monograph, that Messerschmidt spent some time in Mesmer's house is convincingly refuted in Pötzl-Malíková 2003, p. 263. See also the documents in the Viennese city and provincial archives, which are informative on the different addresses of Messerschmidt and Mesmer, both of whom lived in the Vienna 3 district; Messerschmidt, however lived at 93, Landstrasse, now 5, Ungargasse and Mesmer at 261 Landstrasse, now 29, Rasumofskygasse. These data have been taken from a letter dated 25 August 2006 from Dr. Susanne Fritsch, Wiener Stadt- und Landesarchiv.

30 "Wienerisches Diarium", No. 54, 7 July 1770; see also Pötzl-Malíková 1987, pp. 259f.

31 On the merger of the three institutions by Kaunitz in 1772 and the appointments made, see Wagner 1967, pp. 43f. The restructuring of the education system is also described in Pötzl-Malíková 1982, p. 41.

32 Instead of Messerschmidt, after Schletterer's death in 1774, Johann Baptist Hagenauer was appointed professor of sculpture; see Wagner 1967, p. 45. See also "Protokoll der Ratsversammlung der k. k. vereinigten Akademie der bildenden Künste" in Pötzl-Malíková 1982, pp. 130f. (Document XVI).

33 In a letter written by Messerschmidt to his brother dated 14 June 1770, the artist mentions that he is ill without, however, being any more specific about the nature of the illness; see Pötzl-Malíková 1982, pp. 128f. (Document XI).

34 See the extracts from the undated and unsigned "Entwurf einer hohen Protektorats-Resolution" and the protocol

30 »Wienerisches Diarium«, Nr. 54, 7. Juli 1770; siehe auch Pötzl-Malíková 1987, S. 259–260.

31 Zur Vereinigung der drei Institutionen durch Kaunitz 1772 und den Stellenbesetzungen siehe Wagner 1967, S. 43–44. Die Umstrukturierung des Bildungswesens schildert auch Pötzl-Malíková 1982, S. 41.

32 Anstelle von Messerschmidt wurde nach Schletterers Tod 1774 Johann Baptist Hagenauer als Professor der Bildhauerei berufen; siehe Wagner 1967, S. 45. Siehe auch das Protokoll der Ratsversammlung der k. k. vereinigten Akademie der bildenden Künste in Pötzl-Malíková 1982, S. 130–131 (Dokument XVI).

33 In einem Brief Messerschmidts an seinen Bruder vom 14. Juni 1770 erwähnt der Künstler, dass er krank gewesen sei, ohne jedoch näher auf die Art der Erkrankung einzugehen; siehe Pötzl-Malíková 1982, S. 128–129 (Dokument XI).

34 Siehe die Auszüge aus dem undatierten und unsignierten »Entwurf einer hohen Protektorats-Resolution« und dem Protokoll über die Wahl des Nachfolgers für den verstorbenen Schletterer sowie den Vortrag von Kaunitz an die Kaiserin über die Neubesetzung der Bildhauerprofessur in Pötzl-Malíková 1982, S. 130 (Dokument XIV, XVI, XVII).

35 »So stark wich die Gattung der Büste kaum je wieder von den Normen und Idealen ab.« Siehe Maaz 2001, S. 27.

36 Siehe dazu Bückling 1999a, S. 76.

37 Den Grundbucheintrag über den Verkauf des Hauses dokumentiert Pötzl-Malíková 1982, S. 130 (Dokument XV). Die »Nachricht« über den Verkauf von Werken Messerschmidts findet sich im »Wienererischen Diarium«, 6. April 1774.

38 Zum Pensionsangebot von Kaunitz siehe Pötzl-Malíková 1982, S. 131–132 (Dokument XVII). Messerschmidts Weigerung, ohne Gegenleistung die »Almosen« anzunehmen, geht aus mehreren Schriftstücken hervor; siehe Pötzl-Malíková 1982, S. 48, 56 sowie 134–135 (Dokument XXIII–XXVI).

39 Zu Messerschmidts Scheitern in München und seiner dort entstandenen Büste der Religion siehe Pötzl-Malíková 1982, S. 53–54. In einem Brief des Künstlers an den Reichsgrafen Maximilian von Berchem vom 26. Februar 1776 zeigte sich Messerschmidt enttäuscht darüber, dass er seine »Probstückhe«, wahrscheinlich die ebenfalls erwähnten »Sechs Metallenen Köpf-Stückhe«, nicht vorstellen konnte; siehe ebd., S. 133 (Dokument XXII).

40 Zum Aufschwung von Preßburg, der zu Beginn des 18. Jahrhunderts einsetzte, siehe Keleti 2002, S. 97–99.

41 Einen Überblick zu den in Preßburg entstandenen Werken bietet Keleti 2002, S. 102–105. Zu den Marmorbüsten der Batthyánys siehe Pötzl-Malíková 1982, S. 240 (Kat.-Nr. 64, 65). Die Albastermedaillons, u. a. mit Bildnissen des Naturwissenschaftlers Josef Kiss und von Friedrich Nicolai (verschollen), dokumentiert Pötzl-Malíková 1982, S. 235–239 (Kat. 50–61).

42 Messerschmidt fertigte zwei Büsten des Herzogs in Marmor und in Blei sowie eine Miniaturbüste und ein Porträtmedaillon. Dazu und zum Kaufgesuch der Charakterköpfe siehe Krapf, Katalog 2002, S. 274–275 (Kat.-Nr. 64), sowie Keleti 2002, S. 102.

43 Ausführlich zur Gestaltung dieser späten Porträtarbeit und ihrer Einordnung ins Gesamtwerk des Künstlers siehe Bückling 2002, S. 79–80.

44 Johann Friedel schrieb in den »Annalen der bildenden Künste für die österreichischen Staaten«: »In Preßburg zu seyn, und den berühmten Bildhauer Messerschmidt nicht zu besuchen, würde einem Kunstliebhaber zur Schande gereichen.« Siehe Friedel 1785, S. 397. Zu den bedeutenden Persönlichkeiten, die den Künstler in Preßburg aufsuchten, siehe auch Bückling 1999b, S. 101, und Krapf, Leben und Werk 2002, S. 15.

35 dealing with the election of a successor to the deceased Schletterer as well as the remarks made by Kaunitz to the Empress on the appointment of a new professor of architecture in Pötzl-Malíková 1982, p. 130 (Documents XIV, XVI, XVII).

35 "The bust genre hardly ever again deviated so far from the norms and ideals." See Maaz 2001, p. 27.

36 Cf. Bückling 1999a, p. 76.

37 The land-registry entry on the sale of the house is documented in Pötzl-Malíková 1982, p. 130 (Document XV). The report of the sale of Messerschmidt's works is in the "Wienererisches Diarium", 6 April 1774.

38 On the offer of a pension made by Kaunitz, see Pötzl-Malíková 1982, pp. 131f. (Document XVII). Messerschmidt's refusal to accept "alms" for having done nothing and for receiving nothing is shown in several accounts; see Pötzl-Malíková 1982, p. 48, p. 56 and pp. 134f. (Documents XXIII–XXVI).

39 On Messerschmidt's failure in Munich and the bust "Religion" he did there, see Pötzl-Malíková 1982, pp. 53f. In a letter written by Messerschmidt to Count Maximilian von Berchem dated 26 February 1776, Messerschmidt reveals his disappointment that he will not be able to present his trial pieces, probably the also-mentioned "six metal heads"; see ibid., p. 133 (Document XXII).

40 On Bratislava's economic and cultural upturn in the early 18th century, see Keleti 2002, pp. 97ff.

41 A survey of the works Messerschmidt executed in Bratislava is given in Keleti 2002, pp. 102–105. On the marble busts of the Batthyánys see Pötzl-Malíková 1982, p. 240 (cat. nos. 64, 65). The alabaster medallions, including the portraits of the scientist Josef Kiss and of Friedrich Nicolai (lost) are documented in Pötzl-Malíková 1982, pp. 235–239 (cat. nos. 50–61).

42 Messerschmidt executed two busts of the duke in marble and lead as well as a miniature bust and a portrait medallion. On this and on the duke's attempt to buy the Character Heads, see Krapf, Katalog 2002, pp. 274f. (cat. no. 64) and Keleti 2002, p. 102.

43 Extensively on the design of this late portrait and how it fits in with the artist's œuvre, in Bückling 2002, pp. 79f.

44 Johann Friedel wrote in the "Annalen der bildenden Künste für die österreichischen Staaten": "To be in Pressburg and not to visit the famous sculptor Messerschmidt would be a disgrace to any art-lover." See Friedel 1785, p. 397. On the distinguished men who sought out Messerschmidt in Bratislava, see also Bückling 1999b, p. 101, and Krapf, Leben und Werk 2002, p. 15.

45 See for instance Tietze-Conrat 1920, p. 30, and Krapf, Leben und Werk 2002, p. 25, 29.

46 The last to work in Messerschmidt's workshop was Leopold Zeilinger. The works he polished there include the busts of Count and Countess Batthyány; see Pötzl-Malíková 1996, p. 217.

47 The 'Specification' was found ten years ago in the Slovak National Archives; see Pötzl-Malíková 1996. Reproduced in exhib. cat. Messerschmidt 2002 (Appendix), pp. 290ff.

45 Siehe etwa Tietze-Conrat 1920, S. 30, und Krapf, Leben und Werk 2002, S. 25, 29.

46 Zuletzt arbeitete Leopold Zeilinger in Messerschmidts Werkstatt mit. Er polierte unter anderem die Büsten der Gräfin und des Grafen Batthyány; siehe Pötzl-Malíková 1996, S. 217.

47 Die ›Specification‹ wurde vor zehn Jahren im Slowakischen Nationalarchiv aufgefunden; siehe Pötzl-Malíková 1996. Wiederabdruck in Ausst.-Kat. Messerschmidt 2002 (Anhang), S. 290–292. Der Künstler besaß wohl neben den zum Teil kostbaren und nützlichen Dingen kaum Bücher: Die ›Specification‹ führt lediglich »Ein Lateinisch Buch mit verschiedenen Figuren« auf. Nicolai berichtet, dass er ein »altes italienisches Buch von den Verhältnissen des menschlichen Körpers« bei Messerschmidt gesehen habe. Kris vermutet, es habe sich um eine Vitruvius-Ausgabe gehandelt; siehe Kris 1932, S. 211. Siehe auch Pötzl-Malíková 1982, S. 78. Messerschmidt trennte sich laut Nicolai von seinen anderen Büchern, als er 1774 aus Wien wegzog; siehe hierzu S. 236 in diesem Katalog.

48 Siehe Gorsen 2002.

49 Siehe den Entwurf eines Brief Messserschmidts an Schmutzer vom 27. März 1777; Pötzl-Malíková 1982, S.135 (Dokument XXVI).

50 Die Vermutung, der Künstler sei an einer Bleivergiftung gestorben, findet sich mehrfach in der Literatur, unter anderem bei Ronzoni 1997, S. 42. Siehe auch S. 94 in diesem Katalog.

51 Preßburger Zeitung, Nr. 68, 23. August 1783. Dort wird Messerschmidt einleitend als »die Zierde unserer Künstler« und »der Stolz seiner Nation« geehrt.

52 So bezeichnete der Künstler selbst seine legendären Charakterköpfe. Daneben ist in den kurz nach Messerschmidts Tod verfassten Verlassenschaftsakten von »Portreen« die Rede. Zu den Bezeichnungen siehe die Schriftstücke in Pötzl-Malíková 1982, S. 133 (Dokument XXII) und S. 141 (Dokument XXXIX).

53 Ronzoni 1997, S. 40. Zur Rezeption und Interpretation der Charakterköpfe siehe die entsprechenden Kapitel im vorliegenden Katalog.

54 »M., dieser Meister in der Ästhetik des Hässlichen, kann mit gutem Fug und Recht als der ›Hogarth der Plastik‹ bezeichnet werden.« Siehe Wurzbach 1867, S. 447; siehe auch Gräffer 1867, S. 251.

Although the artist possessed some things that were costly and useful, he hardly owned any books at all: all the 'Specification' lists is "a Latin book with various figures". Nicolai reports that he saw an "old Italian book with the proportions of the human body" in Messerschmidt's house. Kris conjectures this may have been an edition of Vitruvius; see Kris 1932, p. 211. See also Pötzl-Malíková 1982, p. 78. According to Nicolai, Messerschmidt had rid himself of his other books when he moved away from Vienna in 1774; cf. p. 236 in the present catalogue.

48 See Gorsen 2002.

49 See the outline of a letter from Messserschmidt to Schmutzer of 27 March 1777; Pötzl-Malíková 1982, p. 135 (Document XXVI).

50 The conjecture that Messerschmidt died of lead poisoning crops up several times in specialist publications, including Ronzoni 1997, p. 42. See also p. 94 in the present catalogue.

51 "Pressburger Zeitung", No. 68, 23. August 1783. There Messerschmidt is honoured in the preamble as "the flower of our artists" and "the pride of his nation".

52 Thus the artist himself designated his legendary Character Heads. In addition, the estate records drawn up shortly after Messerschmidt's death mention "portraits". On these designations see "Schriftstücke" in Pötzl-Malíková 1982, p. 133 (Document XXII) and p. 141 (Document XXXIX).

53 Ronzoni 1997, p. 40. On the reception and interpretation of the Character Heads, see the chapter on this in the present catalogue.

54 "M., that past-master of the aesthetic of the ugly can rightly be termed the 'Hogarth of Sculpture'." See Wurzbach 1867, p. 447; see also Gräffer 1867, p. 251.

Maraike Bückling

Franz Xaver Messerschmidt – Verrücktheit, Intrige und Genie

Die Auseinandersetzung mit Messerschmidt geschieht bis heute unter den Vorzeichen seiner angeblichen »Verrücktheit«. Die Geschichte dieser Legende – oder war es ein absichtsvoll gestreutes Gerücht? – soll im Folgenden nachgezeichnet werden. Im Dezember 1774 schrieb der Hof- und Staatskanzler Fürst Wenzel von Kaunitz-Rietberg an Kaiserin Maria Theresia von einer »Verwürrung im Kopfe«, aufgrund derer der Bildhauer nicht länger in der Lage sei, Studenten zu unterrichten.[1]

1785 veröffentlichte Friedrich Nicolai seine »Beschreibung einer Reise durch Deutschland und die Schweiz im Jahre 1781«.[2] Eine »kleine Nebenreise« führte nach Ungarn; mehrere Seiten des Berichts über diesen Umweg gelten seinem Besuch im Jahr 1781 bei Messerschmidt.[3] Der Künstler wird als ein Mensch geschildert, der in »schwärmerische« Kreise geraten sei, manches aus diesem Gedankengut missverstanden habe, durch seine sitzende Tätigkeit und durch seine Keuschheit mit körperlichen Problemen zu kämpfen habe und der sich sogar einbilde, Geister zu sehen.[4]

In den 1930er Jahren – somit 150 Jahre nach dem Tod des Künstlers – veröffentlichte der Psychoanalytiker und Kunsthistoriker Ernst Kris zwei Aufsätze, in denen er Messerschmidt für geisteskrank, nämlich für schizophren, erklärte.[5] Die Basis seiner Argumentation sind die Korrespondenz aus der Akademie sowie Nicolais Reisebericht. Die zentrale Rolle für seine Diagnose spielten die Charakterköpfe, die das Zentrum unserer Ausstellung bilden. Allerdings erscheint es methodisch fragwürdig, aufgrund der Kunstwerke und auf der Grundlage eines Berichts, der nicht vom Künstler selbst

Franz Xaver Messerschmidt – Madness, Intrigue and Genius

Even today, any discussion of Messerschmidt tends to dwell on his alleged insanity. The history of this legend – or was it a deliberately spread malicious rumour? – is to be traced in the following. In December 1774, Prince Wenceslas von Kaunitz wrote to the Empress Maria Theresia of a "confusion of the mind" which made it impossible for the sculptor to teach students any longer.[1]

In 1785 Friedrich Nicolai published his "Description of a Journey through Germany and Switzerland in 1781"[2]. A "small diversion" took him to Hungary; several pages of this account deal with Nicolai's visit to Messerschmidt in 1781.[3] The artist is described as a man who had been caught up in "enthusiastic circles", had misunderstood some of this thinking and had physical problems stemming from his sedentary occupation and his chastity, a man who even imagined he saw spirits.[4]

In the 1930s – that is, one hundred and fifty years after the artist's death – Ernst Kris, a psychoanalyst and art historian, published two essays in which he declared Messerschmidt to be mentally ill, specifically schizophrenic.[5] Kris based his line of reasoning on correspondence from the Academy in Vienna and Nicolai's account of his travels. The Character Heads which are the focus of our exhibition played a pivotal role in Kris's diagnosis. However, it does seem methodologically questionable to base a diagnosis of mental illness on works of art, on individual quotes from Academy circles, and on an account that was not by the artist himself, was published two years after the sculptor's death and which by the 1930s had been shown to contain some errors. The psychoanalytic method, by contrast, entails direct conversational contact over a period of years between analyst and patient. Moreover, in the past, diagnoses were often made without taking into consideration the different conceptions of insanity entertained in the 18th and the 20th centuries.[6] Kris's texts, important as some

stammte, zwei Jahre nach dem Tod des Bildhauers erschien und dem bereits manche Fehlinformationen nachgewiesen wurden, sowie aufgrund von Einzelzitaten aus dem Umkreis der Akademie eine psychische Krankheit zu diagnostizieren: Zur psychoanalytischen Methode gehört der direkte, langjährige Gesprächskontakt zwischen Analytiker und Patient. Hinzu kommt, dass in die Vergangenheit diagnostiziert wird, ohne die verschiedenen Vorstellungen von Verrücktheit des 18. beziehungsweise des 20. Jahrhunderts in Betracht zu ziehen.[6] Letztlich sagen Kris' Texte, trotz mancher wichtiger Hinweise, mehr über die Forschungssituation seiner Zeit als über Messerschmidt aus. Welchen Sinn eine derartige Diagnose, die in der Kunstgeschichte häufig aufgegriffen und fortgeschrieben wird,[7] auch immer haben soll: Die Faszination, die von den Köpfen ausgeht, vermag sie nicht zu erklären. Messerschmidt wird zu einer bemitleidenswerten Gestalt, zu der man sich »bekennen« muss,[8] den man aber nicht als gebildeten, aufgeklärten und mit den Problemen seiner Zeit beschäftigten Künstler verstehen kann.

Die von Kaunitz, Nicolai und Kris geäußerten Urteile über Messerschmidt haben bis heute eine erstaunliche Wirkung: Wer immer sich mit Messerschmidt beschäftigt, muss sich mit seiner vermeintlichen Verrücktheit auseinandersetzen. Dieses Urteil hat sich derart in unseren Köpfen festgesetzt, dass Messerschmidts Köpfe meist mit dieser Brille gesehen werden: »Es kann ja nicht übersehen werden, dass die Serie von einem neurotischen Repetitionszwang zeugt.«[9] Argumentation tut nicht mehr not: Es erscheint ja offensichtlich, dass Messerschmidt neurotisch, wenn nicht gar verrückt war.

Ist es aber tatsächlich vorstellbar, dass sich hochgestellte Persönlichkeiten wie Graf Franz de Paula Balassa, Präsident des Erziehungswesens in Ungarn, die Grafen Batthyány,[10] die in Preßburg lebten, Angehörige der kaiserlichen Familie, zum Beispiel der Statthalter Habsburgs in Ungarn, Herzog Albert von Sachsen-Teschen, und auch bürgerliche Aufklärer von einem Verrückten porträtieren ließen?[11]

1793 veröffentlichte ein Anonymus eine Abhandlung über 49 Charakterköpfe, in denen er diese durchnummerierte und ihnen Namen gab, die bemüht sind, den jeweiligen Gesichtsausdruck in eine knappe Formel zu fassen. Allerdings wird der Sinn der Köpfe mit diesen Titeln und den beigegebenen, gelegentlich anekdotischen Erläuterungen eher verunklärt als geklärt, gelegentlich gar persifliert. Im Nachwort forderte der Verfasser die »Kenner in den Gesichtsbildungen vorstehender Büsten« auf, ihm weiterführende und erhellendere Erklärungen der dargestellten Leidenschaften zusammen mit neuen Titeln zuzusenden.[12] Mit den Namen orientierte sich der unbekannte Autor möglicherweise an vergleichbaren

points made in them may be, ultimately reveal more about the state of psychoanalytic research in his day than about Messerschmidt. Whatever the point may be of art historians' referring repeatedly to a diagnosis of that kind and even embroidering it,[7] it does nothing to explain what makes the Character Heads so fascinating. Messerschmidt is thus turned into a pitiful figure, who must be "acknowledged"[8] but cannot be viewed as an educated, enlightened artist dealing with the intellectual issues of his day. The verdicts passed on Messerschmidt by von Kaunitz, Nicolai and Kris have, astonishingly, continued to resonate to the present day: anyone studying Messerschmidt must deal with his alleged madness. This prejudice is so firmly entrenched in our minds that Messerschmidt's Heads are usually viewed through spectacles of the same tint: "It can, after all, not be overlooked that the series attests to a neurotic compulsion to repetition."[9] It is no longer necessary to muster cogent arguments: it would seem self-evident that Messerschmidt was neurotic, if not indeed psychotic. Is it conceivable, however, that high-ranking contemporaries from public life such as Count Franz de Paula Balassa, president of education in Hungary, the Counts Batthyány,[10] who lived in Bratislava, members of the imperial family, including the Habsburg governor of Hungary, Albert, Duke of Saxe-Teschen, and members of the bourgeois Enlightenment would have had their portraits done by a madman?[11]

In 1793 an anonymous treatise was published on forty-nine Character Heads, in which the author numbered them in sequence and gave them names that represent an attempt to summarise the facial expression of each head in a succinct formula. However, the significance of the Heads tends to be obscured rather than clarified by these titles and occasionally even travestied. In the epilogue, the anonymous author requests "those knowledgeable about the physiognomic formations of the present busts" to send him further illuminating explanations of the passions represented along with new titles.[12] For his titles, the unknown author may have been inspired by comparable picture captions such as the derisory nicknames and satiric verses accompanying the drawings of Johann Caspar Lavater.[13] Finally, in the 19th

Bildlegenden, nämlich den Spottnamen und -versen zu Zeichnungen Johann Caspar Lavaters.[13] Im 19. Jahrhundert schließlich wurden die Köpfe im Prater im Gasthaus des Bronzefabrikanten und Gastwirts Franz Jakob Steger »Zum Thurm von Gothenburg« aufgestellt.[14] Auch dies trug nicht zu einer sachlichen Beschäftigung mit den Werken bei.

Krankheit oder Intrige?[15]

Tatsächlich hatte eine schwere Erkrankung Messerschmidts offenbar vor dem Frühsommer 1770 zu seiner zeitweiligen Arbeitsunfähigkeit geführt.[16] Wenige Monate später, am 9. November 1770, wurde er als Eigentümer des Hauses Ungargasse 5 eingetragen.[17] Seine Geschäftsfähigkeit unterlag zu diesem Zeitpunkt also keinem Zweifel. Im Dezember 1774 heißt es, er sei seit drei Jahren krank – eine zweite Krankheit wäre somit 1771/72 ausgebrochen.[18] Von der letzteren wurde in Akademiekreisen verbreitet, dass Messerschmidt »im Gehirn« nicht wieder geheilt sei, er an einer »Verwürrung im Kopfe«[19] leide.

Der Staatskanzler Kaunitz hatte im Jahr 1772 die drei in Wien bestehenden Akademien zur k. k. vereinigten Akademie der bildenden Künste zusammengeführt.[20] Mit seinen künstlerischen Vorstellungen, die er hier verwirklicht sehen wollte, orientierte er sich ganz offensichtlich an Johann Joachim Winckelmann (1717–1768), dem Bibliothekar des Kardinals Albani, päpstlicher Antiquar und Verfasser von weithin wirkenden Schriften über die antike Kunst. Für Winckelmann war Schönheit, verwirklicht in der Skulptur der klassischen Antike, als Inbegriff körperlicher und sittlicher Vollkommenheit der »höchste Endzweck« der Kunst. Leidenschaft unmittelbar darzustellen, lehnte er ab, denn Kunst habe »den wahren Charakter der Seele zu schildern«, die »große und gesetzte Seele«. Diese Vorstellungen mündeten in Winckelmanns Abhandlung »Gedancken über die Nachahmung der griechischen Werke« in die berühmten Sätze: »Das allgemein vorzügliche Kennzeichen der Griechischen Meisterstücke ist endlich eine edle Einfalt und stille Größe, sowohl in der Stellung als im Ausdruck. So wie die Tiefe des Meers allezeit ruhig bleibt, die Oberfläche mag noch so wüten, ebenso zeigt der Ausdruck in den Figuren der Griechen bey allen Leidenschaften eine große und gesetzte Seele.«[21]

Kaunitz setzte seine Vorstellungen nicht zuletzt über die Besetzung von Professorenstellen durch. Das traf auch auf die 1774 durch den Tod Jakob Schletterers verwaiste Bildhauerprofessur zu. Auf diese Stelle hatte Messerschmidt, auch nach der Einschätzung Kaunitz', aus juristischen Gründen ein Anwartsrecht. Noch im Oktober 1773, kurz zuvor, hatte Joseph von Sonnenfels »diejenigen Bildhauer namhaft« gemacht, »welche den Schutz der Akademie

century, the Heads were set up in the Prater in a guesthouse belonging to the bronze-founder Franz Jakob Steger, also landlord of the "Zum Thurm von Gothenburg" inn.[14] This has not contributed to an objective treatment of the works either.

Illness or intrigue?[15]

In fact, a severe illness Messerschmidt suffered 1770 evidently did lead to his being unable to work for a while.[16] Some months later, on 9 November 1770, Messerschmidt is recorded as the owner of the house at 5, Ungargasse.[17] He was, therefore, able to conduct business as usual at that point. In December 1774 it is recorded that he had been ill for three years – a second outbreak of illness would, consequently, have occurred in 1771/72.[18] Of this second outbreak, it was bruited in Academy circles that Messerschmidt had not been healed "in the brain", that he suffered from "confusion of the mind".[19] In 1772 Chancellor von Kaunitz had merged the three Academies in Vienna to form the "Royal and Imperial United Academy of the Fine Arts".[20] Kaunitz evidently entertained notions of art imbibed from Johann Joachim Winckelmann (1717–1768), librarian to Cardinal Albani, papal antiquary and author of influential writings on classical art. For Winckelmann, beauty, as exemplified by the sculpture of classical Antiquity, the epitome of physical and moral perfection, was the "loftiest ultimate purpose" of art. He repudiated the raw representation of passion since art was to "describe the true character of the soul", the "great and composed soul". These notions are set down in Winckelmann's treatise in the celebrated sentences: "The universally outstanding distinguishing feature of Greek masterpieces is ultimately a noble simplicity and quiet grandeur, both in pose and expression. Just as the depths of the sea always remain quiet, however much the surface rages, just so does the expression in figures by the Greeks reveal a great and composed soul, all passions notwithstanding."[21] Kaunitz was in a position to assert his ideas, not least by the professorial appointments he made. This also applies to the chair of sculpture, left vacant in 1774 on the death of Jakob Schletterer. By law, even as Kaunitz saw it, Messerschmidt was eligible to apply for this post. As late as October

wirklich geniessen«.[22] Auch Messerschmidt gehörte dazu und wurde für befugt erklärt, Schüler auszubilden.

Nur sechs Monate später formulierte Joseph von Sperges den »Entwurf einer hohen Protektorats-Resolution auf das Akademie Protokoll vom 8ten May«. Auf der Grundlage dieses Entwurfs und aufgrund eines »Protokolls der X. ordentlichen Ratsversammlung« der Akademie vom 20. Oktober 1774[23] schrieb Kaunitz am 5. Dezember 1774 in einem Brief an die Kaiserin von einer seit drei Jahren währenden Krankheit des Bildhauers. Er könne »niemals einrathen, einen Mann für die Akademische Jugend zum Lehrer vorzuschlagen, der von derselben bey jeder Veranlaßung den Vorwurf eines einmal verrükten, und noch nicht ganz heitern Kopfes zu leiden hätte«.[24] »Einmal verrükt« bedeutet, dass Messerschmidt zwar genesen, aber früher verrückt gewesen sei und daher nie eine akademische Autorität darstellen könne. Binnen weniger als einem Jahr hatte sich das Blatt somit gegen Messerschmidt gewendet. Die Äußerungen von Sonnenfels' einerseits (Oktober 1773) und von Sperges und Kaunitz andererseits (Mai, Oktober, Dezember 1774) lassen den Schluss zu, dass eine vergangene Krankheit instrumentalisiert wurde. Es könnte also durchaus eine Intrige gewesen sein, die gegen Messerschmidt gesponnen wurde, dessen Pathologisierung die Entfernung aus der Akademie zum Ziel hatte. Damit waren die Akademiker derart erfolgreich, dass sie bis heute Wirkung zeitigen.

Die Krankheit des Bildhauers diente somit möglicherweise dem Protektor der Akademie als Grund, Messerschmidt, der einen den künstlerischen Vorstellungen Winckelmanns und auch Kaunitz' entgegengesetzten Weg ging, letztlich doch von vornherein aus dem Kreis der für die Bildhauerstelle in Frage kommenden Künstler auszuschließen. Der Gedanke liegt nahe, dass Messerschmidt aus Gründen, die nicht in einer Krankheit, sondern in der Akademiepolitik begründet lagen, missliebig war.[25]

Äußerungen Messerschmidts und seiner Zeitgenossen weisen in diese Richtung. Der Bildhauer selbst schrieb an seinen Bruder: »Ich [werde] schon acht Jahr von meinen Feind verfolgt, [...] ja es scheint, ganz Deutschland meyne, es sey mich zu unterdrücken ihr Pflicht.«[26] Nur einen Monat später, Ende Februar 1777, schrieb Jakob Schmutzer, der Leiter der Kupferstecherakademie, Messerschmidts Verdienste seien »durch seine Vermeinden Freünde, verdunklet und durch den Schwarzen Neüd so Vüeller Müsgönner Vereüdlet«.[27] Der Bildhauer Johann Martin Fischer, ehemals Mitarbeiter Messerschmidts, vermutete im Juni 1777, dass, sollte Messerschmidt nach Wien zurückkommen, ihm »wider ein feiner streich gespilt« werden würde.[28] Selbst Nicolai konstatierte 1781: »Alle Akademien sind Sammelplätze der Zänkereyen und kleinen Intriguen. Zu Wien war es außerdem von jeher Mode gewesen, daß die

1773, not all that long before, Joseph von Sonnenfels had "mentioned the sculptors by name", who "really enjoy the protection of the Academy".[22] Messerschmidt was among their number and was authorised to train pupils. Only six months later, Joseph von Sperges formulated a "draft for a High Protectorate Resolution on the Academy Protocol of 8th May". On the basis of this draft and of a "protocol of the tenth regular council assembly" of the Academy on 20 October 1774,[23] Kaunitz wrote a letter to the Empress on 5 December 1774 about the illness the sculptor had had for three years. He could "never advise proposing a man as a teacher of Academic youth who on every occasion would have to suffer the reproach from the same of having a once insane and not yet entirely serene mind".[24] Statements made by Sonnenfels on the one hand (October 1773), and by Sperges and Kaunitz on the other (May, October, December 1774) allow the conclusion to be drawn that a past illness was being exploited. It may well, therefore, have been a web of intrigue spun against Messerschmidt: representing him as pathological with the aim of removing him from the Academy. The academicians were so successful that the effect of what they wrought has lasted to the present day.

The sculptor's illness may then have served as a reason for Kaunitz, the Protector of the Academy, to exclude Messerschmidt from the outset; he had after all taken a path that was the diametrically opposed to the notions on art entertained by Winckelmann and, indeed, by Kaunitz himself. This suggests that Messerschmidt was unpopular for reasons that had nothing to do with any illness but instead were to be sought in Academy politics.[25] Statements made by Messerschmidt and contemporaries point in this direction. The sculptor himself wrote to his brother: "I have been persecuted by my enemy for eight years now, [...] and it even seems all Germany thinks it is her duty to suppress me."[26] Only a month later, in late February 1777, Jakob Schmutzer, head of the Copperplate Engravers' Academy, wrote that Messerschmidt's achievements were being "obscured by those who pretend to be his friends and thwarted by the black envy of so many who have a grudge against him."[27] The sculptor Johann Martin Fischer, a former

Künstler und die angesetzten Lehrer sich vor den Direktoren und dem akademischen Rathe tief hatten bücken und ganz von denselben abhängen müssen. Dieß war nun freylich keine Sache für einen Mann wie Messerschmidt, der keinen Künstler weiter als nach dem Grade seiner Geschicklichkeit schätzte.«[29] Johann Friedel, Autor der »Annalen der bildenden Künste für die österreichischen Staaten«, schrieb 1782: »In Preßburg zu seyn, und den berühmten Bildhauer Messerschmidt nicht zu besuchen, würde einem Kunstliebhaber zur Schande gereichen. [...] Messerschmidt war Professor bey der wienerischen Universität, aus der ihn einige Zänkereyen mit seinen Kollegen trieben. Es ist wahr, er hat seinen eigenen Kopf, aber einem so außerordentlichen Genie hätte man immer seinen Kopf lassen, und nie zugeben sollen, sich zu entfernen.«[30] Hans Rudolph Füeßli, ehemaliger Kommilitone des Bildhauers und Feldmesser in Preßburg zur Zeit Messerschmidts, erinnerte sich: »Es entstanden [...] bey der Akademie häufige Cabalen gegen ihn, und seine Feinde konnten um so sicherer gegen ihn spielen, da ihnen sein offenes Wesen, und sein cholerisches Temperament immer Blößen zu ihrem Vortheile darboth. Nach Mejtens[31] Ableben hatte er keinen Freund mehr bey der Akademie – und die häufigen Unannehmlichkeiten, die ihm von allen Seiten verursachet wurden, bewogen ihn endlich, Wien zu verlassen, und nach Preßburg zu ziehen.«[32]

»In seiner Kunst ein außerordentliches Genie; im gemeinen Leben ein wenig zur Sonderbarkeit geneigt, welches hauptsächlich aus seiner Liebe zur Unabhängigkeit entstand«[33] – die Einschätzung des Bildhauers als eigensinnig, temperamentvoll, cholerisch oder auch seltsam findet sich häufiger; auffällig ist hingegen, dass man gerade im Umkreis der Akademie der Einschätzung einer Krankheit als »Verrücktheit« begegnet.

employee of Messerschmidt's, suspected in June 1777 that, should Messerschmidt return to Vienna, a "sly trick would again be played" on him.[28] Nicolai himself confirmed in 1781: "All academies are hotbeds of dispute and petty intrigue. In addition, in Vienna it had always been the fashion for artists and employed teachers to bow low before the directors and the academic council and to be entirely dependent on the same. This was, of course, not the thing at all for a man like Messerschmidt, who did not admire any artist beyond the degree of his skill."[29] Johann Friedel, author of "Annalen der bildenden Künste für die österreichischen Staaten", wrote in 1782: "To be in Pressburg [Bratislava] and not visit Messerschmidt, the famous sculptor, would disgrace an art lover. [...] Messerschmidt was a professor at Vienna University, from which some disputes with his colleagues have driven him. It is true he had a mind of his own but one should always give such an extraordinary genius his head and never allow him to depart."[30] Hans Rudolph Füessli, a former fellow student of the sculptor's and a field surveyor in Bratislava while Messerschmidt was living there, recalled: "There arose [...] at the Academy frequent cabals against him and his enemies could intrigue against him with all the more assurance since his open character and his choleric temperament always left him exposed to their advantage. After Mejten's[31] decease he had no longer any friend at the Academy – and the frequent unpleasantnesses thrust at him from all sides finally induced him to leave Vienna and move to Pressburg."[32] "In his art an exceptional genius; in common life tending somewhat to eccentricity, which arose mainly from his love of independence"[33] – the appraisal of the sculptor as stubborn, ardent, choleric or even odd is frequently encountered; what is striking, on the other hand, is that the evaluation of his disease as "insanity" crops up notably in Academy circles.

1 The letter is reproduced in Pötzl-Malíková 1982, pp. 131f.
2 Quoted as Nicolai Reprint 1994. See also the reproduction in the appendix to the present catalogue, pp. 313–323.
3 Nicolai Reprint 1994, pp. 401–420.
4 Nicolai Reprint 1994, pp. 407–419. Seeing spirits was an experience undergone by many contemporaries, notably

1 Der Brief ist abgedruckt bei Pötzl-Malíková 1982, S. 131–132.

2 Zitiert als Nicolai Reprint 1994. Siehe dazu auch die Abschrift im Anhang dieses Kataloges, S. 313–323.

3 Nicolai Reprint 1994, S. 401–420.

4 Nicolai Reprint 1994, S. 407–419. Geisterseherei war eine Erfahrung, die viele Zeitgenossen insbesondere unter Freimaurern machten. Selbst Nicolai war davon betroffen (dazu Sichelschmid 1971, S. 154–155). Die »schwärmerischen« Kreise meinen alchemistisch arbeitende Freimaurer, die dem rationalen Logenbruder Nicolai ein Graus waren.

5 Siehe Kris 1932 und Kris 1933.

6 Vorsichtiger formulierte Glandien (1981, S. 79–90), der Schizophrenie als Diagnose ablehnte, jedoch Paranoia annahm (S. 102–103).

7 So auch zuletzt Ausst.-Kat. Melancholie 2005, S. 419 (Kat.-Nr. 218).

8 Siehe den Aufsatztitel von Pakosta 1976: Mein Bekenntnis zu Franz Xaver Messerschmidt.

9 Kemp 2002.

10 Dazu Pötzl-Malíková 1982, S. 235–236, 240.

11 So auch Wittkower 1965, S. 123; Tietze-Conrat 1920, S. 29.

12 Siehe Anonymus 1794, S. 70.

13 Dazu siehe beispielsweise Ausst.-Kat. Lavater 1999, S. 184, 185, 371, 379.

14 Zur Geschichte der Charakterköpfe, auch im 19. Jahrhundert, siehe Pötzl-Malíková 1982, S. 241–243; Krapf, Musealisierung 2002, S. 107–115.

15 Die Darstellung beruht zum Teil auf meinem Aufsatz, siehe Bückling 2002, S. 84–85.

16 Siehe den Vertrag mit Maria Theresia, Herzogin von Savoyen, vom 23. Februar 1770 (abgedruckt bei Pötzl-Malíková 1982, S. 127) und den Brief an seinen Bruder vom 14. Juni 1770 (ebd., S. 128–129).

17 Siehe Pötzl-Malíková 1982, S. 129.

18 So Behr/Grohmann/Hagedorn 1983, S. 45–46.

19 Zitiert nach Pötzl-Malíková 1982, S. 132.

20 Dazu Wagner 1967, S. 42–44.

21 Winckelmann 1755, S. 19.

22 Zitiert nach Pötzl-Malíková 1982, S. 30.

23 Beide Schriftstücke abgedruckt bei Pötzl-Malíková 1982, S. 130–131.

24 Zitiert nach Pötzl-Malíková 1982, S. 132.

25 So auch Gampp 1998, S. 20; Bückling 1999b, S. 101; Bückling 2002, S. 84–85.

26 Zitiert nach Pötzl-Malíková 1982, S. 134.

27 Zitiert nach Pötzl-Malíková 1982, S. 135.

28 Zitiert nach Pötzl-Malíková 1982, S. 136.

29 Nicolai Reprint 1994, S. 403.

30 Friedel 1785, S. 397–398.

31 Gemeint ist Hofmaler Martin van Meytens, Gönner von Messerschmidt. Zu van Meytens siehe Krapf, Auftraggeber und Freundeskreis 2002, S. 65.

32 Füeßli 1802, S. 25.

33 Nicolai Reprint 1994, S. 401.

Freemasons. Even Nicolai was affected (cf. Sichelschmid 1971, pp. 154f.). The expression "enthusiasts" refers to Freemasons dabbling in alchemy, whom the rationally-minded lodge-brother Nicolai detested.

5 See Kris 1932, 1933.

6 More cautiously put in Glandien (1981, pp. 79–90), who rejected the diagnosis of schizophrenia yet assumed it was paranoia (pp. 102f.).

7 Thus also most recently exhib. cat. Melancholie 2005, p. 419 (cat. no. 218).

8 See also Pakosta 1976.

9 Kemp 2002.

10 Cf. Pötzl-Malíková 1982, pp. 235f., 240.

11 Thus also Wittkower 1965, p. 123; Tietze-Conrat 1920, p. 29.

12 See Anon. 1794, p. 70.

13 Cf. for example, exhib. cat. Lavater 1999, pp. 184f., 371, 379.

14 On the history of the Character Heads, also in the 19th century, see Pötzl-Malíková 1982, pp. 241ff.; Krapf, Musealisierung 2002, pp. 107–115.

15 What follows is based in part on my essay Bückling 2002, see esp. pp. 84f.

16 See the contract with Maria Theresia, Duchess of Savoy, dated 23 February 1770 (reproduced in Pötzl-Malíková 1982, p. 127) and the letter of 14 June 1770 (ibid., pp. 128f.).

17 See Pötzl-Malíková 1982, p. 129.

18 Thus Behr/Grohmann/Hagedorn 1983, pp. 45f.

19 Quoted in Pötzl-Malíková 1982, p. 132.

20 See Wagner 1967, pp. 42ff.

21 Winckelmann 1755, p. 19.

22 Quoted in Pötzl-Malíková 1982, p. 130.

23 The text of both the draft and the protocol are reproduced in Pötzl-Malíková 1982, pp. 130f.

24 Quoted in Pötzl-Malíková 1982, p. 132.

25 Thus also Gampp 1998, p. 20; Bückling 1999b, p. 101; Bückling 2002, pp. 84f.

26 Quoted in Pötzl-Malíková 1982, p. 134.

27 Ibid., p. 135.

28 Ibid., p. 136.

29 Nicolai Reprint 1994, p. 403.

30 Friedel 1785, pp. 397f.

31 The person meant is court painter Martin van Meytens, who extended his protection to Messerschmidt. On van Meytens see Krapf, Auftraggeber und Freundeskreis 2002, p. 65.

32 Füessli 1802, p. 25.

33 Nicolai Reprint 1994, p. 401.

Porträts
Portraits

Die Porträts Messerschmidts 1760–1783

Maraike Bückling

Ein Überblick

Zu den wichtigsten Bildhauergattungen des 18. Jahrhunderts gehörte in ganz Europa die Porträtplastik. Im Herrscherbildnis, seien es Büsten, Reliefs, Statuen oder Reiterstandbilder, war seit dem Barock höchste Prachtentfaltung geboten. Den Herrscher in augenblicklicher Bewegung zu zeigen und diesen Moment gleichzeitig mit Dauerhaftigkeit zu verbinden, ihn sowohl idealisiert als auch authentisch vor Augen zu führen, war das erklärte Ziel der Künstler und ihrer Auftraggeber. Zahlreiche Herrscherporträts in Malerei, Bildhauerei und Graphik führen den diesen Anforderungen gehorchenden barocken Formenkanon vor Augen, dem die illusionistische Wiedergabe auch der unterschiedlichen Materialqualitäten – von Haut, Haaren und verschiedenen Stoffen – eines der Hauptanliegen war.

Der Bildhauer des Hofs und ein Windhauch der Aufklärung

Messerschmidt war in den 1760er Jahren ein vom kaiserlichen Hof gerne beauftragter Porträtbildhauer. Büsten, Reliefs und Statuen von Kaiser Franz I. Stephan von Lothringen und Kaiserin Maria Theresia (Abb. 3), vom Thronfolger Joseph II. (Abb. 8) oder auch von Herzog Albert von Sachsen-Teschen belegen diese Beliebtheit. Die frühesten bekannten Werke sind die von Fürst Joseph Wenzel I. von Liechtenstein im Jahr 1760 in Auftrag gegebenen Halbbüsten von Franz I. Stephan und Maria Theresia für den »Kaisersaal« im Zeughaus in der Wiener Renngasse (Abb. 15).[1] Vom kaiserlichen Hof beauftragt, sind die Statuen der Kaiserin mit den Insignien der

Portraiture was one of the most important genres in 18th-century sculpture throughout Europe. Since the Baroque, formal state portraits of rulers, be they busts, reliefs, or standing or equestrian statues, had required the utmost in magnificence. The stated aim of both artists and patrons was to show the ruler caught at the moment of movement and to link this moment with permanence, to represent him as both idealised and authentic. Numerous portraits of rulers in painting, sculpture and prints illustrate this Baroque canon of forms in accordance with these demands, a chief concern being the illusionist reproduction of the material properties of diverse substances – skin, hair and various fabrics.

15 Franz Xaver Messerschmidt, Kaiserin Maria Theresia, um 1760, Bronze, vergoldet, Österreichische Galerie Belvedere, Wien, Inv.-Nr. 4241
Franz Xaver Messerschmidt, The Empress Maria Theresia, c. 1760, gilt bronze, Österreichische Galerie Belvedere, Vienna, Inv. no. 4241

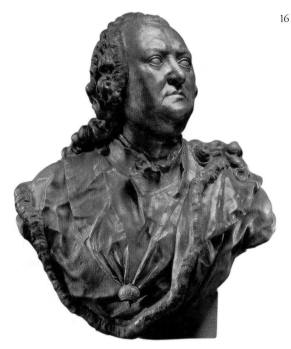

16 Franz Xaver Messerschmidt, Gerard van Swieten, 1769, Blei-Zinn-Legierung, vergoldet, Österreichische Galerie Belvedere, Wien, Inv.-Nr. Lg 18
Franz Xaver Messerschmidt, Gerard van Swieten, 1769, lead-tin alloy, gilt, Österreichische Galerie Belvedere, Vienna, Inv. no. Lg 18

The court sculptor – a whiff of Enlightenment

The imperial court was keen to commission portrait sculpture from Messerschmidt in the 1760s. His popularity is attested by busts, reliefs and statues of the Emperor Francis I and the Empress Maria Theresia (fig. 3), of the Crown Prince, later Joseph II (fig. 8) and of Albert, Duke of Saxe-Teschen. The earliest known Messerschmidt works were half-length busts, commissioned in 1760 by Joseph Wenceslas I, Prince of Liechtenstein, of Francis I and Maria Theresia for the Kaisersaal in the Renngasse Armoury in Vienna (fig. 15).[1] Commissioned by the imperial court, the statue of the Empress has been rendered with the insignia of Hungary (fig. 3), while her spouse is depicted as the representative of the archducal family and as Holy Roman Emperor.[2] The Vienna newspaper "Wienerisches Diarium" reported on 16 August 1766: "The skilled sculptor Herr Messerschmidt, who has been employed to model and execute these statues and to whom has accrued much honour in so doing, has been most graciously rewarded by their Royal and Imperial Majesties with a gratuity and a large gold medal for the encouragement of all artists."[3] The dominant features of this conception are majestic movements, floating cloaks with flaring folds, robes of state resolved in details that artfully conceal the transition from pedestal to bust. The artist continued to execute similar busts, for instance the portrait of Maria Theresia's personal physician, Gerard van Swieten, a man distinguished in his field and the reformer of Austrian medical services, which the Empress herself commissioned (fig. 16).

Another portrait in this sequence which retained the traditional configuration of motifs is the medallion on the tomb of the Viennese Reichshofrat, Heinrich Christian von Senckenberg (1704–1768).[4] After his death in 1768, his widow, née Baroness Palm, commissioned from Messerschmidt a tombstone to be set up in the "imperial cemetery at the Alsergrund near the Schwarzspaniern". The art theorist Franz Christoph von Scheyb, who greatly admired Messerschmidt, wrote an account of it in 1770: "[...] the metal bust in mezzo relievo of the learned and renowned Imperial and Royal

Königin von Ungarn (Abb. 3) und ihres Gemahls als Vertreter des Erzhauses und als römischer Kaiser ausgeführt.[2] Die Zeitung »Wienerisches Diarium« berichtet am 16. August 1766: »Den geschickten Bildhauer Hrn. Messerschmid, welcher sich zur Modelir- und Ausarbeitung dieser Statuen hat brauchen laßen, und der sich dabey viel Ehre erworben, haben Ihro k. k. Maj. mit einem Gnadenpfennige und einer großen goldenen Medaille zu mehrerer Ermunterung aller Künstler, huldreichst zu beschenken geruhet.«[3] Hoheitsvolle Bewegungen, ausladende Faltenschwünge, in Details aufgelöste, herrscherliche Gewänder, die den Übergang zwischen Sockel und Büste überspielen, dominieren die Gestaltung. Vergleichbare Büsten schuf der Künstler weiterhin beispielsweise mit dem 1769 von Maria Theresia in Auftrag gegebenen Porträt ihres Hofarztes, des bedeutenden Mediziners und Reformators des österreichischen Medizinalwesens, Gerard van Swieten (Abb. 16).

In die Reihe derjenigen Porträts, die das traditionelle Motivgefüge übernehmen, gehörte auch das Porträtmedaillon auf dem Grabmal für den aus Frankfurt gebürtigen Wiener Reichshofrat Heinrich Christian von Senckenberg (1704–1768).[4] Nach seinem Tod im Jahr 1768 beauftragte seine Witwe, eine geborene Freiin Palm, Messerschmidt mit einem Grabmal, das auf dem »kaiserlichen Friedhof am Alsergrund bei den Schwarzspaniern« aufgestellt wurde. Der Kunsttheoretiker Franz Christoph von Scheyb, der Messerschmidt außerordentlich schätzte, berichtet im Jahr 1770 darüber: » [...] das halb erhabne metallne Bruststück des gelehrten und berühmten kaiserl. königl. Reichshofraths, Freyherrn von Senken-

berg, welches aus einem kleinen ziemlich schlechten Miniaturpor-
trait in Thon abmodellirt, und in Metall gegossen uns in seiner
Lebensgröße so änlich vor Augen gestellt worden, daß alle Kenner
der Kunst und der Person das Werk mit Vergnügen und Verwunde-
rung ansehen, den Künstler mit allem Lob erheben, mir folglich
Anlaß und Gelegenheit geben, ihm hier öffentlich Gerechtigkeit
wiederfahren zu lassen, ohne der Geschicklichkeit andrer Künstler
nahe zu treten. Franz Xaver Messerschmied, der seinen Namen
durch vielfältige Kunststücke von Holz, Thon, Gyps, Marmor und
Metall, aus welchen Materialien er alle Gegenstände herauszaubert,
bereits schon verewiget hat, war zu Ausarbeitung dieses schweren
Bildnisses ausersehen. Man würde auch Mühe gehabt haben, einen
geschicktern Bildhauer zu finden.«[5] Das Aussehen des Grabmals
wird durch einen Stich (Abb. 6) von Johann Ernst Mansfeld[6] über-
liefert: Die Grabinschrift, die sich als einziger Teil erhalten hat,[7] ist
auf einem Sockel aus weißem Marmor angebracht. Darüber verbin-
det das Wappen des Verstorbenen den Sockel mit dem – wohl bron-
zenen – Porträtmedaillon.[8] Es wurde von zwei sich spiralig bewe-
genden, puttenhaften Genien gehalten. Das einfach gerahmte
Bildnis, von dem heute jede Spur fehlt[9] und dessen Durchmesser
knapp 65 cm betrug,[10] zeigt das Brustbild Senckenbergs (Abb. 17).
Er trägt unter einem Umhang eine geknöpfte Weste und ein Spit-
zenjabot sowie eine Perücke, deren lange Locken auf die Schultern
und den Rücken herabfallen.

 Nach der Auflassung des Wiener Friedhofs stand das Grabmal
im Palmschen Fideikommiß-Haus, das 1799 verkauft wurde. Noch
im selben Jahr gelangte der Stein, bereits ohne die Genien, nach
Frankfurt mit der Absicht, es neben dem Grabmal des Bruders des
Verstorbenen, Johann Christian Senckenberg, aufzustellen. Zunächst
aber wurde es in die alte Stadtmauer neben dem Botanischen Gar-
ten, später in eine Wand der Kapelle des Neuen Bürgerhospitals ein-
gelassen, ehe es 1958 ein weiteres Mal seinen Platz wechselte.[11]

 Mit derartigen Porträts, seien es Statuen, Büsten oder Medail-
lons, bewegte sich der Bildhauer in einem, was die Motive und ihre
Gestaltung betrifft, bis in höchste Kreise akzeptierten Rahmen.
Er fügt sich damit in den Kreis seiner Lehrer und Kollegen Jakob
Christoph Schletterer (1699–1774), Matthäus Donner (1704–1756),
Balthasar Ferdinand Moll (1717–1785) oder auch Karl Georg Mer-
ville (1745–1798). So lassen sich etwa seine Büsten des Kaiserpaars
(Abb. 15) mit denjenigen Molls oder Mervilles vergleichen; Vorbild
für die frühen Halbbüsten des kaiserlichen Paares dürfte beispiels-
weise die Büste des Fürsten von Liechtenstein gewesen sein, die vor
1758 von Moll geschaffen wurde.[12] Ähnliche Motivgefüge fallen
weiterhin in Bezug auf Reliefmedaillons (Abb. 17) bei Donner und
Schletterer auf. Bei den lebensgroßen Statuen des Kaiserpaars könn-

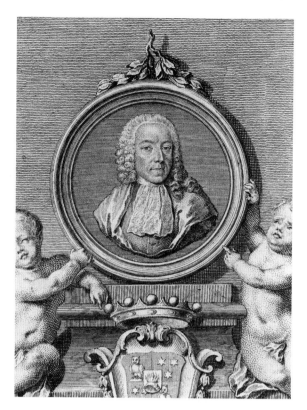

17 Johann Ernst Mansfeld,
Grabmal für den Reichs-
hofrat Heinrich Chris-
tian von Senckenberg,
Detail: Porträtmedail-
lon, 1782, Kupferstich,
Dr. Senckenbergische
Stiftung, Frankfurt am
Main (in: Renatus de
Senckenberg, »Vita
Henrici Christiani L. B.
de Senckenberg«, Fran-
cof. A. M. 1782, Bei-
blatt)

*Johann Ernst Mansfeld,
tomb for Reichshofrat
Christian von Sencken-
berg; detail: Portrait me-
dallion 1782, copperplate
engraving, Dr. Sencken-
bergische Stiftung, Frank-
furt am Main (in: Rena-
tus de Senckenberg, "Vita
Henrici Christiani L. B.
de Senckenberg", Frank-
furt. A. M. 1782,
supplement)*

Reichshofrat, Baron von Senkenberg, which is mod-
elled after a fairly bad miniature portrait in clay and
cast in metal, is represented in such likeness to our
eyes that all who know art and the person himself
view the work with pleasure and admiration, elevate
the artist with all praise, consequently affords me the
occasion to do him justice in public without slighting
the skills of other artists. Franz Xaver Messerschmied,
who has already made his name immortal with all
manner of works of art in wood, clay, plaster, marble
and metal, the materials from which he conjures all
objects, was chosen to execute this difficult portrait.
One would also have been hard put to find a more
skilful sculptor."[5] The appearance of the funerary

te sich Messerschmidt etwa an Gemälden beispielsweise des Hofma-lers Martin van Meytens (1695–1770), seinem Gönner, beziehungs-weise an großformartigen Denkmälern orientiert haben.[13] Zudem sei als Bezugsrahmen auf die im 16. Jahrhundert von Kaiser Maxi-milian I. initiierte Ausstattung der Hofkirche in Innsbruck mit 28 Bronzestatuen hingewiesen.[14]

Die Büsten und Statuen lassen in ihren in Details aufgelösten Gewändern und lang wallenden Perücken und die im Kontrast dazu großflächigen, glatten Gesichter lebendig durchpulste, atmende Körper nicht vermuten. Messerschmidt benutzte traditionelle Moti-ve und führte sie zu einer neuen Form der idealisierten, zeitlos gül-tigen Herrscherrepräsentation zusammen.[15]

Der Bildhauer der Aufklärer und der Akademie – Windstöße der Aufklärung

Die Bedeutung der Porträtgattung sollte sich noch steigern, denn »der einzelne Mensch samt seiner konkreten physischen Erschei-nung wurde dank der Aufklärung zu einem zentralen Gegenstand der bildenden Kunst.«[16] Denis Diderot formulierte: »Die Bildnis-malerei und die Kunst der Büste müssen bei einem republikani-schen Volk in Ehren gehalten werden, denn dort geziemt es sich, den Blick der Mitbürger ohne Unterlaß auf die Verteidiger ihrer Rechte und ihrer Freiheit zu lenken.«[17] Häufig machten Porträt-büsten oder -statuen den größten Teil eines Bildhaueroeuvres aus, so beispielsweise bei Michael Rysbrack (1694–1770), Jean-Bap-tiste II. Lemoyne (1704–1778), Jean-Jacques Caffieri (1725–1792), Jean-Pierre-Antoine Tassaert (1727–1788), Jean-Antoine Houdon (1741– 1828) – und auch bei Franz Xaver Messerschmidt. Zur Zeit Messerschmidts und vor dem Hintergrund der Aufklärung ver-schiebt sich der Akzent der Porträtplastik: Der Einzelne wollte nun eher seine persönlichen Leistungen und unverwechselbaren Beson-derheiten wiedergegeben wissen als gesellschaftlich wiedererkenn-bare, klerikale oder höfische Rangabzeichen.

Messerschmidt brach mit der traditionellen Gestaltung in den Jahren 1769–1772 in Werken für die Akademie oder für Auftrag-geber, für die die ästhetischen Normen des Hofs nicht zwingend waren. Diese Porträts sprechen eine ganz andere Sprache als jene für den Hof. Die Porträtbüste des damals 65-jährigen Franz von Scheyb (Abb. 18), Gelehrter und Autor zweier wichtiger kunsttheoretischer Schriften,[18] war das erste Werk, mit dem sich Messerschmidt von der offiziellen Porträtform lossagte. Sie »zeigt den perückenlosen Kopf Scheybs (1704–1777) auf breitem Hals, frontal ausgerichtet und getragen von einem kleinen, nackten Büstenausschnitt, der sei-nerseits auf einem kleinen, vierkantigen Sockel ruht. Die Konzen-tration auf die individuelle Erscheinung bei gleichzeitiger Idealisie-

monument has come down to us in an engraving (fig. 6) by Johann Ernst Mansfeld:[6] the inscription, which is the only part to have survived,[7] is on a pedestal of white marble. Above it, the armorial bear-ings of the deceased link the pedestal with the por-trait medallion – which was presumably bronze.[8] It was supported by two winged putti in spiralling motion. The simply-framed portrait, of which all trace has been lost,[9] measured just 65 cm in diameter.[10] It bore a bust of Senckenberg (fig. 17), who was depicted wearing a buttoned waistcoat under a cloak, a lace jabot and a wig, the long curls falling to his shoulders and down his back.

After the Viennese cemetery was abandoned, the tombstone stood in the Palmsches Fideikommiss-Haus, which was sold in 1799. That year, the stone, already bereft of the winged putti, was sent to Frank-furt to be set up next to the tombstone of the deceased's brother, Johann Christian Senckenberg. Before that, however, it was set into the old city wall near the Botanical Gardens and later into a wall of the chapel of the Neues Bürgerhospital, before being relocated yet again in 1958.[11]

With portraits of this kind, be they statues, busts or medallions, the sculptor was well within the bounds of what, as far as motifs and the artist's han-dling of them were concerned, was acceptable to the top tiers of society. In this Messerschmidt fitted in with the circle of his teachers and colleagues Jakob Christoph Schletterer (1699–1774), Matthäus Donner (1704–1756), Balthasar Ferdinand Moll (1717–1785) and Karl Georg Merville (1745–1798). His busts of the Emperor and Empress (fig. 15) can, therefore, be compared with those executed by Moll or Merville. The model for the early Messerschmidt half-busts of the imperial couple may well have been the bust of the Prince of Liechtenstein, which Moll executed before 1758.[12] Further, similar motif config-urations are discernible in relief medallions (fig. 17) by Donner and Schletterer. For the life-size statues of the Emperor and Empress, Messerschmidt may have been inspired by paintings, for instance, by the court painter Martin van Meytens (1695–1770), whose protégé Messerschmidt was, or also by large-scale monuments.[13] In addition, the fittings of the

rung, der Verzicht auf jeden Hinweis auf seine gesellschaftliche Stellung, die Frontalität«[19] und die natürliche Nacktheit der Büste charakterisieren diese neue Porträtform. 1769 geschaffen, stammt das Bildnis von Scheybs aus demselben Jahr wie die vergoldete Porträtbüste Gerard van Swietens (Abb. 16), die das barocke Motivgefüge weiterhin tradiert. Geht die Büste van Swietens auf einen Auftrag der Kaiserin zurück, so bewirbt sich der Bildhauer im Jahr 1769 unter anderem mit dem Porträt von Scheybs erfolgreich um die Mitgliedschaft der Wiener Akademie der Malerei, Bildhauerei und Baukunst.[20]

Formal leitet sich die neue Büstenform, für die das Scheyb-Porträt ein Beispiel darstellt, von antiken Vorbildern ab.[21] Für diese antiken Porträts sind die kleinen Ausschnitte typisch, die ehemals in Büsten oder Statuen eingefügt waren und die Messerschmidt in Rom sehen konnte. Die Bezugnahme auf die Antike weist aber über das Formale hinaus. Diderot beispielsweise meint, dass die Antike aufgrund von bestimmten Ausdruckswerten, die die Kunst seiner Zeit vermissen ließe, überzeitlichen Wert besäße. Er nennt: Größe, Einfachheit, Naivität und Natürlichkeit.[22]

Mit derartigen knappen, nackten Büstenausschnitten steht Messerschmidt nicht allein. Auch beispielsweise Joseph Nollekens (1737–1823) bezieht sich auf antike Vorbilder, als er in Rom um

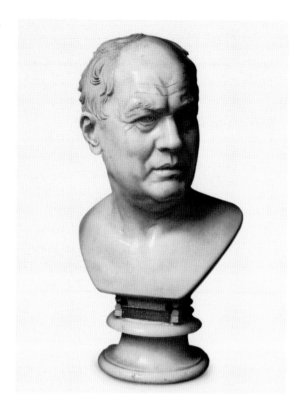

19 Joseph Nollekens, Giovanni Battista Piranesi, 1765/66, Marmor, Accademia Nazionale di San Luca, Rom

Joseph Nollekens, Giovanni Battista Piranesi, 1765/66, marble, Accademia Nazionale di San Luca, Rome

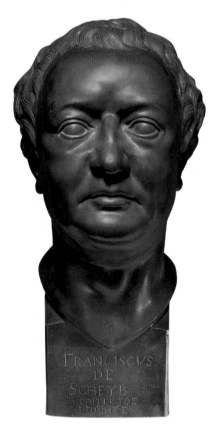

18 Franz Xaver Messerschmidt, Franz von Scheyb, 1769, Blei, Wien Museum, Wien, Inv.-Nr. 95477
Franz Xaver Messerschmidt, Franz von Scheyb, 1769, lead, Wien Museum, Vienna, Inv. no. 95477

Hofkirche in Innsbruck, initiated by Emperor Maximilian I in the 16th century, which included twenty-eight bronze statues, should be pointed out as a frame of reference.[14]

There is nothing about such details of the busts and statues as flowing garments and long, billowing wigs contrasting with the broad surfaces of smooth faces that might suggest animate, breathing bodies pulsing with life. Messerschmidt used traditional motifs and united them to create a new form of the idealised, timelessly valid, formal state portrait of the ruler.[15]

The Academy and private sculptor – gusts of Enlightenment

The importance of the portrait genre would continue to grow since "the individual with the physical appearance specific to him became, by virtue of the

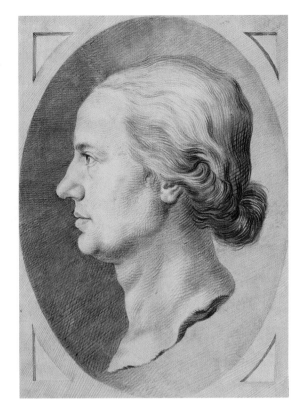

Enlightenment, a central object of the visual arts."[16] As Denis Diderot expressed it: "Portrait painting and the art of the bust must be honoured by a republican people, for there it is fitting to direct the gaze of one's fellow citizens unceasingly to the defenders of their rights and their liberty."[17] Portrait busts often represented the bulk of a sculptor's œuvre, as was the case with, just to take a few examples, Michael Rysbrack (1694–1770), Jean-Baptiste II Lemoyne (1704–1778), Jean-Jacques Caffieri (1725–1792), Jean-Pierre-Antoine Tassaert (1727–1788), Jean-Antoine Houdon (1741–1828) – and not least, Franz Xaver Messerschmidt. In Messerschmidt's day and against the background of the Enlightenment, the focus of portrait sculpture shifted: the individual now wanted to ensure that his personal achievements and distinctive features were reproduced in an individualised form rather than in instantly recognisable insignia, the trappings of clerical or court status.

In the years between 1769 and 1772, Messerschmidt broke with the traditional conception of design in works he executed for the Academy or for patrons who felt under no obligation to accept the aesthetic norms dictated by the court. These portraits speak an entirely different language from those he executed for the court. The portrait bust of the scholar Franz von Scheyb (1704–1777) (fig. 18), then 65 years old and the author of two important treatises on art theory,[18] was the work with which Messerschmidt liberated himself from the constraints of the official portrait form. It "depicts Scheyb's head without a wig, set on a broad neck, frontally, and supported by a small décolleté, which in turn rests on a small, quadrangular base. Concentration on individualised appearance accompanied nonetheless by idealisation, the eschewal of any reference to the sitter's social status, frontality"[19] and the chest bare as in nature are all distinguishing features of this new form of portrait. Executed in 1769, the portrait of von Scheyb dates from the same year as the gilt portrait bust of Gerard van Swieten (fig. 16), which, however, represents a continuation of the traditional Baroque handling of motif configurations. Since the bust of van Swieten goes back to a commission from the Empress herself, it is not surprising that Messerschmidt was successful

1765/66, zur selben Zeit also, zu der sich Messerschmidt dort aufhielt, Laurence Sterne und Giovanni Battista Piranesi (Abb. 19) jeweils mit nackter Büste porträtierte; die Büsten, die in Kopf und Schultern leichte Bewegungen zeigen, ruhen dabei auf einem kleinen, antikischen Sockel.[23] Auch die Büsten anderer Künstler, wie etwa Edmé Bouchardon (1698–1762), geben den antikisch nackten Oberkörper oder Halsausschnitt wieder. In zeitgenössischen Stichwerken gab es vergleichbare Darstellungen. So erscheint der Comte de Caylus auf einem Frontispiz[24] auf einem hochovalen Medaillon im Profil mit kurzem, leicht gewelltem Naturhaar. Der Körper wird, den Profilbildnissen auf antiken Münzen vergleichbar, nur als kleiner, nackter Brustausschnitt gezeigt.[25] Und auch eine Zeichnung (Abb. 20), von der eine rückseitige Beschriftung besagt, sie zeige Messerschmidt im Jahr 1770, gibt den Porträtierten mit nacktem Ausschnitt wieder.

Messerschmidts Porträts weisen nicht nur den nackten Büstenausschnitt auf, mit dem sie sich antiken Werken eng verwandt zeigen; sie sitzen zudem wie aufgebockt, unorganisch auf kubenförmigen Sockeln auf, die entweder zusammen mit den Büstenausschnitten gegossen oder aus demselben Marmorblock gehauen wurden. Künstler wie Houdon,[26] Nollekens oder Bouchardon, die sich gleichfalls auf die Antike beziehen, vermeiden eine derart krasse Komposition.

21 Franz Xaver Messer-
schmidt, Franz Anton
Mesmer, 1770, Blei,
Leihgabe aus Privatbesitz
in der Österreichischen
Galerie Belvedere, Wien,
Inv.-Nr. Lg 1150
*Franz Xaver Messer-
schmidt, Franz Anton
Mesmer, 1770, lead,
loaned by a private collec-
tion to the Österreichische
Galerie Belvedere, Vienna,
Inv. no. Lg 1150*

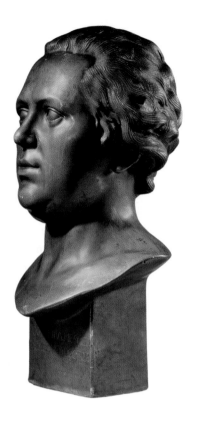

in applying for membership of the Viennese Academy of Painting, Sculpture and Architecture in 1769, for which he submitted, *inter alia*, the Scheyb portrait.[20]

From the formal standpoint, the new bust form as exemplified by the Scheyb portrait derives from classical models.[21] The small V-shaped décolleté, typical of such portraits, were a feature of classical busts and statues; Messerschmidt would have seen them in Rome. The quotation of Antiquity, however, goes beyond the formal aspect. Diderot, for one, was of the opinion that Antiquity, imbued as it was with particular values of expression lacking in the art of his day, possessed a timeless value. Diderot's list of qualities is as follows: grandeur, simplicity, naivety and naturalness.[22]

Messerschmidt was not alone in his use of such curtailed décolletés. Joseph Nollekens (1737–1823) was another portraitist who invoked ancient models in portraying Laurence Sterne and Giovanni Battista Piranesi (fig. 19), both with naked chests, when he was in Rome around 1765/66, that is, at the same time as Messerschmidt; the busts, which reveal a touch of movement in the head and shoulders, rest on a small plinth in the Antique manner.[23] The busts executed by other artists, such as Edmé Bouchardon (1698–1762), replicate the naked upper torso or décolleté in the Antique manner. There are engravings of the time similar enough for comparison in this respect. Comte de Caylus, for instance, is pictured on a frontispiece[24] in an upright oval medallion in profile with short, slightly curly natural hair. His body is, like the profile portraits on ancient coins, only shown as a small section of naked chest.[25] And a drawing (fig. 20), of which an inscription on the reverse says it depicts Messerschmidt in 1770, shows the sitter likewise with a décolleté.

Messerschmidt's portraits not only have the décolleté which reveals their close affinities with works from Antiquity; they also sit unorganically on block-shaped bases, as if jacked-up on top of them. These bases were neither cast with the bust nor were they hewn from the same block of marble. Artists such as Houdon,[26] Nollekens and Bouchardon, who also visibly owe a debt to Antiquity, eschew such blatantly dissonant compositions.

Nur kurze Zeit, nachdem er sich mit der Büste von Scheybs bei der Wiener Akademie der Malerei, Bildhauerei und Baukunst beworben hatte, reichte Messerschmidt eine heute unbekannte Tonbüste bei der k. k. Kupferstecherakademie ein, um auch dort die Mitgliedschaft zu erwerben. Am 11. März 1769 bekunden die Juroren Jakob Schmutzer und Joseph von Sonnenfels im Namen der Akademie »vollkommene Zufriedenheit über das geschmackvolle Bustum, welches Herr Messerschmidt als ein Aufnahmsstück ihrer Prüfung unterworfen. Es gereicht ihr zum Vergnügen einen Mann von unterscheidender Geschicklichkeit und geläuterten Geschmack unter ihre Mitglieder zählen zu können.«[27]

Da es unwahrscheinlich ist, dass Messerschmidt mit dem bei der Kupferstecherakademie eingereichten »Aufnahmsstück« hinter den Stand der für die Akademie der bildenden Künste geschaffenen Büste von Scheybs zurückfiel, werden sich Schmutzer und von Sonnenfels mit ihrem Lob somit auf die neue Büstenform bezogen haben. Vorausgesetzt, dass das »geschmackvolle Bustum« diese neue Porträtform wiederholt, attestieren die Juroren einem Werk »geläuterten Geschmack«, das das barocke Motivgefüge aufgibt, die zeitgenössischen Forderungen der Aufklärung nach Wahrheit, Natürlichkeit und Einfachheit einlöst und auch den formulierten Ansprüchen des Porträtierten an ein Bildnis genügt: »Die einfältigsten Ausdrücke sind die schwersten, und gefallen doch am meisten. [...] Man besorget zuweilen, der Ausdruck sey allzuschwach; er lässet sich aber bis zur ausschweifenden Stärke fortreißen, ohne zu

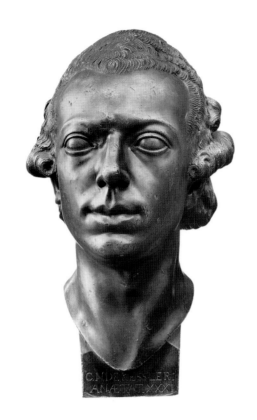

Only shortly after he had applied with the von Scheyb bust to the Viennese Academy of Painting, Sculpture and Architecture, Messerschmidt submitted a now unknown bust to the Royal and Imperial Academy of Copperplate Engravers, of which he also sought to become a member. On 11 March 1769, jurors Jakob Schmutzer and Joseph von Sonnenfels expressed in the name of the Academy their "complete satisfaction with the tasteful bust, which Herr Messerschmidt has submitted to their inspection as a piece to gain admission. It is a pleasure to be able to number a man of such exceptional skill and refined taste among their members."[27]

Since it is highly unlikely that, in the admission-piece he submitted to the Copperplate Engravers' Academy, Messerschmidt reverted to a style preceding that of the Scheyb bust submitted to the Academy of Fine Art, the praise expressed by Schmutzer and von Sonnenfels will have been addressed to the new form of bust. If one can assume that the "tasteful bust" replicated this new form of portrait, the jurors are attesting to a work "of refined taste", which abandons the Baroque motif configuration and instead represents the contemporary call of the Enlightenment for truth, naturalness and simplicity as well as satisfying the following demands made by a sitter: "The simplest works are the most difficult, yet they are the most pleasing. [...] One is concerned at times that the expression might be too weak; however, one allows oneself to be swept away to the extent of rapture without thinking that what is superfluous in general is more displeasing than what is too little" – thus von Scheyb.[28] Around 1770, comparable portraits were executed of Franz Anton Mesmer (figs. 10, 21) and Johann Christoph von Kessler (figs. 22).[29] They all have in common the very curtailed décolleté above square pedestals; this type of base makes it possible to add an inscription – the artist's signature or the name of the sitter. This was done in four of the portraits dating from c. 1770.

The portrait busts of von Scheyb (fig. 18)[30] and Mesmer (fig. 10, 21) depict the facial skin as distended, disrupted by a few pronounced wrinkles that have nonetheless been delicately incised to lend the cheeks, mouth and eye sections, the forehead, chin and nose

bedenken, daß das überflüßige gemeiniglich mehr mißfalle, als das zu wenige« – so von Scheyb.[28] Vergleichbare Porträts entstanden um 1770 von Franz Anton Mesmer (Abb. 10, 21) und von Johann Christoph von Kessler (Abb. 22).[29] Ihnen ist gemein der überaus knappe Büstenausschnitt über rechteckigen Sockeln, die die Möglichkeit bieten, eine Inschrift – die Signatur des Künstlers oder den Namen des Dargestellten – anzubringen. Dies ist bei vier der um 1770 geschaffenen Porträts geschehen.

Die Porträtbüste von Scheybs (Abb. 18)[30] wie auch diejenige Mesmers (Abb. 10, 21) zeigen die Gesichtshaut gebläht, unterbrochen von wenigen markanten, dennoch weich eingetragenen Falten, die den Wangen, der Mund- und Augenpartie, der Stirn, dem Kinn und der Nase klare, wenngleich weich verschliffene Konturen verleihen. Die Haut wirkt wie eine eigenständig belebte Form. Das Zusammentreffen der nackten Büsten und der nahezu monumental wirkenden Köpfe mit den schmucklosen, einfachen Kuben wirkt abrupt, der Porträtierte wird geradezu auf sich selbst zurückgeworfen. Zudem fällt der Kontrast zwischen den glatten gewölbten Flächen der Haut und den detailliert ziselierten Partien auf: Die Haare sind in natürliche Sicheln und Locken frisiert. Dabei sind die einzelnen Strähnen nochmals in sich gestrichelt. Diese einerseits natürliches Haar andeutenden, von der weichen Materialqualität von Haar durch die scharfen Ritzungen andererseits abweichenden, geradezu abstrahierenden Strähnen unterstreichen – mit gegensätzlichen bildhauerischen Mitteln erzielt – den Eindruck, den auch die

Behandlung der Haut hervorruft: Es entsteht artifizielle Natürlich-keit anstelle von lebendig wirkender Körperlichkeit. Auch die anti-kisch blicklosen Augen tragen zu diesem Eindruck bei und ebenso die einfachen Sockel, auf dem die Köpfe als ausgeschnittene Kör-perteile sitzen. Bei von Scheybs und Mesmers Büsten werden somit die individuelle Erscheinung und die idealisierte Einfachheit der Porträtierten jenseits illusionistischer Erscheinung betont. Einen davon abweichenden Eindruck vermitteln Aufnahmen des verschol-lenen Porträts des Schriftstellers von Kessler (Abb. 22,23): Das zart gegliederte Gesicht mit den auffallend großen Augen, den weich geschwungenen Lippen und der glatten, gebläht wirkenden Epider-mis wird gerahmt von einer extravaganten Perücke. Von der Seite betrachtet, wird die Kopfform durch eine markante Einschnürung der Haarteile geradezu deformiert.

Mit der Marmorbüste des Gerard van Swieten (Kat.-Nr. 1)[31] bedient sich der Künstler erneut des beschriebenen Motivgefüges, treibt die Veränderungen aber noch weiter voran. Die unregelmäßig gerundete Büste, die die Inschrift auf dem rechteckigen Sockelblock teilweise überschneidet, trägt den massigen Kopf des korpulenten Mediziners. Die drastische Darstellung der unvorteilhaften Leib-lichkeit steigert der Bildhauer zusätzlich mit Irritationen; so schei-nen beispielsweise die Augen blicklos nach vorne gerichtet zu sein, bis beim Nähertreten der Blick nach links deutlich wird; gleichmü-tige Gesichtszüge sind durch momenthaftes Öffnen der Lippen beunruhigt. Einerseits wendet sich Messerschmidt auch mit diesem Bildnis vehement gegen die traditionellen, höfischen Porträtformen, andererseits nutzt er die aus dem Barock bekannte illusionistische Formensprache, um die Wiedergabe eines bestimmten Moments vorzutäuschen. Ein Moment, der allerdings nicht in eine hoheits-volle Bewegung mündet, sondern eher einen privat anmutenden Augenblick in Stein bannt. Im selben Moment, in dem sich der Bildhauer der barocken Stilmittel bedient, ironisiert er sie.

Den Porträts Mesmers, von Scheybs, von Kesslers und van Swietens ist der überaus knappe Büstenausschnitt gemeinsam, der unorganisch auf einem Kubus angebracht ist. Kleine Unterschiede fallen dennoch auf: Die Büstenausschnitte der Porträts van Swietens und Mesmers laden, breit gelagert und mit gerundetem Abschluss, weit aus und überschneiden den Sockel so, dass von der oberen Sockelfläche nichts zu sehen ist und im Fall van Swietens die In-schrift auf der Vorderseite überschnitten wird. Der Ausschnitt von Scheybs ist dagegen so knapp gewählt und nach unten zu einer abgeflachten Spitze zusammengeführt, dass seitlich Ecken der obe-ren Sockelfläche vorscheinen; Ähnliches ist bei der Büste von Kess-lers, dessen Ausschnitt sich noch stärker nach unten verjüngt, zu beobachten.

clear, albeit soft, contours. The skin seems like a form that is independently alive. The juxtaposition of the naked chests and the almost monumental-looking heads with the unadorned, simple blocks forms an abrupt contrast so that the sitter is veritably thrown back on himself. Moreover, the contrast between the smooth bulging skin surfaces and the detailed, chis-elled parts is noticeable: the hair is dressed in natural curls, which have further internal incised details. These strands suggest natural hair, on the one hand, but, on the other, deviate by dint of the sharp inci-sions from the soft material properties of hair as a substance to the extent that they are almost abstract. This dichotomy underscores – with contrasting sculp-tural devices – the impression also produced by the handling of the skin: the result is artificial naturalness rather than a physical presence that looks alive. This impression is further emphasised by the eyes, gazing in the antique manner from sightless orbs, and the simple bases on which the heads have simply been plumped down as cut-off close-ups of a body detail. Thus in the busts of von Scheyb and Mesmer, the individuality of the sitter's appearance and idealised simplicity are emphasised beyond all appearance of illusionism. Reproductions of the lost portrait of the writer von Kessler (fig. 22, 23) convey a different impression: here a delicately articulated face with strikingly large eyes, the softly curved lips and the smooth, swollen-looking epidermis are framed by an extravagant wig. Viewed from the side, the shape of the head has been veritably deformed by the degree to which the hair has been nipped in.

In the marble bust of Gerard van Swieten (cat. no. 1),[31] Messerschmidt has again made use of the motif configuration described above but has further developed his modifications of it. The irregularly rounded bust, in part overlapped by the inscription on the rectangular base block, carries the massive head of the corpulent physician. Messerschmidt has exaggerated his drastic representation of his sitter's unbecoming fleshiness by additional irregularities; the eyes seem at first sight to be gazing sightlessly ahead until, when one views them from closer up, it becomes apparent that they are gazing to the left; facial features conveying an equable expression have

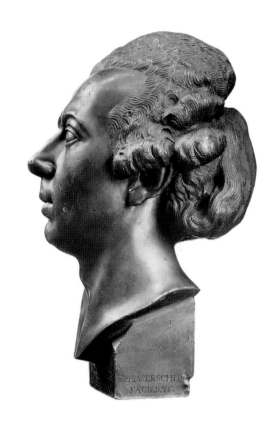

Auch die Sockelkuben unterscheiden sich jeweils ein wenig vonein-ander. Dies ist ebenfalls bei einer bislang nahezu unbekannten Büste des Fürsten Joseph Wenzel I. von Liechtenstein (Kat.-Nr. 2) zu beobachten. Die knappe, nach vorne ausgerichtete, nackte Büste eines Mannes ruht wiederum auf einem rechteckigen Kubus, der hier auffallend breiter als tief ist. Der Kopf ist darauf, wie bei den Porträts Mesmers, von Scheybs, von Kesslers und van Swietens, frontal angebracht. Der Ausschnitt endet mit dem Schulteransatz des Trapezmuskels, so dass der Körper nur ebenso breit ist wie der Kopf. Die Büste verjüngt sich nach unten in gerade gezogener Kon-tur V-förmig bis zu ihrem horizontalen Abschluss, der bis zur Sockelunterkante reicht. Der die Büste stützende Kubus steht zu Seiten des Ausschnitts auch in der Vorderansicht seitlich vor und ist vor allem in der Seiten- und der Rückansicht deutlich zu sehen.[32]

Messerschmidt erreicht durch diese Büstenform eine weitere Vereinfachung im Vergleich zu den anderen um 1769–1772 ent-standenen Porträts, denn nun sind es mit Sockelkubus, Büsten-ausschnitt und Kopf nicht mehr drei Bestandteile, aus denen das Porträt zusammengesetzt ist, sondern, da die beiden ersteren zu-sammenfallen, nur mehr zwei. Dadurch wird die Konzentration noch stärker auf das Gesicht gelenkt. Außerdem ist durch den bis zur unteren Sockelkante gezogenen Ausschnitt die Vorderseite des Sockels bis auf die schmalen, seitlich erscheinenden Dreiecke ver-deckt. Dies, zusammen mit dem schmalen Sockelkubus, hat zur

been disturbed by a momentary opening of the lips. On the one hand, Messerschmidt is vehemently opposing the traditional courtly portrait in this bust, too; on the other, he is nonetheless exploiting the illusionist formal language familiar from the Baroque to simulate the capture of a particular fleeting moment. A moment which, however, does not end in majestic movement but instead captures in stone what seems more like an instant from a private exis-tence. In the act of exploiting the Baroque stylistic devices, the sculptor subjects them to irony.

The portraits of Mesmer, von Scheyb, von Kessler and van Swieten all share the extremely cur-tailed décolleté set inorganically on a block. However, there are some slight differences: the décolletés of the van Swieten and Mesmer portraits are broad and flar-ing with a rounded contour and overlap with the pedestal so that nothing of its upper surface is visible and, in the van Swieten portrait, even the inscription on the front is intersected. The décolleté of the von Scheyb portrait, by contrast, is so curtailed and tapers to such a blunted point at the bottom that, on the sides, the corners of the upper surface of the base are left showing; the bust of von Kessler, with an even more sharply tapering décolleté, is similar in this respect.

The pedestal blocks, too, are all slightly differ-ent. This can also be seen in a hitherto almost unknown bust of Prince Joseph Wenceslas I of Liech-tenstein (cat. no. 2). The scant, frontal naked bust of a man again rests on a rectangular block, which in this case is noticeably broader than it is deep. The head is set frontally on it, as in the portraits of Mes-mer, von Scheyb, von Kessler and van Swieten. The chest section ends laterally at the shoulder end of the trapezius muscle so that the body is only as wide as the head. The bust tapers downwards in a straight V-shaped contour to its horizontal end, which extends to the lower edge of the base. The block supporting the bust juts out to the sides of the chest, even in frontal view and can be seen clearly from the back and sides.[32]

With this form of bust, Messerschmidt succeed-ed in further simplifying the composition he had used for the portraits of 1769 to 1772; now the base

24 Franz Xaver Messer-
schmidt, Herzog Albert
von Sachsen-Teschen,
1777–1780, Blei,
Bayerisches National-
museum, München,
Inv.-Nr. 49/16
*Franz Xaver Messer-
schmidt, Albert, Duke of
Saxe-Teschen, 1777–1780,
lead, Bayerisches
Nationalmuseum,
Munich, Inv. no. 49/16*

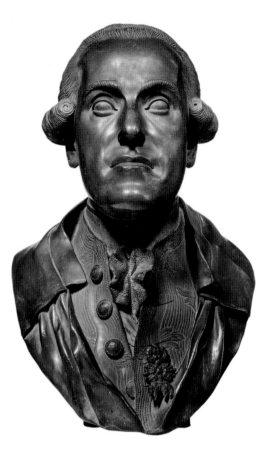

block, the décolleté and the head are no longer three elements stuck together to compose a portrait. Instead, since the first two elements coincide, there are by now only two constituents. This modification focuses attention more strongly on the face. In addition, making the chest extend to the lower edge of the base block to cover the front of the base except for a narrow triangle showing on each side. Consequently, this feature, taken together with the narrowness of the base block, obviated any need for a signature and inscription. This ultimately results in a further diminishing of the portrait nature of the work and, concomitantly, enhances the abstraction in the rendering of the sitter's personality; even his name is missing, after all.

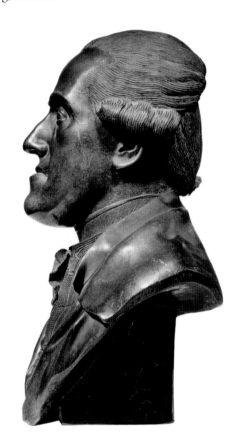

Folge, dass auf Signatur und Inschrift verzichtet werden konnte. Letztlich bedeutet dies eine weitere Zurücknahme von Porträt-haftigkeit, eine zusätzliche Abstraktion von der Person des Darge-stellten, fehlt doch nun sogar sein Name.

Von der Form eines einfachen Kubus als Stütze weicht Mes-serschmidt in der Folge auch bei traditionellen Bildnissen nicht ab, so beispielsweise bei der Büste von Herzog Albert von Sachsen-Teschen (Abb. 24) aus den Jahren 1777–1780. Sein etwas voluminö-serer Büstenausschnitt verjüngt sich in U-Form und verdeckt den von der Seite sichtbaren, großen Kubus, auf dem die Büste ruht (Abb. 25). Ebenso wie der Herzog ist der Historiker Martin Georg Kovachich (Abb. 13, 26) in seinem 1782 entstandenen Porträt nicht mit nackter, sondern mit zeitgenössisch bekleideter Büste wiederge-geben und wird von einem gerundeten Sockel gestützt. Der Histo-riker ist in eine ungarische Tracht gekleidet: Er trägt einen »mente«, einen ungarischen Mantel mit Pelzverbrämung, und ein »atilla« genanntes, in der Mitte geknöpftes, hochgeschlossenes Unterge-wand, eine Halsbinde, die im Nacken von einer Schnalle geschlos-sen wird, sowie eine einfache Zopfperücke. Der Kopf und die Büs-te, die sich nach unten verjüngt, sind frontal ausgerichtet. Unten ist die Büste von einem schmalen Sockelring umfasst, auf dem

25 Franz Xaver Messer-
schmidt, Herzog Albert
von Sachsen-Teschen,
Seitenansicht, 1777–
1780, Blei, Bayerisches
Nationalmuseum, Mün-
chen, Inv.-Nr. 49/16

*Franz Xaver Messer-
schmidt, Albert, Duke
of Saxe-Teschen, side
view, 1777–1780, lead,
Bayerisches Nationalmu-
seum, Munich,
Inv. no. 49/16*

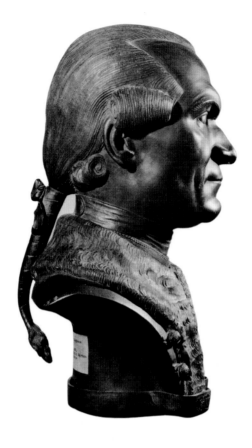

Messerschmidt would subsequently not deviate from the form of the simple block as support even in traditional portraits such as the bust of Albert, Duke of Saxe-Teschen (fig. 24), which dates from 1777–1780. The rather more voluminous chest here tapers in U-form to cover the large block on which the bust is resting, although the base is visible from the side (fig. 25). Like the Duke, the historian Martin Georg Kovachich (fig. 13, 26) is also not represented in the 1782 portrait with a naked chest but is instead clothed in the garb of his day and supported by a rounded base. The historian is depicted in native Hungarian dress: he is wearing a "mente" (a Hungarian fur-trimmed coat), an "atilla" (an undergarment buttoned to the neck up the middle), a cravat round his neck fastened by a clasp at the nape and a simple tye wig. The head and the chest, which tapers to the bottom, are both frontal. At the bottom the bust is surrounded by a narrow base ring, on which Messerschmidt has inscribed Kovachich's motto; the problem of how to find space for an inscription has been resolved in a new way in this form of bust. The detailed reproduction of the Hungarian dress, and the inscription, underscore the close affinities of the historian with the Habsburg-Hungarian cultural landscape of his day and his self-confidence arising from being rooted in it as a quintessentially integral part of his personality. "If your fame can be augmented at all, then certainly it has happened with this work of art," is how the he wrote on 1 May 1783 to thank the sculptor for this "immortal work". Kovachich goes on to say: "You know that I do not like to flatter and, because you think philosophically, I must not flatter you either, otherwise I would have to represent to you the admiration with which all everyone beholds this work and says: this is utterly inimitable."[33]

Messerschmidt die Wahlsprüche Kovachichs einträgt; die Frage der Unterbringung einer Inschrift ist bei dieser Büstenform auf neuartige Weise gelöst. Die detaillierte Wiedergabe der ungarischen Tracht sowie die Inschrift unterstreichen die Einbindung des Historikers in die habsburgisch-ungarische Landschaft und Gegenwart und sein daraus resultierendes Selbstbewusstsein als integraler Bestandteil seines Wesens. »Wenn Ihr Ruhm noch einen Zuwachs haben konnte, so ist's gewiss bey diesem Kunststück geschehen«, so bedankt sich der Historiker Kovachich am 1. Mai 1783 bei dem Bildhauer für das »unsterbliche Werck«. Er fährt fort: »Sie wissen, daß ich nicht gerne schmeichle, und, weil Sie Philosophisch denken, auch Ihnen nicht schmeicheln darf, sonst müste ich Ihnen die Bewunderung dieses Wercks mit vielem vorstellen, mit der es jedermann betrachtet, alles sagt: dieses seye durchgehendt unnachahmlich.«[33]

Deutlicher als bei den Werken für den Hof nahm Messerschmidt sowohl mit jenen, Ende der 1760er Jahre entstandenen als auch mit den später geschaffenen Porträts eine aufklärerische Position ein. Auffallend sind die Härte der Modellierung, die Unbelebtheit der Oberfläche sowie der Kontrast zwischen glatten und detailliert ziselierten Partien. Damit erteilt der Künstler der barocken Illusion von atmender Haut und echt erscheinender Stofflichkeit

In the works he produced in the late 1760s as well as the portraits he subsequently executed, Messerschmidt more clearly adopted an Enlightenment stance than he had done in his works for the court. Striking features of this later work are hard modelling, inanimate surfaces and the contrast between smooth and intricately chiselled parts. In this way the artist repudiates the Baroque illusion of breathing skin and genuine-looking fabrics. The view-

der Gewänder eine Absage. Der Betrachter wird in Bezug auf Natürlichkeit und Lebendigkeit der Porträtierten desillusioniert. Gleichzeitig werden die individuellen Züge, bei Reduktion auf die wesentlichen physiognomischen Eigenheiten, klar herausgearbeitet und damit die Porträtierten ohne Mythos und meist ohne Herausstreichung ihres gesellschaftlichen Ranges wiedererkennbar vor Augen geführt.[34] Auch die Heranziehung der antiken Kunst war folgerichtig: Antike Kunst, so Winckelmann, sei die Kunst der Wahrheit.[35]

In den um 1769–1772 entstandenen Büsten zieht Messerschmidt alles ab, was öffentlich ist. Die Porträts erfahren durch die klaren, einfachen Formen und die Reduktion auf knappe, nackte Büstenausschnitte sowie die im Vergleich verhältnismäßig monumental wirkenden Köpfe auch eine Idealisierung und werden in eine zeitlos gültige Form gebracht. Die Ende der 1760er Jahre entstandenen Büsten führen die Wahrheit des Individuums vor Augen.

er is to be deprived of any illusions he might have respecting naturalness and liveliness in the rendering of a sitter. At the same time, individualising features, despite being reduced to essential physiognomic peculiarities, are clearly worked out and, therefore, present those portrayed recognisably; albeit without myth and usually without emphasis being laid on their social status.[34] Even recourse to the art of Antiquity was consistent with the overall approach: classical art, according to Winckelmann, is the art of truth.[35]

From the busts he did between 1769 and 1772, Messerschmidt has removed everything representing a public persona. However, through clarity and simplicity of form and reduction to brief décolletés as well as heads that appear disproportionately monumental, these portraits have also been idealised and put into a form that is timelessly valid. The busts executed in the late 1760s indeed illustrate the truth about the individual portrayed.

1 Dazu Krapf, Katalog 2002, S. 140.
2 Dazu Krapf, Katalog 2002, S. 148–154.
3 Zitiert nach Pötzl-Malíková 1982, S. 221.
4 Dazu siehe Pötzl-Malíková 1982, S. 227–228; Krapf, Auftraggeber und Freundeskreis 2002, S. 68.
5 Scheyb 1770, Bd. 2, S. 93. Das Grabmal wird ebenfalls erwähnt von Füssli 1779, S. 425.
6 Kupferstich des Denkmals für den Reichshofrat Heinrich Christian von Senckenberg, 29,5 x 19,5 cm; bez. u. l.: F. Messerschmid fecit, u. r.: J. E. Mansfeld sculpsit. Eigentum der Dr. Senckenbergischen Stiftung, Frankfurt am Main. Johann Ernst Mansfeld (1739–1796), Schüler von Jakob Schmutzer, stach Figurenszenen und Bildnisse nach eigenen und fremden Vorlagen.
7 Sie ist im Innenhof des Frankfurter Bürgerhospitals in eine Wand eingelassen.
8 Zum Grabmal siehe Scheidel 1867, S. 75–76. Brief von Renatus von Senckenberg (Sohn des Verstorbenen) vom September 1799 an die Stiftungs-Administration: »Um aber diese mehr denn 1000 fl. kostende Arbeit nicht so ganz ungesehen verderben zu lassen, habe ich mich [...] entschlossen, den Stein aller Kosten ohngeachtet, nach Frankfurt a. M. bringen [...] zu lassen. [...]‹ Das Denkmal besteht aus einem bronzenen Medaillon mit dem Bildnis des Verewigten, welches ehedem von zwei alabasternen Genien getragen wurde. Unter demselben befindet sich das adelige Wappen des Reichshofrates, welches auf einer Tafel von weissem Marmor ruht. Die Inschrift wurde verfasst vom Bibliothekar Schwandter.« (ebd., S. 75).
9 Dazu Crüwell 2006.
10 Der Stich gibt als Maß des Medaillons mit Rahmen $2^{1}/3$ Schuh an; der Wiener Schuh misst nach Felix Czeike (Historisches Lexikon, Wien 1997, Bd. 5, S. 156) bis zum Jahr 1875 0,316 Meter. Für die Angaben danke ich Dr. Susanne Fritsch, Wiener Stadt- und Landesarchiv.
11 Zum Grab Senckenbergs siehe Pötzl-Malíková 1982, S. 227–228.
12 Dazu siehe Krapf, Auftraggeber und Freundeskreis 2002, S. 66.
13 Dazu siehe Pötzl-Malíková 1982, S. 23–30.
14 Ebenso Pötzl-Malíková 1982, S. 23–24.
15 Dazu siehe Bückling 1999b, S. 103.

1 Cf. Krapf, Katalog 2002, p. 140.
2 Ibid., pp. 148–154.
3 Quoted in Pötzl-Malíková 1982, p. 221.
4 Cf. Pötzl-Malíková 1982, pp. 227f.; Krapf, Auftraggeber und Freundeskreis 2002, p. 68.
5 Scheyb 1770, Vol. 2, p. 93. The inscription is also mentioned by Füssli 1779, p. 425.
6 Copperplate engraving of the monument to Reichshofrat Heinrich Christian von Senckenberg, 29.5 x 19.5 cm; inscr. bottom l.: F. Messerschmid fecit, bottom r.: J. E. Mansfeld sculpsit. Owned by the Dr. Senckenbergische Stiftung, Frankfurt am Main. Johann Ernst Mansfeld (1739–1796), a pupil of Jakob Schmutzer, engraved figural scenes and portraits after his own works and other models.
7 It is set into a wall of the inner courtyard of the Frankfurt Bürgerhospital.
8 On the funerary monument see Scheidel 1867, pp. 75f. Letter from Renatus von Senckenberg (son of the deceased) of September 1799 to the administration of the Stiftung: "In order not to allow this monument to decay quite unseen, it having cost more than 1000 florins, I have [...] resolved, regardless of cost, to send the stone to Frankfurt a. M. [...] The monument consists in a bronze medallion with the portrait of the man thus immortalised, which was formerly carried by two alabaster winged putti. Below it are the noble armorial bearings of the Reichshofrat, resting on a plaque of white marble. The inscription was composed by Librarian Schwandter.' (ibid., p. 75).

16 Maaz 2001, S. 26.

17 Zitiert nach Herding 1989, S. 14.

18 Zu von Scheyb siehe Wurzbach 1875, Bd. 29, S. 248–249. Die Schriften von Scheybs: Scheyb 1770; Scheyb 1774.

19 Bückling 2002, S. 79.

20 Dazu Pötzl-Malíková 1982, S. 229.

21 So auch Pfarr 2006, S. 143.

22 So Maek-Gérard 1982, S. 6.

23 Ähnlich das Porträt von Laurence Sterne, das Nollekens um 1765/66 schuf; Abb. siehe Marandel 1987, Abb. 67 (S. 96). Zur Bedeutung antiker Büsten für die Bildnisbüste des 18. Jahrhunderts siehe auch Maaz 2001, S. 27.

24 Frontispiz von Bd. 7 des Receuil d'Antiquités; Abb. siehe Schnapp 1998, S. 142. Siehe außerdem Abb. des Herkules in Philip von Stosch's 1724 herausgegebenen Stichwerk über antike Gemmen; Abb. in Sloan 2003, S. 134.

25 Dem Motivkanon folgt ebenfalls ein Bildnismedaillon Diderots von Augustin de St. Aubin; Abb. siehe Sauerländer 2002, Abb. 6. Bereits 1704 wird Ludwig XIV. in verschiedenen Lebensaltern jeweils mit kleinem nackten Büstenausschnitt wiedergegeben; Abb. siehe Ausst.-Kat. Lockenpracht 2006, S. 114.

26 Dazu siehe Ausst.-Kat. Houdon 2003, Abb. S. 88, 118, 142–145, 152, 162.

27 Zitiert nach Pötzl-Malíková 1982, S. 127.

28 Scheyb 1770, Bd. 1, S. 320.

29 Zum Porträt Mesmers siehe erstmals Pötzl-Malíková 1987, S. 257–267, Abb. 1, 2. Der Dichter Christoph Edler von Kessler, Hofkonzipist und Schauspieldichter in Wien, wurde, so die Inschrift auf der Büste, als 31-jähriger wiedergegeben; 1739 geboren, entstand die Büste somit im Jahr 1770. Zu von Kesslers Porträt siehe Pötzl-Malíková 1982, S. 232.

30 Dazu Bückling 1999b, S. 104.

31 Dazu siehe Bückling 1999a, S. 72–74; Bückling 1999b, S. 107.

32 Vergleichbar erscheint am ehesten das Bildnis Mesmers, dessen Sockelkubus gleichfalls breiter als tief ist.

33 Zitiert nach Pötzl-Malíková 1982, S. 138.

34 So Bückling 2002, S. 79–80.

35 Maek-Gérard 1982, S. 39.

9 Cf. Crüwell 2006.

10 The engraving gives the size of the medallion with frame as $2^{1}/3$ Schuh; the Viennese Schuh measured, according to Felix Czeike (Historisches Lexikon, Vienna 1997, Vol. 5, p. 156) 0.316 metres until 1875. I am indebted to Dr. Susanne Fritsch, Wiener Stadt- und Landesarchiv, for this information.

11 On Senckenberg's grave see Pötzl-Malíková 1982, pp. 227f.

12 Cf. Krapf, Auftraggeber und Freundeskreis 2002, p. 66.

13 Cf. Pötzl-Malíková 1982, pp. 23–30.

14 Thus also Pötzl-Malíková 1982, pp. 23f.

15 Cf. Bückling 1999b, p. 103.

16 Maaz 2001, p. 26.

17 Quoted in Herding 1989, p. 14.

18 On von Scheyb see Wurzbach 1875, Vol. 29, pp. 248f. Scheyb's writings: Scheyb 1770; Scheyb 1774.

19 Bückling 2002, p. 79.

20 Cf. Pötzl-Malíková 1982, p. 229.

21 Thus also Pfarr 2006, p. 143.

22 Thus Maek-Gérard 1982, p. 6.

23 Similarly the portrait of Laurence Sterne, which Nollekens executed c. 1765/66; shown in Marandel 1987, fig. 67 (p. 96). On the importance of ancient busts for 18th-century portrait busts, see also Maaz 2001, p. 27.

24 Frontispiece of Vol. 7 of the Recueil d'Antiquités; shown in Schnapp 1998, p. 142. See also the Hercules reproduced in the body of engravings of ancient gems compiled and edited by Philip von Stosch in 1724; shown in Sloan 2003, p. 134.

25 A medallion with a portrait of Diderot by Augustin de St. Aubin also follows the canon of motifs; pictured in Sauerländer 2002, fig. 6. As early as 1704 Louis XIV was portrayed at various ages, with a small décolleté in each such portrait; shown in exhib. cat. Lockenpracht 2006, p. 114.

26 Cf. exhib. cat. Houdon 2003, illus. pp. 88, 118, 142–145, 152, 162.

27 Quoted in Pötzl-Malíková 1982, p. 127.

28 Scheyb 1770, Vol. 1, p. 320.

29 On the portrait of Mesmer see Pötzl-Malíková 1987, pp. 257–267, figs. 1, 2. The poet Christoph Edler von Kessler, court poet and poetic dramatist in Vienna, was, according to the inscription on the bust, portrayed at the age of 31; since he was born in 1739, the bust must have been executed in 1770. On the portrait of Kessler see Pötzl-Malíková 1982, p. 232.

30 Cf. Bückling 1999b, p. 104.

31 Cf. Bückling 1999a, pp. 72–74; Bückling 1999b, p. 107.

32 Most similar for comparison seems to be the portrait of Mesmer, whose block-shaped pedestal is also broader than it is deep.

33 Quoted in Pötzl-Malíková 1982, p. 138. The German is somewhat obscure.

34 Thus Bückling 2002, pp. 79f.

35 Maek-Gérard 1982, p. 39.

Porträts
Katalognummern 1–3

Portraits
catalogue nos. 1–3

Marmor, Höhe 40 cm
Bez. am Sockel links:
F. MESSERSCHMIT
Bez. am Sockel vorne:
GERARDUS L. B. VAN SWIETEN
Wien, um 1770–1772
Kunsthistorisches Museum, Wien
Kunstkammer, Inv.-Nr. 8921

Marble, height 40 cm
Inscribed on the pedestal left:
F. MESSERSCHMIT
Inscribed on the pedestal front:
GERARDUS L. B. VAN SWIETEN
Vienna, c. 1770–1772
Kunsthistorisches Museum, Vienna
Kunstkammer, Inv. no. 8921

[1]

Porträtbüste des Gerard van Swieten

Das um 1770–1772 entstandene Bildnis des Hofarztes (Kat.-Nr. 1a) von Maria Theresia, der einer der berühmtesten aufgeklärten Männer seiner Zeit in Österreich war und unter anderem das Medizinalwesen Österreichs reformierte,[1] ist wahrscheinlich für die Aufstellung im Direktorenzimmer der Österreichischen Nationalbibliothek geschaffen worden, wo der Mediziner von 1745 bis 1772 wirkte.[2]

Auffällig ist die Betonung der Korpulenz des Arztes: Nicht nur das voluminöse Doppelkinn und die breiten Wangen unterstreichen sie, die Dickleibigkeit wird zudem durch den gedrungenen Hals, die fleischigen Schultern und den fülligen Brustansatz hervorgehoben. Auch der weich glänzende Marmor sowie der breite Büstenrand, der die Dicke der Haut assoziieren lässt, betonen die provokant zur Schau gestellte Korpulenz des Dargestellten.

Büste und van Swietens runder Kopf mit flachem Gesicht sind frontal ausgerichtet. Die Büste ist weich modelliert, plastisch eingetragene Falten, Hebungen und Senkungen der Haut beleben die Oberfläche. Die nur als sparsame Ritzungen eingetragenen Augen sind erst aus der Nähe zu sehen: Sie blicken am Betrachter vorbei nach links. Gleichzeitig scheint van Swieten im Moment der Darstellung zum Sprechen ansetzen zu wollen, denn der Mund ist geöffnet, wobei die Lippen noch an zwei Stellen zusammenkleben. Die Brauen werden zu kompakten Verdickungen über der Nasenwurzel. Fleischige Lider rahmen die nur schwach gewölbten Aug-

Portrait bust of Gerard van Swieten

Dating from c. 1770–1772, this portrait of the Empress Maria Theresia's personal physician (cat. no. 1a), who was one of the leading representatives of the Enlightenment in the Austria of his day and numbered among his achievements the reform of Austria's medical system,[1] was probably made to be set up in the director's room at the Austrian Nationalbibliothek [National Library], where the physician had his office from 1745 until 1772.[2]

A notable feature is the emphasis laid on the court physician's corpulence: not just the massive double chin and the broad cheeks are underscored; the heaviness of his body is also indicated by the thick, short neck, the fleshy shoulders, and the plumpness of the chest (insofar as this is shown). Even the softly gleaming marble as well as the broad edge of the bust, which evokes associations of thick skin, emphasise the sitter's blatantly flaunted corpulence.

The bust of van Swieten with its round head and its flat face is frontal. The bust is softly modelled, with sculpturally indicated folds, elevations and depressions of the skin enlivening the surface. The eyes, indicated merely by sparingly executed incisions, are only discernible close up: they gaze past the viewer to the left. At the same time, at the moment captured in the representation, van Swieten seems to be about to speak, since his mouth is open although his lips still adhere in two places. His brows are dense, compressed above the root of the nose. Fleshy eyelids frame eyeballs that bulge only slightly and are set off from the brow zone by a pronounced fold in the lids.

Divested of his social status, the sitter has been portrayed as he looked, with the emphasis on his physical appearance. Anything formal and stately or even illusionist is lacking; it is a naked body that is exposed to view. Facial features otherwise in repose are disturbed by the momentary opening of the lips. The eyes seem at first to gaze forward, devoid of expression until, on closer scrutiny, one notices that the sitter is looking to the left. The way the hair has been dressed is an additional disturbing factor:

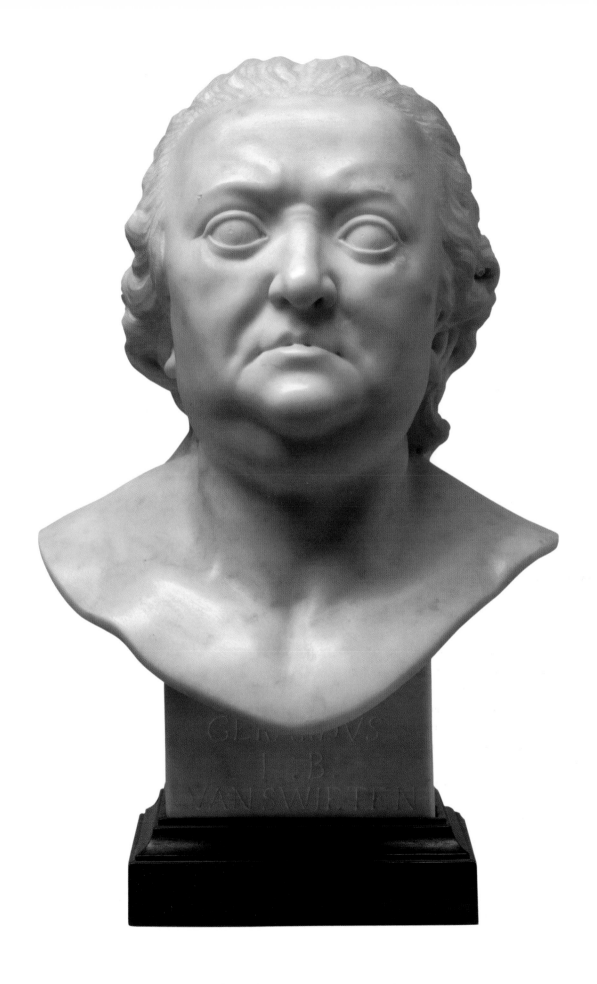

äpfel und sind gegen die Brauenzone durch eine deutliche Lidfalte abgesetzt.

Der Porträtierte ist seines gesellschaftlichen Ranges entkleidet und auf seine physische Erscheinung zurückgeworfen. Alles Repräsentative, Illusionistische fehlt, der Körper wird nackt dargeboten. Ruhige Züge sind durch das momenthafte Öffnen der Lippen beunruhigt, die Augen scheinen zunächst leer nach vorne gerichtet, bis man beim Nähertreten erkennt, dass sie nach links blicken. Eine zusätzliche Irritation entsteht durch die Frisur: Von vorne betrachtet stellt sich der Eindruck natürlich frisierten Haars ein, da aus der Stirn nach hinten gestrichene Haare und halblange Locken auf den Schultern zu sehen sind. Bei der Betrachtung von der Seite und von hinten (Kat.-Nr. 1b–c) wird hingegen deutlich, dass der Arzt entweder eine Perücke trägt, deren längere Locken mit eingerollten

viewed from the front, the hair seems to have been left in its natural state since locks combed back from the forehead and fairly long strands are depicted as falling on to the shoulders. When the bust is viewed from the side and rear (cat. no. 1b–c) however, it becomes obvious that the court physician is either wearing a wig, with quite long locks that curl at the ends to fall down the back, or, alternatively, is wearing his hair dressed to resemble a wig.[3] It is interesting to learn in this connection that van Swieten "confronted the Baroque aristocratic world of the Viennese court without a wig and without lace cuffs. Not until the Empress herself personally sewed him some lace cuffs did van Swieten comply with her

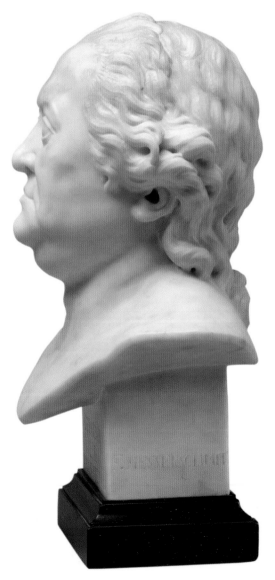

Kat.-Nr. 1b / *Cat. no. 1b*
Franz Xaver Messerschmidt,
Gerard van Swieten,
Seitenansicht
Franz Xaver Messerschmidt,
Gerard van Swieten, side view

Enden auf den Rücken fallen, oder seine Haare perückenähnlich frisiert hat.[3] Dazu ist interessant zu erfahren, dass van Swieten »ohne Perücke und Handkrause der barocken Adelswelt des Wiener Hofs gegenübertrat. Erst als die Kaiserin höchstpersönlich ihm Handkrausen strickte, hat sich van Swieten ihren Kleiderwünschen gefügt.«[4] In dem Marmorporträt könnte Messerschmidt auf diese Abneigung Perücken gegenüber reagiert haben, indem er die Perücke zunächst nicht als solche zu erkennen gab.

Das Bildnis stellt somit eine Persönlichkeit vor, die sich nicht hinter Perücken, Orden und üppigen Gewändern ins Repräsentativ-Unverbindliche zurückzieht. Messerschmidt geht mit seinem Porträt van Swietens einen Schritt weiter als mit denjenigen Mesmers (Abb. 10, 21) oder von Scheybs (Abb. 9, 18), da er den körperlichen Makel der Fettleibigkeit »als Teil der Gesamtwahrheit einer Person«[5]

wishes concerning his clothes."[4] In this marble portrait, Messerschmidt may possibly have responded to his subject's dislike of wigs by not making the wig as such instantly recognisable.

However that may be, the portrait represents a person who did not withdraw to the stately and impersonal by hiding behind wigs, decorations and sumptuous clothing. In his portrait of van Swieten, Messerschmidt has gone a step further than with his portraits of Mesmer (figs. 10, 21) or von Scheyb (figs. 9, 18), since he has convincingly made corpulence, a physical defect, "part of the entire truth about a person".[5] In so doing, Messerschmidt could refer for confirmation to von Scheyb, who wrote as follows on

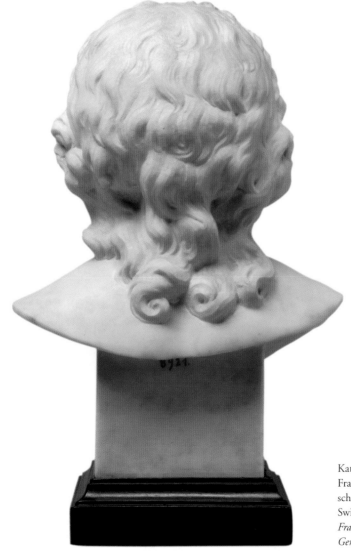

Kat.-Nr. 1c / *Cat. no. 1c*
Franz Xaver Messer-
schmidt, Gerard van
Swieten, Rückansicht
Franz Xaver Messerschmidt,
Gerard van Swieten, rear view

27 Oberarmbüste eines
Mannes, hadrianisch,
Marmor, Museo Chiara-
monti, Vatikan
*Upper arm bust of a man,
reign of Hadrian, marble,
Museo Chiaramonti, The
Vatican*

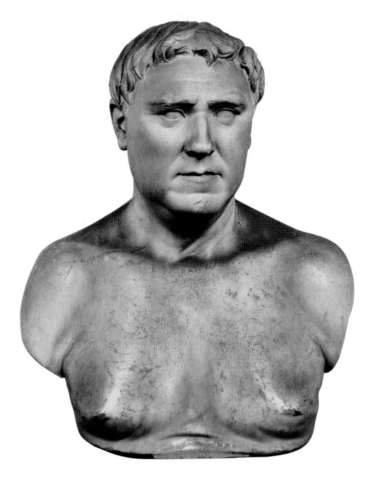

begreifbar macht. Der Künstler kann sich damit auf von Scheyb berufen, der in Bezug auf Porträts schreibt: »Ich würde es gerne sehen, wenn [der Künstler] diese Uebermäßigkeiten der Theile [eines Gesichts] mit solchen Ausdrucke arbeitete, daß sie von jedermann gleich erkannt würden; denn ein Bildniß erlangt durch nichts anders seine vollkommne Aenlichkeit, als durch die Erkenntniß der Linien, welche sich von der Vollkommenheit entfernen.«[6] Was die Darstellung individueller Hässlichkeit betrifft, konnte sich Messerschmidt auf die Antike beziehen, denn fettleibige Büsten gab es durchaus: So die Oberarmbüste eines Mannes aus hadrianischer Zeit (Abb. 27), heute im Museo Chiaramonti im Vatikan, dessen Kopf massiv wirkt, dessen Brüste zudem leicht hängen; zwischen Brust und Bauch sind mehrere Speckfalten wiedergegeben.[7] Gleichzeitig vermag Messerschmidts Büste dem Dargestellten aber ein solches Maß an Würde und Idealität zu vermitteln, dass nicht allein ein Bild körperlicher Unzulänglichkeit geschaffen wurde, sondern eines, in dem sich Wahrhaftigkeit und Idealität vereinen.

Die provokante Zurschaustellung der Korpulenz, das Zusammenkleben der Lippen und die erst bei nahem Hinsehen erkennbaren Pupillen sowie das unvermittelte Aufsetzen des nack-

portraits: "I should like to see [the artist] working those disproportions of parts [of a face] with such expressions that everyone can instantly recognise them; for a portrait only achieves a perfect likeness through recognition of the features which remove it from perfection.[6]" As far as the representation of individual ugliness is concerned, Messerschmidt could refer to Antiquity, since there were certainly corpulent busts then, such as the bust of a man from the reign of Hadrian (fig. 27), now in the Museo Chiaramonti in the Vatican, whose head looks massive and breasts even slightly pendulous, with several fatty folds depicted between the chest and the abdomen.[7] At the same time, Messerschmidt has succeeded in his bust in conveying such a high degree of dignity and idealised portrayal that he has not merely created an image of physical imperfection but rather a likeness in which truth and idealised portrayal are felicitously united.

The unabashed display of corpulence, the lips still lightly stuck together and the circumstance that

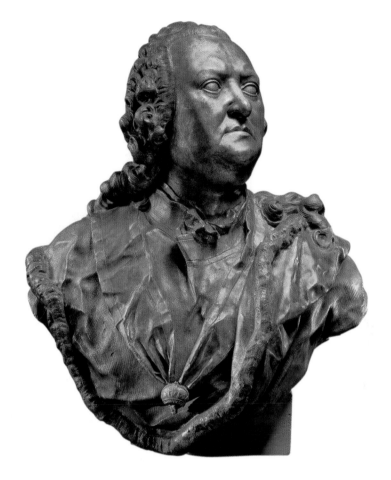

ten Männerkörpers auf dem Kubus unterscheiden das Marmor-
bildnis deutlich von Bildnisbüsten, die den hochbarocken Formen-
kanon durchdeklinieren, wie beispielsweise das ebenfalls von
Messerschmidt geschaffene, vergoldete Bronzeporträt van Swietens
(Abb. 28),[8] das er 1769, somit kurz vor dem Marmorbildnis, im
Auftrag der Kaiserin schuf, nachdem der Arzt die Herrscherin von
einer lebensbedrohlichen Krankheit geheilt hatte. Zunächst im Hör-
saal des medizinischen Kollegs der Universität Wien aufgerichtet
(Abb. 29), stand die Bronzebüste im 19. Jahrhundert im Festsaal des
Allgemeinen Krankenhauses, später im Arkadenhof der Universität,
ehe sie 1922 als Leihgabe in die Österreichische Galerie Belvedere
gelangte.[9] Es handelte sich somit nicht nur um einen offiziellen Auf-
trag; auch der Aufstellungsort war, anders als jener der späteren Mar-
morbüste, offizieller, repräsentativer Natur. Dementsprechend ist van
Swieten dort mit großer ausladender Büste dargestellt, bekleidet mit
einem Umhang mit Pelzbesatz und ausgezeichnet mit dem (abgebro-
chenen) Franz-Stephans-Orden am Band. Seine Perücke fällt in lan-
gen Locken auf den Rücken und über die linke Schulter herab. Der
Arzt ist in herrscherlicher Attitüde, mit großem Büstenausschnitt,
zur Seite gewandtem, leicht angehobenem Kopf, in die Ferne gerich-

the pupils can only be seen close up, as well as the
direct placement of the naked male body on the
plinth, differentiate this marble portrait sharply from
portrait busts that faithfully follow the paradigm of
the High Baroque canon of forms, such as another
Messerschmidt portrait of van Swieten in gilt bronze
(fig. 28),[8] which he did at the Empress's behest in
1769, shortly before the present marble bust, after the
court physician had cured the Empress of a life-
threatening disease. At first set up in the auditorium
of the medical college at Vienna University (fig. 29),
the bronze Messerschmidt bust of van Swieten stood
in the 19th century in the grand hall of the Allge-
meines Krankenhaus [General Hospital] and later in
the university quadrangle, before it was loaned to the
Österreichische Galerie Belvedere in 1922.[9] This
means that it was not only an official commission;
even the place it was set up, unlike that of the later
marble bust, was of an official, formal state character.
Accordingly, van Swieten is there represented in a

large, broad bust, dressed in a fur-trimmed cloak and wearing the (broken off) Order of Franz Stephan on a ribbon. The long locks of his wig fall down his back and over his left shoulder. The court physician is depicted in a regal pose, with a large part of the bust included, turned to the side, his head slightly raised, gazing into the distance with eyes that are, however, without pupils, and a serious, contemplative expression on his face.

The gilt bronze portrait is strikingly different in modelling, thanks to the different properties of the material used, which lend the portrait a striking physical presence that veils the corpulence of the man, so grossly depicted in the marble portrait, by tying it into an ennobling configuration of motifs. The marble bust of van Swieten, on the other hand, is notable for being entirely bereft of embellishing accessories; the reduction of motifs to the essential features of the countenance and the unsparing representation of the sitter in all his fleshy corpulence represent an approach which nonetheless does not result in an animate body pulsing with life.

29 Johann Gottfried Haid,
 Aufstellung der Büste
 Gerard van Swietens von
 F. X. Messerschmidt im
 medizinischen Hörsaal
 der Wiener Universität,
 nach 1769, Schabblatt,
 Österreichische Natio-
 nalbibliothek, Wien,
 Inv.-Nr. NB 508.163 B
 Johann Gottfried Haid,
 The Bust of Gerard van
 Swieten by F. X. Messer-
 schmidt as set up in the
 Medical Lecture Hall of
 Vienna University,
 post-1769, mezzotint,
 Österreichische National-
 bibliothek, Vienna,
 Inv. no. NB 508.163 B

tetem Blick aus allerdings pupillenlosen Augen und mit ernst-nach-
denklichem Gesichtsausdruck dargestellt.

Das vergoldete Bildnis besticht durch die die Materialquali-
täten unterscheidende Modellierung, die dem Porträt zu auffallen-
der körperlicher Präsenz verhilft und die im Marmorbildnis krass
gestaltete Korpulenz des Mannes durch die Einbindung in ein
hoheitsvolles Motivgefüge verschleiert. Das Marmorbildnis van
Swietens besticht hingegen durch den Verzicht auf alles Beiwerk, die
Reduktion der Motive auf die wesentlichen Partien der Physiogno-
mie und durch die schonungslose Darstellung des Porträtierten in
seiner dickleibigen Fleischlichkeit, die jedoch nicht einen lebendig
durchpulsten Körper wiedergibt.

1 Zu Gerard van Swieten siehe Lesky 1973, S. 11–62; Riedl-Dorn 1990,
 S. 66; Krapf, Auftraggeber und Freundeskreis 2002, S. 68–69.
2 So Pötzl-Malíková 1984a, S. 28.
3 Zur Perückenmode um 1770 siehe Jedding-Gesterling/Brutscher 1988,
 S. 143.
4 Lesky 1973, S. 16.
5 Busch 1993, S. 414.
6 Scheyb 1770, Bd. 2, S. 85.
7 Andreae 1995, Teilband 2, Abb. S. 498–499.
8 So auch Bücherl 1989, S. 57.
9 Dazu siehe Ausst.-Kat. Messerschmidt 2002, S. 158.

Literatur

Tietze-Conrat, 1921, S. 49–51 (mit Abb.); Weiss 1924, S. 36–37; Feulner
1929, S. 42; Kris 1932, S. 182, Abb. 152; Malíková 1965, S. 17; Bieder-
mann 1978, S. 27; Glandien 1981, S. 72–73, Abb. 9; Pötzl-Malíková 1982,
S. 46, 233; Ronzoni 1982, S. 2486; Pötzl-Malíková 1984a, S. 27–28;
Pötzl-Malíková 1987, S. 262, Abb. 6 (S. 397); Bücherl 1989, S. 57; Beck
1989, S. 210, Abb. 6; Hàmori 1992, S. 234; Bückling 1999a, S. 72–74,
Abb. 5; Bückling 1999b, S. 106–107; Krapf, Katalog 2002, S. 168–169;
Lehner-Jobst 2002, S. 96 (mit Abb.); Pfarr 2003b, S. 27–28, Abb. 2;
Yonan 2003, S. 561–562; Pfarr 2006, S. 30, Abb. 10–11.

1 On Gerard van Swieten, see Lesky 1973, pp. 11–62;
 Riedl-Dorn 1990, p. 66; Krapf, Auftraggeber und
 Freundeskreis 2002, pp. 68f.
2 Thus Pötzl-Malíková 1984a, p. 28.
3 On fashions in wigs c. 1770 see Jedding-Gesterling/
 Brutscher 1988, p. 143.
4 Lesky 1973, p. 16.
5 Busch 1993, p. 414.
6 Scheyb 1770, Vol. 2, S. 85.
7 Andreae 1995, pt. Vol. 2, fig. pp. 498f.
8 Thus also Bücherl 1989, p. 57.
9 See exhib. cat. Messerschmidt 2002, p. 158.

References

Tietze-Conrat, 1921, pp. 49–51 (illus.); Weiss 1924,
pp. 36–37; Feulner 1929, p. 42; Kris 1932, p. 182, fig.
152; Malíková 1965, p. 17; Biedermann 1978, p. 27;
Glandien 1981, pp. 72–73, fig. 9; Pötzl-Malíková 1982,
p. 46, p. 233; Ronzoni 1982, p. 2486; Pötzl-Malíková
1984a, pp. 27–28; Pötzl-Malíková 1987, p. 262, fig. 6
(p. 397); Bücherl 1989, p. 57; Beck 1989, p. 210, fig. 6;
Hàmori 1992, p. 234; Bückling 1999a, pp. 72–74, fig. 5;
Bückling 1999b, pp. 106–107; Krapf, Katalog 2002,
p. 168–169; Lehner-Jobst 2002, p. 96 (illus.); Pfarr
2003b, pp. 27–28, fig. 2; Yonan 2003, pp. 561–562;
Pfarr 2006, p. 30, figs. 10, 11.

Blei-Zinn-Legierung, mit
Resten alter Versilberung
Höhe 40 cm
Wien, um 1770–1772
Sammlungen des Fürsten von
und zu Liechtenstein, Vaduz-
Wien, LIECHTENSTEIN
MUSEUM. Die Fürstlichen
Sammlungen, Wien
Inv.-Nr. SK 1480

Lead and tin alloy, with traces
of old silvering; height 40 cm
Vienna, c. 1770–1772
Collections of the Prince of
Liechtenstein, Vaduz-Vienna
LIECHTENSTEIN MUSEUM
Die Fürstlichen Sammlungen
Vienna, Inv. no. SK 1480

[2]

Büste des Fürsten Joseph Wenzel von Liechtenstein

Erst im Jahr 2004 wurde ein Kopf bekannt, der, mittlerweile im Besitz des Liechtenstein Museums, als Bildnis des Fürsten Joseph Wenzel I. von Liechtenstein (1696–1772) identifiziert wurde (Kat.-Nr. 2a).[1] Die Beziehung Messerschmidts zum Fürsten nahm wahrscheinlich mit dessen 1760 erfolgten Auftrag für Büsten von Kaiser Franz I. Stephan von Lothringen und von Kaiserin Maria Theresia (Abb. 15) seinen Anfang.[2] Außerdem sind mehrere Arbeiten Messerschmidts für die Herzogin von Savoyen-Carignan bezeugt, eine aus dem Hause Liechtenstein gebürtige Kusine des Fürsten. Auch von weiteren Arbeiten Messerschmidts für den Fürsten berichtet die ältere Literatur, ohne dazu allerdings genauere Angaben machen zu können.[3]

Die Büste zeigt einen knappen, sich V-förmig verjüngenden Brustausschnitt, der an den Rändern ganz leicht geschwungen und schließlich auf Höhe der Sockelunterkante horizontal abgeschnitten ist. Dieser ruht auf einem Kubus, der deutlich zu Seiten des Brustausschnitts vortritt und rechteckig, das heißt weniger tief als breit, ist. Der Büstenausschnitt zeigt naturgetreu das leichte Vorstehen der

Bust of Prince Joseph Wenceslas of Liechtenstein

Not until 2004 did a head become known which, now owned by the Liechtenstein Museum, has been identified as a portrait of Joseph Wenceslas I, Prince of Liechtenstein (1696–1772, cat. no. 2a).[1] Messerschmidt's links with the Prince were probably forged when he was commissioned in 1760 to execute busts of the Francis Stephen of Lorraine (Emperor Francis I) and his consort the Empress Maria Theresia (fig. 15).[2] In addition, several works by Messerschmidt for the Duchess of Savoy-Carignan, a Liechtenstein cousin of the Prince, are attested. Earlier references also mention other works by Messerschmidt for the Prince of Liechtenstein, without, however, going more precisely into details.[3]

This bust shows a scanty V-shaped section of the chest, which curves slightly at the edges and is cut off on a level with the edge of the pedestal. It rests on a plinth which protrudes noticeably beyond the sides of the chest and is rectangular, that is, broader than it is deep. The section of the bust naturalistically shows the slight prominence of the collarbones, the pits of the collarbones, the depression in the breastbone below the Adam's apple as well as, only slightly protruding, the muscles which run from the breastbon to the mastoid, a bone behind the ear, the beginnings of the shoulders as well as the prominent Adam's apple. The stern face is characterised by the striking long narrow nose, large eyes overarched by raised eyebrows, a lofty forehead and a sensitively curved mouth, whose corners are slightly lifted and whose curving upper lip is noticeably narrower than the broad lower lip.

The aquiline nose, the form of the mouth, the small but pronounced chin, the large eyes, the narrow facial form and the rather mocking expression on the face indicated by the quizzically raised brows and lifted corners of the mouth all clearly indicate that this bust is an individualised portrait. Comparisons with other portraits of Joseph Wenceslas I of Liechtenstein, such as the "Likeness of the Prince Dressed as

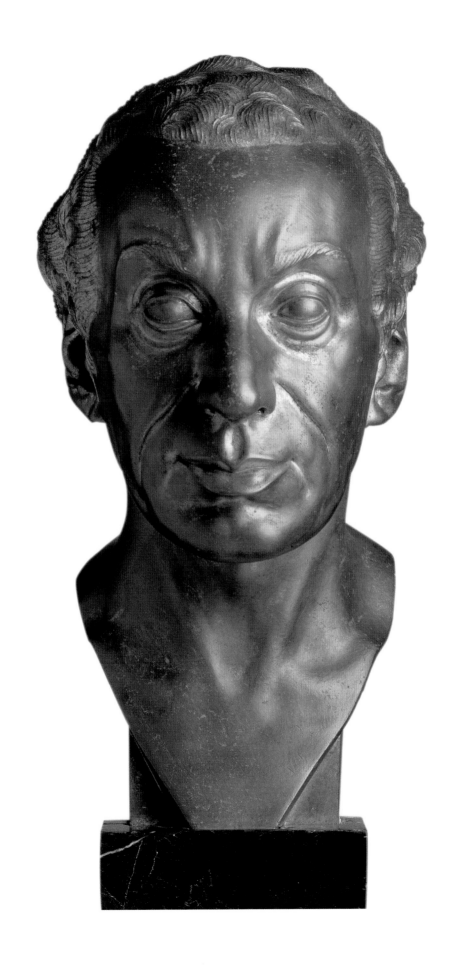

[2a]

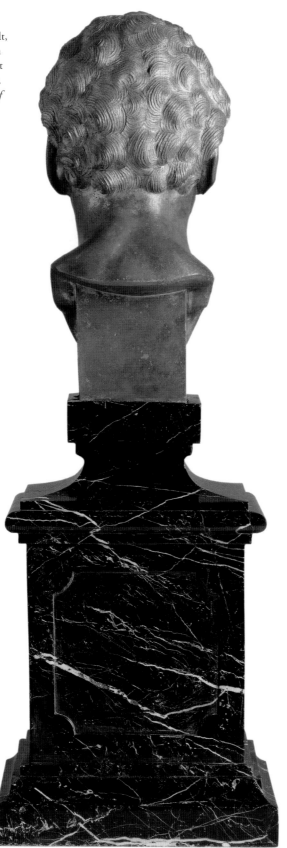

Kat.-Nr. 2b / *Cat. no. 2b*
Franz Xaver Messerschmidt,
Fürst Joseph Wenzel I. von
Liechtenstein, Rückansicht
Franz Xaver Messerschmidt,
Joseph Wenceslas I, Prince of
Liechtenstein, rear view

a Baker" (1765),[4] the 1770 portrait executed in pastels by Johann Baptist Göstl (fig. 30)[5] and even the portrait done as early as 1740 by Hyacinthe Rigaud (fig. 31)[6] support the identification of the Messerschmidt portrait head, even though the lead face is noticeably narrower and the brows raised as if satirically.

Crisply notched, the sharp nasolabial folds extend from the wings of the nose to the chin. The lenticular groove, or philtrum, between the upper lip and the nose has also been strikingly rendered. Between heavy lids framed by folds and the lower lids, which are accompanied by the arcs of the lachrymal sacs, reveal eyeballs of indeterminate gaze. Slightly elevated folds run from the root of the nose to the lofty forehead. They are repeated in the raised areas running up from the beginnings of the eyebrows to the temples.

Locks frame the face. Brushed aside from the face in short crescents, they develop towards the back of the head into more curly, short locks (cat. no. 2c–d). The strands of hair lie on the back of the head in rounded forms (cat. no. 2b); they have been meticulously worked and demarcated from one another in exquisite detail. In a rendering of hair typical of Messerschmidt's style, the strands are differentiated within by finer incisions, which also distinguish the fillet and the locks in the relief bust of Joseph II, the treatment of the hair of Franz Anton Mesmer and, similarly, the handling of the hair in the Character Heads, for example "Satiricus" (cat. no. 20) and "The Noble-Minded Man" (cat. no. 18). These are structures abstracted from natural hair. Messerschmidt uses the same structures for fillets.

Striking features of this head are the hardness of the modelling, the lack of animation of the surface, the contrast between the smooth parts and the finely chiselled hair, rendered in crescents and curls. Even though, and this is equally true of the Messerschmidt heads of Mesmer, von Scheyb, von Kessler and van Swieten, an animated appearance on the part of the sitter has not been aimed at, distinctive facial peculiarities have not been negated.

More noticeably than in the pieces mentioned above for comparison, the portrait of the Prince of Liechtenstein has been idealised through clear, simple forms, reduction to a scant bust detail and pedestal

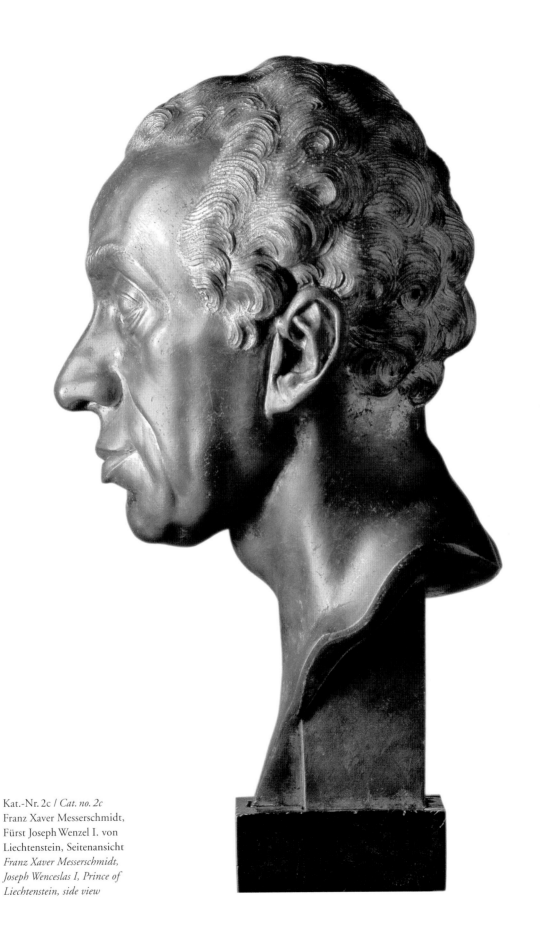

Kat.-Nr. 2c / *Cat. no. 2c*
Franz Xaver Messerschmidt,
Fürst Joseph Wenzel I. von
Liechtenstein, Seitenansicht
Franz Xaver Messerschmidt,
Joseph Wenceslas I, Prince of
Liechtenstein, side view

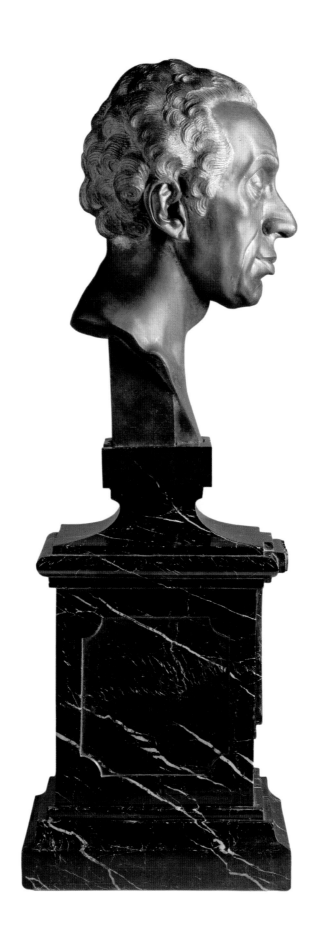

Kat.-Nr. 2d / Cat. no. 2d
Franz Xaver Messerschmidt,
Fürst Joseph Wenzel I. von
Liechtenstein, Seitenansicht
Franz Xaver Messerschmidt,
Joseph Wenceslas I, Prince of
Liechtenstein, side view

66

Schlüsselbeine, die Schlüsselbeingrube, die Sternalgrube unter dem Adamsapfel sowie, nur leicht vortretend, die Muskeln, die sich vom Brustbein zum Mastoid, einem Knochen hinter dem Ohr, ziehen, den Schulteransatz sowie den deutlich ausgeprägten Adamsapfel. Das strenge Gesicht wird von der markanten, langen schmalen Nase, großen Augen, die von hochgezogenen Augenbrauen überwölbt sind, einer hohen Stirn und einem sensibel geschwungenen Mund, dessen Winkel leicht gehoben werden und dessen geschwungene Oberlippe deutlich schmaler als die breite Unterlippe ist, charakterisiert.

Insbesondere die gebogene Nase, die Form des Mundes, das kleine, aber markante Kinn, die großen Augen, die schmale Gesichtsform und der durch die hochgezogenen Augenbrauen und Mundwinkel leise spöttisch wirkende Gesichtsausdruck machen deutlich, dass es sich bei der Büste um ein individuelles Porträt handelt. Vergleiche mit Porträts von Joseph Wenzel I. von Liechtenstein, so dem »Bildnis des Fürsten im Kostüm eines Bäckers« aus dem Jahr 1765,[4] dem 1770 entstandenen Pastel von Johann Baptist Göstl (Abb. 30),[5] oder auch mit bereits 1740 geschaffenen Porträts von Hyacinthe Rigaud (Abb. 31)[6] stützen die Identifikation von Messerschmidts Porträtkopf, auch wenn das bleierne Gesicht deutlich schmaler ist und die Brauen wie satirisch hochgezogen sind.

Deutlich eingekerbt ziehen sich scharfe Nasolabialfalten von den Nasenflügeln bis zum Kinn. Markant wiedergegeben ist auch die linsenförmige, so genannte Fliege zwischen Oberlippe und Nase. Die Augen zeigen zwischen schweren Oberlidern, die durch Lidfalten gerahmt werden, und den Unterlidern, die von bogenförmigen Tränensäcken begleitet sind, einfache blicklose Augäpfel. Leicht erhobene Falten leiten von der Nasenwurzel zur hohen Stirn über. Sie werden von Erhebungen wiederholt, die sich vom Beginn der Augenbrauen jeweils zu den Schläfen hochziehen.

Locken rahmen das Gesicht. Sie sind in kurzen Sicheln aus dem Gesicht gestrichen und entwickeln sich, zum Hinterkopf hin, zunehmend zu stärker gekräuselten, kurzen Locken (Kat. Nr. 2c–d). Auf dem Hinterkopf liegen die Strähnen in gerundeten Formen (Kat. Nr. 2b); sie sind sorgfältig ausgearbeitet und in feiner Detailarbeit gegeneinander abgegrenzt. Die Strähnen weisen in sich feinere Ritzungen auf, eine für Messerschmidt typische Art der Haarbehandlung, die ebenfalls das Haarband und die Locken des Büstenreliefs von Joseph II., die Frisur des Franz Anton Mesmer und gleichermaßen Frisuren von Charakterköpfen, beispielsweise von »Der Satirikus« (Kat.-Nr. 20) oder auch »Der Edelmüthige« (Kat.-Nr. 18), auszeichnen. Es sind Strukturen, die von natürlichem Haar abstrahieren. Dieselben Strukturen benutzt Messerschmidt darüber hinaus für Bänder.

30 Johann Baptist Göstl, Fürst Joseph Wenzel I. von Liechtenstein, 1770, Miniatur auf Elfenbein, Sammlungen des Fürsten von und zu Liechtenstein, Vaduz-Wien, LIECHTENSTEIN MUSEUM. Die Fürstlichen Sammlungen, Wien, Inv.-Nr. GE 3342

Johann Baptist Göstl, Joseph Wenceslas I, Prince of Liechtenstein, miniature on ivory, 1770 Sammlungen des Fürsten von und zu Liechtenstein, Vaduz-Vienna, LIECHTENSTEIN MUSEUM. Die Fürstlichen Sammlungen, Vienna, Inv. no. GE 3342

and through the head being proportionately larger, the idealisation being further underscored by the silvering, which originally coated the entire bust. In addition, the portrait of the Prince, who was about 74 years old at the time, is ennobled by the affinities of such motifs as the narrow, emaciated face, the large aquiline nose and the high forehead with ancient Roman portraits of Julius Caesar.[7]

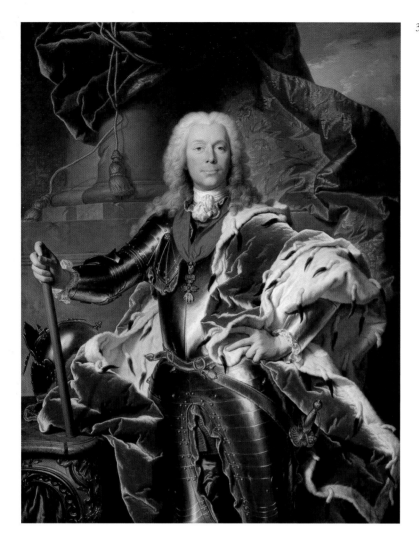

Auffallend an dem Kopf sind die Härte der Modellierung, die Un-
belebtheit der Oberfläche, der Kontrast zwischen glatten Partien
und den fein ziselierten, in Sicheln und Locken gekräuselten Haa-
ren. Zwar ist, wie bei den Köpfen Mesmers, von Scheybs, von
Kesslers und van Swietens, nicht die lebendige Erscheinung des
Porträtierten angestrebt, dennoch werden physiognomische Eigen-
heiten nicht negiert.

 Deutlicher als bei den genannten Vergleichen erfährt das Por-
trät des Fürsten durch die klaren, einfachen Formen, die Reduktion
auf einen knappen Büstenausschnitt und Sockel sowie durch den
im Vergleich dazu großen Kopf eine Idealisierung, die durch die
ehemals vollständige Versilberung zusätzlich unterstrichen wurde.
Außerdem wird das Porträt des damals ungefähr 74-jährigen Fürsten
durch motivische Verwandtschaft in Bezug auf das schmale, hagere
Gesicht, die lange Nase und die hohe Stirn mit antiken Porträts von
Julius Cäsar nobilitiert.[7]

1 Zuerst identifiziert von Dr. Johann Kräftner, Direktor der Sammnlungen des Fürsten von und zu Liechtenstein, Vaduz-Wien, Liechtenstein Museum, Wien.

2 Zu den Büsten siehe Pötzl-Malíková 1982, Nr. 218–220. Zur Familie von Liechtenstein als Auftraggeber Messerschmidts siehe Krapf, Auftraggeber und Freundeskreis 2002, S. 66–67.

3 Dazu siehe Pötzl-Malíková 1982, S. 232.

4 Öl auf Papier, 16,9 x 12,5 cm, Sammlungen des Fürsten von und zu Liechtenstein, Vaduz-Wien, Liechtenstein Museum. Die Fürstlichen Sammlungen, Wien, Inv.-Nr. Hs 2034; dazu siehe Ausst.-Kat. Joseph Wenzel von Liechtenstein 1990, S. 150–151.

5 Miniatur auf Elfenbein, 4,8 x 3,9 cm, Sammlungen des Fürsten von und zu Liechtenstein, Vaduz-Wien, Liechtenstein Museum. Die Fürstlichen Sammlungen, Wien, Inv.-Nr. GE 3342; dazu siehe Ausst.-Kat. Joseph Wenzel von Liechtenstein 1990, S. 152–153; J. Kräftner, in: Ausst.-Kat. Klassizismus und Biedermeier 2004, S. 106.

6 Öl auf Leinwand, 146 x 115 cm, Sammlungen des Fürsten von und zu Liechtenstein, Vaduz-Wien, Liechtenstein Museum. Die Fürstlichen Sammlungen, Wien, Inv.-Nr. G 1496; dazu siehe Ausst.-Kat. Joseph Wenzel von Liechtenstein 1990, S. 105–107; Perreau 2004, Abb. 172, 174.

7 Dazu siehe Boehringer 1933, Abb. 1, 14.

Literatur
J. Kräftner, in: Ausst.-Kat. Klassizismus und Biedermeier 2004, S. 106, Nr. II.27.

1 First identified by Dr. Johann Kräftner, director of the Sammlungen des Fürsten von und zu Liechtenstein, Vaduz-Vienna, Liechtensteinmuseum, Vienna.

2 On the busts see Pötzl-Malíková 1982, nos. 218–220. On the Liechtensteins giving commissions to Messerschmidt see Krapf, Auftraggeber und Freundeskreis 2002, pp. 66f.

3 See Pötzl-Malíková 1982, p. 232.

4 Oils on paper, 16.9 x 12.5 cm, Sammlungen des Fürsten von und zu Liechtenstein, Vaduz-Vienna, Liechtenstein Museum. Die Fürstlichen Sammlungen, Vienna, Inv. no. Hs 2034; on this see exhib. cat. Joseph Wenzel von Liechtenstein 1990, pp. 150f.

5 A miniature on ivory, 4.8 x 3.9 cm, Sammlungen des Fürsten von und zu Liechtenstein, Vaduz-Vienna, Liechtenstein Museum. Die Fürstlichen Sammlungen, Vienna, Inv. no. GE 3342; on this see exhib. cat. Joseph Wenzel von Liechtenstein 1990, pp. 152f.; J. Kräftner, in: exhib. cat. Klassizismus und Biedermeier 2004, p. 106.

6 Oil on canvas, 146 x 115 cm, Sammlungen des Fürsten von und zu Liechtenstein, Vaduz-Vienna, Liechtenstein Museum. Die Fürstlichen Sammlungen, Vienna, Inv. no. G 1496; on this see exhib. cat. Joseph Wenzel von Liechtenstein 1990, pp. 105ff.; Perreau 2004, figs 172, 174.

7 See Boehringer 1933, fig. 1, 14.

References
J. Kräftner, in: exhib. cat. Klassizismus und Biedermeier 2004, p. 106, No. II.27.

Blei-Zinn-Legierung
Höhe 37,4 cm
Bez. rechts am Halsansatz: F. M. SCH.
Preßburg, um 1780
Galéria mesta Bratislavy
Bratislava, Inv.-Nr. B-345

Lead-tin alloy, height 37.4 cm
Inscr. right at bottom neck: F. M. SCH.
Bratislava, c. 1780
Galéria mesta Bratislavy
Bratislava, Inv. no. B-345

[3]

Der Kapuziner

Eine der bekanntesten und zugleich rätselhaftesten Büsten Messerschmidts ist der aufgrund seiner Tonsur und des Vollbarts »Kapuziner« genannte Kopf (Kat.-Nr. 3a). Der Bart, der sowohl realiter als auch im Bildnis während des gesamten 18. Jahrhunderts eigentlich verpönt war,[1] gehörte beim Orden der Kapuziner zu den Erkennungszeichen, da er als »Symbol der Weltabgewandtheit, Demut und Armut«[2] und somit als Zeichen der Treue zu den Ursprüngen des Ordens galt.[3] Der Kopf wird gelegentlich als Porträt des Kapuzinermönchs und späteren prominenten Freimaurers Ignaz Aurel Fessler (1756–1839) angesprochen. Zwar hatte Messerschmidt Wien bereits verlassen, als Fessler dort lebte, und sich in Preßburg niedergelassen; allerdings waren die Beziehungen zwischen den beiden Städten im 18. Jahrhundert so eng, dass es durchaus vorstellbar gewesen ist, dass Fessler einen Aufenthalt in Preßburg nutzte, um den Bildhauer zu besuchen und sein Porträt zu bestellen. Individuelle Züge lassen sich jedoch allenfalls in dem Bart, der aber von der zeitgenössischen Mode abgelehnt wurde, und in dem extrem kleinen Mund mit schmalen Lippen feststellen. Mit letzter Sicherheit kann eine Identifizierung nicht belegt werden, zumal Fessler zu der Zeit, als die Büste entstand, erst ungefähr 24-jährig war, während der Dargestellte deutlich älter wirkt. Die Identität des »Kapuziners« bleibt somit weiterhin unbekannt.[4] Zu den Charakterköpfen dürfte er nicht gehören, denn kein Charakterkopf zeigt einen derart knappen Ausschnitt, verbunden mit einem nahezu unbewegten, ruhigen Gesichtsausdruck.[5]

Die Augen sind von schmalen Graten als Unterlidern, unter denen sich Tränensäcke wölben, und von nahezu halbrund gewölbten Oberlidern eingefasst. Orbitalwülste liegen leicht darauf und werden ihrerseits von den auf einem leicht erhabenen Grat eingeritzten Augenbrauen eingegrenzt. Die hohe Stirn geht nahtlos in die

The Capuchin

One of the best known yet most enigmatic busts by Messerschmidt is the head of a "Capuchin", thus designated because of the figure's tonsure and beard (cat. no. 3a). The beard, which both in reality and in portraits was actually frowned on throughout the 18th century,[1] was however one of the distinguishing marks of the Capuchin order of friars since it was regarded as a "symbol of unworldliness, humility and poverty"[2] and, therefore, a sign of fidelity to the origins of the Franciscan order, of which they were an offshoot.[3] This head is occasionally regarded as a portrait of the Capuchin friar Ignaz Aurel Fessler (1756–1839), who later became an eminent Freemason. Messerschmidt had already left Vienna and had settled in Bratislava by the time Fessler was living in Vienna; however, relations between the two cities were so close in the 18th century that it is easily conceivable that Fessler may have used a sojourn in Bratislava as an opportunity for visiting the sculptor and commissioning a portrait. Individualised features are at best identifiable in the beard which, however, was rejected by the fashion of the time, and in the extremely small mouth with its narrow lips. The identification cannot be verified with any certainty, however, since Fessler was only about 24 years old at the time the bust was executed, whereas the sitter looks appreciably older than that. As a result, the identity of the "Capuchin" remains unknown.[4] It is probably not one of the Character Heads since no Character Head reveals such a scant section of the breast linked with an almost unmoved, calm facial expression.[5]

The eyes are framed by narrow ridges as lower lids, beneath which lachrymal sacs bulge, and by nearly semicircular, bulging upper lids. Orbital ridges lie slightly above the latter, and in turn are bounded by eyebrows incised in a slightly raised ridge. The high forehead slides without transition into the bald head. As in the Frankfurt "Bust of a Bearded Old Man" (cat. no. 5), pronounced nasolabial folds demarcate the protuberant cheeks from the wings of the nose and the upper lip. The face has bulging parts which do not convey an impression of breathing animation. On the contrary, these parts look both strained and distended, and at the same time rigid.[6] The beard and the ring of hair surrounding the little

70

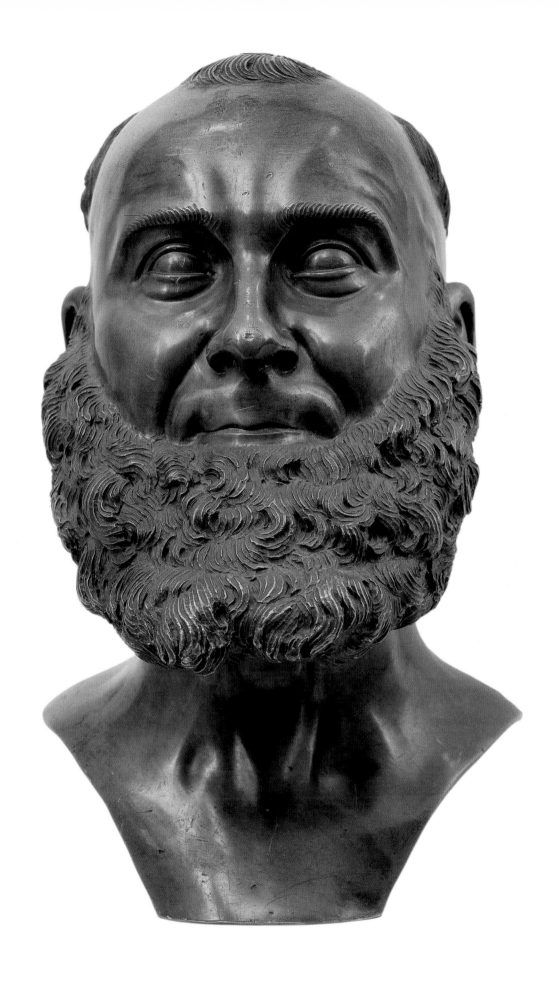

[3a]

Glatze über. Deutliche Nasolabialfalten trennen, wie bei der Frankfurter »Büste eines bärtigen, alten Mannes« (Kat.-Nr. 5), die vortretenden Wangen von den Nasenflügeln und der Partie über dem Mund. Das Gesicht zeigt gewölbte Partien, die nicht den Eindruck atmender Lebendigkeit vermitteln. Im Gegenteil wirken diese Partien eher gespannt gebläht und gleichzeitig starr.[6]

Zu dem in großflächigen Partien modellierten Gesicht kontrastieren deutlich der Bart, der Haarkranz um die Glatze und die kleine Tonsur auf dem Schädel (Kat. Nr. 3b–d).[7] Die Haarpartien sind in kurze Strähnen aufgelöst, die beim Haarkranz in zwei schmalen Reihen angeordnet sind, beim Bart dagegen eine ungeordnet wirkende Masse zu bilden scheinen. Frontal betrachtet, fällt allerdings auf, dass der untere Teil des Bartes von der Löckchenmasse um das Kinn herum durch neu ansetzende Strähnchen abgeteilt ist. Er weist in dieser Partie eine ähnliche Bartform auf wie der Frankfurter Kopf. Anders als bei diesem ist der Bart des Kapuziners jedoch als eine von kleinen Sicheln und Löckchen überlagerte Masse angelegt, die sich nicht mit einzelnen Haaren im Wangenbereich

tonsure on the skull contrast sharply with the broadly modelled surfaces of the face (cat. no. 3b–d).[7] The hair dissolves into short strands, which are arranged in the ring of hair in two narrow rows; in the beard, on the other hand, the strands seem to form an amorphous-looking mass. In frontal view, however, the lower part of the beard is noticeably demarcated from the mass of curls by short "new" growth around the chin. In this part the beard has a form similar to that of the Frankfurt head. Unlike that of the Frankfurt head, however, the Capuchin's beard is laid on as a mass overlaid by small crescents and curls, which are not anticipated in the cheek area but instead are set off sharply from it. This demarcation from "the smooth cheeks and shaven upper lip",[8] as well as modelling which does not reproduce the material properties of hairs, makes the Capuchin look as if he were wearing a "glued-on false beard",[9] which juts forward when viewed from the side.

This head is generally dated to the late Bratislava period, particularly with reference to the 1782 bust of Martin Georg Kovachich (figs. 13, 26).[10] All traces of Baroque bathos have vanished; "the facial features have been modelled clearly, tautly and with extreme crispness. The broad, harsh structure of the face […] has been formed from the tectonically used bone structure into a lifeless, monumentalising appearance."[11] Particularly obvious correspondences can be noted with another portrait, that of Albert, Duke of Saxe-Teschen (figs. 24, 25, 32), dating from 1777–1780: the rigid, distended forms and the distinctive formation of the eyebrows occur in both heads whereas the handling in the bust of Kovachich appears even harsher and more metallic than that of the Capuchin head. Hence a date in the late 1770s is suggested.

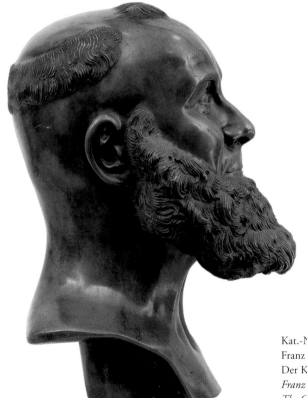

Kat.-Nr. 3b / *Cat. no. 3b*
Franz Xaver Messerschmidt,
Der Kapuziner, Seitenansicht
Franz Xaver Messerschmidt,
The Capuchin, side view

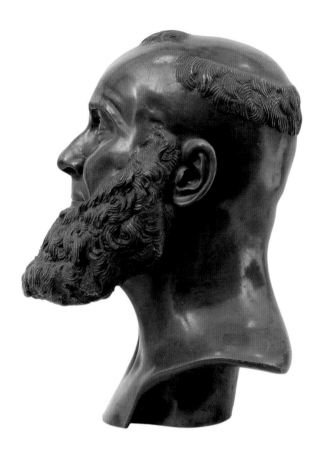

Kat.-Nr. 3c / *Cat. no. 3c*
Franz Xaver Messerschmidt,
Der Kapuziner, Seitenansicht
Franz Xaver Messerschmidt,
The Capuchin, side view

Kat.-Nr. 3d / *Cat. no. 3d*
Franz Xaver Messerschmidt,
Der Kapuziner, Rückansicht
Franz Xaver Messerschmidt,
The Capuchin, rear view

vorbereitet, sondern scharf dagegen abgesetzt ist. Diese Abgrenzung gegen »die glatten Wangen und die rasierte Oberlippe«[8] sowie eine Modellierung, die die Materialqualität von Haaren nicht abbildet, führt zu dem Eindruck, der Kapuziner trage ein »angeklebtes Haarteil«,[9] das, von der Seite betrachtet, nach vorn ragt.

Der Kopf wird allgemein in die späte Preßburger Zeit, insbesondere unter Hinweis auf die Büste des Martin Georg Kovachich von 1782 (Abb. 13, 26),[10] datiert. Alles barocke Pathos ist verschwunden; »die Gesichtszüge sind klar, straff und mit äußerster Prägnanz modelliert. Der großteilige, harte Gesichtsaufbau wird von der architektonisch verwendeten Knochenstruktur zu einem regungslosen, monumentalisierenden Erscheinungsbild [...] geformt.«[11] Besonders deutliche Analogien lassen sich zu einem anderen Porträt, das von Herzog Albert von Sachsen-Teschen (Abb. 24, 25, 32), geschaffen zwischen 1777–1780, herstellen: Sowohl die gleichzeitig starren, geblähten Formen als auch die eigenwillige Gestaltung der Augenbrauen sind bei beiden Köpfen wiederzufinden, während die Gestaltung der Büste des Kovachich noch härter und metallischer wirkt als der Kapuzinerkopf. Daher soll vorgeschlagen werden, Letzteren in die späten 1770er Jahre zu datieren.

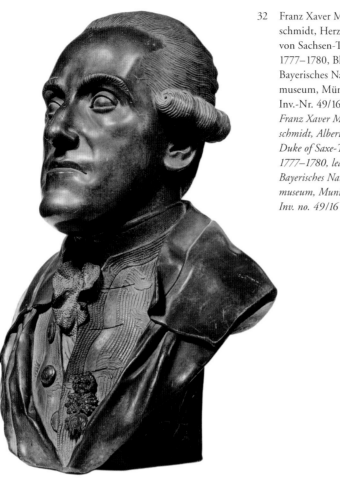

32 Franz Xaver Messer-
schmidt, Herzog Albert
von Sachsen-Teschen,
1777–1780, Blei,
Bayerisches National-
museum, München,
Inv.-Nr. 49/16
Franz Xaver Messer-
schmidt, Albert,
Duke of Saxe-Teschen,
1777–1780, lead,
Bayerisches National-
museum, Munich,
Inv. no. 49/16

1 See Boehn 1969, p. 70. Also Jedding-Gesterling/Brutscher
 1988, p. 131.
2 Thiessen 2006, p. 82.
3 Thus Lehmann 1997, p. 150.
4 On the question of identification see Pötzl-Malíková
 1982, p. 239; Krapf, Katalog 2002, p. 276.
5 Pfarr (2006, p. 399), on the other hand, attributes the
 Character Heads to him.
6 Thus also Kris 1932, p. 185.
7 Thus Pötzl-Maliková 1982, p. 66.
8 Schmid 2004, p. 63.
9 Loc. cit.
10 Thus Maliková 1965, p. 20; Krapf, Katalog 2002, p. 276.
 On the portrait of Martin Georg Kovachich see Ronzoni
 1982, p. 2486; Bückling 1999b, pp. 108f.
11 Ronzoni 1982, p. 2486.

References

Ilg 1885, p. 36; Hevesi 1909, pl. 20; Weiss 1924, p. 39,
p. 165; Kris 1932, p. 185 (fig. 162); Kris 1933, fig. 28;
Malíková 1965, p. 20, fig. 17; Glandien 1981, pp. 74f.;
Pötzl-Malíková 1982, pp. 65f., 239f.; Ronzoni 1982,
p. 2486; Behr/Grohmann/Hagedorn 1983, illus.
pp. 124f.; Fidler 1984, p. 52, fig. 1; exhib. cat. Messer-
schmidt Têtes de caractères 1993, p. 33; Krapf, Katalog
2002, pp. 276f.; Pötzl-Malíková 2004, illus. p. 56; Pfarr
2006, pp. 398f., fig. 16.

1 Dazu siehe Boehn 1969, S. 70. Dazu auch Jedding-Gesterling/Brutscher
 1988, S. 131.
2 Thiessen 2006, S. 82.
3 So Lehmann 1997, S. 150.
4 Zur Frage der Identifikation siehe Pötzl-Malíková 1982, S. 239;
 Krapf, Katalog 2002, S. 276.
5 Pfarr (2006, S. 399) ordnet ihn hingegen den Charakterköpfen zu.
6 So auch Kris 1932, S. 185.
7 So Pötzl-Maliková 1982, S. 66.
8 Schmid 2004, S. 63.
9 Schmid 2004, S. 63.
10 So Maliková 1965, S. 20; Krapf, Katalog 2002, S. 276. Zum Porträt des
 Martin Georg Kovachich siehe Ronzoni 1982, S. 2486; Bückling 1999b,
 S. 108–109.
11 Ronzoni 1982, S. 2486.

Literatur

Ilg 1885, S. 36; Hevesi 1909, Taf. 20; Weiss 1924, S. 39, 165; Kris 1932,
S. 185 (Abb. 162); Kris 1933, Abb. 28; Malíková 1965, S. 20, Abb. 17;
Glandien 1981, S. 74–75; Pötzl-Malíková 1982, S. 65–66, 239–240;
Ronzoni 1982, S. 2486; Behr/Grohmann/Hagedorn 1983, Abb. S. 124–
125; Fidler 1984, S. 52, Abb. 1; Ausst.-Kat. Messerschmidt Têtes de carac-
tères 1993, S. 33; Krapf, Katalog 2002, S. 276–277; Pötzl-Malíková 2004,
Abb. S. 56; Pfarr 2006, S. 398–399, Abb. 16.

Charakterköpfe

Character Heads

The Character Heads – Forms, Names and Numbers

In 1793 the disturbing works known as the Character Heads, which had not been commissioned by anyone, induced an unkown author to give them names in his "Curious Life-story of Franz Xaver Messerschmidt".[1] Those names have, despite the author's stated intention, had no "enlightening" effect. How arbitrarily the names were chosen is revealed in an "advertisement" which the anonymous author appended to his descriptions: "If connoisseurs conduct research into expressions in the

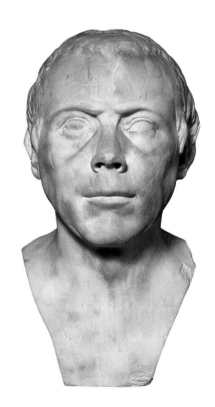

33 Franz Xaver Messerschmidt, Des Künstlers ernste Bildung, nach 1770, Alabaster, Österreichische Galerie Belvedere, Wien, Inv.-Nr. 2283

Franz Xaver Messerschmidt, The Artist's Serious Countenance, after 1770, alabaster, Österreichische Galerie Belvedere, Vienna, Inv. no. 2283

Maraike Bückling

Die Charakterköpfe – Formen, Namen und Zahlen

Im Jahr 1793 veranlassten die irritierenden, so genannten Charakterköpfe, die ohne Auftrag entstanden, einen unbekannten Autor, ihnen in der »Merkwürdigen Lebensgeschichte des Franz Xaver Messerschmidt«[1] Namen zu geben, die allerdings entgegen der erklärten Absicht des Anonymus, keinerlei »erhellende« Wirkung haben. Wie willkürlich die Namen letztlich gewählt sind, verrät eine »Anzeige«, die der anonyme Autor im Anhang seinen Beschreibungen anfügt: »Wenn Kenner in den Gesichtsbildungen vorstehender Büsten, Ausdrüke erforschen, welche die dargestellten Leidenschaften noch vollständiger erhellen und aufklären, und ihre gegründete Bemerkungen postfrei schriftlich einschiken; so werden sie den Eigenthümer dieser Sammlung zu vielem Dank verpflichten.«[2] Diese seit ihrer Prägung im 18. Jahrhundert immer weiter tradierten, nicht selten absurden Namen haben gelegentlich fatale Folgen: Sie bergen die nicht geringe Gefahr, dass sie Einfluss auf die Interpretation nehmen.[3] Wenn auch in dieser Ausstellung darauf zurückgegriffen wird, dann deshalb, weil die Köpfe unter diesen Namen bekannt sind, und neue Namen bisher nicht durchzusetzen waren.[4] Die ebenfalls 1793 vorgenommene Nummerierung der Köpfe, die gleichfalls willkür-

76

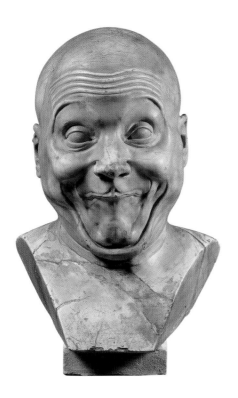

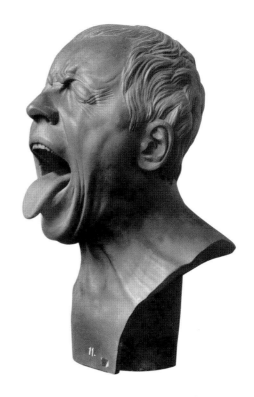

34 Franz Xaver Messer-
schmidt, Ein absicht-
licher Schalksnarr, nach
1770, Alabaster,
Österreichische Galerie
Belvedere, Wien,
Inv.-Nr. 2284
*Franz Xaver Messer-
schmidt, An Intentional
Wag, after 1770,
alabaster, Österreichische
Galerie Belvedere,
Vienna, Inv. no. 2284*

35 Franz Xaver Messer-
schmidt, Der Speyer,
nach 1770, Alabaster,
verschollen
*Franz Xaver Messer-
schmidt, A Man
Vomiting, after 1770,
alabaster, whereabouts
unknown*

lich ist und bestimmte Zusammenstellungen vorgibt, bietet den
Namen gegenüber keine Vorteile, hat aber im Gegensatz dazu vor
allem den Nachteil, einen Text äußerst schwer lesbar zu gestalten.

»Alle diese Köpfe waren sein Bildniß«[5] – so führt Friedrich
Nicolai die Charakterköpfe ein und fährt fort: »Ich sah ihn am ein
und sechzigsten Kopfe arbeiten. Er sah dabey jede halbe Minute in
den Spiegel, und machte mit größter Genauigkeit die Grimasse, die
er brauchte.«[6] Werden allerdings Köpfe wie »Des Künstlers ernste
Bildung« (Abb. 33), »Ein absichtlicher Schalksnarr« (Abb. 34), »Ein
Erzbösewicht« (Kat.-Nr. 10) oder auch die »Büste eines bärtigen,
alten Mannes« (Kat.-Nr. 5) miteinander verglichen, so gibt es
kaum Konstanten in der Kopfbildung, von den äußerst unter-
schiedlichen Frisuren einmal ganz abgesehen, die diese Einschät-
zung Nicolais stützen würden.[7] Dass der Künstler in einen Spiegel,
der zum selbstverständlichen Handwerkszeug in Künstlerwerk-
stätten gehörte, sah, spricht keineswegs für Selbstbildnisse, sondern
nur dafür, dass ihm die korrekte Wiedergabe der Physiognomie am
Herzen lag. Allerdings kristallisieren sich bei einigen Köpfen, dem
lachenden Selbstbildnis (Kat.-Nr. 4), »Der Speyer« (Abb. 35), »Der
Bekümmerte«,[8] »Ein mürrischer alter Soldat« (Kat.-Nr. 7), »Ein
düstrer finsterer Mann« (Kat.-Nr. 21) oder auch »Der Melancholi-
kus« (Kat.-Nr. 8) anatomische Konstanten heraus, die die Annahme
stützen, Messerschmidt habe in einigen Darstellungen Anteile sei-
ner eigenen Physiognomie einfließen lassen.[9]

facial formations of the present busts which even
more completely elucidate and explain the passions
represented and send in their well-founded observa-
tions free of postage, the owner of this collection will
owe them a great debt of gratitude."[2] Since they were
coined in the 18th century, these names, quite a few
of which are absurd, have occasionally had disastrous
consequences: they conceal the quite great danger
that they may influence interpretation.[3] Although
they are also resorted to in the present exhibition, this
is simply because the Heads are known by these
names and it has hitherto not been possible to coin
new names and make them canonical.[4] The number-
ing of the Heads, which was also undertaken in 1793,
is equally arbitrary and prescribes particular group-

Auch wenn die Charakterköpfe somit sehr unterschiedliche Physiognomien und Frisuren zeigen, so ist der Mehrzahl doch die Grundform gemeinsam: Auf der knappen, nach vorne ausgerichteten Büste eines nackten Mannes, auf einem rechteckigen oder, seltener, zylindrischen Kubus ruhend, ist der Kopf frontal angebracht. Der Ausschnitt zeigt die Schultern ungefähr bis zu den Schlüsselbeinen, so dass sie die Breite des Kopfes nur um weniges überragen. Die Büsten verjüngen sich in der überwiegenden Anzahl nach unten V-förmig bis zum horizontalen Abschluss; der sie stützende Kubus steht in der Vorderansicht meist seitlich vor. Diese Reduktion auf eine einfache Kontur und wenige Motive verbindet sich oft mit einem Maximum an – grimassierendem – Ausdruck, der gelegentlich die Brustausschnitte in Mitleidenschaft zieht.

Deutlich wird die Verbindung dieses Formenkanons bei der Porträtbüste des Fürsten von Liechtenstein (Kat.-Nr. 2), mit der der folgenreiche Prototyp dieser Büstenform vorliegt. Nicht Natürlichkeit und Lebendigkeit sind angestrebt. Durch die Reduktion auf einen knappen Büstenausschnitt und Sockel sowie durch den im

36 Franz Xaver Messerschmidt, Ein alter frölicher Lächler, nach 1770, Lindenholz mit Wachsauflage, Österreichische Galerie Belvedere, Wien, Inv.-Nr. 2286
Franz Xaver Messerschmidt, An Old Cheerful Smiler, after 1770, limewood with wax appliqué, Österreichische Galerie Belvedere, Vienna, Inv. no. 2286

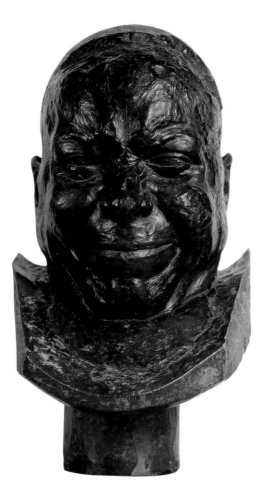

ings, has no advantages over the names but, unlike them, possesses above all the drawback of making it extremely difficult to write a readable text.

"All these Heads were his likeness."[5] Thus Friedrich Nicolai introduces the Character Heads and goes on to relate: "I saw him working on the sixty-first head. While so doing, he kept looking every half minute in the looking-glass and pulling, with the utmost precision, the face he needed."[6] If, however, such Heads as "The Artist's Serious Countenance" (fig. 33), "An Intentional Wag" (fig. 34), "An Arch-Rascal" (cat. no. 10) or even the "Bust of A Bearded Old Man" (cat. no. 5) are compared with one another, there are virtually no constants in the formation of the heads (quite apart from the circumstance that the hair is dressed in widely varying styles) that might support Nicolai's interpretation.[7] That the artist looked in a mirror, which as a matter of course was among the tools employed in artists' workshops, does not in the least speak for self-portraits but rather that Messerschmidt was concerned with correctly reproducing physiognomy. However, from some heads, such as "The Artist As He Imagined Himself Laughing" (cat. no. 4), "A Man Vomiting" (fig. 35), "The Troubled Man",[8] "A Surly Old Soldier" (cat. no. 7), "A Dismal and Sinister Man" (cat. no. 21) and also "The Melancholic" (cat. no. 8), anatomical constants can be extrapolated which support the assumption that Messerschmidt included aspects of his own countenance in some of these representations.[9]

Even though the Character Heads, therefore, reveal very different physiognomies and hair styles, the following basic form is common to the majority of them: the head is positioned frontally to a rectangular or, more rarely, a cylindrical block on which rests a scant frontal naked bust of a man. The breast section depicts the shoulders approximately to the collar bones so that they are not much broader than the head itself. Most of the busts taper down in a V-shape to finish off horizontally at the bottom; when viewed from the front, the block supporting them usually extends to the side. Reduction in this way to a simple contour and only a few motifs is often linked with a maximum of – grimacing – expression, which occasionally also affects the breast section.

Vergleich dazu großen Kopf werden die Büsten abstrakter; die Köpfe gewinnen gegenüber den »Zutaten« an Bedeutung. Die Porträtbüste des Fürsten von Liechtenstein dürfte das bislang fehlende »Verbindungsstück« zwischen der neuen Porträtform der Jahre 1769–1772 und den Charakterköpfen sein. Später scheint sich Messerschmidt interessanterweise auch auf seine Porträts mit Sockelkubus rückbezogen zu haben, denn mehrere Köpfe lassen den sie stützenden Sockel gut sichtbar bleiben: »Der weinerliche Alte« und seine Variante (Kat.-Nr. 11), »Ein Erzbösewicht« (Kat.-Nr. 10), »Ein Heuchler und Verleumder«, »Das zurückgehaltene Lachen«, »Der Trozige« und »Ein alter frölicher Lächler« (Abb. 36). Es dominiert hierbei – mit Ausnahmen, so »Der Gähner« (Kat.-Nr. 12), seine Variante und »Ein Hipochondrist« – die zylindrische Sockelform. Nicht also nur die Mimik, auch die die Köpfe tragenden Sockel und Büstenausschnitte können unterschiedlich gestaltet sein.

Die erste Erwähnung der berühmten Köpfe findet sich im Jahr 1775, als Messerschmidt »fünf ausgearbeitete Büsten«[10] von Wien mit nach Wiesensteig beziehungsweise später mit nach München nahm. Wann genau er mit der Arbeit an den Charakterköpfen begann, ist nicht bekannt, »doch nimmt man allgemein etwa das Jahr 1770 an, das heißt die Zeit der ersten offenen Manifestation von Messerschmidts psychischer Krankheit, mit der diese Serie in direktem kausalem Zusammenhang steht«.[11] Sollte dieses Irresein jedoch mehr einer Überlieferung durch die Akademie entstammen als der Wahrheit entsprechen, wird dieser Datierung die Begründung genommen. Für die Zeit um 1773/74 spricht, dass bereits im Jahr 1775 die erwähnten fünf Köpfe von Wien nach München transportiert wurden. Dabei handelte es sich wahrscheinlich nicht um Porträts, die eher beim Auftraggeber, sei es die Akademie, der Hof oder eine Privatperson, verblieben, sondern um Charakterköpfe. Auch existiert im Porträt des Fürsten aus der Zeit von 1770–1772 nunmehr ein Werk, das die Komposition der Charakterköpfe präformiert.

Die diversen Zollabrechnungen, von Wien nach München sowie von München nach Preßburg, führen nur metallene, oft aus einer Blei-Zinn-Legierung bestehende Werke auf. Von steinernen Köpfen ist weder in amtlichen Unterlagen noch in Briefen des Künstlers die Rede. Es gibt keinen Nachweis dafür, dass Messerschmidt einen der steinernen Charakterköpfe bereits vor 1777 schuf. Es könnte sein, dass sie erst in Preßburg entstanden,[12] in dessen Nähe es, bei Theben, Alabasterbrüche gab.[13] Die räumliche Nähe hatte Messerschmidt möglicherweise dieses Material wählen lassen, das, so wie die Blei-Zinn-Legierung die weich glänzende Variante zu Bronze ist, nicht den kristallinen Glanz von Marmor hat, sondern ebenfalls eine weiche Formbarkeit vor Augen führt.[14]

The link between this canon of forms and the portrait bust of the Prince of Liechtenstein (cat. no. 2), which is the momentous prototype of this form of bust, is clearly evident. Naturalness and animation have not been striven for. Through reduction to a scant bust section and base as well as the disproportionately large head, the busts have become more abstract; the heads gain in importance relative to the "embellishments". The portrait bust of the Prince of Liechtenstein must be the hitherto missing "link" between the new portrait form of the years between 1769 and 1772 and the Character Heads. Interestingly, Messerschmidt seems later to have reverted to his portraits with a block base since several Character Heads openly show the base supporting them: "The Weepy Old Man" and the variant of it (cat. no. 11), "An Arch-Rascal" (cat. no. 10), "A Hypocrite and Slanderer", "The Laughter Kept Back", "The Defiant Man" and "An Old Cheerful Smiler" (fig. 36). The cylindrical base form predominates› with certain exceptions, such as "The Yawner" (cat. no. 12), the variant of it and "A Hypochondriac". Not just the facial expression, therefore, but also the bases supporting the Heads and bust sections can differ in conception and design.

The first mention of the celebrated Heads is recorded for 1775, when Messerschmidt took "five completed busts"[10] with him to Wiesensteig and later also to Munich. It is not known when exactly he began to work on the Character Heads "yet around the year 1770 is generally assumed, that is, the time when Messerschmidt's mental illness first broke out, with which this series is directly causally related."[11] Should, however, his alleged insanity have more to do with Academy tradition than the truth, this date is left unconfirmed. An argument for the 1773/74 is that, by 1775, the above-mentioned five heads had been transported from Vienna to Munich. Those heads were probably not portraits, which would have remained behind with the client, be it the Academy, the court or a private individual, but most likely Character Heads. And, in the portrait of the Prince of Liechtenstein dating from 1770–1772, a work is extant which prefigures the composition of the Character Heads.

The various customs invoices, both those from Vienna to Munich and those from Munich to

Die Anzahl der Charakterköpfe

Um einen Überblick über den Umfang von Messerschmidts Arbeit an den Charakterköpfen zu gewinnen, ist es zunächst wichtig festzustellen, welche Charakterköpfe einerseits bekannt sind, und wie viele Messerschmidt schuf oder auch nur schaffen wollte. Das Problem der Messerschmidt-Forschung über die Charakterköpfe liegt bis heute darin begründet, dass der Künstler selber die Idealzahl von 64 Stücken angegeben hat; Nicolai berichtet 1781, ihn bei der Anfertigung des 61. Kopfes beobachtet zu haben. Der Anonymus von 1793 hingegen verzeichnet in seiner Aufzählung dagegen lediglich 49 Köpfe.

Die nachfolgende Zusammenstellung nach Materialgruppen soll zunächst einen Überblick über die bekannten Charakterköpfe Messerschmidts sowie über deren Verbleib geben.

Stein
1. Ein wollüstig abgehärmter Geck, Alabaster, H. 41,5 cm, Privatbesitz[15]
2. Erster Schnabelkopf, Alabaster, verschollen[16]
3. Zweiter Schnabelkopf (Abb. 39), Alabaster, H. 43 cm, Österreichische Galerie Belvedere, Wien, Inv.-Nr. 5640[17]
4. Die Einfalt im höchsten Grade (Kat.-Nr. 17), Alabaster, H. 41,5 cm, Wien Museum, Wien, Inv.-Nr. 67.137[18]
5. Das hohe Alter, Alabaster, H. 38 cm, Österreichische Galerie Belvedere, Wien, Inv.-Nr. 2282[19]
6. Der Speyer (Abb. 35, 45), Alabaster, verschollen[20]
7. Ein abgezehrter Alter mit Augenschmerzen (Abb. 52), Alabaster, H. 44,5 cm, Österreichische Galerie Belvedere, Wien, Inv.-Nr. 5638[21]
8. Der Schaafkopf (Abb. 64), Alabaster, H. 41 cm, Österreichische Galerie Belvedere, Wien, Inv.-Nr. 5509[22]
9. Der Verdrüssliche, Alabaster, H. 40 cm, Privatbesitz[23]
10. Ein Erhängter (Abb. 80), Alabaster, H. 38 cm, Österreichische Galerie Belvedere, Wien, Inv.-Nr. 5637[24]
11. Der Zuverlässige, Alabaster, H. 39 cm, Österreichische Galerie Belvedere, Wien, Inv.-Nr. 5636[25]
12. Ein aus dem Wasser Geretteter, Alabaster, H. 40 cm, Privatbesitz[26]
13. Des Künstlers ernste Bildung (Abb. 33), Alabaster, H. 39 cm, Österreichische Galerie Belvedere, Wien, Inv.-Nr. 2283[27]
14. Ein Schalksnarr (Abb. 62), Alabaster, H. 34 cm, Österreichische Galerie Belvedere, Wien, Inv.-Nr. 5639[28]
15. Ein absichtlicher Schalksnarr (Abb. 34, 63), Alabaster, H. 42 cm, Österreichische Galerie Belvedere, Wien, Inv.-Nr. 2284[29]
16. Ein starker Arbeiter, Alabaster, H. 42 cm, Österreichische Galerie Belvedere, Wien, Inv.-Nr. 2285[30]
17. Büste eines bärtigen, alten Mannes (Kat.-Nr. 5), Alabaster, H. 42 cm, Liebieghaus Skulpturensammlung, Frankfurt am Main, Inv.-Nr. 2600[31]
18. Unbenannter Charakterkopf, Kalkstein, Magyar Nemzeti Galéria, Budapest, Inv.-Nr. 2002.2 M[32]

Metall
1. Der Künstler, so wie er sich lachend vorgestellt hat (Kat.-Nr. 4), Zinn mit kleinen Mengen Kupfer und Eisen; mit Spuren von Zink, Arsen und Blei, H. 43 cm, Privatbesitz[33]
2. Ein nasenweiser spitzfindiger Spötter, Blei,[34] Maß des Gipsabgusses:

Bratislava, only list works made of a metal alloy, often of lead and tin. There is no mention of stone heads in official records or the artist's correspondence. There is no proof that Messerschmidt may have made one of the Character Heads before 1777. They may not have been made until he was in Bratislava,[12] in the vicinity of which, near Devín, there were alabaster quarries.[13] The fact that the material was available from so close by may have induced Messerschmidt to choose it. Just as the lead-tin alloy is a matte counterpart of bronze, alabaster, as a material, does not have the crystalline sheen of marble but rather, likewise, represents visual softness.[14]

The number of Character Heads

In order to gain an overall idea of the extent of the work Messerschmidt put into the Character Heads, it is first necessary to ascertain, on the one hand, which Character Heads are known, and, on the other, how many Messerschmidt actually produced or even intended to produce. The problem that Messerschmidt scholarship, when dealing with the Character Heads, has faced to the present day is that the artist himself mentioned the ideal number of 64 pieces. Nicolai reported in 1781 on having observed the artist working on the 61st Head. The anonymous writer of 1793, however, lists only 49 heads in his enumeration.

The following grouping by material is intended to provide a survey of the known Messerschmidt Character Heads and their whereabouts.

Stone
1. A Lecherous and Careworn Fop, alabaster, h. 41.5 cm, private collection[15]
2. First Beaked Head, alabaster, whereabouts unknown[16]
3. Second Beaked Head (fig. 39), alabaster, h. 43 cm, Österreichische Galerie Belvedere, Vienna, Inv. no. 5640[17]
4. The Ultimate Simpleton (cat. no. 17), alabaster, h. 41.5 cm, Vienna Museum, Vienna, Inv. no. 67.137[18]
5. Old Age, alabaster, h. 38 cm, Österreichische Galerie Belvedere, Vienna, Inv. no. 2282[19]
6. A Man Vomiting (fig. 35, 45), alabaster, whereabouts unknown[20]
7. A Haggard Old Man with Aching Eyes (fig. 52), alabaster, h. 44.5 cm, Österreichische Galerie Belvedere, Vienna, Inv. no. 5638[21]
8. The Simpleton (fig. 64), alabaster, h. 41 cm, Österreichische Galerie Belvedere, Vienna, Inv. no. 5509[22]
9. The Vexed Man, alabaster, h. 40 cm, private collection[23]

H. 44 cm, Österreichische Galerie Belvedere, Wien, Inv.-Nr. 5700 (Original verschollen)[35]

3. Der Gähner (Kat.-Nr. 12), Zinn, H. 41 cm, Szépmüvészeti Múzeum, Budapest, Inv.-Nr. 53.655[36]

4. Ein kraftvoller Mann (Kat.-Nr. 16), Blei, H. 44 cm, Privatbesitz[37]

5. Der sanfte ruhige Schlaf (Kat.-Nr. 9), Zinn, H. 44 cm, Szépmüvészeti Múzeum, Budapest, Inv.-Nr. 53.656[38]

6. Der Bekümmerte, Zinn, H. 45 cm, Österreichische Galerie Belvedere, Wien, Inv.-Nr. 3198[39]

7. Der Nieser (Abb. 66), Blei,[40] Maß des Gipsabgusses: H. 42 cm, Österreichische Galerie Belvedere, Wien, Inv.-Nr. 5683 (Original verschollen)[41]

8. Der Melancholikus (Kat.-Nr. 8), Blei, H. 44,5 cm, Privatbesitz[42]

9. Der kindisch Weinende (Kat.-Nr. 19), Zinn-Blei-Legierung, H. 45 cm, Szépmüvészeti Múzeum, Budapest, Inv.-Nr. 51.936[43]

10. Der Mismuthige (Abb. 59, 60), Blei, H. 38,7 cm, Musée du Louvre, Paris, Inv.-Nr. RF 4724[44]

11. Ein schmerzhaft stark Verwundeter (Kat.-Nr. 6), Blei,[45] Maß des Gipsabgusses: H. 44 cm, Österreichische Galerie Belvedere, Wien, Inv.-Nr. 5695 (Original verschollen)[46]

12. Der erbosste und rachgierige Zigeuner, Blei,[47] Maß des Gipsabgusses: H. 45 cm, Österreichische Galerie Belvedere, Wien, Inv.-Nr. 5694 (Original verschollen)[48]

13. Der Edelmüthige (Kat.-Nr. 18), Blei-Zinn-Legierung, H. 43,5 cm, Österreichische Galerie Belvedere, Wien, Inv.-Nr. 2612[49]

14. Der starke Geruch, Blei-Zinn-Legierung, H. 48 cm, Privatbesitz[50]

15. Der weinerliche Alte (Abb. 56), Blei,[51] Maß des Gipsabgusses: H. 32 cm, Österreichische Galerie Belvedere, Wien, Inv.-Nr. 5674 (Original verschollen)[52]

16. Der Satirikus (Kat.-Nr. 20), Blei, H. 44 cm, Germanisches Nationalmuseum, Nürnberg, Inv.-Nr. Pl. O. 2540[53]

17. Der unfähige Fagotist, Zinn, H. 44 cm, Privatbesitz[54]

18. Ein mit Verstopfung Behafteter (Kat.-Nr. 13), Blei, H. 30,2 cm, Germanisches Nationalmuseum, Nürnberg, Inv.-Nr. Pl. O. 2539[55]

19. Geruch, der zum Niesen reizt, Blei-Zinn-Legierung, H. 48 cm, Privatbesitz[56]

20. Ein Erzbösewicht (Kat.-Nr. 10), Zinn-Blei-Legierung, H. 38,5 cm, Österreichische Galerie Belvedere, Wien, Inv.-Nr. 2442[57]

21. Ein düsterer finsterer Mann (Kat.-Nr. 21), Blei-Zinn-Legierung, H. 43,5 cm, Österreichische Galerie Belvedere, Wien, Inv.-Nr. 1776[58]

22. Ein Hipochondrist, Blei, H. 42,5 cm, Museum of Fine Arts, Boston, Inv.-Nr. 57 117[59]

23. Ein mürrischer alter Soldat (Kat.-Nr. 7), Zinklegierung, H. 43,5 cm, Bayerisches Nationalmuseum, München, Inv.-Nr. 73/205[60]

24. Ein Heuchler und Verleumder, Blei, H. 37 cm, Privatbesitz[61]

25. Der widerwärtige Geruch, Blei,[62] Maß des Gipsabgusses: H. 47 cm, Österreichische Galerie Belvedere, Wien, Inv.-Nr. 6271(Original verschollen)[63]

26. Der Feldherr (Abb. 65), Blei,[64] Maß des Gipsabgusses: H. 46 cm, Österreichische Galerie Belvedere, Wien, Inv.-Nr. 5697 (Original verschollen)[65]

27. Das schwere Geheimnis (Kat.-Nr. 15), Blei, H. 42 cm, Privatbesitz[66]

28. Das zurückgehaltene Lachen, Blei, verschollen[67]

29. Ein Gelehrter, Dichter (Abb. 49, 53), Blei, Maß des Gipsabgusses: H. 45 cm, Österreichische Galerie Belvedere, Wien, Inv.-Nr. 5686 (ehemals Staatliche Museen zu Berlin, Skulpturensammlung und Museum für Byzantinische Kunst, Eigentum des Kaiser-Friedrich-Museums-Vereins, verschollen)[68]

30. Der Trozige, Blei, verschollen[69]

10. A Hanged Man (fig. 80), alabaster, h. 38 cm, Österreichische Galerie Belvedere, Vienna, Inv. no. 5637[24]

11. The Reliable Man, alabaster, h. 39 cm, Österreichische Galerie Belvedere, Vienna, Inv. no. 5636[25]

12. Just Rescued from Drowning, alabaster, h. 40 cm, private collection[26]

13. The Artist's Serious Countenance (fig. 33), alabaster, h. 39 cm, Österreichische Galerie Belvedere, Vienna, Inv. no. 2283[27]

14. A Mischievous Wag (fig. 62), alabaster, h. 34 cm, Österreichische Galerie Belvedere, Vienna, Inv. no. 5639[28]

15. An Intentional Wag (fig. 34, 63), alabaster, h. 42 cm, Österreichische Galerie Belvedere, Vienna, Inv. no. 2284[29]

16. A Strong Worker, alabaster, h. 42 cm, Österreichische Galerie Belvedere, Vienna, Inv. no. 2285[30]

17. Bust of A Bearded Old Man (cat. no. 5), alabaster, h. 42 cm, Liebieghaus Skulpturensammlung, Frankfurt am Main, Inv. no. 2600[31]

18. An unnamed Character Head, limestone, Magyar Nemzeti Galéria, Budapest, Inv. no. 2002.2 M[32]

Metal

1. The Artist As He Imagined Himself Laughing (cat. no. 4), tin with small quantities of copper and iron; with traces of zinc, arsenic and lead, h. 43 cm, private collection[33]

2. A Know-It-All Quibbling Quipster, lead,[34] height of plaster cast: 44 cm, Österreichische Galerie Belvedere, Vienna, Inv. no. 5700, (whereabouts of original unknown)[35]

3. The Yawner (cat. no. 12), pewter, h. 41 cm, Szépmüvészeti Múzeum, Budapest, Inv. no. 53.655[36]

4. A Strong Man (cat. no. 16), lead, h. 44 cm, private collection[37]

5. Quite Peaceful Sleep (cat. no. 9), pewter, h. 44 cm, Szépmüvészeti Múzeum, Budapest, Inv. no. 53.656[38]

6. The Troubled Man, pewter, h. 45 cm, Österreichische Galerie Belvedere, Vienna, Inv. no. 3198[39]

7. The Sneezer (fig. 66), lead;[40] height of plaster cast: 42 cm, Österreichische Galerie Belvedere, Vienna, Inv. no. 5683 (whereabouts of original unknown)[41]

8. The Melancholic (cat. no. 8), lead, h. 44.5 cm, private collection[42]

9. Childish Weeping (cat. no. 19), tin-lead alloy, h. 45 cm, Szépmüvészeti Múzeum, Budapest, Inv. no. 51.936[43]

10. The Ill-Humored Man (fig. 59,60), lead, h. 38.7 cm, Musée du Louvre, Paris, Inv. no. RF 4724[44]

11. A Grievously Wounded Man (cat. no. 6), lead,[45] height of plaster cast: h. 44 cm, Österreichische Galerie Belvedere, Vienna, Inv. no. 5695 (whereabouts of original unknown)[46]

12. The Enraged and Vengeful Gypsy, lead;[47] height of plaster cast: h. 45 cm, Österreichische Galerie Belvedere, Vienna, Inv. no. 5694 (whereabouts of original unknown)[48]

13. The Noble-Minded Man (cat. no. 18), lead-tin alloy, h. 43.5 cm, Österreichische Galerie Belvedere, Vienna, Inv. no. 2612[49]

14. The Strong Odor, lead-tin alloy, h. 48 cm, private collection[50]

31. Innerlich verschlossener Gram (Kat.-Nr. 14), Blei, H. 38,3 cm, Landesmuseum Württemberg, Stuttgart, Inv.-Nr. WLM 1926/15[70]

32. Der heftigste Geruch, Blei, verschollen[71]

33. Variante zu »Der Gähner«, Blei (?), verschollen[72]

34. Variante zu »Der Edelmüthige«, Blei-Zinn-Legierung, H. 45 cm, Österreichische Galerie Belvedere, Wien, Inv.-Nr. 2613[73]

35. Variante zu »Der starke Geruch«, Blei, H. 48,9 cm, Victoria and Albert Museum, London, Inv.-Nr. A 16-1948[74]

36. Variante zu »Der weinerliche Alte« (Kat.-Nr. 11), Zinn, H. 33 cm, Landesmuseum Württemberg, Stuttgart, Inv.-Nr. WLM 1925/66[75]

37. Variante zu »Die Einfalt im höchsten Grade«, Zinn, H. 42 cm, Gorizia (Görz), Italien, Privatbesitz[76]

38. Variante zu »Der heftigste Geruch«, Zinn, H. 42 cm, Gorizia (Görz), Italien, Privatbesitz[77]

Holz

1. Ein alter frölicher Lächler (Abb. 36), Holz (Linde), H. 36 cm, Österreichische Galerie Belvedere, Wien, Inv.-Nr. 2286[78]

Bekannt sind heute 17 Alabasterköpfe, ein unbenannter Kopf aus Kalkstein und ein weiterer aus Holz sowie 36 oder 38 metallene Köpfe, somit insgesamt 55 Werke. Wenn sich die Zuschreibung der beiden Büsten in einer Privatsammlung in Görz halten lässt, wächst die Anzahl auf 57.[79]

Im Februar 1776 erwähnt Messerschmidt in einem Brief »sechs Metallene Köpf-Stückhe«.[80] Aller Wahrscheinlichkeit nach nahm der Bildhauer fünf »Köpf-Stückhe« von Wien mit nach München. Die Empfangsbestätigung eines Transportes von Wien nach München (8. Mai 1775) führt nur summarisch auf: »Metalen arbeith und Bildhauer Werkzeug gewogen 500 tt«.[81] Vier Köpfe schuf er in München.[82] Im August 1777 heißt es in einer Bestätigung über einen beim Zollamt Wien bezahlten Zoll: »300 tt gearb. zin« sowie »50 tt gegoß. Bleu«.[83] Bei den bearbeiteten Zinnstücken und den gegossenen Bleiarbeiten handelte es sich möglicherweise um jene Köpfe, von denen er Anfang 1777 schrieb: » [...] wenn etwann Jemand an meiner Geschiklichkeit zweifelte und meynete, ich besitze die nemliche nicht mehr, so sind jetzt wirklich 12 Köepfe von mir verfertiget zu sehen. diese können für mich reden und diesen Zweifel auf die Seite räumen«[84] › so Messerschmidt in einem Briefentwurf an seinen Bruder.

Als Nicolai den Bildhauer 1781 besucht, hat sich die Anzahl der Köpfe vervielfacht: Er nennt vier »simpeln der Natur gemäße Köpfe«, 54 konvulsivische und zwei Schnabelköpfe. Er überliefert, dass der Bildhauer am 61. Kopf arbeitete. Wenige Tage nach Messerschmidts Tod ist am 27. August 1783 in einer »Specification deren Meßerschmidischen Mobilien« von 16 alabasternen und 34 metallenen Köpfen, mithin insgesamt 50, die Rede.[85] Bei acht kleineren, alabasternen Köpfen, die die Specification gleichfalls nennt, könnte es sich sowohl um kleinformatige Charakterköpfe als auch um Por-

15. The Weepy Old Man (fig. 56), lead;[51] height of plaster cast: h. 32 cm, Österreichische Galerie Belvedere, Vienna, Inv. no. 5674 (whereabouts of original unknown)[52]

16. The Satirist (cat. no. 20), lead, h. 44 cm, Germanisches Nationalmuseum, Nuremberg, Inv. no. Pl. O. 2540[53]

17. The Incapable Bassoonist, pewter, h. 44 cm, private collection[54]

18. Afflicted with Constipation (cat. no. 13), lead, h. 30.2 cm, Germanisches Nationalmuseum, Nuremberg, Inv. no. Pl. O. 2539[55]

19. Sneeze-Inducing Odor, lead-tin alloy, h. 48 cm, private collection[56]

20. An Arch-Rascal (cat. no. 10), tin-lead alloy, h. 38.5 cm, Österreichische Galerie Belvedere, Vienna, Inv. no. 2442[57]

21. A Dismal and Sinister Man (cat. no. 21), lead-tin alloy, h. 43.5 cm, Österreichische Galerie Belvedere, Vienna, Inv. no. 1776[58]

22. A Hypochondriac, lead, h. 42.5 cm, Museum of Fine Arts, Boston, Inv. no. 57 117[59]

23. A Surly Old Soldier (cat. no. 7), zinc alloy, h. 43.5 cm, Bayerisches Nationalmuseum, Munich, Inv. no. 73/205[60]

24. A Hypocrite and Slanderer, lead, h. 37 cm, private collection[61]

25. Revolting Odor, lead,[62] height of plaster cast: 47 cm, Österreichische Galerie Belvedere, Vienna, Inv. no. 6271 (whereabouts of original unknown)[63]

26. The General (fig. 65), lead;[64] height of plaster cast: 46 cm, Österreichische Galerie Belvedere, Vienna, Inv. no. 5697 (whereabouts of original unknown)[65]

27. The Difficult Secret (cat. no. 15), lead, h. 42 cm, private collection[66]

28. The Laughter Kept Back, lead, whereabouts unknown[67]

29. A Scholar, Poet (fig. 49, 53), lead; height of plaster cast: 45 cm, Österreichische Galerie Belvedere, Vienna, Inv. no. 5686 (formerly Staatliche Museen zu Berlin, Skulpturensammlung und Museum für Byzantinische Kunst, property of Kaiser-Friedrich-Museums-Vereins, whereabouts unknown)[68]

30. The Defiant Man, lead, whereabouts unknown[69]

31. Grief Locked Up Inside (cat. no. 14), lead, h. 38.3 cm, Landesmuseum Württemberg, Stuttgart, Inv. no. WLM 1926/15[70]

32. The Most Pungent Odor, lead, whereabouts unknown[71]

33. Variant "The Yawner", lead (?), whereabouts unknown[72]

34. Variant of "The Noble-Minded Man", lead-tin alloy, h. 45 cm, Österreichische Galerie Belvedere, Vienna, Inv. no. 2613[73]

35. Variant of "The Strong Odor", lead, h. 48.9 cm, Victoria and Albert Museum, London, Inv. no. A 16-1948[74]

36. Variant of "The Weepy Old Man" (cat. no. 11), pewter, h. 33 cm, Landesmuseum Württemberg, Stuttgart, Inv. no. WLM 1925/66[75]

37. Variant of "The Ultimate Simpleton", pewter, h. 42 cm, Gorizia, Italy, private collection[76]

38. Variant of "The Most Pungent Odor", pewter, h. 42 cm, Gorizia, Italy, private collection[77]

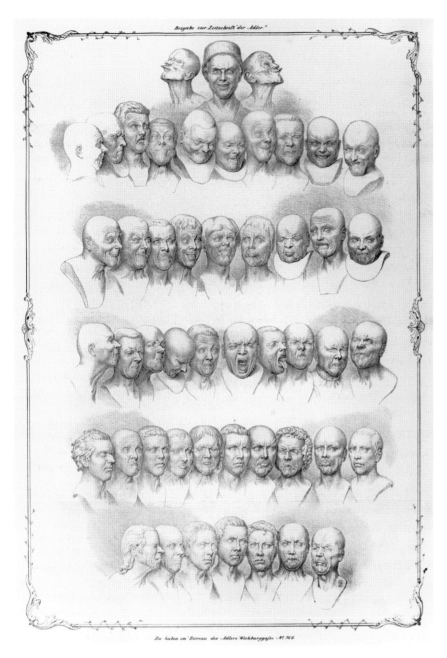

37 Mathias Rudolph Toma, Messerschmidts Charakterköpfe, in: »Der Adler«, Bd. 2, 1839 (Beilage), Lithographie, Österreichische Nationalbibliothek, Wien, Inv.-Nr. WH 1680E

Mathias Rudolph Toma, Messerschmidt's Character Heads, in: "Der Adler", Vol. 2, 1839 (supplement), lithograph, Österreichische Nationalbibliothek, Vienna, Inv. no. WH 1680E

Wood

1. An Old Cheerful Smiler (fig. 36), limewood, h. 36 cm, Österreichische Galerie Belvedere, Vienna, Inv. no. 2286[78]

Today seventeen alabaster Heads are known, an unnamed limestone head and another of wood, and 36 or 38 metal heads: a total of 55 works. If the two busts in a private collection in Gorizia, Italy, can be convincingly attributed to Messerschmidt, the number is increased to 57.[79]

In a letter dated February 1776, Messerschmidt mentions "six metal head pieces".[80] The sculptor is highly likely to have taken five "head pieces" with him from Vienna to Munich. The receipt of delivery of a transport from Vienna to Munich (8 May 1775) tersely mentions the following: "Metal work and sculptor's tools weighed 500 tt".[81] Messerschmidt executed four heads in Munich.[82] A receipt dated August 1777 for customs duty paid to the Vienna Customs office mentions the following: "300 tt worked pewter" and "50 tt cast lead".[83] The finished pewter pieces and the cast lead ones may possibly be the heads of which Messerschmidt wrote early in 1777: "[…] if anyone doubts my skill and believes I no longer possess it, now 12 heads really made by me are to be seen. they can speak for me and remove doubt."[84] – thus Messerschmidt in a draft of a letter to his brother.

By the time Nicolai visited the sculptor in 1781, the number of Heads had multiplied: Nicolai mentions four "simple Heads from Nature", 54 Convulsive Heads and two Beaked Heads. Nicolai records that the sculptor was working on the 61st Head. A few days after Messerschmidt's death, an inventory of his chattels dated 27 August 1783 mentions sixteen alabaster and 34 metal heads, that is, a total of 50.[85] Eight smaller alabaster heads, which are also mentioned in the inventory, may be either Character Heads in small formats or portrait medallions or both.[86] Only one of two more large Heads, of which one is of "plaster" and the other of Genovese marble, can be identified today.[87] The estate records of 29 May 1784 tersely mention "69 portraits".[88]

In 1793 an anonymous writer gave 49 Heads the titles used to the present day. These Heads are shown in a lithograph dating from 1839 (fig. 37).[89] Seven

trätmedaillons handeln.[86] Von zwei weiteren großen Köpfen, der eine aus »Güps«, der andere aus Genueser Marmor, lässt sich nur mehr einer identifizieren.[87] In der Verlassenschaftsabhandlung vom 29. Mai 1784 sind »69. Stück Portreen«[88] summarisch aufgelistet.

1793 verleiht ein Anonymus 49 Köpfen die bis heute verwendeten Titel. Diese Köpfe sind im Jahr 1839 auf einer Lithographie (Abb. 37) wiedergegeben.[89] Erhalten haben sich sieben weitere, bei denen es sich in einigen Fällen um die Varianten bekannter Köpfe handelt:[90] »Büste eines bärtigen, alten Mannes« (hier Nr. 17; Kat.-Nr. 5), die Varianten zu »Der Gähner« (hier Nr. 33), zu »Die Einfalt im höchsten Grade« (hier Nr. 37), zu »Der Edelmüthige« (hier Nr. 34), zu »Der starke Geruch« (hier Nr. 35), zu »Der weinerliche Alte« (hier Nr. 36, Kat.-Nr. 11) und zu »Der heftigste Geruch« (hier Nr. 38). Demnach fehlen – Messerschmidts Angabe von 64 für sein System notwendigen Köpfen ernst genommen – sieben bis neun Köpfe, von deren Aussehen sich keine Vorstellung erhalten hat. Eine weitere Erschwernis erfährt die Frage nach der Anzahl der Charakterköpfe dadurch, dass Friedel berichtet, Messerschmidt habe einzelne Köpfe zerschlagen, »die ihm nicht genug Ausdruck zu haben scheinen«.[91]

61 Köpfe bezeugte Nicolai in seinem Reisebericht von 1781. Friedel schreibt ungenauer, Messerschmidt habe »schon über sechzig Stücke zu Stande gebracht«.[92] Davon ausgehend, dass wenige Tage nach dem Tod des Künstlers Ende August 1783 nur noch fünfzig vorhanden waren, wurden allem Anschein nach Köpfe vorher verkauft[93] oder verschenkt, dabei auch möglicherweise signiert wie die Frankfurter Büste (Kat.-Nr. 5) und der unbenannte Budapester Kopf aus Kalkstein (hier Nr. 18). Bei den »69. Stück Portreen«, mehrere Monate nach dem Tod des Künstlers in der Verlassenschaftsabhandlung aufgeführt, hatte es sich aller Wahrscheinlichkeit nach nicht nur um Charakterköpfe, sondern auch um Porträts gehandelt.[94] Somit ist nicht bekannt, wie viele Charakterköpfe Messerschmidt tatsächlich schuf. Ebenso wenig ist bekannt, in welcher Reihenfolge die Köpfe entstanden. Nur für wenige Köpfe, so zum Beispiel für den »Künstler, so wie er sich lachend vorgestellt hat« (Kat.-Nr. 4), gibt es vage Anhaltspunkte für den Entstehungszeitraum.

more Heads have survived, of which some are variants of known Heads:[90] "Bust of A Bearded Old Man" (here no. 17; cat. no. 5); the variants of "The Yawner" (here no. 33), "The Ultimate Simpleton" (here no. 37), "The Noble-Minded Man" (here no. 34), "Strong Odor" (here no. 35), "The Weepy Old Man" (here no. 36, cat. no. 11) and "The Most Pungent Odor" (here no. 38). If these are taken into consideration and Messerschmidt's mention of 64 Heads needed for his system is taken seriously, seven to nine Heads are missing and no idea of their appearance has come down to us. Another difficulty in ascertaining the real number of Character Heads is that Friedel reports that Messerschmidt smashed several Heads, "which did not seem to him to have enough expression".[91]

In his 1781 account of his travels, Nicolai attests to 61 heads. Friedel writes less precisely that Messerschmidt "had already produced more than 60".[92] If one assumes that only a few days after the artist's death in late August 1783, only 50 Heads existed, this would seem to indicate that Heads had previously been sold[93] or given as presents, possibly also signed like the Frankfurt bust (cat. no. 5) and the unnamed Budapest limestone Head (here no. 18). The "69 portraits" mentioned in the estate transactions several months after the artist's death are highly likely to have included portraits as well as Character Heads.[94] However that may be, it is not known precisely how many Character Heads Messerschmidt actually produced. Nor is the chronological order of production known. Only for a handful of Heads, such as "The Artist As He Has Imagined Himself Laughing" (cat. no. 4) are there any, albeit vague, indications for when they were actually made.

1 Merkwürdige Lebensgeschichte des Franz Xaver Messerschmidt, k. k. öffentlichen Lehrer der Bildhauerkunst, hg. von dem Verfasser der freimüthigen Briefe über Böhmens und Oestreichs Schaafzucht, Wien 1794. Die erste Auflage erschien 1793; hier wird nach der 1794 erfolgten Auflage zitiert.

2 Anonymus 1794, S. 70.

3 Nur wenige Forscher beziehen sich vor allem auf die ebenfalls vom Anonymus vergebenen Nummern, um dieser Gefahr zu entgehen. So Gampp 1998, Schmid 2004, zuletzt Pfarr 2006. In diesem Katalog wird auf die

1 Merkwürdige Lebensgeschichte des Franz Xaver Messerschmidt, k. k. öffentlichen Lehrer der Bildhauerkunst, ed. by the author of the forthright letter on sheep husbandry in Bohemia and Austria, Vienna 1794. The first edition was published in 1793; here the 1794 edition is quoted.

2 Anon. 1794, p. 70.

3 In order to avoid this pitfall, only a few scholars refer to the numbers especially given by Anon. Thus Gampp 1998, Schmid 2004, most recently Pfarr 2006. In the present catalogue the numbering used by Anon. is referred to in the essay by Ulrich Pfarr, in the references cited in the

Nummerierung des Anonymus verwiesen im Essay von Ulrich Pfarr, in den Literaturangaben zu den einzelnen Katalogbeiträgen sowie im vorliegenden Aufsatz. Eine eigene Nummerierung führen Behr / Grohmann / Hagedorn 1983 ein.

4 Zu den Namen und der Nummerierung der Köpfe siehe auch Zoege von Manteuffel 1984, S. 452. Siehe Pfarr 2006, S. 102–118, 434–437, zu den Namen und den gelegentlichen Verwechslungen von Köpfen.

5 Nicolai Reprint 1994, S. 414.

6 Nicolai Reprint 1994, S. 414.

7 Dazu siehe auch »Der Künstler, so wie er sich lachend vorgestellt hat« (Kat.-Nr. 4).

8 Abb. siehe Krapf, Katalog 2002, S. 191.

9 Dazu auch Pfarr 2006, S. 394–398.

10 Anonymus 1794, S. 23; Pötzl-Malíková 1982, S. 241.

11 Pötzl-Malíková 1982, S. 241.

12 So bereits Pötzl-Malíková 1982, S. 241. Alabaster war in Wien allerdings ebenfalls gebräuchliches Bildhauermaterial, insbesondere bei Jakob Christoph Schletterer (siehe Ausst.-Kat. Donner 1993, Kat.-Nr. 104, 107) und Johann Georg Dorfmeister (ebd., Kat.-Nr. 138–141).

13 So Behr / Grohmann / Hagedorn 1983, S. 58.

14 In Preßburg gab es hervorragende Gießereien, zu denen Messerschmidt offenbar gute Beziehungen unterhielt, war doch Johann August Christelly, »k. k. Stück gießer«, sein Testamentsvollstrecker, so Pötzl-Malíková 1982, S. 140–141. Blei beziehungsweise Blei-Zinn-Legierungen waren ein im Wien des 18. Jahrhunderts spätestens seit Georg Raphael Donner überaus beliebtes Material.

15 Die Reihenfolge der Aufzählung folgt der des Anonymus 1793, jedoch hier untergliedert nach den verschiedenen Materialien. Zu »Ein wollüstig abgehärmter Geck« siehe Pötzl-Malíková 1982, S. 244; Anonymus 1794, Nro. 2.

16 Nach Pötzl-Malíková 1982, S. 245. Der Anonymus (1794, Nro. 4) nennt den ersten und zweiten Schnabelkopf »zwei überaus merkwürdige Büsten«.

17 Nach Krapf, Katalog 2002, S. 182; Anonymus 1794, Nro. 6.

18 Nach Krapf, Katalog 2002, S. 188; Anonymus 1794, Nro. 9.

19 Nach Krapf, Katalog 2002, S. 192; Anonymus 1794, Nro. 11.

20 Nach Pötzl-Malíková 1982, S. 249; Anonymus 1794, Nro. 13.

21 Nach Krapf, Katalog 2002, S. 198; Anonymus 1794, Nro. 15.

22 Nach Krapf, Katalog 2002, S. 202; Anonymus 1794, Nro. 17.

23 Nach Pötzl-Malíková 1982, S. 252; Anonymus 1794, Nro. 21.

24 Nach Krapf, Katalog 2002, S. 224; Anonymus 1794, Nro. 25.

25 Nach Krapf, Katalog 2002, S. 228; Anonymus 1794, Nro. 27.

26 Sotheby's London: European Sculpture & Works of Art, 8. Juli 2005, lot 81 (S. 94–101); Anonymus 1794, Nro. 29.

27 Nach Krapf, Katalog 2002, S. 238; Anonymus 1794, Nro. 32.

28 Nach Krapf, Katalog 2002, S. 244; Anonymus 1794, Nro. 35.

29 Nach Krapf, Katalog 2002, S. 248; Anonymus 1794, Nro. 37.

30 Nach Krapf, Katalog 2002, S. 254; Anonymus 1794, Nro. 40.

31 Nach Bückling 1989, S. 328–330.

32 Nach Pötzl-Malíková 2003, S. 260.

33 Nach Pötzl-Malíková 1982, S. 243–244; Anonymus 1794, Nro. 1. Die Angaben zum Material nach einer Analyse, die freundlicherweise aus Privatbesitz zur Verfügung gestellt wurde.

34 Nach Pötzl-Malíková 1982, S. 244.

35 Nach Krapf, Katalog 2002, S. 176; Anonymus 1794, Nro. 3.

36 Nach Krapf, Katalog 2002, S. 178–180; Anonymus 1794, Nro. 5.

37 Nach Krapf, Katalog 2002, S. 184; Anonymus 1794, Nro. 7.

38 Nach Krapf, Katalog 2002, S. 186; Anonymus 1794, Nro. 8.

39 Nach Krapf, Katalog 2002, S. 190; Anonymus 1794, Nro. 10.

individual annotated catalogue entries and in the present essay. Behr / Grohmann / Hagedorn 1983 introduced their own numbering.

4 On the names and numbering of the Heads, also see Zoege von Manteuffel 1984, p. 452. See Pfarr 2006, pp. 102–118, pp. 434ff. on the names and the occasional confusion of Heads with others.

5 Nicolai Reprint 1994, p. 414.

6 Loc. cit.

7 See also "The Artist As He Imagined Himself Laughing" (cat. no. 4).

8 For a picture see Krapf, Katalog 2002, p. 191.

9 See also Pfarr 2006, pp. 394ff.

10 Anon. 1794, p. 23; Pötzl-Malíková 1982, p. 241.

11 Pötzl-Malíková 1982, p. 241.

12 Thus already Pötzl-Malíková 1982, p. 241. Alabaster was, however, also a material commonly used by sculptors in Vienna, especially by Jakob Christoph Schletterer (see exhib. cat. Donner 1993, cat. nos. 104, 107) and Johann Georg Dorfmeister (ibid., cat. no. 138–141).

13 Behr / Grohmann / Hagedorn 1983, p. 58.

14 In Bratislava there were excellent foundries, with which Messerschmidt evidently maintained good relations; after all Johann August Christelly, "Royal and Imperial Founder", was the executor of his will: thus Pötzl-Malíková 1982, pp. 140f. Lead and lead-tin alloys had been a very popular material in 18th-century Vienna since Georg Raphael Donner at the latest.

15 The order follows Anon. 1793 although here it is subdivided by material. On "A Lecherous and Careworn Fop" see Pötzl-Malíková 1982, p. 244; Anon. 1794, no. 2.

16 After Pötzl-Malíková 1982, p. 245. Anon. (1794, no. 4) calls the first and second Beaked Heads "two very peculiar busts".

17 Krapf, Katalog der ausgestellten Werke 2002, p. 182; Anon. 1794, no. 6.

18 Krapf, op. cit., p. 188; Anon. 1794, no. 9.

19 Krapf, op. cit., p. 192; Anon. 1794, no. 11.

20 Pötzl-Malíková 1982, p. 249. Anon. 1794, no. 13.

21 Krapf, op. cit., p. 198; Anon. 1794, no. 15.

22 Krapf, op. cit., p. 202; Anon. 1794, no. 17.

23 Pötzl-Malíková 1982, p. 252; Anon. 1794, no. 21.

24 Krapf, op. cit., p. 224; Anon. 1794, no. 25.

25 Krapf, op. cit., p. 228; Anon. 1794, no. 27.

26 Sotheby's London: European Sculpture & Works of Art, 8 July 2005, lot 81 (pp. 94–101); Anon. 1794, no. 29.

27 Krapf, op. cit., p. 238; Anon. 1794, no. 32.

28 Krapf, op. cit., p. 244; Anon. 1794, no. 35.

29 Krapf, op. cit., p. 248; Anon. 1794, no. 37.

30 Krapf, op. cit., p. 254; Anon. 1794, no. 40.

31 Bückling 1989, pp. 328ff.

32 Pötzl-Malíková 2003, p. 260.

33 Pötzl-Malíková 1982, pp. 243f.; Anon. 1794, no. 1. The data on the materials are the findings from an analysis which was kindly placed at my disposal by a private collection.

34 Pötzl-Malíková 1982, p. 244.

40 Nach Pötzl-Malíková 1982, S. 248–249.

41 Nach Krapf, Katalog 2002, S. 194; Anonymus 1794, Nro. 12.

42 Nach Krapf, Katalog 2002, S. 196; Anonymus 1794, Nro. 14.

43 Nach Krapf, Katalog 2002, S. 200; Anonymus 1794, Nro. 16.

44 Nach Scherf 2005, S. 15–16; Anonymus 1794, Nro. 18.

45 Nach Pötzl-Malíková 1982, S. 251.

46 Nach Krapf, Katalog 2002, S. 206; Anonymus 1794, Nro. 19.

47 Nach Pötzl-Malíková 1982, S. 251–252.

48 Nach Krapf, Katalog 2002, S. 208; Anonymus 1794, Nro. 20.

49 Nach Krapf, Katalog 2002, S. 212; Anonymus 1794, Nro. 22.

50 Nach Krapf, Katalog 2002, S. 216; Anonymus 1794, Nro. 23.

51 Nach Pötzl-Malíková 1982, S. 253–254.

52 Nach Krapf, Katalog 2002, S. 220; Anonymus 1794, Nro. 24.

53 Nach Maué 2005, S. 254–260; Anonymus 1794, Nro. 26.

54 Nach Krapf, Katalog 2002, S. 230; Anonymus 1794, Nro. 28.

55 Nach Maué 2005, S. 254–260; Anonymus 1794, Nro. 30.

56 Nach Krapf, Katalog 2002, S. 236; Anonymus 1794, Nro. 31.

57 Nach Krapf, Katalog 2002, S. 240; Anonymus 1794, Nro. 33.

58 Nach Krapf, Katalog 2002, S. 242; Anonymus 1794, Nro. 34.

59 Nach Krapf, Katalog 2002, S. 246; Anonymus 1794, Nro. 36.

60 Nach Krapf, Katalog 2002, S. 250; Anonymus 1794, Nro. 38.

61 Nach Krapf, Katalog 2002, S. 252; Anonymus 1794, Nro. 39.

62 Nach Pötz-Malíková 1982, S. 261.

63 Nach Krapf, Katalog 2002, S. 256; Anonymus 1794, Nro. 41.

64 Nach Pötzl-Malíková 1982, S. 261–262.

65 Nach Krapf, Katalog 2002, S. 258; Anonymus 1794, Nro. 42.

66 Nach Krapf, Katalog 2002, S. 260; Anonymus 1794, Nro. 43.

67 Nach Pötzl-Malíková 1982, S. 262; Anonymus 1794, Nro. 44.

68 Nach Krapf, Katalog 2002, S. 262; Anonymus 1794, Nro. 45.

69 Nach Pötzl-Malíková 1982, S. 263; Anonymus 1794, Nro. 46.

70 Nach Krapf, Katalog 2002, S. 264; Anonymus 1794, Nro. 47.

71 Nach Pötzl-Malíková 1982, S. 264; Anonymus 1794, Nro. 49.

72 Nach Pötzl-Malíková 1982, S. 264.

73 Nach Krapf, Katalog 2002, S. 214.

74 Nach Krapf, Katalog 2002, S. 218.

75 Nach Krapf, Katalog 2002, S. 222.

76 Nach Pötzl-Malíková 1982, S. 265.

77 Nach Pötzl-Malíková 1982, S. 266.

78 Nach Krapf, Katalog 2002, S. 266; Anonymus 1794, Nro. 48.

79 Pfarr (2006, S. 346–347) äußert Zweifel an der Eigenhändigkeit dieser beiden Werke.

80 Zitiert nach Pötzl-Malíková 1982, S. 133.

81 Zitiert nach Pötzl-Malíková 1982, S. 133.

82 So Meusel 1778, S. 88–89.

83 Zitiert nach Pötzl-Malíková 1982, S. 137.

84 Zitiert nach Pötzl-Malíková 1982, S. 134.

85 Dazu siehe Pötzl-Malíková 1996, S. 220.

86 Zu den kleineren alabasternen Köpfen werden die beiden »Heraklit« und »Demokrit« genannten Köpfe (siehe Kat.-Nr. 22, 23) zählen. Nicht zu den kleineren Werken Messerschmidts dagegen gehören zwei Bleibüsten im Germanischen Nationalmuseum, Nürnberg, »Büste eines Mädchens« (Pl. O. 2805) und »Büste eines Jünglings« (Pl. O. 2804), dazu siehe Maué 2005, S. 251–254, und Pötzl-Malíková 2003, S. 259–260. Diese sind eher Karl Georg Merville zuzuschreiben.

87 Dazu Pötzl-Malíková 1996, S. 220. Bei dem Kopf aus Genueser Marmor handelt es sich Pötzl-Malíková zufolge (ebd., S. 217) um das verschollene Bildnis der Gräfin Barbara Batthyani. Dazu Pötzl-Malíková 1982, S. 240.

35 Krapf, op. cit., p. 176; Anon. 1794, no. 3.

36 Krapf, op. cit., p. 178ff.; Anon. 1794, no. 5.

37 Krapf, op. cit., p. 184; Anon. 1794, no. 7.

38 Krapf, op. cit., p. 186; Anon. 1794, no. 8.

39 Krapf, op. cit., p. 190; Anon. 1794, no. 10.

40 Pötzl-Malíková 1982, pp. 248f.

41 Krapf, op. cit., p. 194; Anon. 1794, no. 12.

42 Krapf, op. cit., p. 196; Anon. 1794, no. 14.

43 Krapf, op. cit., p. 200; Anon. 1794, no. 16.

44 Scherf 2005, pp. 15f.; Anon. 1794, no. 18.

45 Pötzl-Malíková 1982, p. 251.

46 Krapf, op. cit., p. 206; Anon. 1794, no. 19.

47 Pötzl-Malíková 1982, pp. 251f.

48 Krapf, op. cit., p. 208; Anon. 1794, no. 20.

49 Krapf, op. cit., p. 212; Anon. 1794, no. 22.

50 Krapf, op. cit., p. 216; Anon. 1794, no. 23.

51 Pötzl-Malíková 1982, pp. 253f.

52 Krapf, op. cit., p. 220; Anon. 1794, no. 24.

53 Maué 2005, pp. 254–260; Anon. 1794, no. 26.

54 Krapf, op. cit., p. 230; Anon. 1794, no. 28.

55 Maué 2005, pp. 254–260; Anon. 1794, no. 30.

56 Krapf, op. cit., p. 236; Anon. 1794, no. 31.

57 Krapf, op. cit., p. 240; Anon. 1794, no. 33.

58 Krapf, op. cit., p. 242; Anon. 1794, no. 34.

59 Krapf, op. cit., p. 246; Anon. 1794, no. 36.

60 Krapf, op. cit., p. 250; Anon. 1794, no. 38.

61 Krapf, op. cit., p. 252; Anon. 1794, no. 39.

62 Pötzl-Malíková 1982, p. 261.

63 Krapf, op. cit., p. 256; Anon. 1794, no. 41.

64 Pötzl-Malíková 1982, pp. 261f.

65 Krapf, op. cit., p. 258; Anon. 1794, no. 42.

66 Krapf, op. cit., p. 260; Anon. 1794, no. 4.

67 Pötzl-Malíková 1982, p. 262; Anon. 1794, no. 4.

68 Krapf, op. cit., p. 262; Anon. 1794, no. 45.

69 Pötzl-Malíková 1982, p. 263; Anon. 1794, no. 46.

70 Krapf, op. cit., p. 264; Anon. 1794, no. 47.

71 Pötzl-Malíková 1982, p. 264; Anon. 1794, no. 49.

72 Pötzl-Malíková 1982, p. 264.

73 Krapf, op. cit., p. 214.

74 Krapf, op. cit., p. 218.

75 Krapf, op. cit., p. 222.

76 Pötzl-Malíková 1982, p. 265.

77 Ibid., p. 266.

78 Krapf, op. cit., p. 266; Anon. 1794, no. 48.

79 Pfarr (2006, pp. 346f.) expresses doubts that Messerschmidt was the creator of these two works.

80 Quoted in Pötzl-Malíková 1982, p. 133.

81 Ibid., p. 133.

82 Thus Meusel 1778, pp. 88f.

83 Quoted in Pötzl-Malíková 1982, p. 137.

84 Ibid., p. 134.

85 See Pötzl-Malíková 1996, p. 220.

86 The Heads called "Heraclitus" and "Democritus" (see cat. nos. 22, 23) were probably among the smaller alabaster Heads. However, the two lead busts in the Germanisches Nationalmuseum, Nuremberg, "Bust of a Girl" (Pl. O. 2805) and "Bust of a Youth" (Pl. O. 2804) do not belong

88 Aus der Verlassenschaftsabhandlung vom 29. Mai 1784 zitiert nach Pötzl-Malíková 1982, S. 142.

89 Sie blieben bis 1889 als Serie erhalten, dazu Pötzl-Malíková 1982, S. 242.

90 Weder die Variante zu »Der Edelmüthige« noch zu »Der Gähner«, »Die Einfalt im höchsten Grade«, »Der starke Geruch«, »Der weinerliche Alte«, »Der heftigste Geruch« noch die »Büste eines bärtigen, alten Mannes« werden vom Anonymus 1794 oder in der Lithographie von 1839 wiedergegeben.

91 Friedel 1785, S. 398.

92 Friedel 1785, S. 398.

93 So auch Pfarr 2006, S. 385.

94 So auch Pfarr 2003a, S. 11. Zur weiteren Geschichte der Charakterköpfe siehe Pötzl-Malíková 1982, S. 242.

to Messerschmidt's œuvre; see Maué 2005, pp. 251–254, and Pötzl-Malíková 2003, pp. 259f. They would be more convincingly attributed to Karl Georg Merville.

87 Pötzl-Malíková 1996, p. 220. The head of Genovese marble is, according to Pötzl-Malíková (ibid., p. 217), the lost portrait of Barbara, Countess Batthyani; Pötzl-Malíková 1982, p. 240.

88 Estate records proceedings of 29 May 1784 quoted in Pötzl-Malíková 1982, p. 142.

89 They remained as a series until 1889; Pötzl-Malíková 1982, p. 242.

90 The following are not mentioned in Anon. 1794 and are not shown in the 1839 lithograph: the variants of "The Noble-Minded Man" and of "The Yawner", "The Ultimate Simpleton", "Strong Odor", "The Weepy Old Man", "The Most Pungent Odor" and the "Bust of A Bearded Old Man".

91 Friedel 1785, p. 398.

92 Ibid., p. 398.

93 Thus also Pfarr 2006, p. 385.

94 Thus also Pfarr 2003a, p. 11. On the further history of the Character Heads, see Pötzl-Malíková 1982, p. 242.

Heike Höcherl

»Wahngebilde und Kunstwerke zugleich«[1]

Deutungen der Charakterköpfe

Franz Xaver Messerschmidt besitzt insofern Aktualität, als sich an ihm noch immer die Geister scheiden. Die Forschung wird von zwei Fragestellungen beherrscht: Wie ist die Serie der Charakterköpfe, die als sein Hauptwerk gilt, zu interpretieren? Lassen sich in ihrer Gestaltung Anzeichen für eine mögliche Geisteskrankheit Messerschmidts erkennen? Einigkeit herrscht hingegen in der Einschätzung, dass Messerschmidt als einer der bedeutendsten Bildhauer des ausgehenden 18. Jahrhunderts anzusehen ist.[2] Aber selbst das war nicht immer so, wie insbesondere die erstaunliche Geschichte der Charakterköpfe belegt.

Zwischen Kunst- und Wachsfigurenkabinett

Nach Messerschmidts Tod im Jahre 1783 gelangten die Charakterköpfe, die zu Lebzeiten des Künstlers viel Aufsehen erregten, aber nicht veräußert wurden, in den Besitz seines Bruders. Dessen Tochter soll sie en bloc – um, wie es heißt, »Gerümpel zu entsorgen«[3] – an einen Koch des Wiener Bürgerspitals verkauft haben. Dieser organisierte 1793 in den Räumen des Spitals eine Verkaufsausstellung, zu deren Anlass ein Katalog erschien. Er enthält vor allem eine unzuverlässige Ansammlung von Anekdoten, auf ihn gehen aber auch die noch heute gebräuchlichen Benennungen der 49 damals ausgestellten Köpfe zurück.[4] Von Messerschmidt selbst sind

"At Once Configurations of Madness and Works of Art"[1]

Interpretations of the Character Heads

Franz Xaver Messerschmidt is relevant, if for no other reason than that he is still controversial. Messerschmidt research is dominated by two questions: how is the sequence of Character Heads that is regarded as his masterpiece to be interpreted? Are there any discernible signs in their conception that might indicate Messerschmidt may have been mentally ill? Scholars are, on the other hand, unanimously agreed that Messerschmidt must be regarded as one of the most important sculptors of the late 18th century.[2] However, even that was not always the case as the astonishing history of the Character Heads shows.

Between art and waxworks

After Messerschmidt's death in 1783, the Character Heads, which had caused so much commotion during the artist's lifetime but had nonetheless not been sold, came into the possession of his brother, whose daughter in turn is said to have sold them *en bloc* – in order, as the story went, "to clear out old rubbish"[3] – to a cook at the Vienna Bürgerspital. In 1793 the cook organised a sale in the Spital rooms, for which a catalogue was issued. The catalogue mainly contains an unreliable collection of anecdotes. Further, the names still in use for the 49 Heads exhibited at that time, derive from that catalogue.[4] From Messerschmidt himself, only oral statements have been handed down,[5] without, however, any work titles or numbering which might give some indication of chronology or a system inherent in the sequence, for which the artist preferred the term "Head pieces".[6]

On 6 and 11 October 1793 announcements were made in the "Wiener Zeitung" drawing attention to the exhibition and praising the busts as unique, rare masterpieces which embodied the "manifold human

nur mündliche Äußerungen überliefert,[5] jedoch keine Werktitel oder eine Nummerierung, die Aufschluss geben könnte über die zeitliche Folge oder eine mögliche Systematik der Serie, für die er die Bezeichnung »Köpf-Stückhe« bevorzugte.[6]

Am 6. und 11. Oktober 1793 wurden in der Wiener Zeitung Ankündigungen veröffentlicht, die auf die Ausstellung aufmerksam machten und in denen die Büsten als einzigartige und seltene Meisterstücke angepriesen wurden, welche die »mannigfaltigen menschlichen Leidenschaften« im Gesicht der Menschen verkörperten. »Kenner der Gesichtsbildung« wurden aufgefordert, »ihre begründeten Bemerkungen« an den Eigentümer der Sammlung zu senden, um »die dargestellten Leidenschaften noch vollständiger [zu] erhellen und auf[zu]klären«.[7] Einhergehend mit einer Folge von Besitzerwechseln sank die Serie der Charakterköpfe im Laufe des 19. Jahrhunderts mehr und mehr zu einer Jahrmarktattraktion herab, die dazu diente, ein Vergnügen suchendes Publikum zu unterhalten. Wachskopien und Gipsabgüsse wurden angefertigt, teilweise polychrom gefasst und mit realen Kleidern versehen,[8] um vordergründig die Suggestivkraft zu erhöhen, die Expressivität der Köpfe jedoch ins Kuriose kippen zu lassen. Mehrfach wurden die Köpfe auf dem

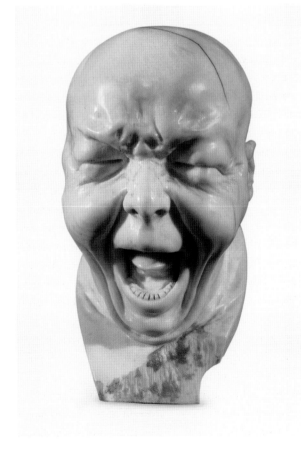

38 Nach Franz Xaver Messerschmidt, Der Gähnende, 1. Hälfte 19. Jahrhundert, Elfenbein, Privatbesitz
After Franz Xaver Messerschmidt, The Yawner, 1st half 19th century, ivory, private collection

passions" in the human face. "Those with a knowledge of physiognomy" were requested to send "their well-founded observations" to the owner of the collection in order "to elucidate and clarify more completely the passions represented".[7] Concomitantly with a series of changes in owners, the sequence of Character Heads became increasingly degraded in the course of the 19th century to a fun-fair attraction shown for the purpose of amusing a pleasure-seeking public. Wax copies and plaster casts were made, some of them polychromed and dressed in real clothes.[8] The purpose was to enhance superficially the suggestiveness of the Heads but these additions allowed their expressive quality to tilt towards the peculiar. The Heads were displayed several times on the Prater on stalls and at inns. They were presented together with peep-show pictures and a "mechanical trumpet player" in what was known as a "Kunstkabinett" and arranged in scenic tableaux in a waxworks cabinet.[9] Collectors had replicas made – some of them considerably scaled down – in ivory (fig. 38), bronze, plaster or pewter. Attempts made by the various owners to sell the originals to museums or similar institutions failed.[10] In 1889 the sequence was sold at auction by the owner of the time, Joseph Klinkosch, and, as a result, the Heads were scattered to the four winds. Not until the early years of the 20th century did some of the Character Heads find their way into a public collection.[11]

Ernst Kris and the psychoanalytical approach

The history of the reception of the Character Heads conveys the impression they must have led a peculiar life of their own after Messerschmidt's death, which reflects both the lack of comprehension and of interest shown in them by contemporaries and subsequent generations. After a first monograph published in 1885 by Albert Ilg, Messerschmidt's life and work were rediscovered for the 20th century chiefly by Ernst Kris and an essay he published in 1932.[12] Kris, a curator at the Kunsthistorisches Museum in Vienna and also a trained psychoanalyst,[13] seemed just the right person to approach Messerschmidt's disturbing and seemingly contradictory work on the basis of 1930's scientific knowledge.[14] Kris, however, was not

Prater in Buden und Gasthäusern zur Schau gestellt. Man präsentierte sie zusammen mit Guckkastenbildern und einem »mechanischen Trompeter« in einem so genannten Kunstkabinett und zu szenischen Tableaus angeordnet in einem Wachsfigurenkabinett.[9] Sammler ließen Repliken – zum Teil stark verkleinert – in Elfenbein (Abb. 38), Bronze, Gips oder Zinn anfertigen. Bemühungen der Eigentümer, die Originale an museale Einrichtungen zu verkaufen, scheiterten.[10] 1889 wurde die Serie von ihrem damaligen Besitzer Joseph Klinkosch zur Versteigerung gebracht und in der Folge in alle Winde zerstreut. Erst zu Beginn des vorigen Jahrhunderts fanden einige der Charakterköpfe Eingang in eine öffentliche Sammlung.[11]

Ernst Kris und der psychoanalytische Sonderweg

Die Rezeptionsgeschichte der Charakterköpfe vermittelt den Eindruck, als hätten sie nach Messerschmidts Tod ein kurioses Eigenleben geführt, worin sich sowohl das Unverständnis als auch das Desinteresse der Zeitgenossen und folgender Generationen zu spiegeln scheint. Nach einer ersten monographischen Veröffentlichung im Jahre 1885 durch Albert Ilg wird das Leben und Werk Messerschmidts vor allem durch Ernst Kris und dessen 1932 publizierten Aufsatz für das 20. Jahrhundert wieder entdeckt.[12] Kris, Kustode am Kunsthistorischen Museum in Wien und zugleich ausgebildeter Psychoanalytiker,[13] schien die ideale Persönlichkeit zu sein, um sich dem irritierenden und scheinbar widersprüchlichen Werk Messerschmidts auf der Grundlage der wissenschaftlichen Erkenntnisse der 1930er Jahre zu nähern.[14] Kris' Interesse galt jedoch nicht allein dem Werk Messerschmidts und dessen Person, er hatte auch ein grundsätzliches wissenschaftliches Anliegen. Er beabsichtigte, die um die Jahrhundertwende von Sigmund Freud entwickelte Psychoanalyse methodisch innerhalb der Kunstgeschichte zu verankern und verstand seine Untersuchung in der Tradition so genannter Pathographien.[15] Hierbei fungierte Messerschmidt als »Grenzfall«,[16] der die Möglichkeiten des Ansatzes veranschaulichen sollte, unter der Prämisse, dass die gewonnenen Einsichten nicht verallgemeinerbar, also allein für den individuellen Fall des Franz Xaver Messerschmidt Gültigkeit besäßen.[17]

Die »Spezifität der Bedingung«[18] für den Grenzfall Messerschmidt sah Kris in der überaus guten Quellenlage begründet, die über Messerschmidts Leben und Verhalten berichtet und seiner Ansicht nach die Tatsache sicherte, dass Messerschmidt geisteskrank war. Auf dieser Basis unternahm er den Versuch, das Werk nach Anzeichen einer Geisteskrankheit zu untersuchen. Einen Augenzeugen für die Geisteskrankheit Messerschmidts glaubte Kris in Fried-

simply interested in Messerschmidt's work and the artist as a person; he also had a scientific and scholarly concern in the matter. He intended to anchor psychoanalysis, which Sigmund Freud had developed at the turn of the century, methodologically within art history and viewed his study as being in the tradition of what were then termed pathologies.[15] To this end, Messerschmidt functioned as a "borderline case",[16] which would elucidate the possibilities inherent in the approach under the premise that the insight thus gained could not be generalised but would only be applicable to the individual case of Franz Xaver Messerschmidt.[17]

Kris saw the "specificity of the condition"[18] for Messerschmidt's being a borderline case as based on a very good supply of sources, which recorded Messerschmidt's life and behaviour and, in Kris's opinion, verified the fact that Messerschmidt was mentally ill. That was the basis on which Kris attempted to probe Messerschmidt's work for indications of mental illness. Kris believed that he had found a contemporary eyewitness in Friedrich Nicolai, who had visited Messerschmidt in his Bratislava studio and gives an account of that event in the sixth volume of his "Beschreibung einer Reise durch Deutschland und die Schweiz im Jahre 1781".[19]

In analysing the Character Heads, Kris noticed that no unequivocal facial expression could be read in most of them so that the work titles in common use, which go back to the 1793 catalogue, consequently addressed only a small part[20] of the mimetic aspect.[21] Kris speaks of "mimetic constellations",[22] with which he distinguishes the discrepancy revealed in these heads between the upper and lower half of the face. Kris concludes that two contradictory principles of design inform all these heads: a tendency to make faces and to distort the facial features, which subverts the possibility of decoding them, as well as a tendency to characterisation, which means the accentuation of qualities specific to a particular personality.[23] Kris derives Messerschmidt's inclination to characterisation from a basic interest in physiognomy; for the tendency to "make faces", however, Kris is unable to come up with a plausible art-historical explanatory model.[24] In general, Kris points out "an aggressive

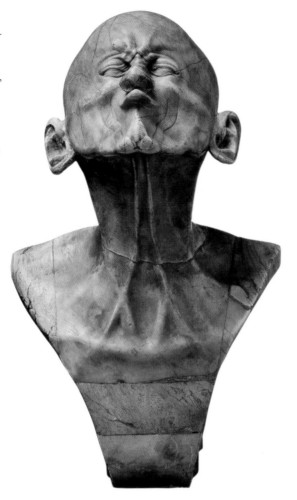

39 Franz Xaver Messer-
schmidt, Zweiter Schna-
belkopf, vor 1781, Ala-
baster, Österreichische
Galerie Belvedere, Wien,
Inv.-Nr. 5640
*Franz Xaver Messer-
schmidt, Second Beaked
Head, before 1781,
alabaster, Österreichische
Galerie Belvedere,
Vienna, Inv. no. 5640*

tendency" common to both making faces and carica-
ture. Even before this observation, Kris had outlined,
as his study proceeded, a number of art-historical
approaches to explanation – all of which have been
taken up again by recent scholarship – only to be
rejected as unspecific.[25]

On the basis of this finding and Nicolai's text –
in which the description of the Spirit of Proportion
assumed pivotal importance – Kris subjected Messer-
schmidt's personality to a posthumous psychoanaly-
sis. It led to the diagnosis that Messerschmidt had
"fallen ill of an acute outbreak of a psychosis […] in
the early [17]60s".[26] Kris recognised symptoms of
paranoid schizophrenia in the conception and design
of the Character Heads.[27] He attached particular sig-
nificance to the motif of the compressed lips, which
occurs in several of the Messerschmidt Heads, and
interpreted it as symptomatic of repressed sexuality.[28]
Taking into consideration both Nicolai's account of
the Spirit of Proportion (especially with the torments
linked with that Spirit) and the design of the Beaked
Heads (fig. 39), Kris believed he had indications for a
projection of latent homosexuality on the part of the
sculptor.[29]

The work of several scholars has pointed out the
importance of Nicolai's account of his visit to the
sculptor in the course of his travels, which even in
more recent research has been regarded as a reliable
source both for Messerschmidt's mental condition
and the genesis of his Character Heads.[30] Very recent-
ly, however, plausible doubts have arisen about
whether Nicolai is to be believed and whether his
descriptions can be relied on. In his doctoral disserta-
tion, published in 2006, Ulrich Pfarr subjects Nicolai
as a source to a thorough, critical text analysis, which
shows clearly that Nicolai definitely did not confront
Messerschmidt without prejudice. On the contrary, it
must be assumed that in his description of the eccen-
tric Messerschmidt, Nicolai, as a man of the Enlight-
enment, also pursued the intention of warning about
the dangers of rapturous enthusiasm and belief in
spirits.[31]

Ostensible proof of the artist's mental illness,
which had enormous repercussions for past Messer-
schmidt scholarship and still shapes the picture of

rich Nicolai gefunden zu haben, der Messerschmidt in seinem Ate-
lier in Preßburg aufsuchte und von diesem Ereignis im sechsten
Band seiner »Beschreibung einer Reise durch Deutschland und die
Schweiz im Jahre 1781« berichtete.[19]

Bei seiner Analyse der Charakterköpfe stellte Kris fest, dass
der Mehrzahl kein eindeutiger mimischer Ausdruck zu entnehmen
sei, so dass die gebräuchlichen Werktitel, die auf den anonymen Ver-
kaufskatalog des Jahres 1793 zurückgehen, folgerichtig nur einen
Teilaspekt[20] des Mimischen ansprechen.[21] Kris spricht von »mimi-
schen Konstellationen«,[22] womit er die bei diesen Köpfen vorhande-
ne Inkohärenz zwischen oberer und unterer Gesichtshälfte kenn-
zeichnet. Er kommt zu dem Ergebnis, dass allen diesen Köpfen zwei
einander widerstreitende Gestaltungsprinzipen zugrunde liegen: der
Hang zur Grimasse und zur Verzerrung der Gesichtszüge, was deren
mögliche Dechiffrierung unterläuft; sowie die Tendenz zur Charak-
teristik, womit die Akzentuierung konkreter Persönlichkeitsmerk-
male gemeint ist.[23] Messerschmidts Neigung zur Charakteristik
führt Kris auf ein grundlegendes physiognomisches Interesse

zurück, für die Tendenz zur Grimasse kann er dagegen kein plausibles kunsthistorisches Erklärungsmodell finden.[24] Generell verweist er auf eine »aggressive Tendenz«, die der Grimasse und der Karikatur gemeinsam sei. Bereits zuvor hatte Kris im Fortgang seiner Untersuchung eine Reihe von kunsthistorischen Erklärungsansätzen nachgezeichnet – die heute sämtlich von der jüngeren Forschung wieder aufgegriffen werden –, sie jedoch als unspezifisch abgelehnt.[25]

Auf der Basis dieses Befundes und des Nicolai'schen Textes – wobei der Schilderung des »Geistes der Proportion« zentrale Bedeutung zukommt – unterzog Kris die Persönlichkeit Messerschmidts einer postumen Psychoanalyse. Sie führte zu der Diagnose, dass Messerschmidt »Anfang der Siebzigerjahre, [...] an einem akuten Schub einer Psychose erkrankt«[26] sei. In der Gestaltung der Charakterköpfe erkannte Kris Merkmale einer paranoiden Schizophrenie.[27] Besondere Bedeutung maß er dem Motiv der zusammengepressten Lippen bei, das sich mehrfach an den Köpfen Messerschmidts findet und das er als Symptom einer verdrängten Sexualität deutete.[28] In der Zusammenschau von Nicolais Schilderung des Geistes der Proportion (vor allem in den mit diesem verbundenen Peinigungen) und der Gestaltung der Schnabelköpfe (Abb. 39) glaubt Kris Anzeichen für eine Projektion der latenten Homosexualität des Bildhauers feststellen zu können.[29]

Auf die zentrale Bedeutung des Nicolai'schen Reiseberichts, der auch bei der jüngeren Forschung noch als zuverlässige Quelle für Messerschmidts Geisteszustand und zur Genese seiner Charakterköpfe gilt,[30] wurde mehrfach hingewiesen. An Nicolais Glaubwürdigkeit und der Zuverlässigkeit seiner Schilderungen kamen jedoch jüngst berechtigte Zweifel auf. Ulrich Pfarr unterzieht Nicolai in seiner 2006 erschienenen Dissertation einer ausführlichen Quellenkritik, die anschaulich macht, dass dieser Messerschmidt keineswegs unvoreingenommen gegenübertrat. Vielmehr muss man davon ausgehen, dass der Aufklärer mit seiner Schilderung des Exzentrikers Messerschmidt auch die Absicht verfolgte, vor den Gefahren der Schwärmerei und des Geisterglaubens zu warnen.[31]

Dem Nachweis der Geisteskrankheit des Künstlers, der in der Forschungsgeschichte von ungeheurem Nachhall war und noch heute das Bild eines breiten Publikums bestimmt, muss also mit größerer Vorsicht begegnet werden. Betrachtet man Kris' Studie als eine historische, als einen der ersten Versuche, die Erkenntnismöglichkeiten der Freud'schen Psychoanalyse für die Kunstgeschichte nutzbar zu machen, so kann man wohl von einem Schlüsseltext der Kunstgeschichtsschreibung des 20. Jahrhunderts sprechen. Dies erklärt die anhaltende Präsenz Kris'scher Thesen in der Messerschmidt-Forschung.[32]

him entertained by a broad public, must, therefore, be treated with the utmost caution. If one regards the Kris study from the epistemological standpoint as one of the earliest attempts to apply Freudian psychoanalysis to art history, one probably can speak of it as a key 20th-century art-historical text. This would explain the persistence of Kris's hypotheses in Messerschmidt scholarship.[32]

Kris's interpretation of the Character Heads was modified and revised from the psychoanalytical standpoint during the 1980s and 1990s especially. In his 1981 doctoral dissertation in medical history, Otto Glandien arrived at a diagnosis of paranoia.[33] Symptoms of schizophrenia, however, could not be verified[34] although Glandien notes as a critique of methodology that the usual psychiatric criteria would "not be applicable to the full extent to such a highly gifted and sensitive artist as Messerschmidt". In 1983 Behr / Grohmann / Hagedorn conjectured that Messerschmidt's symptoms might be traced to lead poisoning.[35] Three years later, Paul Krauss again attested schizophrenia, coming to the conclusion that that psychosis afforded, as far as both symptoms and the course they took, "a phenomenon of considerable completeness".[36] In 1997 Peter Gorsen saw a diagnosis of megalomania confirmed in Nicolai's description of the Spirit of Proportion and again underscored the magical significance of the Character and Beaked heads.[37] In the most recent analysis, that of Renate Fanta, many of Kris's interpretation schemata return. Fanta, too, sees in Nicolai's Spirit of Proportion a "figment of a paranoid imagination" and diagnoses "tabooisation of sexuality". Like Kris, Fanta ascribes psychosexual symbolism to the human lips as depicted in Messerschmidt's world-view.[38]

Art historical alternatives

Following publication of Kris's essay, Messerschmidt research stagnated for several decades. In the mid-1960s Rudolf and Margot Wittkower registered misgivings about this interpretation in their book "Born under Saturn. The character and conduct of artists" (1963). On the whole, they questioned the reliability of Nicolai's account and referred to Erica Tietze-Conrat, who as early as 1920 conjectured that Messer-

Die Deutung der Charakterköpfe durch Kris wurde vor allem in den 1980er und 1990er Jahren von psychoanalytischer Seite modifiziert und revidiert. So kommt Otto Glandien in seiner medizinhistorischen Dissertation aus dem Jahre 1981 zur Diagnose einer Paranoia.[33] Merkmale einer schizophrenen Gestaltung seien jedoch nicht nachzuweisen,[34] wobei er methodenkritisch anmerkt, dass die üblichen psychiatrischen Kriterien für einen »hochbegabten und sensiblen Künstler wie Messerschmidt nicht in vollem Umfang anwendbar« seien. 1983 führen Behr / Grohmann / Hagedorn die Krankheitssymptome Messerschmidts auf eine mögliche Bleivergiftung zurück.[35] Drei Jahre später attestiert Paul Krauß erneut eine Schizophrenie und kommt zu dem Resultat, dass die Psychose in ihrer Symptomatik und ihrem Verlauf ein »Phänomen von beachtlicher Geschlossenheit«[36] biete. Verfolgungswahn findet Peter Gorsen 1997 in Nicolais Schilderung des Geistes der Proportion erfüllt und unterstreicht erneut die magische Bedeutung der Charakter- und Schnabelköpfe.[37] In der jüngsten Analyse von Renate Fanta kehren viele der Kris'schen Interpretationsschemata wieder. Auch sie sieht in Nicolais Geist der Proportion ein »paranoides Phantasiegeschöpf« und diagnostiziert eine »Tabuisierung der Sexualität«. Wie schon Kris spricht sie den menschlichen Lippen in Messerschmidts Vorstellungswelt eine psychosexuelle Symbolik zu.[38]

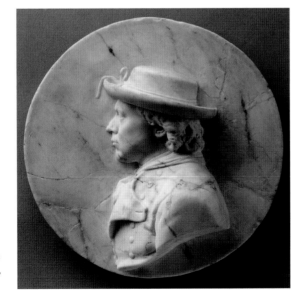

40 Franz Xaver Messerschmidt, Bildnis eines Mannes, um 1780, Alabastermedaillon, Staatliche Museen zu Berlin, Skulpturensammlung und Museum für Byzantinische Kunst, Inv.-Nr. 12/65
Franz Xaver Messerschmidt, Portrait of a Man, alabaster medallion, Staatliche Museen zu Berlin, Skulpturensammlung und Museum für Byzantinische Kunst, Inv. no. 12/65

schmidt may have feigned madness when confronted with the "superficial exponent of the Enlightenment".[39] The Wittkowers go on to add that, while working on the Character Heads, Messerschmidt also completed some portrait busts, which certainly would not have been commissioned from him if he had been known to his contemporaries as mentally ill. Rudolf and Margot Wittkower justify the discrepancies in Messerschmidt's work as the parallel existence of an official public œuvre and a private one, a state of affairs that would indeed be typical of the late 18th and early 19th centuries.[40] The Wittkowers believed the Character Heads, too, can be explained in their historical context. According to this view, the Heads reflect the subject matter of interest at the time among the educated, which included the theory of proportions, physiognomy and pathognomy as well as the revival of spiritualism in secret societies.

A similar interpretation is pursued by Gottfried Biedermann in an essay published in 1978. He, too, views Messerschmidt as representing the dawning of a new era[41] and bases this assertion on Messerschmidt's stylistic development as well as stylistic features of the Character Heads. Biedermann sees indications that Messerschmidt was re-orienting himself along the lines of an interest in physiognomy and anthropology in the artist's rejection of the Baroque formal state portrait and his embrace of a more private, intimate form of portraiture in his late portrait busts. Biedermann regards the sequence of Character Heads as a sort of field for mimetic experimentation, within which Messerschmidt plumbed the expressive possibilities of the human face.[42]

The first and hitherto only standard monograph on Messerschmidt was Maria Pötzl-Malíková's, published in 1982, which is a compendium of all archive material known to that date and contains the complete catalogue of works referred to by scholars down to the present day. Maria Pötzl-Malíková's numerous achievements in advancing Messerschmidt research include the publication of works believed lost, such as the bust of Franz Anton Mesmer[43] (figs. 10, 21) and an alabaster medallion (fig. 40) as well as drawing on the written sources in Messerschmidt's estate and other important documents. In 1996 Pötzl-Malíková

Kunsthistorische Alternativen

Nach Kris' Veröffentlichung stagnierte die Messerschmidt-Forschung für mehrere Jahrzehnte. Mitte der 1960er Jahre meldeten Rudolf und Margot Wittkower in ihrem Buch »Künstler als Außenseiter« erhebliche Bedenken an dessen Deutung an. Allgemein stellten sie die Zuverlässigkeit von Nicolais Bericht in Frage, indem sie auf Erika Tietze-Conrat verwiesen, die bereits 1920 gemutmaßt hatte, Messerschmidt habe sich dem »seichten Aufklärer«[39] gegenüber verstellt. Auch habe Messerschmidt, während er an den Charakterköpfen arbeitete, einige Porträtbüsten fertig gestellt, mit denen man ihn sicher nicht beauftragt hätte, wenn er bei seinen Zeitgenossen als geisteskrank bekannt gewesen wäre. Das Spannungsverhältnis seines Werks führen Rudolf und Margot Wittkower auf das Nebeneinander eines offiziellen und privaten Œuvres zurück, das für das späte 18. und frühe 19. Jahrhundert geradezu prototypisch gewesen sei.[40] Auch die Charakterköpfe sind ihrer Ansicht nach im historischen Kontext erklärbar. Sie spiegeln die zeittypischen Interessensgebiete der damaligen Bildungsschicht, Fragen der Proportionslehre, der Physiognomie und Pathognomie sowie den wiedererwachten Spiritualismus der Geheimbünde.

Eine ähnliche Deutung verfolgt auch Gottfried Biedermann in seinem 1978 erschienenen Aufsatz. Auch er sieht in Messerschmidt den Vertreter einer Epochenschwelle[41] und macht diese Aussage an Messerschmidts stilistischer Entwicklung und an Merkmalen der Charakterköpfe fest. In Messerschmidts Abkehr vom barocken Repräsentationsbildnis und seiner Hinwendung zu einer mehr privaten, intimen Wiedergabe bei den späten Bildnisbüsten sieht er Indizien einer Neuorientierung des Künstlers und dessen Interesse an Physiognomie und Anthropologie. Die Reihe der Charakterköpfe betrachtet der Autor als eine Art mimisches Experimentierfeld, innerhalb dessen Messerschmidt die Ausdrucksmöglichkeiten des menschlichen Gesichts ausgelotet habe.[42]

1982 erscheint von Maria Pötzl-Malíková die erste, nach wie vor grundlegende Monographie über Messerschmidt mit einem Kompendium des gesamten, bis dahin bekannten Archivmaterials und einem umfassenden Werkkatalog, auf den die Forschung bis heute Bezug nimmt. Zu ihren zahlreichen Verdiensten für die Messerschmidt-Forschung gehören etwa die Veröffentlichung verschollen geglaubter Werke wie die Büste von Franz Anton Mesmer[43] (Abb. 10, 21) und ein Alabastermedaillon (Abb. 40) sowie die Erschließung von Messerschmidts schriftlichem Nachlass und anderer wichtiger Dokumente. 1996 publizierte Pötzl-Malíková ein Nachlassinventar des Künstlers aus dem Archiv der Familie Pálffy,[44] durch welches belegt werden konnte, dass Messerschmidt nicht am Rande des Existenzminimums lebte, wie die Forschung bis dahin

published an inventory of the artist's estate from the Pálffy family archives,[44] which furnished proof that Messerschmidt was not living in destitution, as scholars had up to that point believed, but instead led quite a comfortable bourgeois life.[45] In evaluating the Character Heads, Pötzl-Malíková does follow Kris in essentials, believing that Messerschmidt was mentally ill[46] and ascribes to the Heads the magical apotropaic function of warding off evil spirits.[47]

Jörg Oberhaidacher links the Character Heads to the grotesque series of heads in 17th-century rubbings[48] and Late Gothic painting in southern Germany and Austria.[49] He sees the Heads as being in the tradition of an anti-classical, expressively oriented art, which was present, via Gothic form elements, in architecture as well. In the different styles of the early portraits executed c. 1770–1772 of Franz von Scheyb (figs. 9, 18) or Gerard van Swieten (cat. no. 1) and such late portraits as that of Martin Georg Kovachich (figs. 13, 26) from 1782, Oberhaidacher finds features justifying a chronology of the various Character Heads. At the beginning he places such heads as "The Noble-Minded Man" (cat. no. 18), which reveal a rather soft, fluid handling of surfaces. At the end of his chronology come Heads such as "An Arch-Rascal" (cat. no. 10), in which everything is subordinate to the overall form and the emphasis on the silhouette.[50]

Kris's pronouncement that the Character Heads are "at once configurations of madness and works of art",[51] which Kris himself was ultimately unable to prove, comes close to Herbert Beck's findings in his study of an alabaster "Bust of A Bearded Old Man", which dates from c. 1770–1772 (cat. no. 5).[52] Beck links the bust with the iconography of Socrates portraits, drawing on Winckelmann's polemic attacking the work of Gian Lorenzo Bernini as all too sensual and presumably not obeying a classical ideal[53] and comes to the conclusion that the Messerschmidt bust should be interpreted as a representation of Philosophy overcoming human nature as driven by basic instincts and urges.[54] Accordingly, the moral and social discourse conducted by the late 18th century, which was, of course, also carried out on the aesthetic plane, concurs with Messerschmidt's personal obses-

41 Charles Le Brun, *Charles Le Brun,*
 Le Pleurer, um 1668, *The Weeper,*
 schwarze Kreide, Feder *c. 1668, black chalk,*
 in Schwarz, auf *and ink on cream*
 weißgelbem Papier, *paper, Musée du*
 Musée du Louvre, Paris, *Louvre, Paris,*
 Inv.-Nr. 28344 *Inv no. 28344*

glaubte, sondern ein durchaus komfortables bürgerliches Leben führte.[45] In der Bewertung der Charakterköpfe folgt die Autorin im Wesentlichen dem Kris'schen Urteil, dass Messerschmidt geisteskrank gewesen sei[46] und misst ihnen die Funktion einer magischen Geisterabwehr bei.[47]

Jörg Oberhaidacher stellt die Charakterköpfe in Beziehung zu grotesken Kopfserien in der Schabkunst des 17. Jahrhunderts[48] und zur spätgotischen Malerei Süddeutschlands und Österreichs.[49] Er sieht die Köpfe in der Tradition einer antiklassischen, expressiv ausgerichteten Kunst, die über gotische Formelemente auch in der Architektur des 18. Jahrhunderts präsent war. In der unterschiedlichen Stilistik der frühen, um 1770–1772 entstandenen Porträts eines Franz von Scheyb (Abb. 9, 18) oder Gerard van Swieten (Kat.-Nr. 3) und den späten Porträts eines Martin Georg Kovachich (Abb. 12, 26) aus dem Jahre 1782 entnimmt Oberhaidacher Anhaltspunkte für eine zeitliche Einordnung der verschiedenen Charakterköpfe. An den Anfang stellt er Köpfe wie »Der Edelmüthige«

sion: the apotropaic function of the Character Heads as described by Nicolai. In Beck a synthesis of personal and supra-individual significance in Messerschmidt's is suggested for the first time – provided that one is to a certain extent willing to follow Kris's interpretation. Via this premise, the sequence of Character Heads could really be read as "configurations of madness and works of art at the same time". However, accepting that does not resolved the conflict for Beck; after all, he views Messerschmidt's form of bust as a negation of the physical. As Beck sees it, behind Messerschmidt's wrestling with the Spirit of Proportion lies the artist's search for an ideal of physical beauty freed of all sensuality and unrealisable in art.[55]

Axel Christoph Gampp pursues an approach that is at once markedly sociological and historical. Gampp suspects that the expressive quality of the Character Heads and the eccentricity of their creator are due to a marketing strategy Messerschmidt adopted after failing both at the Academy and at court while he was trying to establish himself on the "free market".[56] Gampp emphasises Messerschmidt's preoccupation with the new aesthetic ideals of the day, which ended around 1770 in his appropriating a Neo-Classical repertoire of forms, as exemplified, for instance in the bust of Franz von Scheyb (figs. 9, 18). Gampp viewed the Viennese art theorist and poet, who published "Natur und Kunst in Gemälden, Bildhauereyen, Gebäuden und Kupferstichen" in 1770 and "Von den drey Künsten der Zeichnung" in 1774, as Messerschmidt's intellectual mentor, as it were. Gampp describes the Character Heads as the "first series in the modern sense" on the grounds that the sequential principle ordering them has been left open and is not unequivocally prescriptive.[57]

Even though he does not refer directly to Messerschmidt, Thomas Kirchner and the research he has conducted into the representation of the emotions in French 17th and 18th-century art must be mentioned in the present connection.[58] Kris had already drawn attention to the Le Brun's 1671 lecture "Traité sur la physionomie" although he denied it had any influence on Messerschmidt.[59] In fact the sequence of Character Heads looks like the very antithesis of Le Brun's rigid system of laws (fig. 41).[60] In his study, Kirchner

CONCOURS pour le PRIX de l'Etude des TÊTES et de l'EXPRESSION
Fondé à l'Académie Royale de Peinture et Sculpture par Mr. le Comte de CAYLUS Honoraire Amateur, en 1760.

42 Charles-Nicolas Cochin,
 Wettbewerbssitzung des
 »Prix de l'étude des têtes
 et de l'expression«, 1761,
 Kreide, weiß gehöht,
 Musée du Louvre, Paris,
 Inv.-Nr. 2054
 Charles-Nicolas Cochin,
 Competition for the "Prix
 de l'étude des têtes et de
 l'expression" [Prize for a
 Study of Heads and
 Expression], 1761, chalk,
 white highlihts, Musée du
 Louvre, Paris,
 Inv no. 2054

(Kat.-Nr. 18), denen eine eher weiche, fließende Oberflächenbehandlung zu eigen ist. Das Ende der Chronologie bilden Köpfe wie »Ein Erzbösewicht« (Kat.-Nr. 10), bei denen alles der Gesamtform und der Betonung der Silhouette untergeordnet wird.[50]

Dem Kris'schen Diktum, die Charakterköpfe seien »Wahngebilde und Kunstwerke zugleich«,[51] das Kris selbst letztlich nicht einzulösen vermochte, kommt Herbert Beck mit seiner Untersuchung der »Büste eines bärtigen, alten Mannes« nahe, einer um 1770–1772 entstandenen Alabasterbüste (Kat.-Nr. 5).[52] Beck bringt die Büste mit der Ikonographie von Sokrates-Bildnissen in einen Zusammenhang, zieht Winckelmanns Polemik gegenüber dem allzu sinnlichen, vermeintlich keinem klassischen Ideal gehorchenden Werk Gian Lorenzo Berninis[53] hinzu und kommt zu dem Ergebnis, dass die Büste als Darstellung der Überwindung der Triebnatur durch die Philosophie zu verstehen sei.[54] Damit kommt der gesellschaftlich geführte Moraldiskurs des ausgehenden 18. Jahrhunderts, der natürlich auch auf ästhetischer Ebene ausgetragen wurde, mit Messerschmidts persönlicher Obsession zur Deckung: der von Nicolai geschilderten apotropäischen Funktion der Charakterköpfe. Hiermit deutet sich erstmals so etwas wie eine Synthese aus persönlicher und überindividueller Bedeutung im Werk Messerschmidts an – vorausgesetzt man folgt der Kris'schen Interpretation ein Stück weit. Unter dieser Prämisse ließe sich die Serie der Charakterköpfe

devotes himself extensively to the Comte de Caylus and his "Prix d'expression" at the Paris Art Academy.[61] That competition[62] was intended to counteract the rigid pathos formulae which Le Brun had prescribed as canonical.[63] The emotion to be represented – a different one each year – was demonstrated by means of a model, usually a professional actress who had rehearsed it in advance under the supervision of the professor in charge of the competition (fig. 42).[64] Thus a concept for reviving the representation of the emotions is placed chronologically closer to the creation of the Character Heads. After all, a passage from von Scheyb's "Von den drey Künsten der Zeichnung" proves that a revival of representing emotions was also going on in Messerschmidt's immediate environment. In the chapter headed "Academia", von Scheyb suggests hiring mime artists so that pupils might study in them how to represent the emotions: "Mime artists can be very useful in painting schools; without speaking, they explain all emotions and passions. What a fine opportunity the pupil would have of naturally imitating one or another of them and drawing them [...] Are they not, without uttering a

tatsächlich als »Wahngebilde und Kunstwerke zugleich« begreifen. Damit ist für Beck der Konflikt jedoch nicht ausgetragen, sieht er doch in Messerschmidts Büstenform eine Negation des Körperlichen. Hinter Messerschmidts Ringen mit dem Geist der Proportion stehe dessen Suche nach einem von aller Sinnlichkeit befreiten, nicht künstlerisch verwirklichbaren Ideal von körperlicher Schönheit.[55]

Einen prononciert sozialgeschichtlichen Ansatz verfolgt Axel Christoph Gampp, der in der Expressivität der Charakterköpfe und der Exzentrik ihres Schöpfers eine Vermarktungsstrategie Messerschmidts vermutet, nachdem dieser an Akademie und Hof gescheitert war und sich auf dem »freien Markt«[56] zu etablieren suchte. Er unterstreicht Messerschmidts Auseinandersetzung mit den neuen ästhetischen Idealen der Zeit, die um 1770 in die Aneignung eines klassizistischen Formenrepertoires mündete, beispielsweise bei der Büste des Franz von Scheyb (Abb. 9, 18). In dem Wiener Kunstschriftsteller und Dichter, der 1770 »Natur und Kunst in Gemälden, Bildhauereyen, Gebäuden und Kupferstichen« und 1774 »Von den drey Künsten der Zeichnung« veröffentlichte, sieht Gampp gewissermaßen den geistigen Vater Messerschmidts. Gampp beschreibt die Charakterköpfe aufgrund ihres offenen, nicht eindeutig festgeschriebenen Ordnungsprinzips als »erste Serie im modernen Sinn«.[57]

Ohne direkten Bezug auf Messerschmidt muss auch auf Thomas Kirchner und seine Forschungen zur Darstellung der Affekte in der französischen Kunst des 17. und 18. Jahrhunderts hingewiesen werden.[58] Bereits Kris hatte auf Le Bruns 1671 gehaltenen »Traité sur la physionomie« aufmerksam gemacht, einen Einfluss auf Messerschmidt jedoch negiert.[59] Tatsächlich wirkt die Serie der Charakterköpfe wie eine Antithese angesichts des starren Regelwerks von Le Brun (Abb. 41).[60] Kirchner widmet sich in seiner Untersuchung ausführlich dem Comte de Caylus und seinem »Prix d'expression« an der Pariser Kunstakademie.[61] Der Wettbewerb[62] sollte den erstarrten Pathosformeln entgegenwirken, die Le Brun kanonisch festgeschrieben hatte.[63] Der darzustellende Affekt – das Thema wechselte jährlich – wurde von einem Modell vorgeführt, meist einer professionellen Schauspielerin, die diesen zuvor unter Anleitung des betreuenden Professors einstudiert hatte (Abb. 42).[64] Damit rückt ein Konzept zur Erneuerung der Leidenschaftsdarstellung in eine größere zeitliche Nähe zur Entstehung der Charakterköpfe. Denn dass der Gedanke einer Wiederbelebung der Affektdarstellung auch im Umkreis Messerschmidts präsent war, belegt eine Passage aus von Scheybs »Von den drey Künsten der Zeichnung«. Im Kapitel »Academia« schlägt von Scheyb vor, Pantomimen zu engagieren, anhand derer die Schüler die Darstellung der Affekte studieren sollen: »Pantomimen können in Malerschulen sehr viel nutzen; ohne Reden

word, the most garrulous chatterboxes? Their eyes, the expressions on their faces, speak for them."[65]

Michael Krapf has made an important contribution to interpreting the two extremely distorted Beaked Heads in identifying them as personifcations of Thoth, the Egyptian deification of the moon and of proportion.[66] Krapf views the extremely exaggerated lengthening of the lips in both heads (fig. 39) as an allusion to the ibis-headed deity sporting a long curved beak. Hence the configuration of the Beaked Heads confirms Nicolai's description of the "Egyptian Hermes".[67] Krapf points out the importance of that deity in the occult and spiritualist writings of the latter half of the 18th century and assigns the role of transmitter of those arcana to Franz Anton Mesmer, who was close to the Freemasons. In the 2002 Viennese catalogue, Krapf demonstrates how motifs in some of the Character Heads can be traced back to Mesmer's methods of treatment and his theory of "animal magnetism".[68]

Maraike Bückling sees Messerschmidt as an exponent of the Enlightenment, whose views were no longer approved by the Academy, from about 1774. For Bückling, the Character Heads are the expression of Messerschmidt's researches into his own ego,[69] reflecting experiments conducted by Messerschmidt on himself to discover the relationship of body language and facial expression as the expression of the soul.[70] In so doing, Messerschmidt was guided by an alchemist's view of nature and the thinking of Freemasonry, which at that time – as Bückling makes clear – was widespread in broad segments of the public and in which Messerschmidt would probably have been instructed by Gerard van Swieten and Joseph von Sonnenfels, who were both members of a Masonic lodge. Behind Messerschmidt's battle with the Spirit of Proportion as described by Nicolai, Bückling sees the artist's preoccupation with the teachings of alchemy; in the sequence of Character Heads, she sees Messerschmidt's endeavour to bequeath to posterity the findings from his empirical experiments on himself.[71] Bückling does not see the wellsprings of his art in a mental disorder of any kind "but rather as his personal interpretation of the Enlightenment, which links aspects of Freemasonry, natural science and art

erklären sie alle Affekten und Leidenschaften. Wie eine schöne Ge-legenheit hätte der Schüler, diese oder jene natürlich nachzuahmen, und sie zu zeichnen [...] Sind sie nicht, ohne ein Wort zu reden, die gesprächigsten Schwätzer? Ihre Augen, ihre Gesichtsbildungen reden für sie.«[65]

Einen wichtigen Beitrag zur Interpretation der beiden extrem verzerrten Schnabelköpfe leistet Michael Krapf, der diese als Personi-fikationen des ägyptischen Mondgottes und Gott des Maßes Thot identifiziert.[66] Krapf sieht in den extrem verlängerten Lippen der bei-den Köpfe (Abb. 39) eine Anspielung auf die ibisköpfige, mit einem langen Schnabel bewehrte Gottheit. Damit findet sich in der Gestalt der Schnabelköpfe eine Bestätigung für Nicolais Schilderung des »ägyptischen Hermes«.[67] Krapf verweist auf die Bedeutung des Got-tes in der okkulten und spiritistischen Literatur der zweiten Hälfte des 18. Jahrhunderts und ordnet Franz Anton Mesmer, der den Frei-maurern nahestand, die Rolle eines Vermittlers zu. Im Wiener Katalog von 2002 weist Krapf bei einigen Charakterköpfen Motive nach, die auf Mesmers Behandlungsmethode und dessen Theorie des »thieri-schen Magnetismus« zurückgeführt werden können.[68]

Maraike Bückling betrachtet Messerschmidt als einen Vertre-ter der Aufklärung, dessen Anschauungen von der Akademie ab ungefähr 1774 nicht mehr gebilligt wurden. Für sie sind die Cha-rakterköpfe Ausdruck von Messerschmidts Erforschung des eigenen Ich,[69] Spiegelungen von Messerschmidts Selbstversuch, dem Ver-hältnis von Körper und Mimik als Ausdruck des Seelischen auf die Spur zu kommen.[70] Geleitet wurde Messerschmidt dabei durch eine alchemistische Naturauffassung und freimaurerisches Gedankengut, das damals – wie die Autorin deutlich macht – in weiten Teilen der Gesellschaft verbreitet war und dem Künstler wohl durch Gerard van Swieten und Joseph von Sonnenfels, beide Mitglieder einer Freimaurerloge, sowie Mesmer nahegebracht wurde. In dem von Nicolai geschilderten Kampf mit dem Geist der Proportion sieht sie Messerschmidts Auseinandersetzung mit der alchemistischen Lehre der Entsprechungen verborgen, in der Serie der Charakterköpfe Messerschmidts Streben, die im empirischen Selbstversuch gewon-nenen Resultate der Nachwelt zu überliefern.[71] Die Ursachen seiner Kunst sieht sie nicht in einer wie auch immer gearteten geistigen Verwirrung »als vielmehr in seiner eigenwilligen Interpretation der Aufklärung, die freimaurerische, naturwissenschaftliche und künst-lerische Aspekte auf höchstem bildhauerischen Niveau miteinander verbindet«.[72] Damit geht die Autorin auf deutliche Distanz zur Interpretation von Ernst Kris. Auch der Kris'schen These, es handle sich bei allen Charakterköpfen um Selbstporträts des Künstlers, widerspricht die Autorin in einer differenzierten Betrachtung einzel-ner Charakterköpfe, bei der diese aufgrund anatomischer Unter-

in sculpture of the highest quality".[72] In drawing this conclusion, Bückling has emphatically distanced her-self from Kris's interpretation. She also refutes Kris's theory that all the Character Heads were self-portraits by subjecting individual Character Heads to a sophis-ticated reading in which they are either compared on the grounds of anatomical differences, constants and similarities or grouped in series.[73]

In his recently published doctoral dissertation, Ulrich Pfarr has attempted to approach an interpreta-tion of the facial expressions in the Messerschmidt Heads by using the Facial Action Coding System (FACS) developed by affect psychology.[74] His contri-bution to a re-evaluation of the Friedrich Nicolai's writings has already been mentioned.

In conclusion

Looking at the history of research on Franz Xaver Messerschmidt, one can actually confirm something like a "specificity of condition",[75] albeit in a sense dif-ferent from that intended by Ernst Kris back in the 1930s. Now it seems to consist in Messerschmidt's having touched on *topoi* pivotal to the Romantic artist-ideal of the 19th and 20th centuries, which undoubtedly are still rampant. Messerschmidt still does not leave us indifferent; he challenges us to question critically the prejudices and popular stereo-types. Friedrich Nicolai of all people, about whose lack of prejudice doubts have had to be voiced, warns, in criticising Johann Heinrich Lavater's treatises on physiognomy, which were published between 1775 and 1778: "In explaining a physiognomy, I must 1st look at the object, 2nd at myself. If I notice a striking sign in the object, what has been designated is really in the object but the reason why I see this sign more clearly than all others may also lie in me."[76]

1 Kris 1932, p. 222. Frank Oberacker has collaborated on the present essay.

2 "Messerschmidt's portraits are among the best things pro-duced by Late Baroque sculpture in Europe."; see Kemp 2002, p. 44. This sounds almost like a paraphrase of the verdict pronounced 71 years before by Ernst Kris: "One may say that the portrait busts of his "late period" [...] are among the most important and advanced artistic achieve-ments in the German sculpture of their day."; see Kris 1932, p. 184.

schiede, Konstanten und Ähnlichkeiten nebeneinander gestellt oder in Reihen zusammengefasst werden.[73]

In seiner jüngst publizierten Dissertation hat Ulrich Pfarr den Versuch unternommen, mit Hilfe des von der Emotionspsychologie entwickelten Facial Action Coding System (FACS) dem Mienenspiel der Messerschmidt'schen Köpfe auf die Spur zu kommen.[74] Auf seinen Beitrag zu einer Neubewertung der Überlieferung Friedrich Nicolais wurde bereits hingewiesen.

Resümee

Betrachtet man die Forschungsgeschichte zu Franz Xaver Messerschmidt, so kann man tatsächlich so etwas wie eine »Spezifität der Bedingung«[75] feststellen, allerdings in einem anderen Sinne als dies Ernst Kris in den 30er Jahren des vorigen Jahrhunderts verstanden wissen wollte. Diese scheint vielmehr darin zu bestehen, dass Messerschmidt zentrale Topoi des romantischen Künstlerideals des 19. und 20. Jahrhunderts berührt, die fraglos noch immer virulent sind. Messerschmidt lässt uns noch immer nicht unberührt, er fordert uns dazu auf, vorgefasste Meinungen und lieb gewonnene Denkschemata kritisch zu hinterfragen. Ausgerechnet Friedrich Nicolai, an dessen Unvoreingenommenheit Zweifel geäußert werden mussten, gibt dies zu bedenken, indem er an Johann Heinrich Lavaters zwischen 1775 und 1778 erschienenen physiognomischen Schriften Kritik übt: »Bey der Erklärung einer Physiognomie muß ich 1. auf das Object, 2. auf mich selbst sehen. Wenn ich ein hervorspringendes Zeichen im Objecte bemerke, so ist das bezeichnete zwar wirklich im Objecte, es kann aber in mir der Grund liegen, warum ich dieses Zeichen vorzüglich von allen andern sehe.«[76]

1 Kris 1932, S. 222. Der vorliegende Aufsatz entstand unter Mitarbeit von Frank Oberacker.

2 »Die Bildnisse Messerschmidts gehören zum besten, was die spätbarocke Skulptur in Europa hervorgebracht hat.«; siehe Kemp 2002, S. 44. Dies klingt beinahe wie eine Paraphrase des von Ernst Kris 71 Jahre zuvor gefällten Urteils: »Man darf sagen, dass die Bildnisbüsten seiner ›Spätzeit‹ [...] zu den bedeutendsten und fortgeschrittensten künstlerischen Leistungen der deutschen Plastik ihrer Tage gehörten.«; siehe Kris 1932, S. 184.

3 Zitiert nach Krapf, Musealisierung 2002, S. 108.

4 Identisch mit Anonymus 1794. Ein Reprint mit einem Nachwort von Maria Pötzl-Malíková erschien 1982 als Jahresgabe der Wiener Bibliophilen-Gesellschaft. Zur Überlieferung der ursprünglichen Anzahl der Köpfe siehe S. 80–84 in diesem Katalog. Die damals präsentierten Köpfe trugen eine Nummer und ein Etikett, das bei Kat.-Nr. 15, 16 und 18, auch bei »Der Mismuthige« aus der Skulpturensammlung des Musée du Louvre (Paris) noch sichtbar ist; zu Letzterem siehe Scherf 2005, S. 15.

5 Als wichtigste und zuverlässigste Quelle gilt Nicolai 1785; siehe Nicolai Reprint 1994.

6 Siehe S. 25 und Anm. 52 in diesem Katalog.

7 Wiener Zeitung, 6. November 1793 und 11. Dezember 1793.

3 Quoted in Krapf, Musealisierung 2002, p. 108.

4 Identical with Anon. 1794. A reprint with an epilogue by Maria Pötzl-Malíková was published in 1982 as a Jahresgabe of the Wiener Bibliophilen-Gesellschaft. On the records of the original number of heads, see p. 80–84 in the present catalogue. Each of the heads presented at that time bore a number and a label, both of which are still visible on the head labelled "The Ill-Humored Man" from the sculpture collection at the Musée du Louvre (Paris); see Scherf 2005, p. 15.

5 Nicolai 1785 is regarded as the most important and reliable source; see Nicolai Reprint 1994.

6 See p. 23 and note 52 in the present catalogue.

7 "Wiener Zeitung", 6 November 1793 and 11 December 1793.

8 See Krapf, Musealisierung 2002, pp. 109f., figs. 2 and 3.

9 Frimmel 1914; see also Krapf, Musealisierung 2002, pp. 110f.

10 See Krapf, Musealisierung 2002, pp. 112f.

11 In 1907, the Österreichisches Museum für Kunst und Industrie acquired by way of an exchange nine heads which had found their way more or less by chance into the store of the k. k. Staatsgewerbe-Schule in Vienna. They probably came from the teaching-materials collection and had served pupils as demonstration objects illustrating facial expressions or physiognomic features. Five of those heads went after the end of the First World War to the newly founded Baroque Museum in the Unterer Belvedere, where they still are today; see Krapf, Musealisierung 2002, p. 114.

12 Kris 1932. A second version of Kris's text was published in 1933, which was addressed to a specialist public familiar with psychoanalysis. This version derives from a lecture Kris gave to the Viennese Psychoanalytical Society on 24 November 1932.

13 See Strauss/Röder 1983, pp. 665f.

14 Even in his day, Albert Ilg called for a "psychiatrist" when confronted with the Character Heads; see Ilg 1885, p. 56.

15 Kris refers expressly to Freud, who "realised [...] the applicability of the insight gained to material from the arts and humanities"; Kris 1932, pp. 170f.

16 Kris 1932, p. 171.

17 Kris's notion of what constituted a work of art is even today as viewed from the current standpoint enormously modern and entirely abreast of his time. He sees the work of art as a sort of interface for all sorts of intentions and influences, which entail the use of all sorts of processes. Kris himself speaks of "layers of significance" ["Sinnschichten"], which, however, makes one think of existing hierarchies; see Kris 1932, p. 171.

18 Kris 1932, p. 170.

19 Nicolai 1785, pp. 401–420; see also the reprint in the appendix, pp. 313–323.

20 Kris himself speaks of a "part element" or "part impression"; see Kris 1932, pp. 189, 191.

21 Kris convincingly assigns a facial expression to a group of five heads which he defines as self-portraits but he feels

8 Siehe Krapf, Musealisierung 2002, S. 109–110, Abb. 2 und 3.

9 Frimmel 1914; siehe auch Krapf, Musealisierung 2002, S. 110–111.

10 Siehe Krapf, Musealisierung 2002, S. 112–113.

11 Das Österreichische Museum für Kunst und Industrie erwarb 1907 auf dem Tauschweg neun Köpfe, die man eher zufällig im Depot der k. k. Staatsgewerbe-Schule in Wien gefunden hatte. Sie stammten wohl aus der Lehrmittelsammlung und hatten den Schülern als mimische oder physiognomische Demonstrationsobjekte gedient. Fünf davon gelangten nach Ende des Ersten Weltkriegs in das neu gegründete Barockmuseum im Unteren Belvedere, wo sie sich noch heute befinden; siehe Krapf, Musealisierung 2002, S. 114.

12 Kris 1932. Eine zweite Fassung des Kris'schen Textes erschien 1933, die sich an ein mit der Psychoanalyse vertrautes Fachpublikum richtete. Diese Fassung geht auf einen Vortrag zurück, den Kris am 24. November 1932 bei der Wiener Psychoanalytischen Vereinigung hielt.

13 Siehe Strauss/Röder 1983, S. 665–666.

14 Bereits Albert Ilg ruft angesichts der Charakterköpfe nach einem »Psychiatriker«; siehe Ilg 1885, S. 56.

15 Kris beruft sich ausdrücklich auf Freud, der »die Anwendung der gewonnenen Einsicht auf das Material der Geisteswissenschaft erkannt [...] habe«; Kris 1932, S. 170–171.

16 Kris 1932, S. 171.

17 Kris' Begriff vom Kunstwerk erweist sich auch aus heutiger Sicht noch als immens modern und ganz auf der Höhe seiner Zeit. Er begreift das Kunstwerk als eine Art Schnittstelle unterschiedlichster Absichten und Einflüsse, die das Heranziehen unterschiedlichster Verfahren nach sich ziehen. Kris selbst spricht von »Sinnschichten«, was allerdings an vorhandene Hierarchien denken lässt; siehe Kris 1932, S. 171.

18 Kris 1932, S. 170.

19 Nicolai 1785, S. 401–420; siehe auch die Abschrift im Anhang, S. 313–323.

20 Kris selbst spricht von »Teilelement« oder »Teileindruck«; siehe Kris 1932, S. 189 und 191.

21 Einer Gruppe von fünf Köpfen, die Kris als Selbstporträts anspricht, ordnet er zwar einen schlüssigen mimischen Ausdruck zu, empfindet diesen jedoch als so unspezifisch, dass er sie eher als handwerkliche Übungen verstanden wissen will und an der Formulierung »einer bestimmten seelischen Verfassung« zweifelt. Ähnlich verhält es sich mit einer Gruppe, in deren Zügen er eher somatische Reflexe und ein allgemeines physiognomisches Interesse formuliert findet als ein psychisches Moment; Kris 1932, S. 192 und 203–204.

22 Kris 1932, S. 205.

23 Je nach Ausprägung der einen Tendenz zu Ungunsten der anderen kommt es also bei den Köpfen zu mehr oder weniger glücklichen Lösungen. So können sich diese gegenseitig aufheben oder es kann zu einer Färbung der mimischen Konstellation mit Ausdruckselementen kommen; siehe Kris 1932, S. 206–207.

24 »Denn gehört das Streben nach Charakteristik noch zum Bereich seiner physiognomischen Interessen, so sind die Grimassen – sowohl das Ganze des Phänomens wie auch einzelne der mimischen Konstellationen – nur aus der Kenntnis von Messerschmidts Wahn einer weiteren Interpretation zugänglich.«; Kris 1932, S. 209.

25 »Aber auch hier ist eher von Konvergenz als von Abhängigkeit zu sprechen [...].«; Kris 1932, S. 202.

26 Kris 1932, S. 185.

27 »Mancherlei Züge an seinen Werken führen auf den Komplex von Merkmalen, der für die große Krankheitsgruppe der Schizophrenie kennzeichnend ist.«; Kris 1932, S. 213.

that it is so unspecific that he prefers to view it as practice in craft skills and doubts that it can be the formulation of a "specific psychic state". He deals similarly with another group, in whose facial features he tends to find the formulation of somatic reflexes and a general interest in physiognomy rather than a psychic event; see Kris 1932, pp. 192, 203f.

22 Kris 1932, p. 205.

23 The degree to which the solutions arrived at for the heads are successful depends on how pronounced a particular tendency is at the cost of the others. They can cancel each other out or the mimetic constellation can be tinged with expressive elements; Kris 1932, pp. 206f.

24 "For striving for characterisation still belongs to the area of his interest in physiognomy; consequently the grimaces – both the phenomenon as a whole and individual mimetic constellations – are only accessible to a wider interpretation through a knowledge of Messerschmidt's madness."; Kris 1932, p. 209.

25 "Here, too, it is a question of convergence rather than dependence [...]."; Kris 1932, p. 202.

26 Kris 1932, p. 185.

27 "Some traits of his works lead to the complex of symptoms which are diagnostic of the large group of illnesses that is schizophrenia."; Kris 1932, p. 213.

28 Kris underscores the magic content which, according to him, they possessed for Messerschmidt. In the wide open or shut eyes of some of the heads, Messerschmidt's reactions to apparition of spirits are reflected. In this Messerschmidt's attempt "[to] deny his hallucinations [to] himself" is revealed; Kris 1932, p. 215.

29 Kris speaks euphemistically of a "suppression of all sexual urges of the unconscious [...] which are feminine in character"; Kris 1932, p. 217.

30 "There is not the slightest doubt about the authentic value of Nicolai's account [...]"; Pötzl-Malíková 1982, p. 78. "His [Nicolai's] notes on the visit to Messerschmidt contain errors but, because of their objective basic orientation, they have become indispensable [...] for any later biography."; Gorsen 1997, p. 74.

31 Nicolai himself mentions as the occasion of his journey to Hungary in the prologue of the volume in question "to staunchly combat hierarchical oppression, bigotry and superstition and as frankly as possible to defend the rights of reason and liberty." Although Nicolai assures his readers in another passage of his neutrality and his interest in shedding light on the individual causes of Messerschmidt's enthusiasms, his description of his visit to the artist cannot have been entirely untinged by the overtly stated agenda of his journey. This insight is also supported by the circumstance that Nicolai gleaned more information on Messerschmidt after visiting him and in fact even – as Pfarr reports – had him literally spied on; see Pfarr 2003a, p. 11. There is an extensive critical discussion of the sources in Pfarr 2006, pp. 47–64.

32 After emigrating to the US, Ernst Kris made a university career in psychology. He does not seem to have enjoyed

28 Kris unterstreicht den magischen Gehalt, den die Köpfe ihm zufolge für Messerschmidt besitzen. In den aufgerissenen oder verschlossenen Augen einiger Köpfe spiegelten sich Reaktionsweisen auf dessen Geistererscheinungen. Hierin offenbare sich Messerschmidts Versuch, »seine Halluzinationen vor sich [zu] verleugnen«; Kris 1932, S. 215.

29 Kris spricht in diesem Zusammenhang umschreibend von einer »Abwehr jener sexuellen Strebungen des Unbewussten [...], die femininen Charakter haben«; Kris 1932, S. 217.

30 »Es besteht kein Zweifel am authentischen Wert von Nicolais Bericht [...].«; Pötzl-Malíková 1982, S. 78. »Seine [Nicolais] Aufzeichnungen über den Besuch bei Messerschmidt enthalten Fehler, sind aber durch ihre sachliche Grundeinstellung [...] für jede nachfolgende Biographie unentbehrlich geworden.«; Gorsen 1997, S. 74.

31 Als Anlass seiner Reise nach Ungarn schildert Nicolai selbst in der Vorrede des entsprechenden Bandes »hierarchische Unterdrückung, Bigotterie und Aberglauben unverrückt zu bestreiten und die Rechte der Vernunft und der Freyheit zu denken aufs freymüthigste zu vertheidigen«. Zwar versichert Nicolai an anderer Stelle seine Neutralität und sein Interesse an der Aufklärung der individuellen Ursachen für die Schwärmereien Messerschmidts, doch kann seine Schilderung des Besuchs von dieser unverhohlenen Programmatik der Reise nicht gänzlich unberührt geblieben sein. Diese Einsicht wird auch dadurch gestützt, dass Nicolai nach seinem Besuch weitere Informationen über Messerschmidt einholte und ihn – wie Pfarr berichtet – förmlich bespitzeln ließ; siehe Pfarr 2003a, S. 11. Eine ausführliche Quellenkritik findet sich bei Pfarr 2006, S. 47 – 64.

32 Ernst Kris absolvierte nach seiner Emigration in die USA eine universitäre Karriere im Fachbereich Psychologie. An seine Vergangenheit als Kunsthistoriker soll er sich nicht gerne erinnert haben; siehe Mikoletzky 1982, S. 49.

33 Glandien 1981, S. 90.

34 Glandien 1981, S. 85 – 89.

35 »Seine erste Erkrankung könnte also durchaus eine schwere akute Bleivergiftung gewesen sein [...]«; Behr / Grohmann / Hagedorn 1983, S. 66.

36 Krauß 1986, S. 133.

37 Siehe Gorsen 1997, S. 75 – 76.

38 Siehe Fanta 2002, S. 136 – 138. Von dem in den 1970er Jahren entfachten Diskurs um die Problematik des psychoanalytischen Symbolbegriffs scheint die Messerschmidt-Forschung unberührt geblieben zu sein. Paul Ricœur, einer der Protagonisten der Diskussion, hatte die Bedingtheit psychoanalytischer Ästhetik formuliert, die letztlich darauf zurückzuführen sei, dass diese ihr Interesse, ihre operativen Begriffe und Topoi nicht am Kunstwerk, sondern am psychopathologischen Phänomen gebildet habe. Ricœur spricht von einer »innere[n] Beschränkung« der Psychoanalyse. Daraus soll nach Ricœur resultieren, dass die psychoanalytische Kunstbetrachtung nur die »Libido in der Kultursituation« im Blick haben kann; siehe Ricœur 1974, S. 165 – 166.

39 Siehe Tietze-Conrat 1920, S. 29.

40 Siehe Wittkower 1965, S. 124. Dies scheint mit den Begriffen »Bifokalität« und »Desillusionierung« zu korrespondieren, die Werner Hofmann für Kennzeichen eines »entzweiten Jahrhunderts« hält; siehe Hofmann 1995, S. 96 – 97.

41 »Messerschmidt ist in einer Zeit geboren, in der alte (barocke) Anschauungen zu Ende gingen und geistige Veränderungen passierten, die man schon als einen neuen Wendepunkt der Kunst ganz global bezeichnen und umschreiben könnte. [...] Typisch für die gesamte geistige Entwicklung des späteren 18. Jahrhunderts ist jedenfalls das Vorstoßen in Phantastisches, Sinnenhaftes, Dionysisches und in Geheimnisse des Lebens.«; Biedermann 1978, S. 31.

being reminded of his past as an art-historian; see Mikoletzky 1982, p. 49.

33 Glandien 1981, p. 90.

34 Ibid., pp. 85 – 89.

35 "His first illness may well have been a severe attack of acute lead poisoning [...]"; Behr / Grohmann / Hagedorn 1983, p. 66.

36 Krauss 1986, p. 133.

37 See Gorsen 1997, pp. 75f.

38 See Fanta 2002, pp. 136ff. Messerschmidt scholarship seems to have been left untouched by the discourse that flared up in the 1970s on the problems associated with the psychoanalytical conception of symbolism. Paul Ricœur, one of the leaders of those debates, formulated the limitations of the psychoanalytical aesthetic, which ultimately derive from the circumstance that it did not develop its interest, its operative terminology and *topoi* from the work of art but from psychopathological phenomena. As a result, according to Ricœur, psychoanalytical study of art can only be focused on the "libido in the cultural situation"; see Ricœur 1974, pp. 165f.

39 See Tietze-Conrat 1920, p. 29.

40 See Wittkower (the German translation) 1965, p. 124. This seems to correspond to the terms "bifocality" and "disillusionment", which Werner Hofmann regards as the distinguishing characteristics of an "alienated century"; see Hofmann 1995, pp. 96f.

41 "Messerschmidt was born at a time when the old (Baroque) world-views were drawing to a close and intellectual changes were occurring which might already be designated and redefined in general as a new turning taken by art. [...] Typical of the overarching intellectual development in the late 18th century is in any case an urge to penetrate the fantastic, sensual, Dionysian and the mysteries of life"; Biedermann 1978, p. 31.

42 According to Biedermann, the gamut of expressions achieved in the Character Heads ranges from the reproduction of a simple physiognomic state such as repose to polysemic meanings, which are problematic for any interpretation; see Biedermann 1978, p. 29.

43 See Pötzl-Malíková 1987. See also the alabaster medallion in the sculpture collection owned by the Staatliche Museen in Berlin, which the author identified in 1994 as a self-portrait of Messerschmidt; Pötzl-Malíková 2003, p. 255 (fig. 40).

44 See Pötzl-Malíková 1996. In addition to the inventory of Messerschmidt's chattels, the "Specification deren Meßerschmidischen Mobilien" of 1783, she also included in that publication a record of money owed to him tendered by Messerschmidt's last employee, Leopold Zeilinger.

45 See on this p. 23 – 24 in the present catalogue.

46 "In parallel [...] the artist was preoccupied [...] of his own accord with working on the 'Character Heads'. This occupation [...] is causally related to a mental illness [...]"; Pötzl-Malíková 1982, p. 90.

47 "The heads or rather the grimaces of these heads thus fulfil an apotropaic function; they perpetuate the faces which

42 Das Ausdrucksspektrum der Charakterköpfe reicht laut Biedermann von der Wiedergabe eines einfachen physiognomischen Zustandes, wie Ruhe, bis zu mehrschichtigen Bedeutungsinhalten, die für eine Interpretation problematisch sind; siehe Biedermann 1978, S. 29.

43 Siehe Pötzl-Malíková 1987. Siehe auch das Alabastermedaillon in der Skulpturensammlung der Staatlichen Museen in Berlin, das die Autorin 1994 als Selbstbildnis von Messerschmidt identifiziert; Pötzl-Malíková 2003, S. 255 (Abb. 40).

44 Siehe Pötzl-Malíková 1996. Neben der »Specification deren Meßerschmidischen Mobilien« von 1783 publiziert sie an gleicher Stelle ein Schriftstück über eine finanzielle Forderung von Messerschmidts letztem Mitarbeiter Leopold Zeilinger.

45 Siehe dazu S. 23–24 in diesem Katalog.

46 »Parallel [...] beschäftigte sich der Künstler [...] aus eigenem Antrieb mit der Arbeit an den ›Charakterköpfen‹. Diese Tätigkeit [...] steht in kausaler Beziehung zu einer Geisteskrankheit [...]«; Pötzl-Malíková 1982, S. 90.

47 »Die Köpfe, besser gesagt, die Grimassen dieser Köpfe, erfüllen damit eine apotropäische Funktion, sie verewigen die Grimassen, die er selber zur Abwehr gegen diese Geister schnitt.«; Pötzl-Malíková 1982, S. 78.

48 Siehe Oberhaidacher 1984, S. 32.

49 Siehe Oberhaidacher 1984, S. 34–35.

50 Siehe Oberhaidacher 1984, S. 40–41.

51 Kris 1932, S. 222.

52 In diesem Katalog wird die Frankfurter Büste in die Zeit nach 1777 datiert; siehe Kat.-Nr. 5.

53 Siehe Beck 1989, S. 215–217.

54 Siehe Beck 1989, S. 214.

55 Siehe Beck 1989, S. 218.

56 »Ihren Anfang genommen hatte die Serie aus der Absicht heraus, sich damit auf dem ›freien Markt‹ zu bewähren [...].«; siehe Gampp 1998, S. 27.

57 Und weiter: »Es entsteht also ein zirkuläres Modell, das sich deutlich abhebt von linearen Vorstellungen einer Serie im älteren Sinne, die an eine ›Historia‹ gebunden ist.«; Gampp 1998, S. 33–34. Ähnlich charakterisiert Luigi A. Ronzoni die Serie der Charakterköpfe: »Sie bildet, ohne inneren nachvollziehbaren Zusammenhang oder erklärbare Chronologie der Entstehung, eine akkumulative Reihe fratzenhafter Ausdrucksstudien männlicher Porträts.«; Ronzoni 1997, S. 36.

58 Siehe Kirchner 1991.

59 Siehe Kris 1932, S. 199.

60 Willibald Sauerländer bezeichnete Le Bruns Traité als »der extreme Versuch einer Dressur der Leidenschaften für ihre Wiedergabe durch Malerei und Skulptur, den die Geschichte der Kunsttheorie kennt.«; Sauerländer 1989, S. 20.

61 Kirchner 1991, S. 190–229.

62 Nach einem Probelauf wurde er ab 1760 jährlich veranstaltet. Einige Male fiel der Wettbewerb wohl aus finanziellen Gründen aus; siehe Kirchner 1991, S. 208.

63 Kirchner 1991, S. 204–205.

64 An ihrer Darstellung sollten sich die künstlerischen Beiträge der Teilnehmer orientieren; siehe Kirchner 1991, S. 197–203.

65 Scheyb 1774, Bd. 1, S. 5–6.

66 Siehe Krapf, Schnabelköpfe 2002, S. 92. Es handelt sich um eine Überarbeitung eines bereits 1995 erschienenen Aufsatzes; siehe Krapf 1995.

67 Krapf stellt Messerschmidts Faszination vom Proportionsstudium in einen ursächlichen Zusammenhang mit dessen Wettkampf mit Thot; siehe Krapf, Schnabelköpfe 2002, S. 95.

he himself made to ward off these spirits." Pötzl-Malíková 1982, p. 78 and Oberhaidacher 1984, pp. 34f.

48 See Oberhaidacher 1984, p. 32.

49 Ibid., pp. 34f.

50 Ibid., pp. 40f.

51 Kris 1932, p. 222.

52 In the present catalogue, the Frankfurt bust is dated to after 1777; see cat. no. 5.

53 See Beck 1989, pp. 215ff.

54 Ibid., p. 214.

55 Ibid., p. 218.

56 The series had been embarked on from an intention to prove himself with it on the "free market"; Gampp 1998, p. 27.

57 And Gampp goes on to say: "Thus arose a circular model, which clearly differs from linear notions of a series in the older sense, which is linked to a 'historia'."Gampp 1998, pp. 33f. Luigi A. Ronzoni characterises the sequence of Character Heads in similar terms: "It forms, without any observable intrinsic connection or explainable chronology of emergence, an accumulative array of mask-like studies of expression in masculine portraits." Ronzoni 1997, p. 36.

58 See Kirchner 1991.

59 See Kris 1932, p. 199.

60 Willibald Sauerländer called Le Brun's Traité "the most extreme attempt at sublimating the passions in order to reproduce them in painting and sculpture known to the history of art theory." Sauerländer 1989, p. 20.

61 Kirchner 1991, pp. 190–229.

62 After a trial, it was repeated annually from 1760. The competition was probably not held sometimes for financial reasons; see Kirchner 1991, p. 208.

63 Ibid., pp. 204f.

64 Their performances were to be the guideline for the art submitted by the contestants; see Kirchner 1991, pp. 197–203.

65 Scheyb 1774, Vol. 1, pp. 5f.

66 See Krapf, Schnabelköpfe 2002, p. 92. This is a revised version of an essay published in 1995; see Krapf 1995.

67 Krapf finds the causal link of Messerschmidt's fascination with the study of proportion in his competition with Thoth; see Krapf, Schnabelköpfe 2002, p. 95.

68 Krapf, Charakterköpfe 2002, pp. 62–63. The author calls Messerschmidt "Mesmer's Adept", his "alter ego", who translated his therapeutic method and theory of animal magnetism into art; see Krapf, Auftraggeber und Freundeskreis 2002, p. 72. In her 1987 essay – published to mark the occasion of the bust of Mesmer resurfacing – Pötzl-Malíková eliminates the possibility of a direct connection between Mesmer's teachings and the Character Heads; see Pötzl-Malíková 1987, p. 266.

69 "With them [the Character Heads] the artist sought [...] the most profound truth about man, his soul and its 'recondite stirrings'." Bückling 2002, p. 80.

70 See Bückling 2002, p. 82.

71 See Bückling 2002, pp. 82f. According to Bückling, Messerschmidt failed at the Academy because his aesthetic and

68 Krapf, Charakterköpfe 2002, S. 62 – 63. Der Autor bezeichnet Messerschmidt als Mesmers Adept, als dessen Alter ego, der die Heilmethode und die Theorie des animalischen Magnetismus in die Kunst übertrug; siehe Krapf, Auftraggeber und Freundeskreis 2002, S. 72. In ihrem – anlässlich der wieder aufgetauchten Büste Mesmers publizierten – Aufsatz von 1987 schließt Pötzl-Malíková einen direkten Zusammenhang zwischen den Lehren Mesmers und den Charakterköpfen aus; siehe Pötzl-Malíková 1987, S. 266.

69 »Mit ihnen [den Charakterköpfen] fragte der Künstler […] nach der tiefsten Wahrheit des Menschen überhaupt, seiner Seele und ihren ›geheimen Bewegungen‹.«; Bückling 2002, S. 80.

70 Siehe Bückling 2002, S. 82.

71 Siehe Bückling 2002, S. 82 – 83. An der Akademie sei Messerschmidt gescheitert, weil seine ästhetischen und weltanschaulichen Vorstellungen so gar nicht ins Konzept der Herrschenden passen wollten. 1776 hatte sich Hof- und Staatskanzler Fürst Wenzel von Kaunitz-Rietberg in einer Anweisung an die Akademie ausdrücklich zu einer Ästhetik Winckelmann'scher Prägung bekannt, jener Kaunitz, der zwei Jahre zuvor Messerschmidt eine »Verwürrung im Kopfe« attestiert hatte, was zu dessen Ausscheiden aus der Akademie geführt hatte. Dies ist für Bückling Beleg dafür, dass Messerschmidt »einer Intrige zum Opfer gefallen [war], die sich gegen einen Künstler richtete, der sich mit seinen Werken den kunsttheoretischen Vorgaben von Kaunitz widersetzte«; Bückling 2002, S. 85.

72 Zur These der Autorin, dass gegen den Künstler intrigiert wurde und seine vermeintliche Verwirrtheit als Vorwand für seine Ausgrenzung benutzt wurde, siehe Bückling 2002, S. 84 – 85. Zur Kausalität von Messerschmidts Scheitern und seiner neuen Formensprache siehe Bückling 1999a, S. 77 und Bückling 1999b, S. 110.

73 Messerschmidts Mienenspielexperimente vor dem Spiegel stellt sie in eine künstlerische Tradition wie auch in den Kontext der in den 1760er Jahren in Kunsttheorie und Medizin verbreiteten Selbsterforschung und Selbstbeobachtung; siehe Bückling 1999b, S. 109.

74 Pfarr 2006. Zum FACS siehe auch Städtler 2003, S. 399 – 400.

75 Kris 1932, S. 170.

76 Siehe Goeckingk 1820, S. 139 – 140.

world-views did not at all match the conception espoused by the rulers. In a 1776 instruction addressed to the Academy, Wenceslas, Prince Kaunitz-Rietberg, chancellor of court and state, had expressly professed an aesthetic shaped by Winckelmann; this was the same Kaunitz, who, two years before, had attested Messerschmidt's "confusion of mind", which led to the artist's leaving the Academy. For Bückling, this is evidence that Messerschmidt "[had] fallen victim to an intrigue directed at the artist, who opposed with his works the art theories prescribed by von Kaunitz"; Bückling 2002, p. 85.

72 On the author's hypothesis that intrigues were aimed at the artist and that his alleged insanity was used an excuse for expelling him, see Bückling 2002, pp. 84f. On the causes of Messerschmidt's failure and his new language of forms, see Bückling 1999a, p. 77 and Bückling 1999b, p. 110.

73 She positions Messerschmidt's experiments with facial expressions before the mirror in the context of artistic tradition and the experiments on oneself and observations of oneself frequently conducted in the 1760s in both art history and medicine; see Bückling 1999b, p. 109.

74 Pfarr 2006. On FACS see also Städtler 2003, p. 399f.

75 Kris 1932, p. 170.

76 See Goeckingk 1820, p. 139f.

Charakterköpfe
Katalognummern 4–23

Character Heads
catalogue nos. 4–23

Zinn mit kleinen
Mengen Kupfer und
Eisen, Spuren von
Zink, Arsen und Blei[1]
Höhe 43 cm
Preßburg, 1777–1781
Privatbesitz

Pewter with small
additions
of copper and iron,
traces of zinc,
arsenic and lead [1]
height 43 cm
Bratislava, 1777–1781
Private collection

[4]

Der Künstler, so wie er sich lachend vorgestellt hat

Zu den berühmtesten Charakterköpfen zählt jener, den der Anonymus in seiner »Merkwürdigen Lebensgeschichte des Franz Xaver Messerschmidt« 1794 am Beginn seiner Aufzählung behandelt (Kat.-Nr. 4a). Auf dem Kupferstich, den er seiner Broschüre voranstellt (Abb. 43), ist der Kopf als Teil eines imaginären Denkmals inszeniert und in einer Nische aufgestellt: »Der Künstler, so wie er sich lachend vorgestellt hat«.[2] Auch in Mathias Rudolph Tomas 1839 veröffentlichter Lithographie von 49 Charakterköpfen (Abb. 37) nimmt er in der obersten Reihe zwischen den beiden Schnabelköpfen eine auffallende Position ein. In der Vorzeichnung zu dieser Lithographie von Joseph Haßlwander (1812–1878, Abb. 44) steht diese Position noch nicht fest: Der Graphiker gibt sie ein zweites Mal zwischen »Der Gähner« und »Der Speyer« wieder.[3]

Es ist die vielleicht bekannteste Büste, die allgemein als Selbstporträt akzeptiert wird. Zwei Äußerungen bezeichnen den Kopf als solches. Zum einen handelt es sich um Nicolais Bericht: »Er hatte sich einmal lachend sehr schön, und dann auch den Mund ganz aufsperrend, gebildet […]; Gegenstände die vielleicht noch nie von einem Bildhauer sind vorgestellet worden. Dieß war mit einer bewunderungswürdigen Richtigkeit und Wahrheit gearbeitet.«[4] Zum anderen schreibt der Anonymus: »Seine Gesichtsbildung ist sprechend getroffen. Wer ihn persönlich kannte und seiner Büste nur mit

The Artist As He Imagined Himself Laughing

One of the most famous Character Heads is the one mentioned at the beginning of the enumeration in the anonymous "Merkwürdige Lebensgeschichte des Franz Xaver Messerschmidt" in 1794 (cat. no. 4a). In a copperplate engraving placed at the beginning of the treatise (fig. 43), this Head is presented as part of an imaginary monument and placed in an alcove: "The Artist As He Imagined Himself Laughing".[2] This head is also given a prominent place in the lithograph of 49 Character Heads published by Mathias Rudolph Tomas in 1839 (fig. 37) in the upper row between the two Beaked Heads. In the preliminary sketch for that lithograph by Joseph Hasslwander (1812–1878, fig. 44), the position has not yet been decided: the graphic artist shows it a second time between "The Yawner" and "A Man Vomiting".[3]

Probably the best-known of these busts, it is generally believed to be a self-portrait. Two recorded statements describe the head as a self-portrait. One is in Nicolai's account: "He had represented himself once, laughing very handsomely and then also opening his mouth as wide as possible […]; objects that perhaps have never yet been represented by a sculptor. This was wrought with an admirable justness and truth."[4] The second is written by Anonymous: "The formation of his countenance has been caught to a speaking likeness. Anyone who knows him personally and encounters his bust at a glance must exclaim with utter conviction: that is Messerschmidt!"[5]

This bust reveals motif configurations that are typical of the Character Heads: a quite scant section of bust is set on an almost square block and supports the head frontally, which looks especially monumental in comparison with the bust section because of the head-dress. In this case, it is not an abnormal distortion that contorts the facial features. Instead the viewer is astonished by open-mouthed laughter with the mouth so wide open that the upper jaw is bared to expose a regular row of teeth and even the gums

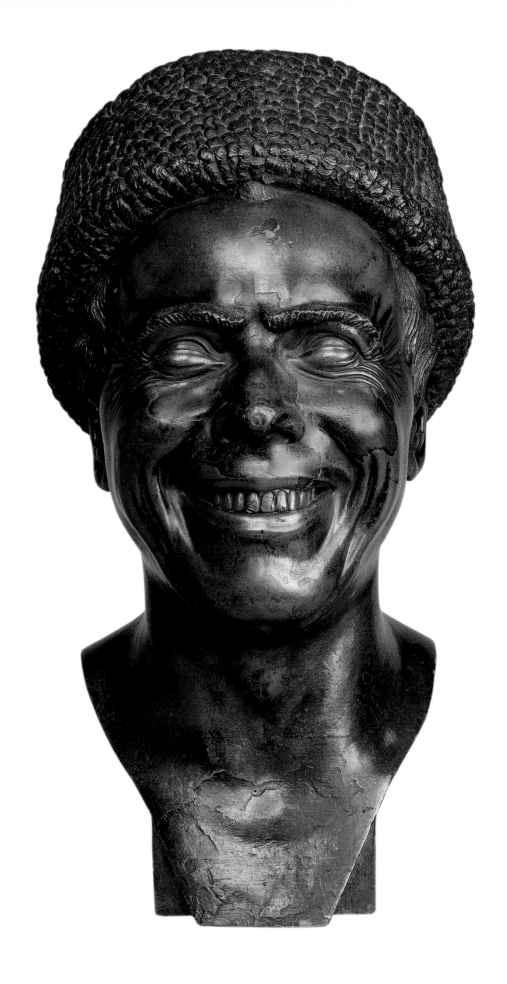

[4a]

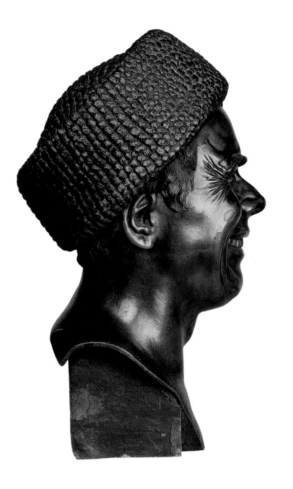

Kat.-Nr. 4b / *Cat. no. 4b*
Franz Xaver Messer-
schmidt, Der Künstler,
so wie er sich lachend
vorgestellt hat, Seiten-
ansicht
Franz Xaver Messer-
schmidt, The Artist As
He Imagined Himself
Laughing, side view

Kat.-Nr. 4c / *Cat. no. 4c*
Franz Xaver Messer-
schmidt, Der Künstler,
so wie er sich lachend
vorgestellt hat, Rück-
ansicht
Franz Xaver Messer-
schmidt, The Artist As
He Imagined Himself
Laughing, rear view

einem Blick begegnet, muß mit aller Überzeugung ausrufen: Das ist Messerschmidt!«[5]

Die Büste weist das für die Charakterköpfe typische Motivgefüge auf: Ein recht knapper Büstenausschnitt ist auf einem annähernd quadratischen Kubus aufgesockelt und trägt den frontal ausgerichteten Kopf, der durch die Kopfbedeckung besonders monumental im Vergleich zum Brustausschnitt wirkt. Es ist in diesem Fall keine abnorme Verzerrung, die die Gesichtszüge entstellt, sondern es verblüfft das Lachen mit offenem Mund, das die oberen Zähne als regelmäßige Zahnreihe entblößt und zwar so weit, dass etwas Zahnfleisch zu sehen ist (Kat.-Nr. 4d). Die durch das Lachen breit gezogenen Lippen schieben die Wangen zu hochgewölbten, prallen Bäckchen zusammen, in die sich zu Seiten der Mundwinkel tiefe Falten eingraben. Eingekerbte Krähenfüße unterstützen als Lachfalten die fröhliche Mimik des Kopfes. Gleichzeitig sind durch die hochgewölbten Wangen Tränensäcke und Unterlider nach oben geschoben, voneinander durch tief eingegrabene Falten getrennt und zu einer unnatürlich wirkenden Partie verformt. Die Augen sind dadurch nur als

(cat. no. 4d). The lips, being stretched so wide, push the cheeks up to bulging, plump little puffs in which the sides of the corners of the mouth have left deep lines. Notched crow's feet support the cheerful expression of the face as wrinkles caused by laughter. At the same time, the lachrymal sacs and lower lids are pushed upwards by the bulge of the cheeks, separated by deep wrinkles and deformed into an unnatural looking facial zone. This leaves the eyes open only as narrow slits, especially since the orbital ridge lies heavily above the upper lids. The eyes are overarched by brows with the hairs meticulously rendered. As in "A Surly Old Soldier" (cat. no. 7), "The Melancholic" (cat. no. 8) and "Quiet Peaceful Sleep" (cat. no. 9), they look like forms deliberately applied with a raised ridge. Wrinkles incised as lines underscore the entire orbital zone, including lachrymal sacs and upper and lower lids, to create a disturbing impression since the

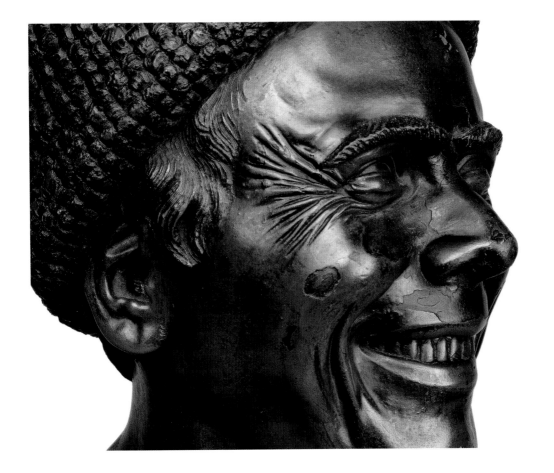

schmale Schlitze geöffnet, zumal sich die Orbitalwülste schwer über die Oberlider legen. Die Augen werden überwölbt von Augenbrauen, deren Haare minutiös eingetragen sind. Sie wirken, wie bei »Ein mürrischer alter Soldat« (Kat.-Nr. 7), »Der Melancholikus« (Kat.-Nr. 8) oder »Der sanfte ruhige Schlaf« (Kat.-Nr. 9), wie eigens aufgesetzte Formen mit einem erhabenen Grat. Die gesamte Augenpartie mit Tränensack, Unter- und Oberlid macht, unterstrichen noch durch die graphisch eingetragenen Falten, einen irritierenden Eindruck, da gelegentlich das vorgewölbte, in sich leicht verformte Unterlid wie ein Augapfel wirkt.

Wie Nicolai schrieb, hatte Messerschmidt mit seinem lachenden Bildnis einen »Gegenstand [gebildet, der] vielleicht noch nie von einem Bildhauer« wiedergegeben worden war; anders »Der Speyer« (Abb. 45), auf den sich der zweite Teil des oben wiedergegebenen Zitats aller Wahrscheinlichkeit nach bezog: »Er hatte sich [...] dann auch den Mund ganz aufsperrend gebildet«. In Darstellungen wie der »Anima Dannata« Gian Lorenzo Berninis (1598 – 1680, Abb. 74) beziehungsweise der Kopie von Massimiliano Soldani

slightly deformed lower lid occasionally looks like an eyeball.

As Nicolai wrote, Messerschmidt had created an object in this laughing self-portrait which might "never before have been represented by a sculptor". Unlike "A Man Vomiting" (fig. 45), to which the second part of the above quotation is highly likely to refer: "he had represented himself [...] with his mouth wide open." The models for facial action of this kind can be found in representations such as the "Anima Dannata" of Gian Lorenzo Bernini (1598 – 1680), or the copy by Massimiliano Soldani Benzi (1656 – 1740) in the Sammlungen der Fürsten von und zu Liechtenstein (Vaduz-Vienna)[6] or even in allegories of damnation or vice.[7] By contrast, laughter is unusual in sculpture.[8] Otherwise laughing faces occur in, for example, paintings or reliefs depicting Democritus (fig. 46). Paintings by Hendrick ter Brugghen (1588 – 1629)

Benzi (1656–1740) in den Sammlungen des Fürsten von und zu Liechtenstein (Vaduz-Wien)[6] oder auch in Allegorien der Verdammnis oder des Lasters[7] findet eine solche Mimik ihre Vorbilder. Demgegenüber ist das Lachen in der Skulptur unüblich.[8] Ansonsten finden sich lachende Gesichter etwa bei gemalten oder reliefierten Darstellungen des Demokrit (Abb. 46). Gemälde von Hendrick ter Brugghen (1588–1629) oder Johannes Moreelsen (nach 1602–1634) geben den lachenden Philosophen mit weit geöffnetem Mund und – häufig – halbnacktem Oberkörper wieder.[9] Dasselbe trifft auf Darstellungen von »fröhlichen Trinkern« (Abb. 47) zu, die insbesondere in der niederländischen Malerei des 17. Jahrhunderts beliebt waren.[10] Gelegentlich stellten sich Künstler, so Joseph Ducreux (1735–1802, Abb. 48), selbst als Demokrit dar, verzichteten auf Perücke und gesellschaftlich angemessene Kleidung.[11]

Messerschmidt stellt sich mit seinem lachenden Bildnis außerhalb der Norm, wie ein Zitat aus von Scheybs Kunstbetrachtungen zeigt: »Das Lachen drückt sich in allen Theilen des Angesichts wunderbar aus; absonderlich im Mund und in den Augen, und zwar dergestalt, daß die Augenbrauen sich plötzlich gegen die Schläfe erhöhen, und die Augen, die Wangen, und die Augenlieder in Bewe-

and Johannes Moreelsen (after 1602–1634) depict the laughing philosopher with his mouth wide open and – frequently – a half-naked torso.[9] This also applies to representations of "jolly drunkards" (fig. 47), which were particularly popular in 17th-century Dutch genre painting.[10] An artist may even occasionally depict himself as Democritus, for example Joseph Ducreux (1735–1802) (fig. 48), eschewing the wig and clothing appropriate to his actual social status.[11]

With his laughing self-portrait, Messerschmidt has disregarded the norm as is shown in a quotation from Scheyb's observations on art: "Laughter is wonderfully expressed in all parts of the countenance: especially in the mouth and eyes and in the form that the eyebrows are suddenly raised above the temples and the eyes, cheeks and eyelids are set in motion. Even the nostrils and the mouth dilate, which causes the cheeks to bulge. Here, however, it can be observed that Antiquity only opened the mouth far enough for the upper lip at the beginning

gung kommen. So gar die Nasenlöcher und der Mund erweitern sich, wodurch die Wangen anschwellen. Hier ist aber zu beobachten, daß das Antique den Mund nur so viel geöffnet habe, als die Oberlippe gleich anfangs die Zähne ein wenig sehen läßt. Außerdem bemerke man auch, daß das Lachen nur in Köpfen von Satyrn und Faunen anzubringen sey, weil es, wenn solches wider das gehörige Maaß und Ziel geschieht, ein leichtsinniges Gemüth bedeutet.«[12]

Abgesehen von der Mimik ist ungewöhnlich, dass der Kopf eine Fellkappe (Kat.-Nr. 4b–c) trägt, eine Ausnahme in der Serie der Charakterköpfe.[13] Es handelt sich dabei möglicherweise um eine so genannte Baranica aus Lammfell, um eine Mütze, die slowakischen Bauern als winterliche Kopfbedeckung diente und von denen Messerschmidt wohl zwei – »2 St Budl Hauben«[14] – besaß. Sie ist aus zahlreichen kleinen, fest in sich zusammengerollten Löckchen zusammengesetzt, die Messerschmidt minutiös ziselierte, und auf der Rückseite mit einer Naht versehen. Unter ihr lugen von der Stirn bis zum Hinterkopf kurze, an den Schläfen längere, leicht gewellte Haarsträhnen hervor, die in ihrer zwischen Detailliertheit und groberen Strukturen schwankenden Gestaltung an »Ein mürrischer alter Soldat« (Kat.-Nr. 7), »Der Melancholikus« (Kat.-Nr. 8) und »Ein Gelehrter, Dichter« (Abb. 49) erinnern. Mit der Tracht der Baranica wäre die Datierung der Büste auf vier Jahre eingeengt, denn Messerschmidt lebte in der slowakischen Hauptstadt erst seit 1777, und Nicolai beschrieb den Kopf nach seinem Besuch bei Messerschmidt im Jahr 1781.[15]

to reveals only a little of the teeth. In addition, one should note that laughter should only be depicted in the heads of Satyrs and Fauns because it signifies a frivolous disposition opposing the proper proportion and purpose"[12]

Apart from the facial expression, it is unusual for a Head to wear a fur cap (cat. nos. 4b–c), which is the exception in the sequence of Character Heads.[13] This may possibly be what was known as a baranica made of lambskin, a cap worn by Slovak peasants in winter and of which Messerschmidt probably had two – "2 St Budl Hauben".[14] It is made up of countless little tight curls, which Messerschmidt meticulously chiselled, and has a seam on the back. Beneath it fairly long, slightly wavy strands of hair peep out from beneath it from the forehead to the back of the head. In wavering between intricate detailing and coarser textures, the handling of these locks is reminiscent of the rendering of the hair in "A Surly Old Soldier" (cat. no. 7), "The Melancholic" (cat. no. 8) and "A Scholar, Poet" (fig. 49). If the cap is a baranica, it would narrow down the dating of the bust to four years since Messerschmidt had only lived in the Slovak capital since 1777 and Nicolai described the head after visiting Messerschmidt in 1781.[15]

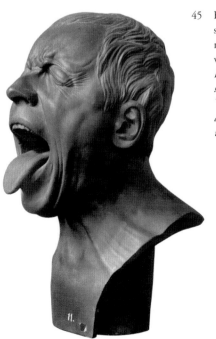

45 Franz Xaver Messerschmidt, Der Speyer, nach 1770, Alabaster, verschollen
Franz Xaver Messerschmidt, A Man Vomiting, after 1770, alabaster, whereabouts unknown

46 Demokrit, 1. Hälfte 18. Jahrhundert, Speckstein, Holz, Liebieghaus Skulpturensammlung, Frankfurt am Main, Inv.-Nr. St. P. 153
Democritus, 1st half 18th century, soapstone, wood, Liebieghaus Sculpture Collection, Frankfurt am Main, Inv. no. St. P. 153

Representations of head-dress are extremely rare in sculpture. As a rule, wigs were the only head covering permitted to be worn publicly, apart from military and clerical head-dress. In the 18th century, hats or caps were, if permitted at all, carried under the arm or only worn in the house.[16] Messerschmidt is, therefore, infringing a social convention by alluding to peasant dress in covering his head. Laughing figures occur in the visual arts almost exclusively in coarse peasant scenes such as the "jolly drunkards" (fig. 47). On the one hand, Messerschmidt has appropriated village genre representations for this – his? – head. In addition, the head-dress may possibly, through the ironic memory of drinking scenes, stand for the close ties he has forged with his new place of residence.[17] However, self-portraits of artists wearing hats, stocking-caps or caps are certainly not rare in painting and prints.[18] Messerschmidt may, via von Scheyb, have been made acquainted with a self-portrait by William Hogarth (1697–1764) dating from 1745, which decorated a 1749 sequence of engravings as the frontispiece (fig. 50).[19]

Darstellungen von Kopfbedeckungen sind in der Skulptur außerordentlich selten. Als öffentliche Kopfbedeckung waren, von militärischen oder klerikalen Hüten und Mützen abgesehen, in der Regel nur Perücken erlaubt. Hut oder Kappe wurden, wenn überhaupt, im 18. Jahrhundert unter dem Arm oder nur im Haus getragen.[16] Messerschmidt bricht somit mit einer Konvention der Gesellschaft, indem er sich auf eine bäuerliche Tracht bezieht. Lachende Gestalten kommen in der bildenden Kunst fast ausnahmslos in derb-bäuerlichen Szenen, wie den fröhlichen Trinkern (Abb. 47), vor. Messerschmidt verwandelt zum einen diesen – seinen? – Kopf dörflichen Genredarstellungen an; außerdem steht die Kopfbedeckung möglicherweise, ironisch gebrochen durch die Erinnerung an Trinkerszenen, für seine Verbundenheit mit seinem neuen Lebensort.[17] Allerdings sind Selbstporträts von Künstlern mit Hut, Mütze oder Kappe in der Malerei und Graphik nicht selten.[18] Insbesondere könnte Messerschmidt über von Scheyb Kenntnis über ein Selbstbildnis von William Hogarth (1697–1764) aus dem Jahr 1745 erhalten haben, das eine Stichfolge als Frontispiz 1749 (Abb. 50) schmückte.[19]

Der Kopf »Der Künstler, so wie er sich lachend vorgestellt hat« könnte, und so wurde er sowohl von Nicolai als auch vom Anonymus verstanden, eine Vorstellung vom Aussehen Messerschmidts

47 Hendrick ter Brugghen,
Der fröhliche Trinker,
um 1625, Öl auf Lein-
wand, Centraal
Museum, Utrecht,
Inv.-Nr. 11480
Hendrick ter Brugghen,
The Jolly Drinker,
c. 1625, oil on canvas,
Centraal Museum,
Utrecht, Inv. no. 11480

49 Franz Xaver Messer-
schmidt, Ein Gelehrter,
Dichter, 1777–1781,
Blei, ehemals Staatliche
Museen zu Berlin,
Skulpturensammlung
und Museum für
Byzantinische Kunst,
Eigentum des Kaiser-
Friedrich-Museums-
Vereins, seit 1945
verschollen,
Inv.-Nr. M 193
Franz Xaver Messer-
schmidt, A Scholar,
Poet, 1777–1781, lead,
formerly Staatliche
Museen zu Berlin,
Skulpturensammlung
und Museum für
Byzantinische Kunst,
property of Kaiser-
Friedrich-Museums-
Vereins, whereabouts
unknown since 1945,
Inv. no. M 193

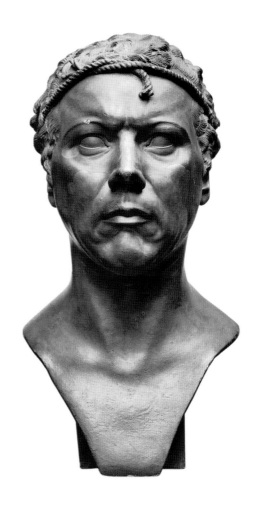

vermitteln. Damit könnte er einen Ausgangspunkt bei der Frage nach der Selbstbildnishaftigkeit aller Charakterköpfe darstellen. Allerdings steht dem die Mimik, das heißt das Lachen, entgegen, die nicht erkennen lässt, wie groß die Augen sind – zeigt das Bildnis sie doch zu Schlitzen verengt –, und die auch den Gesichtsschnitt und die gesamte Physiognomie durch die breit verzogenen Lippen und die prall hochgewölbten Bäckchen verändert. Die Schädelform wird wiederum von der aufgesetzten Kappe verunklärt. So können wir tatsächlich nur, Nicolai und dem Anonymus vertrauend, erkennen, wie Messerschmidt aussah, wenn er lachte. Weitere Schlussfolgerungen sind nicht möglich.

48 Joseph Ducreux,
Selbstbildnis als Spötter,
nach 1780, Öl auf
Leinwand, Musée du
Louvre, Paris,
Inv.-Nr. RF 2261
Joseph Ducreux, Self-
Portrait as a Mocker,
after 1780, oil on canvas,
Musée du Louvre,
Paris, Inv. no. RF 2261

The Head "The Artist As He Imagined Himself Laughing" might be interpreted as conveying an idea of Messerschmidt's appearance and this is how it was viewed both by Nicolai and Anonymous. Consequently, it might represent a point of departure for considering the extent to which all the Character Heads might be self-portraits. However the facial action, that is, the laughter, would seem to refute this since it conceals the size of the eyes – the portrait depicts them as narrowed to slits – and the cut of the face and the entire countenance are changed by the lips being stretched wide and the puffed cheeks bulging with such plumpness. Moreover, the shape of the skull is obscured by the cap set on it. As a result, if we trust Nicolai and Anonymous, we can only recognise what Messerschmidt looked like when he was laughing. No further conclusions as to his appearance can be drawn.

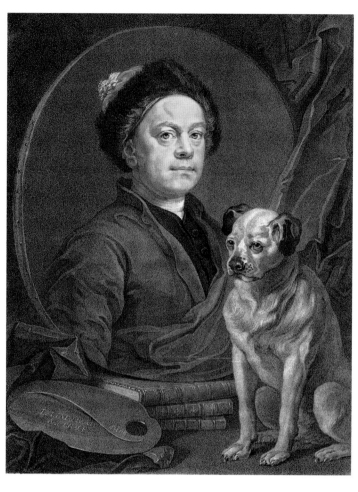

50 Benjamin Smith
nach William Hogarth,
Selbstbildnis mit Hut,
Roulette, Städel
Museum, Frankfurt am
Main, Inv.-Nr. 27507
Benjamin Smith
after William Hogarth,
Self-Portrait with Dog,
Roulette, Städel Museum,
Frankfurt am Main,
Inv. no. 27507

1 The material analysis was kindly placed at my disposal by a private collection.
2 Anon. 1794, frontispiece.
3 The preliminary drawing was first published in Pötzl-Malíková 2003, pp. 260f., fig. 304. The drawing is in the Vienna Museum, Vienna, Inv. no. 64.770/1.
4 Nicolai Reprint 1994, p. 415.
5 Anon. 1794, p. 42.
6 For picture see Bückling 1996, p. 77.
7 Messerschmidt might have seen a representation of Vice in the collections of the Prince of Liechtenstein (Filippo Parodi, Inv. no. p. 11), a work with the mouth shown wide open; shown in Bückling 1996, p. 57; for a representation of Damnation, see, for example, an ivory medallion (1736) by Johann Christoph Lücke in: exhib. cat Elfenbein 2001, pp. 40f.
8 Jean-Antoine Houdon was the first to show it, in his 1787 portrait of his wife: Jean-Antoine Houdon, "Portrait of Mme Houdon", Paris, Musée du Louvre, Inv. no. RF 1391. The portraits Houdon executed in 1778 of Voltaire, whose toothless closed mouth has a suggestion of a smile, conform with the convention, unlike Messerschmidt's self-portrait.
9 Julien Offroy La Mettrie, physician, philosopher and reader to Frederick the Great of Prussia, is depicted as "Democritus" in a well-known print dating from 1751 that is almost a caricature; shown in: exhib. cat Lavater 1999, pp. 320f.
10 Helmus 1999, pp. 162–164 (Hendrick ter Brugghen, "The Jolly Drinker", c. 1625); pp. 218–222 (Johannes Moreelsen, "Heraclitus", c. 1630). See also Weisbach 1928, p. 149f., 152, 157.
11 See Lyon 1958, pls. XVI, XXIV. See also Kris 1932, pp. 202f.; Pfarr 2006, pp. 393–398. Isaac Jourdeville, a pupil of Rembrandt, also painted a laughing self-portrait, shown in: Grimm 1991, fig. 20. Messerschmidt may have known Ducreux since the latter was sent to Vienna in 1769 to paint a portrait of Archduchess Marie Antoinette. Ducreux stayed in Vienna for several years; on this see Jean Locquin in: Thieme-Becker, Leipzig, Vol. 10, pp. 45ff.
12 Scheyb 1770, Vol. 2, pp. 79f.
13 On this see Gampp 1998, p. 23; Bückling 2002, p. 81.

1 Die Materialanalyse wurde freundlicherweise von privat zur Verfügung gestellt.
2 Anonymus 1794, Frontispiz.
3 Die Vorzeichnung wurde erstmals publiziert von Pötzl-Malíková 2003, S. 260–261, Abb. 304. Die Zeichnung befindet sich im Wien Museum, Wien, Inv.-Nr. 64.770/1.
4 Nicolai Reprint 1994, S. 415.
5 Anonymus 1794, S. 42.
6 Abb. siehe Bückling 1996, S. 77.
7 In den Sammlungen des Fürsten von Liechtenstein hatte Messerschmidt eine Darstellung des Lasters (Filippo Parodi, Inv.-Nr. S 11), das mit weit geöffnetem Mund dargestellt ist, sehen können; Abb. siehe Bückling 1996, S. 57; zur Darstellung der Verdammnis siehe beispielsweise ein Elfenbeinmedaillon von Johann Christoph Lücke von 1736 in: Ausst.-Kat. Elfenbein 2001, S. 40–41.
8 Erst Jean-Antoine Houdon zeigte es 1787 in einem Porträt seiner Frau: Jean-Antoine Houdon, »Porträt der Mme Houdon«, 1787, Paris, Musée du Louvre, Inv.-Nr. RF 1391. Houdons 1778 geschaffene Porträts von Voltaire, dessen zahnloser, geschlossener Mund ein Lächeln andeutet, entsprechen, anders als Messerschmidts Bildnis, eher der Konvention.
9 Als »Demokrit« wurde in einer bekannten Graphik von 1751, nahezu karikierend, Julien Offroy La Mettrie, Arzt, Philosoph und Vorleser Friedrichs II. von Preußen, gezeigt; Abb. in: Ausst.-Kat. Lavater 1999, S. 320–321.

10 Helmus 1999, S. 162–164 (Hendrick ter Brugghen, »Der fröhliche Trinker«, um 1625); S. 218–222 (Johannes Moreelsen, »Heraklit«, um 1630). Dazu siehe ebenfalls Weisbach 1928, S. 149, 150, 152, 157.

11 Siehe Lyon 1958, Tf. XVI, XXIV. Dazu auch Kris 1932, S. 202–203; Pfarr 2006, S. 393–398. Ein lachendes Selbstbildnis malte gleichfalls der Rembrandt-Schüler Isaac Jourdeville, Abb. in: Grimm 1991, Fig. 20. Messerschmidt konnte Ducreux gekannt haben, wurde dieser doch 1769 nach Wien gesandt, um das Bildnis von Erzherzogin Marie Antoinette zu malen. Er blieb mehrere Jahre, dazu siehe Jean Locquin in: Thieme-Becker, Bd. 10, S. 45–47.

12 Scheyb 1770, Bd. 2, S. 79–80.

13 Dazu siehe Gampp 1998, S. 23; Bückling 2002, S. 81. Krapf (Katalog 2002, S. 172) weist darauf hin, dass die Reiterfigur des Heiligen Martin der monumentalen Gruppe von Georg Raphael Donner im Martinsdom zu Bratislava gleichfalls eine der Baranica verwandte Kopfbedeckung trägt. Dazu siehe Abb. in: Ausst.-Kat. Donner 1993, Abb. S. 51.

14 So auch Krapf (Katalog 2002, S. 172), der auf die 1996 von Pötzl-Malíková veröffentlichte »Specification deren Meßerschmidischen Mobilien« (Pötzl-Malíková 1996, S. 220) verweist.

15 Zur Datierung von »Ein mürrischer alter Soldat« (Kat.-Nr. 7), »Der Melancholikus« (Kat.-Nr. 8) und »Ein Gelehrter, Dichter«, die sich aufgrund der Haar- und Augenbrauengestaltung sowie aufgrund der großflächigen Modellierung der Physiognomie an der des lachenden Selbstbildnisses orientieren, siehe Kat.-Nr. 8.

16 Dazu siehe beispielsweise das Selbstbildnis Paul Trogers im Deshabillé und mit Hausmütze, Abb. in: Ausst.-Kat. Donner 1993, S. 111; Porträt des Matthäus Donner mit modischer Kappe, Abb. siehe ebd., S. 232.

17 Ähnlich siehe dies bei der Büste des Martin Georg Kovachich, dazu Bückling 1999b, S. 108–109.

18 Dazu siehe Vergleiche insbesondere aus dem 17. Jahrhundert in: Ausst.-Kat. face to face 1994, S. 42, 43, 52, 53, 65–68.

19 Dazu siehe Ausst.-Kat. face to face 1994, S. 54, 76.

Literatur

Anonymus 1794, S. 42–43 (Nro. 1); Kris 1932, S. 192, 204, Abb. 167–168 (Abguss); Kris 1933, S. 393, 399, Abb. 2; Glandien 1981, S. 46; Biedermann 1978, S. 28; Pötzl-Malíková 1982, S. 71, 243–244 Behr/Grohmann/Hagedorn 1983, S. 158; Bücherl 1989, S. 58, 62; Presler 1996, S. 77–78, Abb. S. 74; Gampp 1998, S. 23; Krapf, Katalog 2002, S. 170–173; Bückling 2002, S. 81; Pötzl-Malíková 2004, Abb. S. 68; Schmid 2004, S. 12; Pfarr 2006, S. 232–234, 393–398, Abb. 32–33.

Krapf (Katalog 2002, p. 172) points out that the equestrian figure of St Martin in the monumental group by Georg Raphael Donner in St Martin's Cathedral in Bratislava also wears a baranica on his head. On this see the illustration in: exhib. cat Donner 1993, illus. p. 51.

14 Thus also Krapf (Katalog 2002, p. 172), who refers to the inventory of Messerschmidt's chattels published in Pötzl-Malíková 1996, p. 220.

15 On the dating of "A Surly Old Soldier" (cat. no. 7), "The Melancholic" (cat. no. 8) and "A Scholar, Poet", on the grounds that the handling of hair and eyebrows as well as the large surfaces in the modelling of the countenance resemble the Laughing Self-Portrait, see cat. no. 8.

16 See for example the self-portrait of Paul Troger *en déshabille* and wearing a cap, shown in: exhib. cat Donner 1993, p. 111; portrait of Matthäus Donner wearing a stylish cap, shown ibid., p. 232.

17 Similarly, the bust of Martin Georg Kovachich; on this Bückling 1999b, pp. 108f.

18 See comparison, especially from the 17th century in: exhib. cat. face to face 1994, pp. 42f., 52, 53, 65–68.

19 See exhib. cat. face to face 1994, pp. 54, 76.

References

Anon. 1794, pp. 42f. (Nro. 1); Kris 1932, pp. 192, 204, figs. 167–168 (cast); Kris 1933, pp. 393, 399, fig. 2; Glandien 1981, p. 46; Biedermann 1978, p. 28; Pötzl-Malíková 1982, pp. 71, 243f.; Behr/Grohmann/Hagedorn 1983, p. 158; Bücherl 1989, p. 58, p. 62; Presler 1996, pp. 77f., fig. p. 74; Gampp 1998, p. 23; Krapf, Katalog 2002, pp. 170–173; Bückling 2002, p. 81; Pötzl-Malíková 2004, fig. p. 68; Schmid 2004, p. 12; Pfarr 2006, pp. 232ff., 393–398, figs. 32, 33.

Alabaster, Höhe 42 cm
Bez. am Sockel links:
F. M. SCH
Preßburg, nach 1777
Liebieghaus
Skulpturensammlung
Frankfurt am Main
Inv.-Nr. 2600

Alabaster, height 42 cm
Inscr. on base left:
F. M. SCH
Bratislava, after 1777
Liebieghaus
Skulpturensammlung
Frankfurt am Main
Inv. no. 2600

[5]

Büste eines bärtigen, alten Mannes

Die »Büste eines bärtigen, alten Mannes« (Kat.-Nr. 5a) ist gekennzeichnet durch den Formenkanon der Charakterköpfe: Der mächtige Kopf des Alten ruht über einem V-förmig sich verjüngenden Brustausschnitt, gestützt und hinterfangen von einem quaderförmigen Sockel, der auch in der Vorderansicht seitlich vorsteht und dabei die Natürlichkeit des Büstenausschnitts ad absurdum führt.[1] Während der Kopf durch Falten, eingesunkene Augen, unterschiedlich tief herabhängende Lider, eine Halbglatze und lang wallenden Bart eindeutig als der eines alten Mannes gekennzeichnet ist, weist die Büste auf den ersten Blick keine Zeichen des Alters auf. Durch den Bart verborgen, zeichnen sich allerdings dahinter am Hals deutlich ausgeprägte Falten ab. Büste und Kopf sind frontal ausgerichtet. Die blicklosen Augen des Alten ruhen, von Falten gerahmt, in tiefen Augenhöhlen unter gerunzelten Brauen. Tiefe Falten trennen die prallen Wangen von der kleinen, knollenförmigen Nase. Der untere Teil des Gesichts wird von einem Schnurrbart, einem Kinnbart und einem Vollbart verdeckt. In der wuchernden Haarmasse des Bartes, der seine Fortsetzung im Haarkranz um den Kopf (Kat.-Nr. 5b–c) findet, vermitteln nur die Mundöffnung und der Kinnbart anatomische Anhaltspunkte.

Messerschmidt exerziert in der Büste repertoireartig verschiedene Gestaltungsmöglichkeiten durch: Die ornamental formulierten Augenbrauen kontrastieren zu den masken- und perückenähnlichen Bärten, andere Partien wiederum treten stark plastisch hervor, wie die Augäpfel, die Nase, die Wangen und die Schädelkalotte. In diesem

Bust of A Bearded Old Man

"Bust of A Bearded Old Man" (cat. no. 5a) is distinguished by the use of the canon of forms peculiar to the Character Heads: The powerful head of the old man rests on a V-shaped tapering section of breast supported and backed by a block-like base, which also projects to the sides when viewed frontally, thus rendering the naturalness of the bust section absurd.[1] Even though the head is unequivocally marked as that of an old man by wrinkles, sunken eyes, the lids of which droop to different levels, a half-bald head and a long, billowing beard, the bust does not at first glance reveal indications of the subject's age. Hidden by the beard, heavy wrinkles do show up behind it on the neck. The bust and the head are frontal. The sightless eyes of the old man, framed by wrinkles, are sunk in deep sockets beneath furrowed brows. Deep furrows separate the plump cheeks from the small, bulbous nose. The lower part of the face is covered by a moustache, a chin beard and a full beard. Only the opening of the mouth and the beard on the chin represent anatomical details in the luxuriant mass of hair that is the beard, which is continued in the fringe of hair on the head (cat. nos. 5b–c).

In this bust, Messerschmidt has tried out various stylistic possibilities, drawing on several repertoires of forms: the ornamentally conceived eyebrows contrast with the mask and wig-like beard parts. Other parts in turn project forwards in strong plasticity, such as the eyeballs, the nose, the cheeks and the top of the skull. In this so excitingly varied head, the open mouth resembles an empty cavity: with the lips suggested as narrow, the oral cavity remains without further artistic intervention since the teeth and tongue are not represented. The whitish-ochre-coloured alabaster with irregularly distributed blots of varying sizes increases the unquiet tension which this bust radiates because of the way it has been conceived in respect of both form and content. The facial expression is just as dynamically conceived as the sculptural handling: it wavers between a mocking grin, weepiness and senility.

In the Frankfurt bust, Messerschmidt has created neither an individualised portrait nor a mimetically

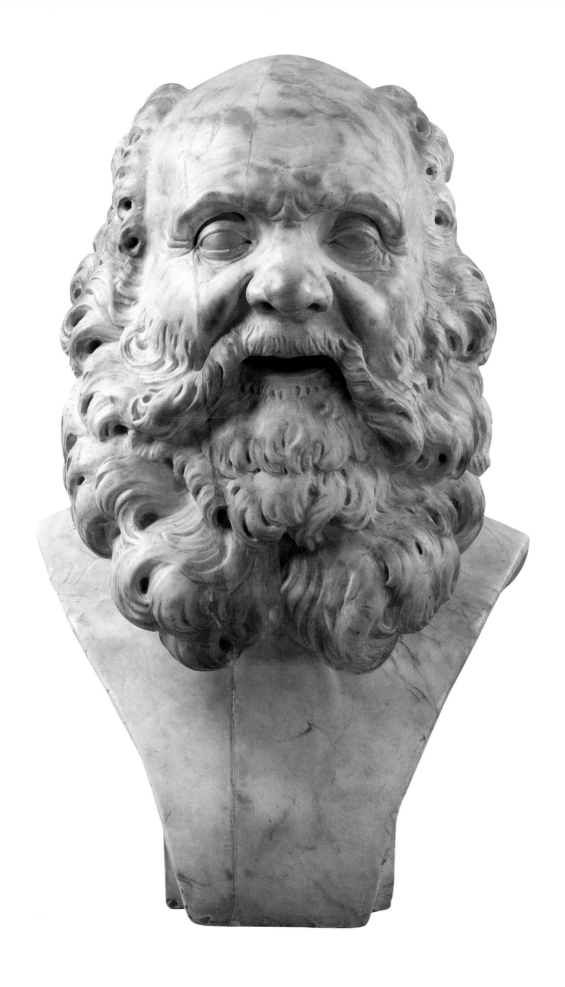

[5a]

so spannungsreich variierten Kopf nimmt sich der offene Mund wie eine leere Höhle aus: Die Lippen schmal angedeutet, bleibt die Mundhöhlung ohne gestalterische Eingriffe, da Zähne und Zunge nicht dargestellt sind. Der weißlich-ockerfarbene Alabaster mit den unregelmäßig verteilten und unterschiedlich großen Flecken verstärkt die unruhige Spannung, die die Büste aufgrund ihrer inhaltlichen und formalen Gestaltung ausstrahlt. Ebenso dynamisch wie die plastische Gestaltung ist die Mimik des Gesichts: Sie schwankt zwischen einem spöttischen Grinsen, Weinerlichkeit und Senilität.

Mit der Frankfurter Büste schafft Messerschmidt weder ein individuelles Porträt noch eine mimisch besonders charakterisierte Maske. Erinnerungen werden wach an Bildnisse des Philosophen Sokrates (Abb. 51). »Die stumpfe Nase, die hervorquellenden runden Augen, das insgesamt Hässliche gelten seit je als Merkmale des griechischen Philosophen«,[2] der bereits in der Antike als Ironiker bezeichnet wird, der seine Weisheit nicht zu erkennen gibt.[3] Gleich-

particularly characterised mask. Recollections are aroused of portraits of the philosopher Socrates (fig. 51). "A blunt nose, protuberant round eyes, the overall ugliness, have been regarded since time immemorial as the features of the Greek philosopher,"[2] who even in Antiquity was described as ironical, a man who did not boast overtly of his wisdom.[3] At the same time, the bust reflects the figure of the Satyr with whose appearance Socrates was often compared. In this connection, it is striking that Socrates was not only regarded as epitomising the beautiful soul in an ugly body but also in this respect as "the hero of a tradition of physiognomic scepticism".[4] Socrates as the association striven for – and not as a portrait of a philosopher – was therefore intended in order to demonstrate the ambiguous interplay of content and

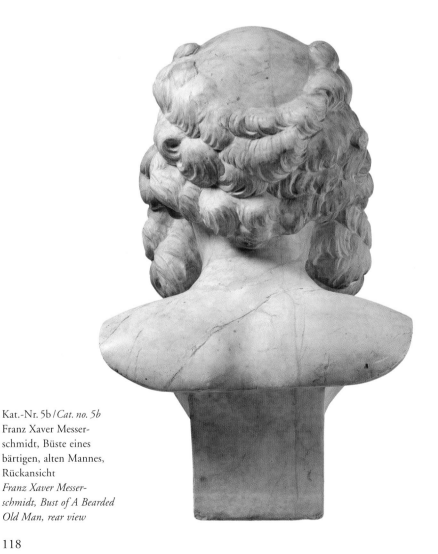

Kat.-Nr. 5b / *Cat. no. 5b*
Franz Xaver Messer-
schmidt, Büste eines
bärtigen, alten Mannes,
Rückansicht
Franz Xaver Messer-
schmidt, Bust of A Bearded
Old Man, rear view

Kat.-Nr. 5c / *Cat. no. 5c*
Franz Xaver Messer-
schmidt, Büste eines
bärtigen, alten Mannes,
Seitenansicht
Franz Xaver Messer-
schmidt, Bust of A Bearded
Old Man, side view

zeitig reflektiert die Büste die Gestalt des Satyrn, mit dessen Aussehen Sokrates oft verglichen wurde. In diesem Zusammenhang fällt auf, dass Sokrates nicht nur als Inbegriff der schönen Seele in einem hässlichen Körper, sondern dadurch auch als »Held einer Tradition der Physiognomieskepsis« galt.[4] Sokrates als angestrebte Assoziation – und nicht als Philosophenporträt – bot sich somit an, um das Vexierspiel mit Inhalten und Formen vorzuführen sowie auf Hintergründigkeiten hinzuweisen, zumal die Verbindung mit dem Satyr Marsyas und dessen Häutung auf die Verwandlung von »dionysischer Dunkelheit zu apollinischer Klarheit, von der Äußerlichkeit zur inneren Wahrheit«[5] verweist.

Mit der Schwierigkeit, allein einen Gesichtsausdruck als den vorherrschenden zu bestimmen, sowie mit dem Verwirrspiel um die gestalterischen Möglichkeiten zielt Messerschmidt auf einen Betrachter, der dem Spiel zu folgen und darüber zu reflektieren versteht. Die Sinnlichkeit des Satyrn wird in der Hinfälligkeit des Alten auf-

form and to refer to hidden meanings, since the link with the Satyr Marsyas and the flaying of the latter refer to the metamorphosis of "Dionysian darkness into Apollonian clarity, from externals to inner truth".[5]

With the difficulty of determining a single facial expession as the prevailing one as well as the confusing interplay of stylistic possibilities, Messerschmidt is addressing a viewer who is able to follow the play and reflect on it. The sensuality of the Satyr is subverted by the frailty of the old man and transformed into a recollection of Socrates, the ancient philosopher. However, the converse also happens: philosophy is linked with sensuality through the association with a Satyr and at the same time is transformed into both weepiness and cheerfulness. The viewer does not

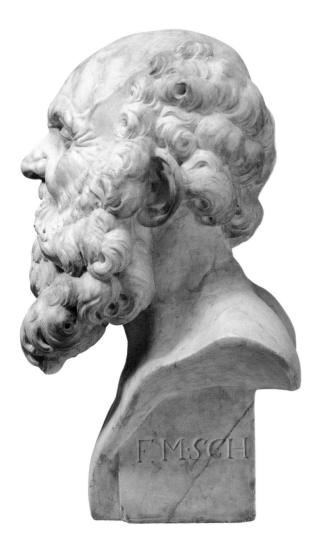

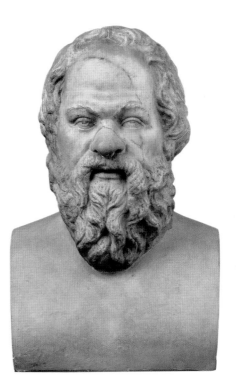

51 Sokrates – Typus B, Marmor, Skulpturensammlung, Staatliche Kunstsammlungen, Dresden, Inv.-Nr. Hm 205
Socrates – Type B, Marble, Sculpture Collection, Staatliche Kunstsammlungen, Dresden, Inv. no. Hm 205

gehoben und in die Erinnerung an den antiken Philosophen Sokrates verwandelt. Aber auch die Umkehrung geschieht: Die Philosophie verbindet sich durch die Assoziation mit einem Satyr mit Sinnlichkeit und wird gleichzeitig in Weinerlichkeit oder Heiterkeit überführt: Der Betrachter weiß nicht, »wie ihm geschieht, vor seinen Augen verwandelt sich der Akteur«.[6] Uneindeutigkeit des Ausdrucks, die Irritation des Betrachters und das Spiel mit dem gestalterischen Repertoire brechen mit der barocken Tradition des Porträtschaffens, des Philosophenporträts und auch mit der Verkörperung von Allegorien, wie sie beispielsweise die »Anima Dannata« Gian Lorenzo Berninis (Abb. 74) darstellt. Es gibt keine Sicherheiten mehr, keine Heilsgewissheit, keinen Rückzug in die Gedankenwelt der Antike. Messerschmidt verlässt mit Büsten wie der des bärtigen, alten Mannes den Weg zur Einfachheit und Natürlichkeit, den er beispielsweise mit der Büste von Scheybs (Abb. 9, 18) eingeschlagen hat, und folgt einem neuen Weg hin zur Darstellung des Menschen in seiner Mehrdeutigkeit, Rätselhaftigkeit und Vielschichtigkeit. Damit weist die Frankfurter Büste Charakteristika der so genannten Charakterköpfe auf und lässt sich dieser Serie zuordnen.

Durch den Bericht eines Anonymus von 1793[7] dokumentiert und rund 36 Jahre später in einer Lithographie abgebildet, ist das Aussehen von 49 Charakterköpfen überliefert. Im Jahr 1889 wurde das bis dahin als Serie erhaltene Konvolut von inzwischen nur noch 47 Köpfen[8] versteigert und auseinander gerissen. Manche der Köpfe sind bis heute verschollen, einige davon blieben aber zumindest durch die Lithographie (Abb. 37) und frühe Gipsabgüsse bekannt. Wie erläutert, wissen wir von 55 oder 57 »Portreen«.[9] Messerschmidt hatte während Nicolais Besuch den 61. Kopf in Arbeit; 64 wurden von dem Bildhauer als notwendig erachtet, um sein Proportionssystem darzustellen. Von den sieben bis neun fehlenden Köpfen, die, sofern sie fertig wurden,[10] was angesichts der Messerschmidt verbleibenden ungefähr zwei Jahre zu vermuten ist, sein Haus verlassen haben müssen, ehe wenige Tage nach seinem Tod ein Verzeichnis seines Besitzes angelegt wurde, ist das Aussehen nicht überliefert. Überliefert ist, dass sich in seinem Nachlass 16 alabasterne Köpfe befanden; der Frankfurter Kopf ist der 17. bekannte aus Messerschmidts Œuvre.

Auffallend beim Frankfurter Kopf ist unter anderem die wuchernde Haarpracht der Bärte, die eher vegetabil anmuten, als dass sie die Materialqualität von Haaren wiedergeben. Ähnlich ist die Gestaltung der Haare beim Wiener Stück »Ein abgezehrter Alter mit Augenschmerzen« (Abb. 52). Auch hier sprießen üppige Haarbüschel, deren weiche Massen mit locker eingetragenen Details gestaltet sind. Wie beim Frankfurter Kopf ist beim Wiener Alten die Wiedergabe der Materialität von Haaren nicht angestrebt; die Masse erweckt

know "what is happening to him; the protagonist changes before his very eyes."[6] The ambivalence of the expression, the disturbing impact made on the viewer and the play with stylistic repertoire break with the Baroque portrait tradition, the philosopher portrait and even the personification of allegories, as exemplified by the "Anima Dannata" of Gian Lorenzo Bernini. Nothing is certain any longer, there is no hope of redemption, no refuge to be sought in the philosophy of antiquity. With busts like that of the Bearded Old Man, Messerschmidt has abandoned the route to simplicity and naturalness which he started out on with the bust of von Scheyb (fig. 9, 18), for example, to follow a new path leading to the representation of man's deep-rooted ambivalence, his enigmatic character and often split personality. In all these respects, the Frankfurt bust reveals characteristic features of the so-called Character Heads and can be assigned to this group.

Documented by the account of an anonymous author in 1793[7] and roughly 36 years later shown in a lithograph, the appearance of 49 of the Character Heads has come down to us. In 1889 the set of by now only 47, which had up to then been kept together[8] was sold at auction and scattered. The whereabouts of many of the heads is unknown; some of these are known at least from lithograph (fig. 37) or from early plaster casts. As has been explained, we know of 55 or 57 "portraits".[9] Messerschmidt was working on the 61st head during Nicolai's visit to him; 64 was the number the sculptor regarded as necessary for representing his system of proportions. The appearance of the seven to nine missing heads, which, if they were indeed even completed,[10] (presumably they were, since Messerschmidt still had two years to live), must have left his house before an inventory of his possessions was drawn up just a few days after he died, has not been handed down. What is known, however, is that there were sixteen alabaster heads in his estate; the Frankfurt Head is the seventeenth known from Messerschmidt's œuvre.

A striking feature of the Frankfurt Head is the luxuriant growth of facial hair, which seems more vegetal than reproducing the material properties of hair. The hair is similarly handled in the Viennese

eher den Eindruck einer Perücke, unter der Haare hervorlugen, die allerdings gleichfalls nicht wie natürliches Haar wirken. Auch dem Frankfurter Kopf haften die Bärte eher wie Perücken an, als dass sie wie natürliches Haar hervorsprießen. Beide Köpfe könnten, ebenso wie der »Kapuziner« (Kat.-Nr. 3) Kritik an der Perückenmode üben. Statt den kahlen Schädel zu bedecken, wurde als Perücke der Bart angeheftet. Wie die Perücke auf dem Kopf verdeckt er physiognomische Eigenheiten und vergrößert, wie die gerade um und nach 1770 gelegentlich absurd-gewaltigen Damen- und Herrenperücken, den Kopf um ein nicht geringes. Bei beiden Köpfen – der »Büste eines bärtigen, alten Mannes« und »Ein abgezehrter Alter mit Augenschmerzen« – arbeitete der Künstler mit graphischen und ornamentalen Mitteln, während die Schädelkalotte, die Wangen, die Nase und auch der Büstenausschnitt plastisch erscheinen. Die Plastizität allerdings wird im Gesicht des Alten durch die Verzerrungen der

piece "A Haggard Old Man with Aching Eyes" (fig. 52). Here, too, tufts of hair sprout luxuriantly, with details of locks in the soft mass laid on with a light hand. As in the Frankfurt Head, reproducing the physical properties of hair as substance has not been the aim in the Viennese Old Man; the mass of hair instead makes the impression of being a wig, from beneath which peep locks that do not look like natural hair either. The facial hair of the Frankfurt Head looks more like hair-pieces than naturally growing hair. Both Heads, as well as the "Capuchin" (cat. no. 3) may well represent criticism of the fashion in wigs. Instead of covering a bare skull, the beard has been stuck on like a false one. Like a wig on a head, the beard obscures physiognomic peculiarities

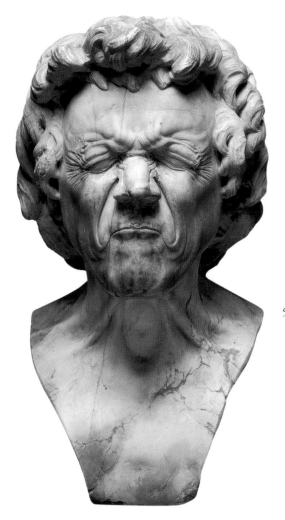

52 Franz Xaver Messerschmidt, Ein abgezehrter Alter mit Augenschmerzen, nach 1770, Alabaster, Österreichische Galerie Belvedere, Wien, Inv.-Nr. 5638
Franz Xaver Messerschmidt, A Haggard Old Man with Aching Eyes, after 1770, alabaster, Österreichische Galerie Belvedere, Vienna, Inv. no. 5638

Mimik und die graphischen und ornamentalen Gestaltungsweisen eingeschränkt, während beim Bärtigen die verschiedenen Gestaltungsvariationen zwar irritieren, die Wirkung des Kopfes aber steigern.

Das Schwanken zwischen geradezu übersteigerten Naturformen, Lebendigkeit und Abstraktion verbindet das Frankfurter Werk auch mit der um 1770–1772 geschaffenen Büste des Gerard van Swieten (Kat.-Nr. 1).[11] Letztlich aber ist die Nähe zu den Porträts der Zeit 1769–1772 nicht so eng wie die zu den Charakterköpfen. Da Messerschmidt zudem allem Anschein nach vor 1777, das heißt vor seinem Umzug nach Preßburg, nur metallene Köpfe schuf, müssten die alabasternen, und somit auch der Frankfurter Kopf, nach 1777 zu datieren sein.[12] Damit würde es sich bei dem Frankfurter Werk nicht um einen Vorläufer handeln. Des Formenkanons und der der Büste innewohnenden Irritationen wegen könnte es sich bei der »Büste des bärtigen, alten Mannes« um einen derjenigen noch fehlenden Charakterköpfe handeln, über deren Aussehen nichts bekannt ist,[13] der die Werkstatt wahrscheinlich vor Messerschmidts Tod oder sofort danach verließ.[14]

1 Die Unnatürlichkeit der Sockel und Büstenausschnitte ist noch deutlicher herausgehoben bei Köpfen wie »Ein Erzbösewicht« (Kat.-Nr. 10).
2 Beck 1989, S. 212.
3 So Giuliani 1996, S. 37.
4 Arburg 1999, S. 43. Ebenso Neumann 1988, S. 95.
5 Busch 1993, S. 402.
6 Busch 1993, S. 402.
7 In diesem Katalog wird einheitlich nach der ein Jahr später erfolgten Auflage Anonymus 1794 zitiert.
8 »Der Gähner« (Kat.-Nr. 12) und »Der sanfte ruhige Schlaf« (Kat.-Nr. 9) waren bereits vor 1889 verkauft worden, siehe Pötzl-Malíková 1982, S. 242.
9 Dazu siehe S. 82 in diesem Katalog. Die Bezeichnung »Portreen« verwendet die »Verlassenschaftsabhandlung des Franz Xaver Messerschmidt« vom 30. April 1784, abgedruckt bei Pötzl-Malíková 1982, S. 141.
10 Möglicherweise blieben Köpfe auch im Entwurfsstadium zurück; die Variante zu »Der weinerliche Alte« (Kat.-Nr. 11) und »Ein alter frölicher Lächler« (Österreichische Galerie Belvedere, Wien, Inv.-Nr. 2286) sprechen dafür. Pfarr (2006, S. 378) vermutet, dass auch »Der Trozige« (verschollen) unfertig geblieben ist.
11 So die Autorin des vorliegenden Beitrags in: Bückling 1989, S. 330; Bückling 1999b, S. 112. Auch Beck 1989, S. 210.
12 Tatsächlich wird nur von einem vor der Preßburger Zeit entstandenen Werk aus Alabaster berichtet, von einem »Hermaphrodit« aus der Zeit vor 1774, dazu siehe Pötzl-Malíková 1982, S. 233.
13 Weder Krapf (Katalog 2002, S. 166) noch Pötzl-Malíková (2003, S. 254) halten die Büste für einen Charakterkopf. Pötzl-Malíková: »Der schwer deutbare, ja irritierende Gesichtsausdruck dieses Werkes und das üppig wuchernde Barthaar bringen dieses Werk in die Nähe der ›Charakterköpfe‹, ohne dass man es in diese Serie direkt einreihen kann.« Krapf überlegt, ob die Büste neben der Erinnerung an Sokrates auch ein »reales« Porträt

and considerably enlarges the head like the sometimes absurdly voluminous ladies' and gentlemen's wigs that became fashionable at the time: around and after 1770. In both Heads – the "Bust of A Bearded Old Man" and "A Haggard Old Man with Aching Eyes" – the artist has worked with linear and ornamental devices whereas the top of the skull, the cheeks, the nose and the section of bust look sculptural. However, the plasticity of the Old Man's face is reduced by the contortions of the facial action and the ornamental handling whereas in the Bearded Man the stylistic variation may be confusing but on the whole enhances the impact made by this head.

Fluctuation between really exaggerated natural forms, life-likeness and abstraction is a quality that also links the Frankfurt work with the bust of Gerard van Swieten (cat. no. 1), executed c. 1770–1772.[11] However, the Frankfurt bust is not so close to the portraits of the years 1769–1772 as it is to the Character Heads. Moreover, since Messerschmidt apparently only made metal heads before 1777, i. e. before he moved to Bratislava, the alabaster heads and with them the Frankfurt head, should be dated to after 1777.[12] Consequently, the Frankfurt head was not a model for the others. The canon of forms used and the disturbing qualities inherent in the bust suggest "Bust of A Bearded Old Man" might be one of those still unaccounted-for missing Character Heads, about whose appearance nothing is known,[13] which probably left the workshop before Messerschmidt died or not long afterwards.[14]

1 The unnaturalness of the base and bust section is even more pronounced in heads such as "An Arch-Rascal" (cat. no. 10).
2 Beck 1989, p. 212.
3 Thus Giuliani 1996, p. 37.
4 Arburg 1999, p. 43. Also Neumann 1988, p. 95.
5 Busch 1993, p. 402.
6 Ibid.
7 Throughout the present catalogue, the 1794 edition of Anonymous, which was published a year after the first one, is quoted.
8 "The Yawner" (cat. no. 12) and "Quiet Peaceful Sleep" (cat. no. 9) had already been sold by 1889; see Pötzl-Malíková 1982, p. 242.

darstellen könnte. Pfarr (1999) ordnet die Büste in die Reihe der Charakter-
köpfe ein.

14 Die Signatur spricht für die erste Annahme.

Literatur

Beck 1989, S. 205, 210–215, Abb. 1–2; Bückling 1989, S. 328–330, Abb. 8;
Gampp 1998, S. 27–28; Bückling 1999b, S. 112–113; Krapf, Katalog 2002,
S. 166–167; Pötzl-Malíková 2003, S. 254, Abb. 297; Schmid 2004, S. 63;
Pötzl-Malíková 2004, Abb. S. 41; Pfarr 2006, S. 398–399, Abb. 14–15.

9 On this see p. 83 in the present catalogue. The term
 "portraits" ("Portreen") is used in the legal document
 relating to Messerschmidt's estate dated 30 April 1784,
 printed in Pötzl-Malíková 1982, p. 141.

10 Both heads may just possibly have remained in the design
 stage; the variant of "The Weepy Old Man" (cat. no. 11)
 and "An Old Cheerful Smiler" (Österreichische Galerie
 Belvedere, Vienna, Inv. no. 2286) would indicate that this
 is so. Pfarr (2006, p. 378) conjectures that 'The Defiant
 Man' (whereabouts unknown) was also never finished.

11 Thus the author of the present essay in: Bückling 1989,
 p. 330; Bückling 1999b, p. 112 Also Beck 1989, p. 210.

12 In fact only one work in alabaster is mentioned before
 Messerschmidt's Bratislava period: a "Hermaphrodite"
 dating from before 1774; see Pötzl-Malíková 1982, p. 233.

13 Neither Krapf (Katalog 2002, p. 166) nor Pötzl-Malíková
 (2003, p. 254) think that the bust is a Character Head.
 Pötzl-Malíková: "The facial expression of this work, which
 is difficult to interpret, and even disturbing, and the luxu-
 riant growth of beard hair bring this head close to the
 'Character Heads' although it cannot be directly included
 in that series." Krapf wonders whether the bust might
 not represent a "real" portrait in addition to being reminis-
 cent of Socrates. Pfarr (1999) assigns the bust to the
 Character Heads.

14 The signature suggests that the first assumption may be
 correct.

References

Beck 1989, p. 205, pp. 210–215, figs. 1, 2; Bückling 1989,
pp. 328ff., fig. 8; Gampp 1998, pp. 27f.; Bückling 1999b,
pp. 112f.; Krapf, Katalog 2002, pp. 166f.; Pötzl-Malíková
2003, p. 254, fig. 297; Schmid 2004, p. 63; Pötzl-Malíková
2004, illus. p. 41; Pfarr 2006, pp. 398f., figs. 14, 15.

Gipsabguss, Höhe 44 cm
Original nach 1770
Österreichische
Galerie Belvedere, Wien
Inv.-Nr. 5695

Plaster cast, height 44 cm
Original after 1770
Österreichische
Galerie Belvedere, Vienna
Inv. no. 5695

[6]
Ein schmerzhaft stark Verwundeter

Das Gesicht von »Ein schmerzhaft stark Verwundeter« (Kat.-Nr. 6a) ist zu Grimassen, die zwischen einem Grinsen und starkem Schmerz changieren, verzerrt: Die Lippen sind nahezu zu einem Strich zusammengekniffen, über ihnen wölbt sich die darüber liegende Partie vor und bildet in der Mitte eine dreieckige Form. Das Kinn ist derart angespannt, dass sich das Muskelgeflecht unter der Haut abzeichnet. Die gekrauste, hoch gezogene Nase mit scharf eingekerbten Nasolabialfalten weist eine ornamental verformte Nasenwurzel auf. Unter den Augen liegen dicke Falten und Tränensäcke; von den äußeren Augenwinkeln gehen einige strahlenförmig angebrachte Falten aus.

Darüber erhebt sich die symmetrisch verformte Schädelkalotte. Zwischen Stirn und Schädel existiert insofern keine logische Beziehung, als sich die Schädelverformungen hier nicht vorbereiten. Auf dem Kopf wechseln leichte Erhöhungen mit kreisförmigen als auch längsgerichteten Mulden ab. Die Abnormitäten setzen sich auch auf dem Scheitel und am Hinterkopf fort (Kat.-Nr. 6b–c). Auffällig sind kräftige seitliche Erhebungen, die an die so genannten Seitenlappen des Gehirns erinnern und auf Höhe der aus dem Kopf wachsenden Scheiben abflachen. Diese verdecken die Ohren halb und führen in einem sanften Bogen nach hinten. Am Hinterkopf fällt eine spitze Erhebung auf, die von seitlichen Strängen begleitet wird, die auf Höhe der Ohrläppchen enden. Die über der Stirn und den Seitenflügeln in waagerechten Strichelungen angedeutete »Perücke«, die sich in konzentrischen Kreisen um den Kegel am Hinterkopf legt, malt den oberen Teil der Stirn und den gesamten Schädel – der Übergang ist fließend – wie eine zweite Haut ab. Es

A Grievously Wounded Man

The face of "A Grievously Wounded Man" (cat. no. 6a) is contorted to grimaces that seem to oscillate between a grin and severe pain: the lips have been compressed almost to a thin line; the zone above them bulges to form a triangle in the middle. The chin is so contracted that the web of muscles shows up beneath the skin. The wrinkled, turned-up nose with crisply notched nasolabial folds has an ornamentally deformed root. Below the eyes there are thick wrinkles and lachrymal sacs; a few wrinkles radiate from the outer corners of the eyes.

The symmetrically formed skull rises above the eyes. Between the forehead and the skull there is no logical relationship since the deformations of the skull are not anticipated in the former. On the head, slight rises alternate with circular as well as elongated depressions. These anomalies continue on the parting and the back of the head (cat. nos. 6b–c). A striking feature is the prominently raised areas on the sides, which recall the frontal lobes of the brain and flatten out on a level with the discs growing out of the head to end in a gentle arc at the back. A notable feature of the back of the head is a pointed mound accompanied by strands at the side ending on a level with the ear lobes. The "wig" suggested above the forehead and the sides in horizontal stippling, which is laid about the conical formation on the back of the head in concentric circles, paints the upper part of the forehead and the whole skull – the transition is fluid – like a second skin. It remains unclear whether the strikingly abnormal deformations of the skull are pathological growths on the head covered as if by a wig an almost transparent skin or whether they are parts of a springy wig.

Face and skull correspond in respect of the barely readable grimace and the equally inexplicable top of the skull with its growths. The grimace is enhanced by the warped effect created by the wig. At the same time, the bust section is so tranquil and smooth that it provides a balanced foundation for the expressive qualities of the head.

The head covering and the deformation of the skull are the most striking features of this Head. Simi-

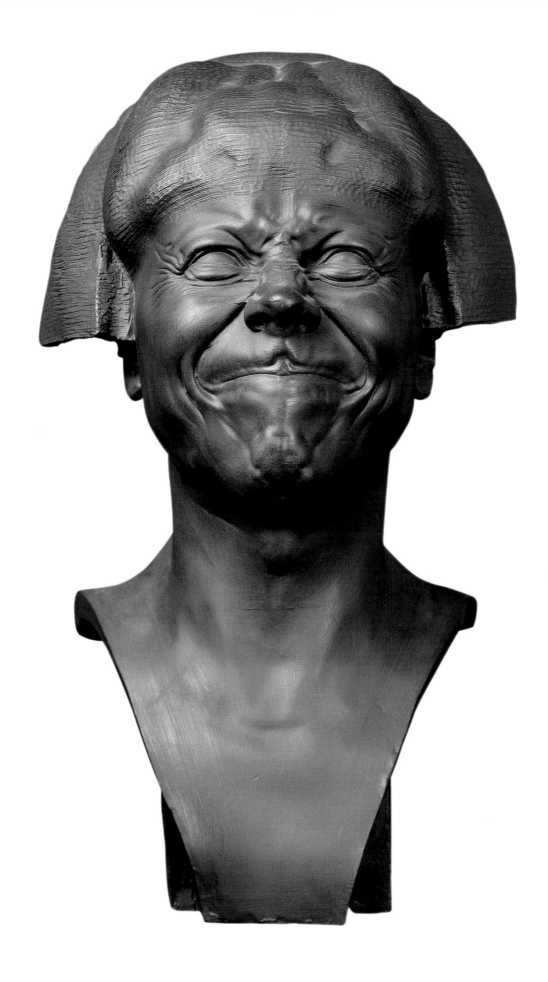

[6a]

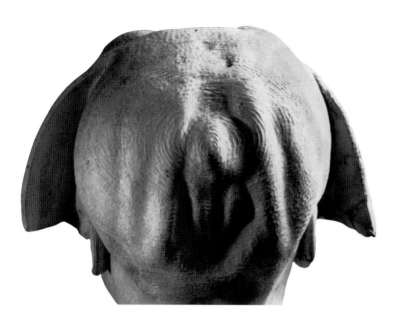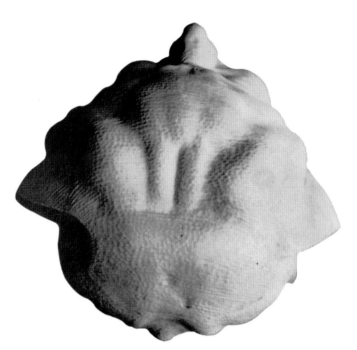

bleibt unklar, ob die auffallenden und abnormen Verformungen des Schädels krankhafte Auswüchse des Kopfes sind, die von einer nahezu transparenten Perückenhaut überzogen sind, oder ob es Teile einer sich aufwerfenden Perücke sind.

In Bezug auf die kaum nachvollziehbaren Grimassen und die gleichfalls unerklärliche Kalotte mit ihren Auswüchsen entsprechen sich Gesicht und Schädel. Die Grimasse erfährt eine Steigerung in den Verwerfungen der Perücke. Gleichzeitig liefert der Büstenausschnitt in seiner Ruhe und Glätte die ausgewogene Grundlage für die Expressivität des Kopfes.

Kopfbedeckung und Schädeldeformation sind neben der Grimasse die auffallendsten Merkmale des Kopfes. Wegen der Ähnlichkeit der Frisur mit altägyptischen Perücken ist dieser Charakterkopf gelegentlich als ägyptisierender Kopf [1] beschrieben worden. Johann Friedel, der Messerschmidt im November 1782 besuchte, nannte gar alle Köpfe »egyptisch«. [2] Tatsächlich aber ist die Ähnlichkeit zu ägyptischen Vorbildern nicht so groß wie der erste Anschein vermuten lässt. Es sind die seitlich vom Kopf abstehenden, bis zu den Ohren herabreichenden Scheiben, die, von vorne betrachtet, an Perücken erinnern. Jedoch fallen die Haare der ägyptischen Perücken bis auf Brust und Rücken herab; sie setzen gleichfalls mitten auf der Stirn an, zeigen aber eine glatte, klare Kontur und sind – im Fall, dass es ein Binnenlineament gibt – meist senkrecht und nicht waagerecht strukturiert. Messerschmidt spielt, wie im Fall der Porträtbüste des Gerard van Swieten (Kat.-Nr. 1), mit dem traditionellen Motivgefüge, aber auch mit vorbildhaften Werken, in diesem

larities of the hair style with ancient Egyptian wigs have occasionally caused this Character Head to be described as an neo-Egyptian head. [1] Johann Friedel, who visited Messerschmidt in November 1782, even called all the heads "Egyptian". [2] However, the similarity with Egyptian works is not so great as might at first appear. It is the discs standing out from the sides of the head and extending down to the ears, which, when viewed from the front, recall wigs. However, the locks of Egyptian wigs hang down as far as the chest and back; they also begin in the middle of the forehead but reveal a smooth, clear contour and – in cases featuring linear elements within the contours – are articulated vertically rather than horizontally. As in the portrait bust of Gerard van Swieten (cat. no. 1), Messerschmidt is playing with the traditional motif configuration as well as models, in this case, from Antiquity. He uses them, recalling Antiquity but without quoting verbatim. [3] As in "Bust of A Bearded Old Man" (cat. no. 5), Messerschmidt's method of evoking associations is apparent.

Messerschmidt may possibly be using artistic devices to criticise the wigs of his day, which had assumed such abnormal dimensions by then that they made heads look huge. The old clarity of Antiquity is missing – the yawning gulf between this era

Kat.-Nr. 6b / *Cat. no. 6b*
Franz Xaver Messer-
schmidt, Ein schmerzhaft
stark Verwundeter,
Rückansicht
Franz Xaver Messerschmidt,
A Grievously Wounded
Man, rear view

Kat.-Nr. 6c / *Cat. no. 6c*
Franz Xaver Messer-
schmidt, Ein schmerzhaft
stark Verwundeter,
Ansicht von oben
Franz Xaver Messerschmidt,
A Grievously Wounded
Man, view from above

Fall der Antike. Er benutzt sie, erinnert an die Antike, ohne sie konkret zu zitieren.[3] Wie bei der »Büste eines bärtigen, alten Mannes« (Kat.-Nr. 5) wird auch hier das assoziative Verfahren Messerschmidts deutlich.

Möglicherweise trägt Messerschmidt mit künstlerischen Mitteln eine Kritik an den zeitgenössischen, den Kopf vergrößernden Perücken vor, die zu dieser Zeit geradezu abnorme Ausmaße annahmen. Die alte Klarheit der Antike fehlt – der Abstand zur Antike ist nicht zu überbrücken. Perücken, so ließe sich angesichts des fließenden Übergangs zwischen Stirn und Haarteil sowie den Verformungen des Schädels folgern, können einer Identität und einem Charakter übergestülpt werden, bis sowohl der Schädel als auch das Wesen eines Menschen zur Unkenntlichkeit deformiert sind. So wird beispielsweise in einem Werk Messerschmidts die Silhouette des Kopfes von Johann Christoph von Kessler (Abb. 22, 23) durch eine Perücke entstellt und verformt und mit eigenen Formen überzogen. Die Kritik an Perücken wurde seit den 1770er Jahren zunehmend geäußert.[4] Katharina II. verabscheute sie bekanntlich zumindest in der Porträtplastik,[5] und Gerard van Swieten (Kat.-Nr. 1) musste von Kaiserin Maria Theresia zum Tragen einer Perücke überredet werden.

1 Dazu siehe Pötzl-Malíková 1982, S. 72, 80.
2 Friedel 1785, S. 398.
3 Pfarr (2006, S. 394) beschreibt ähnlich die Selbstbildnismedaillons als »Spiel mit unsicher gewordenen Zeichen«.
4 Siehe Kleinert 1995, S. 302. Dazu siehe S. 214–216 in diesem Katalog.
5 Siehe Réau 1964, S. 45.

Literatur
Friedel 1785, S. 398; Anonymus 1794, S. 52–53 (Nro. 19); Kris 1932, S. 211, Abb. 232 (Abguss); Baum 1980, S. 418; Glandien 1981, S. 51–52, Abb. 47; Pötzl-Malíková 1982, S. 72, 80, 251; Behr/Grohmann/Hagedorn 1983, Abb. S. 127–128; Krapf 1995, S. 53, Abb. 11; Ronzoni 1997, S. 40; Ausst.-Kat. Louise Bourgeois 1998, o. S. (betr. Abguss in Bratislava); Bückling 1999a, S. 74–76, Abb. 6; Krapf, Katalog 2002, S. 206–207; Bückling 2002, S. 80–81; Stastny 2003, S. 48, 51, Abb. 1–2; Schmid 2004, S. 30; Pötzl-Malíková 2004, Abb. S. 90; Pfarr 2006, S. 238, Abb. 54.

and classical times cannot be bridged. Wigs, as can be conjectured in light of the fluid transition between forehead and hair as well as the deformations of the skull, can cover identity and character until both the skull and the essence of a human being have been disfigured to the point that they are unrecognisable. In one Messerschmidt work, the silhouette of the head of Johann Christoph von Kessler (figs. 22, 23), for example, has been disguised by a wig and deformed by being covered in its own forms. Criticism of wigs had been growing more vociferous since the 1770s.[4] Catherine the Great is known to have despised them in portrait sculpture[5] and Gerard van Swieten (cat. no. 1) had to be persuaded by the Empress Maria Theresia to wear one.

1 See Pötzl-Malíková 1982, pp. 72, 80.
2 Friedel 1785, p. 398.
3 Pfarr (2006, p. 394) similarly describes the self-portrait medallion as a "play with signs that have become indeterminate".
4 See Kleinert 1995, p. 302, and p. 214–216 in the present catalogue.
5 See Réau 1964, p. 45.

References
Friedel 1785, p. 398; Anon. 1794, pp. 52f. (no.19); Kris 1932, p. 211, fig. 232 (cast); Baum 1980, p. 418; Glandien 1981, pp. 51f., fig. 47; Pötzl-Malíková 1982, pp. 72, 80, p. 251; Behr/Grohmann/Hagedorn 1983, illus. pp. 127f.; Krapf 1995, p. 53, fig. 11; Ronzoni 1997, p. 40; exhib. cat. Louise Bourgeois 1998, n. p. (concerns cast in Bratislava); Bückling 1999a, pp. 74ff., fig. 6; Krapf, Katalog 2002, pp. 206f.; Bückling 2002, pp. 80f.; Stastny 2003, pp. 48, 51, figs. 1–2; Schmid 2004, p. 30; Pötzl-Malíková 2004, illus. p. 90; Pfarr 2006, p. 238, fig. 54.

Zink-Legierung
Höhe 43,5 cm
Preßburg, 1777–1781
Bayerisches National-
museum, München
Inv.-Nr. 73/205

Zinc alloy, height 43.5 cm
Bratislava, 1777–1781
Bayerisches Nationalmuseum
Munich, Inv. no. 73/205

[7]

Ein mürrischer alter Soldat

»Ein mürrischer alter Soldat« (Kat.-Nr. 7a) zeigt auf dem bekannten Prototyp der Büsten den frontal ausgerichteten Kopf, dessen expressive Mimik auffällig ist (Kat.-Nr. 7b). Über verhältnismäßig schmalen Augen, nach unten durch nur wenig vortretende Tränensäcke abgegrenzt, wölben sich unter stark gerunzelten Augenbrauen die Orbitalwülste so, dass sie teilweise auf den Oberlidern ruhen. Die erhaben modellierten Augenbrauen, die dem Gesicht wie aufgesetzt wirken,[1] zeigen feine Strichelungen, die in einem Grat zusammentreffen. Über den Brauen bilden sich durch das Runzeln Faltenverdickungen, die wie Knorpel oder Stränge aussehen. Sie ziehen sich sowohl zu den Schläfen als auch nach oben über die Stirn, die dadurch leicht deformiert ist.

Auffallender ist die Mimik des Mundes, dessen Mundwinkel so tief gezogen sind, dass er geradezu wie nach oben gewölbt wirkt. Die Lippen sind zu einem Strich zusammengepresst. Nasolabialfalten ziehen bis kurz vor die Mundwinkel herab. Hier haben sich weitere Falten gebildet, die in gerundeter Form um die Mundwinkel geschwungen sind. Durch die starke Bewegung des Mundes ist zugleich die Kinnmuskulatur angespannt und weist – widersinnigerweise – in der Mitte ein Grübchen auf.

Die Frisur mit deutlichen Geheimratsecken zeigt zurückgestrichene Haare, die sich zu kurzen, leicht gewellten Büscheln zusammenfinden. Sie liegen struppig und kaum geordnet über- und nebeneinander und weisen eine – zum Hinterkopf hin zunehmend – buckelige Oberfläche auf, die jeweils durch Binnenzeichnung in eher grob gestrählte einzelne Strähnen aufgeteilt ist. Am Hinterkopf findet sich eine irritierende Zone (Kat.-Nr. 7d–e): Hier fällt im unteren

128

A Surly Old Soldier

"A Surly Old Soldier" (cat. no. 7a) combines the familiar bust prototype and frontal head with strikingly expressive facial action (cat. no. 7b). Above relatively narrow eyes, demarcated at the bottom by only slightly bulging lachrymal sacs, the orbital ridges bulge so strongly beneath strongly furrowed eyebrows that they rest in places on the upper lids. The eyebrows, modelled as raised, which look as if applied to the face,[1] reveal fine streaks converging in a ridge. Above the brows, wrinkles are so thickened by the brows being furrowed that they resemble cartilage or sinews. They extend both to the temples and upwards above the forehead, which is slightly deformed by them.

A more striking feature is the action of the mouth, whose corners are pulled down so far that the mouth seems to bulge upwards. The lips are compressed to a line. The nasolabial folds extend almost to the corners of the mouth. Here other wrinkles have formed, which are rounded and curvilinear about the corners of the mouth. The strong action of the mouth contracts the chin muscles to reveal – illogically – a dimple at the centre.

The hair style, with the hair noticeably receding at the temples, has been combed back to form slightly wavy tufts. Shaggy and disorderly, they go every which way to reveal – increasingly towards the back of the head – a bumpy surface subdivided into what are rather coarsely combed strands of hair indicated by lines within contours. The back of the head has a disturbing zone (cat. nos. 7d–e): here there is a noticeable hiatus in the lower area of the hair. Across the full width of the head, it divides the ends of the curls from the mass of the hair. The hairs above and below this hiatus do not flow into one another; that is, a different lock formation sets in here, which roughly oriented to the way the hair lies above the hiatus, nevertheless does not represent a continuation of it. Once one has become aware of this, one notices something similar on both sides of the head (cat. no. 7c): in the form of narrow notches, the hiatus, which is, however, not so clearly demarcated as on the back of the head, extends to each ear. And here, too, the sequence of curls is disrupted.

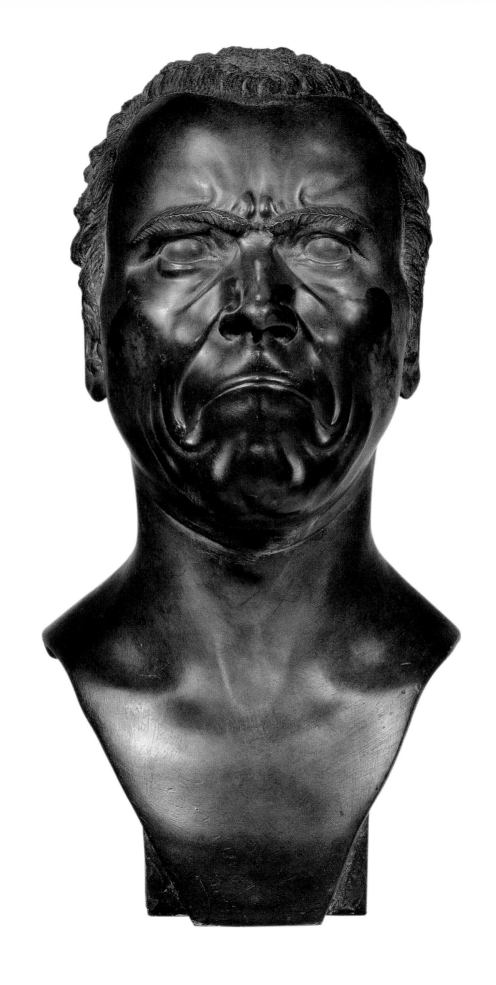

[7a]

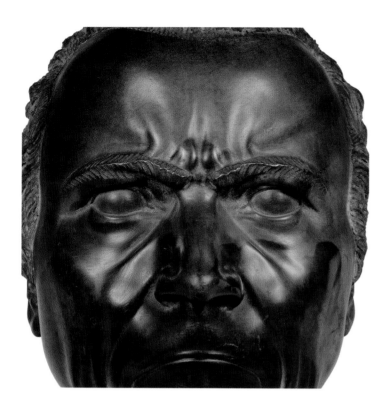

Bereich der Frisur eine deutliche horizontale Zäsur auf. Sie trennt über die gesamte Breite des Kopfes die Lockenenden von der übrigen Haarmasse. Die Haare über und unter diesem Einschnitt gehen dabei nicht ineinander über, das heißt, es beginnt hier eine andere Lockenformation, die sich zwar grob an der Anlage der Haare über der Zäsur orientiert, sie aber nicht fortsetzt. Einmal aufmerksam geworden, ist an beiden Seiten des Kopfes (Kat.-Nr. 7c) Ähnliches festzustellen: In Form von schmalen Einkerbungen wird der Einschnitt, der sich allerdings nicht so deutlich abzeichnet wie derjenige am Hinterkopf, jeweils bis zu den Ohren fortgeführt. Und auch hier ist die Lockenabfolge unterbrochen.

»Ein mürrischer alter Soldat« weist deutliche Analogien zu »Der Melancholikus« (Kat.-Nr. 8)[2] und zu »Ein Gelehrter, Dichter« (Abb. 53) auf. Deutlich sind auch beim Melancholiker die Mund-winkel gesenkt, so dass der Mund leicht nach oben gewölbt er-scheint. Allerdings presst der Mann die Lippen nicht fest aufeinan-der; sie ruhen hier entspannt und ohne Bewegung aufeinander. Wie aufgesetzt wirkende Augenbrauen, die dieselbe Struktur wie die des Soldaten aufweisen, verschatten gleichfalls beim Melancholiker zusammen mit den vorgewölbten Orbitalwülsten den Blick. In bei-den Fällen entsteht ein ernster, strenger, beim Münchener Kopf mürrischer Gesichtsausdruck; dabei ist die Starrheit des Melancholi-kus beim Soldaten durch die ausdrucksstarke Mimik aufgelockert.

"A Surly Old Soldier" reveals noticeable correspon-dences with "The Melancholic" (cat. no. 8)[2] and "A Scholar, Poet" (fig. 53). The corners of the Melan-cholic's mouth also droop so noticeably that the mouth seems to bulge slightly upwards. However, the Melancholic's lips are not so firmly compressed; they rest on each other in a relaxed manner without any suggestion of movement. Eyebrows that look as if applied, which have the same structure as those of the Surly Soldier, with bulging orbital ridges, also shade the glance of the Melancholic Man. The effect created in both cases is a serious, severe expression, in the Munich Head, a sullen one; the rigidity of the Melancholic has been relaxed in the Surly Soldier by the expressive play of feature.

Further, another similarity is the hair style: both in the "Surly Old Soldier" and "The Melan-cholic", to which may also be added "A Scholar, Poet" (figs. 49, 53), the hair is conceived as a single tuft fall-ing, left at a stage without division into locks and not extremely finely combed but worked rather more coarsely. Unlike the Surly Soldier's locks, however, those of the Melancholic spread out from the crown

Auffällig ist ferner die ähnliche Gestaltung der Frisur: Sowohl bei »Ein mürrischer alter Soldat« als auch bei »Der Melancholikus«, denen sich »Der Gelehrte, Dichter« (Abb. 49, 53) anschließt, sind die Haare als einzelne Büschel aufgefasst, die lockig ungeordnet herabfallen und nicht feinst gestrählt, sondern etwas grober gearbeitet stehen geblieben sind. Anders als beim Soldaten aber breiten sich die Locken beim Melancholikus vom Wirbel aus und sind in kurzen Strähnen in die Stirn gestrichen. Beim Gelehrten wiederum sind sie nach hinten geführt.[3] In den beiden zuletzt genannten Fällen ist durch die Haare ein Band beziehungsweise eine Kordel geschlungen, das im Fall des Melancholikus hinten, im Fall des Gelehrten auf der Stirn verknotet ist. Ein Band beziehungsweise eine Kordel vermögen möglicherweise die Zäsur in der Haarstruktur am Hinterkopf des Soldaten zu erklären: Vielleicht dachte Messerschmidt auch beim Soldaten an die Anlage eines Bandes und bereitete in Form der Unterbrechung und der seitlichen Einkerbungen seine Lage vor, um schließlich doch darauf zu verzichten. Dann wäre die Verwandtschaft zwischen den drei Köpfen noch enger, als bisher angenommen. Deutlicher wären damit auch die bereits vermuteten Verbindungen der drei Köpfe zu antiken Bildnissen.

and are combed into the forehead in short strands. In the Scholar, on the other hand, they are combed back.[3] In the last two cases, a band or a cord has been passed round the hair, which, in the Melancholic is knotted at the back and, in the Scholar, on the forehead. The band or cord may possibly be the explanation for the hiatus articulating the hair on the back of the Surly Soldier's head: Messerschmidt may also have thought of adding a band to the soldier and may have prepared its position in the form of the hiatus and the side notches although he ultimately did not bother with it. If he had, the similarities between the three Heads would have been even closer than hitherto assumed. The already suspected link between the three Heads and ancient portraits would also be more noticeable.

Messerschmidt would have seen fillets on many heads from Antiquity; they occur in devices on coins as well as the portrait heads of the Ptolemys (fig. 54); the ends of such fillets are sometimes depicted as

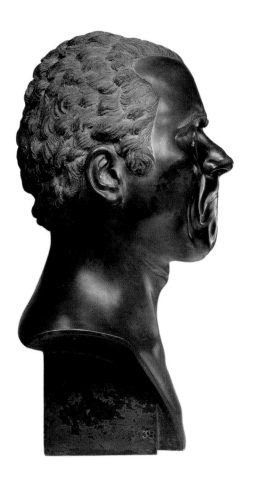

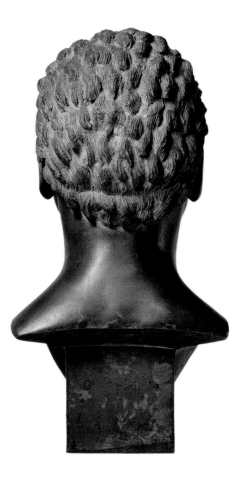

Kat.-Nr. 7c / *Cat. no. 7c*
Franz Xaver Messerschmidt, Ein mürrischer alter Soldat, Seitenansicht
Franz Xaver Messerschmidt, A Surly Old Soldier, side view

Kat.-Nr. 7d / *Cat. no. 7d*
Franz Xaver Messerschmidt, Ein mürrischer alter Soldat, Rückansicht
Franz Xaver Messerschmidt, A Surly Old Soldier, rear view

Haarbänder kann Messerschmidt bei zahlreichen antiken Köpfen gesehen haben, denn man findet sie sowohl auf Münzbildern als auch bei Porträtköpfen ptolemäischer Herrscher (Abb. 54); die Enden flattern gelegentlich vom Hinterkopf herab.[4] Auch griechische Dichterporträts wie diejenigen von Homer, Anakreon, Aischylos und Sophokles zeigen Haarbinden.[5] Herrscher-, Sieger- und Priesterbinden aus Metall, natürlichen Materialien und aus Stoff waren in der griechischen Antike zeitweise gebräuchlich.[6] Zeitgenossen des 18. Jahrhunderts galt die antikische Haarbinde als besondere Auszeichnung. So verlieh Jean-Antoine Houdon (1741–1828) einer Porträtversion des sitzenden Voltaire den »ruban de l'immortalité«.[7] Die Kordel hingegen, die »Der Gelehrte, Dichter« trägt, verweist möglicherweise noch auf einen weiteren Kontext: Franz Anton Mesmer, der als Mediziner die neue Heilmethode des animalischen Magnetismus einsetzte, legte Stricke um erkrankte Körperglieder der Patienten und verband sie mit einer magnetisierten Wanne. Über diese Verbindung geschah die Heilung, nachdem zunächst krampfartige Konvulsionen und Schmerzen die Patienten quälten, ehe sie in Heilschlaf verfielen.[8]

fluttering down the back of the wearer's head.[4] Ancient Greek portraits of poets, such as those of Homer, Anacreon, Aeschylus and Sophocles also have fillets.[5] Fillets for rulers, victors and priests made of metal and, of course, other materials as well as textiles were at times quite usual in ancient Greece.[6] Messerschmidt's 18th-century contemporaries regarded a fillet in the Antique manner as quite a distinction. Jean-Antoine Houdon (1741–1828), for instance, gave a seated portrait of Voltaire the "ruban de l'immortalité" ["Fillet of Immortality"].[7] The cord worn by the "Scholar, Poet", on the other hand, may allude to yet another context: Franz Anton Mesmer, who used the new therapeutic method of animal magnetism, laid cords about the affected limbs of patients and linked them with a magnetising bath. Healing was supposed to be effected via this link following spasms and pain that tortured the poor patients before they fell into a deep, healing sleep.[8]

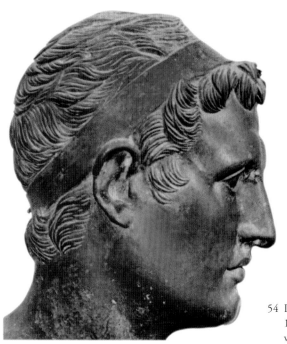

54 Ptolemäus II. Philadelphos, 1. Hälfte 3. Jahrhundert v. Chr., Bronze, Museo Archeologico Nazionale, Neapel, Inv.-Nr. 5600
Ptolemy II Philadelphos, 1st half 3rd century BC, bronze, Museo Archeologico Nazionale, Naples, Inv. no. 5600

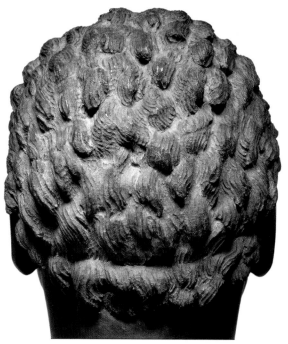

Kat.-Nr. 7e / *Cat. no. 7e*
Franz Xaver Messerschmidt, Ein mürrischer alter Soldat, Detail
Franz Xaver Messerschmidt, A Surly Old Soldier, detail

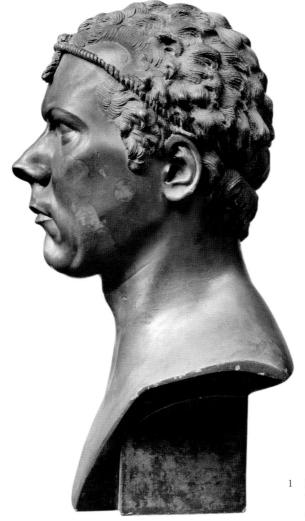

53 Franz Xaver Messerschmidt,
Ein Gelehrter, Dichter,
1777–1781, Blei,
ehemals Staatliche Museen
zu Berlin, Skulpturen-
sammlung und Museum
für Byzantinische Kunst,
Eigentum des Kaiser-
Friedrich-Museums-Vereins,
seit 1945 verschollen,
Inv.-Nr. M193
Franz Xaver Messer-
schmidt, A Scholar, Poet,
1777–1781, lead,
formerly Staatliche Museen
zu Berlin, Skulpturen-
sammlung und Museum
für Byzantinische Kunst,
property of Kaiser-
Friedrich-Museums-Vereins,
whereabouts unknown
since 1945, Inv. no. M193

1 Ähnlich siehe »Der sanfte ruhige Schlaf« (Kat.-Nr. 9), »Der Melancho-
likus« (Kat.-Nr. 8), »Der Künstler, so wie er sich lachend vorgestellt hat«
(Kat.-Nr. 4) oder auch die Porträtbüste des Martin Georg Kovachich
(Abb. 13, 26).
2 Ebenso Kris 1932, S. 204; Pötzl-Malíková 1982, S. 71; Schmid 2004, S. 49.
3 Zur Datierung von »Ein mürrischer alter Soldat«, »Der Melancholikus«
(Kat.-Nr. 8), »Der Gelehrte, Dichter« analog zum lachenden Selbstbildnis
(Kat.-Nr. 4) siehe Kat.-Nr. 8.
4 Abb. siehe Richter 1965, Bd. 3, Fig. 1766–1786, 1835–1969.
5 Abb. siehe Richter 1965, Bd. 1, Fig. 1–109, 271–290, 593–603, 611–713.
6 Dazu siehe Paulys Realencyclopädie 1912, Sp. 2109–2150.
7 So Houdon in einem Werkverzeichnis von 1781 zu einer Statue des sitzen-
den Voltaire, zitiert nach Sauerländer 1963, S. 16.
8 Dazu siehe Krapf, Katalog 2002, S. 262.

Literatur

Anonymus 1794, S. 64–65 (Nro. 38); Kris 1932, S. 204, Abb. 186–187;
Kris 1933, S. 393, Abb. 5; Baum 1980, S. 415, Kat. 271; Glandien 1981,
S. 51, Abb. 45; Pötzl-Malíková 1982, S. 71, 259–260; Oberhaidacher 1984,
S. 33, Abb. 34; Krauß 1986, Abb. 53 (S. 128); Ronzoni 1997, Abb. S. 44;
Krapf, Katalog 2002, S. 250–251; Pötzl-Malíková 2004, Abb. S. 113;
Schmid 2004, S. 49; Pfarr 2006, Abb. 79–80.

1 For a similar effect see "Quiet Peaceful Sleep" (cat. no. 9),
"The Melancholic" (cat. no. 8), "The Artist As He Imagi-
ned Himself Laughing" (cat. no. 4) or even the portrait
bust of Martin Georg Kovachich (figs. 13, 26).
2 Likewise Kris 1932, p. 204; Pötzl-Malíková 1982, p. 71;
Schmid 2004, p. 49.
3 On dating "A Surly Old Soldier", "The Melancholic"
(cat. no. 8), "The Scholar, Poet" analogously with the
Laughing Self-Portrait (cat. no. 4), see cat. no. 8.
4 Shown in Richter 1965, Vol. 3, figs. 1766–1786, 1835–
1969.
5 Shown in Richter 1965, Vol. 1, figs. 1–109, 271–290,
593–603, 611–713.
6 On this see Paulys Realencyclopädie 1912, col. 2109–2150.
7 Thus Houdon in a 1781 catalogue of works on a statue
of Voltaire, seated, quoted in Sauerländer 1963, p. 16.
8 See Krapf, Katalog 2002, p. 262.

References

Anon. 1794, pp. 64f. (Nro. 38); Kris 1932, p. 204,
figs. 186–187; Kris 1933, p. 393, fig. 5; Baum 1980, p. 415,
Cat. 271; Glandien 1981, p. 51, fig. 45; Pötzl-Malíková
1982, p. 71, pp. 259, 260; Oberhaidacher 1984, p. 33,
fig. 34; Krauss 1986, fig. 53 (p. 128); Ronzoni 1997, illus.
p. 44; Krapf, Katalog 2002, pp. 250f.; Pötzl-Malíková
2004, illus. p. 113; Schmid 2004, p. 49; Pfarr 2006, figs.
79, 80.

Blei, Höhe 44,5 cm
Preßburg, 1777–1781
Privatbesitz

Lead, height 44.5 cm
Bratislava, 1777–1781
Private collection

[8]

Der Melancholikus

Der vom Anonymus Ende des 18. Jahrhunderts als »Der Melankolikus«[1] bezeichnete Kopf zeigt den prototypischen Aufbau der Charakterköpfe (Kat.-Nr. 8a): Auf einem schmal geschnittenen, sich V-förmig verjüngenden Brustausschnitt ruht auf breitem Hals der frontal ausgerichtete Kopf. Ein Quader, der in der Frontalansicht seitlich vorsteht, stützt die Büste. Anders aber als bei der Mehrzahl der nach dem Prototyp aufgebauten Charakterköpfe gehen Sockel und Büste in den Seiten und auf der Rückseite in sanftem Schwung ineinander über (Kat.-Nr. 8b). Damit erinnert die Büste an Köpfe wie die Variante zu »Der Edelmüthige«, »Der Feldherr«, »Der weinerliche Alte«, »Ein Erzbösewicht« (Kat.-Nr. 10), »Ein kraftvoller Mann« (Kat.-Nr. 16) und »Ein Heuchler und Verleumder«.[2]

»Der Melancholikus« zeigt ein ruhiges Gesicht, das mit wenigen hervorgehobenen Details – den weich eingetragenen Nasolabialfalten und Tränensäcken, der zwischen Nase und Mund liegenden so genannten Fliege sowie dem leicht angespannten Kinn – großflächig modelliert ist. Die Mundwinkel sind leicht herabgezogen, so dass sich der Mund nach oben wölbt. Auffällig sind in dem Gesicht die Augenbrauen, die über den Orbitalwülsten wie eigens aufgesetzte, über den Augen lastende Fremdkörper wirken. Die Brauenhaare sind in sorgfältiger Ziselierung eingetragen. Über den Augenbrauen bilden sich, hierin dem Kopf von »Ein mürrischer alter Soldat« (Kat.-Nr. 7) in abgemildeter Form vergleichbar, Runzeln, die die Stirn leicht verformen und die Wirkung von zusammengezogenen Brauen hervorrufen. Insgesamt besteht große Ähnlichkeit mit dem Soldaten, sowohl was die klare, nur von wenigen Falten unterteilte Physiognomie, die Mundbewegung, die wie aufgesetzt wirkenden, erhaben modellierten Augenbrauen als auch die Stirnfalten betrifft.

134

The Melancholic

The Head called "The Melancholic" by Anonymous in the late 18th century[1] reveals the prototype Character Head structure (cat. no. 8a): the broad neck of a frontal head rests on a V-shaped, narrow tapering breast section. A block, which projects at the sides when viewed frontally, supports the bust. However, unlike most of the Character Heads built up along the lines of the prototype, the bust glides fluidly in a gentle curve into the base at the sides and back (cat. no. 8b). In this respect, the present bust is reminiscent of Heads such as the variants of "The Noble-Minded Man", "The General", "The Weepy Old Man", "An Arch-Rascal" (cat. no. 10), "A Strong Man" (cat. no. 16) and "A Hypocrite and Slanderer".[2]

"The Melancholic" has a composed face, which, with only a few details emphasised – the softly incised nasolabial folds and lachrymal sacs, the philtrum between nose and mouth and the slightly taut chin – has been modelled in large surfaces. The corners of the mouth droop slightly so that the mouth bulges upwards. The eyebrows are striking in this face; they look like alien elements set expressly above the orbital ridges to weigh on the eyes. The eyebrow hairs have been meticulously chiselled in. Comparable in this respect to the head of "A Surly Old Soldier" (cat. no. 7), wrinkles slightly deform the forehead to produce an effect, albeit slightly modified, of the brows being knit. Altogether the present Head reveals close similarity with the soldier, both in the clear countenance slightly articulated by a few wrinkles, in the action of the mouth, in the eyebrows modelled as raised and, therefore, looking as if applied, as well as the wrinkles on the forehead.

The hair is not brushed off the forehead, as it is in the soldier, whose hair is noticeably receding at the temples. In the "Melancholic", by contrast, it grows luxuriantly forwards towards the forehead in short, thick locks. In being of loosened structure, the locks are similar to the rendering of the hair in the sullen soldier and "A Scholar, Poet" (fig. 49) and "The Troubled Man".[3] The locks growing luxuriantly over the forehead are virtually identical in "The Enraged and Vengeful Gypsy".[4] Further, the same compact, curled

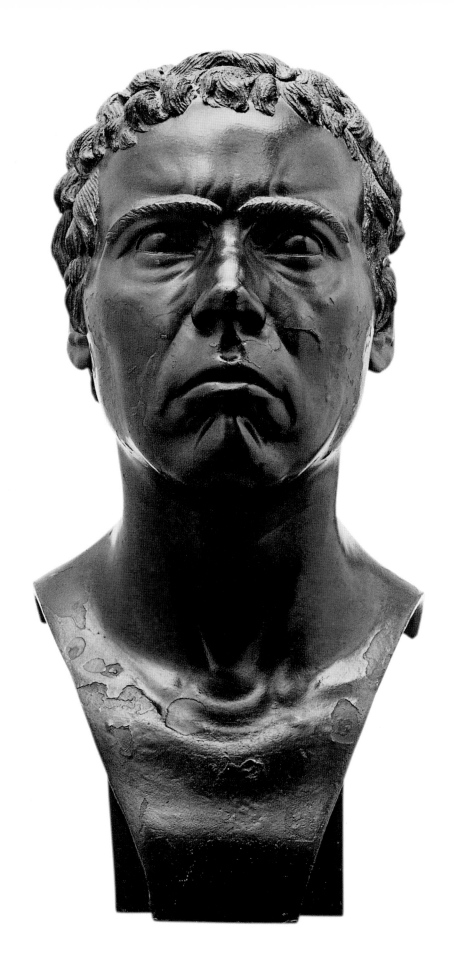

[8a]

Die Haare sind nicht aus der Stirn gestrichen, wie beim Soldaten, bei dem ausgeprägte Geheimratsecken auffallen: Beim Melancholikus wuchern sie statt dessen in kurzen, kräftigen Locken nach vorn in die Stirn. In der aufgeflockten Struktur sind sie wiederum mit der Haargestaltung des Soldaten vergleichbar sowie mit der von »Ein Gelehrter, Dichter« (Abb. 49) und »Der Bekümmerte«.[3] Ihre über die Stirn wuchernde Form findet sich desgleichen bei »Der erbosste und rachgierige Zigeuner«.[4] Dieselbe kompakte, gelockte Form zeigen ferner die seitlich unter der Kappe hervorlugenden Haare beim lachenden Selbstporträt (Kat.-Nr. 4). In allen Fällen sind die Locken zwar fein gesträhnt, aber nicht derart minutiös ziseliert, wie es bei »Der Edelmüthige« (Kat.-Nr. 18), »Der kindisch Weinende« (Kat.-Nr. 19) oder auch »Der Satirikus« (Kat.-Nr. 20) ins Auge fällt.

form appears on the sides peeping beneath the cap worn by "The Artist As He imagined Himself Laughing" (cat. no. 4). In all these cases, the locks are in fine strands yet not so minutely detailed in the chiselling as they are so notably in "The Noble-Minded Man" (cat. no. 18), "Childish Weeping" (cat. no. 19) and "The Satirist" (cat. no. 20).

"The Melancholic" also has the fillet in the hair like that worn on the head of "A Scholar, Poet" (fig. 53). The scholar is, however, wearing a cord that is loosely knotted over the forehead; the melancholic is wearing a narrow fillet over his curls that is knotted in the back. In "A Surly Old Soldier"

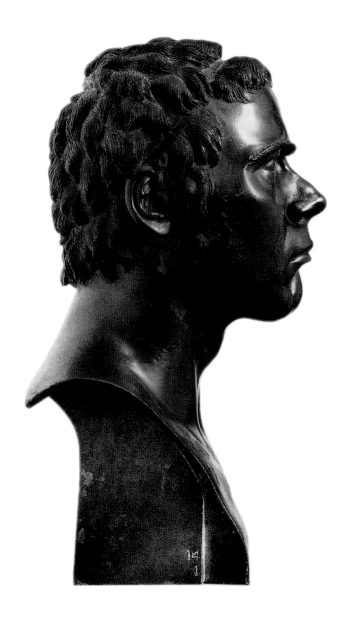

Kat.-Nr. 8b / *Cat. no. 8b*
Franz Xaver Messerschmidt, Der Melancholikus, Seitenansicht
Franz Xaver Messerschmidt, The Melancholic, side view

136

Mit dem Kopf von »Ein Gelehrter, Dichter« (Abb. 53) hat der Melancholikus auch das Band im Haar gemeinsam. Bei dem Gelehrten handelt es sich allerdings um eine Kordel, die über der Stirn locker verknotet ist; beim Melancholikus liegt ein schmales Band auf den Locken, das hinten verknüpft ist. Auch bei »Ein mürrischer alter Soldat« (Kat.-Nr. 7) könnte Messerschmidt an die Einfügung einer Haarbinde gedacht haben, wie die Anlage der Haare am Hinterkopf und an den Seiten vermuten lässt. Diese Haarbinden gehen zurück auf ptolemäische Herrscherporträts (Abb. 54), die Messerschmidt in Rom auf Münzbildern sowie als Porträtköpfe gesehen haben kann.[5]

Jean Clair datiert die Büste ohne Angabe von Gründen in die Jahre um 1775–1780,[6] das heißt in die Münchener und ersten Preßburger Jahre. Sollte die Ähnlichkeit zwischen dem lachenden Selbstporträt in Bezug auf die Gestaltung der Haare und Brauen und aufgrund der vergleichbar großflächigen Modellierung der Gesichtspartien auf dieselbe Entstehungszeit hinweisen, wäre auch der Melancholikus in den Jahren zwischen 1777 und 1781 entstanden.[7] Unter der genannten Voraussetzung würde dies dann auch für »Ein mürrischer alter Soldat« (Kat.-Nr. 7), »Der Bekümmerte«, »Der erbosste und rachgierige Zigeuner« sowie für den Gelehrten gelten.

1 Anonymus 1794, S. 49.
2 Abb. siehe Krapf, Katalog 2002, S. 214, 221, 252, 258.
3 Abb. siehe Krapf, Katalog 2002, S. 190–191.
4 Abb. siehe Krapf, Katalog 2002, S. 209.
5 Dazu auch ausführlicher Kat.-Nr. 7. Ähnlich beispielsweise bei der »Statue eines hellenistischen Herrschers«, Liebieghaus Skulpturensammlung, Frankfurt am Main, Inv.-Nr. 127. Siehe weitere Abb. in: Richter 1965, Bd. 1, Fig. 1–109, 271–290, 593–603, 611–713. Kris (1932, S. 203) weist als Vorbild auf Lorbeerkränze römischer Imperatorenbüsten hin; diesen Hinweis, ergänzt durch klassisch-antike Porträtplastik und römische Darstellungen von Isispriestern (für die Kahlköpfe), greift Oberhaidacher (1984, S. 34) auf.
6 Siehe Clair in: Ausst.-Kat. Melancholie 2005, S. 419.
7 Dazu siehe Kat.-Nr. 4.

Literatur
Anonymus 1794, S. 49–50 (Nro. 14); Ilg 1885, S. 51, 58; Weiss 1924, S. 48, 51, 69, 139; Kris 1932, S. 203, Abb. 183; Kris 1933, S. 393, 401, 403, Abb. 4; Glandien 1981, Abb. 15; Pötzl-Malíková 1982, S. 71–72, 249; Oberhaidacher 1984, S. 34, Abb. 27; Krapf, Katalog 2002, S. 196–197; Lehner-Jobst 2002, Abb. S. 95; Schmid 2004, S. 25; Clair in: Ausst.-Kat. Melancholie 2005, S. 419; Pfarr 2006, Abb. 48 (Gipsabguss).

(cat. no. 7), Messerschmidt may also have thought of adding a fillet, as the articulation of the hair on the back and sides of the head suggests. These fillets derive from portraits of Ptolemaic rulers (fig. 54), which Messerschmidt might have seen in Rome both as devices on coins as well as on portrait heads.[5]

Without giving any reasons for so doing, Jean Clair dates the present bust to c. 1775–1780,[6] that is, to Messerschmidt's Munich and early Bratislava years. Should the similarity between "The Artist As He imagined Himself Laughing" in the handling of the hair and brows and on the grounds of the similarly broad modelling of facial surfaces suggest a similar date, "The Melancholic" would have to be dated to the years between 1777 and 1781.[7] Should that be the case, the same would apply to "A Surly Old Soldier" (cat. no. 7), "The Troubled Man", "The Enraged and Vengeful Gypsy" and "A Scholar, Poet".

1 Anon. 1794, p. 49.
2 Shown in Krapf, Katalog 2002, pp. 214, 221, 252, 258.
3 Ibid., pp. 190f.
4 Ibid., p. 209.
5 On this more extensively also see cat. no. 7. Similarly, also, in a "statue of a Hellenistic ruler", Liebieghaus Skulpturensammlung, Frankfurt am Main, Inv. no. 127. See more illus. in: Richter 1965, Vol. 1, figs. 1–109, 271–290, 593–603, 611–713. Kris (1932, p. 203) points out the laurel wreath crowning busts of the Roman emperors as the model; this pointer, to which the portrait sculpture of classical Antiquity and Roman representations of Isis priests (for the bald heads) may be added, is taken up by Oberhaidacher (1984, p. 34).
6 See Clair in: exhib. cat. Melancholie 2005, p. 419.
7 Cf. cat. no. 4.

References
Anonymous 1794, pp. 49f. (no. 14); Ilg 1885, pp. 51, 58; Weiss 1924, pp. 48, 51, 69, 139; Kris 1932, pp. 203, fig. 183; Kris 1933, pp. 393, 401, 403, fig. 4; Glandien 1981, fig. 15; Pötzl-Malíková 1982, pp. 71f, 249; Oberhaidacher 1984, p. 34, fig. 27; Krapf, Katalog 2002, pp. 196f.; Lehner-Jobst 2002, illus. p. 95; Schmid 2004, p. 25; Clair in: exhib. cat. Melancholie 2005, p. 419; Pfarr 2006, fig. 48 (plaster cast).

Zinn, Höhe 44 cm
nach 1770
Szépmüvészeti Múzeum
Budapest, Inv.-Nr. 53.656

Pewter, height 44 cm
after 1770
Szépmüvészeti Múzeum
Budapest, Inv. no. 53.656

[9]

Der sanfte ruhige Schlaf

»Der sanfte ruhige Schlaf« (Kat.-Nr. 9a) ähnelt mit seinem vom Ausdruck her wenig verzogenen Gesicht dem Edelmüthigen (Kat.-Nr. 17) und seiner Variante.[1] Auf dem bekannten Sockel-Brustausschnitt-Typus ruhend, zeigt das Gesicht, oberflächlich betrachtet, ruhige Züge. Insbesondere die geschlossenen Augen vermitteln einen entspannten Ausdruck. Dazu tragen auch die klaren Formen bei, die die Physiognomie bestimmen und die ruhige Gestaltung des Brustausschnitts und Halses fortsetzen: die Wangen, das Kinn, die Stirn, die Nase und sogar die geschlossenen Augen, das heißt die Oberlider (Kat.-Nr. 9c), sind in großflächigen Formen gestaltet. Wenige, eher weich eingetragene Falten verleihen dem Gesicht klare Konturen und teilen es in verschiedene Partien auf. Allein eine Falte unter den Augen und ein schmaler Schlitz zwischen Unter- und Oberlid sind in feinen Ritzungen eingetragen.

Bei eingehender Betrachtung allerdings verrät das Gesicht eine gewisse Anspannung, die dem ersten Eindruck von Entspannung zuwiderläuft: Die Augenbrauen, zur Nasenwurzel hin verdickt, sind leicht gerunzelt, Stirnfalten, die sich sowohl nach oben als auch zu den Schläfen ziehen, unterstreichen diese angedeutete Bewegung. Auch der Mund wirkt leicht angespannt, das Kinn ist in kaum wahrnehmbarer Form vorgereckt, die Partie zwischen Mund und Nase wirkt gebläht.

138

Quiet Peaceful Sleep

"Quiet Peaceful Sleep" (cat. no. 9a) resembles, in its face being slightly contorted by its expression, "The Noble-Minded Man" (cat. no. 17) and the variants of that bust.[1] Resting on the familiar base-breast-section type, the facial features, viewed superficially, seem composed. The closed eyes especially convey a relaxed impression. The clear forms determining the physiognomy also contribute to this effect and are continued in the quiet design of the breast section and neck: the cheeks, chin, forehead, nose and even the closed eyes, that is, the upper lids (cat. no. 9c) have been rendered in forms with large surfaces. A few, rather gently incised wrinkles lend the face clear contours and articulate it in various sections. Only a wrinkle below the eyes and a narrow slit between the lower and upper lids have been finely incised.

On closer scrutiny, however, the face reveals a certain tension, which contradicts the first, relaxed impression: the eyebrows, slightly thicker towards the root of the nose, are slightly knit; wrinkles on the forehead underscore this suggested action by being drawn both up and across to the temples. The mouth, too, seems slightly tense; the chin juts forward almost imperceptibly and the area between nose and mouth looks distended.

In "Quiet Peaceful Sleep" it is mainly the style of the hair and the eyebrows that look at odds with the initial impression. Viewed frontally, the hair, which is combed into fine strands, is drawn back in occasionally crescent-like forms (cat. no. 9b). Viewed from the side or back, the picture changes (cat. no. 9e–f). The strands lie smoothly, as if combed, across the forehead and the temples but grow away from the skull and gradually become thick, compact, long shaggy locks towards the side and back of the head (cat. no. 9d), which are tousled and even stand out slightly from the head. But not just the way they have been laid out is rather coarse; the careful combing discernible on forehead and temples is abandoned for texturing that is disrupted by thicker strands, breaks off abruptly or suddenly starts and ends. One occasionally believes one is seeing the lumps of wax from which the casting mould was modelled. All appear-

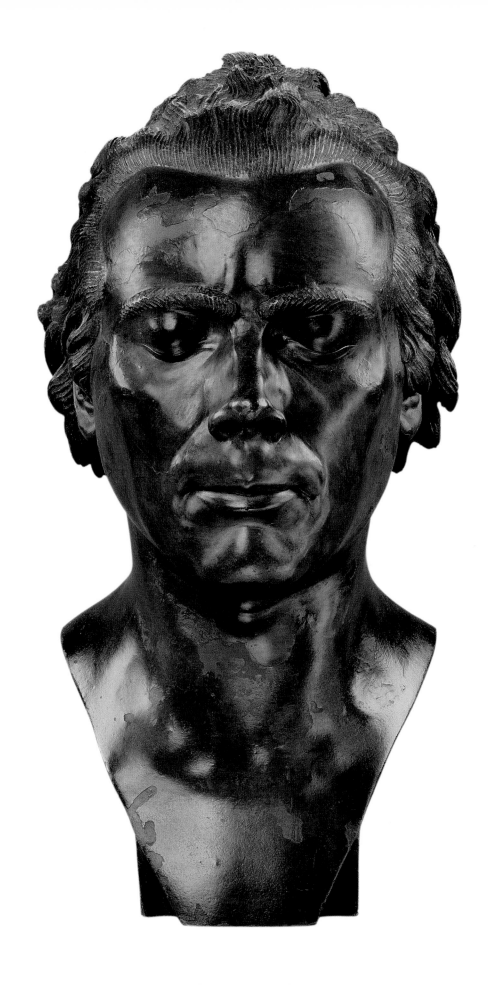

[9a]

Es sind im Fall von »Der sanfte ruhige Schlaf« vor allem die Frisur und die Augenbrauen, die exzentrisch wirken. Von vorne betrachtet sieht man nur Haar, das, fein in sich gestrählt, in Strähnen, gelegentlich sichelförmig gebogen, nach hinten gestrichen ist (Kat.-Nr. 9b). Von der Seite oder von der Rückseite aus betrachtet, wandelt sich das Bild (Kat.-Nr. 9e–f). Über der Stirn und an den Schläfen liegen die Strähnen glatt und wie gekämmt an, lösen sich aber zunehmend vom Schädel und werden allmählich an den Seiten und am Hinterkopf zu dicken, kompakten, langen Haarzotteln (Kat.-Nr. 9d), die ungeordnet und struppig übereinander liegen oder gar leicht vom Kopf abstehen. Nicht aber nur ihre Anlage ist eher grob. Auch die sorgfältige Strählung, die an Stirn und Schläfen zu sehen war, wird aufgegeben zugunsten einer Strukturierung, die von dickeren Streifen unterbrochen ist, abrupt abbricht oder unvermittelt ansetzt und endet. Gelegentlich glaubt man, den Klumpen Wachs noch zu sehen, aus dem das Gussmodell modelliert wurde. Jeder Anschein natürlichen Haars wird negiert. Die Augenbrauen bilden an der Nasenwurzel dicke Wülste und flachen zu den Seiten hin ab. Sie sind genauso gestrählt wie die Haare und bestehen jeweils aus zwei aufeinander zu laufenden, schrägen Strichelungen, die sich auf dem obersten Grat der Brauen treffen.

ance of natural hair has been eschewed. At the root of the nose, the eyebrows form thick strips and flatten towards the sides. They look just as combed as the hair and the hairs each consist of two converging, oblique streaks that meet on the upper ridge of the brows.

In the visual arts, sleepers are represented with their eyes closed and limbs relaxed. Famous representations of sleep include Michelangelo's sculpture of "Night" on the tomb of Giuliano de' Medici in the Medici Chapel in Florence, Giorgione's representations of reclining Venus and representations of the sleeping Disciples, of the boy Jesus asleep and also Hypnos, the ancient personification of sleep as a Cupid or a youth. As can often be seen in the Cristo morto type, closed eyes can be symbolic of death. In the 18th century, death masks, for example, those of Gotthold Ephraim Lessing, Jean-Jacques Rousseau and the Comte de Mirabeau, were taken from the actual body and often reproduced in engravings.[2] Messerschmidt's bust is most closely related to those

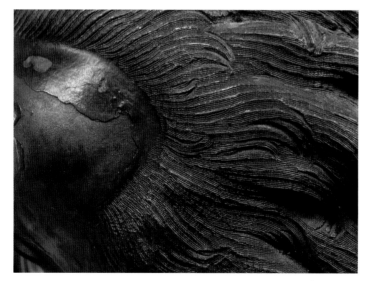

Kat.-Nr. 9b / *Cat. no. 9b*
Franz Xaver Messerschmidt, Der sanfte ruhige Schlaf, Detail
Franz Xaver Messerschmidt, Quiet Peaceful Sleep, detail

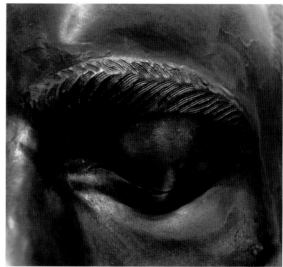

Kat.-Nr. 9c / *Cat. no. 9c*
Franz Xaver Messerschmidt, Der sanfte ruhige Schlaf, Detail
Franz Xaver Messerschmidt, Quiet Peaceful Sleep, detail

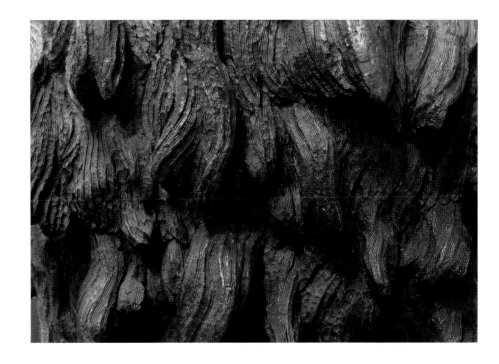

In der bildenden Kunst werden schlafende Menschen mit geschlossenen Augen und entspannten Gliedern wiedergegeben. Zu berühmten Darstellungen des Schlafs gehören Michelangelos (1475–1564) Skulptur der »Nacht« auf dem Grabmal Giuliano de' Medicis in der Florentiner Medici-Kapelle, Giorgiones (1478–1510) Darstellungen der schlafenden Venus sowie Wiedergaben der schlafenden Jünger, des schlafenden Jesusknaben oder auch die Darstellung der antiken Personifikation des Schlafs Hypnos durch Erotendarstellungen oder einen Jüngling. Wie häufig beim Typus des Cristo morto zu sehen, sind geschlossene Augen gleichfalls sinnfällige Zeichen für den Tod. Im 18. Jahrhundert wurden auch Totenmasken, wie beispielsweise von Gotthold Ephraim Lessing, Jean-Jacques Rousseau, Comte de Mirabeau, abgenommen und häufig in Stichen wiedergegeben.[2] Am ehesten ließe sich Messerschmidts Büste auf jene Darstellungen von Thanatos oder Hypnos beziehen, die schlafend und gelegentlich mit an den Schläfen ansetzenden Flügeln dargestellt sind.[3] Die leichte Anspannung des Gesichts könnte von einem Traum herrühren, wäre da nicht die aufrechte Position des Kopfes auf dem Kubus und das wild bewegte Haar.

Insgesamt erweckt dieser Charakterkopf eher den Eindruck eines wachen Menschen, der die Augen geschlossen hält: »Die geschlossenen Augen und der schmale Mund vermitteln [...] in ihrer gespannten Ruhe den Eindruck, sie könnten sich im nächsten Moment in eine der Grimassen verwandeln.«[4] Der erste Eindruck täuscht somit ebenso wie dies bei der Variante zu »Der Edelmüthige«[5]

representations of Thanatos or Hypnos sleeping with little wings sprouting out of their temples in some instances.[3] The slight tension in the face of the present bust might come from a dream if the head were not set upright on the block and the hair were not so tousled.

The overall impression made by this Character Head is that of a man wide awake but with his eyes closed: "The closed eyes and the narrow mouth convey [...] in their tense repose, the impression they might change the next instant into one of the grimaces."[4] The first impression is deceptive as it is in a variant of "The Noble-Minded Man":[5] here, too, the uncontorted face changes from its simplicity and repose on longer scrutiny into something subliminally violent. This disconcerting aspect, which sets in once one looks at the face, is magnified by the link with the wildly textured hair. Hair standing on end or hair wildly blowing about is traditionally used in representations of Damnation, Vice and Hell to underscore the pains, the fears, which in such cases mark the faces, by the rendering of the hair. In "Quiet Peaceful Sleep", coarse texturing and shaggy locks of unkempt hair standing on end contrast with an externally composed face that is only tense beneath the surface. As in other

Kat.-Nr. 9e / *Cat. no. 9e*
Franz Xaver Messer-
schmidt, Der sanfte
ruhige Schlaf, Rück-
ansicht
Franz Xaver Messer-
schmidt, Quiet Peaceful
Sleep, rear view

Kat.-Nr. 9f / *Cat. no. 9f*
Franz Xaver Messer-
schmidt, Der sanfte
ruhige Schlaf, Seiten-
ansicht
Franz Xaver Messer-
schmidt, Quiet Peaceful
Sleep, side view

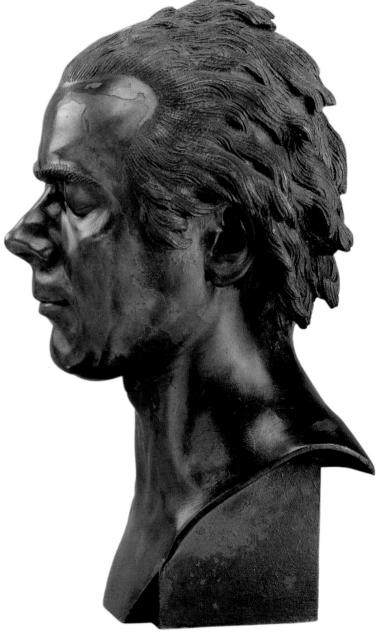

der Fall ist: Auch hier wandelt sich das unverzerrte Gesicht in seiner Einfachheit und Ruhe bei längerer Betrachtung zu etwas unterschwellig Gewalttätigem. Diese Irritation, die sich bereits beim Blick in das Gesicht einstellt, verstärkt sich noch durch die Verbindung mit dem wild strukturierten Haar. Zu Berge stehende oder wild wehende Haare werden traditionell bei Darstellungen der Verdammnis, des Lasters, der Hölle wiedergegeben, um die Schmerzen, das Erschrecken, das in diesen Fällen das Gesicht kennzeichnet, durch die Gestaltung der Haare zu unterstreichen. Bei »Der sanfte ruhige Schlaf« kontrastieren grobe Strukturen und abstehende Haarzotteln mit einem äußerlich ruhigen, nur unter der Oberfläche angespannten Gesicht. Wie bei anderen Büsten fällt auch hier Messerschmidts Bestreben auf, wechselnde Eindrücke, die sich gelegentlich zu widersprechen scheinen, unlösbar miteinander zu verknüpfen. Die Irritationen können nicht aufgelöst werden, rufen aber doch unterschiedliche Eindrücke hervor, die nicht zur Deckung gebracht werden können.

Krapf verbindet diese Darstellung mit der Lehre des Magnetiseurs Franz Anton Mesmer und dem Zustand des »magnetischen Schlafs« als sechsten Grad der »Abwesenheit«: Mesmer nennt innerhalb seiner Magnetkuren den Begriff des »kritischen Schlafes« oder auch »Heilschlafes«, der einer Krise folge und zur Heilung führe.[6]

1 Dazu siehe Bückling 1999b, S. 111–112.
2 Abb. der Totenmaske Mirabeaus (1791) siehe in: Mraz / Schlögl 1999, S. 370–371; Abb. der Totenmaske Rousseaus siehe in: Sauerländer 2002, S. 36; zur Bedeutung von Totenmasken siehe auch Bücherl 1989, S. 61–62.
3 Pötzsch 1993, Abb. S. 125.
4 Bücherl 1989, S. 58. Ähnlich auch Kris 1932, S. 192; Krapf, Katalog 2002, S. 186; Hàmori 1992, S. 238.
5 Abb. in Krapf, Katalog 2002, S. 215.
6 Krapf, Katalog 2002, S. 186.

Literatur
Anonymus 1794, S. 46 (Nro. 8); Ilg 1885, S. 52; Kris 1932, S. 192, Abb. 163; Kris 1933, S. 392, Abb. 1; Klára 1974, Abb. 41; Biedermann 1978, S. 28; Pötzl-Malíková 1982, S. 72, 247; Behr / Grohmann / Hagedorn 1983, S. 129–132; Bücherl 1989, S. 57–58, 61–62, Abb. S. 65; Hàmori 1992, S. 238–239, Abb. 6; Ausst.-Kat. Messerschmidt Têtes de caractère 1993, S. 57; Hàmori 1994, S. 19, 23, Abb. 19; Krapf, Katalog 2002, S. 186–187; Pötzl-Malíková 2004, Abb. S. 76; Schmid 2004, S. 19; Pfarr 2006, Abb. 40–41.

Messerschmidt busts, the artist is notably striving to indissolubly link changing impressions, which occasionally seem to contravene each other. The disturbing conflicts cannot be resolved but they evoke differing, irreconcilable, impressions.

Krapf links this representation with the teachings of the magnetism expert Franz Anton Mesmer and the state of "magnetised slumber" as the sixth degree of "absence": Mesmer mentioned in connection with his magnet cures the concept of "critical slumber" or "therapeutic slumber" following on a crisis and leading to healing.[6]

1 On this see Bückling 1999b, pp. 111f.
2 For a picture of Mirabeau's death mask (1791) see: Mraz / Schlögl 1999, pp. 370f.; for a picture of Rousseau's death masks see: Sauerländer 2002, p. 36; on the meaning of death masks, see also Bücherl 1989, pp. 61f.
3 Pötzsch 1993, shown p. 125.
4 Bücherl 1989, p. 58. Similarly also Kris 1932, p. 192; Krapf, Katalog 2002, p. 186; Hàmori 1992, p. 238.
5 Shown in Krapf, Katalog 2002, p. 215.
6 Ibid., p. 186.

References
Anon. 1794, p. 46 (no. 8); Ilg 1885, p. 52; Kris 1932, p. 192, fig. 163; Kris 1933, p. 392, fig. 1; Klára 1974, fig. 41; Biedermann 1978, p. 28; Pötzl-Malíková 1982, pp. 72, 247; Behr/Grohmann/Hagedorn 1983, pp. 129–132; Bücherl 1989, pp. 57f., 61f., illus. p. 65; Hàmori 1992, pp. 238f., fig. 6; exhib. cat. Messerschmidt Têtes de caractère 1993, p. 57; Hàmori 1994, pp. 19, 23, fig. 19; Krapf, Katalog 2002, pp. 186f.; Pötzl-Malíková 2004, illus. p. 76; Schmid 2004, p. 19; Pfarr 2006, figs. 40, 41.

Zinn-Blei-Legierung,
Höhe 38,5 cm
nach 1770
Österreichische
Galerie Belvedere
Wien, Inv.-Nr. 2442

Tin-lead alloy,
height 38.5 cm
after 1770
Österreichische Galerie
Belvedere, Vienna
Inv. no. 2442

[10]

Ein Erzbösewicht

Der auf die Brust gepresste Kopf des so genannten Erzbösewichts (Kat.-Nr. 10a) ruht, scheinbar halslos, auf einem Brustausschnitt, der sich nach unten verjüngt, jedoch nicht bis zur Sockelfläche reicht, so dass der zylindrische Sockel, der den Kopf trägt, zu sehen bleibt. In der Vorderansicht erscheint der in sich geschwungene und nach vorn ragende Büstenausschnitt als voluminöser Körper, während er in den Seitenansichten, von einem schmalen Steg begrenzt, in sanftem Schwung ohne Absatz in den Sockel übergeht. Die Verschleifung von Ausschnitt und Sockel sowie die anatomisch absurde Fortführung des Brustausschnitts in eine geometrische Form bedeuten eine Radikalisierung der Ausdrucksmittel in Messerschmidts Büsten, denn die Illusion eines Körperausschnitts wird nahezu zur Gänze aufgegeben.[1] Der geneigte Kopf des Erzbösewichts ist so fest auf die Brust gedrückt, dass ein zweifacher Faltenring, der bis zum Rücken führt, um den Kopf entsteht. Dieser »Ring« trennt den Kopf deutlich von der Brust, deren Fleisch durch den aufliegenden Kopf wellenartig nach vorn geschoben wird. Das auf der Brust ruhende Kinn ist ornamental in Grübchen und Wülste aufgelöst und kaum als natürliche Form wiederzuerkennen (Kat.-Nr. 10b).

Die stark verformte Augenpartie zieht die Nasenwurzel, Ober- und Unterlider, Augenbrauen sowie sich in die Stirn fortsetzende Falten in Mitleidenschaft. Die Oberlider und die Orbitalwülste sind nicht mehr zu unterscheiden: Die ornamental geblähten Verdickungen werden von tiefen, als Falten dienenden Rillen eingerahmt und zwar so, dass der Augapfel völlig überdeckt ist. Ja, es scheint so, als sei der gewölbte Orbitalwulst selbst das vom Oberlid bedeckte Auge.

144

An Arch-Rascal

The head pressing against the breast of the bust known as "An Arch-Rascal" (cat. no. 10a) rests, seemingly without a neck, on a section of breast tapering to the bottom but not extending to the surface of the base, so that the cylindrical base carrying the head remains visible. Viewed from the front, the curvilinear, jutting bust section seems to have volume whereas from the side, it is bounded by a small strip that joins the base in a gentle curve without a transition. The blurring of breast section and base as well as the anatomically absurd continuation of the breast section in a geometric form signify a radicalisation of expressive devices in Messerschmidt's busts, since the illusion of a detail of the body has been almost entirely abandoned.[1] The Arch-Rascal's tilted head is pressed so firmly against his breast that a double ring of wrinkles leading to the back is created around the head. This "ring" clearly demarcates the head from the breast, the flesh of which is pushed forward in waves by the head being pressed against it. The chin resting on the breast has been ornamentally resolved in dimples and folds and is hardly recognisable as a natural form (cat. no.10b).

The pronounced deformation of the orbital zones affects the root of the nose, the upper and lower lids, the eyebrows and wrinkles that continue on to the forehead. The upper lids and the orbital ridge are indistinguishable: the decoratively distended thickened sections are framed by deep grooves serving as wrinkles in such a manner that the eyeballs are completely overlaid. In fact it seems as if the bulging orbital ridge is the eye covered by the upper lid. However, the course of the folds and wrinkles created by such grotesque-looking facial action has been naturalistically reproduced.

Raised bands delimit the wrinkles surrounding the orbital ridge from above and develop into eyebrows. These in turn are deformed across the bridge of the nose to thickened folds whereas above the "orbital eyes", slightly shifted towards the temples, distended parts again deform the forehead. Numerous finer wrinkles start at the contracted upper and lower lids and continue on to the temples as crow's feet, spreading like a fan. Incised wrinkles lead from

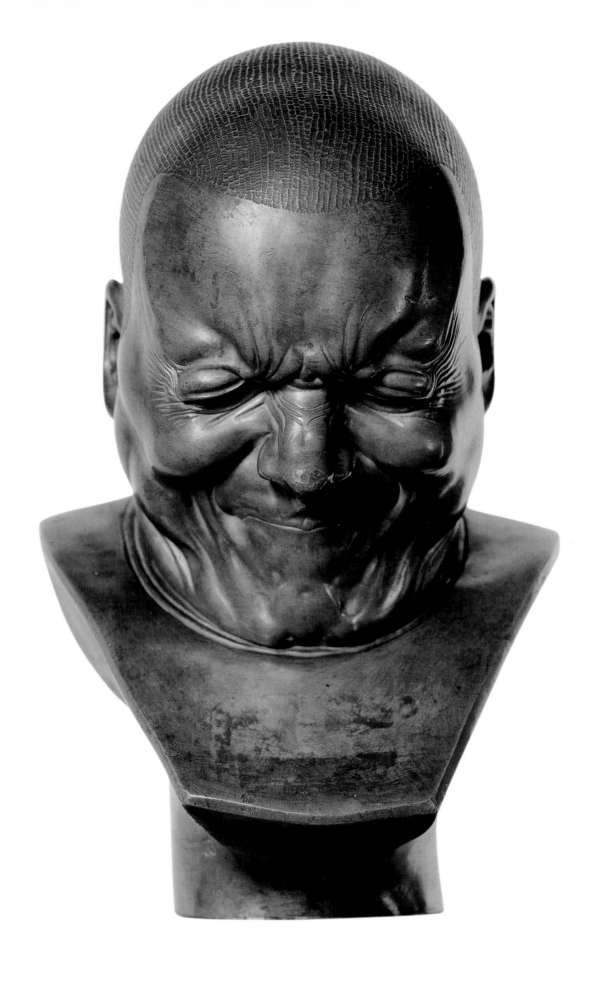

[10 a]

Allerdings: Der Verlauf von Wülsten und Falten, die bei einer solch grotesk wirkenden Mimik entstehen, ist natürlich wiedergegeben.

Stege grenzen die Falten, die die Orbitalwülste einfassen, nach oben ab und entwickeln sich zu Augenbrauen. Diese wiederum verformen sich über der Nasenwurzel zu von Falten durchzogenen Verdickungen, während über den »Orbital-Augen«, leicht zu den Schläfen hin versetzt, nochmals geblähte Partien die Stirn verformen. Zahlreiche feinere Falten setzen an den zusammengekniffenen Ober- und Unterlidern an und ziehen sich als fächerförmig ausgebreitete »Krähenfüße« bis zu den Schläfen. Von den inneren Augenwinkeln aus führen wiederum eingeritzte Falten zur Nase; eine liegt quer über dem Nasenrücken, andere brechen kurz davor ab oder führen bis zu den Nasenflügeln. Ähnliche Falten finden sich nahezu stereotyp über der Nase bei »Der Gähner« (Kat.-Nr. 12), »Ein düstrer finsterer Mann« (Kat.-Nr. 21), »Der weinerliche Alte« und seiner Variante (Kat.-Nr. 11) sowie bei »Der Trozige«.[2]

the inner corners of the eyes to the nose; one lies across the bridge of the nose while others break off just before it or lead to the wings of the nose. Similar wrinkles are almost stereotypes across the nose of "The Yawner" (cat. no. 12), "A Dismal and Sinister Man" (cat. no. 21), "The Weepy Old Man" and the variant of it (cat. no. 11) as well as "The Defiant Man".[2]

A stubbly hair-style covers the sculpturally domed skull and is crisply demarcated from the forehead. The individual strands are formed of horizontal streaks and they border raised strips that look as if they had been punched. These strands of hair are pulled back in straight, parallel rows; they converge radially at the crown of the head. The rows of hair running parallel to them from the side and the back of the head also lead to the crown but bend in a gen-

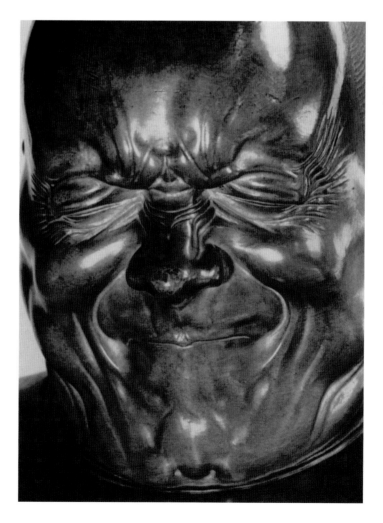

Kat.-Nr. 10b / *Cat. no. 10b*
Franz Xaver Messerschmidt, Ein Erzbösewicht, Detail
Franz Xaver Messerschmidt, An Arch-Rascal, detail

146

Den sich plastisch wölbenden Schädel überzieht eine scharfkantig gegen die Stirn abgesetzte Stoppelhaarfrisur. Die einzelnen »Strähnen« bilden sich aus quer liegenden kleinen Strichelungen und sie begrenzenden Stegen, die aussehen wie Punzen. Diese »Haarsträhnen« sind in geraden Reihen parallel nach hinten geführt; am Haarwirbel treffen sie sternförmig zusammen. Auch die dazu gleichfalls parallel verlaufenden Haarreihen von der Seite und vom Hinterkopf aus führen zum Haarwirbel, biegen am Hinterkopf in weicher Kurve nach oben, um zusammen mit den vom Nacken kommenden Reihen im Scheitel aufeinander zu treffen. Die von der Stirn nach hinten geführten Haarstreifen stoßen unvermittelt auf die gekurvten. Um die Ohren führt ein Streifen herum, die davor und dahinter angegebenen geraden Reihen enden darauf beziehungsweise setzen ebenfalls abrupt hinter den Ohren wieder an. Ein ähnlicher Streifen verläuft am Rand der Stirn als Abschluss gegen die Hautoberfläche. Diese Streifen, die der Frisur eine Art Rahmung verleihen, könnten

tle curve on the back of the head to meet at the parting the rows of hair coming from the back of the neck. The strands of hair pulled back from the forehead abruptly meet the curvilinear strands. A strip leads around the ears, the straight rows indicated in front of and behind them end there or continue abruptly behind the ears. A similar strip runs around the edge of the forehead as a boundary between it and the surface of the skin. This strip, which lends the hair a sort of frame, may be derived from ancient models since there are Egyptian heads (fig. 55) which have a line of this type.[3]

The same punched-looking texture, which suggests a stubbly hair cut, occurs in "The Yawner" (cat. no. 12), "A Hypocrite and Slanderer",[4] "The Incapable Bassoonist",[5] "A Strong Man" (cat. no. 16) and

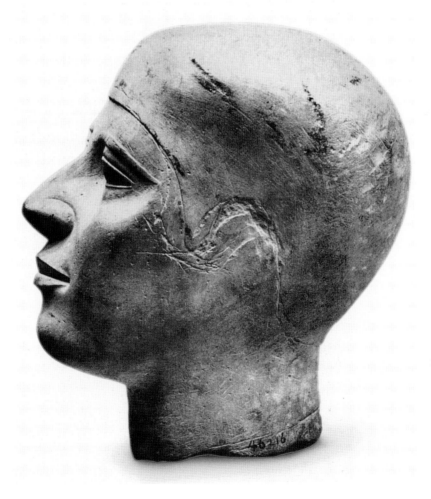

55 Ägyptischer Kopf aus dem Königsfriedhof von Gisa, 4. Dynastie, Ägyptisches Museum, Kairo
An Egyptian Head from the Royal Cemetery at Gizeh, 4th dynasty, Egyptian Musem, Cairo

sich möglicherweise von antiken Vorbildern herleiten, gibt es doch ägyptische Köpfe (Abb. 55), die eine solche Linie aufweisen.³

Dieselbe gepunzt wirkende Struktur, die an eine Stoppelhaarfrisur gemahnt, findet sich auch bei »Der Gähner« (Kat.-Nr. 12), »Ein Heuchler und Verleumder«,⁴ »Der unfähige Fagotist«,⁵ »Ein kraftvoller Mann« (Kat.-Nr. 16) und »Das schwere Geheimnis« (Kat.-Nr. 15). Hinsichtlich des Abstraktionsgrades und der ornamentalen Struktur sind die Frisuren des kraftvollen Mannes und des Fagottisten derjenigen des Erzbösewichts dabei am nächsten verwandt. Bei »Der Gähner« orientieren sich die Streifen am Haarschnitt und folgen ihm in gebogenen Parallelen, so dass es das abrupte Aufeinanderstoßen von Strähnen hier nicht gibt. Mehrere elipsenförmige Schmuckformen bilden die Haarreihen auf dem Schädel des Heuchlers. Selbst die an sich schon abstrakt wirkende Struktur wird also von Messerschmidt durch geometrische Muster weiter verfremdet. Wie fern die Struktur Frisuren tatsächlich ist, wird deutlich, wenn man sich überlegt, wo diese »Punzungen« ansonsten verwendet werden: So gibt es vergleichbare Linien – in größerem Maßstab – beispielsweise beim Gewand und der Mantelinnenseite der Statue von Kaiser Franz I. Stephan von Lothringen.⁶

Der Erzbösewicht kneift die Augen wie in großem Schmerz oder Unwillen zusammen, während die gerümpfte Nase, der fest zusammengepresste Mund und die hochgewölbten Wangen den Eindruck eines verschmitzt Amüsierten erwecken. Trotz aller Verformungen greift Messerschmidt bei gerümpfter Nase, zusammengekniffenen Augen und zusammengepresstem Mund auf sich natürlich bildende Falten zurück. In dieser Kombination von natürlichen Faltengebungen und Wülsten mit unnatürlichen Deformationen, wie sie beispielsweise bei der ornamental verwölbten Kieferpartie vor Augen geführt wird, liegt ein großer Teil der Provokation und Irritation, die diese Büste erweckt.

Es soll hier die These ausgesprochen werden, dass es Gefühle sind, die den natürlichen Körper so verformen, dass er sich dann doch als deformierte Masse darstellt. Da die körperlose Welt der Gefühle zur Darstellung drängt, ist die künstlerische Gestaltung weder an die anatomische Logik noch an die Einheitlichkeit des Ausdrucks gebunden. Jeder Eindruck wird konterkariert, gelegentlich in sein Gegenteil verkehrt. Realistische Verzerrungen werden abgebildet, Bewegungen werden geklärt und kontrastieren zu Partien, die ornamental verformt sind. Plastisch sich wölbende Teile, wie der Schädel oder die Nase, werden zur Gänze von einem graphisch formulierten »Haarnetz« überfangen oder von hart eingravierten Falten durchfurcht.

"The Difficult Secret" (cat. no. 15). As far as the degree of abstraction and the ornamental texturing of the hair are concerned, the hair styles of the Strong Man and the Incompetent Bassoonist are most similar to those of the Arch-Rascal. In "The Yawner" the strips are oriented towards the haircut and follow it in bent parallel waves so that there are no abrupt collisions of strands here. Several elliptical decorative shapes form the rows of hair on the skull of "The Hypocrite and Slanderer". Messerschmidt has further defamiliarised even this already abstract-looking configuration. How far this configuration really is from actual hairstyles becomes apparent when one considers where such punching is otherwise used: there are similar lines – albeit on a larger scale – on the apparel and the inside of the cloak worn by the statue of the Emperor Francis I.⁶

The Arch-Rascal is squinting as if he were in great pain or very angry about something whereas the wrinkled nose, the firmly compressed lips and the bulging cheeks make him seen as if he is amused, maliciously gloating in a rather tongue-in-cheek manner. Despite all the deformations, Messerschmidt has reverted to naturally formed wrinkles on the wrinkled nose, the squinting eyes and compressed lips. In large part, the provocative, disturbing character of this bust lies on this combination of naturalistic wrinkle formation and folds that are unnaturalistically deformed, as shown in the decoratively bulging chin.

The hypothesis intended here is that it is feelings which thus deform the natural body so that it is represented as deformed mass. Since the disembodied realm of feelings thrusts itself forward in representation, the design owes nothing to anatomical logic nor to unity of expression. Every impression is counteracted, occasionally reversed. Realistic distortions are reproduced, facial actions clarified and contrasted with parts that are decoratively distorted. Sculpturally bulging parts, such as the skull or the nose, are made into a whole by being covered by a "hairnet" formulated in line or furrowed by harshly engraved wrinkles.

1 Ähnliches geschieht bei »Der Gähner« (Kat.-Nr. 12) und »Ein mit Verstopfung Behafteter« (Kat.-Nr. 13). Zu der Gruppe gehören außerdem »Der weinerliche Alte« (Variante siehe Kat.-Nr. 11), »Ein Schalksnarr« (Pötzl-Malíková 1982, S. 258–259, Kat.-Nr. 101), »Ein Hipochondrist« (siehe ebd., S. 259, Kat.-Nr. 102), »Ein absichtlicher Schalksnarr« (siehe ebd., S. 259, Kat.-Nr. 103), »Ein Heuchler und Verleumder« (siehe ebd., S. 260, Kat.-Nr. 105), »Das zurückgehaltene Lachen« (siehe ebd., S. 262, Kat.-Nr. 110), »Der Trozige« (siehe ebd., S. 263, Kat.-Nr. 112) und »Ein alter frölicher Lächler« (siehe ebd., S. 263–264, Kat.-Nr. 114).

2 Siehe Behr / Grohmann / Hagedorn 1983, Abb. des Trozigen S. 107.

3 Dazu siehe Krapf 1995, Abb. 12.

4 Dazu siehe Pfarr 2006, Abb. 81.

5 Siehe Krapf, Katalog 2002, Abb. S. 231.

6 Siehe ebd., Abb. S. 153.

Literatur

Anonymus 1794, S. 61–62 (Nro. 33); Weiss 1924, S. 133–134; Kris 1932, S. 207, Abb. 214; Kris 1933, Abb. 18; Pakosta 1976, Abb. S. 44; Baum 1980, S. 392–393; Glandien 1981, S. 51, Abb. 42; Pötzl-Malíková 1982, S. 70, 257–258; Ronzoni 1982, Abb. S. 2487; Behr / Grohmann / Hagedorn 1983, S. 110–111; Pötzl-Malíková 1984b, Abb. 30; Oberhaidacher 1984, S. 41, Abb. 44 (S. 38); Ausst.-Kat. L'âme au corps 1993, S. 223 (Abb.); Presler 1996, S. 79, Abb. S. 77; Ronzoni 1997, Abb. S. 38; Bückling 1999b, S. 116; Krapf, Katalog 2002, S. 240–241; Lehner-Jobst 2002, Abb. S. 98; Pötzl-Malíková 2004, Abb. S. 105; Schmid 2004, S. 44; Pfarr 2006, Abb. 31, 71–72.

1 Something similar happens in "The Yawner" (cat. no. 12) and "Afflicted with Constipation" (cat. no. 13). Other Character Heads that belong to this group are "The Weepy Old Man" (variant: see cat. no. 11), "A Mischievous Wag" (Pötzl-Malíková 1982, pp. 258f., cat. no. 101), "A Hypochondriac" (see ibid., p. 259, cat. no. 102), "An Intentional Wag" (see ibid., p. 259, cat. no. 103), "A Hypocrite and Slanderer" (see ibid., p. 260, cat. no. 105), "The Laughter Kept Back" (see ibid., p. 262, cat. no. 110), "The Defiant Man" (see ibid., p. 263, cat. no. 112) and "An Old Cheerful Smiler" (see ibid., pp. 263–264, cat. no. 114).

2 See Behr / Grohmann / Hagedorn 1983, the "Defiant Man" pictured p. 107.

3 See Krapf 1995, fig. 12.

4 See Pfarr 2006, fig. 81.

5 See Krapf, Katalog 2002, illus. p. 231.

6 Ibid. illus. p. 153.

References

Anon. 1794, pp. 61f. (no. 33); Weiss 1924, pp. 133f.; Kris 1932, p. 207, fig. 214; Kris 1933, fig. 18; Pakosta 1976, illus. p. 44; Baum 1980, pp. 392f.; Glandien 1981, p. 51, fig. 42; Pötzl-Malíková 1982, p. 70, pp. 257f.; Ronzoni 1982, illus. p. 2487; Behr / Grohmann / Hagedorn 1983, pp. 110f.; Pötzl-Malíková 1984b, fig. 30; Oberhaidacher 1984, p. 41, fig. 44 (p. 38); exhib. cat. L'âme au corps 1993, p. 223 (illus.); Presler 1996, p. 79, illus. p. 77; Ronzoni 1997, illus. p. 38; Bückling 1999b, p. 116; Krapf, Katalog 2002, pp. 240f.; Lehner-Jobst 2002, illus. p. 98; Pötzl-Malíková 2004, illus. p. 105; Schmid 2004, p. 44; Pfarr 2006, fig. 31, figs. 71, 72.

Zinn, Höhe 33 cm
nach 1770
Landesmuseum
Württemberg
Stuttgart
Inv.-Nr.
WLM 1925/66

Pewter, height 33 cm
after 1770
Landesmuseum
Württemberg
Stuttgart
Inv. no.
WLM 1925/66

[11]

Der weinerliche Alte (Variante)

Der Stuttgarter Kopf (Kat.-Nr. 11a) der Variante zu »Der weinerliche Alte« (Abb. 56) ist in Bezug auf seinen Erhaltungszustand, den ungewöhnlichen Büstenausschnitt und die verzerrte Grimasse auffallend. Wie bei »Ein mit Verstopfung Behafteter« (Kat.-Nr. 13), »Ein Erzbösewicht« (Kat.-Nr. 10) und »Der Gähner« (Kat.-Nr. 12) veränderte Messerschmidt den Prototyp des Büstenausschnitts auch im Fall des weinerlichen Alten radikal: Seine Kontur ist, von vorne betrachtet, schüsselförmig. Damit radikalisiert die hier gezeigte Variante noch die Form des in Privatbesitz befindlichen Originals der Büste »Der weinerliche Alte«.[1] Die Schultern sind bei Letzterem nicht so stark hochgezogen; der mit nur leicht angezogenen Schultern gezeigte Ausschnitt führt in einer sacht bewegten Kontur nach unten, um in einem gerade abgeschnittenen Abschluss zu enden. Der fest auf die Brust gedrückte Kopf verursacht bei der Stuttgarter Büste eine Bewegung, die sich zunächst in einer leicht hochgeschobenen Welle ausdrückt, die sich wiederum zum Büstenrand zurückzieht, so dass nicht nur die Kontur die Assoziation einer Schüssel hervorruft, sondern sich die Brust schüsselartig vertieft (Kat.-Nr. 11b–c). In keinem Fall, weder im Original des weinerlichen Alten noch in der Variante, entsteht der Eindruck eines naturgetreu wiedergegebenen Oberkörpers. Weder die Verformung noch die Materialität weisen insbesondere bei der Variante auf einen Körper hin. Eher verbindet sich die Materialität der Brust mit der des zylindrischen Sockels, der die Büste trägt. Es ist eine der am stärksten von einem Körperausschnitt abstrahierenden Formen.

150

Variant of "The Weepy Old Man"

The Stuttgart Head (cat. no. 11a), a variant of "The Weepy Old Man" (fig. 56), is notable for its good state of preservation, the unusual bust section and the contorted grimace. As he did with "Afflicted with Constipation" (cat. no. 13), "An Arch-Rascal" (cat. no. 10) and "The Yawner" (cat. no. 12), Messerschmidt has radically changed the archetype of the bust section in the Weepy Old Man: viewed frontally, its contour is key-shaped. This means the variant shown here is even more radical in form than the original of the bust of "The Weepy Old Man", which is in a private collection.[1] The shoulders of the original are not drawn up so high; the breast section shown with only slightly drawn up shoulders leads down in a soberly drawn contour to end cut straight off. The head, pressed firmly against the breast, is, in the Stuttgart bust, performing an action which is at first expressed in a wave pressed slightly upwards only to recede at the edge of the bust, so that not just the contour awakens associations of a key but the breast, too, tapers like a key (cat. nos. 11b–c). Neither the original of the Weepy Old Man nor the variant creates the impression that the torso has been represented naturalistically. Neither the deformation nor the physical properties of the material of the variant especially indicate a body. The material substance of the breast instead links it with the cylindrical base supporting the bust. This is one of the most abstract forms used for this body detail.

Both busts display grimaces with eyes squinting to bulges, deeply furrowed crow's feet radiating like fans, and wrinkled noses towards which wrinkles lead from the inner corners of the nose. Further, another striking common feature is the tightly compressed mouth, with corners deeply drooping and, in addition, lengthened to beneath the chin by wrinkles which join the nasolabial folds. Both busts also have skulls affected by the deformation of the orbital and brow zones: strands of muscle and notches deform the forehead and the base of the skull.

The unfinished state of the busts makes these striking features all the more noticeable:

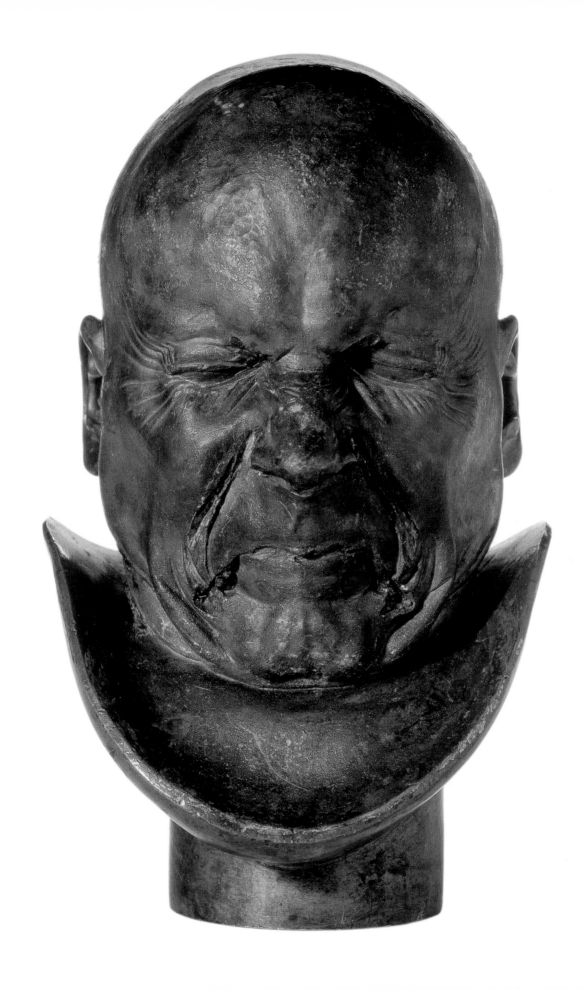

[11a]

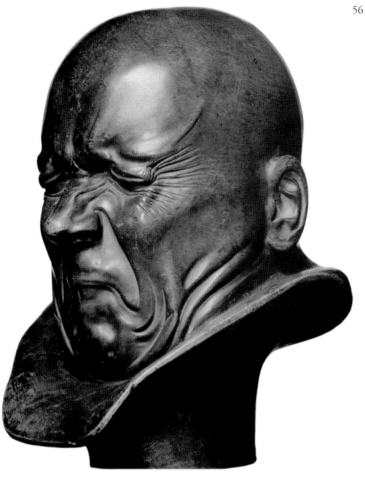

56 Franz Xaver Messer-
schmidt, Der weinerliche
Alte, Blei, nach 1770,
verschollen
Franz Xaver Messer-
schmidt, The Weepy Old
Man, lead, after 1770,
whereabouts unknown

Beiden Büsten sind Grimassen mit zu Wülsten zusammengeknif-
fenen Augen, fächerförmig ausstrahlenden, tief gefurchten Krähen-
füßen und gerümpfter Nase, auf die sich von den Augeninnenwin-
keln her Falten ziehen, eigen. Auffallend ist weiterhin der zusammen-
gepresste Mund, dessen Mundwinkel sich tief nach unten ziehen
und zudem durch Falten bis unter das Kinn verlängert werden, die
sich mit den Nasolabialfalten vereinen. Ebenfalls ist bei beiden
Fällen der Schädel von den Verformungen der Augen- und Brauen-
partie in Mitleidenschaft gezogen: Muskelstränge und Einkerbungen
verformen die Stirn und den Schädelansatz.

Der unfertige Zustand der Büste lässt diese Auffälligkeiten
noch deutlicher hervortreten: So sind die Nasolabialfalten nur mehr-
fach grob geritzte Kerben, und auch der Mund ist nur als vage
Form angedeutet. Dadurch, dass »Der weinerliche Alte«, ebenso wie
die Nürnberger Büste von »Ein mit Verstopfung Behafteter« (Kat.-
Nr. 13), sein Kinn gegen die Brust presst, entstehen unter dem
Kinn und zu den Seiten unanatomische, amorphe Erhebungen, von
groben Faltenrillen voneinander abgetrennt. Es ist, mit Ausnahme

the nasolabial folds are merely coarsely scratched
notches and even the mouth is just suggested as
a vague form. Since in both "The Weepy Old Man"
and the Nuremberg bust of "Afflicted with Constipa-
tion" (cat. no. 13) the chin is pressed against the
breast, amorphous raised areas that do not resemble
anything anatomical are created beneath the chin and
at the sides, which are demarcated from one another
by coarse wrinkle grooves. Except in the case of
the head of "An Old Cheerful Smiler" and the variant
shown here of "The Weepy Old Man", it is not known
how many Character Heads in an unfinished state
were in Messerschmidt's estate; "The Defiant Man"
may have also been left unfinished.[2]

des Kopfes von »Ein alter frölicher Lächler« und der hier gezeigten Variante zu »Der weinerliche Alte« nicht bekannt, wie viele Charakterköpfe sich ursprünglich in unfertigem Zustand in Messerschmidts Nachlass befanden; möglicherweise gehörte auch »Der Trozige« dazu.[2]

1 Zu »Der weinerliche Alte« siehe Pötzl-Malíková 1982, S. 253–254.
2 So Pfarr 2006, S. 386.

Literatur

Anonymus 1794, S. 55 (Nro. 24, betr. »Der weinerliche Alte«); Kris 1932, S. 207 (betr. »Der weinerliche Alte«); Pötzl-Malíková 1982, S. 266; Pfarr 2001, S. 455–456, Pl. 3 (S. 457); Krapf, Katalog 2002, S. 222–223; Schmid 2004, S. 57; Pfarr 2006, S. 365–372, Abb. 102, 135, 138.

1 On "The Weepy Old Man" see Pötzl-Malíková 1982, pp. 253f.
2 Thus Pfarr 2006, p. 386.

References

Anon. 1794, p. 55 (no. 24, concerns "The Weepy Old Man"); Kris 1932, p. 207 (concerns "The Weepy Old Man"); Pötzl-Malíková 1982, p. 266; Pfarr 2001, pp. 455f., pl. 3 (p. 457); Krapf, Katalog 2002, pp. 222f.; Schmid 2004, p. 57; Pfarr 2006, pp. 365–372, figs. 102, 135, 138.

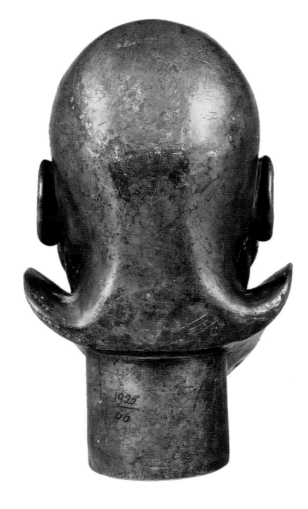

Kat.-Nr. 11b / *Cat. no. 11b*
Franz Xaver Messerschmidt, Der weinerliche Alte (Variante), Seitenansicht
Franz Xaver Messerschmidt, The Weepy Old Man (variant), side view

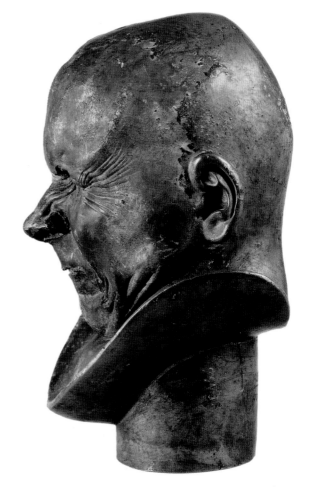

Kat.-Nr. 11c / *Cat. no. 11c*
Franz Xaver Messerschmidt, Der weinerliche Alte (Variante), Rückansicht
Franz Xaver Messerschmidt, The Weepy Old Man (variant), rear view

153

Zinn, Höhe 41 cm
nach 1770
Szépmüvészeti
Múzeum
Budapest
Inv.-Nr. 53.655

Pewter, height 41 cm
after 1770
Szépmüvészeti
Múzeum
Budapest
Inv. no. 53.655

[12]

Der Gähner

»Der Gähner« gehört zu den ausgefallensten Köpfen Messerschmidts (Kat.-Nr. 12a). Er teilt mit den anderen Charakterköpfen die Reduktion auf wesentliche Motive: den hier kubischen Sockel, den frontal ausgerichteten Büstenausschnitt eines nackten Mannes und den ebenfalls frontal ausgerichteten Kopf. Gemeinsam mit Werken wie »Ein mit Verstopfung Behafteter« (Kat.-Nr. 13), »Ein Heuchler und Verleumder«, »Ein Erzbösewicht« (Kat.-Nr. 10), »Ein Hipochondrist«, »Ein alter frölicher Lächler«, »Das zurückgehaltene Lachen« und »Der Trozige« sowie »Ein weinerlicher Alter« und seiner Variante (Kat.-Nr. 11) ist ihm eine noch weiter als beim »Prototyp« der Charakterköpfe gehende Zurücknahme der Illusion eines Körperausschnitts eigen. Die Büste, von der Seite her gesehen eine scheibenartig dünne Hohlform (Kat.-Nr. 12b, d), sitzt unorganisch auf dem quaderförmigen Kubus, ähnlich wie es bei den Büsten von Scheybs (Abb. 9, 18), Mesmers (Abb. 10, 21) oder van Swietens (Kat.-Nr. 1) der Fall ist. Beim Gähner allerdings ist der Brustausschnitt weder gerundet noch bis zu einer Spitze verjüngt, sondern wird auf halber Sockelhöhe horizontal abgeschnitten und endet in einer schräg zum Sockel verlaufenden Dreieckform. Diese Form steigert noch den Eindruck der Verfremdung. Auch sitzt der Kopf nahezu halslos auf den hochgezogenen, feisten Schultern. Das Kinn, das durch den weit aufgerissenen Mund auf die Brust gedrückt ist, schiebt dabei das Fleisch etwas nach vorn.

Es ist aber weniger die Büstenform oder die Sockelung, die die Expressivität der Büste allein ausmachen und den Blick des Betrachters auf sich ziehen, sondern es ist vielmehr das verzerrte Gesicht. Der Mund ist wie zu einem Schrei geöffnet (Kat.-Nr. 12f), lässt die Zähne, das Zäpfchen, den Gaumen, die hochgereckte Zunge und das Zungenband sehen. Tief eingefurchte Falten rahmen Mundöffnung und Kinn und setzen sich als Speckringe um den Hals fort.

Gleichzeitig mit dem Aufreißen des Mundes kraust der Mann die Nase und kneift die Augen fest zusammen (Kat.-Nr. 12e, g).

154

The Yawner

"The Yawner" is one of Messerschmidt's most striking Heads (cat. no. 12a). It shares with the other Character Heads the reduction to the following essential motifs: the base, here cubic, the frontal décolleté of a man and the likewise frontal head. As in such works as "Afflicted with Constipation" (cat. no. 13), "A Hypocrite and Slanderer", "An Arch-Rascal" (cat. no. 10), "A Hypochondriac", "An Old Cheerful Smiler", "The Laughter Kept Back" and "The Defiant Man" as well as "The Weepy Old Man" and variants (cat. no. 11), the reduction of the illusion of a section of the body goes further in "The Yawner" than it does in the archtetype of the Character Heads. A disc-like, hollow form when viewed from the side (cat. nos. 12b, d), the present bust sits inorganically on the block-shaped base, in this respect similar to the busts of von Scheyb (figs. 9, 18), Mesmer (figs. 10, 21) and van Swieten (cat. no. 1). The breast section of "The Yawner", however, is neither rounded nor tapering to a point; instead it is cut off in the horizontal half-way up the base to end in a triangular form running obliquely to the base. This form enhances the impression of defamiliarisation. The head also sits almost without any visible neck on the drawn up, stout shoulders. The chin, which is pressed to the breast by the wide-open mouth, pushes the flesh slightly forwards.

It is, however, the contorted face rather than the bust form or the base that makes for the expressiveness of the bust and attract the viewer's gaze. The mouth is open as if for a scream (cat. no. 12f), showing the teeth, the uvula, the palate, the underside of the tongue, and the frenum. Deep furrows frame the open mouth and the chin and continue on around the neck as flab.

While opening his mouth so wide, the man is also wrinkling his knows and squinting fiercely (cat. no. 12e, g). The resulting form virtually denies the existence of eyeballs: drawn up lower lids that bulge forward to meet the even more distended orbital ridges. The convergence is marked by a pronounced groove. The crow's feet fan out, some of them from the lower lids, like abstract, graphic lines to the temples. Instead of eyebrows, a part composed of symmetrical, cartilaginous strips and depressions emerges

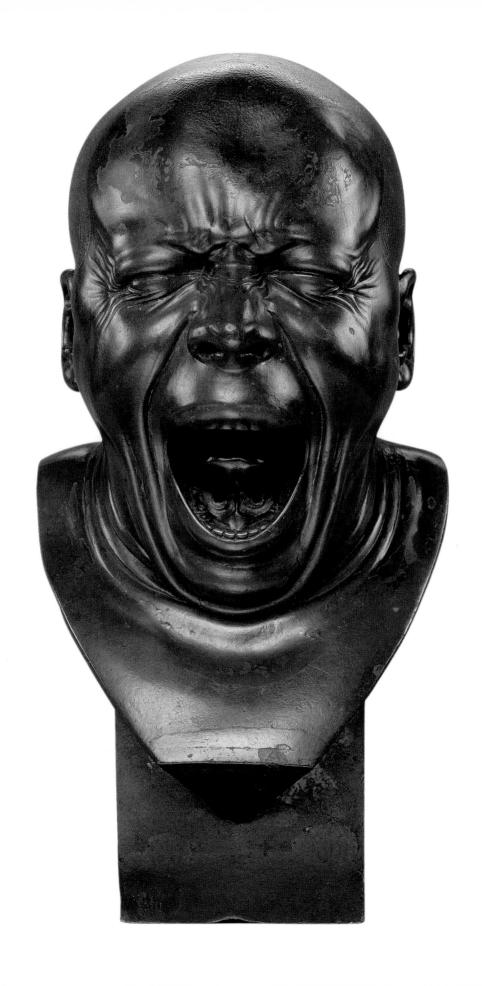

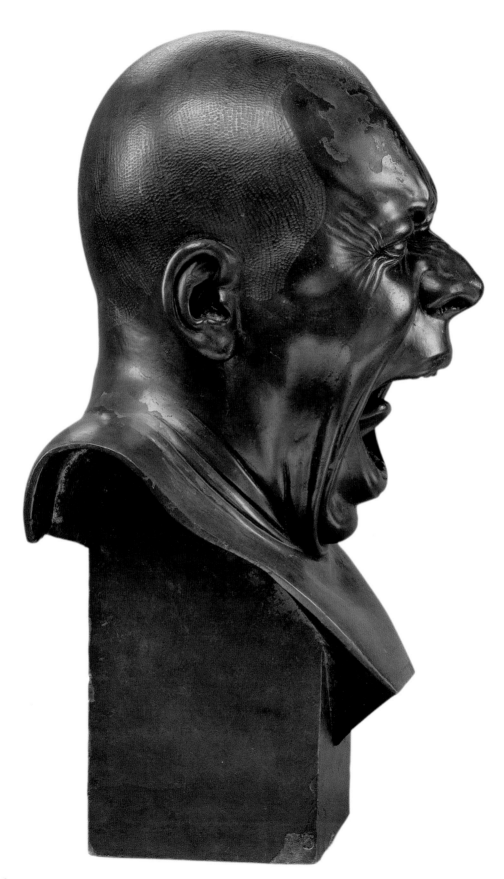

Kat.-Nr. 12b / *Cat. no. 12b*
Franz Xaver Messer-
schmidt, Der Gähner,
Seitenansicht
Franz Xaver Messerschmidt,
The Yawner, side view

Es entsteht eine Form, die das Vorhandensein der Augäpfel geradezu leugnet: Hochgezogene, plastisch sich vorwölbende Unterlider treffen auf die sich noch stärker blähenden Orbitalwülste. Ihr Zusammentreffen ist von einer markanten Rille markiert. Wie abstrakte, graphische Linien breiten sich Krähenfüße, die teilweise auf den Unterlidern ihren Anfang nehmen, fächerförmig bis zu den Schläfen aus. An die Stelle von Brauen tritt über der Nasenwurzel eine symmetrische, aus kleinen knorpelartigen Wülsten und Vertiefungen verformte Partie (Kat.-Nr. 12e), deren »Ausläufer« als Faltenstränge in die Stirn hineinragen. Auch hier wird, wie bei »Ein Erzbösewicht« (Kat.-Nr. 10), »Ein Heuchler und Verleumder«, »Der unfähige Fagotist« und »Ein kraftvoller Mann« (Kat.-Nr. 16) der plastisch gewölbte Schädel von einer gepunzten Stoppelhaarfrisur bedeckt.[1] Die Reihen orientieren sich beim Gähner am Haarschnitt und folgen ihm in gebogenen Parallelstreifen. Am Hinterkopf legen sie sich um schlaufenförmig angelegte Strähnen (Kat.-Nr. 12c).

above the root of the nose (cat. no. 12e), with "outliers" that extend on to the forehead as strands of wrinkle. Here, as in "An Arch-Rascal" (cat. no. 10), "A Hypocrite and Slanderer", "The Incapable Bassoonist" and "A Strong Man" (cat. no. 16), the sculpturally domed skull is covered by punched stubbly hair.[1] In the Yawner, the rows of hair are oriented to the haircut, following it in bent parallel strips. On the back of the head, they lie about looped strands (cat. no. 12c).

The ornamental formation of the entire orbital and forehead zone, the distended forms of the cheeks and the wrinkled nose, the sculpturally domed skull covered with a punched and, therefore, abstract 'hairnet' that is linear in conception and, finally, the linear, harshly incised wrinkles all contrast with

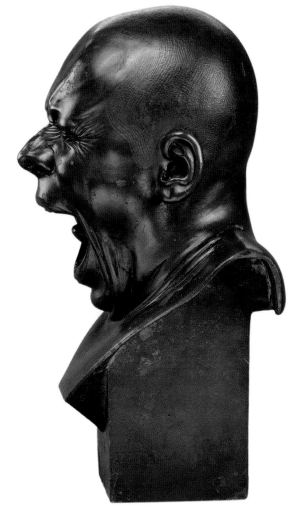

Kat.-Nr. 12c / *Cat. no. 12c*
Franz Xaver Messerschmidt, Der Gähner, Rückansicht
Franz Xaver Messerschmidt, The Yawner, rear view

Kat.-Nr. 12d / *Cat. no. 12d*
Franz Xaver Messerschmidt, Der Gähner, Seitenansicht
Franz Xaver Messerschmidt, The Yawner, side view

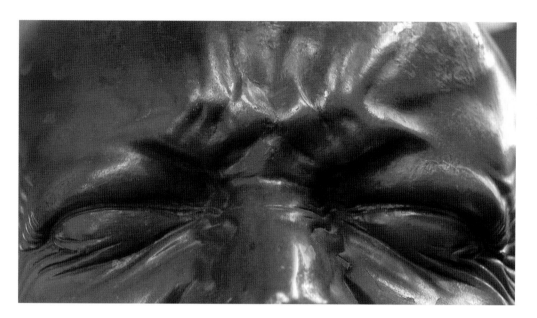

Die ornamentale Verformung des gesamten Augen-Stirn-Bereichs,
die geblähten Formen der Wangen und der gekrausten Nase, der plas-
tisch gewölbte Schädel, der von einem gepunzten und damit ab-
strakt-zeichnerisch gestalteten »Haarnetz« überzogen ist, und schließ-
lich graphisch-hart eingetragene Falten kontrastieren zueinander
und entsprechen der außergewöhnlichen Mimik dieses Kopfes.
Sie machen gleichzeitig das bildnerische Vokabular, über das Messer-
schmidt verfügen konnte, offenbar. Die Vielfalt der Mittel veran-
schaulicht das hohe Abstraktionsvermögen und -wollen des Bild-
hauers. Die Abstraktion von Körper, Schädel und Physiognomie
dient der Hervorhebung des dargestellten Ausdrucks: Der natürliche
Körper ist die »Modelliermasse« für die Seele und ihr körperloses
Leiden. Eine ganz andere Vorstellung vertritt eine zeitgenössische
Kunstauffassung, die sich durch antike Theorien gestützt sieht und
die von Scheyb so formuliert: »Das Antique hat den Mund, wenn
gleich der Kopf ein Geschrey ausdrückt, wenig geöffnet.«[2] Seit dem
1769 geschaffenen Bildnis von Scheybs (Abb. 9, 18) hat sich Messer-
schmidt diesen am nachdrücklichsten von Johann Joachim Winckel-
mann postulierten Vorstellungen nicht mehr gebeugt.

 Messerschmidt konnte sich, was den weit aufgerissenen Mund
betrifft, auf bekannte Vorbilder beziehen: auf Gian Lorenzo Ber-
ninis »Anima Dannata« (Abb. 74), auf Köpfe von Balthasar Permoser
(1651–1732) und von Andreas Schlüter (um 1660–1714, Abb. 92),[3]
Allegorien der Verdammnis oder des Lasters,[4] auf kleinplastische
Darstellungen von Furien[5] oder auch einen »schreienden Reiter«,[6]
auf »Gähner« wie von Pieter Breughel,[7] Adrian Brouwers (1608–
1640) »Der bittere Trank« (Abb. 57), nicht zuletzt auf Affektaus-

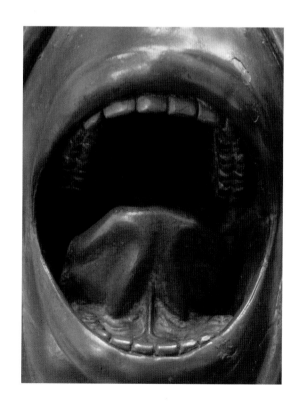

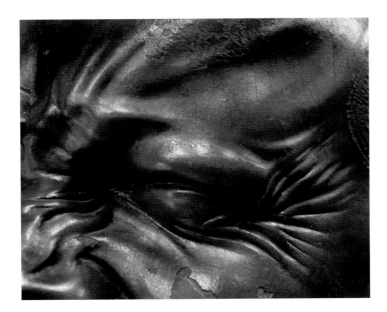

Kat.-Nr. 12g / *Cat. no. 12g*
Franz Xaver Messer-
schmidt, Der Gähner,
Detail
Franz Xaver Messer-
schmidt, The Yawner,
detail

drücke, wie sie James Parsons und Charles Le Brun (1619–1690) durchexerzierten.[8] Die hochgereckte Zunge hingegen ist einzigartig und in ihrer Ausgefallenheit noch am ehesten mit Messerschmidts »Der Speyer« (Abb. 58) zu vergleichen. Und gerade damit traf er auf Zustimmung: Nicolai schreibt, dass sich Messerschmidt in einem Selbstbildnis »den Mund ganz aufsperrend [gebildet hatte], so daß man Zähne, Gaumen und die Zunge bis an ihre Wurzel sehen konnte; Gegenstände die vielleicht noch nie von einem Bildhauer sind vorgestellet worden. Dieß war mit einer bewunderungswürdigen Richtigkeit und Wahrheit gearbeitet.«[9] Der Kopf wird vom Anonymus[10] Ende des 18. Jahrhunderts als »Der Gähner« bezeichnet, in seiner Wirkung so überzeugend, dass es hieß: »Man gähnt nach.«[11] Nicolais Äußerung jedoch ernst genommen, spricht aber nichts zwingend vom Gähnen, zumal die Zunge, anders als beim Gähnen, hochgereckt ist.[12]

each other, thus entirely suiting the extraordinary facial expression of this Head. At the same time, these qualities reveal the sculptural vocabulary available to Messerschmidt. The diversity of devices at the sculptor's disposal demonstrates how capable he was of abstraction to a high degree and how much he strove for it. The abstractness of body, skull and countenance serves to enhance the facial expression represented: the natural body is "modelling clay" for the soul and its disembodied suffering. Another contemporary conception of art was entirely different; seeing itself as supported by theories from Antiquity, it was formulated as follows by von Scheyb: "Antiquity keeps the mouth almost closed, even though the head expresses a scream."[2] Since executing the portrait of von Scheyb in 1769 (fig. 9, 18), Messerschmidt had abandoned these ideas, which were most cogently formulated by Johann Joachim Winckelmann.

As far as the wide-open mouth is concerned, Messerschmidt could draw on a host of well-known models: Gian Lorenzo Bernini's "Anima Dannata" (fig. 74), heads by Balthasar Permoser (1651–1732) and Andreas Schlüter (c. 1660–1714, fig. 92),[3] allegories of Damnation or Vice,[4] small-scale sculptural representations of the Furies[5] or a "screaming equestrian",[6] a "Yawner" like the Pieter Breughel figure,[7] Adrian Brouwer's (1608–1640) "A Bitter Drink" (fig. 57) and

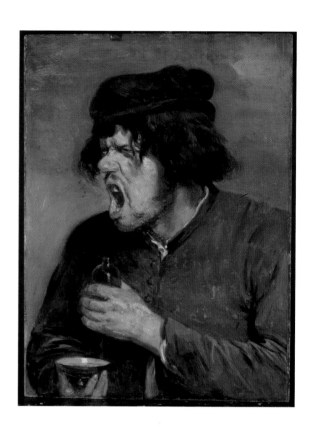

57 Adriaen Brouwer,
Der bittere Trank,
um 1636–1638, Öl auf
Holz, Städel Museum,
Frankfurt am Main,
Inv.-Nr. 1076
Adriaen Brouwer,
A Bitter Drink,
c. 1636–1638, oil on
wood, Städel Museum,
Frankfurt am Main,
Inv. no. 1076

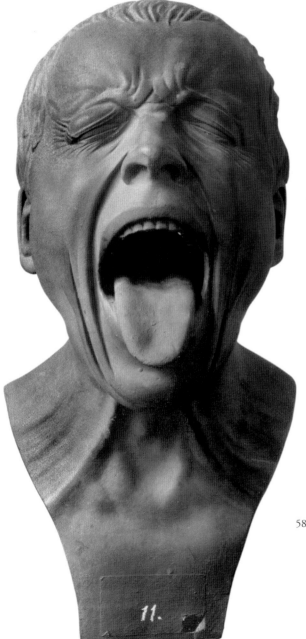

not least of expressions of the emotions as demonstrated by James Parsons and Charles Le Brun (1619–1690).[8] The tongue drawn up so high is unique and, for its exceptional form, is best compared with Messerschmidt's own "A Man Vomiting" (fig. 58). And it was in this very point that Messerschmidt encountered approval from a contemporary observer: Nicolai writes that in a selfportrait, Messerschmidt formed "the mouth opened so wide that the teeth and palate were visible, and the tongue to its roots; objects that perhaps have never yet been represented by a sculptor. This was wrought with an admirable justness and truth."[9] The head is called "The Yawner" by the late 18th-century Anonymous[10] and is described as so convincing in the effect created that: "It makes us yawn too."[11] Even if one takes Nicolai's statement seriously, nothing is said that might be compelling proof the present head is yawning, especially since the tongue is drawn up so high, which does not occur in yawning.[12]

58 Franz Xaver Messer-
schmidt, Der Speyer,
1777–1781, Alabaster,
verschollen
Franz Xaver Messer-
schmidt, A Man
Vomiting, 1777–1781,
alabaster, where-
abouts unknown

160

1 Zur Struktur der Haarstreifen siehe Kat.-Nr. 10.
2 Scheyb 1770, Bd. 2, S. 72.
3 So beispielsweise Weiss 1924, S. 134; Krapf, Katalog 2002, S. 178.
4 Abb. siehe Bückling 1996, S. 57 (Filippo Parodi, »Darstellung des Lasters«, Sammlungen des Fürsten von und zu Liechtenstein, Vaduz-Wien, Inv.-Nr. S. 11); eine – kleinplastische – Darstellung der »Verdammnis« siehe beispielsweise in: Ausst.-Kat. Elfenbein 2001, S. 41.
5 Dazu siehe Ausst.-Kat. Furienmeister 2006, S. 31, 41, 44.
6 Abb. in: Ausst.-Kat. Natur und Antike 1985, S. 383.
7 Dazu Pötzsch 1993, Abb. S. 153.
8 So Krapf, Katalog 2002, S. 178. Zu Parsons und Le Brun siehe Kirchner 1991, S. 320; Philipe 1994.
9 Nicolai Reprint 1994, S. 415.
10 Anonymus 1794, S. 45.
11 Kris 1932, S. 192; ähnlich der Anonymus 1794, S. 45: »Wir gähnen nach!«
12 Ähnlich Hàmori 1992, S. 238.

Literatur

Anonymus 1794, S. 45 (Nro. 5); Ilg 1885, S. 52; Weiss 1924, S. 134; Kris 1932, S. 192, 202, Abb. 164; Kris 1933, S. 392, 404, Abb. 9; Glandien 1981, S. 51, Abb. 43; Pötzl-Malíková 1982, S. 70, 245; Behr/Grohmann/Hagedorn 1983, Abb. S. 113–115; Oberhaidacher 1984, S. 36, Abb. 40; Bücherl 1989, S. 58, 61, Abb. S. 66; Hàmori 1992, S. 238, Abb. 8 (S. 241); Hàmori 1994, S. 23, Abb. 20; Presler 1996, S. 80, Abb. S. 75; Ausst.-Kat. Louise Bourgeois 1998, o. S.; Bückling 1999b, S. 117; Krapf, Katalog 2002, S. 178–181; Pötzl-Malíková 2004, Abb. S. 75; Schmid 2004, S. 5, 54; Pfarr 2006, Abb. 29–30.

1 On the structure of the hair strips, see cat. no. 10.
2 Scheyb 1770, Vol. II, p. 72.
3 Thus for instance Weiss 1924, p. 134; Krapf, Katalog 2002, p. 178.
4 For a picture see Bückling 1996, p. 57 (Filippo Parodi, "Representation of Vice", Sammlungen des Fürsten von und zu Liechtenstein, Vaduz-Vienna, Inv. no. p. 11); a – small sculpture – representation of "Damnation" see e. g. in: exhib. cat. Elfenbein 2001, p. 41.
5 See exhib. cat. Furienmeister 2006, pp. 31, 41, 44.
6 Pictured in: exhib. cat. Natur und Antike 1985, p. 383.
7 Cf. Pötzsch 1993, fig. p. 153.
8 Thus Krapf, op. cit., p. 178. On Parsons and Le Brun see Kirchner 1991, p. 320; Philipe 1994.
9 Nicolai Reprint 1994, p. 415.
10 Anon. 1794, p. 45.
11 Kris 1932, p. 192; similarly Anon. 1794, p. 45: "Makes us yawn too!"
12 Similarly Hàmori 1992, p. 238.

References

Anon. 1794, p. 45 (no. 5); Ilg 1885, p. 52; Weiss 1924, p. 134; Kris 1932, pp. 192, 202, fig. 164; Kris 1933, pp. 392, 404, fig. 9; Glandien 1981, p. 51, fig. 43; Pötzl-Malíková 1982, pp. 70, 245; Behr/Grohmann/Hagedorn 1983, illus. pp. 113ff; Oberhaidacher 1984, p. 36, fig. 40; Bücherl 1989, pp. 58, 61, illus. p. 66; Hàmori 1992, p. 238, fig. 8 (p. 241); Hàmori 1994, p. 23, fig. 20; Presler 1996, p. 80, illus. p. 75; exhib. cat. Louise Bourgeois 1998, n. p.; Bückling 1999b, p. 117; Krapf, Katalog 2002, pp. 178–181; Pötzl-Malíková 2004, illus. p. 75; Schmid 2004, pp. 5, 54; Pfarr 2006, figs. 29, 30.

Blei, Höhe 30,2 cm
nach 1770
Germanisches
Nationalmuseum
Nürnberg
Inv.-Nr. Pl. O. 2539

Lead, height 30.2 cm
after 1770
Germanisches
Nationalmuseum
Nuremberg
Inv. no. Pl. O. 2539

[13]

Ein mit Verstopfung Behafteter

Einen besonders lebendigen Eindruck vermittelt der Kopf eines Mannes mit Vollglatze, der den Titel »Ein mit Verstopfung Behafteter« trägt (Kat.-Nr. 13a). Die vom Anonymus ausgeschmückte Geschichte eines »Quitten- und Knödelfressers« soll Messerschmidt von Freunden erzählt worden sein und ihn zur Gestaltung der Büste angeregt haben.[1] Wie die anderen Titel, deren geradezu absurder Charakter öfter bemerkt wurde, ist auch dieser Titel postum vergeben worden.

Der Schädel wölbt sich als plastischer Körper. Die Schultern sind hochgezogen, das Kinn auf die Brust gepresst, so dass der Hals nicht mehr zu sehen ist. Der Büstenausschnitt ist eine kaum mehr als Nachbildung eines Körpers erkennbare, weich geformte Masse, die auf einem zylindrischen Sockel aufruht (Kat.-Nr. 13c). Der Ausschnitt weist keine scharfe und klare Abgrenzung auf; sein Rand besitzt eher eine weich verschwimmende Form mit einem schmalen Begrenzungssteg. Das auf die Brust gedrückte Kinn schiebt das Fleisch leicht nach vorn und ruft eine wellenförmige Bewegung hervor. Seitlich des Kinns (Kat.-Nr. 13b) quellen dadurch voluminöse Falten hervor. Faltenwülste entstehen desgleichen durch die hochgezogenen Schultern unterhalb der Kinnbacken. Diese Falten und Wülste vollziehen nahezu eigenständige Bewegungen, sind mal voluminöser, dann wieder schmal gequetscht. Eingegrabene Rillen unterstreichen die Härte und Kantigkeit von Falten und Wülsten, die nahezu abstrakt formuliert sind (Kat.-Nr. 13e).

Deutlich ausgeprägte Nasolabialfalten finden ihre parallel verlaufenden Entsprechungen in Falten, die zum Kinn und den seitlichen Wangenpartien überleiten. Die Hautpartien zwischen den

Afflicted with Constipation

The Head of an entirely bald man, entitled "Afflicted with Constipation" (cat. no. 13a) is particularly animated and lifelike. As embroidered by Anonymous, the story goes that Messerschmidt was told by friends of a "man eating quinces and dumplings" and was inspired to create the present bust.[1] Like the other titles, the absurdity of which has so often been noted, this title, too, was given posthumously.

The skull is sculpturally domed. The shoulders are drawn up high, the chin pressed to the breast so that the neck is no longer visible. The bust section, a softly formed mass that hardly bears any resemblance to a representation of a body, rests on a cylindrical base (cat. no. 13c). The breast section is devoid of crisp, clear contours; indeed its edge is a softly blurred form with a narrow demarcating strip. The chin pressed to the breast nudges the flesh slightly forwards to produce a wavy motion. This causes voluminous pouches (cat. no. 13b) to swell from the sides of the chin. Wrinkles, too, are created by the shoulders being drawn up to beneath the lower jaw bone. These wrinkles and folds perform almost independently, at times more voluminously, at others squashed to narrowness. Incised grooves underscore the harshness and angularity of both wrinkles and folds, which have been rendered in virtually abstract terms (cat. no. 13e).

Pronounced nasolabial folds are matched by wrinkles running parallel that lead into the chin and the sides of the cheeks. The main parts between the wrinkles are modelled as broad, flattened surfaces. This handling makes them lack the quality of soft, living skin just as the wrinkles are more reminiscent of milled grooves than anatomically correct forms. Below the mouth the nasolabial folds take a hairpin bend upwards. They delimit the part where a horizontally added, narrow "rod" is discernible instead of a mouth. This part of the face seems broad-surfaced and relaxed whereas the chin reveals slight tautening of the muscles.

The cheeks are structured by varying depressions and bulges: on the one hand, they are sunken yet, on the other, they develop into sculptural puffed cheeks

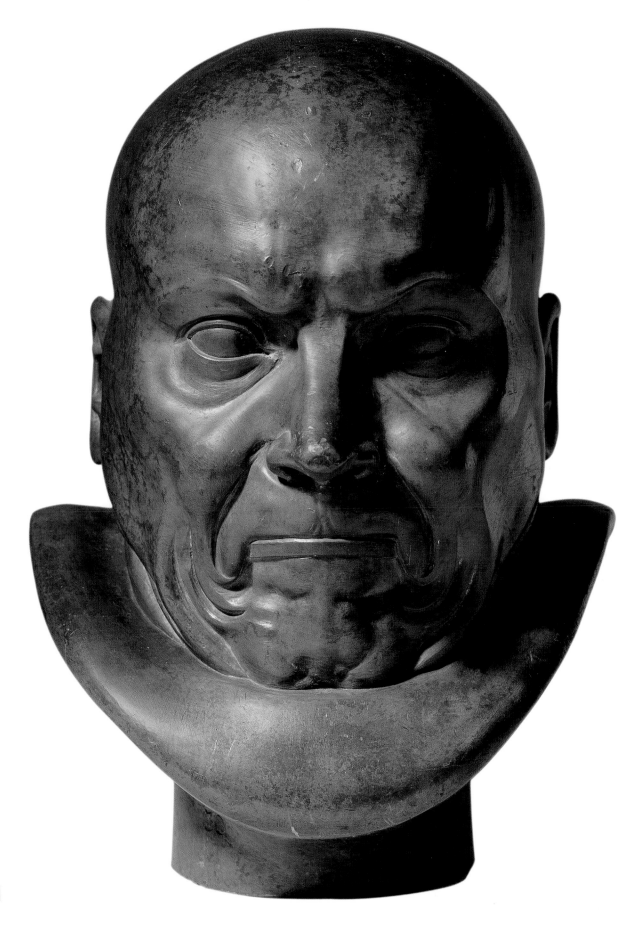

[13a]

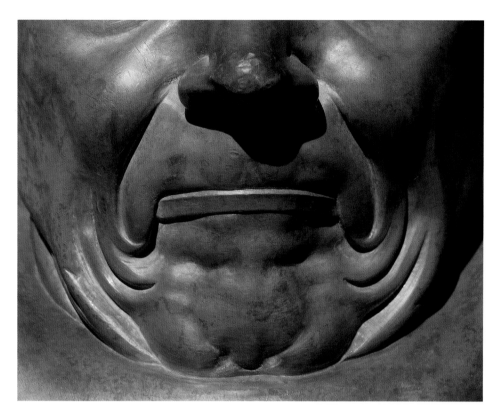

Falten sind flächig und abgeplattet modelliert. Sie lassen somit eine weiche, lebendige Hautqualität ebenso vermissen wie die Falten eher an eingefräste Rillen erinnern als an eine anatomisch korrekte Form. Unterhalb des Mundes biegen die Nasolabialfalten in einer Haarnadelkurve nach oben. Sie begrenzen die Partie, in der anstelle des Mundes ein waagerecht eingefügter, schmaler Stab zu sehen ist. Dieser Teil des Gesichts wirkt flächig und entspannt, während das Kinn leichte Muskelanspannung aufweist.

Die Wangen sind durch unterschiedliche Mulden und Wölbungen strukturiert: Zum einen sind sie eingefallen, zum anderen entwickeln sie sich zwischen den Nasolabialfalten und denjenigen Falten, die die Tränensäcke nach unten begrenzen, zu plastischen, hochgewölbten Bäckchen, die sich durch ihre Begrenzungen in länglicher Form erstrecken. Die flächig wiedergegebenen Tränensäcke und im Kontrast dazu plastisch vortretende, gleichzeitig ornamental geschwungene Brauen rahmen große, durch klar konturierte Lider scheibenförmig eingefasste Augen.

Der Mund ist durch einen schmalen Gegenstand ersetzt. Dieser verbindet die Nürnberger Büste mit »Innerlich verschlossener Gram« (Kat.-Nr. 14) und mit »Der Mismuthige« (Abb. 59), denn auch bei diesen Köpfen sind die Münder von einem Fremdkörper

that are elongated by their boundaries between the nasolabial folds and the wrinkles that demarcate the lower boundary of the lachrymal sacs, which are flat, in contrast to the sculpturally rendered and ornamentally curvilinear brows that frame large, disc-shaped edged eyes framed by clearly contoured lids.

The mouth has been replaced by a narrow object. It links the Nuremberg bust with "Grief Locked Up Inside" (cat. no. 14) and "The Ill-Humored Man" (fig. 59), since in those Heads, too, the mouths are covered by an object that is not a facial feature. In "Afflicted with Constipation", it seems to be a rod in stiff form (cat. no. 13b), which is covered over at the sides by the flesh of the mouth zone. In the two other busts, the object looks more like a flexible strip. Scholars have yet to clarify convincingly what they call either a rod or a strip. Krapf conjectures "a magnet specially adapted for the purpose which is held in the mouth for therapeutic purposes during Franz Anton Mesmer's treatments based on magnetism".[2] If that is so, it would make "Afflicted with

überlagert. Bei »Ein mit Verstopfung Behafteter« scheint es sich um einen Stab mit einer festen Form (Kat.-Nr. 13b) zu handeln, der zu den Seiten vom Fleisch der Mundpartie überdeckt wird. Bei den beiden anderen Büsten wirkt der Gegenstand eher wie ein beweglicher Band. Der Sinn dieses in der Literatur als Stab oder auch Band umschriebenen Gegenstands ist noch immer nicht restlos geklärt. Krapf vermutet hierin »einen eigens adaptierten Magneten, der in den Magnetkuren Franz Anton Mesmers zu Heilungszwecken im Mund gehalten wird«.[2] Damit würde »Ein mit Verstopfung Behafteter« ebenso wie »Innerlich verschlossener Gram« und »Der Mismuthige«, schließlich auch »Ein Erhängter« (Abb. 80) und »Ein Gelehrter, Dichter« (Abb. 49, 53) einen Reflex auf Mesmers »animalischen Magnetismus« darstellen.[3]

Wie bei anderen Charakterköpfen exerziert Messerschmidt in der Büste verschiedene Gestaltungsmöglichkeiten durch: Plastische Partien (Schädelkalotte, Bäckchen) wechseln ab mit ornamental

Constipation" like "Grief Locked Up Inside" and "The Ill-Humored Man", ultimately also "A Hanged Man" (fig. 80) and "A Scholar, Poet" (figs. 49, 53) reflect Mesmer's "animal magnetism".[3]

As in the other Character Heads, Messerschmidt has adopted an eclectic approach to handling: sculpturally conceived parts (the top of the skull, the puffed cheeks) alternate with ornamental-looking ones (the eyebrows). The lachrymal sacs and the philtrum are, on the other hand, conceived as surfaces. Furrowed grooves and amorphous, indeed abstract rounded strips characterise both the wrinkles and the folds created by the head being drawn in the shoulders drawn up. An element that contributes to abstraction is the cylindrical base, which visibly supports the bust.

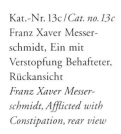

Kat.-Nr. 13c / *Cat. no. 13c*
Franz Xaver Messerschmidt, Ein mit Verstopfung Behafteter, Rückansicht
Franz Xaver Messerschmidt, Afflicted with Constipation, rear view

Kat.-Nr. 13d / *Cat. no. 13d*
Franz Xaver Messerschmidt, Ein mit Verstopfung Behafteter, Seitenansicht
Franz Xaver Messerschmidt, Afflicted with Constipation, side view

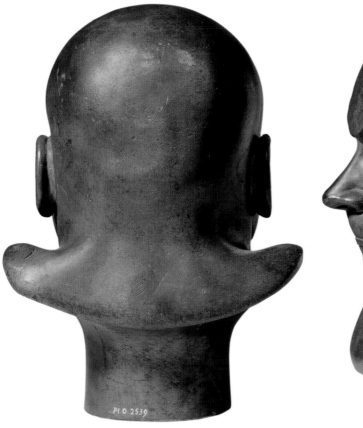

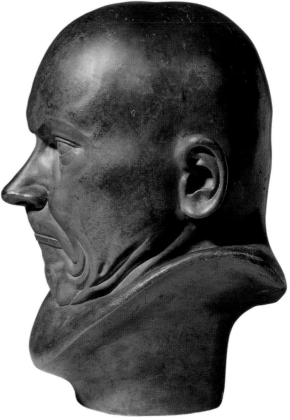

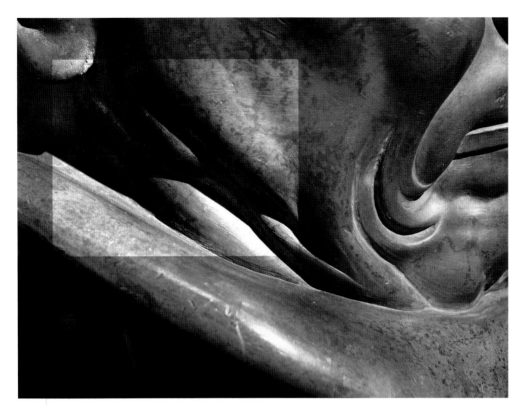

Kat.-Nr. 13e / *Cat. no. 13e*
Franz Xaver Messer-
schmidt, Ein mit
Verstopfung Behafteter,
Detail
Franz Xaver Messer-
schmidt, Afflicted with
Constipation, detail

wirkenden (Augenbrauen). Flächig wiederum sind die Tränensäcke sowie die Partie zwischen Nase und Mundscheibe gestaltet. Einge-furchte Rillen und amorphe, ja abstrakte Wülste charakterisieren sowohl die Falten als auch die durch den eingezogenen Kopf und die hochgezogenen Schultern entstehenden Fleischwülste. Ein abstra-hierendes Element ist weiterhin der zylindrische Sockel, der deutlich sichtbar die Büste trägt.

Die gerunzelten Brauen, die Falten sowie die verschlossene Mundpartie verleihen dem Gesicht einen finsteren, ernsten Ausdruck. Gleichzeitig vermitteln die Gesichtszüge und Falten zusammen mit den weich modellierten Hebungen und Senkungen von Kinn, Wangen und Stirn einen lebendigen Eindruck.

1 Dazu siehe Anonymus 1794, S. 59 – 60.
2 So Krapf, Katalog 2002, S. 234.
3 Dazu siehe Krapf, Katalog 2002, S. 234.

The wrinkled brows, the wrinkles as well as the closed mouth lend this face a forbidding, serious expres-sion. At the same time, the facial features and wrinkles together with the softly modelled elevations and depressions of chin, cheeks and forehead convey a life-like impression.

1 See Anon. 1794, pp. 59f.
2 Thus Krapf, Katalog 2002, p. 234.
3 Cf. loc. cit.

Literatur

Anonymus 1794, S. 59–60 (Nro. 30); Ilg 1885, S. 52; Kris 1932, S. 207, 219, Abb. 215–216; Kris 1933, S. 404, 406, Abb. 23; Glandien 1981, S. 51, Abb. 29; Pötzl-Malíková 1982, S. 70, 71, 256; Behr/Grohmann/Hagedorn 1983, Abb. S. 110 (Gipskopie); Bückling 1999b, S. 114–116; Maaz 2001, S. 27; Krapf, Katalog 2002, S. 234–235; Stastny 2003, S. 51, Abb. 9–10; Pötzl-Malíková 2004, Abb. S. 101; Schmid 2004, S. 41; Kammel 2004, S. 139–143; Maué 2005, S. 254–260; Pfarr 2006, Abb. 67.

References

Anon. 1794, pp. 59f. (no. 30); Ilg 1885, p. 52; Kris 1932, pp. 207, 219, figs. 215, 216; Kris 1933, pp. 404, 406, fig. 23; Glandien 1981, p. 51, fig. 29; Pötzl-Malíková 1982, pp. 70f., 256; Behr/Grohmann/Hagedorn 1983, illus. p. 110 (Gipskopie); Bückling 1999b, pp. 114ff.; Maaz 2001, p. 27; Krapf, Katalog 2002, pp. 234f.; Stastny 2003, p. 51, figs. 9, 10; Pötzl-Malíková 2004, illus. p. 101; Schmid 2004, p. 41; Kammel 2004, pp. 139–143; Maué 2005, pp. 254–260; Pfarr 2006, fig. 67.

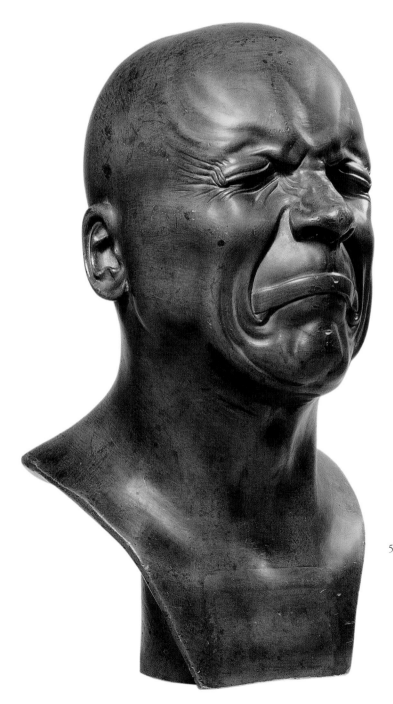

59 Franz Xaver Messer-
 schmidt, Der Mismuthige,
 nach 1770, Blei,
 Musée du Louvre, Paris,
 Inv.-Nr. RF 4724
 *Franz Xaver Messer-
 schmidt, The Ill-Humored
 Man, after 1770, lead,
 Musée du Louvre, Paris,
 Inv. no. RF 4724*

Blei, Höhe 38,3 cm
nach 1770
Landesmuseum
Württemberg
Stuttgart
Inv.-Nr.
WLM 1926/15

Lead, height 38.3 cm
after 1770
Landesmuseum
Württemberg
Stuttgart
Inv. no.
WLM 1926/15

[14]

Innerlich verschlossener Gram

»Innerlich verschlossener Gram« (Kat.-Nr. 14a–c) zeigt einen glatzköpfigen Mann, dessen knappe Büste auf einem runden Sockel aufsitzt. Der breite Hals mit dem deutlich aus der Halsgrube vortretenden Adamsapfel trägt einen plastisch gewölbten, wuchtigen Kopf mit eingefallenen oder eingezogenen Wangen. Die Lippen sind verdeckt von einem »Band«, das von den tiefen Falten überschnitten wird, die sich von den Nasenflügeln zu den Mundwinkeln ziehen und die ihrerseits in einem Bogen unter dem Mundband verschwinden. Seitlich der Nasolabialfalten entwickeln sich weitere, abgeplattete Falten und strukturieren die seitlichen Partien des Kinns.

Am nächsten steht dem innerlich verschlossenen Gram die Büste »Der Mismuthige« (Abb. 60).[1] Ein nur um Weniges breiterer Ausschnitt, ein breiter Hals – hier ohne den ausgeprägten Adamsapfel – und die Kahlköpfigkeit des ovalen, mächtigen Kopfes lassen beide wie Pendants erscheinen. Kinn und Mund sind in beiden Fällen vom Doppelkinn, den Nasolabialfalten und den dazwischen vermittelnden Falten »topfartig« eingefasst. Das als beweglich dargestellte Mundband und die Faltengebung um die Mundpartie unterstreichen die Nähe beider Büsten.

Die offenen Augen von »Innerlich verschlossener Gram« sind von scheibenartig harten Lidern schablonenhaft eingefasst. Sowohl die Einrahmungen ober- und unterhalb der Augen als auch die Partie zwischen Mund und Nase sind eher flächig, fast maskenhaft ausgebildet. Dies, obwohl sich bei gerunzelten Brauen die Lider und

Grief Locked Up Inside

"Grief Locked Up Inside" (cat. nos. 14a–c) depicts a bald-headed man, with a scant section of bust resting on a round base. The broad neck with a prominent Adam's apple emerging from a depression in the neck supports a sculpturally domed, massive head with sunken or sucked-in cheeks. The lips are covered by a "band", which is intersected by the deep wrinkles running from the wings of the nose to the corners of the mouth, only to disappear in an arc beneath the mouth band. Outside the nasolabial folds, more, flattened, wrinkles develop to structure the sides of the chin.

"Grief Locked Up Inside" is closest to the bust of "The Ill-Humored Man" (fig. 60).[1] An only slightly broader bust section, a broad neck – here without the prominent Adam's apple – and the baldness of an oval, massive head in both cases make these works look like companion pieces. In both, chin and mouth look as if "potted" in a double chin, the nasolabial folds and the intermediate wrinkles. The mouth band, which is represented as flexible, and the handling of the wrinkles around the mouth underscore the affinities between these two busts.

The open eyes of "Grief Locked Up Inside" are set as if stencilled in harsh, disc-like lids. Both the framing above and below the orbital zone and the area between mouth and nose have been rendered flat, almost mask-like. And this, although the brows are knit and the lids and orbital ridges lie heavily above the eyes. The orbital zone has been handled entirely differently in "The Ill-Humored Man". He is squinting so hard his eyes are almost shut and he is wrinkling his nose. These facial actions make the orbital zone, including the lids and the orbital ridge, look deformed, as in "A Dismal and Sinister Man" (cat. no. 21), "Just Rescued from Drowning" (fig. 69) and even "The Yawner" (cat. no. 12). "The Ill-Humored Man" has no brows but instead short, narrow bands run from the strips above the root of the nose, over which there is a slight furrow, with a strand of muscle continuing on each side in an arc to the cranium. The knit, arc-shaped brows of "Grief Locked Up Inside", on the other hand, merge with the steep wrinkles developing at the same time above the nose into a sculpturally

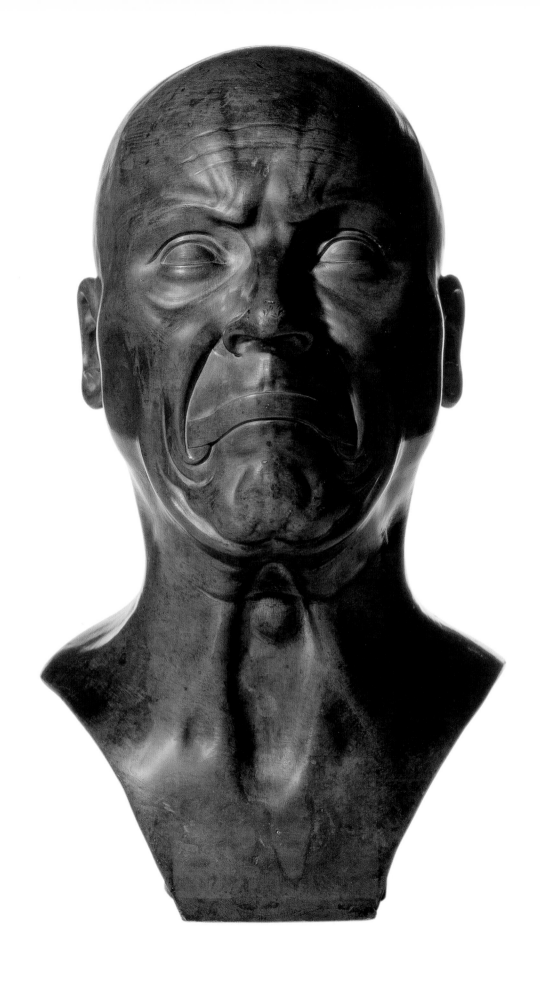

[14a]

Orbitalwülste schwer über die Augen legen. Völlig anders hingegen ist bei »Der Mismuthige« die Partie um die Augen gestaltet. Seine Augen sind fest zusammengekniffen und die Nase gerümpft. Dadurch entsteht eine deformiert wirkende Augen-Lider-Orbitalwulst-Partie, die denen der Köpfe »Ein düstrer finsterer Mann« (Kat.-Nr. 21), »Ein aus dem Wasser Geretteter« (Abb. 69), ja sogar »Der Gähner« (Kat.-Nr. 12) vergleichbar ist. Brauen sind beim Mismuthigen keine vorhanden; statt dessen bilden sich aus den Wülsten über der Nasenwurzel schmale, kurze Stege, über denen sich jeweils eine leichte Einfurchung und ein Muskelstrang anschließen, der sich in einem Bogen zum Schädel zieht. Die gerunzelten, bogenförmig geschwungenen Brauen von »Innerlich verschlossener Gram« dagegen vereinen sich mit den gleichzeitig entstehenden steilen Falten über der Nase zu einer plastisch vortretenden Form, die sich über der Stirn bis zum Schädel wellenförmig fortsetzt. Waagerecht verlaufende Stirnfalten liegen über den wulstartigen Verformungen.

Wie in anderen Büsten spielt Messerschmidt auch hier sein formales Repertoire aus. Ein einheitliches Erscheinungsbild wird durch die variationsreiche Gestaltung verhindert. Messerschmidt reduziert das Mienenspiel auf wenige, wesentliche Bewegungen, vereinfacht

raised form that continues on over the forehead to the skull in wavy configurations. Horizontal forehead wrinkles lie above these strap-like forms.

As he has done with other busts, Messerschmidt is displaying his skill at deploying his repertoire of forms. His diverse approach to handling is what keeps the faces from all looking alike. Messerschmidt has reduced the play of feature to a few, essential facial actions, has simplified and clarified – to obscure at the same time. Instead of being rounded in form, the ridges of the wrinkles about the mouth zone have been flattened. The forehead with its wavy action leaves viewers puzzled as to whether this facial action results from the brows being knit or a deformation of the frontal bone itself. Messerschmidt has aimed for a disturbing effect: the facial actions represented and, therefore, the expression described, are at once impracticable yet true.

The band covering or replacing the mouth is even more disturbing. The physical properties of its

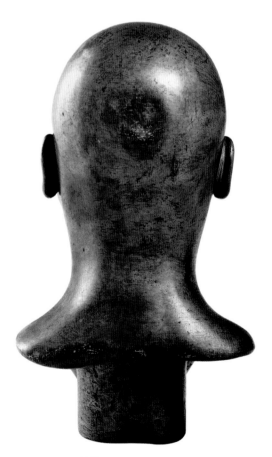

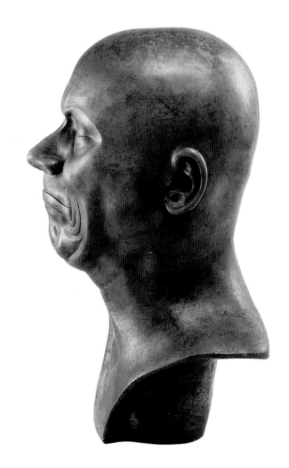

Kat.-Nr. 14b / *Cat. no.14b*
Franz Xaver Messerschmidt, Innerlich verschlossener Gram, Rückansicht
Franz Xaver Messerschmidt, Grief Locked Up Inside, rear view

Kat.-Nr. 14c / *Cat. no.14c*
Franz Xaver Messerschmidt, Innerlich verschlossener Gram, Seitenansicht
Franz Xaver Messerschmidt, Grief Locked Up Inside, side view

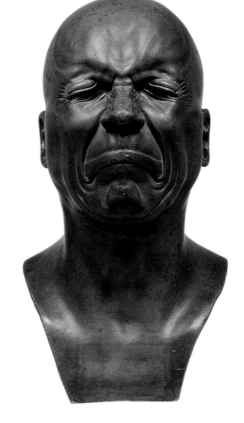

60　Franz Xaver Messer-
schmidt, Der Mismuthige,
nach 1770, Blei,
Musée du Louvre,
Paris, Inv.-Nr. RF 4724
*Franz Xaver Messer-
schmidt, The Ill-Humored
Man, after 1770, lead,
Musée du Louvre,
Paris, Inv. no. RF 4724*

und klärt, um gleichzeitig zu verunklären. Anstatt gerundete Formen aufzuweisen, sind die Falten um die Mundpartie auf ihrem oberen Grat abgeplattet. Die wellenartig bewegte Stirn lässt den Betrachter im Ungewissen, ob dies Folge der gerunzelten Brauen oder eine Verformung des Stirnknochens ist. Messerschmidt erzielt eine irritierende Wirkung: Die dargestellte Bewegung und damit auch der geschilderte Ausdruck sind gleichzeitig undurchführbar und doch wahr.

Eine noch größere Irritation entsteht durch das Band, das den Mund verdeckt oder ersetzt und dessen materielle Qualität unklar bleibt. Krapf schlägt, wie bei »Ein mit Verstopfung Behafteter« (Kat.-Nr. 13), vor, das Band als »Band-Eisen in Magnet-Form, das bei den Mesmerschen Heilmethoden des ›Animalischen Magnetismus‹ zu Anfang der Magnet-Kuren seit den frühen 1770er Jahren als Heilmittel eingesetzt wurde«,[2] zu verstehen. Formal schafft der Künstler jedenfalls eine Leerstelle im Gesicht, ohne dass dadurch die Gestaltung des übrigen Gesichts beeinträchtigt würde. »Innerlich verschlossener Gram« zeigt einen finsteren Gesichtsausdruck, dessen abweisende Unzugänglichkeit auch von dem Band ausgedrückt wird. Innerer Druck scheint, beispielsweise durch einen Schrei, nicht nach außen dringen zu können und formt sich allein im Mienenspiel des Gesichts ab.

1　Paris, Musée du Louvre, Inv.-Nr. RF 4724.
2　Krapf, Katalog 2002, S. 264.

Literatur
　　Anonymus 1794, S. 69 (Nro. 47); Kris 1932, S. 219, Abb. 229; Kris 1933, S. 401, Abb. 24; Pötzl-Malíková 1982, S. 70, 263; Krauß 1986, Abb. 55 (S. 132); Ronzoni 1997, Abb. S. 42; Bückling 1999b, S. 114; Pfarr 2001, S. 456, Pl. 4 (S. 457); Krapf, Katalog 2002, S. 264–265; Lehner-Jobst 2002, Abb. S. 96; Pötzl-Malíková 2004, Abb. S. 124; Schmid 2004, S. 54, 58; Maué 2005, S. 256; Ausst.-Kat. Kunst lebt 2006, S. 49–50, Abb. S. 61; Pfarr 2006, Abb. 91–92.

substance remain unclear. Krapf suggests, as in "Afflicted with Constipation" (cat. no. 13), interpreting the band as a "bar of iron in the form of a magnet which had been used at the outset of Mesmer's therapeutic treatments entailing 'animal magnetism' since the early 1770s."[2] Be that as it may, the artist has created a gap in the face without, however, impairing the handling of the rest of the face. "Grief Locked Up Inside" depicts a forbidding expression, whose stern inaccessibility is also expressed in the band. Pressures bottled up within, caused, for example, by suppressing a scream, cannot be relieved by letting them out and this is depicted entirely in the play of feature.

1　Paris, Musée du Louvre, Inv. no. RF 4724.
2　Krapf, Katalog 2002, p. 264.

References
　　Anon. 1794, p. 69 (no. 47); Kris 1932, p. 219, fig. 229; Kris 1933, p. 401, fig. 24; Pötzl-Malíková 1982, pp. 70, 263; Krauss 1986, fig. 55 (p. 132); Ronzoni 1997, illus. p. 42; Bückling 1999b, p. 114; Pfarr 2001, p. 456, pl. 4 (p. 457); Krapf, Katalog 2002, pp. 264f.; Lehner-Jobst 2002, illus. p. 96; Pötzl-Malíková 2004, illus. p. 124; Schmid 2004, pp. 54, 58; Maué 2005, p. 256; exhib. cat. Kunst lebt 2006, pp. 49f., illus. p. 61; Pfarr 2006, figs. 91, 92.

Blei, Höhe 42 cm
nach 1770
Privatbesitz

Lead, height 42 cm
after 1770
Private collection

[15]

Das schwere Geheimnis

Auf recht schmalem Büstenausschnitt, hinter dem auch in der Vorderansicht seitlich der tragende, annähernd quadratische Sockelkubus, der in sanftem Schwung in den Büstenausschnitt übergeht, vorsteht, ruht über einem breiten Hals der mächtige, ovale Kopf eines Mannes (Kat.-Nr. 15a). Die Büste entspricht somit im Wesentlichen dem Prototyp der Charakterköpfe. Der Büstenausschnitt bleibt ruhig und modelliert in weichen Formen den Oberkörper des Mannes. Klare, plastisch formulierte Partien prägen auch Kopfform und Physiognomie. Das Gesicht zeigt zwar ein leicht verzogenes Mienenspiel, ist aber dennoch eher ruhig gestaltet: Die Lippen sind eingezogen, so dass statt der Lippen Wülste entstehen, von deren Winkel aus sich bogenförmige Falten nach oben ziehen und fast mit den Andeutungen von Nasolabialfalten zusammentreffen. Das Kinn ist nach oben eingezogen und angespannt. Dadurch bildet sich in der Mitte eine leicht vorgeschobene Buckelung ab. In Bezug auf die plastische Gestaltung könnte sich Messerschmidt auf römische Porträtköpfe bezogen haben: Ein Männerkopf aus der Zeit um 50 v. Chr. ist in seiner plastischen Form der Büste »Das schwere Geheimnis« vergleichbar.[1]

Über den weit geöffneten, pupillenlosen Augen wölben sich die Orbitalwülste leicht vor; die haarlosen, zu knorpeligen Erhebungen verformten Augenbrauen sind deutlich gerunzelt. Eine steile Falte zwischen den Brauen trennt sie voneinander. Anders als bei »Ein Erzbösewicht« (Kat.-Nr. 10) oder »Ein kraftvoller Mann« (Kat.-Nr. 16) ist die Mimik zwar ein wenig düster und verschlossen, aber nachvollziehbar. Grenzen der Anatomie, von den Köpfen häufig durchbrochen, werden bei diesem Kopf eher eingehalten. Wie »Ein kraftvoller Mann« (Kat.-Nr. 16), »Ein Erzbösewicht« (Kat.-Nr. 10), »Der Gähner« (Kat.-Nr. 12) und »Ein Heuchler und Verleumder« trägt er eine Stoppelhaarfrisur, deren gepunzt wirkende Strähnen ungewöhnlich liegen (Kat.-Nr. 15b, d): Die Haarstreifen über der Stirn und zur

The Difficult Secret

The massive, oval head of a man on a broad neck rests on a rather narrow bust section. Behind it, when viewed frontally, the supporting base, which is block-like, almost a cube, is revealed on the sides gliding into the bust section in a gentle curve without transition (cat. no. 15a). This bust, therefore corresponds in essentials to the archetype of the Character Heads. The bust section is calm and the torso of the man is modelled in soft forms. Clear, sculpturally defined parts predominate in the form of the head and the countenance. The face does reveal a slight twinge of action yet is nonetheless tranquil in design: the lips are retracted so that rounded bands instead of lips appear. From the corners of the mouth folds arc upwards and almost converge with the nasolabial folds, which are merely suggested. The tense chin juts upwards. This causes a slightly bulging humped effect in the middle of the chin. For the sculptural handling, Messerschmidt may have drawn on Roman portrait heads: the head of a man dating from c. 50 BC is similar in its sculptural treatment to the bust "The Difficult Secret".

Above the wide open eyes devoid of pupils, the orbital ridges bulge slightly. The hairless eyebrows, formed into cartilaginous raised elements, are noticeably knit. A steep wrinkle between the brows demarcates them. The play of feature here is, in contrast to "An Arch-Rascal" (cat. no. 10) and "A Strong Man" (cat. no. 16), slightly less forbidding and stern but nonetheless readable. The bounds of anatomy, often infringed in the Heads, tend to be observed in this Head. As in "A Strong Man" (cat. no. 16), "An Arch-Rascal" (cat. no. 10), "The Yawner" (cat. no. 12) and "A Hypocrite and Slanderer", this figure sports a stubbly haircut, whose punched-looking strands lie in an unusual pattern (cat. nos. 15b, d): the strands above the forehead on the right side run diagonally across the head. On the left side, however, they run horizontally. Concentric circles are formed on the back of the head round the parting and converge on the horizontal rows of hair (cat. no. 15c). Horizontal parallel strands show up on the back of the neck. Messerschmidt has added disruptions to the bust in the form of the linear 'hairnet', which contrasts with the

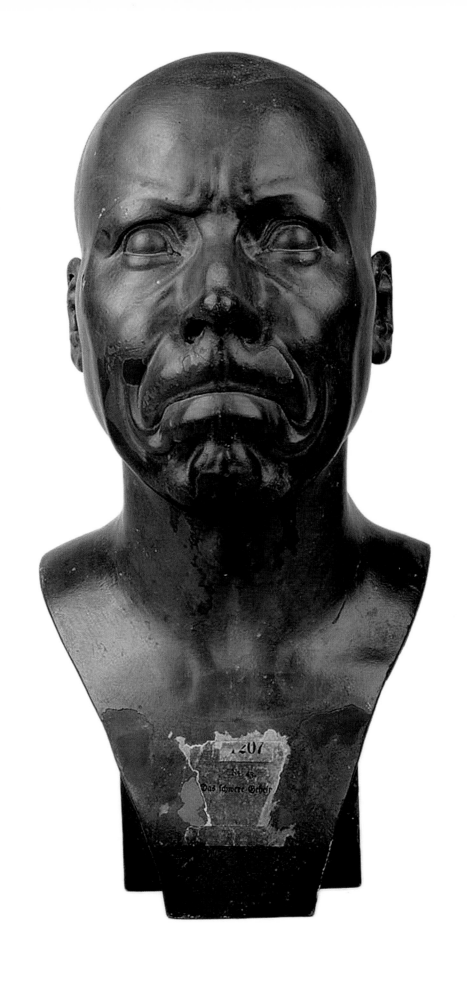

rechten Seite liegen quer über dem Kopf. An der linken Seite dagegen verlaufen sie waagerecht. Auf dem Hinterkopf (Kat.-Nr. 15c) bilden sich um den Scheitel konzentrische Kreise, auf die die horizontalen Reihen unvermittelt auftreffen. Im Nacken zeigen sich waagerechte Parallelsträhnen. Durch das graphische Haarnetz, das im Gegensatz zu der plastischen Modellierung des Kopfes steht, fügt Messerschmidt der Büste Irritationen bei. Sie werden durch die ungewöhnliche asymmetrische Anlage der Haarreihen unterstrichen.

Hinsichtlich der breiten Anlage des Halses, der ovalen Kopfform und den groß geöffneten Augen (Kat.-Nr. 15a) steht der Büste eine Graphik von Jakob Schmutzer (1733–1811) nahe, die – mit schwerem Helm versehen – den ägyptischen Weisen oder Gott Hermes Trismegistos (Abb. 61) darstellt.[2] Aber nicht nur die körperliche Ähnlichkeit fällt auf: Auch die sich zu Knorpeln zu Seiten der Nasenwurzel verdickenden Augenbrauen, die sich in der Mitte nach oben ziehen und in einer Biegung in die Stirn hineinragen und diese leicht verformen, findet hier einen Widerhall. Diese Deformation der Stirn verbindet »Das schwere Geheimnis« gleichzeitig mit Köpfen wie »Innerlich verschlossener Gram« (Kat.-Nr. 14).

sculptural modelling of the head. The disturbing elements are underscored by the unusual asymmetry of the rows of hair.

The broadness of the neck, the oval head form and the wide open eyes (cat. nos. 15a) place this bust close to a print by Jakob Schmutzer (1733–1811) representing the Egyptian Wise Old Man or the deity Hermes Trismegistos (fig. 61) – wearing a heavy helmet. But it is not just the physical similarity that is so striking: the eyebrows, thickened to cartilaginous forms beside the bridge of the nose and drawn up towards the centre to bend into the forehead and slightly deform it, are echoed in the print. The same deformation of the forehead links "The Difficult Secret" with such Heads as "Grief Locked Up Inside" (cat. no. 14).

Also closely related to the present Head is "A Strong Man" (cat. no. 16). The similarity lies primarily in the oval head form, the pronounced jaw bones,

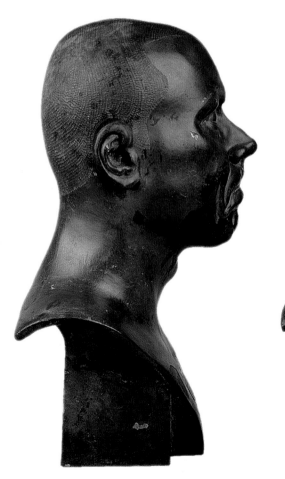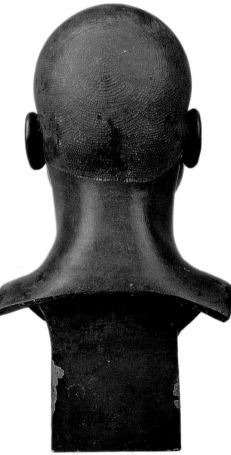

Kat.-Nr. 15b / *Cat. no. 15b*
Franz Xaver Messerschmidt, Das schwere Geheimnis, Seitenansicht
Franz Xaver Messerschmidt, The Difficult Secret, side view

Kat.-Nr. 15c / *Cat. no. 15c*
Franz Xaver Messerschmidt, Das schwere Geheimnis, Rückansicht
Franz Xaver Messerschmidt, The Difficult Secret, rear view

Kat.-Nr. 15d / *Cat. no. 15d*
Franz Xaver Messerschmidt, Das schwere Geheimnis, Seitenansicht
Franz Xaver Messerschmidt, The Difficult Secret, side view

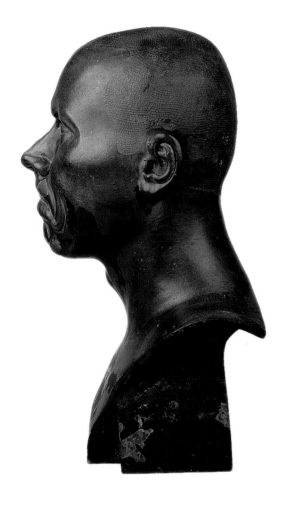

61 Jakob Schmutzer,
 Hermes Toth, Kupferstich,
 Albertina, Wien,
 Inv.-Nr. D I 58, fol. 5
 Jakob Schmutzer,
 Hermes Thoth, copperplate
 engraving, Albertina,
 Vienna, Inv. no. D I 58, fol. 5

Nah verwandt ist dem Kopf auch »Ein kraftvoller Mann« (Kat.-Nr. 16). Insbesondere die ovale Kopfform mit ausgeprägten Kieferknochen, die Massigkeit des Kopfes und die Stoppelhaarfrisur tragen zu der Ähnlichkeit bei. Die Einziehung des Halses beim kraftvollen Mann kontrastiert dagegen zu dem breiten Hals des schweren Geheimnisses; die verzogene Mimik des einen findet ihren Gegenpart in der größeren Einfachheit des anderen. Mit beiden verwandt sind in Bezug auf die Kopfform »Der unfähige Fagotist« und »Ein Hipochondrist«. Letzterer allerdings besitzt einen etwas anders gestalteten Sockel, denn der Büstenausschnitt endet, wie dies bei »Der Gähner« der Fall ist, über der Sockelunterkante, so dass der tragende Sockelkubus deutlich auffällt. Darüber hinaus trägt er keine Frisur, sondern ist mit Glatze wiedergegeben.

1 Schweitzer 1948, Abb. 131.
2 Zuerst mit den Köpfen Messerschmidts in Verbindung gebracht von Krapf 1995, S. 49–50.

Literatur
 Anonymus 1794, S. 67 (Nro. 43); Ilg 1885, S. 52; Kris 1932, S. 207, Abb. 217; Glandien 1981, S. 50; Pötzl-Malíková 1982, S. 70, 262; Krapf, Katalog 2002, S. 260–261; Pötzl-Malíková 2003, S. 254, Abb. 295; Schmid 2004, S. 54; Pfarr 2006, Abb. 87.

the massiveness of the head and the stubbly hair. The way the Strong Man ducks his head into a broad neck contrasts with the broad neck in "The Difficult Secret". The slight contortion of the features contrasts with the greater simplicity of the other. In respect of the head form, both are related to "The Incapable Bassoonist" and "A Hypochondriac". The last-named, however, has a rather differently configured base since the bust section ends, as in "The Yawner", above the upper edge of the base so that the supporting function of the base block is emphasised. Moreover, the figure is hairless, indeed completely bald.

1 Schweitzer 1948, fig. 131.
2 First linked to Messerschmidt's Heads by Krapf 1995, pp. 49f.

References
 Anon. 1794, p. 67 (no. 43); Ilg 1885, p. 52; Kris 1932, p. 207, fig. 217; Glandien 1981, p. 50; Pötzl-Malíková 1982, pp. 70, 262; Krapf, Katalog 2002, pp. 260f.; Pötzl-Malíková 2003, p. 254, fig. 295; Schmid 2004, p. 54; Pfarr 2006, fig. 87.

Blei, Höhe 44 cm
nach 1770
Privatbesitz

Lead, height 44 cm
after 1770
Private Collection

[16]

Ein kraftvoller Mann

»Ein kraftvoller Mann« (Kat.-Nr. 16a) zeigt den zu einer Grimasse verzerrten Kopf auf dem üblichen, hier von einem zylindrischen Sockel gestützten Büstenausschnitt ruhend, der in der Vorderansicht vorsteht. Alle Teile der Physiognomie, die Brust und auch die Halsmuskeln sind von Verspannungen in Mitleidenschaft gezogen (Kat.-Nr. 16b, d).

Sowohl von den Augen beziehungsweise von den Tränensäcken her ziehen sich Falten bis zu den Nasenflügeln. Dort setzen zugleich die Nasolabialfalten an, so dass die Nase als »Treffpunkt« verschiedener Faltenformationen fungiert. Auf der leicht gerümpften Nase bilden sich hingegen kaum Falten. Die Nasolabialfalten biegen noch oberhalb des Mundes um und ziehen sich zu den Mundwinkeln hin. Ihr Verlauf wird von Falten wiederholt, die sich unterhalb des Kinns bilden und in den Wangen fortsetzen. In der so von Falten umrissenen, verhältnismäßig ruhig und flächig gestalteten Partie erscheint der Mund, die Lippen fest aufeinander gepresst, als schmaler Strich.

Die Augen, die sich zu Schlitzen öffnen, werden von formelhaft gestalteten Lidfalten und Tränensäcken gerahmt, die klar, fast hart gegeneinander abgesetzt sind. Krähenfüße entstehen an den äußeren Augenwinkeln und ziehen sich als Rillen bis zu den Schläfen. Die Augen werden überwölbt von hohen, flachen Orbitalwülsten, die in ornamental gebogene Augenbrauen beziehungsweise geschwungene Stirnfalten übergehen. Die Augenpartie gleicht beinahe einer Maske, wie es auch bei »Der kindisch Weinende« (Kat.-Nr. 19) oder »Der Schaafkopf« (Abb. 64) zu beobachten ist. Demgegenüber erinnern die das Kinn verdoppelnden Falten, die diese verhältnismäßig großflächige Partie optisch zusätzlich vergrößern, an die Köpfe der »Schalksnarren« (Abb. 62, 63).[1] Die in die Stirn nach vorne gezogene Frisur samt Geheimratsecken wiederholt in abgemilderter

A Strong Man

"A Strong Man" (cat. no. 16a) is depicted with the head contorted in a grimace above the usual bust section resting in the present instance on a cylindrical base, which juts forward when viewed frontally. All parts of the countenance, the breast and even the neck muscles are fraught with tensions (cat. no. 16b, d).

Wrinkles extend from the eyes, or lachrymal sacs, to the wings of the nose. There the nasolabial folds start immediately so that the nose functions as the "point of convergence" of various wrinkle formations. There are, by contrast, hardly any wrinkles in the slightly turned-up nose. The nasolabial folds bend just above the mouth to extend to the corners of the mouth. their course is repeated in the wrinkles formed beneath the chin and continuing on to the cheeks. In this relatively calm part, which is formed as a surface and is thus outlined by wrinkles, the mouth, with lips firmly compressed, appears as a narrow line.

The slitted eyes are framed by lid folds handled as formulae and lachrymal sacs, which are clearly, almost harshly, demarcated. Crow's feet start in the outer corners of the eyes and extend as grooves to the temples. High, flat orbital ridges, which turn into ornamentally bent eyebrows and curvilinear forehead wrinkles bulge over the eyes. The orbital zone is almost mask-like; in this it resembles what can be observed in "Childish Weeping" (cat. no. 19) and "The Simpleton" (fig. 64). In contrast, the wrinkles forming the double chin, which visually enlarge this relatively flat part, are reminiscent of the "Mischievous Wag" Heads (figs. 62, 63).[1] The hair, pulled forward into the forehead and receding at the temples, repeats in modified form the course of the eyebrows and forehead wrinkles. As in "An Arch-Rascal" (cat. no. 10) and "The Yawner" (cat. no. 12), this Head sports stubbly hair, with the rows of strands articulated by small rows of stippling, which lead back in parallel to converge radially on the crown (cat. no. 16c).

Grooves incised in the neck beneath the chin mark wrinkles, which do not, however depend on the action of the chin and lower jaw. Powerful muscle contractions draw from the collar bones and the breast bone radially to the neck and upwards via the wrinkle

176

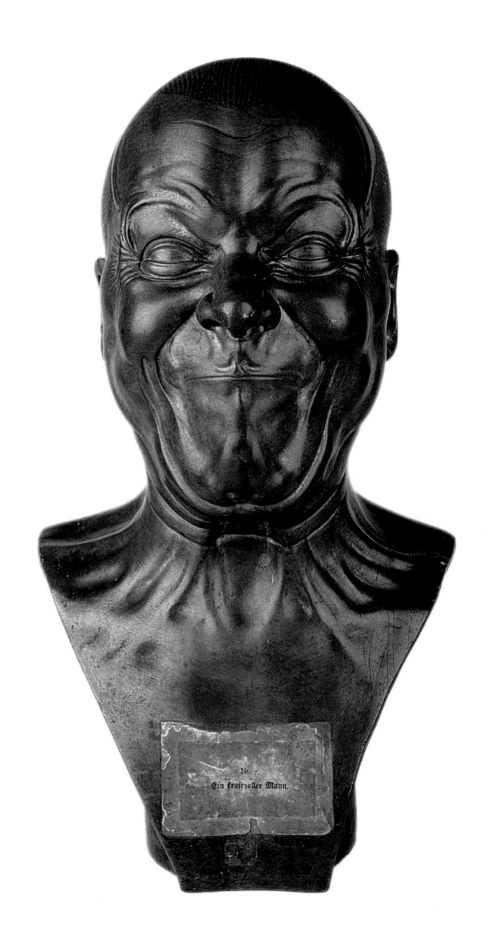

Nr.
Ein kraftvoller Mann.

[16a]

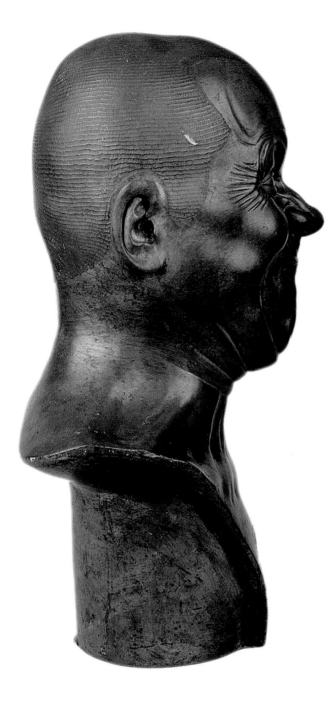

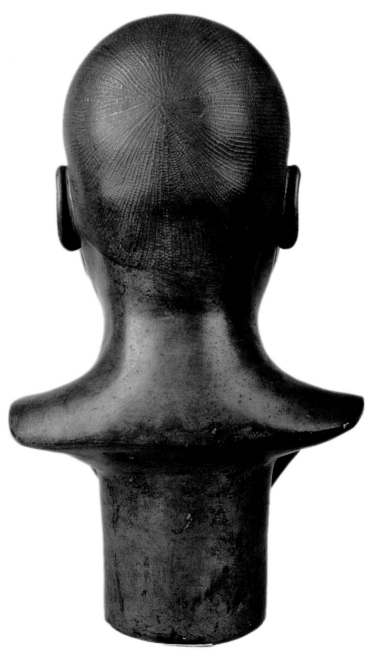

Kat.-Nr. 16b / *Cat. no. 16b*
Franz Xaver Messer-
schmidt, Ein kraftvoller
Mann, Seitenansicht
Franz Xaver Messer-
schmidt, A Strong Man,
side view

Kat.-Nr. 16c / *Cat. no. 16c*
Franz Xaver Messer-
schmidt, Ein kraftvoller
Mann, Rückansicht
Franz Xaver Messer-
schmidt, A Strong Man,
rear view

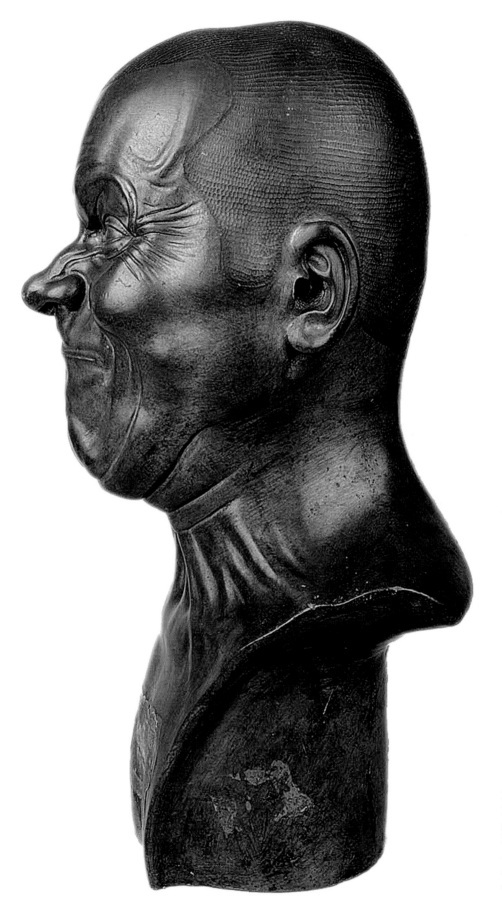

Form den Verlauf der Augenbrauen und Stirnfalten. Es handelt sich, wie bei »Ein Erzbösewicht« (Kat.-Nr. 10) oder auch »Der Gähner« (Kat.-Nr. 12), um eine Stoppelhaarfrisur, bei der die Strähnenreihen durch kleine Strichelungen unterteilt sind, die hier in parallelen Reihen nach hinten führen und im »Haarwirbel« strahlenförmig aufeinandertreffen (Kat.-Nr. 16c).

In den Hals eingeritzte Rillen unterhalb des Kinns markieren Falten, die jedoch nicht von der Bewegung des Kinns und des Kiefers abhängig sind. Starke Muskelverspannungen ziehen sich von den Schlüsselbeinen und dem Brustbein strahlenförmig zum Hals und über die Faltenrillen hinweg nach oben. Zwischen den Muskelsträngen entstehen muldenartige Vertiefungen, die die angespannten Muskeln voneinander trennen. Diese Muskelverspannungen enden, noch bevor sie Kinn und Kiefer erreichen. Tatsächlich also haben die Verspannungen des Halsbereiches und des Gesichts nichts miteinander zu tun.

grooves. Between the strands of muscle, depressions are created that demarcate the taut muscles. These muscle contractions end before the chin and lower jaw. In fact the tensions in the neck region and those of the face have nothing to do with one another.

On the whole, this bust unites abstract elements, such as the hair, which is stretched taut across the rounded cranium and, on the other hand, mask-like elements or sculpturally rounded ones such as the forms of the head and cheeks. The strongly bulging cheeks and the laughter lines in the corners of the mouth as well as the broad, albeit firmly closed, mouth lend the face a look of malicious amusement. Messerschmidt has used linear devices in incising the wrinkles, the strands of hair and the hard rims of the eyes. The distortions of face and neck go well

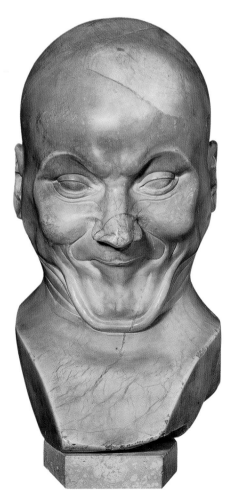

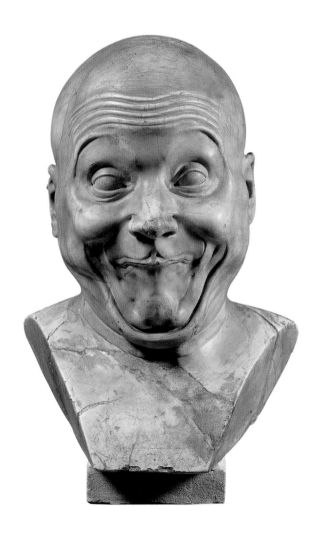

62 Franz Xaver Messerschmidt, Ein Schalksnarr, nach 1770, Alabaster, Österreichische Galerie Belvedere, Wien, Inv.-Nr. 5639
Franz Xaver Messerschmidt, A Mischievous Wag, after 1770, alabaster, Österreichische Galerie Belvedere, Vienna, Inv. no. 5639

63 Franz Xaver Messerschmidt, Ein absichtlicher Schalksnarr, nach 1770, Alabaster, Österreichische Galerie Belvedere, Wien, Inv.-Nr. 2284
Franz Xaver Messerschmidt, An Intentional Wag, after 1770, alabaster, Österreichische Galerie Belvedere, Vienna, Inv. no. 2284

Insgesamt vereint die Büste somit einerseits Abstraktionen wie die Frisur, die sich über den gerundeten Schädel spannt, andererseits maskenhafte Partien oder auch plastisch gewölbte wie die Kopfform und die Wangen. Die hoch gewölbten Backen verleihen dem Gesicht ebenso wie die Lachfalten in den Augenwinkeln und der breite, wenngleich fest geschlossene Mund einen verschmitzten Ausdruck. Graphische Mittel verwandte Messerschmidt bei der Eintragung der Falten, der Haarsträhnen sowie bei den harten Einfassungen der Augen. Die Verzerrungen von Gesicht und Hals gehen weit über die physiognomischen Möglichkeiten des Menschen hinaus. Weder die zahlreichen Muskelverspannungen des Halses, die zudem vor der Kinn- und Kieferpartie enden, noch das in die Länge gezogene Kinn, seine Verbindung mit den Kinn- und Nasolabialfalten, die prallen Wangen und geschlitzten Augen, von ornamental geschwungenen Brauen- und Faltenformationen überwölbt, lassen sich gleichzeitig in die Form bringen, die »Ein kraftvoller Mann« zur Schau trägt.

1 Abb. in Krapf, Katalog 2002, S. 245, 248–249.

Literatur
Anonymus 1794, S. 45–46 (Nro. 7); Ilg 1885, S. 52; Kris 1932, Abb. 202–203; Pötzl-Malíková 1982, S. 70, 246; Krapf, Katalog 2002, S. 184–185; Pötzl-Malíková 2003, S. 254, Abb. 295; Pötzl-Malíková 2004, Abb. S. 76; Schmid 2004, S. 18; Pfarr 2006, Abb. 39.

beyond the actual physical possibilities of facial action. Neither the numerous contractions of the neck muscles, which, moreover, end before the chin and lower jaw, nor the extended chin, its links with the chin and nasolabial folds, the plump cheeks and slitted eyes, over which ornamentally curvilinear brows and wrinkle formations bulge, can plausibly occur simultaneously in the overarching design of "A Strong Man".

1 Shown in Krapf, Katalog 2002, pp. 245, 248f.

References
Anon. 1794, pp. 45f. (no. 7); Ilg 1885, p. 52; Kris 1932, figs. 202, 203; Pötzl-Malíková 1982, pp. 70, 246; Krapf, Katalog 2002, pp. 184f.; Pötzl-Malíková 2003, p. 254, fig. 295; Pötzl-Malíková 2004, illus. p. 76; Schmid 2004, p. 18; Pfarr 2006, fig. 39.

Alabaster, Höhe 41,5 cm
nach 1770
Wien Museum, Wien
Inv.-Nr. 67.137

Alabaster, height 41.5 cm
after 1770
Wien Museum, Vienna
Inv. no. 67.137

[17]

Die Einfalt im höchsten Grade

»Die Einfalt im höchsten Grade« (Kat.-Nr. 17a–c) gehört in die Reihe der siebzehn überlieferten Alabasterköpfe. Der verhältnismäßig breite, in sich geschwungene Büstenausschnitt wird von einem zylindrischen Sockel gestützt, der aus der Vorderansicht verdeckt ist. Der kahlköpfige Mann streckt seinen Kopf weit vor, so dass die Kinnpartie von der rundbogig geführten Kontur der Schultern überschnitten wird. Am Hals bilden sich einige angespannte Falten, die jedoch eher durch das Vorschieben des Kinns entstehen als durch das Vorstrecken des Kopfes.

Der Mund ist zu einem schmalen Strich zusammengepresst, die Mundwinkel sind leicht gesenkt; nach unten führende Falten unterstreichen diese Abwärtsbewegung. Die tiefen Nasolabialfalten reichen bis kurz vor diese Mundfalten heran, so dass der Eindruck entsteht, als vollzögen sie eine kleine Haarnadelbiegung, um sich nach oben zu den Mundwinkeln zu ziehen. Zu Seiten der Falten wölben sich die Wangen hoch. Weitere Falten trennen erst unterhalb der Augen die Tränensackpartie von den Wangen, die sich in leicht modellierter Oberfläche über die Wangenknochen bis zu den Ohren ziehen. Die weit aufgerissenen Augen sind gerahmt von halbrund gewölbten Oberlidern und nahezu waagerecht verlaufenden Unterlidern. Augenbrauen sind nur als sich leicht abzeichnende Knochen angedeutet; statt dessen ziehen sich einige, leicht gewellte Falten

The Ultimate Simpleton

"The Ultimate Simpleton" (cat. nos. 17a–c) belongs to the group of sixteen alabaster heads. The relatively broad, curvilinear bust section is supported by a cylindrical base, which is invisible when the work is viewed frontally. The man stretches his bald head so far forwards that the chin is intersected by the rounded arc of the shoulder contour. A few tense wrinkles have formed on the neck but they have been caused by the chin being thrust forwards rather than the similar action of the head.

The mouth is compressed to a narrow line, the corners of the mouth droop slightly. Wrinkles lead downwards to underscore this downward motion. The deep nasolabial folds extend almost to those mouth wrinkles, creating the impression they are executing a small hairpin turn to draw upwards to the corners of the mouth. The cheeks bulge upwards beside the wrinkles. Other wrinkles demarcate the lachrymal sacs from the cheeks, which, in lightly modelled surface treatment, extend over the cheek bones to the ears, but only just below the eyes. The wide-open eyes are framed by domed hemispherical lids and almost horizontal lower lids. The eyebrows are only suggested as bony ridges that scarcely show up. In place of eyebrows, a few, slightly wavy wrinkles cross the forehead. The furrowed forehead and the wide open eyes lend this face an astonished expression, which is made to appear almost sceptical by the compressed lips.

The areas that are large surfaces, which are demarcated by a few wrinkles and clearly contoured lids, structure both the face and the bust. The nose, the cheeks, the chin and the cheek bones as well as the round skull are sculptural in handling. By contrast, the eyes, the root of the nose, the orbital ridge over which ornamental, linear incised forehead wrin-kles bulges, have all been handled as surfaces. What has been aimed for is a formulaic, mask-like expression, reminiscent of "Childish Weeping" (cat. no. 19), distantly also of "The Simpleton" (fig. 64) and what are known as the Wags (figs. 62, 63). The head stretched forward links the present Head with "Strong Odor",[1] "Sneeze-Inducing Odor",[2] "Revolting Odor"[3] and, the most extreme case of all, the "Beaked Heads" (fig. 39).[4]

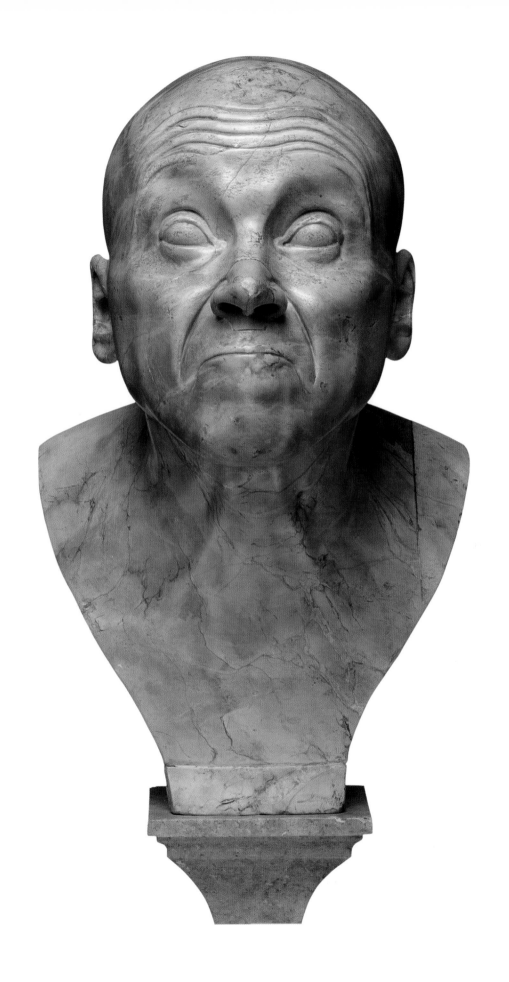

[17a]

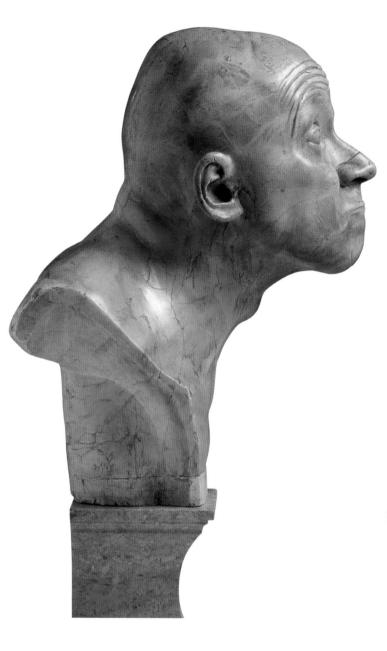

Kat.-Nr. 17b / *Cat. no. 17b*
Franz Xaver Messer-
schmidt, Die Einfalt
im höchsten Grade,
Seitenansicht
Franz Xaver Messer-
schmidt, The Ultimate
Simpleton, side view

Kat.-Nr. 17c / *Cat. no. 17c*
Franz Xaver Messer-
schmidt, Die Einfalt
im höchsten Grade,
Rückansicht
Franz Xaver Messer-
schmidt, The Ultimate
Simpleton, rear view

64 Franz Xaver Messer-
 schmidt, Der Schaafkopf,
 nach 1770, Alabaster,
 Österreichische
 Galerie Belvedere, Wien,
 Inv.-Nr. 5509
 Franz Xaver Messer-
 schmidt, The Simpleton,
 after 1770, alabaster,
 Österreichische
 Galerie Belvedere,
 Vienna, Inv. no. 5509

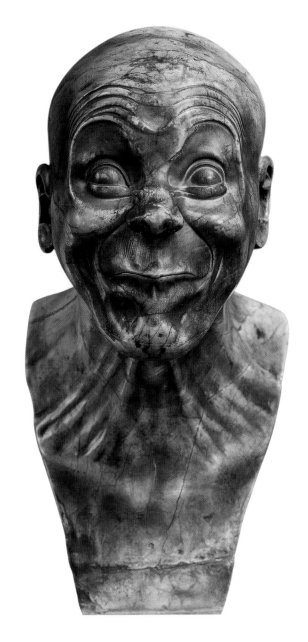

quer über die Stirn. Die gefurchte Stirnpartie und die weit aufgeris-
senen Augen verleihen dem Gesicht einen erstaunten Ausdruck, der
durch die zusammengepressten Lippen beinahe skeptisch erscheint.

Die großflächigen Partien, die durch wenige Falten und durch
klar konturierte Lider voneinander getrennt sind, strukturieren
sowohl das Gesicht als auch die Büste. Plastisch formuliert sind die
Nase, die Wangen, das Kinn und die Backenknochen sowie der runde
Schädel. Flächig stehen dagegen die Augen, die Nasenwurzel, der
Orbitalwulst, überwölbt von ornamental und graphisch eingetrage-
nen Stirnfalten. Erzielt wird ein formelhafter, maskenhafter Aus-
druck, der an »Der kindisch Weinende« (Kat.-Nr. 19), entfernt an
»Der Schaafkopf« (Abb. 64) oder auch an die so genannten Schalks-
narren (Abb. 62, 63) erinnert, während die vorgestreckte Kopf-
haltung ihn mit »Der Starke Geruch«,[1] »Geruch, der zum Niesen
reizt«,[2] »Der widerwärtige Geruch«[3] und dem extremsten Fall, den
»Schnabelköpfen« (Abb. 39),[4] verbindet.

1 Abb. siehe Krapf, Katalog 2002, S. 217.
2 Abb. siehe Krapf, Katalog 2002, S. 237.
3 Abb. siehe Krapf, Katalog 2002, S. 257.
4 Abb. siehe Krapf, Katalog 2002, S. 183.

Literatur
 Anonymus 1794, S. 47 (Nro. 9); Kris 1932, S. 206, Abb. 205; Kris 1933,
 S. 393; Glandien 1981, S. 51, Abb. 25; Pötzl-Malíková 1982, S. 70, 247;
 Krauß 1986, Abb. 48 (S. 115); Bücherl 1989, Abb. S. 58, 64; Ausst.-Kat. L'âme
 au corps 1993, Abb. S. 222; Krapf, Katalog 2002, S. 188–189; Pötzl-Malí-
 ková 2004, Abb. S. 77; Schmid 2004, S. 20.

1 For a picture see Krapf, Katalog 2002, p. 217.
2 Ibid., p. 237.
3 Ibid., p. 257.
4 Ibid., p. 183.

References
 Anon. 1794, p. 47 (no. 9); Kris 1932, p. 206, fig. 205; Kris
 1933, p. 393; Glandien 1981, p. 51, fig. 25; Pötzl-Malíková
 1982, pp. 70, 247; Krauß 1986, fig. 48 (p. 115); Bücherl
 1989, illus. pp. 58, 64; exhib. cat. L'âme au corps 1993,
 illus. p. 222; Krapf, Katalog 2002, pp. 188f.; Pötzl-Malíková
 2004, illus. p. 77; Schmid 2004, p. 20.

Blei-Zinn-Legierung,
Höhe 43,5 cm
nach 1770
Österreichische
Galerie Belvedere
Wien, Inv.-Nr. 2612

Lead-tin alloy,
height 43.5 cm
after 1770
Österreichische
Galerie Belvedere
Vienna, Inv. no. 2612

[18]

Der Edelmüthige

»Der Edelmüthige«
führt mit einem nahezu würfelförmigen Sockelkubus (Kat.-Nr. 18a),
der sich V-förmig verjüngenden Büste und dem frontal angebrach-
ten Kopf den Prototyp der Charakterköpfe vor Augen. Großflächige
Formen charakterisieren die Physiognomie und setzen die ruhige
Gestaltung des Brustausschnitts und Halses fort. »Der Kopf gliedert
sich in Wölbungen, die von Gesichtspartie zu Gesichtspartie, von
Motiv zu Motiv weiterleiten.« [1] Wenige, zum Teil nur angedeutete
Falten strukturieren das glatte Gesicht mit der hohen Stirn, dem
weich geschwungenen, vollen Mund über dem markanten Kinn, der
geraden Nase mit breitem Rücken und den im Vergleich nicht allzu
großen Augen. Mund, Kinn, Nase und die Augen sind in ruhigem
Zustand dargestellt; allein die sich zu knorpelartigen Verdickungen
zusammenziehenden Augenbrauen scheren aus dieser Ruhe aus und
verleihen dem Gesicht eine ernste, im Bereich der Augen nahezu
finstere Note. Die Rahmung der Augen und ein schmaler Schlitz
zwischen den Lippen sind in feinen Ritzungen und mit klarer Kon-
turierung eingetragen. Die Brauen sind zunächst als schmale Grate
formuliert, die sich zur Nasenwurzel hin in einem ornamentalen
Wulst verdicken, dessen Bewegung sich in der Stirnpartie fortsetzt
(Kat.-Nr. 18b).

Dieser Glätte steht die Gestaltung der Haare entgegen. Der
Haarwirbel ist hervorgehoben, indem von dort einige Locken aus-
gehen. Ansonsten machen die nach vorne in die Stirn gestrichenen,
formelhaft und graphisch wiedergegebenen Strähnen fast den

The Noble-Minded Man

"The Noble-Minded
Man" represents the archetype of the Character
Heads with an almost cubic base block (cat. no. 18a),
the tapering V-shaped bust and the frontal head. The
countenance is characterised by large surfaces that
continue on in the tranquil design of the breast sec-
tion and neck. "The head is articulated in bulges
leading from one part of the face to the next, from
motif to motif." [1] A few wrinkles, some of them
merely suggested, articulate the smooth face with its
lofty forehead, gently curvilinear, full-lipped mouth
via the pronounced chin, the straight nose with its
broad bridge and the eyes, which are relatively
small in comparison to the other facial features. The
mouth, chin, nose and eyes are represented in a state
of repose; only the eyebrows, knit as they are to
thickened, cartilaginous forms, are incompatible with
this tranquillity and lend the face a serious touch, in
the orbital zone, even a forbidding expression. The
framing of the eyes and a narrow slit between the lips
have been incised in fine scratches and crisply con-
toured. At first formulated as narrow ridges, the brows
thicken to an ornamental band towards the bridge
of the nose; the action of the brows continues on into
the forehead (cat. no. 18b).

This smoothness contrasts with the rendering
of the hair. The crown has been emphasised by hav-
ing some locks radiate out from it. In other respects,
the strands of hair combed forwards into the fore-
head have been handled in a formulaic, linear man-
ner so they almost make the impression of a cap
of hair articulated on the surface in individual locks
that lie flat. In fact the hair has been arranged in
rows that are juxtaposed without any interconnection;
the aim was not to reproduce organically growing
hair. Strands of this type are not limited in Messer-
schmidt's work to the Character Heads; they also
occur on the bust of Mesmer (figs. 10, 21), the wig worn
by Joseph II (fig. 8) and can be observed in the ren-
dering of the hair in the statue of Maria Theresia.
Other sculptors, including Karl Georg Merville (1745–
1798), use them [2] although in Messerschmidt the
strands have been more succinctly handled and are
less detailed.

186

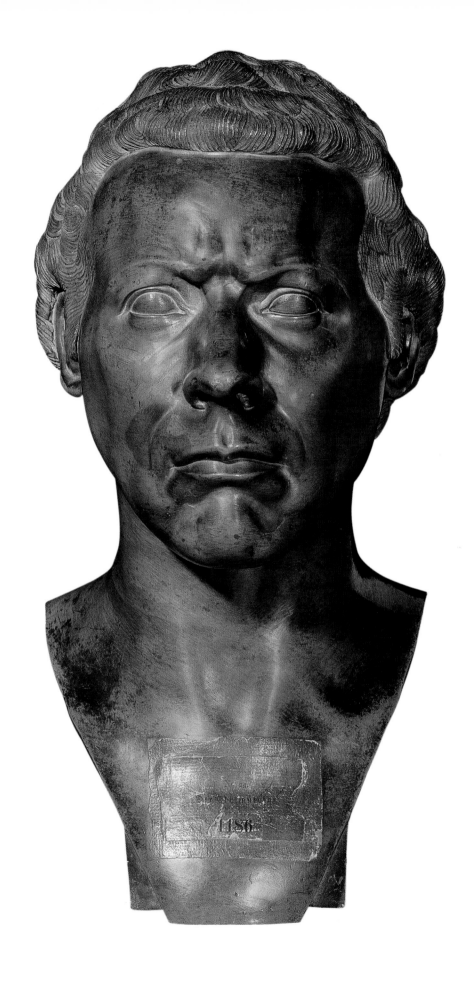

[18a]

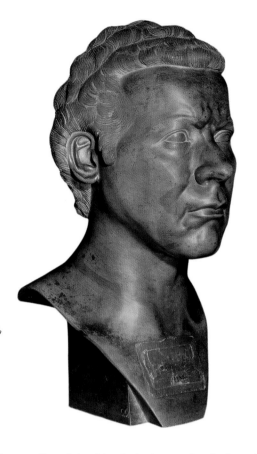

Kat.-Nr. 18b / *Cat. no. 18b*
Franz Xaver Messer-
schmidt, Der Edel-
müthige, Seitenansicht
Franz Xaver Messer-
schmidt, The Noble-
Minded Man, side view

65 Franz Xaver Messer-
schmidt, Der Feldherr,
Original nach 1770,
Gipsabguss, Österreichische
Galerie Belvedere,
Wien, Inv.-Nr. 5697
Franz Xaver Messer-
schmidt, The General,
original after 1770,
plaster cast, Österreichische
Galerie Belvedere,
Vienna, Inv. no. 5697

Eindruck einer Haarkappe, die auf der Oberfläche in einzelne flach liegende Locken strukturiert ist. Tatsächlich liegen die in Reihen angeordneten Haare unverbunden nebeneinander; organisch wachsendes Haar wiederzugeben ist nicht angestrebt. Diese Strähnen sind keine Spezialität der Charakterköpfe, sondern gleichfalls bei der Büste Mesmers (Abb. 10, 21), bei der Perücke Josephs II. (Abb. 8) oder der Haargestaltung der Statue Maria Theresias zu beobachten. Auch andere Bildhauer, wie Karl Georg Merville (1745–1798), nutzen sie,[2] allerdings erfolgen die Strähnungen hier summarischer und weniger kleinteilig.

»Der Edelmüthige« gehört zu einer Reihe von Köpfen, die denselben Kopftypus, dieselbe, nur leicht variierte Frisur und dieselbe Gestaltung der Haare durch feine Strähnungen vorweisen. Zusammen mit »Der Feldherr« (Abb. 65) könnte er am Beginn dieser Reihe stehen und einen Typus verkörpern, der in weiteren Büsten zum Teil starken Grimassen unterworfen wird: »Der Nieser« (Abb. 66), »Der Satirikus« (Kat.-Nr. 20) und »Der kindisch Weinende« (Kat.-Nr. 19).[3]

Kris vermutet in »Der Edelmüthige« ebenso wie in »Ein Gelehrter, Dichter« (Abb. 49, 53), »Der Zuverlässige«, »Der Feldherr«, »Der Melancholikus« (Kat.-Nr. 8) und in »Des Künstlers ernste Bildung« (Abb. 33) Selbstporträts, die zugleich vom Typus römischer Bildnisbüsten in der spätrepublikanischen oder der frühen Kaiserzeit angeregt sind.[4] Allerdings lassen sich unter den von Kris

"The Noble-Minded Man" belongs to a group of Heads, all of which reveal the same type of head, the same hair style, albeit slightly varied, and the same handling of the hair in fine strands. Together with "The General" (fig. 65), "The Noble-Minded Man" could be placed at the beginning of this series as embodying a type which in other busts is subjected to grimaces, some of them very pronounced indeed: "The Sneezer" (fig. 66), "The Satirist" (cat. no. 20) and "Childish Weeping" (cat. no. 19).[3]

Kris suspects that "The Noble-Minded Man" as well as "A Scholar, Poet" (figs. 49, 53), "The Reliable Man", "The General", "The Melancholic" (cat. no. 8) and "The Artist's Serious Countenance" (fig. 33) are all self-portraits, which at the same time have been inspired by Roman portraits of the late Republic or the early Empire.[4] However, only generalising physiognomic comparisons of the Heads mentioned by Kris in this connection can be drawn, which do not support the use of the same head – Messerschmidt's – as the model. Should the bust of the Artist Laughing (cat. no. 4) actually reproduce the sculptor's countenance, the only correspondence in feature between it and the Noble-Minded Man occurs in the

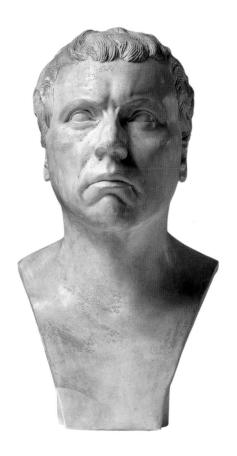
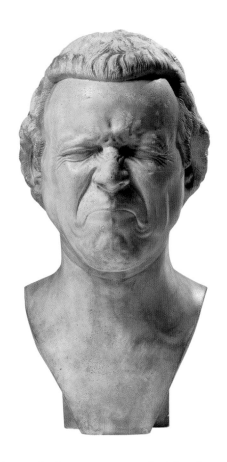

66 Franz Xaver Messer-
schmidt, Der Nieser,
Original nach 1770,
Gipsabguss, Österreichi-
sche Galerie Belvedere,
Wien, Inv.-Nr. 5683
*Franz Xaver Messer-
schmidt, The Sneezer,
original after 1770,
plaster cast, Österrei-
chische Galerie Belvedere,
Vienna, Inv. no. 5683*

genannten Köpfen nur allgemeine physiognomische Vergleiche zie-
hen, die die Benutzung desselben – nämlich Messerschmidts – Kop-
fes nicht stützen. Sollte die lachende Büste (Kat.-Nr. 4) tatsächlich
die Physiognomie des Bildhauers wiedergeben, zeigt allein die Nase
dieselbe kräftige Form wie die des Edelmüthigen. Alle anderen
physiognomischen Merkmale – die spezifischen Formen der Augen,
der Brauen, des Mundes, des Kinns – lassen sich wegen der ausge-
prägten Mimik des einen und wegen der völlig unterschiedlich
gestalteten Brauen beider Gesichter nicht miteinander vergleichen.

1 Oberhaidacher 1984, S. 40.
2 Siehe beispielsweise Mervilles Büste des jugendlichen Erzherzogs Franz,
 des späteren Franz II. (1778–1780), Österreichische Galerie Belvedere,
 Wien, Inv.-Nr. 7661, Abb. in: Ronzoni 2004, S. 4.
3 So auch Kris 1932, S. 204–205; Kris (S. 204) zufolge liefert der Edel-
 müthige »mit perückenartig anliegendem Haar […] die Grundform
 für den als ›Satirikus‹ bezeichneten und völlig verzerrten Kopf.« Ebenso
 Pötzl-Malíková 1982, S. 72.
4 Siehe Kris 1932, S. 203.

Literatur

Anonymus 1794, S. 54 (Nro. 22); Kris 1932, S. 203, Abb. 184; Baum 1980,
S. 393; Glandien 1981, S. 50, Abb. 14; Pötzl-Malíková 1982, S. 72, 252–
253; Behr/Grohman/Hagedorn 1983, S. 71; Oberhaidacher 1984, S. 40–
42, S. 38 (Abb. 43); Krapf, Katalog 2002, S. 212–213; Pötzl-Malíková
2004, Abb. S. 93; Schmid 2004, S. 23, 33; Pfarr 2006, Abb. 58.

nose, which has the same powerful shape as that of
the Noble-Minded Man. The emphatic rendering
of the facial expression in the one case and the entirely
different handling of the eyebrows in the two busts
make it impossible to compare all the other facial
features – the forms specific to the eyes, brows, mouth
and chin.

1 Oberhaidacher 1984, p. 40.
2 See for example Merville's bust (1778–1780) of the youth-
 ful Archduke Francis, later Francis II, Österreichische
 Galerie Belvedere, Vienna, Inv. no. 7661; pictured in:
 Ronzoni 2004, p. 4.
3 Thus also Kris 1932, pp. 204f.; according to Kris (p. 204),
 the Noble-Minded Man "with his wig-like close hair […]
 provided the basic form for the entirely contorted head
 called 'The Satirist'." Similarly Pötzl-Malíková 1982, p. 72.
4 See Kris 1932, p. 203.

References

Anon. 1794, p. 54 (no. 22); Kris 1932, p. 203, fig. 184;
Baum 1980, p. 393; Glandien 1981, p. 50, fig. 14; Pötzl-
Malíková 1982, pp. 72, 252f.; Behr/Grohman/Hagedorn
1983, p. 71; Oberhaidacher 1984, pp. 40ff, 38 (fig. 43);
Krapf, Katalog 2002, pp. 212f.; Pötzl-Malíková 2004,
illus. p. 93; Schmid 2004, pp. 23, 33; Pfarr 2006, fig. 58.

189

Zinn-Blei-Legierung
Höhe 45 cm
nach 1770
Szépmüvészeti
Múzeum
Budapest
Inv.-Nr. 51.936

Tin-lead alloy
height 45 cm
after 1770
Szépmüvészeti
Múzeum
Budapest
Inv. no. 51.936

[19]

Der kindisch Weinende

Einer der bekanntesten Köpfe aus der Serie der Charakterköpfe ist derjenige, den der Anonymus »Der kindisch Weinende« (Kat.-Nr. 19a) taufte. Er ist auf einem nahezu quadratischen Kubus und einem ruhig gestalteten Brustausschnitt aufgesockelt. Das Gesicht ist in einer heftigen Grimasse verzogen. Seine Augen sind weit geöffnet, die blanken Augäpfel (Kat.-Nr. 19b) von dem wie aus einer Scheibe ausgeschnittenen und sich nach oben wölbenden Oberlid und dem Unterlid, geformt als ein schmaler Grat, gerahmt. Die Wölbung des Oberlids findet sich wieder in den hoch gewölbten, allerdings kaum ausgeprägten Brauen, wodurch abnorm hohe Orbitalwülste entstehen, die leicht aufgebläht sind. Diese Wölbungen der Oberlider und der Brauen werden von rillenartig vertieften und ornamental erhabenen Stirnfalten ein weiteres Mal wiederholt, so dass ein Dreiklang gleichartiger Wölbungen von Oberlid, Brauen und Falten entsteht. Unter den Augen fallen geblähte Tränensäcke auf, von zwei eingetieften Falten begrenzt, die sich bis zu den Nasenflügeln ziehen. Insgesamt entsteht ein maskenhafter, clownesker Ausdruck, wie ihn die Gestalt des Pulcinella aus der Commedia dell'Arte vor Augen führt.[1] Noch formelhafter in seiner Maskenhaftigkeit gestaltet ist ein weiterer, mit dem kindisch Weinenden vergleichbarer Charakterkopf Messerschmidts, »Der Schaafkopf« (Abb. 64).

Childish Weeping

One of the best-known Character Heads is the one that Anonymous calls "Childish Weeping" (cat. no. 19a). The base it is on is almost square and the head rests on a restfully configured breast section. The face is contorted in a fierce grimace. His eyes are wide open, the blank eyeballs (cat. no. 19b), are framed as if cut from a disc by the upper lid, that bulges upwards and the lower lid, formed as a narrow ridge. The bulge of the upper lid is repeated in the high arched brows, which are, however, hardly plastic so that the abnormally high orbital ridges which are created are slightly distended. The bulges of the upper lids and the brows are again echoed in the forehead wrinkles, which alternate between groove-like depressions and ornamentally raised areas. Thus a triple accord of similarly configured bulges is created in the upper lid, the brows and the forehead wrinkles. Beneath the eyes distended lachrymal sacs stand out; they are delimited by two depressed wrinkles, which extend to the wings of the nose. The overall impression thus created is mask-like, clownish even, as represented in the Commedia dell'Arte figure Pulcinella.[1] The formulaic handling that has produced such a mask-like quality goes even further in another Messerschmidt Head that can be compared to "Childish Weeping": "The Simpleton" (fig. 64).

The ornamentally worked part of the eyes and brow contrasts with the sculptural treatment of the mouth, with lips open and slightly pouting to reveal a few of the teeth in the upper jaw. The handling of the hair is linear (cat. no. 19c–e). The hair style looks like a cap set on the head. It is articulated in individual, bulging "patches", which consist in turn of several strands that are finely grooved within the contours. Tousled, the strands do not add up to an organic mass of hair. As with other Heads, Messerschmidt is demonstrating his versatility in his deployment of his sculptural vocabulary on "Childish Weeping": sculptural, linear and ornamental forms alternate to lend the head a fraught appearance, quite apart from the grimace itself.

"Childish Weeping" is similar in several respects to "The Noble-Minded Man" (cat. no. 18): on the one hand, the bust form in both is identical because the

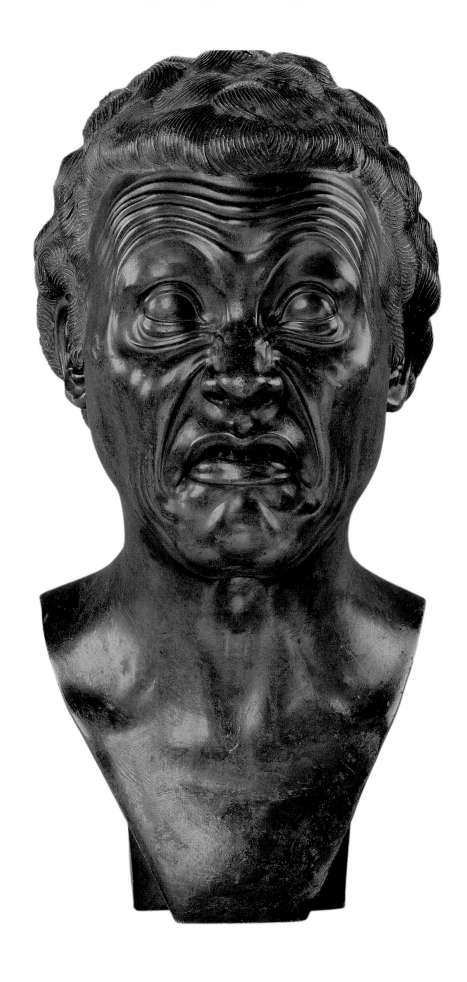

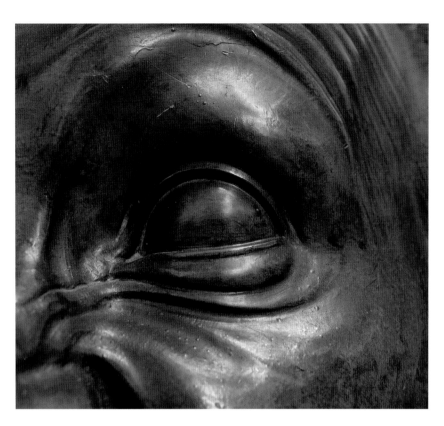

Der ornamental gearbeiteten Augen-Stirn-Partie steht der plastisch aufgefasste Mund gegenüber, dessen aufgeworfene und leicht nach vorn geschobene Lippen einige Zähne der oberen Zahnreihe entblößen. Graphisch sind die Haare angelegt (Kat.-Nr. 19c−e). Die Frisur mutet wie eine Kappe an, die dem Kopf aufgesetzt wurde. Sie ist in einzelne, sich wölbende »Placken« aufgeteilt, die wiederum jeweils aus mehreren Strähnen bestehen, die in sich nochmals fein gerillt sind. Sie sind unvermittelt auf- und nebeneinander gesetzt, bilden somit keine organische Haarmasse. Wie in anderen Köpfen entfaltet Messerschmidt beim Weinenden sein bildhauerisches Vokabular: Plastische, graphische und ornamentale Formen wechseln sich ab und verleihen dem Kopf zusätzlich zu der Grimasse ein spannungsvolles Aussehen.

Deutliche Bezüge zeigt »Der kindisch Weinende« zu »Der Edelmüthige« (Kat.-Nr. 18): So gleichen sich zum einen die Büstenformen durch Verwendung des Prototyps der Charakterköpfe. Zudem tragen sie eine überaus ähnliche »Haarkappe«, deren einzelne Partien zwar unterschiedlich liegen, aber dieselbe kurzgelockte, gesträhnte Struktur zeigen. Auch die Haare von »Der Satirikus« (Kat.-Nr. 20) und der Gipsabgüsse von »Der Nieser« (Abb. 66) und »Der Feldherr« (Abb. 65)[2] haben denselben kappenartigen Charakter, wobei bei

Character Head prototype has been used. In addition, they sport a very similar "cap of hair", with identical, short curly strands, even though they are arranged differently. The hair in "The Satirist" (cat. no. 20), the plaster casts of "The Sneezer" (fig. 66) and "The General" (fig. 65)[2] all reveal the same, cap-like character although in the last-named the hair looks natural because of the way the locks fall naturally over the forehead and to the sides. In both "Childish Weeping" and "The General", the ears are exposed, framed by wavy locks and long mutton- chop whiskers.

The action of the mouth has occasionally been compared to Le Brun's "Despair" (fig. 67) and Parsons' "Envy" and "Rage".[3] Nevertheless, there are striking differences between "Childish Weeping" and Le Brun's representation: the action of the mouth in the Messerschmidt Head, expressive as it is, is noticeably more reticent. This action in fact is more reminiscent of weeping or whimpering; it can, therefore, be just as convincingly linked with Le Brun's "Weeper" (fig. 68) even though the teeth of that weeping figure are not

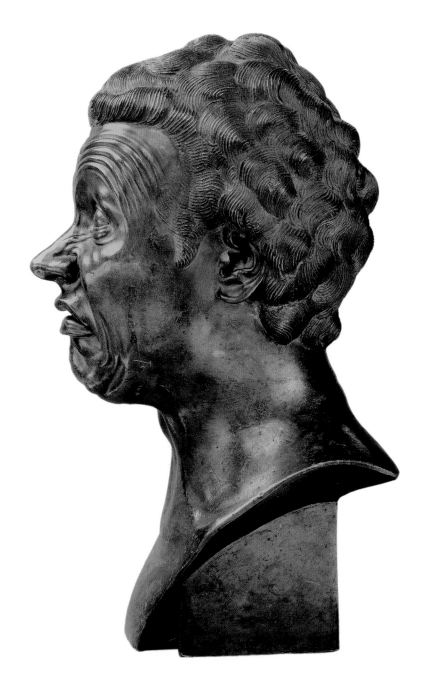

Kat.-Nr. 19 c / *Cat. no. 19 c*
Franz Xaver Messer-
schmidt, Der kindisch
Weinende, Seitenansicht
Franz Xaver Messer-
schmidt, Childish Weeping,
side view

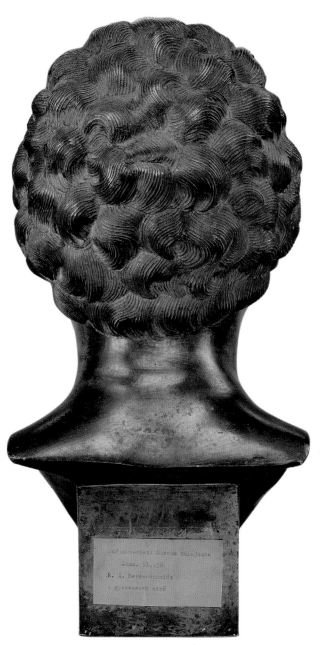

Kat.-Nr. 19 d / *Cat. no. 19 d*
Franz Xaver Messer-
schmidt, Der kindisch
Weinende, Rückansicht
Franz Xaver Messer-
schmidt, Childish Weeping,
rear view

193

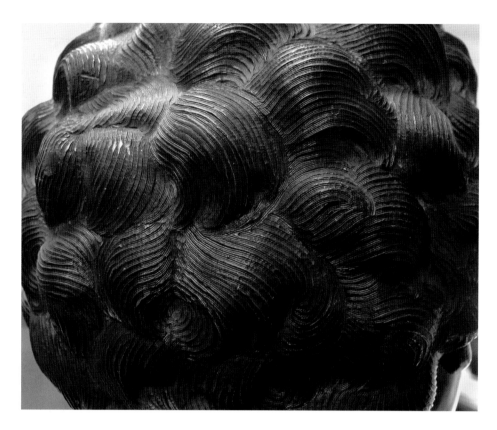

Kat.-Nr. 19e / *Cat. no. 19e*
Franz Xaver Messer-
schmidt, Der kindisch
Weinende, Detail
Franz Xaver Messerschmidt,
Childish Weeping, detail

67 Charles Le Brun,
Le Désespoir,
um 1668, schwarze
Kreide, Feder in
Schwarz, auf weiß-
gelbem Papier,
Musée du Louvre,
Paris, Inv.-Nr. 28312
Charles Le Brun,
Despair, c. 1668,
black chalk and ink,
on cream paper,
Musée du Louvre,
Paris, Inv. no. 28312

Letzterem die Haare über der Stirn und an den Seiten den Anschein natürlich fallenden Haars machen. Auch bleiben in beiden Fällen die Ohren, gerahmt von buckligen Locken und tief reichenden Kote-letten, frei.

Die Mundbewegung wird gelegentlich mit Le Bruns »Le Désespoir« (Abb. 67) und Parsons »Envy« beziehungsweise »Rage« verglichen.[3] Unterschiede zu Le Bruns Darstellung fallen gleich-wohl auf, denn die Mundbewegung bei Messerschmidts Kopf ist doch trotz aller Expressivität deutlich zurückgenommen. Diese Bewegung erinnert am ehesten an ein Weinen oder Greinen; insofern könnte man ebenso Verbindungen zu Le Bruns »Pleurer« (Abb. 68) herstellen, auch wenn dort die Zähne nicht entblößt werden. Die obere Gesichtshälfte findet sich in keiner der zitierten Gefühlsdarstellungen.

displayed. The upper half of the Messerschmidt figure's face does not occur in any of the representations of emotions cited.

1 See for instance the group of porcelain Commedia dell' Arte figurines "Harlequin, Pantaloon and Pulcinella Playing Cards", c. 1750, Neapolitan workshop, in: Caròla-Perrotti 2001, p. 259.
2 On the close correspondences between the heads, see also Pötzl-Malíková 1982, p. 72; she also adds "Quiet Peaceful Sleep" (cat. no. 9) to this group; Schmid 2004, p. 23.
3 Thus Pfarr 2006, p. 44.

References

Anon. 1794, pp. 50f. (no. 16); Kris 1932, p. 214, fig. 223; Kris 1933, fig. 25; Pötzl-Malíková 1982, pp. 72, 250; Behr / Grohmann / Hagedorn 1983, pp. 78f.; Oberhaidacher 1984, pp. 26, 34, 41, fig. 25; Krauss 1986, fig. 49 (p. 117); Bücherl 1989, pp. 58, 61; Hàmori 1992, p. 238, fig. 4 (p. 237); Hàmori 1994, p. 23, fig. 21; Ronzoni 1997, p. 42; exhib. cat. Louise Bourgeois 1998, n. p.; Bückling 1999b, p. 119; Krapf, Katalog 2002, pp. 200f.; Pötzl-Malíková 2004, illus. p. 86; Schmid 2004, pp. 23, 27; Pfarr 2006, pp. 44, 377.

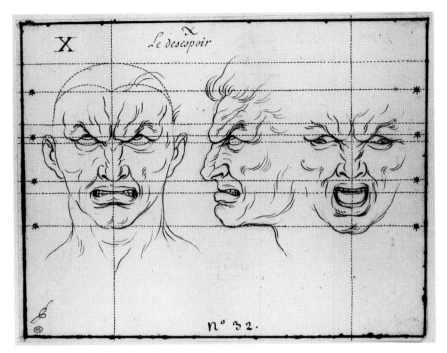

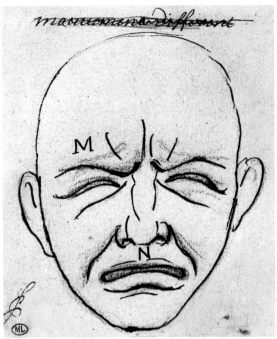

1 Siehe beispielsweise die Porzellangruppe »Harlekin, Pantalon und Pulci-
 nella beim Kartenspiel«, um 1750, neapolitanische Werkstatt, in: Caròla-
 Perrotti 2001, S. 259.
2 Zur Nähe zwischen den Köpfen siehe auch Pötzl-Malíková 1982, S. 72, die
 der Gruppe zudem noch »Der sanfte ruhige Schlaf« (Kat.-Nr. 9) hinzufügt;
 Schmid 2004, S. 23.
3 So Pfarr 2006, S. 44.

Literatur

Anonymus 1794, S. 50–51 (Nro. 16); Kris 1932, S. 214, Abb. 223; Kris
1933, Abb. 25; Pötzl-Malíková 1982, S. 72, 250; Behr/Grohmann/Hage-
dorn 1983, S. 78–79; Oberhaidacher 1984, S. 26, 34, 41, Abb. 25; Krauß
1986, Abb. 49 (S. 117); Bücherl 1989, S. 58, 61; Hàmori 1992, S. 238,
Abb. 4 (S. 237); Hàmori 1994, S. 23, Abb. 21; Ronzoni 1997, S. 42; Ausst.-
Kat. Louise Bourgeois 1998, o. S.; Bückling 1999b, S. 119; Krapf, Katalog
2002, S. 200–201; Pötzl-Malíková 2004, Abb. S. 86; Schmid 2004,
S. 23, 27; Pfarr 2006, S. 44, 377.

Blei, Höhe 44 cm
nach 1770
Germanisches
Nationalmuseum
Nürnberg
Inv.-Nr. Pl. O. 2540

Lead, height 44 cm
after 1770
Germanisches
Nationalmuseum
Nuremberg
Inv. no. Pl. O. 2540

[20]

Der Satirikus

»Der Satirikus« (Kat.-Nr. 20a–b) zeigt einen Mann mit kurz gewelltem Haar auf dem für die Charakterköpfe typischen Büstenausschnitt. Er rümpft seine spitze Nase und presst die Lippen skeptisch zu einem schmalen, leicht geschwungenen Strich zusammen. Die deutlich konturierten Nasolabialfalten, am unteren Ende wie eine Haarnadel gebogen, verbinden die Nasenflügel und die herabgezogenen Mundwinkel. Zugleich ist die Stirn in tiefe, rillenartige Falten gelegt, die die Form der hochgezogenen Brauen wiederholen. Mit diesen nach oben gewölbten Formen korrespondieren unter den Augen einige wenige geblähte und scheibenhafte Falten, die von der gerümpften Nase ausgehen, dem Bogen des Unterlids folgen und auf Höhe der Augenwinkel enden.

Die Begrenzung der Frisur zur Stirn wiederholt durch die Geheimratsecken die wellenartige Form der Stirnfalten (Kat.-Nr. 20c–e). An den Seiten des Kopfes bricht die Frisur in einem spitzen Winkel um und entwickelt sich zu tief reichenden Koteletten. Kurze Strähnen sind nach oben und zurück gekämmt, so dass die Frisur durch eine klare Konturlinie von der Stirn abgesetzt ist. Es entsteht dadurch der Eindruck einer aufgesetzten Kappe oder Perücke. Die Locken sind sichelförmig gebogen und bilden einzelne »Placken«, die in sich nochmals in feinere Strähnen und Strähnchen aufgeteilt und unvermittelt nebeneinander gesetzt sind. Das Haupthaar vermittelt somit nicht den Eindruck einer nachvollziehbaren Frisur. Zudem bilden die metallisch harten Strähnen keine weiche Haarmaterialität ab; es dominiert eine graphisch harte Gestaltung. Wie bei »Der Edelmüthige« (Kat.-Nr. 18) und »Der kindisch Weinende« (Kat.-Nr. 19) bleiben auch hier die Ohren frei, was Messerschmidt die Möglichkeit gibt, in bewährter Form wohlgeformte Ohren zu gestalten.

196

The Satirist

"The Satirist" (cat. no. 20a–b) depicts a man with short, wavy hair above the bust section typical of the Character Heads. He is wrinkling his pointed nose and sceptically compressing his lips to a narrow, slightly curved line. Prominently contoured nasolabial folds, bent like a hairpin at the lower end, link the wings of the nose and the drooping corners of the mouth. The forehead is set in deep, groove-like wrinkles, which repeat the form of the raised brows. A few distended, disc-like wrinkles below the eyes correspond with those forms that bulge upwards from the wrinkled nose, following the arc of the lower lid to end on a level with the corners of the eyes.

In the way the hair recedes at the temples, the boundary between the hair and the forehead echoes the wavy form of the forehead wrinkles (cat. nos. 20c–e). At the sides of the head, the hair style bends at an acute angle and develops into whiskers that extend far down the face. Short strands are combed up and back so that the hair style is demarcated from the forehead by a clear contour line. This creates the impression of a cap or a wig set on the head. The locks are crescent-shaped and form individual "patches", which are articulated in quite fine and very fine strands and juxtaposed without any linkage. The hair thus conveys the impression of being dressed in a particular, recognisable style. Moreover, the metallic, hard strands do not represent hair as a soft physical substance; the dominant feature is harsh linear handling. As in "The Noble-Minded Man" (cat. no. 18) and "Childish Weeping" (cat. no. 19), the ears are exposed in "The Satirist", which enabled Messerschmidt to render them in the tried and tested form as pleasingly shaped.

Viewed separately, the upper and lower halves of the face do look highly unusual in the exaggerated play of feature. Taken as a whole, however, the face makes a confusing impression because the different aspects of grimacing entailed in the facial action as shown can only with difficulty be carried out all at once. The impression created is that of a man whose eyes are wide open and his forehead furrowed and who seems to be alternately amused and startled.

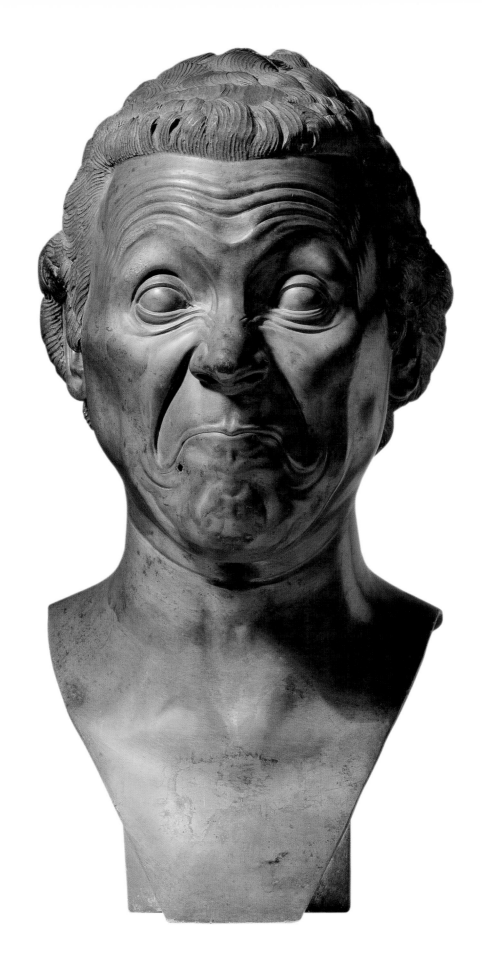

[20a]

Für sich genommen wirken die obere und die untere Gesichtshälfte zwar ungewöhnlich in ihrer übertriebenen Ausprägung des Mienenspiels, gemeinsam aber erwecken sie einen verwirrenden Eindruck, da die unterschiedlichen Grimassen nur mit Mühe gleichzeitig durchzuführen sind. Es entsteht der Eindruck eines erstaunt die Augen aufreißenden, die Stirn runzelnden Mannes, der scheinbar abwechselnd amüsiert und erschrocken ist.

Zusammen mit »Der Nieser« (Abb. 66), »Der Feldherr« (Abb. 65) und »Der Edelmüthige« (Kat.-Nr. 18) gehören »Der Satirikus« und »Der kindisch Weinende« (Kat.-Nr. 19) zu einer Gruppe innerhalb der Reihe der Charakterköpfe, die nicht nur den gleichen Kopftypus aufweist, sondern auch die gleiche Frisur und, soweit erkennbar, die gleiche Physiognomie bei unterschiedlichen Grimassen. Die Frisur in ihrer graphischen Gestaltung, vor allem aber die wellenförmig gestalteten Stirnfalten, die weit geöffneten Augen, die gerümpfte Nase und die sich von den Tränensäcken auf die Nasenflügel ziehenden Falten sind beim Satirikus und beim kindisch Weinenden nahezu identisch.[1] So sehr sich die Köpfe des Satirikus

Along with "The Sneezer" (fig. 66), "The General" (fig. 65) and "The Noble-Minded Man" (cat. no. 18), "The Satirist" and "Childish Weeping" (cat. no. 19) belong to a group within the set of Character Heads which not only have the same head type but also the same hair style, and, as far as it can be recognised, the same countenance grimacing in different ways. In the Satirist and "Childish Weeping", the linear handling of the hair style is virtually identical and perhaps even more strikingly so in the wavy rendering of the forehead wrinkles, the wide open eyes, the wrinkled nose and the wrinkles running from the lachrymal sacs to the wings of the nose.[1] Although the heads of the Satirist and "Childish Weeping" resemble each other so closely in head form and in the forehead and orbital zone, they differ greatly in the handling of the mouth zone. Whereas the Satirist is pinching his lips together to a narrow line, the corners of the Childish Weeper's

Kat.-Nr. 20b / *Cat. no. 20b*
Franz Xaver Messerschmidt, Der Satirikus, Detail
Franz Xaver Messerschmidt, The Satirist, detail

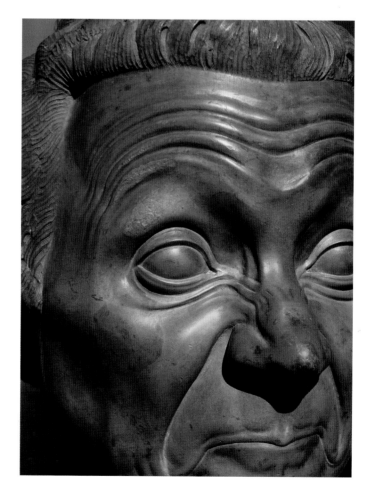

198

und des Weinenden auch in der Kopfform und im Stirn-Augen-Bereich gleichen, so sehr unterscheiden sie sich in der Gestaltung der Mundpartie. Während der Satirikus die Lippen zu einem schmalen Strich zusammenkneift, zieht der kindisch Weinende die Mundwinkel nach unten, stülpt die Unterlippe ein wenig vor und zieht die Oberlippe nach oben, so dass zwischen den Lippen Zähne zu sehen sind. Messerschmidt wählte einen gemeinsamen Kopftypus, behielt sogar einen Teil der Grimassen bei, um durch die allerdings gravierende Abänderung nur eines Details, hier des Mundes, die unterschiedlichen Möglichkeiten des Mienenspiels zu untersuchen.

Die Büsten von »Der Satirikus« und »Der kindisch Weinende« demonstrieren nicht nur die Zusammenfügung von Grimassen, die die anatomischen Möglichkeiten von Gesichtsmuskeln nahezu sprengen; sie machen auch einmal mehr deutlich, dass die Wiedergabe von realistischer Körperlichkeit nicht angestrebt ist. Aufgrund der kappenartigen Frisur, der waschbrettartigen Stirnfalten, der scharfkantigen Einfassung der Augen, die glatt und wie aufgebläht wirken, und auch aufgrund der von vorne sichtbaren, die Büste stützenden Kuben ist pulsierende Lebendigkeit nicht assoziierbar. Dennoch scheinen es starke Kräfte zu sein, die auf die Köpfe einwirken: Sie machen das Wechselbad der Gefühle deutlich, das den Gesichtsausdruck formt, ihm Lebendigkeit, Bewegtheit, aber auch Starrheit verleiht.

mouth are drooping, with the lower lip slightly protruding and the upper lip drawn up so that teeth are visible between the lips. Messerschmidt chose the same head type for both, even retaining part of the overall grimace, but probed the different possibilities of the play of feature by changing a detail, here of the mouth, which has had serious repercussions for the overall effect created.

"The Satirist" and "Childish Weeping" demonstrate not just the fitting together of elements of an overall grimace in a way that almost overtaxes the anatomical reality of the facial muscles. Further, this once again goes to show that the reproduction of physical realism was not the aim. The cap-like hair, the washboard forehead wrinkles, the crisply angular setting of the eyes, which look both smooth and distended, and even the circumstance that the block supporting the busts is visible in frontal view all contravene associations of throbbing life. Nonetheless, the forces that deform the heads seem powerful: they show the rapid alternation of feelings which forms the facial expression, lending it liveliness and animation but also rigidity.

Kat.-Nr. 20e / *Cat. no 20e*
Franz Xaver Messer-
schmidt, Der Satirikus,
Seitenansicht
*Franz Xaver Messer-
schmidt, The Satirist,
side view*

Kat.-Nr. 20d / *Cat. no. 20d*
Franz Xaver Messer-
schmidt, Der Satirikus,
Rückansicht
*Franz Xaver Messer-
schmidt, The Satirist,
rear view*

1 Pfarr (2006, S. 377) überlegt, ob Messerschmidt für die oberen Gesichts-
 hälften von »Der kindisch Weinende« und »Der Satirikus« dasselbe
 Gussmodell verwandte. Dies scheint angesichts der in Details deutlich
 unterschiedlich formulierten Augenpartien nicht der Fall zu sein.

Literatur
 Anonymus 1794, S. 56 (Nro. 26); Kris 1932, S. 204, 206, Abb. 188 – 189;
 Kris 1933, S. 393, Abb. 8; Biedermann 1978, S. 29; Glandien 1981,
 S. 51, Abb. 37; Pötzl-Malíková 1982, S. 72, 254 – 255; Presler 1996, S. 81;
 Bückling 1999b, S. 118; Krapf, Katalog 2002, S. 226 – 227; Pötzl-Malíková
 2004, Abb. S. 97; Schmid 2004, S. 23, 37; Kammel 2004, S. 139 – 143;
 Maué 2005, S. 254 – 260; Pfarr 2006, S. 377, Abb. 140 – 141.

1 Pfarr (2006, p. 377) wonders whether Messerschmidt may
 not have used the same plaster model for the upper half
 of the face in "Childish Weeping" and "The Satirist".
 However, this does not seem to have been the case in view
 of the noticeably different handling of the orbital zones.

References
 Anon. 1794, p. 56 (no. 26); Kris 1932, pp. 204, 206, figs. 188,
 189; Kris 1933, p. 393, fig. 8; Biedermann 1978, p. 29;
 Glandien 1981, p. 51, fig. 37; Pötzl-Malíková 1982, pp. 72,
 254f.; Presler 1996, p. 81; Bückling 1999b, p. 118; Krapf,
 Katalog 2002, pp. 226f.; Pötzl-Malíková 2004, illus. p. 97;
 Schmid 2004, pp. 23, 37; Kammel 2004, pp. 139 – 143;
 Maué 2005, pp. 254 – 260; Pfarr 2006, p. 377, figs. 140, 141.

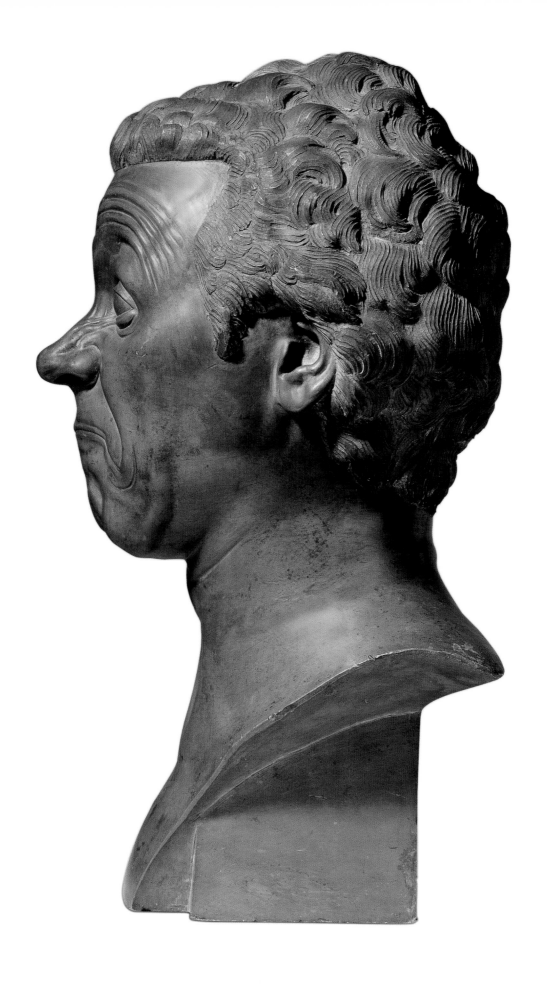

Blei-Zinn-Legierung
Höhe 43,5 cm
nach 1770
Österreichische
Galerie Belvedere
Wien
Inv.-Nr. 1776

Pewter, height 43.5 cm
after 1770
Österreichische
Galerie Belvedere
Vienna
Inv. no. 1776

[21]

Ein düstrer finsterer Mann

Die stark verzerrte Büste trägt den Titel »Ein düstrer finsterer Mann« (Kat.-Nr. 21a). Auf dem typischen, schmalen Büstenausschnitt ist der Kopf frontal ausgerichtet. Zwei deutlich ausgeprägte Sehnen ziehen sich vom Brustbein bis zum Kinn und rahmen den oval vorspringenden Adamsapfel. Über dem Hals erhebt sich der Kopf, der durch die zusammengekniffenen Augen, die Verformungen der Nasenwurzel und der Stirn, durch Erhebungen und Vertiefungen, durch eingekerbte Krähenfüße, die gerümpfte, lange Nase, die fest zusammengepressten Lippen, die mehrfachen Wölbungen zwischen Unterlippe und Kinn und unnatürlich tief eingekerbten Falten zu Seiten von vorgewölbten Bäckchen zu einer expressiven Grimasse, dem Zerrbild eines Gesichts, entstellt ist.

Der Mund, dessen Oberlippe in der Mitte eine kleine, nach unten gerichtete Dreieckform aufweist und dessen Winkel nach unten gezogen sind, ist fest zusammengepresst. Die abwärts gerichtete Bewegung wird zunächst von Falten unterstrichen, die dann aber in einer Haarnadelbiegung zu den Nasolabialfalten führen, die tief in die Wangen einschneiden und diese geradezu zur Seite zu schieben scheinen. Dadurch wölben sie sich zu prallen Bäckchen, in die grobe Falten seitlich des Mundes und etwas feinere Krähenfüße eingetragen sind und den plastischen Charakter der Wangen wieder zurücknehmen.

Bereits der Ausdruck der Mundpartie mit ihren Falten ist ungewöhnlich; er erfährt noch eine Steigerung in der oberen Gesichtshälfte. Von der gerümpften Nase ziehen sich einige kurze, aber tiefe Falten zu den fest geschlossenen Augen hin. Über einem nur als schmaler Streifen wiedergegebenen Unterlid folgt das orna-

A Dismal and Sinister Man

This greatly contorted bust bears the title "A Dismal and Sinister Man" (cat. no. 21a). The head is frontal on the typical, narrow section of bust. Two pronounced sinews run from the collar bone to the chin, framing the prominent ovoid Adam's apple. Above the neck, the head displays the following facial actions that add up to an expressive grimace, a caricature of a face: the eyes squint, the bridge of the nose is deformed as is the forehead by raised areas alternating with depressions, crow's feet have been notched in, the nose is long and wrinkled, the lips are pressed firmly together, there are several bulges between the lower lip and the chin and the wrinkles beside the bulging cheeks have been notched more deeply than would be natural.

The mouth, with a small, triangular form tapering to the bottom on the upper lip and drooping corners, is firmly shut. The downward action is first underscored by wrinkles, which then lead in a hairpin bend to the nasolabial folds, which, in turn, cut so deeply into the cheeks that they seem to thrust them aside. This makes the cheeks puff up, with coarse wrinkles incised to the side of the mouth and somewhat finer crow's feet, which reduce the sculptural character of the cheeks.

The expression of the mouth area, with its wrinkles, is unusual. The unusual quality is enhanced in the upper half of the face. A few short but deep wrinkles run from the wrinkled nose to the almost closed eyes. Above a lower lid that is rendered as a narrow stripe is an ornamentally deformed upper lid. It is pulled downwards by a band and upwards by a notch, and ultimately demarcated by a ridge. The upper lid area itself bulges strongly and its form has no relationship to the eyeball beneath. The upper ridge ends at the outer corners of the eyes in the crow's feet that begin at the upper lid and, in the lower part, continue in wrinkles formed below the eyes at the outer corners. Towards the bridge of the nose, the ridge running over each upper lid is deformed into a cartilaginous mass demarcated by small notches, with outliers extending as far as the forehead. In addition, a strand of muscle or a deformed frontal bone extends from the cartilaginous

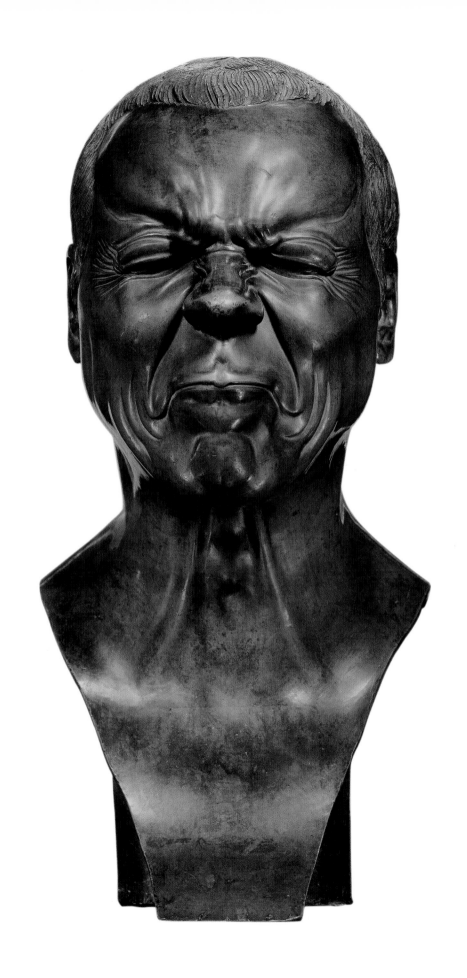

[21a]

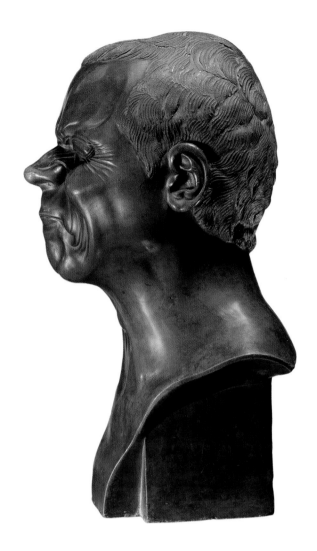

Kat.-Nr. 21b / *Cat. no. 21b*
Franz Xaver Messer-
schmidt, Ein düstrer
finsterer Mann,
Seitenansicht
Franz Xaver Messer-
schmidt, A Dismal and
Sinister Man, side view

mental verformte Oberlid. Es wird nach unten durch einen Steg, nach oben durch eine Kerbe, gefolgt von einem Grat abgegrenzt. Die Oberlidpartie selbst wölbt sich hoch und hat in ihrer Form keinerlei Bezug zum darunter liegenden Augapfel. Der obere Grat mündet zu den äußeren Augenwinkeln hin in die Krähenfüße, die am Oberlid ansetzen beziehungsweise im unteren Teil Falten fortsetzen, die sich unter den Augen bilden. Zur Nasenwurzel hin verformt sich der jeweils über den Oberlidern verlaufende Grat zu von kleinen Kerben getrennten Knorpeln, die Ausläufer bis in die Stirn haben. Zudem zieht sich von dieser Knorpelmasse ein Muskelstrang oder ein verformter Stirnknochen zu den Schläfen hin. Der trotz dieser Verformung plastische Charakter der Stirn wird durch den Haaransatz konterkariert. Die Kurzhaarfrisur besteht aus einfachen, sichelförmig gebogenen Strähnen, die sowohl nochmals in sich gesträhnt sind als auch auf der Stirn Details aufweisen, die, vergleichbar den Stoppelhaarfrisuren, gepunzt erscheinen (Kat.-Nr. 21b). Die Frisur zeigt aber nicht die geordnete Struktur wie bei »Der kin-

mass to the temples. The sculptural quality of the forehead achieved despite this deformation is counteracted by the handling of the roots of the hair. The hair is dressed in a short style, consisting of simple, crescent-shaped strands, which are subdivided into strands and on the forehead boast details that look punched, in this respect resembling the stubbly hair cut featured by other busts (cat. no. 21b). The hair style is not, however, articulated in an orderly way as it is in "Childish Weeping" (cat. no. 19), where the individual bunches of hair are clearly and meticulously delimited.

The detailing of the Adam's apple shows how Messerschmidt dealt with the body of his Character Heads as well as the portraits: the Prince of Liechtenstein (cat. no. 2) also has a prominent Adam's apple, where it bulges organically. In contrast, a bust such as

disch Weinende« (Kat.-Nr. 19), bei dem die einzelnen Haarplacken deutlich und sorgfältig gegeneinander abgegrenzt sind.

Am Detail des Adamsapfels ist abzulesen, wie Messerschmidt bei den Charakterköpfen beziehungsweise bei Porträts mit dem Körper umging: Auch der Fürst von Liechtenstein (Kat.-Nr. 2) weist einen ausgeprägten Adamsapfel auf. Dieser wölbt sich organisch vor, während er bei einer Büste wie »Innerlich verschlossener Gram« (Kat.-Nr. 14) wie eine kleine Blase erscheint, im oberen Drittel einer Vertiefung angebracht, die von einer elipsenförmigen Erhebung eingefasst wird. Beim düsteren Mann springt der Adamsapfel ebenfalls blasenförmig vor, hier allerdings von zwei Sehnen begleitet, die keinen ovalen Rahmen für ihn bilden, sondern nach unten auseinander streben. Diese körperliche Besonderheit des Adamsapfels verbindet sich bei den Charakterköpfen somit nicht organisch mit dem Körper, sondern wird als Einzelform und wie von innen aufgebläht verstanden.

Wieder zeigt Messerschmidt in dieser Büste sein bildhauerisches Können: Ornamental verformte Partien wie die Oberlider oder die verknorpelte Nasenwurzel, plastisch gewölbte wie die Wangen und die Stirn, graphisch harte wie die Falten und die Frisur unterstreichen den Ausdruck dieser stark verzerrten Grimasse.

Literatur

Anonymus 1794, S. 62 (Nro. 34); Kris 1933, Abb. 7; Wittkower 1963, Abb. 34; Keller 1971, S. 303–304, Abb. 241b; Baum 1980, S. 386; Glandien 1981, S. 51, Abb. 44; Pötzl-Malíková 1982, S. 71, 258; Behr/ Grohmann/Hagedorn 1983, S. 82–83; Krapf, Katalog 2002, S. 242–243; Lehner-Jobst 2002, Abb. S. 97; Pötzl-Malíková 2004, Abb. S. 107; Schmid 2004, S. 23, 45; Pfarr 2006, Abb. 73–74.

"Grief Locked Up Inside" (cat. no. 14) boasts an Adam's apple that looks like a small bubble with a depression in the upper third that is surrounded by an ellipsoid raised element. In "A Dismal and Sinister Man" the Adam's apple also protrudes in the shape of a bubble but here it is accompanied by two sinews that, instead of framing it, diverge. This physical peculiarity of the Adam's apple in the Character Heads shows that it is not organically linked with the body but should be read as a discrete formal entity that is distended as if blown up from within.

Once again Messerschmidt has used a bust to demonstrate his virtuosic skill as a sculptor: a combination ornamentally deformed parts such as the upper lids or the cartilaginous bridge of the nose, sculpturally bulging elements such as the cheeks and forehead and harsh linear ones such as the wrinkles and hair style enhances the expression of this greatly distorted grimace.

References

Anon. 1794, p. 62 (no. 34); Kris 1933, fig. 7; Wittkower 1963, fig. 34; Keller 1971, pp. 303f., fig. 241b; Baum 1980, p. 386; Glandien 1981, p. 51, fig. 44; Pötzl-Malíková 1982, pp. 71, 258; Behr/Grohmann/Hagedorn 1983, pp. 82f.; Krapf, Katalog 2002, pp. 242f.; Lehner-Jobst 2002, illus. p. 97; Pötzl-Malíková 2004, illus. p. 107; Schmid 2004, pp. 23, 45; Pfarr 2006, figs. 73, 74.

Alabaster
Höhe 23 cm
nach 1770
Landesmuseum
Württemberg
Stuttgart, Inv.-Nr.
WLM 1982/122

Alabaster
height 23 cm
after 1770
Landesmuseum
Württemberg
Stuttgart, Inv. no.
WLM 1982/122

Alabaster
Höhe 21,5 cm
nach 1770
Landesmuseum
Württemberg
Stuttgart, Inv.-Nr.
WLM 1982/123

Alabaster
height 21.5 cm
after 1770
Landesmuseum
Württemberg
Stuttgart, Inv. no.
WLM 1982/123

[22]

Variante zu »Die Einfalt im höchsten Grade« oder: »Demokrit«

[23]

Variante zu »Ein aus dem Wasser Geretteter« oder: »Heraklit«

»8 St. d° kleine« alabasterne »Köpf« führt die »Specification deren Meßerschmidischen Mobilien« am 27. August 1783 auf.[1] Zu ihnen gehören möglicherweise zwei kleine Büsten (Kat.-Nr. 22/23a), die zusammengehörig aus Wiener Privatbesitz vom Landesmuseum Württemberg angekauft wurden.[2] Pötzl-Malíková beschreibt sie als Variante einerseits zu »Ein aus dem Wasser Geretteter«, andererseits zu »Die Einfalt im höchsten Grade« (Kat.-Nr. 17).[3] Ihre Erhaltung als Paar zog aber auch andere Deutungen nach sich: Zoege von Manteuffel nimmt als Thema den weinenden und den lachenden Philosophen an, Heraklit und Demokrit.[4] Allerdings zeigen traditionelle Darstellungen dieses Philoso-

Variant of "The Ultimate Simpleton" or: "Democritus"

Variant of "Just Rescued from Drowning" or: "Heraclitus"

"Eight such little alabaster 'heads'" are listed in the inventory of Messerschmidt's chattels drawn up on 27 August 1783.[1] Their number may possibly include two little busts (cat. no. 22/23a) that were acquired from a Viennese private collection as belonging together by the Landesmuseum Württemberg.[2] Pötzl-Malíková describes them as variants of "Just Rescued from Drowning" and "The Ultimate Simpleton" (cat. no. 17) respectively.[3] But because they had been kept as companion pieces, other interpretations have emerged: Zoege von Manteuffel assumes that the theme is that of the weeping and laughing philosophers, Heraclitus and Democritus.[4] However, traditional representations of that pair of philosophers tend to portray both as at least contemplative or usually as laughing (fig. 46) or mourning. Neither of these emotions can, however, be associated with the little Stuttgart busts. Pfarr suggests instead that they might be portraits of philosophers in the manner of the Pseudo-Seneca and the statue of the Dying Seneca.[5]

First and foremost, however, what is striking about the busts is their closeness to the Character Heads, as listed by Pötzl-Malíková. In both miniature busts the heads are linked with disproportionately powerful torsos with broad shoulders and upper arms. This would mean that Messerschmidt has here reversed the ratio known from the Character Heads, where the heads are monumental in comparison to the bodies.

"Democritus" (cat. no. 22a) reveals a naked, muscular torso, with a long-sleeved upper garment

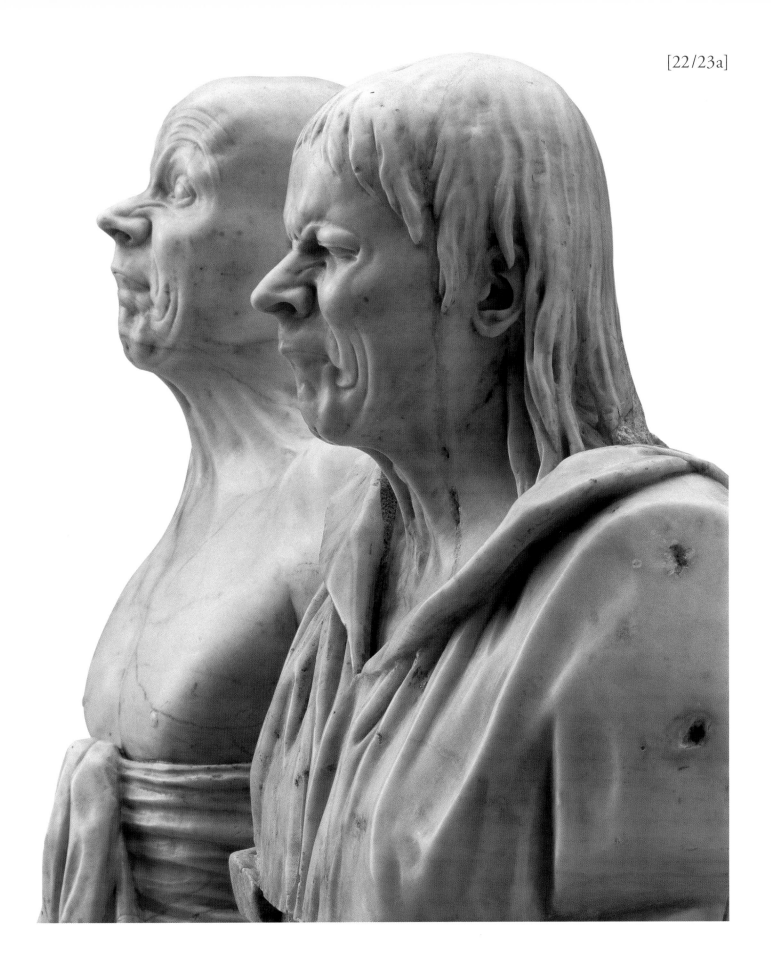

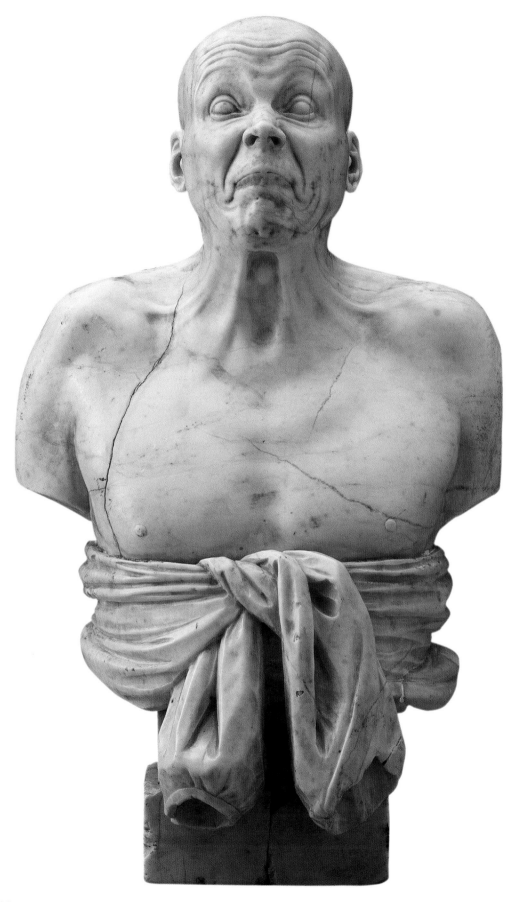

Kat.-Nr. 22a /
Cat. no. 22a
Franz Xaver
Messerschmidt,
Demokrit
*Franz Xaver
Messerschmidt,
Democritus*

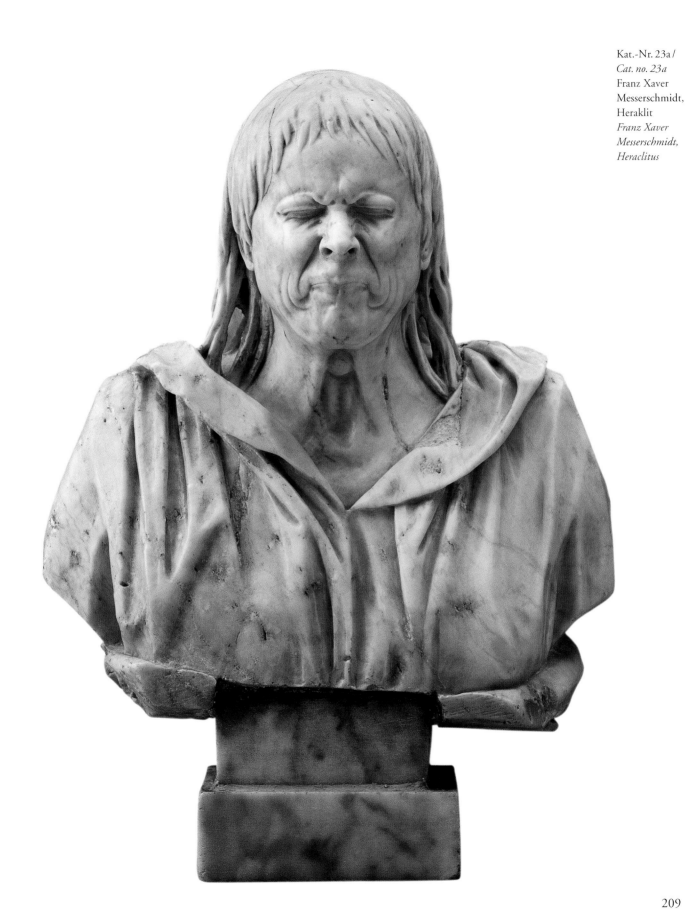

Kat.-Nr. 23a /
Cat. no. 23a
Franz Xaver
Messerschmidt,
Heraklit
*Franz Xaver
Messerschmidt,
Heraclitus*

phenpaars beide wenigstens nachdenklich, meist lachend (Abb. 46) beziehungsweise trauernd. Keine dieser Gemütsbewegungen lässt sich jedoch mit den kleinen Stuttgarter Büsten verbinden. Pfarr schlägt statt dessen vor, in ihnen Philosophenporträts zu sehen, die sich am Pseudo-Seneca und an der Statue des sterbenden Seneca orientieren.[5]

Zunächst allerdings fällt tatsächlich die Nähe der Büsten zu den von Pötzl-Malíková genannten Charakterköpfen auf. Bei beiden Miniaturbüsten sind die Köpfe mit im Vergleich dazu mächtigen Oberkörpern mit breiten Schultern und Armansätzen verbunden; Messerschmidt kehrte die Verhältnisse der Charakterköpfe, bei denen die Köpfe monumental im Vergleich zu den Büstenausschnitten sind, somit um.

»Demokrit« (Kat.-Nr. 22a) zeigt dabei einen bloßen, muskulösen Oberkörper, unter dessen Brust ein langärmeliges Oberteil verknotet ist. »Heraklit« (Kat-Nr. 23a) trägt ein weites Hemd mit weit offen stehendem Kragen. Ob unter diesem Hemd ein weiteres Kleidungsstück den Körper umschlang, lässt sich aufgrund des Erhaltungszustandes der Büste[6] nicht sagen. Über diesen Büsten, die für sich genommen nicht als außergewöhnlich gelten können, sind es wieder die Köpfe, die irritieren. Heraklit presst den Mund zusammen, tiefe Falten verbinden die Nasenflügel der – gerümpften – Nase mit den Mundwinkeln; die Augen sind zusammengepresst und – dem düsteren finsteren Mann (Kat.-Nr. 21) ähnlich – zusammen mit den Orbitalwülsten und den Brauen in eine ornamental deformierte Form verzogen. Strähnige Haare, die über der Stirn kürzer, bis zur Rückseite immer länger werden, hängen vom Kopf herab. Sie erinnern deutlich an die, selbst für Messerschmidts Köpfe ungewöhnliche Haargestaltung des aus dem Wasser Geretteten (Abb. 69). Hier schwappt vom Wirbel auf dem Hinterkopf eine lappig wirkende Haarmasse in das Gesicht und fallen Haare in langen Strähnen zu allen Seiten am Kopf herab. Dabei liegen sie auf dem Scheitel plan auf und gewinnen immer mehr Volumen, je weiter sie herabfallen. Einzig die Ohren bleiben, anders als bei der kleinen Büste, frei. Die entstehenden Strähnen klumpen zu breiten Zotteln zusammen und liegen auf Schultern und Rücken auf. Die Haare des »Heraklit« sind länger, kleben aber ähnlich zusammen und weisen keine weiche, sondern ebenfalls spröd-lappige Materialqualität auf. Auf der Rückseite entsteht dabei ein interessantes Zusammenspiel von Haarsträhnen einerseits und den in der Mitte der Büste entstehenden ebenfalls nach unten führenden Falten andererseits: Unterschiedliche Materialität fällt nicht auf, eher wirken die Falten wie die Fortsetzung der langen Haare.

»Demokrit« zeigt eine der Einfalt im höchsten Grade (Kat.-Nr. 17) nah verwandte Mimik, wobei mehr Falten das Gesicht

knotted below the breast. "Heraclitus" (cat. no. 23a) wears a loose shirt with the collar wide open. Whether another piece of clothing enveloped the body beneath the outer garment cannot be ascertained as a result of the poor state of preservation of this bust.[6] The heads are again the unsettling feature of these busts, which are not otherwise exceptional. Heraclitus' mouth is firmly shut. Deep wrinkles link the wings of the – wrinkled – nose with the corners of the mouth. The eyes squint and – in this respect they are similar to the "A Dismal and Sinister Man" (cat. no. 21) – are distorted, together with the orbital ridges and the brows, to an ornamental form. Strands of hair, which are shorter above the forehead but are represented as increasingly longer towards the back, hang from the head. They are obviously reminiscent of the handling of the hair in "Just Rescued from Drowning", which is unusual, even for Messerschmidt's heads (fig. 69). Here a wattle-like mass of hair on the back of the head falls into the face and long stringy strands dangle around the entire head. On the crown of the head they lie flat but gain in volume towards the ends. Only the ears are exposed, which is not the case with the small bust. The strands thus created are clumped into shaggy locks lying on both the shoulders and back. Heraclitus' hair is longer but is stuck together in much the same way. Nor does it reveal the physical properties of soft hair but is instead similarly brittle and shaggy in substance. On the back this gives rise to an interesting interplay of hair strands and the wrinkles created at the centre of the bust, which also lead downwards: here no differences are revealed in the properties of two different physical substances. The wrinkles look more like a continuation of the long locks of hair.

"Democritus" reveals a play of feature that makes this bust resemble "The Ultimate Simpleton" (cat. no. 17) although more wrinkles furrow the face and the forehead wrinkles are more curvilinear. Continuing these unsettling aspects of the face, several wrinkles radiating from the shoulders, the collar-bones and the breast to the chin break through beside the depression of the breast-bone to disrupt the quiet surface of the body. This only happens on the front; on the back the neck is articulated by

zerfurchen und die Stirnfalten stärker geschwungen sind. Die Irritationen des Gesichts fortführend, durchbrechen zur Seite der Sternalgrube mehrere sich strahlenförmig von den Schultern, den Schlüsselbeinen und der Brust zum Kiefer ziehende Falten die ruhige Oberfläche des Körpers. Dies allerdings nur auf der Vorderseite: Auf der Rückseite ist der Hals durch zwei querliegende Speckwülste strukturiert, angespannte Sehnen sind hier nicht angegeben.

Zeigen die Miniaturbüsten auch einen anderen Motivkanon als die Charakterköpfe, so ist doch auch hier das Bestreben festzustellen, eine irritierende Wirkung zu erzielen. Barocke Porträtbüsten oder auch kleinformatige, antikische Herrscherbüsten weisen in der Regel einen die Büste in großzügigen Falten weit umschlingenden Umhang auf, der den Übergang zwischen Sockel und Büste verschleiert, auch um die natürliche Erscheinung des Porträtierten zu unterstreichen. In seinen um 1769/70 geschaffenen Büsten hatte Messerschmidt mit diesem Formenkanon gebrochen. Mit den Miniaturbüsten findet er eine neue Form der Büste; er greift die Funktion des Umhangs in völlig veränderter Form auf: Die Arme des Demokrit sind abgeschnitten, dafür hängen lange Ärmel vor seinem Leib herab. Beim Heraklit fällt das offene, weite, nachlässig wie ein Deshabillé wirkende Hemd auf, das – auf der Rückseite – die Haare fortzusetzen scheint und unorganisch von einem waagerecht angelegten Wulst abgeschlossen wird.

two horizontal flabs of fat and no taut sinews are indicated.

The miniature busts reveal a canon of motifs that is different to that used for the Character Heads. In both, however, the aim was to create a disturbing effect. Baroque portrait busts and small-scale busts of rulers in the Antique manner generally have a cloak loosely enveloping the bust in generous folds to conceal the transition between base and bust and, of course, also to make the likeness of the subject portrayed more faithful to nature. In the busts he executed in 1769/70, Messerschmidt broke with that canon of forms. In the miniature busts, he has invented a new form of bust. He has refunctioned the cloak to create an entirely different form: Democritus' arms are cut off but long sleeves dangle in front of his body. In Heraclitus, the notable feature is the open, loose, shirt, worn carelessly as if *en déshabille,* which seems – on the back – to continue the hair and is closed off by a horizontal strip laid on in an inorganic manner.

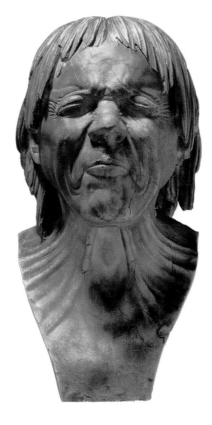

69 Franz Xaver Messerschmidt, Ein aus dem Wasser Geretteter, nach 1770, Alabaster, Privatbesitz
Franz Xaver Messerschmidt, Just Rescued from Drowning, after 1770, alabaster, private collection

1 So Pötzl-Malíková 1996, S. 220.
2 Dazu Zoege von Manteuffel 1984, S. 453.
3 Pötzl-Malíková 1982, S. 266.
4 Siehe Zoege von Manteuffel 1984, S. 459–460.
5 Siehe Pfarr 2006, S. 311–314.
6 Ein um die Büste gelegter Wulst, der sich an den Seiten und an der Rückseite erhalten hat, ist an der Vorderseite großenteils abgebrochen. Auch hat sich der Sockel des »Heraklit«, im Gegensatz zu demjenigen des »Demokrit«, nicht erhalten.

Literatur

Pötzl-Malíková 1982, S. 72, 266; Zoege von Manteuffel 1984, S. 451–469; Pfarr 2001, S. 452–455, Pl. I, II (S. 453); Fischer in: Ausst.-Kat. Große Kunst in kleinem Format 2004, S. 91–95; Pötzl-Malíková 2004, Abb. S. 133; Schmid 2004, S. 40, 62; Ausst.-Kat. Kunst lebt 2006, S. 49–50, Abb. S. 56; Pfarr 2006, S. 301–328.

1 Thus Pötzl-Malíková 1996, p. 220.
2 See Zoege von Manteuffel 1984, p. 453.
3 Pötzl-Malíková 1982, p. 266.
4 See Zoege von Manteuffel 1984, pp. 459–460.
5 See Pfarr 2006, pp. 311–314.
6 Most of a strip laid about the bust, which has survived on the sides and the back, has broken off in front. The base of 'Heraclitus', unlike that of 'Democritus', has been lost.

References

Pötzl-Malíková 1982, pp. 72, 266; Zoege von Manteuffel 1984, pp. 451–469; Pfarr 2001, pp. 452–455, pls. I, II (p. 453); Fischer in: exhib. cat. Grosse Kunst in kleinem Format 2004, pp. 91–95; Pötzl-Malíková 2004, illus. p. 133; Schmid 2004, pp. 40, 62; exhib. cat. Kunst lebt 2006, pp. 49–50, illus. p. 56; Pfarr 2006, pp. 301–328.

Maraike Bückling

Die Wahrheit des Menschen

Barocke Kunst hatte »den Wirklichkeitssinn des Betrachters [vermindert], bis er Mühe gehabt haben mag, Herr seiner selbst zu bleiben«.[1] Die dem Barock von zeitgenössischen Kritikern unterstellte Überwältigung des Gläubigen und Betrachters durch die Kunst wurde im 18. Jahrhundert im Zusammenhang mit der damals wie heute mit dem Begriff der Aufklärung verknüpften Diskussion als dem modernen, zur Vernunft begabten Menschen unangemessen empfunden. Die Formensprache des Barock, beispielsweise die Fortsetzung einer gebauten Architektur in einen gemalten Himmel oder die illusionistische Wiedergabe von Haut, Haaren oder auch Stoffen in Malerei und Bildhauerei, wurde als Missbrauch der Kunst verstanden. Damit stellte sich zum einen die Frage, wie die alte Kunst als Täuschung zu entlarven war; zum anderen ging es darum, welche Kunst den Menschen ebenso wie die Natur authentisch und ehrlich zeigt.[2] Die Kritik an der Tradition, Grundprinzip der Aufklärung, verknüpfte sich mit neuen Inhalten, um der Aufgabe der Kunst gerecht zu werden, das wahre Wesen des Menschen nicht nur zu erkennen, sondern zur Erlangung von Tugend und höherer Erkenntnis beizutragen. Die bisherigen höfischen und kirchlichen Normen verloren an Glaubwürdigkeit, das Verhältnis zwischen Künstlern und Auftraggebern wandelte

The Truth about Man

Baroque art had reduced "the viewer's sense of reality until he may have had difficulty remaining in control of himself."[1] The Baroque was accused by critics of the time of overwhelming the believer and the viewer through art. Linked in the 18th century with the concept of Enlightenment, this effect was considered inappropriate to modern man, endowed as he was with reason. The Baroque language of forms, for example, extending a building with a painted sky into another plane of reality or the deceptively realistic trompe l'œil reproduction of skin, hair or fabrics in painting and sculpture, was regarded in the 18th century as an abuse of art. Consequently, the question was raised, on the one hand, of how the old art was to be exposed as deceptive; on the other, what was at stake was which art might depict man as well as nature.[2] Criticism of tradition, a basic Enlightenment principle, was linked with new content in order to deal with the task assigned to art, not just to recognise the true essence of man but also to attain virtue and higher knowledge. The court and ecclesiastical norms that had previously held sway lost credence and the relationship between artist and patron changed fundamentally. Artists, musicians, men and women of letters, physicians and scholars of jurisprudence now had to explain their personal world-views in their works or writings. In the process, the various sciences made it possible to investigate representations and, therefore, the truth about the essence and nature of man, a pivotal Enlightenment theme.

Messerschmidt was thoroughly familiar with Enlightenment themes and issues. In his portraits, he incorporated the rejection of the Baroque illusion of corporeality through linearity of outline, through the smoothness or even harshness of surfaces and abstraction from natural form on down to artificial naturalness.[3] Mastering as he did the Baroque repertory of

sich grundlegend. Künstler, Musiker, Literaten, Mediziner und Rechtsgelehrte mussten nun in ihren Werken oder Schriften ihre eigene Weltsicht erläutern. Dabei ermöglichten es die unterschiedlichen Wissenschaften, Darstellungen nachzuprüfen und somit die Wahrheit über das Wesen und die Natur des Menschen, ein zentrales Thema der Aufklärung, zu verbreiten.

Messerschmidt war mit den aufklärerischen Inhalten und Fragen gut vertraut. In seinen Porträts setzte er sich mit der Ablehnung der barocken Illusion von Körperlichkeit durch die Linearität von Umrissen, durch die Glätte oder auch Härte von Oberflächen und mit der Abstraktion von der natürlichen Form hin zu artifizieller Natürlichkeit auseinander.[3] Er beherrschte die barocken Stilmittel und Motivgefüge und vermochte es gleichzeitig, beides ad absurdum zu führen. Innerhalb von zehn Jahren, von 1760 bis ungefähr 1770, vollzog sich in seinem Werk eine Entwicklung, die ihn von höfischen Normen fort zu einer selbst gewählten, neuartigen Gestaltung von Porträts führte. Messerschmidt zieht von diesen Porträts alles ab, was öffentlich-repräsentativ ist. Übrig bleibt das Individuum. Das mit der neuen Porträtform Erreichte ist schließlich der Ausgangspunkt für seine weiteren Werke, die Charakter–köpfe. Dabei stellt das Porträt des Fürsten Joseph Wenzel I. von Liechtenstein (Kat.-Nr. 2) das bislang fehlende Verbindungsglied zu den Charakterköpfen dar.

Insbesondere nach dem Scheitern seiner akademischen Karriere erhob sich für Messerschmidt die Frage, wie er sich zur künstlerischen Tradition und gesellschaftlichen Konvention stellen sollte. Hatte er bereits mit den Porträts einiger Aufklärer deutlich Position bezogen, so spitzte er die Frage in den Charakterköpfen noch zu. Sie hätte lauten können: »Was kann und was darf die Büste leisten, und wie weit kann sie sich vom Individuum lösen?«[4] Die »Köpf-Stückhe« stellten eine bisher unbekannte Radikalisierung der Gattung der Bildnisbüste dar. Mit ihnen verließ Messerschmidt endgültig die ausgetretenen Pfade der Tradition.

Perücken

Mehrere Köpfe haben die Auseinandersetzung mit dem Thema der Kopfbedeckungen zum Gegenstand: Die Bärte von »Büste eines bärtigen, alten Mannes« (Kat.-Nr. 5) und des »Kapuziners« (Kat.-Nr. 3) gemahnen an barocke Perücken und formulieren ironisierend Kritik an barocken Traditionen:[5] Die Perücke ist gewissermaßen vom Kopf gerutscht und am Kinn hängen geblieben. Auch die voluminöse Haarmasse von »Ein abgezehrter Alter mit Augenschmerzen« (Abb. 52) gemahnt an eine Perücke, unter der einige Strähnen des natürlichen Haares hervorzublitzen scheinen. Außerdem erinnern die an den Kopf angesetzten »Flügel« von »Ein schmerzhaft stark

styles and forms, he was capable of reducing both to absurdity. Within a space of ten years, from 1760 to about 1770, a development took place in his work that led him away from the court norms to a new handling of portraiture that he had chosen himself. Messerschmidt has removed everything that is public and ostentatiously formal and official from these portraits. What remained was the individual. What he achieved with his new form of portrait was ultimately the point of departure for the rest of his work, the Character Heads. The portrait of Joseph Wenceslas I, Prince of Liechtenstein (cat. no. 2), is the hitherto overlooked link to the Character Heads.

Especially after he had failed in making an academic career, the question arose for Messerschmidt of how he should confront artistic tradition and social convention. Although he had already taken up an explicit stance in his portraits of men of the Enlightenment, he made the question more pointed in the Character Heads. It could have been expressed as: "What can a bust achieve, what may it achieve and how far can it detach itself from the individual?"[4] The "Head Pieces" represented an unprecedented radicalisation of the portrait bust as a genre. With them Messerschmidt left the beaten path of tradition for ever.

Wigs

Several Heads deal with his study of the subject of hair: the beard and moustache in the "Bust of A Bearded Old Man" (cat. no. 5) and of "The Capuchin" (cat. no. 3) are reminiscent of Baroque wigs and formulate an ironic criticism of Baroque tradition:[5] the wig has, in a certain sense, slid from the head to remain stuck on the chin. The voluminous mass of hair displayed in "A Haggard Old Man with Aching Eyes" (fig. 52) looks like a wig, with a few strands of natural hair apparently straggling forth beneath it. In addition, the "wings' set on the head of "A Grievously Wounded Man" (cat. no. 6) recall ancient Egyptian heads covered with whigs. The short hair in the laughing self-portrait (cat. no. 4) is covered with a simple fur cap of the kind worn by peasants in Bratislava and environs. Messerschmidt thus revolted against contemporary convention, which

70　William Hogarth, Die fünf Perückenordnungen, 1761, Radierung und Kupferstich, Städel Museum, Frankfurt am Main, Inv.-Nr. 27507

William Hogarth, The Five Orders of Periwigs, 1761, etching and copperplate engraving, Städel Museum, Frankfurt am Main, Inv. no. 27507

Verwundeter« (Kat.-Nr. 6) an altägyptische, mit Perücken bedeckte Köpfe. Das lachende Selbstporträt (Kat.-Nr. 4) zeigt als Kopfbedeckung eine einfache, dem bäuerlichen Milieu aus der Umgebung Preßburgs entstammende Fellmütze auf kurzem Haar. Messerschmidt widersetzte sich damit zeitgenössischen Konventionen, die das Tragen von Hüten in der Öffentlichkeit untersagten. Hüte wurden in der Öffentlichkeit meist unter dem Arm getragen, keinesfalls auf der Perücke oder dem eigenen Haar.[6] Mit dem bäuerlichen Requisit passte sich der Künstler zudem seiner Umgebung, der slowakischen Bevölkerung, an. Er wollte damit möglicherweise auch ausdrücken, was Ignaz Edler von Born (1742–1791), Meister vom Stuhl der Freimaurer-Loge »Zur Eintracht« und Großsekretär der Großen Landesloge von Österreich,[7] 1784 formulieren sollte. Born

prohibited the wearing of hats in public. Hats were usually carried under the arm in public, certainly never over a wig or one's own hair.[6] With this peasant prop as his attribute, the artist was also conforming to his immediate demographic environment, the Slovak people. He may possibly also have wanted to express what Ignaz Edler von Born (1742-1791), Master of the Chair of the Freemasons' lodge "Zur Eintracht" and Grand Secretary of the Grand National Lodge of Austria,[7] would formulate in 1784. Born begins by maintaining that craftsmen and farmhands did not possess the knowledge necessary for understanding the "royal art" of Freemasonry but makes one exception: if "[...] the man is distinguished [...] by constant noble acts arising from his way of feeling and thinking, our circle is opened to him and then the peasant smock and the herdsman's staff, which ennobles a lofty soul, is more welcome to us than the ribbon of a decoration and the purple cloak, those ambivalent gifts of fortune, those fortuitous, uncertain proofs of distinguishing merit."[8]

In dealing with wigs, Messerschmidt had chosen a subject with which his contemporaries were very much preoccupied: wigs had attained the zenith of their popularity in the third quarter of the 18th century; the 1764 "Encyclopédie perruquière" lists 115 different types of wig for gentlemen.[9] Ladies preferred hair-pieces with wire frames and horse-hair cushions which could be decorated with boats, toboggan-slides and fountains.[10] In 1774 the Duchess of Chartres, for instance, sported figurines of her son, his nurse, her favourite parrot and a blackamoor between her locks.[11] Marie-Antoinette was still decorating her wig in 1785 with an artichoke, a carrot and a bunch of radishes, thus inadvertently caricaturing the Enlightenment call for naturalness.[12] Vast quantities of wheat and rice flour were needed for powdering wigs.[13] Prince Wenzel von Kaunitz is known to have walked the gauntlet in the morning through menservants who sprayed powder at him from all sides.[14] Gentlemen, too, often owned several wigs, which were kept when not in use at home on wooden dummy heads.[15]

By 1770, however, the arguments against wigs had multiplied. It was not just the hygiene aspect[16] but also a rejection of "aristocratic artificiality and

spricht zunächst Handwerkern und Ackerleuten die Kenntnisse ab, die zum Begreifen der »königlichen Kunst« der Maurerei nötig seien, macht aber eine Ausnahme: » […] zeichnet sich der Mann […] durch fortwährende, edle, aus seiner Gemüths- und Denkart fliessende Handlungen aus, dann wird auch ihm unser Kreis geöfnet, und dann ist auch der Bauernkittel und Hirtenstab, den eine erhabne Seele adelt, uns willkommener, als das Ordensband und der Purpurmantel, diese zweydeutigen Geschenke des Glücks, diese zufälligen unsichern Beweise eines eigenen unterscheidenden Verdienstes.«[8]

In der Auseinandersetzung mit Perücken behandelte Messerschmidt ein Thema, das seine Zeitgenossen sehr beschäftigte: Perücken hatten im dritten Viertel des 18. Jahrhunderts einen Zenit ihrer Beliebtheit erreicht; die »Encyclopédie perruquières« von 1764 verzeichnete 115 verschiedene Perücken für Herren.[9] Damen bevorzugten Haarteile mit Drahtgestellen und Rosshaarkissen, die mit Schiffen, Rodelbahnen und Springbrunnen verziert werden konnten.[10] Die Herzogin von Chartres trug 1774 beispielsweise kleine Figuren ihres Sohnes, seiner Amme, ihres Lieblingspapageis und eines Mohren zwischen den Locken;[11] Marie-Antoinette schmückte ihre Frisur, die aufklärerische Forderung nach Natürlichkeit unfreiwillig karikierend, noch 1785 mit einer Artischocke, einem Kohlkopf, einer Karotte und einem Bund Radieschen.[12] Zum Bestäuben von Frisuren wurden große Mengen an Weizen- und Reispuder verbraucht.[13] Von Fürst Wenzel von Kaunitz ist bekannt, dass er morgens durch ein Spalier von Dienern schritt, die ihn von allen Seiten bestäubten.[14] Auch Herren besaßen nicht selten mehrere Perücken, die im Haus auf hölzernen Perückenköpfen deponiert wurden.[15]

Um 1770 mehrten sich schließlich die Gründe, die gegen Perücken sprachen. Dazu zählten nicht nur hygienische Aspekte,[16] sondern auch die Ablehnung von »aristokratischer Künstlichkeit und Affektation«.[17] Perückenkritik mit künstlerischen Mitteln übte außer Messerschmidt unter anderen auch William Hogarth in seiner 1761 entstandenen Radierung »Die fünf Perückenordnungen« (Abb. 70).[18]

Antike und Nachantike

In der Zeit der Aufklärung war der Rückbezug insbesondere auf die Antike bedeutungsvoll, da diese dem Ursprung des Menschen zeitlich am nächsten war und sie nicht verdächtigt wurde, von Hof oder Kirche missbraucht worden zu sein. »Die antike Statue wurde als sinnfälliges Gegenbild gegen die verhüllende Draperie der Barock- und Rokoko-Kunst [verstanden]. Die antike Statue repräsentierte natürliche Schönheit, unverhüllte Wahrheit.«[19]

affectation".[17] Another artist besides Messerschmidt who used art as a medium for criticising wigs was William Hogarth in his 1761 etching "The Five Orders of Periwigs" (fig. 70).[18]

Antiquity and post-Antiquity

In the age of Enlightenment, reference to Antiquity was especially meaningful since Antiquity was closest in time to the origins of man and could not be suspected of having been abused by court or Church. "The ancient statue was [interpreted] as the meaningful antithesis of the veiling drapery of Baroque and Rococo art. The ancient statue represented natural beauty, unveiled truth."[19]

Even Messerschmidt's earliest known work shows him preoccupied with Antiquity as exemplary by 1759–1761: as prescribed by his mentor Martin van Meytens and borrowing the proportions of the Borghese Fencer as his model from Antiquity, Messerschmidt carved a skeleton.[20] In 1765 his devotion to Antiquity induced Messerschmidt to journey to Rome at his own expense to study ancient art.[21] Small-scale heads after the Farnese Hercules,[22] the Borghese Fencer, the Dying Gaul and a statuette of Apollo are attributed to Messerschmidt and dated to 1765, when he was in Rome.[23] Even after his return from Rome, echoes of Antiquity are known to have lingered. The exception was the piece he submitted in 1769 for admission to the Academy of the Fine Arts, a relief depicting the subject of "How Ulysses was discovered amongst the Wenches".[24] The portraits Messerschmidt executed from 1769 to 1772, such as the one of von Scheyb (figs. 9, 18), are modelled after Roman Republican portraits.[25] Even in the portrait of van Swieten (cat. no. 1), in which no attempt has been made to disguise any unattractive features of the subject, might have been inspired by Antiquity; after all, ugliness is occasionally also represented in ancient portraits.[26] Further, the enigmatic representation of "Religion" (fig. 71), done in Munich between 1775 and 1777,[27] which was appended to the tombstone of the wife of Messerschmidt's uncle and instructor during his apprenticeship, Johann Baptist Straub (1704–1784), can be linked with representations from Antiquity: the head type and the cloth laid

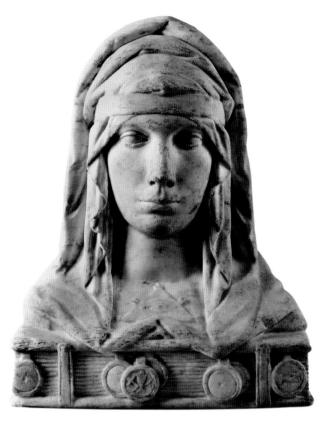

71 Franz Xaver Messer-
schmidt, Religion,
1775–1777, Marmor,
Bayerisches National-
museum, München,
Inv.-Nr. R 8726,
Franz Xaver Messer-
schmidt, Religion,
1775–1777, marble,
Bayerisches National-
museum, Munich,
Inv. no. R 8726

Bereits das früheste überlieferte Werk Messerschmidts zeigt ihn um 1759–1761 mit der vorbildhaften Antike beschäftigt: Nach den Vorgaben seines Mentors Martin van Meytens und orientiert an den Proportionen der antiken Skulptur des borghesischen Fechters schnitzte Messerschmidt ein Skelett.[20] Im Jahr 1765 führte die Hinwendung zur Antike dazu, dass er auf eigene Kosten eine Studienreise nach Rom unternahm.[21] Messerschmidt zugeschrieben und in die Zeit seines Aufenthaltes in Rom 1765 datiert werden kleinformatige Kopien nach dem Herkules Farnese,[22] dem borghesischen Fechter, dem sterbenden Gallier sowie eine Apollostatuette.[23] Auch nach seiner Romreise sind Antikenremineszenzen, abgesehen von dem 1769 geschaffenen Aufnahmestück für die Akademie der bildenden Künste, einem Relief mit dem Thema »Wie Ulysses den Achilles unter den Frauenzimmern entdecket«,[24] bekannt. Die Porträts der Zeit 1769–1772, wie beispielsweise dasjenige von Scheybs (Abb. 9, 18), fanden ihre Vorbilder unter den römischen Porträts der republikanischen Ära.[25] Selbst das Porträt van Swietens (Kat.-Nr. 1), das die unvorteilhaften Züge des Dargestellten nicht leugnet, sondern hervorhebt, könnte auf antike Anregungen zurückgreifen, wird doch auch in antiken Porträts gelegentlich Hässlichkeit wiedergegeben.[26] Ferner kann die zwischen 1775 und 1777 in München entstandene, rätselhafte Darstellung der »Religion« (Abb. 71),[27] die auf dem Grabmal der Ehefrau von Messerschmidts Onkel und Lehrherrn Johann Baptist Straub (1704–1784) angebracht war, mit

about the head, which corresponded to a familiar gesture of mourning,[28] refer back to representations of Vestal Virgins and the work interpreted as Penelope Mourning.[29]

In his 1780s' account of his travels, Friedrich Nicolai describes two of the Character Heads as worked "in the style of Antiquity".[30] It is not known which Heads he meant. However, there are several to which this statement might apply: "The Artist's Serious Countenance" (fig. 33), "The Melancholic" (cat. no. 8), "The Noble-Minded Man" (cat. no. 18), "The Reliable Man" and "The General" (fig. 65). They may be compared to a portrait of Cicero, for example,[31] or the bald bronze head of a priest of Isis,[32] which, in their composure and concentration, may have been the models that inspired the artist.

Even the grimacing Character Heads may reveal borrowings from the heavily furrowed Republican portraits of men. Republican heads which certainly bear comparison to the Character Heads are the "Portrait of an old man with bust section" (fig. 72) or, less obviously, the "Portrait of a man, his head covered, with the bust part added".[33] Models from Antiquity can also be found for the stubbly hair style of "An

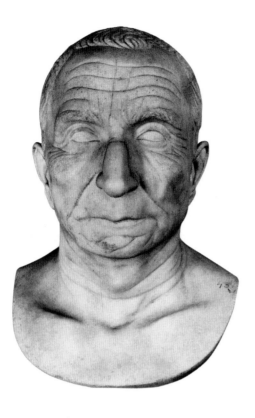

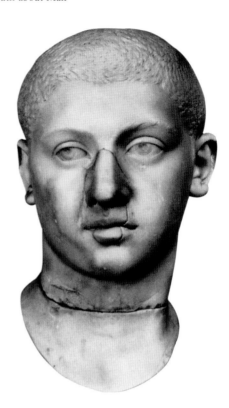

72 Bildnis eines alten Mannes mit Büstenausschnitt, 2. Hälfte 1. Jhd. v. Chr., Marmor, Museo Chiaramonti, Vatikan
Portrait of an old man with bust section, 2nd half of 1st century BC, marble, Museo Chiaramonti, The Vatican

73 Bildnis des Severus Alexander (222–235 n. Chr.), frühe Regierungszeit, Marmor, Museo Chiaramonti, Vatikan
Portrait of Alexander Severus (222–235 AD), early in his reign, marble, Museo Chiaramonti, The Vatican

antiken Darstellungen in Verbindung gebracht werden: Der Kopftypus und das um den Kopf gelegte Tuch, das einem bekannten Trauergestus entsprach,[28] weisen zurück auf Darstellungen der Vestalinnen und auf die so genannte trauernde Penelope.[29]

Friedrich Nicolai bezeichnete in seinem Reisebericht in den 1780er Jahren zwei der Charakterköpfe als »im antiken Stile« gearbeitet.[30] Welche der Köpfe er damit meinte, ist unbekannt. Tatsächlich gibt es mehrere, auf die diese Äußerung gemünzt sein könnte: »Des Künstlers ernste Bildung« (Abb. 33), »Der Melancholikus« (Kat.-Nr. 8), »Der Edelmüthige« (Kat.-Nr. 18), »Der Zuverlässige« oder »Der Feldherr« (Abb. 65). Als Vergleiche bieten sich beispielsweise ein Bildnis des Cicero[31] oder der kahle Bronzekopf eines Isispriesters[32] an, die in ihrer abgeklärten Ruhe und Konzentriertheit Vorbildcharakter erlangt haben könnten.

Selbst die grimassierenden Charakterköpfe können bei altrömischen, stark zerfurchten Männerporträts Anleihen genommen haben. Antike Köpfe, die einem Vergleich mit Charakterköpfen nahezu standhalten würden, sind die »Büste eines alten Mannes mit Büstenausschnitt« (Abb. 72) oder, weniger eindrücklich, das »Bildnis eines Mannes, capite velato, mit ergänztem Büstenansatz«.[33] Auch für die Stoppelhaarfrisuren beispielsweise von »Ein Erzbösewicht« (Kat.-Nr. 10) ließen sich Vorbilder in der Antike finden (Abb. 73). »Der Melancholikus« (Kat.-Nr. 8) mit Kopfbinde zitiert Motive der antiken Herrscherikonographie, und auch »Ein mürri-

Arch-Rascal" (cat. no. 10) (fig. 73). "The Melancholic" (cat. no. 8) with a fillet round his head quotes a motif from the iconography of ancient rulers and "A Surly Old Soldier" (cat. no. 7), where Messerschmidt may also have originally thought of adding a fillet, is reminiscent of Ptolemaic and Roman portrait heads (fig. 54). Finally, the "Bust of A Bearded Old Man" (cat. no. 5) recalls ancient portraits of Socrates (fig. 51).

The art of ancient Egypt within the art of Antiquity evidently played a particular role for Messerschmidt: "A Grievously Wounded Man" (cat. no. 6) cannot, as mentioned above, be explained with knowledge of ancient Egyptian heads with wigs.[34] Further, Nicolai reports that Messerschmidt had attached "to the window an Egyptian statue without arms on half a sheet of paper",[35] perhaps a Herm. Nicolai continues condescendingly: "One knows how much fuss and bother the Enthusiasts of various kinds make about the knowledge of nature which the so-called Egyptian Hermes (who, unfortunately! never existed in this world) is supposed to have possessed. So M., too, turned his eyes towards Egypt; and, since he was an artist, allowed himself to dream the true secret of the proportions actually lay in the

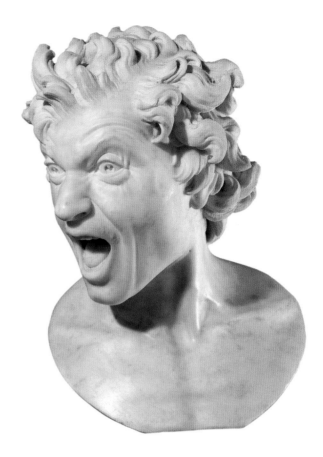

74 Gian Lorenzo Bernini,
Anima Dannata, um 1620,
Marmor, Ambasciata di
Spagna presso la Santa
Sede, Rom
*Gian Lorenzo Bernini,
Anima Dannata, c. 1620,
marble, Ambasciata di
Spagna presso la Santa
Sede, Rome*

scher alter Soldat« (Kat.-Nr. 7), bei dem Messerschmidt möglicherweise ursprünglich ebenfalls an die Anlage einer Haarbinde gedacht hatte, gemahnt an ptolemäische und römische Porträtköpfe (Abb. 54). Die »Büste eines bärtigen, alten Mannes« (Kat.-Nr. 5) erinnert schließlich deutlich an antike Bildnisse des Sokrates (Abb. 51).

Eine besondere Rolle für Messerschmidt nahm innerhalb der antiken Kunst offenbar die ägyptische ein: »Ein schmerzhaft stark Verwundeter« (Kat.-Nr. 6) ist, wie bereits erwähnt, ohne die Kenntnis altägyptischer Perückenköpfe[34] nicht zu erklären. Ferner berichtete Nicolai, dass bei Messerschmidt »am Fenster auf einem halben Bogen die Zeichnung einer ägyptischen Statue ohne Arme«,[35] vielleicht einer Herme, angebracht war. Er fährt herablassend fort: »Man weiß, wie viel Aufhebens die Schwärmer von mancherley Art aus den Naturkenntnissen machen, welche der sogenannte ägyptische Hermes (der aber leider! nie in der Welt existirt hat) besessen haben soll. Also kehrte auch M. seine Augen nach Aegypten; und, da er ein Künstler war, so ließ er sich träumen, das rechte Geheimniß der Verhältnisse läge eigentlich in den Verhältnissen der Glieder der ägyptischen Statuen, besonders in der Zeichnung, die er an seinem Fenster aufgehängt hatte […].«[36] Noch im Nekrolog in der Preßburger Zeitung vom 28. August 1783 heißt es, dass sich Messerschmidt »auch die Meister des Alterthums, da, wo er sollte, zum Muster aufstellte. So hat er in seinem Kunstfache, besonders den Egyptischen, Griechischen und Römischen Künstler studiert und

proportions of the limbs of Egyptian statues, in particular in the drawing he had hung up at his window […]."[36] Even the obituary in the "Pressburger Zeitung" of 28 August 1783 reports that Messerschmidt "also set up the masters of Antiquity where he should, as models. Thus he studied in his art course the Egyptian, Greek and Roman artists and developed his genius particularly on his journey to Italy and during his stay in Rome and schooled it admirably."[37]

However, Messerschmidt's reception of Antiquity was a broken one since, on close scrutiny, the affinities with models, in the Frankfurt and the Egyptian head (cat. nos. 5 a–c, cat. nos. 6 a–c), for instance, are not as close at might be surmised at first glance. Messerschmidt is playing with the motif configurations handed down from Antiquity. The "Bust of A Bearded Old Man" (cat. no. 5) exemplifies the ambiguity of expression which obscures any retreat to the thinking of Antiquity. Only when viewed frontally is the wig of the neo-Egyptian Head vaguely reminiscent of ancient Egyptian hair styles, which extend to the breast and do not, as in Messerschmidt, end above the shoulders. Viewed from a different angle,

75 Jean-Étienne Liotard,
Liotard lachend, um
1770, Öl auf Leinwand,
Musée d'art et d'histoire,
Genf, Inv.-Nr. 1893-9
*Jean-Étienne Liotard,
Liotard Laughing,
c. 1770, oil on canvas,
Musée d'art et d'histoire,
Geneva, Inv. no. 1893-9*

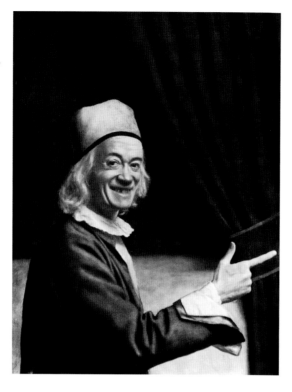

the side pieces of the wig turn out to be discs set on
and bent forwards. There were other artists and art
theorists among his contemporaries who did not
accept Antiquity without question. In "The Five
Orders of Periwigs" (fig. 70), Hogarth criticised not
only wigs but also excessive veneration of Antiquity:
"He contrasts the painstaking measuring of ancient
buildings and sculpture [...] with measuring wigs. He
proclaims in the caption that the measurements of
ancient wigs would also be available in about seven-
teen years' time in six folio volumes. This was made
possible by measurements being taken on statues,
reliefs and busts."[38] Georg Christoph Lichtenberg
(1742–1799), a physicist and Enlightenment man of
letters, scoffed at the rapturous eyes with which so
many in Wincklemann's following who had journeyed
to Rome observed Antiquity[39] and the French sculp-
tor Étienne Falconet (1716–1791) vociferously
attacked the craze for Antiquity which had befallen so
many of his contemporaries.[40]

Messerschmidt did not draw exclusively on
ancient sources: that works by Andreas Schlüter,
Balthasar Permoser and Gian Lorenzo Bernini (fig.
74) may possibly have been models for "The Yawner"
(cat. no. 12) has been frequently pointed out;[41] the
French artist Joseph Ducreux (1735–1802) has been
suggested for comparison to "The Artist As He Imag-
ined Himself Laughing" (cat. no. 4, fig. 48),[42] also
Georges de la Tour (1593–1652), Paul Troger
(1698–1762), Jean-Étienne Liotard (1702–1789)
(fig. 75) or 17th-century Flemish and Dutch self-
portraits.[43] Sculptors such as Edmé Bouchardon
(1698–1762) and the Englishman Joseph Nollekens
(1737–1823) (fig. 19), whose works Messerschmidt
may have seen in Rome, used motifs similar to
Messerschmidt's in their portraits, following Antiqui-
ty in including décolletés. Messerschmidt's use of
masks like that associated with Pulcinella is another
noticeable borrowing. Finally, series, such as those
represented by Charles Le Brun in the "Traité des pas-
sions", which Messerschmidt may also have become
familiar with through the busts of men by Orazio
Marinali (1643–1720) (figs 76, 77) and Giovanni
Giuliani (1664–1744) (fig. 78),[44] may have inspired
Messerschmidt in his Character Heads project.

sein Genie besonders auf seiner Reise nach Italien und während sei-
nes Aufenthaltes in Rom entwickelt und bis zur Bewunderung aus-
gebildet.«[37]

Die Antike wird hingegen nicht ungebrochen rezipiert, denn
bei genauer Betrachtung sind die Verwandtschaften mit den Vorbil-
dern, beispielsweise bei dem Frankfurter und dem ägyptischen Kopf
(Kat.-Nr. 5 a–c, Kat.-Nr. 6 a–c), nicht so groß wie beim ersten Blick
vermutet. Messerschmidt spielt mit dem antiken Motivgefüge. Der
bärtige, alte Mann (Kat.-Nr. 5) führt die Uneindeutigkeit des Aus-
drucks vor Augen, der den Rückzug in die Gedankenwelt der Anti-
ke verstellt. Die Perücke des ägyptisierenden Kopfes erinnert nur in
der Vorderansicht vage an altägyptische Frisuren, die bis auf die
Brust fallen und nicht wie bei Messerschmidt noch über den Schul-
tern enden. Aus anderen Blickwinkeln betrachtet, entpuppen sich
die Seitenteile der Perücke als angesetzte, nach vorn geklappte
Scheiben. Auch andere Künstler und Kunsttheoretiker akzeptierten
die Antike nicht, ohne sie zu hinterfragen. In dem Blatt »Die fünf
Perückenordnungen« (Abb. 70) wandte sich Hogarth nicht nur
gegen Perücken, sondern gleichzeitig gegen die übertriebene Vereh-
rung der Antike: »Dem akribischen Vermessen von antiken Bau-
werken und Skulpturen [...] setzt er das Vermessen der Perücken
entgegen. Er kündigt in der Bildunterschrift an, in etwa 17 Jahren
würden in sechs Foliobänden auch Maße der antiken Perücken vor-
liegen. Ermöglicht werde dies durch Messungen an Statuen, Reliefs

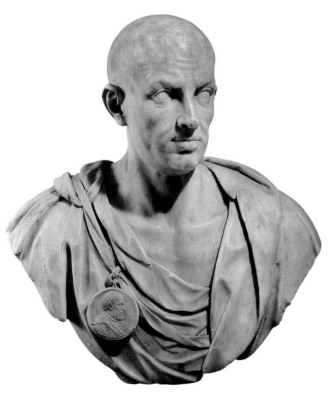

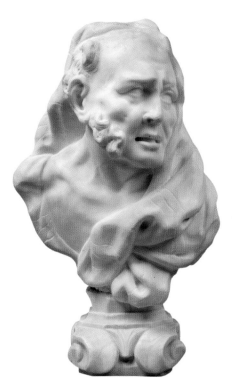

76 Orazio Marinali, Cicero, vor 1700, Marmor, Nordico-Museum der Stadt Linz, Inv.-Nr. P 815
Orazio Marinali, Cicero, before 1700, marble, Nordico-Museum der Stadt Linz, Inv. no. P 815

77 Orazio Marinali, Philosophenbüste (Heraklit?), um 1700, Marmor, Kunsthistorisches Museum, Wien, Inv.-Nr. 7523
Orazio Marinali, Bust of a philosopher (Heraclitus ?), c. 1700, marble, Kunsthistorisches Museum, Vienna, Inv. no. 7523

und Büsten.«[38] Georg Christoph Lichtenberg (1742–1799), Physiker und aufklärerischer Schriftsteller, spottete über die entzündeten Augen, mit denen viele Romreisende im Gefolge Winckelmanns die Antike betrachteten,[39] und der französische Bildhauer Étienne Falconet (1716–1791) wandte sich mit Verve gegen die Antikenmanie seiner Zeitgenossen.[40]

Messerschmidt schöpfte aber nicht nur aus antiken Quellen: Auf die mögliche Vorbildhaftigkeit von Werken von Andreas Schlüter, Balthasar Permoser und Gian Lorenzo Bernini (Abb. 74) im Zusammenhang mit »Der Gähner« (Kat.-Nr. 12) wird häufig verwiesen;[41] der Franzose Joseph Ducreux (1735–1802) wird als Vergleich zu »Der Künstler, so wie er sich lachend vorgestellt hat« (Kat.-Nr. 4, Abb. 48) genannt;[42] ebenso Georges de la Tours (1593–1652), Paul Troger (1698–1762), Jean Étienne Liotard (1702–1789, Abb. 75) oder Künstlerselbstbildnisse des flämisch-niederländischen 17. Jahrhunderts.[43] Bildhauer wie Edmé Bouchardon (1698–1762) und der Engländer Joseph Nollekens (1737–1823, Abb. 19), deren Werke Messerschmidt in Rom gesehen haben könnte, führen, in Nachfolge der Antike mit nackten Büstenausschnitten in ihren Porträts, vergleichbare Motive wie Messerschmidt vor. Auch der Rückgriff auf Masken wie Pulcinella fällt auf. Schließlich können Reihungen, wie sie beispielsweise Charles Le Brun im »Traité des passions« darstellte und wie sie Messerschmidt durch die Männerbüsten von Orazio Marinali (1643–1720, Abb. 76, 77) und Giovanni Giuliani (1664–

While in Italy, Messerschmidt may also have seen the Quattrocento busts by Guido Mazzoni († 1518): a Mazzoni portrait bust[45] has the frontal, bald head of a man above the breast section typical of the Early Renaissance; the pronounced wrinkles and bulging parts such as cheeks, lachrymal sacs and eyebrows that lend the face an expressive character recalling Messerschmidt's Character Heads. And other works by Mazzoni, to whom a Lamentation group in Padua is attributed, reveal starkly expressive weeping or screaming mourning figures, often with wide open mouths, some of whose faces are also furrowed by notched wrinkles rendered in line (fig. 79).[46] Further, a 17th-century representation of Lachesis, one of the three Fates[47] may have possibly been drawn on as a source of inspiration in the bust "Just Rescued from Drowning" (fig. 69).

The study of physiognomy, pathognomy and mesmerism

The 18th century sought a new attitude to the individual that was not based on ecclesiastical and court prescription but was instead grounded in empirical research. The natural sciences and even theology and

221

78 Giovanni Giuliani,
 Chorgestühl der Stifts-
 kirche Heiligenkreuz,
 1707 / 08, Lindenholz,
 Kloster Heiligenkreuz
 bei Wien
 Giovanni Giuliani,
 choir stalls from the
 Heiligenkreuz monastery
 church, 1707 / 08,
 Limewood, Heiligenkreuz
 Monastery near Vienna

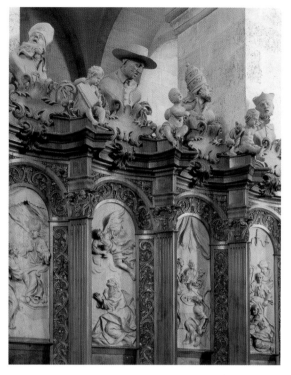

letters strove for an authentic, honest image of man. Numerous systems were invented by the various disciplines, only to be rejected, redeveloped and again refuted.

The study of both physiognomy and pathognomy represented such attempts at systematic investigation and understanding of man. The study of physiognomy entailed endeavouring to read the true essence of man in his unalterably arbitrary facial features. The study of physiognomy was, according to its most celebrated exponent, Johann Caspar Lavater, in 1775 "the skill of recognising the inner being of a man through his external appearance".[48] Preoccupation with the study of physiognomy was in full swing when Lavater brought out his celebrated "Physiognomische Fragmente zur Beförderung der Menschenkenntniss und Menschenliebe" (1775 – 1778).[49] Georg Christoph Lichtenberg, a vehement opponent of Lavater and an adherent of the study of pathognomy, had already spoken by 1774, that is, even before publication of Lavater's work, of the "physiognomy mania",[50] which drew on a long body of antecedents in the form of writings on physignomy.[51] The study of pathognomy, on the other hand, comprised "the entire semiotics of affect or knowledge of the natural signs of the emotions according to all their gradations and combinations."[52] Instead of studying bone structure as the 'science' of physiognomy did, pathognomy was devoted to the mobile aspects of the body and paid attention to the play of the facial features and gestures. The heated debates on physiognomy *v.* pathognomy surely cannot have passed Messerschmidt by. Nevertheless, knowledge of physiognomy or pathognomy cannot be read in Messerschmidt's Heads: on the one hand, the heads differ too widely in form and are often abnormally shaped and, on the other, the expressions depicted are often difficult to interpret. The skull deformation in "A Grievously Wounded Man" (cat. no. 6), to take the most vivid example, make the study of phyiognomy look absurd and incapable of explaining anything. The ill-sorted expressions on the face of Character Heads such as "A Dismal and Sinister Man" (cat. no. 21) and "An Arch-Rascal" (cat. no. 10) totally exclude pathognomy as the model for explaining Messerschmidt's Heads.

1744, Abb. 78)[44] kennengelernt haben konnte, den Bildhauer zu seinem Projekt der Charakterköpfe animiert haben.

Gleichfalls könnte Messerschmidt in Italien Büsten des Quattrocento von Guido Mazzoni († 1518) gesehen haben: Eine Bildnisbüste[45] zeigt über dem für die Frührenaissance typischen Brustausschnitt den frontal ausgerichteten kahlen Männerkopf, dessen ausgeprägte Falten und gewölbte Partien wie Wangen, Tränensäcke und Augenbrauen dem Gesicht einen expressiven Charakter verleihen, der an Charakterköpfe Messerschmidts erinnert. Und auch andere Werke Mazzonis, dem eine Beweinungsgruppe in Padua zugeschrieben wird, zeigen ausdrucksstarke, häufig mit weit offenem Mund weinende oder schreiende Trauerfiguren, deren Gesichter gelegentlich von graphisch eingekerbten Falten zerfurcht sind (Abb. 79).[46] Weiterhin könnte eine italienische Darstellung der Parze Lachesis aus dem 17. Jahrhundert[47] als mögliche Anregung im Zusammenhang mit der Büste »Ein aus dem Wasser Geretteter« (Abb. 69) gedient haben.

Physiognomik, Pathognomik und Mesmerismus

Das 18. Jahrhundert suchte nach einer neuen Einstellung dem Individuum gegenüber, die nicht auf kirchlichen und höfischen Fundamenten ruhte, sondern auf Forschung und Empirie. Die Naturwissenschaft oder auch die Theologie und die Literatur bemühten sich um ein authentisches, ehrliches Bild des Menschen. Zahlreiche

79 Guido Mazzoni,
 Nikodemus, Terrakotta,
 San Giovanni Battista,
 Modena
 Guido Mazzoni, Nicode-
 mus, terracotta, San Gio-
 vanni Battista, Modena

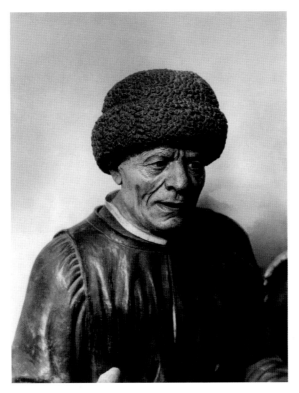

The study of physiognomy and pathognomy were not the only theories that preoccupied and agitated 18th-century emotions. Natural science and medicine celebrated triumphs in new discoveries with which it was believed the truth might be tracked down but also suffered bitter defeats: electric fire, magnetism, homoeopathy, alchemy, magic and exorcism. Charlatans, faith healers, physicians, researchers and self-styled reformers split their intellectual environment into schools of gullible adherents and fanatical opponents.[53] Their attempts to put the findings of research and therapy on a systematic basis produced an overload of writings and linked them with other disciplines which also tried to build up a solid edifice of doctrine on the basis of empirically secured data. Messerschmidt's 18th-century contemporaries were enthralled and bewildered by the scientific revelation that they were surrounded by marvellous invisible forces.[54] The new state of knowledge and theories were sure of encountering the liveliest interest everywhere.

This is equally true of the therapeutic method developed by the physician Franz Anton Mesmer (1734–1815): animal magnetism or what is today also known as mesmerism. Franz Anton Mesmer studied in Vienna and took his doctorate in medicine with a dissertation in which he expatiated on "the influence of the planets on each other" and their effect "inter alia" on earthly organisms.[55] His dissertation already contained the nucleus of the idea "of attributing to the magnetic stone a power transcending the property of attracting iron and ultimately of thinking of this property of magnets separately as a fundamentally intercorporeally effective power, as general magnetism."[56] Mesmer assumed that the cosmos, nature and man were linked by a "universal flux" and that disease arose from a disruption of this flux.

The close relationship between Messerschmidt and Franz Anton Mesmer is well-known:[57] Messerschmidt had done a portrait of the famous physician (figs. 10, 21) and created a group of statuary for his garden.[58] The two also lived only a few minutes' walk from each other.[59] Their personal relationship, therefore, may have made Messerschmidt study Mesmer's therapeutic method more intensively than he did other scientific knowledge. Even Albert Ilg, Messer-

Systeme wurden von verschiedenen Disziplinen erfunden und wieder verworfen, neu entwickelt und gleich widerlegt.

Zu den Versuchen, den Menschen systematisch zu erforschen und zu verstehen, gehörten die Physiognomik und Pathognomik. Unter Physiognomik wurde die Wissenschaft verstanden, die an den festen Gesichtsteilen das wahre Wesen des Menschen abzulesen versuchte. Physiognomik, so 1775 ihr berühmtester Vertreter Johann Caspar Lavater, sei »die Fertigkeit durch das Äußerliche eines Menschen sein Inneres zu erkennen«.[48] Die Auseinandersetzung mit der Physiognomik war in vollem Gange, als er 1775–1778 seine berühmten »Physiognomischen Fragmente zur Beförderung der Menschenkenntniß und Menschenliebe«[49] herausgab. Georg Christoph Lichtenberg, entschiedener Gegner Lavaters und Anhänger der Pathognomik, sprach bereits 1774, also noch bevor Lavaters »Fragmente« erschienen, von der »Raserei für Physiognomik«,[50] die sich auf eine lange Ahnenreihe von physiognomischen Schriften beziehen konnte.[51] Pathognomik wiederum umfasste »die ganze Semiotik der Affekte oder die Kenntnis der natürlichen Zeichen der Gemütsbewegungen, nach allen ihren Gradationen und Mischungen«.[52] Statt mit dem Knochenbau wie die Physiognomik beschäftigte sich die Pathognomik mit den beweglichen Teilen des Körpers und achtete auf Mimik und Gestik. Die hitzigen Debatten um Physiognomik und Pathognomik dürften nicht ungehört an Messerschmidt

223

vorübergegangen sein, und dennoch können weder physiognomische noch pathognomische Erkenntnisse an Messerschmidts Köpfen abgelesen werden: Die Köpfe sind zum einen zu unterschiedlich in ihrer Form und häufig abnorm geformt und weisen zum anderen schwer deutbare Ausdrücke auf. Die Verformungen von Schädeln wie bei »Ein schmerzhaft stark Verwundeter« (Kat.-Nr. 6), um nur die krasseste Form zu nennen, lassen die Physiognomik als absurd und zu wenig erklärungsfähig erscheinen. Die nicht zueinander passenden mimischen Ausdrucksformen eines Charakterkopfes wie »Ein düstrer finsterer Mann« (Kat.-Nr. 21) oder »Ein Erzbösewicht« (Kat.-Nr. 10) entziehen wiederum der Pathognomik als Erklärungsmodell der Köpfe Messerschmidts die Grundlage.

Nicht nur Physiognomik und Pathognomik beschäftigten und erhitzten die Gemüter. In der Naturwissenschaft und Medizin feierten neue Entdeckungen, mit denen man glaubte, der Wahrheit auf der Spur zu sein, Triumphe und erlitten zugleich herbe Niederlagen: das elektrische Feuer, der Magnetismus, Homöopathie, Alchemie, Magie und Exorzismus. Scharlatane, Wunderheiler, Ärzte, Forscher und selbsternannte Weltverbesserer spalteten ihre Umgebung in euphorische Anhänger und fanatische Gegner.[53] Ihre Versuche, die Forschungs- und Heilungsergebnisse zu systematisieren, brachten eine Flut von Schriften hervor und verbanden sie mit anderen Disziplinen, die gleichfalls versuchten, aus empirisch gewonnenen Daten feste Lehrgebäude zu errichten. Die Wissenschaft fesselte die Zeitgenossen des 18. Jahrhunderts durch die Enthüllung, dass sie von »wunderbaren unsichtbaren Kräften umgeben waren«[54] und verwirrte sie gleichzeitig. Die neuen Erkenntnisse und Theorien konnten sich allerorten größten Interesses sicher sein.

Dies gilt auch für die Heilmethode des Arztes Franz Anton Mesmer (1734–1815): den animalischen Magnetismus oder auch den heute so genannten Mesmerismus. Franz Anton Mesmer studierte und promovierte in Wien mit einer Doktorarbeit in Medizin, in der es ihm um »den Einfluss der Planeten untereinander« und ihre Einwirkungen unter anderem auf irdische Organismen ging.[55] In seiner Dissertation lag bereits die Idee nahe, »dem Magnetstein eine Kraft zuzuschreiben, die über die Fähigkeit, Eisen anzuziehen hinausgeht, und schließlich diese Fähigkeit vom Magneten losgelöst als grundsätzlich interkörperlich wirkende Kraft, als Magnetismus generalis, zu denken«.[56] Mesmer ging davon aus, dass der Kosmos, die Natur und die Menschen über ein »universelles Fluidum« miteinander verbunden seien, Krankheit durch eine Störung dieses Fluidums entstehe.

Die enge Verbindung zwischen Messerschmidt und dem Arzt Franz Anton Mesmer ist bekannt:[57] Messerschmidt hatte den berühmten Arzt porträtiert (Abb. 10, 21) und für seinen Garten eine

schmidt's first biographer, interpreted in 1885 "Messerschmidt's curious Character Heads as the artistic symbolisation of the most manifold phenomena [...] which can appear as the visible results of the fluctuating innervation of the human countenance",[60] that is, as the artistic expression of what Mesmer termed animal magnetism. The effects of magnetism, which was only applied to parts of the body whose harmony was disturbed,[61] were "at times drawing, burning, at other cutting, tearing like rheumatic [pains] yet again like electric shocks".[62] Patients' reactions ranged from convulsive spasms to a sleep-like state.[63]

During a Mesmer treatment, hempen cords were bound about patients' diseased members to link the sufferers together. In addition, each patient was linked with a magnetised bath by an iron rod on the diseased part of the body.[64] Michael Krapf cites several Heads in proof of his theory that Messerschmidt had studied Mesmer's animal magnetism, including: "A Scholar, Poet" (figs 49, 53) and "A Hanged Man" (fig. 80).[65] The Scholar is wearing a knotted rope round his head; a rope is round the Hanged Man's neck: in both cases Messerschmidt might be alluding to the above-mentioned hempen ropes. A new interpretation has been advanced for "Afflicted with Constipation" (cat. no. 13), whose face has been rendered as wracked with cramps (cat. no. 13). His mouth may have been stopped up with a magnet, which would mean the figure represented was being treated according to Mesmer's method. The same might also be true of "Grief Locked Up Inside" (cat. no. 14) and "The Ill-Humored Man" (figs 59, 60). Even "The Yawner" (cat. no. 12), who seems to be crying out in pain, might echo this therapeutic method. In "Quiet Peaceful Sleep" (cat. no. 9), Krapf conjectures an allusion to the healing sleep induced by Mesmer's treatment.

Mesmer had not practised and published his new therapeutic method until 1774. Nevertheless, it is inconceivable that the physician had not already experimented on it. Messerschmidt, who, after all, was in contact with Mesmer due to the commissions he had received from the physician, may well have been informed on those experiments and the underlying theoretical construct. Since the chronological

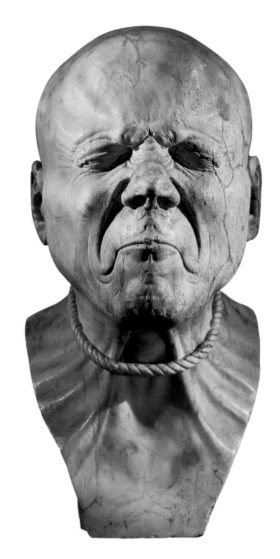

80 Franz Xaver Messerschmidt, Ein Erhängter, nach 1770, Alabaster, Österreichische Galerie Belvedere, Wien, Inv.-Nr. 5637
Franz Xaver Messerschmidt, A Hanged Man, after 1770, alabaster, Österreichische Galerie Belvedere, Vienna, Inv. no. 5637

Skulpturengruppe geschaffen;[58] zudem wohnten beide nur wenige Minuten Fußweg voneinander entfernt.[59] Ihre persönliche Beziehung könnte dazu geführt haben, dass sich Messerschmidt intensiver als mit anderen wissenschaftlichen Erkenntnissen mit der Heilmethode Mesmers auseinandersetzte. Bereits Albert Ilg, erster Biograph Messerschmidts, verstand 1885 »die wunderlichen Charakterköpfe Messerschmidt's als die künstlerischen Versinnlichungen der mannigfachsten Erscheinungen […], welche als sichtbare Ergebnisse der fluctuirenden Innervation im Menschenantlitz auftreten können«,[60] mithin als künstlerischer Ausdruck des von Mesmer so genannten animalischen Magnetismus. Die Auswirkungen des Magnetismus, der sich nur auf jene Körperteile beziehe, deren Harmonie gestört sei,[61] seien »bald ziehend, brennend, bald schneidend, zerreißend wie die rheumatischen [Schmerzen], und bald den elektrischen Schlägen gleich«.[62] Die Reaktionen der Patienten reichten von konvulsivischen Zuckungen bis zum schlafartigen Zustand.[63]

Während der Mesmer'schen Behandlung waren Hanfschnüre um die erkrankten Körperglieder der Patienten geschlungen, die die Erkrankten miteinander verbanden. Jeder war außerdem durch einen Eisenstab am erkrankten Körperteil mit einer magnetisierten Wanne verbunden.[64] Es sind mehrere Köpfe, die Michael Krapf als Beleg für seine These heranzieht, Messerschmidt habe sich mit Mesmers animalischem Magnetismus auseinandergesetzt. Dies sind zunächst: »Ein Gelehrter, Dichter« (Abb. 49, 53) und »Ein Erhängter« (Abb. 80).[65] Der Gelehrte trägt ein um den Kopf verknüpftes Seil, beim Erhängten liegt es um den Hals: Damit könnte Messerschmidt auf die erwähnten Hanfschnüre anspielen. Eine neue Deutung erfuhr der mit verkrampftem Gesicht wiedergegebene, mit Verstopfung Behaftete (Kat.-Nr. 13). Sein Mund ist möglicherweise mit einem Magneten verschlossen, mit dem der Dargestellte nach Mesmers Heilmethode behandelt wurde. Dasselbe könnte für »Innerlich verschlossener Gram« (Kat.-Nr. 14) und »Der Mismuthige« (Abb. 59, 60) gelten. Auch »Der Gähner« (Kat.-Nr. 12), der schein-

order of the Character Heads is not known, the Heads linked with mesmerism might possibly date from after 1774. Messerschmidt did, in fact, not leave Vienna until May 1775.

Further, Messerschmidt is suspected by Nicolai as being in the "society of people" who "boast of arcane knowledge, of associating with invisible spirits and having dominion over the forces of Nature", people who read "extremely stupid, enthusiastic books".[66] Nicolai is here alluding to the Freemasons, who adopted ancient Egyptian rites as the model for their own. To them, the Egyptian Hermes, meaning Hermes Trismegistos, was a "human being full of truth and science",[67] who had decoded the hieroglyphs that contained the knowledge and transmitted his knowledge. At the same time, he was credited with having founded the "science" of alchemy[68] and was equated

bar Schmerz herausschreit, könnte einen Reflex auf diese Heilmethode darstellen. Bei »Der sanfte ruhige Schlaf« (Kat.-Nr. 9) vermutet Krapf einen Hinweis auf den Heilschlaf, der der Behandlung durch Mesmer folgte.

Mesmer hatte seine neue Heilmethode zwar erst seit 1774 praktiziert und schriftlich niedergelegt. Es ist jedoch nicht vorstellbar, dass der Arzt nicht bereits vorher experimentierte. Der Künstler, der ja durch Bildhaueraufträge mit Mesmer in Kontakt stand, kann über diese Versuche und das zugrunde liegende gedankliche Konstrukt durchaus informiert gewesen sein. Da die chronologische Reihenfolge der Charakterköpfe nicht bekannt ist, wäre es zudem möglich, dass die mit dem Mesmerismus in Verbindung zu bringenden Köpfe nach 1774 entstanden, verließ Messerschmidt Wien doch erst im Mai des Jahres 1775.

Messerschmidt wird von Nicolai ferner in einer »Gesellschaft von Leuten« vermutet, »die sich geheimer Kenntnisse, des Umgangs mit unsichtbaren Geistern, und der Herrschaft über die Kräfte der Natur rühmen«, die »höchstdumme schwärmerische Bücher« läsen.[66] Damit spielt er auf Freimaurer an, die altägyptische Riten als Vorbild für die ihren übernahmen. Für sie war der ägyptische Hermes, mit dem Hermes Trismegistos gemeint ist, »wahrer und Wissenschaft voller Mensch«,[67] der die Hieroglyphen, die das Wissen enthielten, entschlüsselt und sein Wissen weitergegeben habe. Gleichzeitig galt er als Gründer der Alchemie[68] und wurde mit dem Gott der Weisheit und der Verwaltung, Thot, identifiziert, der seinerseits mit dem griechischen Gott Hermes verschmolz.[69]

Messerschmidt fügte möglicherweise Überlegungen zusammen, die Mesmer und die Freimaurer in ähnlicher Weise formulierten: Mesmer ging von einem universellen Fluidum aus, das Kosmos, Natur und Menschen verbände. Der Leitspruch der alchemistischen Naturauffassung, die Lehre von den Entsprechungen, lautete: »Alles, was in den oberen Sphären geschieht, wirkt auf die untere Welt und prägt sich ihr ein, alles auf Erden ist ein Abbild der Kräfte, die vom Himmel ausstrahlen.«[70]

Diese Lehre der Entsprechungen findet sich, auf den Körper und Kopf übertragen, bei Messerschmidt, Nicolai zufolge, wieder: Messerschmidt »kam auf den sehr wahren Satz: daß alle Dinge in der Welt ihre bestimmten Verhältnisse haben und daß alle Wirkungen ihren Ursachen entsprechen. [...] Es werde alles in der Welt durch die Proportionen regiert, und wer diejenigen Proportionen an sich erwecke, welche der Proportion des andern entsprächen oder ihr überlegen wären, müsse Wirkungen hervorbringen, welche der Wirkung des andern entsprechen, oder ihr überlegen seyn müßten. [...] Er bildete sich gleichfalls ein: das nämliche Verhältniß was sich am Haupte eines Menschen finde, sey auch über den ganzen Körper

with Thoth, deity of wisdom and administration, who in turn fused with the Greek god Hermes.[69]

Messerschmidt may possibly have merged thoughts formulated similarly by Mesmer and the Freemasons: Mesmer assumed a universal flux that linked the universe, nature and man. The alchemistic view of nature was summed up in the following motto: "Everything that happens in the upper spheres affects the nether world and, note, everything on earth is a copy of the forces radiating from Heaven."[70]

According to Nicolai, this doctrine of correspondences, applied to body and head, informs Messerschmidt's work: Messerschmidt "came up with the very true sentence: that all things in the world have their specific proportions and that all effects have their causes. [...] Everything in the world is governed by proportions and he who discovers those proportions in himself, which correspond to the proportions of another or may be superior to them, must bring forth effects which correspond to the effects of the other or must be superior to it [...] He also imagined: the very proportion [ratio] which is found in the head of a man also extends to the entire body"[71] It was evidently not clear to Nicolai just what those proportions were except that they derived from the drawing of an armless Egyptian stature. Whether it can be deciphered at all seems unlikely since Messerschmidt linked this system with research conducted on himself: "When he felt pains in his abdomen or in his thighs [...], he imagined that this came from his working at the time on the very place in the face of a marble or lead statue which corresponded by analogy to a specific place in the lower part of the body."[72]

The soul and feelings

The question of the soul and its "hidden stirrings" was a major 18th-century concern. Since God's right to read man's soul was disputed in the Enlightenment, since the 1760s especially both art and all the sciences linked the question of the constitution of the soul, its anatomical position and the diseases to which it was subject with the question of what might be the most profound inner truth about man.[73] Consequently, von Scheyb required that the passions of the soul should be the artist's main theme.

einzeln ausgebreitet.«[71] Worin die Proportionen bestanden, außer, dass sie sich an der Zeichnung einer armlosen, ägyptischen Statue orientierten, ist Nicolai offenbar nicht klar gewesen. Ob es überhaupt entschlüsselbar ist, scheint fraglich, verknüpfte Messerschmidt doch dieses System mit der Selbsterforschung: »Wenn er in seinem Unterleibe oder an seinen Schenkeln Schmerzen empfand […]; so bildete er sich ein, dieß käme daher, daß er an einem marmornen oder bleyernen Bilde gerade an einer Stelle des Gesichtes arbeitete, welche mit einer gewissen Stelle der untern Theile des Körpers analog wäre.«[72]

Seele und Gefühle

Die Frage nach der Beschaffenheit der Seele und nach ihren »geheimen Bewegungen« gehörte zu den Hauptanliegen des 18. Jahrhunderts. Da das Vorrecht Gottes, die Seele des Menschen zu lesen, in der Aufklärung bestritten wurde, stellten insbesondere seit den 1760er Jahren nicht nur die Künste, sondern alle Wissenschaften mit der Frage nach der Beschaffenheit der Seele, nach ihrem anatomischen Ort und ihren krankhaften Störungen zugleich die Frage nach der tiefsten, innersten Wahrheit des Menschen.[73] Entsprechend forderte von Scheyb, dass die Leidenschaften der Seele die Hauptgegenstände eines Künstlers ausmachen sollten.

Das Mienenspiel galt als Abbild der Gefühle, die die Seele eines Menschen bewegen.[74] Lichtenberg zufolge können wir »gar nichts von der Seele sehen wenn sie nicht in den Mienen sitzt, die Gesichter einer großen Versammlung von Menschen könnte man eine Geschichte der menschlichen Seele nennen. […] Die Seele legt, so wie der Magnet Feinstaub, so das Gesicht um sich herum.«[75] Von Scheyb formulierte im Jahr 1770 unter der Überschrift »Von den Wirkungen, so die Gemüthsbewegungen im Angesicht verursachen« nahezu identisch: »Es hat das Ansehn, daß der Kopf dem Ausdrucke der Leidenschaften am meisten das Leben und die Stärke mittheile. Die Züge des Angesichts scheinen die geheimen Bewegungen der Seele äußerlich zu offenbaren. […] Weil aber alle Theile des Angesichts sich verändern und rege gemacht werden, wenn die Seele bewegt wird; so müssen wir nun auch die verschiedenen Leidenschaften und ihre Wirkungen, die durch jene entstehn, untersuchen. Alle Handlungen der sinnlichen Begierden werden Leidenschaften genennet, in sofern sie die Seele dermaßen erregen, daß der Körper dadurch leidet und sich merklich verändert.«[76]

Künstler bemühten sich gleichfalls, dem wahren Wesen des Menschen durch Erkenntnisse über seine Gefühle näher zu kommen und es zur Darstellung zu bringen. Im 17. Jahrhundert teilte Charles Le Brun Gefühle in »passions simples« und »passions composées« ein und setzte sich mit dem »Einfluss [der Mimik] auf die

The facial expression was regarded as reproducing the feelings stirring a person's soul.[74] According to Lichtenberg, we cannot "see anything of the soul when it is not seated in the expressions; one might call the faces of a great assembly of men a history of the human soul. [...] As the magnet arranges fine dust, so does the soul arrange the face about itself."[75] In 1770 von Scheyb couched this thinking in almost identical terms under the heading "Von den Wirkungen, so die Gemüthsbewegungen im Angesichts verursachen" (Of the Effects which the Stirrings of the Emotions Cause in the Countenance): "It would appear that the head imparts the most liveliness and strength to the expression of the emotions. The facial features seem to reveal the hidden stirrings of the soul. [...] Because, however, all parts of the countenance change and can be agitated when the soul is stirred, we must now also examine the different passions and the effects which are produced by them. All acts of voluptuous lust are called passions in so far as they agitate the soul to the extent that the body suffers from this and changes perceptibly."[76]

Artists also strove to come closer to the true essence of man through knowledge of his feelings and to render their knowledge in visual terms. In the 17th century Charles Le Brun distinguished between feelings as "passions simples" and "passions composées" and thoroughly studied the "influence [of facial expression] proportionately to the human countenance."[77] In the 18th century, his treatise "Traité des passions" (1668) was still regarded as a penetrating scientific examination of the matter. On into the latter half of the century, artists and art theorists following Le Brun continued to be concerned with classifying and describing emotions and thus making the study and representation of them scientific. Claude-Henri Watelet (1718–1786) and Michel-François Dandré-Bardon (1700–1783) were two of the leading theorists. Comte de Buffon ordered and described the passions by the features marking their expression and distinguished between the direct expression of emotion and studied behaviour patterns. Treatises of this kind became very well known by being reprinted in numerous editions, being printed in other publications such as the "Encyclopédie" and through being translated.

81 James Parsons, Weiblicher Frauenkopf mit unterschiedlichen Gefühlsausdrücken, in: »Human Physiognomy Explain'd«, 1747
James Parsons, Head of a Woman Expressing Various Emotions, in: Human Physiognomy Explain'd, 1747

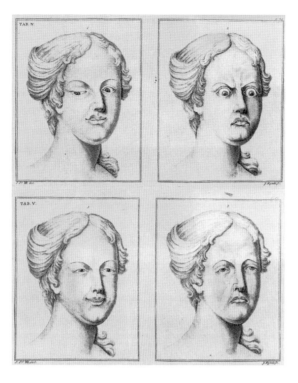

The theoretically oriented method increasingly encountered the "more practically oriented call for anatomical correctness in artistic reproduction of man and animals based on medical knowledge."[78] It was medical men, therefore, who were preoccupied with the question of structuring the passions and reproducing them with anatomical correctness. One of the first to do so was James Parsons (1705–1770), a physician who researched in the treatise "Human Physiognomy explain'd" (1747) into the mechanisms particular to the facial muscles and their precise dependence on the influence of emotion.[79] Since the muscles were "the instruments of every passion of the soul", his study was based on describing them.[80] Muscular action, that is, the passions, were invariably illustrated in the same female head (fig. 81). Parsons' thinking may have been transmitted to Messerschmidt by the anglophile art theorist von Scheyb, who is known to have received deliveries of books from London.[81]

 It also seems highly likely that Messerschmidt knew Le Brun's treatise since it was regarded as a standard work on the subject. And "characteristically, the French painter and theorist used mainly bald skull types as exemplifying in reduced form the range of human emotions,"[82] which also applies to numerous Messerschmidt Character Heads. They depict grimaces with which viewers can associate such emotions as anger, anxiety, earnestness, composure, grief or amusement although facial actions differ throughout and varying emotions are, therefore, combined.[83] Messerschmidt could draw on Le Brun even in thus linking divergent emotions. Le Brun had achieved "facial expression through the more or less mechanical interplay of individual parts of the face."[84] After 1750 the theory of "mixed emotions"[85] was further developed. It concerned, in connection with the impact made by pieces for the theatre, both the constant change in the illusion of emotion as shown by actors and disillusionment, that is, the spectator's realisation that what he was seeing was illusion rather than reality.[86]

 The sculptor must certainly have encountered such theories about the representation of the emotions through his academic training, his acquain-

proportionellen Verhältnisse des menschlichen Antlitzes gründlich auseinander«.[77] Noch im 18. Jahrhundert wurde seine Abhandlung »Traité des passions« (1668) als wissenschaftliche Durchdringung des Anliegens verstanden. Le Brun folgend bewegte die Frage nach der Kategorisierung und Beschreibung von Gefühlen und ihre dadurch erfolgende Verwissenschaftlichung die Künstler und Kunstschriftsteller bis in die zweite Hälfte des 18. Jahrhunderts. Zu bedeutenden Theoretikern gehörten zum Beispiel Claude-Henri Watelet (1718–1786) und Michel-François Dandré-Bardon (1700–1783). Comte de Buffon ordnete und beschrieb die Leidenschaften nach ihren Ausdrucksmerkmalen und unterschied den direkten Affektausdruck von den gelernten Verhaltensweisen. Durch mehrfache Auflagen, wiederholtes Abdrucken in anderen Publikationen, wie zum Beispiel in der Encyclopédie, und durch Übersetzungen erlangten derartige Schriften einen großen Bekanntheitsgrad.

 Das wissenschaftsorientiert theoretische Vorgehen traf immer häufiger auf das »mehr praxisorientierte Verlangen nach einer anatomischen Korrektheit der künstlerischen Wiedergabe von Menschen und Tieren, deren Grundlage medizinische Kenntnisse waren«.[78] Zunehmend waren es daher Mediziner, die sich mit der Frage nach der Strukturierung der Leidenschaften und ihrer korrekten anatomischen Wiedergabe beschäftigten. Einer der Ersten hierbei ist der Arzt James Parsons (1705–1770), dessen besonderes Forschungsinteresse in der Schrift »Human Physiognomy Explain'd« (1747) »die

besonderen Mechanismen der Gesichtsmuskeln und ihre genaue Abhängigkeit vom Einfluss des Gemüts« waren.[79] Da die Muskeln die »wahren Werkzeuge jeder Leidenschaften der Seele« seien, bildet ihre Beschreibung die Grundlage seiner Untersuchung.[80] Die verschiedenen Muskelbewegungen, das heißt Leidenschaften, werden von immer demselben weiblichen Kopf vor Augen geführt (Abb. 81). Die Überlegungen Parsons könnten Messerschmidt, vermittelt durch den anglophilen Kunstschriftsteller von Scheyb, von dem man weiß, dass er Bücherlieferungen aus London erhielt, bekannt gewesen sein.[81]

Es erscheint gleichfalls selbstverständlich, dass Messerschmidt die Abhandlung Le Bruns kannte, galt dieses Werk doch als Grundlagenwerk. Und »bezeichnenderweise verwendete der französische Maler und Theoretiker für die reduzierten Exempel der menschlichen Affektmöglichkeiten überwiegend unbehaarte Schädeltypen«,[82] was auch für zahlreiche Charakterköpfe Messerschmidts zutrifft. Die Köpfe zeigen Grimassen, mit denen der Betrachter beispielsweise Zorn, Angst, Ernst, Ruhe, Schmerz oder Amüsement assoziieren kann, obwohl fast durchgängig verschiedene Gesichtsbewegungen und damit verschiedene Empfindungen miteinander kombiniert sind.[83] Auch mit dieser Zusammensetzung voneinander divergierender Gefühle konnte sich Messerschmidt auf Le Brun berufen. Dieser hatte den »Ausdruck eines Gesichts durch das mehr oder weniger mechanische Spiel einzelner Gesichtsteile« erreicht.[84] Nach 1750 entwickelte sich die Theorie der »vermischten Empfindungen«[85] weiter. Sie hatten im Zusammenhang mit der Wirkung von Theaterstücken den fortdauernden Wechsel der Illusion eines Gefühls, wie es von Schauspielern gezeigt wurde, und der Desillusionierung, nämlich der Erkenntnis des Zuschauers, nicht Wirklichkeit, sondern Illusion zu sehen, zum Thema.[86]

Sicherlich war der Bildhauer durch die akademische Ausbildung, durch seine Bekanntschaft mit von Scheyb oder auch durch den Kontakt mit Mitgliedern der Académie de France in Rom mit Thesen zur Gefühlsdarstellung in Berührung gekommen. Die anhaltenden Diskussionen können Messerschmidt angeregt haben, sich des Themas ebenfalls anzunehmen. Informationen über die Verbindung bestimmter Köpfe mit bestimmten Gefühlen oder Gefühlskombinationen haben sich aber nicht erhalten; auch sind an den Köpfen benennbare Leidenschaften nicht abzulesen. Konkrete Bezüge also lassen sich zu den verschiedenen Ausprägungen der Leidenschaftsdarstellungen nicht herstellen, selbst wenn einzelne Gesichtszüge, wie beispielsweise die Mundbewegung von »Der kindisch Weinende« (Kat.-Nr. 19), bei Le Brun (Abb. 82) und Parsons präformiert sind. Zusammengekniffene Augen und zu einem Strich zusammengepresste Lippen, gelegentlich in einem Charakterkopf

tanceship with von Scheyb or even through contact to members of the Académie de France in Rome. The constant debates may have inspired Messerschmidt to deal with the subject himself. Information on the linkage of particular Character Heads with specific feelings or combinations of feelings has not come down to us; nor can specific passions be read from the Heads. As a result, specific links cannot be discovered to the various forms assumed by this representation of the passions even though the action of individual facial features, such as the action of the mouth of "Childisch Weeping" (cat. no. 19), were prefigured in Le Brun (fig. 82) and Parsons. Squinting eyes and lips compressed to a line, occasionally combined in one and the same Character Head, occur neither in Le Brun nor in any other writer who dealt with the representation of feelings. Consequently, the systems set up by artists, art theorists and theologians in the 18th century do not help to explain Messerschmidt's Heads. In view of the torment and pain depicted in the Character Heads, such theorising and systematisation seem academically pretentious and patently absurd. Messerschmidt was plumbing the depths, suffering and emotions which leave all theories behind. He has removed everything individual from his Character Heads. What remains are "universal human experiences".[87] We are left with the Head with its "hair style" or baldness, the bust and its pedestal as well as, and this is often profoundly disconcerting, the facial action.

Self-experimentation and systems

The physiognomy craze, the many writings on human feelings, the question of man's soul being copied in his face via the passions were debates that certainly did not pass Messerschmidt by. They may have induced him, on the one hand, to research into the most profound individual truth about his models in his portraits. On the other, they may have inspired him to attempt a system of the emotions himself. This seems all the more plausible since the systems he would have known evidently did not seem suitable to Messerschmidt for expressing his intentions. Hence he saw himself faced with the necessity of developing a personal system of his own by experimenting on himself.

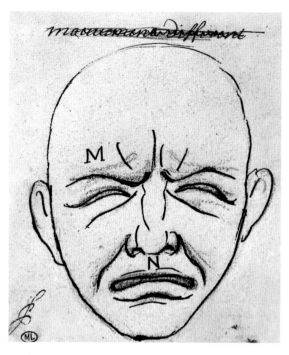

82 Charles Le Brun,
 Le Pleurer, um 1668,
 schwarze Kreide,
 Feder in Schwarz, auf
 weißgelbem Papier,
 Musée du Louvre, Paris,
 Inv.-Nr. 28309
 Charles Le Brun,
 The Weeper, c. 1668,
 black chalk and ink on
 cream paper, Musée du
 Louvre, Paris,
 Inv. no. 28309

kombiniert, finden sich weder bei Le Brun noch bei einem anderen Autor, der sich mit der Darstellung von Gefühlen beschäftigte. Die von Künstlern, Kunsttheoretikern, Medizinern, Theologen im 18. Jahrhundert erstellten Systeme taugen somit nicht, die Köpfe Messerschmidts zu erklären. Sie erscheinen angesichts der gezeigten Qualen und Schmerzen absurd, geradezu akademisch abgehoben. Messerschmidt lotet Abgründe, Leid und Emotionen aus, die jede Theorie hinter sich lassen. Er zieht in seinen Charakterköpfen alles Individuelle ab. Was bleibt, sind die »allgemein menschlichen Erfahrungen«.[87] Es bleibt der Kopf mit »Frisur« oder Kahlköpfigkeit, die Büste und sein Sockel, sowie, oft zutiefst verstörend, die Mimik.

Selbsterforschung und Systeme

Die Physiognomiewut, die zahlreichen Schriften über die Gefühle des Menschen, die Frage nach seiner Seele, die sich im Gesicht über

In the 18th century, experimenting on oneself, liberating oneself, thinking for oneself, educating oneself, loving oneself, being responsible for oneself, redeeming oneself were keywords in the way an individual saw himself or herself since the individual had been forced to create his own rules and truths in a defamiliarised world in which doubts about tradition and traditional norms were becoming rife.[88] Messerschmidt attempted to transmit to posterity a system he developed through observing in himself proportions and the correspondences between body and head. Attempts at systematisation and empirical verifiability both of recently discovered and long known phenomena were the foundation of scientific work in the 18th-century Enlightenment.[89] Artists were also urged to experiment on themselves by Johann Georg Meusel (1743–1880), a lexicographer and professor of history. He observed that "in Nature [there is] no still moment: our ideas and our sensations are in unceasing flux and must, therefore, change the state of the nerves with each [passing] instant."[90] Meusel concluded from this that the portrait painter should observe "the play of the muscles, on which the entire visible expression depends"[91] since the muscles reflected feelings and thoughts. Artists "who have experimented on themselves"[92] might confirm this.

Messerschmidt, too, attempted to systematise the knowledge he had gained in experimenting on himself and that he wanted to bequeath to posterity. Concentrating solely on the head would seem to make sense since, as Le Brun had put it: "Even though the language of the entire body is said to be one of the most perceptible signs", one could nevertheless limit oneself to the head, in which, as Apuleius affirmed, man showed himself in his entirety. If man was a microcosm of the world, the head was, as it were, an abbreviation for the entire body.[93]

Nicolai's account implicitly equates Messerschmidt's thoughts with Le Brun's conviction. The sculptor "also imagined that particular ratio which occurs in the head of a man also extends severally to the entire body. [...] The study of the physiognomy of every really existing human body rests on this"[94] and: "He rejoiced at his system and decided to set it down through reproductions of these grimacing relation-

die Leidenschaften abbildet, waren jedoch Diskussionen, die keinesfalls an Messerschmidt vorbeigingen. Sie könnten ihn bewogen haben, zum einen in seinen Porträts nach der tiefsten, individuellen Wahrheit seiner Modelle zu fragen. Zum anderen könnten sie ihn angeregt haben, sich selbst an einem System der Gefühle zu versuchen. Dies scheint umso plausibler, als die bekannten Systeme Messerschmidt offenbar als nicht geeignet schienen, seine Intentionen auszudrücken. So stand er vor der Notwendigkeit, mit Hilfe der Selbsterforschung sein ganz persönliches System zu entwickeln.

Selbsterforschung, Selbstbefreiung, Selbstdenken, Selbstbildung, Selbstliebe, Selbstverantwortung, Selbsterlösung waren im 18. Jahrhundert Schlüsselworte zum Selbstverständnis des Individuums, das gezwungen war, sich angesichts zunehmender Zweifel an der Tradition und an überkommenen Normen in einer fremd gewordenen Welt eigene Regeln und Wahrheiten zu schaffen.[88] Messerschmidt versuchte, die an sich wahrgenommenen Proportionen und die Entsprechungen zwischen Körper und Kopf in einem von ihm neu entdeckten System der Nachwelt zu überliefern. Derartige Versuche einer Systematisierung und empirischen Nachprüfbarkeit sowohl von neuen als auch von altbekannten Phänomenen waren die Grundlage der wissenschaftlichen Arbeit des aufklärerischen 18. Jahrhunderts.[89] Selbsterforschung wurde Künstlern auch von Johann Georg Meusel (1743–1880), Lexikograph und Geschichtsprofessor, nahegelegt. Er stellte fest, dass es »in der Natur keinen stehenden Moment [gebe]: unsre Vorstellungen und unsre Empfindungen sind in einem unaufhörlichen Flusse, und müssen folglich den Zustand der Nerven mit jedem Augenblick verändern.«[90] Er folgert daraus für den Porträtmaler, dass dieser »das Spiel der Muskeln, wovon der ganze sichtbare Ausdruck abhängt«,[91] zu beobachten habe, da sie die Empfindungen und Gedanken spiegelten. »Selbstforscher«[92] unter den Künstlern könnten dies bestätigen.

Auch Messerschmidt versuchte sich an einer Systematisierung seiner in Selbsterforschung gewonnenen Erkenntnisse, die er der Nachwelt überliefern wollte. Sich dabei nur auf den Kopf zu konzentrieren, lag nahe, hatte doch Le Brun formuliert: »Wenngleich man sagt, dass die Gebärde des ganzen Körpers eines der auffälligsten Zeichen sei«, könne man sich trotzdem auf die Zeichen des Kopfes beschränken, in denen der Mensch sich ganz zeige, wie schon Apuleius versichert habe. Wenn der Mensch eine verkleinerte Welt sei, so sei der Kopf gleichsam das Kürzel des ganzen Körpers.[93]

In dem Bericht Nicolais findet sich die Überzeugung Le Bruns als Überlegung Messerschmidts wieder. Der Bildhauer »bildete sich gleichfalls ein: das nämliche Verhältniß was sich am Haupte eines Menschen finde, sey auch über den ganzen Körper einzeln ausgebreitet. [...] Hierauf beruhet die Physiognomik eines jeden

ships and to bequeath it to posterity. In his opinion, there were 64 different versions of the grimace."[95]

Followed to its logical conclusion, this thought leads to the formation of series, for instance of a face which continues to change and reproduces different feelings and passions.

A large series and small groups

The "Heads" were regarded by earlier scholars, following Nicolai, as self-portraits. However, some of the skull forms and countenances differ so considerably that there can be no question of the overwhelming majority of the Heads being self-portraits. However, Messerschmidt formed groups of typologically similar heads; the "Beaked Heads" (fig. 83) represent only the most immediately obvious form of grouping.[96]

Since Antiquity, portraits of philosophers, ancestors and rulers had been variously grouped by similarity. The doctrine of the temperaments and companion pieces such as "Heraclitus" and "Democritus" also represented further developments of the serial theme. Series figure prominently in the 17th and 18th centuries as well: Le Brun assembled different heads in order to distinguish various feelings through the play of their features. Parsons did the same with the female head he kept using to demonstrate his theory. Groups of heads that changed were created by the painter, etcher and draughtsman Daniel Chodowiecki (1726–1801) with his 1777 sequence of "Der Fortgang der Tugend und des Lasters" (The Progress of Virtue and Vice).[97] Messerschmidt might have been made familiar with Hogarth engravings such as "Characters and Caricatures"[98] by von Scheyb. The painter Joseph Ducreux did a series of self-portraits in which the facial expression fluctuates between laughter, scepticism and suspicion (fig. 78).[99] Messerschmidt is likely to have been more familiar with Rembrandt's self-portraits, in which he deliberately tried out expressions, than with Ducreux's paintings.

Messerschmidt may have seen busts, such as those done by Orazio Marinali, in Italy, known as bravos, identified occasionally also as philosophers (Aristotle, Diogenes) and the gods of Antiquity (Apollo), although Marinali only hinted at the tra-

83 Franz Xaver Messer-
schmidt, Zweiter
Schnabelkopf, vor 1781,
Alabaster, Österreichi-
sche Galerie Belvedere,
Wien, Inv.-Nr. 5640
*Franz Xaver Messer-
schmidt, Second Beaked
Head, before 1781,
alabaster, Österreichische
Galerie Belvedere,
Vienna, Inv. no. 5640*

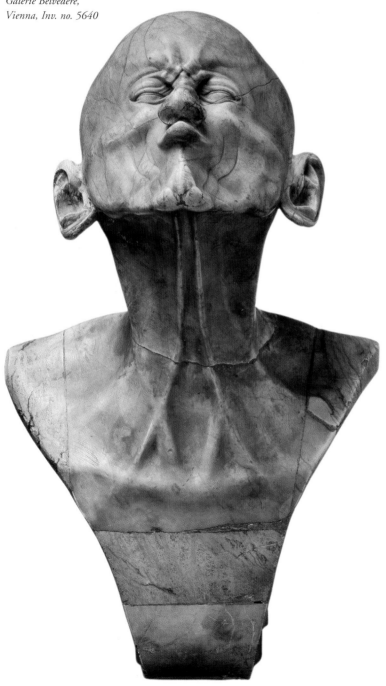

ditional iconography (figs. 76, 77).[100] These "bravos"
were also a guideline for Giovanni Giuliani, with his
series of busts (1707 / 08) for the choir stalls at Heili-
genkreuz Monastery south-west of Vienna (fig. 78, 91).
Hermits, philosophers, clergymen, rulers and scholars
are depicted in the busts, enveloped in sketchily indi-
cated drapery and set on "sections of bust tapering
markedly to a point at the bottom." This resulted in
"the physiognomy being emphasised."[101] The busts
depict expressive faces that reveal stirrings of the
emotions and concomitant facial actions. In the
curvilinear V-shaped contours of the tapering busts
and the occasionally exaggerated rendering of the
countenances with ornamentally stylised eyebrows
arching powerfully above the eyes, the deeply fur-
rowed wrinkles, sunken cheeks, eyelids that look like
cut-outs and the stylisation of the brows with hairs
that represent an abstract rendering of the natural
properties of hair as a substance are all features of the
Giuliani busts that may have confirmed the younger
Messerschmidt in his handling of his own Heads.
Among the Giuliani heads, a virtually bald old man,
whose head juts forward and whose chin is extended
by a beard on it, is strikingly reminiscent of Messer-
schmidt's Beaked Heads.

Messerschmidt portrait types with obviously
recurrent yet non-individualised features include
"The Noble-Minded Man" (cat. no. 18), whose facial
features are subjected to convulsive contortions in
another group of busts. It is the same hair style on
each of these heads that makes them obviously belong
to the "Noble-Minded Man" group.[102] The heads in
"The Difficult Secret" (cat. no. 15) und "A Strong
Man" (cat. no. 16, fig. 84) may, together with "A
Hypochondriac" und "The Incapable Bassoonist" as
well as "A Strong Worker" form a group of that kind.
A theme in variations on it is common to the follow-
ing works, which may allude to Mesmer's therapeutic
method: "A Scholar, Poet" (fig. 49, 53), "A Hanged
Man" (fig. 80), "Afflicted with Constipation" (cat. no.
13), "Grief Locked Up Inside" (cat. no. 14) and "An
Ill-Humored Man" (fig. 59, 60). "An Arch-Rascal"
(cat. no. 10), "The Weepy Old Man" (cat. no. 11),
"The Yawner" (cat. no. 12) and "The Ultimate Sim-
pleton" (cat. no. 17) may fit into a group that can be

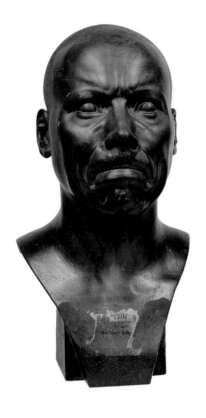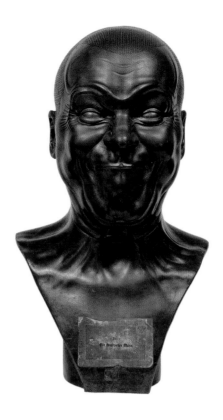

wirklich vorhandenen menschlichen Körpers.«[94] Sowie: »Er freuete sich seines Systems, und beschloß, es durch Abbildungen dieser grimassirenden Verhältnisse festzusetzen und auf die Nachwelt zu bringen. Seiner Meinung nach waren es 64 verschiedene Abänderungen der Grimassen.«[95]

Konsequent weitergedacht führt dies zur Bildung von Reihen beispielsweise eines Gesichts, das sich fortwährend verändert und verschiedene Gefühle und Leidenschaften zur Darstellung bringt.

Große Serie und kleine Reihen

Die »Köpfe« wurden in der älteren Literatur, Nicolai folgend, als Selbstbildnisse des Künstlers verstanden. Die Schädelformen und Physiognomien weichen aber zum Teil derart gravierend voneinander ab, dass in der überwiegenden Mehrzahl der Köpfe von Selbstbildnissen nicht die Rede sein kann. Allerdings bildete Messerschmidt Reihen von typologisch einander ähnlichen Köpfen; die »Schnabelköpfe« (Abb. 83) stellen dabei nur die auffallendste Form von Pendantbildung dar.[96]

Seit der Antike wurden unterschiedlich gruppierte Philosophen-, Ahnen- und Herrscherbildnisse zu gleichartigen Reihen zusammengestellt. Temperamentenlehre und Pendants wie »Heraklit« und »Demokrit« führten gleichfalls das Thema der Serie weiter. Auch im 17. und 18. Jahrhundert fielen, wie gezeigt, Serien auf: Le Brun stellte unterschiedliche Köpfe zusammen, um anhand ihrer Mimik verschiedene Gefühle zu differenzieren. Dasselbe stellte Par-

associated with a – painful? – movement. And the Character Heads derived from ancient models may form another of these groups. However, the Heads sometimes seem to "change places": the Frankfurt "Bust of A Bearded Old Man" (cat. no. 5) can, like "A Grievously Wounded Man" (cat. no. 6), stand for both Messerschmidt's reception of Antiquity and his criticism of wigs as well as his criticism of the study of physiognomy. The "Scholar, Poet", who has a rope round his head, could, on the other hand, change from the Mesmer group to the group of works representing their creator's reception of Antiquity if the rope was meant to serve as an ironic response to Ptolemaic and other royal and imperial fillets. This "modular principle" only works when the entire series, as far as it can be reconstructed, is looked at as a whole so that new groups can continue to form.

Fantastic Heads

This is what makes Messerschmidt's series quintessentially different from previously created groups or series that served didactic allegorical purposes or celebrated groups of ancestors or rulers and, therefore, were limited to a particular content. Nicolai did record that Messerschmidt wanted to demonstrate a

sons an einem immer wiederkehrenden Frauenkopf dar. Reihen von sich verändernden Köpfen schuf der Maler, Radierer und Zeichner Daniel Chodowiecki (1726–1801) mit seiner Folge »Der Fortgang der Tugend und des Lasters« von 1777.[97] Stichwerke von Hogarth wie die Radierung »Charaktere und Karikaturen«[98] könnte Messerschmidt über von Scheyb kennengelernt haben. Der Maler Joseph Ducreux schuf eine Reihe von Selbstbildnissen, in denen der Gesichtsausdruck zwischen Lachen, Skepsis und Misstrauen changiert (Abb. 78).[99] Eher als die Gemälde Ducreux' waren Messerschmidt die Selbstbildnisse Rembrandts (1606–1669) bekannt, in denen dieser Gesichtsausdrücke geradezu durchprobiert.

Büsten beispielsweise von Orazio Marinali konnte Messerschmidt in Italien gesehen haben: die so genannten Bravos, unter denen gelegentlich Philosophen (Aristoteles, Diogenes) wie antike Göttergestalten (Apoll) erkannt werden, wobei sich Marinali nur andeutungsweise auf die überkommene Ikonographie bezog (Abb. 76, 77).[100] An diesen »Bravos« orientierte sich Giovanni Giuliani mit einer um 1707/08 entstandenen Büstenreihe für das Chorgestühl des Klosters Heiligenkreuz (Abb. 78, 91), südwestlich von Wien gelegen. Eremiten, Philosophen, Kleriker, Herrscher und Gelehrte werden in Büsten gezeigt, umweht von knapp gehaltener Draperie und auf »nach unten betont schmal konzipierten Büstenausschnitten« aufgesetzt. Dadurch wird eine »verstärkte Präsenz der Physiognomie« erzielt.[101] Die Büsten zeigen ausdrucksstarke Gesichter, die emotional und körperlich bewegt sind. Sowohl die in geschwungener Kontur V-förmig sich verjüngenden Büsten als auch die gelegentlich übertrieben wirkende Ausgestaltung der Physiognomien mit ornamental gestalteten Augenbrauen, die sich mächtig über den Augen wölben, tief eingefurchte Falten, eingefallene Wangen, wie ausgeschnitten wirkende Augenlider oder auch von natürlicher Haarqualität abstrahierende Brauengestaltung könnten den jüngeren Bildhauer in seiner Gestaltung gestützt haben. Insbesondere fällt ein nahezu kahlköpfiger Alter auf, dessen Hals sich nach vorne reckt und dessen Kinn, durch einen Kinnbart verlängert, vorgestreckt ist und deutlich an die Schnabelköpfe Messerschmidts erinnert.

Zu Porträttypen mit scheinbar wiedererkennbaren, jedoch nicht individuellen Zügen zählt »Der Edelmüthige« (Kat.-Nr. 18), dessen Gesichtszüge in einer Reihe weiterer Büsten konvulsivischen Verzerrungen unterworfen sind. Vor allem dieselbe Frisur dieser Köpfe macht ihre Zugehörigkeit zur Gruppe des Edelmüthigen deutlich.[102] Auch die Köpfe von »Das schwere Geheimnis« (Kat.-Nr. 15) und »Ein kraftvoller Mann« (Kat.-Nr. 16, Abb. 84) könnten zusammen mit »Ein Hipochondrist« und »Der unfähige Fagotist« sowie »Ein starker Arbeiter« eine derartige Reihe bilden. Ein gemeinsames Thema variieren die Werke, die sich möglicherweise auf Mesmers Heil-

system with 64 heads; the series may, therefore, have been subordinated to an overarching ordering principle. Stylistically, too, the heads form an aesthetic whole. One of the most striking features of the Messerschmidt series is its "freedom" and lack of constraint: within the overarching context of the series, smaller groups or pairs of companion pieces can emerge, which are defined by content, for instance, in respect of reception of artistic tradition (cat. nos. 4–9) or variation on a particular head type (cat. nos. 18–20). These groups are not rigid and compulsory. They do not simply represent variations on a particular theme but rather overlap and supplement each other.

In the dissolubility and multiple ambiguity of possible "groupings", Messerschmidt has applied the stylistic principles informing the Character Heads to the series as such: in the groups, facial expression and style are distinguished by a disturbing quality, (implicit) criticism, ambiguity, the dissolution of traditional motif configurations as well as an enigmatic quality. Messerschmidt has made the naturalness of the bust section in the "prototype" ridiculous with his base block; in other cases, he has eschewed any trace of recognisable carnation in his modelling of the breast section. Anomalies in the configuration of the physiognomy often owe a debt to empirically observed reality – and nonetheless look unreal and grotesque. Moreover, the artist has combined facial actions which cannot possibly be performed synchronously although each, taken alone, is natural: no real body system can still function here.

A stubbly hair style rendered in line is occasionally laid like a hairnet above sculpturally rendered parts such as the skull; wrinkled folds are demarcated by harsh grooves and reveal the physical properties of a stiff fabric rather than those of soft flesh (cat. no. 13d). The sculptor has often practised his repertory of forms in a single bust, playing with a vexing optical illusion with its full gamut of stylistic possibilities and thus enhancing the tension and the disturbing as well as the enigmatic qualities of the Heads.

Another notable feature is his associative method: The Frankfurt Head (cat. no. 5) is clearly reminiscent of Socrates but is not a portrait of him. The "wings" of "A Grievously Wounded Man"

methode beziehen lassen: »Ein Gelehrter, Dichter« (Abb. 49, 53), »Ein Erhängter« (Abb. 80), »Ein mit Verstopfung Behafteter« (Kat.-Nr. 13), »Innerlich verschlossener Gram« (Kat.-Nr. 14) und »Der Mismuthige« (Abb. 59, 60). »Ein Erzbösewicht« (Kat.-Nr. 10), »Der weinerliche Alte« (Kat.-Nr. 11), »Der Gähner« (Kat.-Nr. 12) und »Die Einfalt im höchsten Grade« (Kat.-Nr. 17) könnten sich in eine Reihe einfügen, die eine – schmerzhafte? – Bewegung assoziieren lassen. Und auch die sich auf antike Werke als Vorbilder beziehenden Charakterköpfe könnten eine solche Reihe bilden. Gelegentlich aber scheinen die Köpfe ihre »Plätze zu tauschen«: Die Frankfurter »Büste eines bärtigen, alten Mannes« (Kat.-Nr. 5) kann ebenso wie »Ein schmerzhaft stark Verwundeter« (Kat.-Nr. 6) nicht nur für Antikenrezeption oder Perückenkritik stehen, sondern ebenso für Kritik an der Physiognomik. Der Gelehrte, der eine Kordel um den Kopf gelegt hat, könnte dagegen aus der Mesmer-Reihe zur Gruppe der die Antike rezipierenden Werke überwechseln, sollte die Kordel als ironische Replik auf ptolemäische, herrscherliche Haarbinden dienen. Dieses »Baukastenprinzip« funktioniert allerdings nur dann, wenn die gesamte Serie, sofern sie zu rekonstruieren ist, in den Blick genommen wird, um immer wieder neue Reihen zu bilden.

Phantastische Köpfe

Damit unterscheidet sich Messerschmidts Serie im Kern von den bis dahin geschaffenen Reihen oder Serien, die belehrenden, allegorischen Zwecken dienten oder Ahnen- oder Herrscherreihen feierten und somit auf bestimmte Inhalte festgelegt waren. Zwar ist durch Nicolai überliefert, dass Messerschmidt mit 64 Köpfen ein System darlegen wollte, die Serie also möglicherweise einem übergeordneten Ordnungsprinzip geschuldet war. Auch ihre formale Gestaltung bindet die Köpfe zu einem Ganzen zusammen. Eines der herausstechendsten Merkmale ist aber die »Freiheit« und Ungebundenheit der Messerschmidt'schen Serie: Innerhalb des großen Serienzusammenhangs können kleinere Reihen- oder Pendantbildungen erfolgen, die inhaltlich definiert sind, zum Beispiel was die Beschäftigung mit der künstlerischen Tradition (Kat.-Nr. 4–9) oder die Variation eines bestimmten Kopftypus (Kat.-Nr. 18–20) betrifft. Diese Reihen sind nicht starr und bindend. Sie variieren nicht jeweils nur ein bestimmtes Thema, sondern überschneiden und ergänzen sich.

Mit der Auflösbarkeit und Mehrdeutigkeit möglicher »Reihen« überträgt Messerschmidt somit die Gestaltungsprinzipien der Charakterköpfe auf die Serie: Irritation, (versteckte) Kritik, Ambiguität, die Auflösung von traditionellen Motivgefügen sowie Rätselhaftigkeit zeichnen die Reihen ebenso wie die Gesichtsausdrücke und die formale Gestaltung aus. So führt Messerschmidt beispielsweise die Natürlichkeit der Büstenausschnitte beim »Prototyp«

(cat. no. 6) recall at first sight ancient Egyptian wigs but the impression disappears on closer inspection. Messerschmidt has detached traditional motifs from their contexts and put them together in new ones: this can also be seen in a bust such as "Quiet Peaceful Sleep" (cat. no. 9). Closed eyes are depicted, which generally indicate relaxed sleep or death. At the same time, this figure's locks of hair are leading an unruly life of their own. This is a feature that traditionally tends to suit representations such as Damnation screaming or engravings after Le Brun's "Le Désespoir" (fig. 67).[103] The screaming head ("The Yawner", cat. no. 12), on the other hand, wears his hair in a rigid "hairnet", which would harmonise better with a composed head type. The associative method also informs the various groupings within the series.

Messerschmidt has often been described as quite uneducated. Among the evidence cited as proof of this is that he only owned one book. Nicolai, however, explains that Messerschmidt sold "all his art things, drawings, engravings, books" in 1774.[104] Should this really have been the case, Messerschmidt's education, and, after all, he did serve a complete apprenticeship in sculpture and completed a course of training at the Academy, is revealed in an altogether different light.[105] Nor does the sculptor's œuvre suggest that he was uneducated: the analysis of the Character Heads has shown that Messerschmidt created a cosmos of his own, drawing on inspiration from ancient art and post-Antiquity, from science, the debate on the emotions and the thinking of Freemasonry. He was ironical about Baroque art, used motifs from Antiquity and later periods, dissolved traditional motif configurations, only to fit them together in a disturbing manner in new compositions. Messerschmidt defies all explanatory paradigms; his reception of his models is refracted through multiple lenses.

The soul as a part of man, whose precise anatomical location was always being sought in the 18th century, leaves its stamp, thus the variously expressed conviction in the age of Enlightenment, on the face in the form of facial expression. The animation of the face is therefore, indissolubly linked with the stirrings of the disembodied soul.[106] Consequently, it is not necessary to end the contortions of the

durch den Sockelkubus ad absurdum; in anderen Fällen wird bei der Modellierung des Brustausschnitts auf jede wiedererkennbare Fleischlichkeit verzichtet. Abnorm wirkende Verformungen der Physiognomie sind oft der beobachteten Wirklichkeit geschuldet – und wirken dennoch irreal und grotesk. Der Künstler kombiniert zudem Bewegungen, die gleichzeitig unmöglich auszuführen, die jeweils für sich aber natürlich sind: Kein Körpersystem kann hier noch funktionieren.

Über plastisch sich wölbenden Partien wie dem Schädel liegt gelegentlich eine graphisch gestaltete Stoppelhaarfrisur wie ein Haarnetz; Faltenwülste sind durch harte Rillen voneinander getrennt und weisen eher die Materialqualität schwer knickenden Stoffes als weichen Fleischs auf (Kat.-Nr. 13d). Oft exerziert der Bildhauer in einer Büste sein Formenrepertoire durch, spielt ein Verwirrspiel mit seinen gestalterischen Möglichkeiten und erhöht damit die Spannung, Irritation und Rätselhaftigkeit der Köpfe.

Auch fällt als wesentlich seine assoziative Methode auf: Der Frankfurter Kopf (Kat.-Nr. 5) erinnert deutlich an Sokrates, porträtiert ihn aber nicht. Die »Flügel« des schmerzhaft stark Verwundeten (Kat.-Nr. 6) erinnern auf den ersten Blick an altägyptische Perücken, nehmen diesen Eindruck aber beim zweiten Blick zurück. Messerschmidt löst traditionelle Motive aus ihrem Zusammenhang und fügt sie in einen neuen Kontext: Dies ist auch bei einer Büste wie »Der sanfte ruhige Schlaf« (Kat.-Nr. 9) zu sehen. Gezeigt sind geschlossene Augen, was gemeinhin auf entspannten Schlaf oder Tod schließen lässt. Gleichzeitig führen seine Haare ein bewegtes Eigenleben. Dies passt traditionell wiederum eher zu Darstellungen wie der schreienden Verdammnis oder zu Stichen nach Le Bruns »Le Désespoir« (Abb. 67).[103] Der schreiende Kopf (»Der Gähner«, Kat.-Nr. 12) hingegen trägt eine starre Haarnetz-Frisur, was eher mit einem ruhigen Kopftypus harmonieren würde. Auch die Reihen sind somit durch die Methode der Assoziation geprägt.

Messerschmidt wird häufig als wenig gebildet geschildert. Als Beleg wird unter anderem angeführt, dass er nur ein Buch besessen habe. Nicolai aber führte aus, dass Messerschmidt 1774 »alle seine Kunstsachen, Zeichnungen, Kupferstiche, Bücher«[104] verkauft habe. Sollte dies tatsächlich der Fall gewesen sein, erscheint die Bildung Messerschmidts, der ja eine Bildhauerlehre und eine akademische Ausbildung absolviert hatte, in einem anderen Licht.[105] Auch das Œuvre des Bildhauers spricht nicht für mangelnde Bildung: Die Analyse der Charakterköpfe zeigte, dass Messerschmidt aus Anregungen aus der antiken und nachantiken Kunst, aus der Wissenschaft, der Diskussion um Gefühle und aus freimaurerischem Gedankengut einen eigenen Kosmos schuf. Er ironisierte die barocke Kunst, nutzte Motive der Antike und Nachantike, löste traditionelle

facial features where anatomy would set the natural boundaries of the grimace. Messerschmidt reveals truth and naturalness transcending the simplicity called for by such art theorists as von Scheyb, Nicolai and especially Winckelman: namely man as an emotional being, in all his ambivalence and the authenticity of the play of facial expression that is unceasingly changing.[107] The viewer, exposed to the suggestive, elemental powers of these expressive Heads, is challenged to discover their meaning, which, when found, must immediately be questioned. These works promote his "sensitisation, but also [lead] him to the threshold behind which it grows dark."[108]

"A Grievously Wounded Man" (cat. no. 6) is not the only work that speaks clearly of Messerschmidt's fascination with Egyptian sculpture. All the Character Heads have on occasion been called "Egyptian Heads".[109] Egyptomania was an influential movement in 18th-century Vienna. One high point is Mozart's "The Magic Flute", another is Freemasonry, which invokes ancient Egypt as its model. The hieroglyphs were among the great "Egyptian secrets": "Hieroglyph is the term used for a pictorial symbol, whose original meaning had entirely or partly been forgotten but it was nevertheless an element of a living language of forms that could be creatively further developed."[110] Taking "The Magic Flute" as an example, Jan Assmann describes the hieroglyph as an aesthetic principle. "Understanding [the opera] *qua* hieroglyph does not mean interpreting it but rather eschewing interpretation, at least in the sense of simple, exhaustive interpretation. A hieroglyph is an ambiguous aesthetic form."[111]

Messerschmidt's entire series can also be interpreted as a "hieroglyph" in that sense. After all, despite all the interpretations that are possible for individual Heads, which can even be grouped as occasion arises, the series taken as a whole is highly unlikely to unveil its mysteries unless new documents are found that explain it beyond all doubt. Franz Xaver Messerschmidt's Heads reveal the artist's consummate mastery of his medium and remain disturbing, ambiguous, unreal, deceptive: fantastic.

Motivgefüge auf und fügte sie auf irritierende Weise zu neuen Kompositionen zusammen. Messerschmidt bricht aus allen Erklärungsmustern aus, rezipiert seine Vorbilder nicht ungebrochen.

Die Seele als Teil des Menschen, nach dessen Ort im 18. Jahrhundert immer wieder gesucht wurde, drückt, so die vielfach geäußerte Überzeugung im Zeitalter der Aufklärung, dem Gesicht ihren Stempel in Form der Mimik auf. Unlösbar miteinander verbunden, ist die Lebendigkeit des Gesichts also der Bewegung der körperlosen Seele geschuldet.[106] Insofern ist es nicht notwendig, dass die Verzerrungen der Gesichtszüge da enden, wo die Anatomie den Grimassen ihre natürlichen Grenzen setzen würde. Messerschmidt zeigt Wahrheit und Natürlichkeit jenseits der von Kunsttheoretikern wie von Scheyb, Nicolai oder auch Winckelmann geforderten Einfachheit: nämlich den Menschen in seiner Gefühlhaftigkeit, Mehrdeutigkeit und Authentizität des bewegten, sich fortwährend verändernden Mienenspiels.[107] Der Betrachter wird, der suggestiven, elementaren Ausdruckskraft der Köpfe ausgeliefert, zu einer Sinngebung aufgefordert, die er jedoch sofort wieder in Frage stellen muss. Die Werke treiben seine »Sensibilisierung voran, [führen] ihn aber auch bis zu der Schwelle, hinter der es dunkel wird«.[108]

Nicht nur »Ein schmerzhaft stark Verwundeter« (Kat.-Nr. 6) spricht, was Messerschmidts Faszination durch ägyptische Bildwerke betrifft, eine deutliche Sprache. Gelegentlich gar werden alle Charakterköpfe als »egyptische Köpfe« bezeichnet.[109] Die Ägyptomanie war im Wien des 18. Jahrhunderts eine einflussreiche Strömung. Ein Höhepunkt ist Mozarts »Zauberflöte«, ein anderer das sich auf das ägyptische Vorbild berufende Freimaurertum. Zu den großen »egyptischen Geheimnissen« gehörten unter anderem die Hieroglyphen: »Die Hieroglyphe bezeichnete ein bildhaftes Symbol, dessen ursprünglicher Sinn ganz oder teilweise in Vergessenheit geraten war und das trotzdem Element einer lebendigen und kreativ weiterzuentwickelnden Formensprache war.«[110] Jan Assmann beschreibt am Beispiel der Zauberflöte die Hieroglyphe als ästhetisches Prinzip. Die Zauberflöte »als Hieroglyphe verstehen heißt, nicht sie deuten, sondern auf eine Deutung, zumindest im Sinne der einfachen und erschöpfenden Ausdeutung, zu verzichten. Eine Hieroglyphe ist eine ästhetische Form mit doppeltem Boden.«[111]

Auch die gesamte Serie Messerschmidts kann in diesem Sinn als »Hieroglyphe« verstanden werden. Denn trotz aller möglichen Interpretationen einzelner Köpfe, die gelegentlich sogar in Reihen zusammenzufassen sind, wird die Serie in ihrer Gesamtheit, sollten nicht neue Dokumente auftauchen, die sie zweifelsfrei erklären, ihre Rätsel kaum enthüllen. Die Köpfe des Franz Xaver Messerschmidt offenbaren die große Meisterschaft des Künstlers und bleiben irritierend, mehrdeutig, unwirklich, trügerisch: phantastisch.

1 Beck 1985, p. 130.
2 Thus Geyer-Kordesch 1985, p. 17; see also Bückling 1999a, pp. 61–65.
3 See Bückling 1999b, pp. 102f.; Bückling 2002, pp. 78f.
4 Maaz 2001, p. 27.
5 Another Head that confronts the Baroque tradition of wigs is "Just Rescued from Drowning" (fig. 69).
6 Boehn 1969, p. 70.
7 Thus Kuéss / Scheichelbauer 1959, p. 47.
8 Born in 1784, pp. 89f. A satirical work by Born was published anonymously in 1772: "Die Staatsperücke", according to Abafi 1891, Vol. 2, pp. 123f.
9 Thus Jedding-Gesterling / Brutscher 1988, p. 128.
10 Möller / Domnick 1986, p. 48; also see Wolf 1952, pp. 111–113.
11 Thus Jedding-Gesterling / Brutscher 1988, p. 137.
12 Ibid., p. 148.
13 Boehn 1969, p. 69f. On dressing the hair, see Wolf 1952, p. 105f.
14 Thus Jedding-Gesterling / Brutscher 1988, p. 126.
15 Boehn 1969, p. 69. Messerschmidt himself may have had three wigs: In the inventory of his chattels, there is an entry for: "3 regular cowls with bows" (quoted in Pötzl-Malíková 1996, p. 220); this might mean wigs fitted out with bows or hairnets.
16 Also Kleinert 1995, p. 302; Loschek 2005, p. 398.
17 Cillessen 1995, p. 273; also Karner 2001, p. 43. In Goethe's Faust (Part 1), the writer has Mephistopheles say to Faust: "You are in the end – what you are. / Set wigs of a million locks on your head, / Put your foot on stockings ells in length, / You still always remain what you are", see Goethe 1996, p. 60.
18 See the explanation given by Dillmann in the caption to "The Five Orders of Periwigs" in: exhib. cat. Hogarth 1998, p. 98; there quoted on p. 220–221.
19 Jäger 1975, p. 59.
20 See Pötzl-Malíková 1982, p. 218.
21 Shortly after his journey, the "Wienerisches Diarium" of 6 May 1767 reported on it; on the journey to Rome, see also Nicolai Reprint 1994, pp. 402f.
22 For Messerschmidt copying a Hercules in Rome, see Nicolai Reprint 1994, pp. 402f.
23 See Pötzl-Malíková 1982, "Farnese Hercules" see p. 223 (cat. no. 11); "Dying Gaul" see p. 223, cat. no. 12; "Borghese Fencer" see p. 223 (cat. no. 13); "Apollo" see pp. 223f. (cat. no. 14).
24 Thus Pötzl-Malíková 1982, p. 229.
25 Ibid., pp. 43f.
26 See cat. no. 1.
27 See Pötzl-Malíková 1982, pp. 233f.
28 Also see Bückling 2006, p. 180f.
29 Shown in Bol 2004, fig. 29.
30 Nicolai Reprint 1994, p. 416.
31 See West 1933, fig. 51.
32 Ibid., fig. 49.
33 Shown in: Andreae 1995, Part Vol. 1, pp. 52, 58. Also see Schweitzer 1948, figs. 91–93, 171.

1 Beck 1985, S. 130.

2 So Geyer-Kordesch 1985, S. 17; siehe auch Bückling 1999a, S. 61–65.

3 Dazu siehe Bückling 1999b, S. 102–103; Bückling 2002, S. 78–79.

4 Maaz 2001, S. 27.

5 Mit der barocken Tradition der Perücke setzt sich auch der Kopf »Ein aus dem Wasser Geretteter« (Abb. 69) auseinander.

6 Boehn 1969, S. 70.

7 So Kuéss / Scheichelbauer 1959, S. 47.

8 Born 1784, S. 89–90. Von Born erschien, anonym, im Jahr 1772 ein satirisches Werk: »Die Staatsperücke«, so Abafi 1891, Bd. 2, S. 123–124.

9 So Jedding-Gesterling / Brutscher 1988, S. 128.

10 Möller / Domnick 1986, S. 48; dazu siehe auch Wolf 1952, S. 111–113.

11 So Jedding-Gesterling / Brutscher 1988, S. 137.

12 So Jedding-Gesterling / Brutscher 1988, S. 148.

13 Boehn 1969, S. 69–70. Zur Herstellung einer Frisur siehe Wolf 1952, S. 105–106.

14 So Jedding-Gesterling / Brutscher 1988, S. 126.

15 Boehn 1969, S. 69. Auch Messerschmidt besaß möglicherweise drei Perücken: In der »Specification deren Meßerschmidischen Mobilien« findet sich der Eintrag: »3 St. ord. Schlaufhauben« (zitiert nach Pötzl-Malíková 1996, S. 220); damit könnten Perücken gemeint sein, die mit Schleifen oder Haarbeuteln versehen waren.

16 Dazu auch Kleinert 1995, S. 302; Loschek 2005, S. 398.

17 Cilleßen 1995, S. 273; dazu auch Karner 2001, S. 43. In Goethes Faust (Teil 1) lässt der Schriftsteller Mephistopheles zu Faust sagen: »Du bist am Ende – was du bist. / Setz dir Perücken auf von Millionen Locken, / Setz deinen Fuß auf ellenhohe Socken, / Du bleibst doch immer, was du bist.«, siehe Goethe HA 1996, S. 60.

18 Dazu siehe die Erläuterung von Dillmann in der Bildlegende zu »Die fünf Perückenordnungen«, in: Ausst.-Kat. Hogarth 1998, S. 98, hier zitiert auf S. 220–221.

19 Jäger 1975, S. 59.

20 Dazu siehe Pötzl-Malíková 1982, S. 218.

21 Kurz nach seiner Reise schrieb darüber das »Wienerische Diarium« am 6. Mai 1767; zur Romreise ebenfalls Nicolai Reprint 1994, S. 402–403.

22 Zur Kopie eines Herkules durch Messerschmidt in Rom siehe Nicolai Reprint 1994, S. 402–403.

23 Dazu siehe Pötzl-Malíková 1982, »Herkules Farnese« siehe S. 223 (Kat.-Nr. 11); »Sterbender Gallier« siehe S. 223 (Kat.-Nr. 12); »Borghesischer Fechter« siehe S. 223 (Kat.-Nr. 13); »Apollo« siehe S. 223–224 (Kat.-Nr. 14).

24 So Pötzl-Malíková 1982, S. 229.

25 So Pötzl-Malíková 1982, S. 43–44.

26 Dazu siehe Kat.-Nr. 1.

27 Dazu Pötzl-Malíková 1982, S. 233–234.

28 Dazu auch Bückling 2006, S. 180–181.

29 Abb. siehe Bol 2004, Abb. 29.

30 Nicolai Reprint 1994, S. 416.

31 Siehe West 1933, Abb. 51.

32 Siehe West 1933, Abb. 49.

33 Abb. siehe in: Andreae 1995, Teilband 1, S. 52, 58. Siehe auch Schweitzer 1948, Abb. 91–93, 171.

34 Lehner-Jobst (2002, S. 98) konstatiert ein »ägyptisches Interesse«, das zu den Schnabelköpfen führte, und verweist auf Krapf 1995, S. 51–55.

35 Nicolai Reprint 1994, S. 405.

36 Nicolai Reprint 1994, S. 411. Auf Anwürfe wie den Nicolais antwortet Born 1784, S. 72.

34 Lehner-Jobst (2002, p. 98) confirm an "Egyptian interest" which led to the Beaked Heads and refer to Krapf 1995, pp. 51–55.

35 Nicolai Reprint 1994, p. 405.

36 Ibid., p. 411. Born replies to accusations such as those made by Nicolai: Born 1784, p. 72.

37 Quoted in Ilg 1885, p. 76. Also see Kris 1932, p. 203.

38 Dillmann, captions to "The Five Orders of Periwigs", in: exhib. cat. Hogarth 1998, p. 98.

39 See Promies 1992, p. 310.

40 See Maek-Gérard 1982, p. 6, p. 8.

41 Most recently Krapf, Katalog 2002, p. 178.

42 See Thieme-Becker, Vol. 10, p. 46. In 1769 the painter was sent to Vienna to paint the portrait of Archduchess Marie-Antoinette. He stayed for several years. "D. loved to caricature himself with strange contortions, laughing, yawning or in simulated states of emotion." Engravings were done of three of these self-portraits in 1791: called "Le Moquer" ["The Mocker"] or "Le Rieur" ["The Laughing Man"] (1782), "Le Joueur" ["The Gambler"] and "Le Discret" ["The Discreet Man"].

43 For inspiration that postdated Antiquity, also see Krapf, Characterköpfe 2002, pp. 53–55; Pfarr 2006, p. 393.

44 See p. 256–259 in the present catalogue.

45 Pictured in Weinberger 1930, p. 191.

46 Ibid., pp. 191–193.

47 Pictured in Hàmori 1994, p. 3.

48 Quoted in Sauerländer 1989, p. 16.

49 Johann Caspar Lavater, Physiognomische Fragmente zur Beförderung der Menschenkenntniss und Menschenliebe, Leipzig / Winterthur 1775–1778.

50 Ohage 1990, p. 33.

51 See Arburg 1999, pp. 44–46.

52 Pfarr 2006, p. 148. In general on the study of physiognomy and pathognomy ibid. pp. 139–156.

53 See Darnton 1986, pp. 20–49; Ego 1991, pp. 51–57.

54 Darnton 1986, pp. 18, 31.

55 Ego 1991, p. 29.

56 Ibid., p. 34.

57 See: Pötzl-Malíková 1987, pp. 259f, 263; Pfarr 2003a, pp. 13f.; Krapf, Character Heads 2002, pp. 61–63, 186, 224, 234, 262, 264.

58 In the "Wienerisches Diarium" of 7 July 1770, this group is described as follows: "[…] a seated life-sized female, who is surrounded by 3 children in a tub and in the pleasantest way by a pyramidal group that contrasts excellently."

59 See p. 18 and note 29 in the present catalogue.

60 Ilg 1885, p. 18. On Ilg in this point see Pötzl-Malíková 2003, p. 263.

61 Ego 1991, p. 37.

62 Ibid., p. 36.

63 See Barkhoff 1994, pp. 7–76; Bauer 1995, p. 62; Pötzl-Malíková 1987, pp. 264–266.

64 See Krapf, Auftraggeber und Freundeskreis 2002, pp. 70–72. Thus also Darnton 1986, pp. 15f. This procedure was outlined even in Mesmer's dissertation; see Ego 1991, p. 29.

65 See Krapf, Auftraggeber und Freundeskreis 2002, p. 70;

37 Zitiert nach Ilg 1885, S. 76. Dazu auch Kris 1932, S. 203.

38 Dillmann, Bildlegende zu »Die fünf Perückenordnungen«, in: Ausst.-Kat. Hogarth 1998, S. 98.

39 Dazu siehe Promies 1992, S. 310.

40 Dazu siehe Maek-Gérard 1982, S. 6, 8.

41 Zuletzt Krapf, Katalog 2002, S. 178.

42 Dazu siehe Thieme-Becker, Bd. 10, S. 46: 1769 wurde der Maler nach Wien geschickt, um das Porträt der Erzherzogin Marie-Antoinette zu malen. Er blieb mehrere Jahre. »D. liebte es, sich karikierend, mit seltsamen Verzerrungen, lachend, gähnend, oder in fingierten Gemütszuständen darzustellen.« Von drei dieser Selbstporträts gibt es Radierungen: »Le Moquer« oder »Le Rieur« genannt (1782), »Le Joueur« und »Le Discret« 1791 gestochen.

43 Zu nachantiken Anregungen siehe auch Krapf, Charakterköpfe 2002, S. 53–55; Pfarr 2006, S. 393.

44 Dazu siehe S. 256–259 in diesem Katalog.

45 Abb. siehe Weinberger 1930, S. 191.

46 Abb. siehe Weinberger 1930, S. 191–193.

47 Abb. siehe Hàmori 1994, S. 3.

48 Zitiert nach Sauerländer 1989, S. 16.

49 Johann Caspar Lavater, Physiognomische Fragmente zur Beförderung der Menschenkenntniß und Menschenliebe, Leipzig / Winterthur 1775–1778.

50 Ohage 1990, S. 33.

51 Dazu Arburg 1999, S. 44–46.

52 Pfarr 2006, S. 148. Allgemein zu Physiognomik und Pathognomik ebd. S. 139–156.

53 Dazu siehe Darnton 1986, S. 20–49; Ego 1991, S. 51–57.

54 Darnton 1986, S. 18; dazu weiterhin S. 31.

55 Ego 1991, S. 29.

56 Ego 1991, S. 34.

57 Dazu siehe: Pötzl-Malíková 1987, S. 259–260, 263; Pfarr 2003a, S. 13–14; Krapf, Charakterköpfe 2002, S. 61–63, 186, 224, 234, 262, 264.

58 Im »Wienerischen Diarium« vom 7. Juli 1770 wird diese Gruppe beschrieben: » […] eine sitzende Weibsperson in Lebensgröße, die von 3. Kindern in einem Baßin und in einer auf die angenehmste Weise angebrachten pyramidalischen vortreflich contrastirten Gruppe umgeben wird.«

59 Siehe S. 20 und Anm. 29 in diesem Katalog.

60 Ilg 1885, S. 18. Zu Ilg in diesem Punkt siehe Pötzl-Malíková 2003, S. 263.

61 Dazu Ego 1991, S. 37.

62 Dazu Ego 1991, S. 36.

63 Dazu siehe Barkhoff 1994, S. 7–76; Bauer 1995, S. 62; Pötzl-Malíková 1987, S. 264–266.

64 Dazu siehe Krapf, Auftraggeber und Freundeskreis 2002, S. 70–72. So auch Darnton 1986, S. 15–16. So bereits in Mesmers Dissertation, dazu siehe Ego 1991, S. 29.

65 Dazu siehe Krapf, Auftraggeber und Freundeskreis 2002, S. 70; ebenfalls Krapf, Katalog 2002, Kat.-Nr. 38 (S. 224), Kat.-Nr. 57 (S. 262).

66 Nicolai Reprint 1994, S. 406.

67 Ebeling 2005, S. 159.

68 Ebeling 2005, S. 162–164.

69 Ebeling 2005, S. 19. Dazu siehe auch Krapf 1995, S. 50–51.

70 Frick 1973, S. 85.

71 Nicolai Reprint 1994, S. 410–411.

72 Nicolai Reprint 1994, S. 412.

73 So auch Kemp 1975, S. 118; Wöbkemeier 1990, S. 160–166; Košenina 1995, S. 58–151.

74 Dazu u. a. Geyer-Kordesch 1985, S. 21–22; Müller 1986, S. 201–202; Kirchner 1991, S. 316–327; Suthor 1999, S. 376.

also Krapf, Katalog 2002, cat. no. 38 (p. 224), cat. no. 57 (p. 262).

66 Nicolai Reprint 1994, p. 406.

67 Ebeling 2005, p. 159.

68 Ibid., pp. 162–164.

69 Ibid. 2005, p. 19. Also see Krapf 1995, pp. 50f.

70 Frick 1973, p. 85.

71 Nicolai Reprint 1994, pp. 410f.

72 Ibid., p. 412.

73 Thus also Kemp 1975, p. 118; Wöbkemeier 1990, pp. 160–166; Košenina 1995, pp. 58–151.

74 See Geyer-Kordesch 1985, pp. 21f.; Müller 1986, pp. 201f.; Kirchner 1991, pp. 316–327; Suthor 1999, p. 376, et al.

75 Quoted in Müller 1986, pp. 201f.

76 Scheyb 1770, Vol. 1, pp. 293f.

77 Ronzoni 1997, p. 44. The following is according to Kirchner 1991, pp. 309f.

78 Kirchner 1991, p. 315.

79 Ibid., p. 317.

80 Loc. cit.

81 Ronzoni has convincingly demonstrated this link; see Ronzoni 1997, p. 44.

82 Loc. cit.

83 For what were called mixed feelings, see Zelle 1987.

84 Kirchner 1991, p. 34. Also see Zelle 1987, p. 316.

85 Zelle 1987, p. 316; Zelle 1989, p. 95; Gampp 1998, pp. 31f.

86 Thus Zelle 1987, pp. 316–339.

87 Maaz 2001, p. 27.

88 For experimenting on oneself, see Möller 1974, p. 103; Obermeit 1980, pp. 61–69.

89 Möller 1974, pp. 57f.; Wöbkemeier 1990, p. 162; Kirchner 1991, pp. 306–341, et al.

90 Meusel 1781, p. 11.

91 Ibid., p. 12.

92 Loc. cit.

93 Baltrušaitis 1989, p. 183.

94 Nicolai Reprint 1994, pp. 410–412.

95 Ibid., p. 413.

96 For a picture of the now lost bust "First Beaked Head", see Pötzl-Malíková 1982, p. 245. The "Wags" are also similar to each other (figs. 62, 63); see Krapf, Katalog 2002, illus. p. 245, p. 249.

97 See exhib. cat. Hogarth 1998, p. 126.

98 Ibid., p. 88.

99 See Lyon 1958, pls. XIV–XVI; Ducreux, however, did not execute those self-portraits until c. 1780 so the painter would have known Messerschmidt's Character Heads rather than vice versa.

100 See Androssov, 1994–1996, pp. 71–76.

101 Both quotations: Ronzoni 2005, p. 317.

102 "Childish Weeping" (cat. no. 19) and "The Satirist" (cat. no. 20). Other variants are only known from plaster copies: for "The Sneezer" (fig. 66) see Krapf, Katalog 2002, illus. p. 195; ibid. for "The General" (fig. 65), illus. p. 259.

103 See Philipe 1994, fig. p. 101.

104 Nicolai Reprint 1994, p. 404.

75 Zitiert nach Müller 1986, S. 201–202.

76 Scheyb 1770, Bd. 1, S. 293–294.

77 Ronzoni 1997, S. 44. Das Folgende nach Kirchner 1991, S. 309–310.

78 Kirchner 1991, S. 315.

79 Zitiert nach Kirchner 1991, S. 317.

80 So Kirchner 1991, S. 317.

81 Diesen Bezug stellt Ronzoni überzeugend her, siehe Ronzoni 1997, S. 44.

82 Ronzoni 1997, S. 44.

83 Zu den so genannten vermischten Empfindungen siehe Zelle 1987.

84 Kirchner 1991, S. 34. Dazu siehe auch Zelle 1987, S. 316.

85 Zelle 1987, S. 316; Zelle 1989, S. 95; Gampp 1998, S. 31–32.

86 So Zelle 1987, S. 316–339.

87 Maaz 2001, S. 27.

88 Zur Selbsterforschung siehe Möller 1974, S. 103; Obermeit 1980, S. 61–69.

89 Dazu unter anderem Möller 1974, S. 57–58; Wöbkemeier 1990, S. 162; Kirchner 1991, S. 306–341.

90 Meusel 1781, S. 11.

91 Meusel 1781, S. 12.

92 Meusel 1781, S. 12.

93 Baltrušaitis 1989, S. 183.

94 Nicolai Reprint 1994, S. 410–412.

95 Nicolai Reprint 1994, S. 413.

96 Abb. der heute verschollenen Büste »Erster Schnabelkopf« siehe Pötzl-Malíková 1982, S. 245. Einander ähnlich sind auch die »Schalksnarren« (Abb. 62, 63), dazu siehe Krapf, Katalog 2002, Abb. S. 245, 249.

97 Siehe Ausst.-Kat. Hogarth 1998, S. 126.

98 Siehe Ausst.-Kat. Hogarth 1998, S. 88.

99 Siehe Lyon 1958, Taf. XIV–XVI; Ducreux schuf diese Selbstbildnisse allerdings erst um 1780, so dass eher der Maler Messerschmidts Charakterköpfe kannte als umgekehrt.

100 Dazu siehe Androssov, 1994–1996, S. 71–76.

101 Beide Zitate: Ronzoni 2005, S. 317.

102 »Der kindisch Weinende« (Kat.-Nr. 19) und »Der Satirikus« (Kat.-Nr. 20). Weitere Variationen sind nur noch durch Gipskopien bekannt: »Der Nieser« (Abb. 66), dazu siehe Krapf, Katalog 2002, Abb. S. 195; ebd. zu »Der Feldherr« (Abb. 65), Abb. S. 259.

103 Siehe Philipe 1994, Abb. S. 101.

104 Nicolai Reprint 1994, S. 404.

105 Auch hätte van Meytens einen ungebildeten Künstler wohl nicht zum Substitutprofessor ernannt.

106 Ebenso siehe Scheyb 1770, Bd. 1, S. 293–294: »Weil aber alle Theile des Angesichts sich verändern und rege gemacht werden, wenn die Seele bewegt wird [...].« Dazu auch Geyer-Kordesch 1985, S. 21.

107 Ähnlich Diderot: Er habe am Tag hundert verschiedene Gesichtsausdrücke, je nachdem, was ihn gerade beschäftige, dazu siehe Diderot / Seznec 1957–1967, Bd. 3, S. 67.

108 Busch 1998, S. 46.

109 So Friedel 1785, S. 398; Pfarr 2006, S. 106.

110 Assmann 2005, S. 95.

111 Assmann 2005, S. 95.

105 Nor would van Meytens have been likely to appoint an untrained artist as a substitute professor.

106 Similarly Scheyb 1770, Vol. 1, pp. 293f.: "Because all parts of the countenance change and are rendered animate when the soul is stirred [...]" See also Geyer-Kordesch 1985, p. 21.

107 Similarly Diderot: he had, he claimed, a hundred different facial expressions in a single day, depending on what he was preoccupied with at a given moment; see Diderot / Seznec 1957–1967, Vol. 3, p. 67.

108 Busch 1998, p. 46.

109 Thus Friedel 1785, p. 398; Pfarr 2006, p. 106.

110 Assmann 2005, p. 95.

111 Loc. cit. p. 95.

Essays

Essays

Frank Matthias Kammel

Die Serie als System

Franz Xaver Messerschmidts »Charakterköpfe« und der Reihencharakter

Bei seinem Besuch im Preßburger Atelier Franz Xaver Messerschmidts im Jahre 1781 bekam der Berliner Verleger Friedrich Nicolai (1733–1811) sechzig jener Büsten zu Gesicht, die der Künstler selbst »Köpf-Stückhe« und die »Verlassenschaftsabhandlung« kurze Zeit nach seinem Tod »Portreen« nannte, im Zusammenhang mit der ersten großen Ausstellung im Wiener Bürgerspital zehn Jahre später aber als »Charakterköpfe« bezeichnet werden sollten. Sie beeindruckten und veranlassten den prominenten Gast zu ihrer relativ ausführlichen Darstellung in seiner 1785 erschienenen »Beschreibung einer Reise durch Deutschland und die Schweiz«.[1] Außerdem notierte Nicolai, dass er den Bildhauer bei der Arbeit an einem weiteren solchen Kopf beobachten konnte. Neben den außergewöhnlichen Bildwerken interessierten ihn aber auch merkwürdiger Charakter und seltsame Weltanschauung jenes Mannes, in dessen Hirn er eine Reihe unaufgeklärter Verfinsterungen diagnostizierte. Der Meister, der den weitgereisten Berliner offenbar redselig über seine Sicht der Kunst, irdischer wie überirdischer Dinge unterrichtet hatte, litt in seinen Augen an dämonischen Erscheinungen, die jener für Heimsuchungen durch den Geist der Proportion halte. Vom Neid auf die weitreichende Erkenntnis entsprechender Gesetzmäßigkeiten geweckt, suche den Künstler das immaterielle Wesen bösartig zu belästigen und zu behindern. Schließlich ließe sich diesem Gegner allein durch die »Vollkommenheit der Kenntniß der Proportion« siegreich wehren, die er zu erringen suche, indem er den Geist in jene Büsten banne. Seine selbstgesetzte Aufgabe bestand folglich in der Schaffung eines

Series as System

Franz Xaver Messerschmidt's "Character Heads" and serial character

On the occasion of his visit to Franz Xaver Messerschmidt's Bratislava studio in 1781, the Berlin publisher Friedrich Nicolai (1733–1811) was shown 60 of those busts which the artist himself called "Head Pieces" and his estate inventory shortly after his death listed as "portraits" but, however, ten years later, at the first large scale exhibition mounted at the Viennese Bürgerspital would be designated as "Character Heads". They impressed the distinguished guest so much that he treated them to quite thorough coverage in Beschreibung einer Reise durch Deutschland und die Schweiz, published in 1785.[1] In addition, Nicolai noted that he had been able to observe the sculptor at work on another head of this kind. Apart from the extraordinary works of sculpture, Nicolai was also interested in the peculiar character and strange world-view of the man in whose mind he diagnosed a certain degree of inexplicable benightedness. The master, who had evidently expatiated at great length on his view of art, as well as of things worldly and unworldly, to the man from Berlin who had come so far to see his work, suffered, as Nicolai saw it, from demonic apparitions, which Messerschmidt took for visitations from the Spirit of Proportion. Aroused by envy of the profound knowledge of the laws of which he was the deity, the immaterial being sought maliciously to plague the artist and to hinder his endeavour. Finally, Messerschmidt might successfully ward off this adversary only by "perfecting his knowledge of proportion", which he was trying to attain by banishing that Spirit into the busts. The task the sculptor had set himself, therefore, consisted in creating a canon of proportion, specifically a representation of the relationship between body and countenance.

Whatever Messerschmidt may have said and meant and whatever degree of truth Nicolai's account may possess, the latter's commentary is a prime source for interpreting this unusual group of sculptural works, on which the sculptor's fame primarily

Kanons der Proportion, insbesondere einer endgültigen Darstellung der Beziehung zwischen Körper und Gesicht.

Was immer Messerschmidt gesagt und gemeint haben, und welchen Grad authentischer Wiedergabe die Niederschrift Nicolais auch besitzen mag, der Kommentar des preußischen Aufklärers gehört zu den erstrangigen Quellen für die Interpretation dieser ungewöhnlichen Gruppe plastischer Werke, die den Nachruhm des Bildhauers wesentlich begründete. Wie stark hier auch immer die akademischen Diskurse zur rechten Veranschaulichung der Affekte, die philosophischen und medizinischen Debatten der Zeit um die menschliche Seele, die seinerzeit hoch im Kurs stehende Physiognomik und die nicht weniger brisanten Experimente und Diskussionen um magnetischen Animalismus und Phrenologie, schließlich Spiritismus und freimaurerisches Gedankengut als geistige Hintergründe und inspirierende Elemente wirkten: Nicolais Einschätzung lässt keinen Zweifel daran, dass Messerschmidt mit den »Charakterköpfen« ureigenste Intentionen verfolgte, die mit keinem der aufgezählten Theoriengebäude allein oder unmittelbar zu erklären sind, seine Büsten also auch keine direkte Visualisierung entsprechender Inhalte darstellen.

Fest steht, dass die Köpfe aus eigenem Antrieb und ohne Auftrag entstanden. Nach Nicolai diente dem Künstler jede einzelne Büste zur Verewigung einer selbsterprobten Grimasse, deren Wirkung er der eines Apotropaions gleichgesetzt habe, um die Macht der Geister über ihn zu brechen. Messerschmidt, der auf dem Land in der Nähe von Dillingen aufgewachsen war, dürften magisch wirkende Abwehrmittel von Kindheit an bekannt gewesen sein, denn in Aberglaube und Volkskultur waren gerade ekstatisch und hysteroid geformte Masken in Gestalt von so genannten Neidköpfen und Schrecklarven wesentlicher Ausdruck von Schutz- und Abwehrbedürfnissen sowie Überwältigungswille.[2] Die von Friedrich Nicolai geschilderte Auffassung seines Gegenübers könnte auf solchen bildmagischen Vorstellungen gefußt haben.

Besaßen die Köpfe also auch apotropäischen Charakter, war ihnen Macht zugesprochen. Und sie manifestieren darüber hinaus einen Absolutheitsanspruch. Erfolgversprechend schien ihrem Schöpfer letzten Endes nämlich nicht allein die Darstellung einzelner solcher körperlich bedingter Verfassungen des menschlichen Antlitzes, sondern die Visualisierung eines vollständigen Repertoires, das heißt des grundsätzlich Möglichen. Der Besucher jedenfalls hörte dies aus dessen Worten und vermerkte neben seinem Eindruck, dass sämtliche Köpfe das Bildnis Messerschmidts zeigten: » […] er kniff sich, er schnitt Grimassen vor dem Spiegel, und glaubte die bewundernswürdigsten Wirkungen von seiner Herrschaft über die Geister zu erfahren. Er freute sich seines Systems,

rests. How strong the impact of the academic discourse on the right way of illustrating the emotions, the philosophical and medical debates of the day on the human soul, the study of physiognomy, which rated high at the time and the no less explosive experiments then being conducted in animal magnetism and phrenology, and, ultimately, also spiritism and Freemasonry may have been as an intellectual background and as elements of inspiration, Nicolai's assessment leaves no doubt that Messerschmidt was pursuing, with his "Character Heads", objectives that were entirely of his own making and cannot be explained solely or directly by any individual one of the theoretical edifices cited above. The Messerschmidt busts do not, therefore, represent the visualisation of content corresponding directly to any of the above.

It is clear that he created the Heads of his own volition without being commissioned to do so. According to Nicolai, each Head provided the artist with an opportunity of immortalising a grimace he had tried out on himself, whose effect he identified as apotropaic, in order to break the power of the spirits over him. Messerschmidt, who had grown up in the country near Dillingen on the Danube, may well have been acquainted since childhood with the magic properties of substances and objects. After all, as superstition and popular culture had it, ecstatic and hysterogenically deformed masks in the form of so-called "Neidköpfe" ["Envy Heads"] and "Schrecklarven" [frightening spectres] represented a quintessential expression of a need for protection and self-defence as well as the will to overcome horrors.[2] Messerschmidt's views, as described by Nicolai, may have been grounded in such attribution of magical properties to images.

If the heads, therefore, also possessed an apotropaic character, they were invested with power. And, moreover, they made manifest a claim to absoluteness. What ultimately seemed to promise their creator success was ultimately not just that they represented individual, physically conditioned states of the human countenance but rather the visualisation of a complete repertory, i.e, what was in fact possible. The visitor in any case understood this from what the sculptor said and noted, apart from his

243

und beschloß, es durch Abbildung dieser grimassierenden Verhält-
nisse festzusetzen und auf die Nachwelt zu bringen. Seiner Meinung
nach waren es 64 verschiedene Abänderungen der Grimassen.«[3] Der
scharfsinnige Beobachter hatte erkannt, dass der Künstler weder
planlos noch ohne festgelegtes Ziel vorging, sondern dass er mit den
Büsten auf die Schaffung eines »Systems« hinsteuerte.

Auch wenn heute möglicherweise von mehr als 64 solcher
Ausprägungen ausgegangen werden kann,[4] wäre hinter der im
Gegensatz zur Nicolai'schen Mitteilung eventuell höheren Anzahl
nicht mehr als eine Revision im Sinne noch tieferer Erkenntnis und
damit eine Erweiterung des eigenen Vorhabens durch den Bildhauer
selbst zu vermuten. Ungeachtet dessen darf behauptet werden, dass
Messerschmidt das Resultat seiner Arbeit in der Erstellung eines
umfassenden und vollkommenen »Systems« sah. Nicolai jedenfalls
gebrauchte den Begriff mehrfach; freilich nicht immer wertfrei, so
er beispielsweise das »scharfsinnig scheinende System voll Unsinns«
erwähnte.

Knapp zehn Jahre nach Messerschmidts Tod berichtete Chris-
toph Ludwig Seipp, die Nicolai'sche Interpretation der Büsten
grundsätzlich stützend, in seiner »Reise von Preßburg durch Mäh-
ren« von dem außergewöhnlichen Preßburger Bildhauer: »Er fieng
an, sein Brodstudium minder zu treiben, um eine Grille auszufüh-
ren, die seinen Namen verewigen sollte. Er studierte den Ausdruck
der Leidenschaften in den Gesichtszügen des Menschen; sein Stu-
dium sollte eine vollständige Mimik darzustellen fähig werden. [...]
Schon in Wien verfertigte er fünf dergleichen Köpfe in Kompo-
sition, deren jeder eine eigene Leidenschaft ausdrückte, lauter
Messerschmidte. Er nahm seinen eigenen Kopf zum Gegenstande
seines Studiums.«[5]

Beide Gewährsmänner bescheinigten der Serie übereinstim-
mend die Zugrundelegung des Messerschmidt'schen Bildnisses und
betonten, egal ob als »System«, »das ganze System in aller Vollkom-
menheit« oder »vollständige Mimik« bezeichnet, ihren ganzheit-
lichen Charakter. Zugegebenermaßen wurden die Büsten von ihnen
wie von anderen Kunstfreunden, die das Preßburger Atelier besuch-
ten, dessen ungeachtet auch als jeweils eigenständige Kunst- und
Meisterwerke betrachtet. Nicolai ordnete sie in diesem Sinn nach
ihm vertrauten ästhetischen Kategorien in »wahrhaft bewunde-
rungswürdige Meisterstücke«, »Armseligkeiten« von Grimassen und
die als Schnabelköpfe bezeichneten »Karikaturen«. Dennoch bele-
gen schon die von ihm mitgeteilte Offerte eines ungarischen Gra-
fen, der die Serie habe kaufen wollen, und die darauf erfolgte Reak-
tion Messerschmidts das Verständnis als nichttrennbare Reihe sehr
deutlich: Das Gebot war mit 8000 Gulden mindestens um ein
Fünftel zu gering ausgefallen. Sollte jedoch jemand eine entspre-

impression that all the Heads were portraits of
Messerschmidt: "[...] he pinched himself, made faces
in front of the looking-glass and believed he was
experiencing the most remarkable effects from his
dominion over the spirits. He was pleased with his
system and decided to capture it by reproducing these
grimacing conditions and bequeath it to posterity. In
his opinion, there were 64 different types of gri-
mace."[3] This discerning observer had realised that the
artist was neither without a plan nor was his goal
established. Instead he was striving with his busts to
create a "system".

Even though today perhaps more than 64 such
expressions of emotions can be assumed,[4] behind the
assumption of a possibly greater number than Nicolai
reports nothing more can be conjectured than that
the sculptor was deepening his knowledge and thus
enlarging his own project. Be that as it may, it may be
contended that Messerschmidt viewed the outcome
of his work as setting up a comprehensive, perfect
"system". Nicolai at any rate used the word several
times; of course, not always without prejudice
because he did mention a "system that seemed saga-
cious yet was full of nonsense".

Just ten years after Messerschmidt's death,
Christoph Ludwig Seipp, basically affirming Nicolai's
interpretation of the busts, wrote the following in
Reise von Pressburg durch Mähren [Journey from
Pressburg [i.e. Bratislava] through Moravia] on the
unusual Bratislava sculptor: "He began to reduce his
gainful work in order to execute a caprice which
would immortalise his name. He studied the expres-
sion of the passions in the facial features of man; his
study was intended to be able to represent the full
play of facial expression. [...] While still in Vienna, he
made five heads of that kind in composition, of
which each expressed a passion of his own, all of
them Messerschmidts. He used his own head as the
object of his study."[5]

Both sources concur in attesting that the series
was based on Messerschmidt's likeness and empha-
sised, no matter whether they called it a "system", "the
whole system perfected" or "the full play of facial
expression", its holistic character. Admittedly, they
and other art lovers who visited the Bratislava studio

chend höhere Summe offerieren, gab Messerschmidt dem Preußen zu wissen, »wolle er die ganze Folge noch einmal und besser machen; nur die beiden Schnabelköpfe ausgenommen, welcher er nicht zum zweytenmal hervor bringen könne«.[6]

In doppelter Hinsicht spielte also die Gruppe als nicht dividierbare Größe eine Rolle, sowohl bezüglich eines eventuellen Verkaufs als auch, wenngleich unter einer geringfügigen Einschränkung, einer Wiederholung. Seipps Vorschlag, ein deutscher Fürst solle die seinerzeit in Prag aufbewahrten Bildwerke, »Meisterstücke deutscher Kunst« erwerben, damit sie zum »Nacheiferungsstudium« zugänglich gemacht werden könnten, gedacht war offenbar an ihre Verwendung als Modelle in einer landesfürstlichen Kunstakademie oder Zeichenschule, richtete sich ebenfalls auf sämtliche der damals noch gemeinsam gehorteten Büsten. Dass die Serie als Ganzes gedacht war, belegt nicht zuletzt die Tatsache, dass Messerschmidt bei all seinen Umzügen von Wien nach Wiesensteig, von dort nach München und schließlich nach Preßburg fast seine gesamte Habe jeweils veräußerte, seine Köpfe aber immer an die neue Heimstatt mitführte.

Der bereits von Zeitgenossen des Künstlers aus der Reihe der »Portreen« gelesene Anspruch auf Totalität ist sicherlich ein für die Deutung der Charakterköpfe entscheidendes Wesensmerkmal. Der Bedeutung der Serie als Reihe gleichartiger, zueinander passender Dinge, die eine zusammenhängende Folge und damit ein Ganzes darstellen, widerspricht die von Nicolai gewählte Bezeichnung »System« nicht, ist darunter doch ebenfalls ein aus mehreren Teilen zusammengesetztes Gefüge zu denken, die Gesamtheit von Objekten, die in einem ganzheitlichen Zusammenhang stehen und durch die Wechselwirkung untereinander gegenüber ihrer Umgebung abgrenzbar sind. Der gebildete Büchermensch verwandte den Terminus sicherlich mit Bedacht, definierte doch auch Johann Heinrich Zedlers »Grosses vollständiges Universallexikon aller Wissenschaften und Künste«, die deutsche Enzyklopädie des 18. Jahrhunderts, das System als einen Begriff, welcher »eigentlich die Verbindung gewisser Wahrheiten nach ihrem Zusammenhange anzeiget«.[7]

In diesem Sinn zog Axel Christoph Gampp aus der Betrachtung der »Charakterköpfe« unlängst den zutreffenden Schluss, dass »die von Messerschmidt sich selbst gestellte Schwierigkeit« gewesen sei, »den stets gleichen Kopf, nämlich seinen eigenen, immer verschieden darzustellen«.[8] Ziel der künstlerischen Anstrengungen wäre demzufolge eine Serie gewesen, die keiner linearen Erzählung, keiner Historia folgt, keinem Handlungszusammenhang verpflichtet ist, sondern eher zirkulär funktioniert und deren Bestandteile, »eine potentiell nicht einschränkbare Anzahl von Variationen eines Themas«, sich »in gleicher Distanz zu einem Vorbild bewegen«.[9] Ist

also viewed each of the busts, regardless of what they called them, as autonomous works of art, indeed masterpieces. Nicolai classified them according to the aesthetic categories with which he was familiar as "truly admirable masterpieces" or "wretched" grimaces and he called the Beaked Heads "caricatures". Nevertheless, the offer made to Messerschmidt by a Hungarian count, who is alleged to have wanted to buy the series, and Messerschmidt's reaction, make it very clear that he viewed the whole as a set that could not be broken up: the offer of 8,000 guilders was at least twenty per cent below what he thought they were worth. Should, however, someone offer a sum that was higher by that amount, Messerschmidt assured Nicolai, "he would make the entire sequence again and make it better; except for the two Beaked Heads, which he would not be able to replicate."[6]

In two senses, therefore, the group plays a role as a unit that defies subdivision, both in view of a possible sale and, with slight reservations, replication. Seipp's suggestion that a German prince should acquire these "masterpieces of German art", which were in Prague at the time, he wrote, so they might be accessible "to emulating study", evidently meaning that they should be used as models in a royal state art academy or drawing school, also applied to all the busts, which were then still kept together. That the series was conceived as a whole is shown not least in the fact that Messerschmidt, in the course of all his removals from Vienna to Wiesensteig, from there to Munich and finally to Bratislava sold almost all his possessions yet always took his Heads with him to his new homes.

The claim to totality, which even contemporaries of the artist inferred from the set of "portraits", is certainly quintessential to interpreting the Character Heads. Interpreting the series as a set of similar things that match, which represent a coherent sequence and, therefore, a whole, does not contravene Nicolai's choice of the term "system". That presupposes a batch composed of several discrete parts, the total sum of objects that belong together in a holistic context and are distinguishable from their context by their interrelationship. The bookish scholar definitely used the term with deliberate forethought. After all, Johann Heinrich Zedler's "Grosses vollständiges Uni-

85 Michael Heinrich Rentz, Der Spieler. Der Narr. Der Mörder. Drei Szenen aus der Totentanzfolge »Geistliche Todts-Gedanken Bey allerhand Gemaehlden und Schildereyen … «, 1753, Kupferstiche, Kunstkammer Georg Laue, München

Michael Heinrich Rentz, The Player. The Fool. The Murderer. Three scenes from the Dance of Death Sequence "Geistliche Todts-Gedanken Bey allerhand Gemaehlden und Schildereyen … ", 1753, copperplate engravings, Kunstkammer Georg Laue, Munich

es korrekt, dem Künstler pathognomische Interessen zu unterstellen, die Erforschung der von Leidenschaften und Affekten hervorgerufenen Gesichtsbewegungen, so war für die intendierte Wirkung »insbesondere die Wahrnehmung des Kunstwertes aus dem wohligen Schauern heraus […] wenn man alle Köpfe zusammen sehen würde«, das heißt die gleichzeitig mögliche Gesamtsicht aller Köpfe, von größter Bedeutung.[10] Einer aus dieser Überlegung resultierenden Folgerung soll hier nun noch einmal nachgegangen werden: Ob Messerschmidts »System« die Serie im modernen Sinn, die sich in Ausdrucksvarianten eines Typs erschöpft und die nach Gottfried Boehm erst im 19. Jahrhundert entstanden sei, Ende des 18. Jahrhunderts tatsächlich erstmals vorwegnahm.[11]

Ohne Zweifel lässt sich das Phänomen der Werkreihung in diesem Säkulum in ausgiebigerer Formulierung beobachten als je zuvor. Statuarische und szenische Bildreihen, wie die Personifikationen von Tugenden und Lastern oder der Totentanz, verzeichnen ein Quantum an Bestandteilen, das vorher kaum erreicht worden war. Als Reichsgraf Franz Anton von Sporck (1662–1738), um ein bekanntes Beispiel zu nennen, den aus Tirol nach Böhmen gerufenen Bildhauer Matthias Bernhard Braun (1684–1738) im Jahr 1718

versallexikon aller Wissenschaften und Künste", the German encyclopaedia of the 18th century, defines "system" as a term which "actually indicates the linkage of certain truths according to their contexts".[7]

In that sense, Axel Christoph Gampp has recently drawn the apposite conclusion from observing the "Character Heads" that "the difficulty Messerschmidt caused himself" was "always representing the same head, namely his own, in different ways".[8] Accordingly, the aim of his artistic endeavour would have been a series that followed no linear narration, no historia, no coherent plot but rather functioned in a circular sense and whose constituents "were all equidistant to a model".[9] If it is correct to attribute to the artist an interest in pathognomy, research into the facial actions produced by the passions and emotions, it was of paramount importance for grasping the effect intended "especially the perception of their value as art from the delicious shivers of awe [...] to see all Heads together", which means the Heads should be viewed together if possible.[10] A conclusion that can be drawn from this thought is to be pursued here again: whether Messerschmidt's "system" actually did anticipate in the late 18th century the "series" in the modern sense of exhaustively handling all variants of expression possible in one type, which, according to Gottfried Boehm, did not arise until the 19th century.[11]

Without doubt, the phenomenon of arranging works in series can be observed in the 18th century in an unprecedentedly extensive formulation. Sets of statuary and scenes, such as the personifications of

mit dem Entwurf einer Skulpturenreihe für den Kloster- und Hospitalkomplex von Kukus am Oberlauf der Elbe beauftragte, welche die sittlich wertvollen wie die verwerflichen menschlichen Grundeigenschaften thematisieren sollte, gab er ihm je zwölf der geläufiger Weise auf sieben beschränkten Kategorien vor.[12] Derselbe Adlige hatte in seiner Stiftung einen in Fresken gemalten Totentanz anlegen lassen, der aus 52 Bildern bestand und somit, ähnlich der von Hans Holbein d. J. (1497–1543) um 1524 geschaffenen Holzschnittfolge mit 53 Szenen, zu den umfangreichsten monumentalen, sämtliche denkbaren Stände und Berufe vereinenden Formulierung dieses Sujets zählt.[13] Sporck ließ die Gemälde, in denen der von einem Skelett symbolisierte Tod seine Opfer im typischen Ambiente ihrer jeweiligen Profession überrascht, Mitte des 18. Jahrhunderts von Michael Heinrich Rentz (1701–1758) nachstechen und edierte sie 1753 in Passau und Linz unter dem Titel »Geistliche Todts-Gedanken Bey allerhand Gemaehlden und Schildereyen …« (Abb. 85).[14]

Zwar zielen in diesen beispielhaft ausgewählten Fällen sämtliche Glieder der Reihe auf einen Inbegriff, den des moralischen Grundstatus des Menschen beziehungsweise seiner grundsätzlichen Todverfallenheit, doch wird dieser alle Bilder zusammenhaltende Sinn nicht oder nicht vorrangig in der gleichzeitigen Zusammenschau, sondern narrativ erschlossen, die Erzählung didaktisch konstruiert und ihrer Aussage moralisierende Konnotation verliehen. In die Tradition dieser Bildstrategie stellte man in jener Zeit sogar neuartige Themen. Hier sei nur das von Adam Wolfgang Winterschmidt (1734–1789) im Jahr 1764 zum Druck gebrachte »Studentenleben« genannt.[15] Mittels dreißig Kupferstiche, die von Versen Heinrich Emanuel Minks begleitet werden, meinte der Nürnberger Stecher und Verleger den »tugend- und lasterhafte[n] Studente« zu entwerfen, indem er sämtliche denkbaren Charaktereigenschaften studierender Burschen, die entsprechenden Ausdrucksformen und Folgen von Fleiß, Frohsinn und Traurigkeit, Frömmigkeit und Gottlosigkeit, Verzagtheit, Unzüchtigkeit, Verschwendungssucht, Reinlichkeit usw. zu visualisieren suchte (Abb. 86). Die einzelnen Bilder, autonome Werkeinheiten, sind somit unter einer übergreifenden Idee zu einer umfassenden künstlerischen Einheit zusammengebracht. Wiewohl einem bewussten Aussageziel geschuldet und ohne linearen Handlungszusammenhang konzipiert, besteht die Aufeinanderfolge von Figuren beziehungsweise Szenen nur bedingt in der Variation einer Szene beziehungsweise Typs und muss daher eher der der Serie zwar verwandten, sich jedoch in diesen wichtigen Punkten davon unterscheidenden Reihenkategorie des Zyklus zugerechnet werden.[16]

In Hinblick auf Messerschmidts Büsten ist dagegen das additive Kompositionsprinzip der Serie, das auf der vielfachen Wieder-

the Virtues and Vices, or the Dance of Death, show a number of constituents that had scarcely been achieved before. When Count Franz Anton von Sporck (1662–1738), just to take a well-known example, summoned the sculptor Matthias Bernhard Braun (1684–1738) from the Tyrol to Bohemia in 1718 and commissioned him to design a set of sculptures for the monastery and hospital complex at Kukus on the upper reaches of the Elbe, a set which was to deal with both the morally valuable and the reprehensible basic human qualities, Sporck prescribed twelve works each for what was usually limited to seven categories.[12] That same aristocrat had had a Dance of Death narrated in frescoes in his foundation consisting of 52 pictures, which like the woodcut sequence of 53 scenes executed c. 1524 by Hans Holbein the Younger (1497–1543), is one of the most extensive and monumental formulations of this subject, encompassing all estates and trades imaginable.[13] Sporck had the paintings, in which Death, symbolised by a skeleton, surprises his victims in the surroundings typical of their respective professions, reproduced in engravings in the mid-18th century by Michael Heinrich Rentz (1701–1758) and edited it in Passau and Linz in 1753 under the title "Geistliche Todts-Gedanken Bey allerhand Gemaehlden und Schildereyen …" (fig. 85).[14]

In the examples chosen, all members of a set aim at a concept, that of the basic moral status of man and his being doomed to death. However, the significance linking all pictures is not, or not primarily, revealed when all are viewed together. Instead, it is narrated. The narrative is structured on didactic lines and the statement it makes had moralising connotations. New themes, even, were presented in the tradition of this pictorial strategy. Here the "Studentenleben" of Adam Wolfgang Winterschmidt (1734–1789), printed in 1764, may suffice as an example.[15] The Nuremberg engraver and publisher intended to convey "the virtuous and vicious student" in 30 copperplates, with verses by Heinrich Emanuel Minks, by visualising all character qualities imaginable in young men at university via the forms of expression corresponding with, and resulting from, industriousness, cheerfulness and sadness, piety and impiety,

holung ähnlicher Darstellungen basiert und auf die Vorstellung einer ideellen Einheit zielt, von vordergründigem Interesse. Im Mittelalter folgten ihm beispielsweise die Königsgalerien an den Kathedralfassaden der Île-de-France, die das französische Königtum zu repräsentieren und zu verherrlichen hatten. Mit Legitimationsabsichten waren auch die Serien der zwölf ersten römischen Kaiser ausgestattet, die sich seit dem 16. Jahrhundert besonderer Beliebtheit erfreuten und in Form von Gemmen und Plaketten, aber auch in der Monumentalbildnerei, Malerei und Graphik Verbreitung gefunden hatten (Abb. 87). Die kanonische Zwölfzahl der Bilder, die auf das Buch »De Vite XII Caesarorum« von Caius Suetonius Tranquillus († um 130) zurückgeht, ist schon wegen ihrer grundlegenden Bedeutung für die Einteilung der Zeit Ausdruck eines Ideals und universellen Anspruchs. Dieserart Kaiserreihen waren somit stets Sinnbilder für die Idee des Kaisertums, des Reiches und der

despair, concupiscence, wastefulness, cleanliness, etc (fig. 86). The individual pictures, autonomous units in their own right, have, therefore been assembled under the subsuming conception of a comprehensive artistic unity. Although lacking the aim of making a conscious statement and conceived without a linear narrative context, the sequence of figures and scenes consists only to a limited extent in the variation on a scene or type and must, therefore, be accounted as belonging to the differentiating category of the cycle as set, which differs from the series in just those important points.[16]

In connexion with Messerschmidt's busts, on the other hand, the paratactic principle of serial composition, based as it is on the frequent reiteration of similar representations and on the concept of an ideal unity, is only superficially of interest. In the Middle Ages, it was followed, for instance, in the royal galleries on the cathedral façades of the Île-de-France, which were supposed to represent and glorify the French monarchy. The series of busts of the first twelve Roman emperors were also invested with the purpose of legitimating the imperial form of state. These busts were particularly popular from the 16th century and circulated in miniature form as carved gems and plaquettes and on a monumental scale in sculpture, as well as in paintings and prints (fig. 87). The canonical number of twelve pictures, which derives form the book "De Vite XII Caesarorum by

86 Adam Wolfgang Winterschmidt, Der Gottlose. Der Lustige. Der Liederliche. Aus: »Der Tugend- und Lasterhafte Studente«, 1764, Kupferstiche, Germanisches Nationalmuseum, Nürnberg
Adam Wolfgang Winterschmidt, The Atheist. The Jolly Student. The Dissipated Student. From: "Der Tugend- und Lasterhafte Studente", 1764, copperplate engravings, Germanisches Nationalmuseum, Nuremberg

souveränen Herrschaft über den Erdkreis. Wer immer sich damit in bildhafte Beziehung setzte, sah sich als Nachfolger oder Teilhaber des imperialen Gedankens oder Bewahrer und Verteidiger der entsprechenden Kultur.

In vergleichbarer Weise rekonstruieren Herrscher- und Philosophenreihen vergangene Geschichte, konstatieren aber vor allem die Zivilisation oder die Entfaltung der Weltweisheit schlechthin. Die italienische Renaissance kannte die Uomini illustri, die galerieartig gereihte Darstellung berühmter Persönlichkeiten einschließlich legendärer Gestalten aus Vergangenheit und Gegenwart, die Kunst nördlich der Alpen seit Mitte des 14. Jahrhunderts in ähnlicher Absicht die »Neun guten Helden«, beliebte Gruppen vorbildhafter Idealgestalten ritterlicher Tugenden, die gleichermaßen den Inbegriff höchster irdischer Gerechtigkeit veranschaulichten und daher Rathäuser, Gerichtslauben und Marktbrunnen zierten. Im 16. und 17. Jahrhundert konnten Bildreihen berühmter Frauen Regentinnen im Sinne einer »femme forte« legitimieren.

In Legitimation und Repräsentation besitzen auch Ahnengalerien ihren eigensten Sinn. Sie fungieren als herrschafts- und besitzbestätigende Bildfolgen bedeutsamer Dynastien und signalisieren die dauernde Existenz von Geschlechtern und deren begnadete Souveränität. In besonderer Weise demonstrieren »künstliche« Ahnengalerien, die dort entstanden, wo gewachsene Porträtgalerien fehlten, das Repräsentationsbedürfnis des Adels und des Patriziats. Die Geschlossenheit des Stammbaumes wurde somit nicht zuletzt aufgrund der Einheitlichkeit im Dekorativen demonstriert. Nürnberger Patrizierfamilien, wie die Holzschuher, die Löffelholz oder

Caius Suetonius Tranquillus" (d. c. 130), is important, if only because of its fundamental significance in expressing the subdivision of time as the expression of an ideal universally aspired to. Sets of Roman emperors of this kind were, therefore, always symbols of the imperial idea, of the empire itself and sovereignty over the known world. Anyone who related himself pictorially to it viewed himself as the successor to, or participant in, the imperial idea or the preserver and defender of the culture associated with it.

Similarly, sets of monarchs and philosophers reconstruct past history and in particular affirm civilisation or epitomise the evolution of universal wisdom. The Italian Renaissance had its uomini illustri, representations like a gallery of distinguished men that included legendary figures of past and present. Since the 14th century, art north of the Alps had had its "Nine Heroes Good and True", popular groupings of exemplary ideal figures symbolising the chivalric virtues, which in turn exemplified the highest earthly justice and therefore, adorned town halls, court arcades and market-place fountains. In the 16th and 17th centuries, rows of pictures of celebrated female regents legitimated, as it were, the femme forte.

Galleries of ancestral portraits also possess a significance peculiarly their own. They function as sequences of pictures affirming the sovereignty and

die Imhoff, ließen im späten 16. und 17. Jahrhundert ganze Reihen gleichförmig gearbeiteter und in altertümlichem Duktus stereotyp bemalter Totenschilde anfertigen, die ihre gegebenenfalls bis ins 14. Jahrhundert zurückzuverfolgenden Ahnherrn vertraten, um in ihren Patronats- oder ihren Pfarrkirchen die lückenlose Sukzession in formaler Einheit vorzuführen.

Bildnisse entsprechender künstlicher Ahnengalerien folgen meist bestehenden Idealvorstellungen und sind anstatt von zu erwartender Charakteristik von Typenhaftigkeit gekennzeichnet. Ein sprechendes Beispiel beherbergt Schloss Ludwigsburg. Als Herzog Friedrich II. von Württemberg (1754–1816), der spätere erste König des Landes, 1799 die Umgestaltung des herrschaftlichen Gebäudes in Angriff nahm, ließ er auch die dort befindliche Ahnengalerie ergänzen. Sämtliche vorhandenen Bilder wurden in die gleiche Größe gebracht und identisch gerahmt. Die ergänzten Stücke zeigen ideale, einem Typus entlehnte Häupter.[17] Die weniger auf Darstellung von persönlicher Authentizität denn auf Repräsentation des Geschlechts und Demonstration seiner ununterbrochenen Herrschaft gerichtete Funktion, die aus der Form solch einer Bilderserie spricht, könnte offensichtlicher kaum sein. Schließlich tritt der Stellenwert des einzelnen Gemäldes in der Bedeutung als Glied eines übergeordneten Zusammenhangs deutlich vor Augen.

Eine bemerkenswerte gleichzeitige Erscheinung bildete die Porträtsammlung des Münchner Buchhändlers Johann Baptist Strobl (1748–1805). Der Sohn eines Schäfflermeisters aus Aichach, der in Ingolstadt Theologie studiert hatte und kurze Zeit als Lehrer in Straubing sowie am Münchner Gymnasium tätig gewesen war, befleißigte sich ab 1777 als Verleger historischer, geistlicher und landwirtschaftlicher Schriften sowie von Kinder- und Schulbüchern in der bayerischen Residenzstadt. Der Pädagoge und Philanthrop, der ob seiner eindeutigen Haltung zur republikanischen Umgestaltung der Gesellschaft während der Franzosenzeit von den Zeitgenossen als »bayerischer Robespierre« bezeichnet wurde, war im ausgehenden 18. Jahrhundert der berühmteste Kunstsammler Münchens. Vorrangig kaufte er Porträts von Menschen seiner Tage, und er bestellte Ölgemälde mit Bildnissen ihm bedeutsam erscheinender Landsleute, insbesondere beim Münchner Hofmaler Johann Georg Edlinger (1741–1819).

In seinen »Statistischen Aufschlüssen über das Herzogthum Baiern« vermerkte Joseph Hazzi (1768–1845) im Jahr 1803 diesbezüglich, man treffe dort auf »einen Bildersaal, wie man ihn in keiner Gallerie findet, von mehr als 200 Porträts von Gelehrten, verdienter und merkwürdiger Männer Baierns, meist von dem berühmten Hofmaler Etlinger gemalt. Überraschend ist der Anblick so vieler in ihren Karakterzügen verschiedener Menschen, deren gut getroffene

possessions of important dynasties and signal the permanence of reigning families and their divine right of sovereignty. "Artificial" ancestral portrait galleries were created where none had grown naturally in order to satisfy the need felt by the lower ranks of the aristocracy, the gentry and the mercantile classes for formal representation. A complete pedigree was, therefore, demonstrated by uniformity shown in the decorative. Nuremberg mercantile families such as the Holzschuhers, Löffelholzes and Imhoffs had array after array of escutcheons with portraits of the dead uniformly worked and rendered in a stereotyped archaising style to represent their ancestors, which in some cases could be traced back to the 14th century, in order to publicly parade a formal unity of uninterrupted succession in the churches dedicated to their patron saints or their parish churches.

Portraits from such artificial ancestral galleries usually represent existing ideals and are distinguished by being types, rather than characterising as might be expected. Schloss Ludwigsburg provides an eloquent example. When Frederick II, Duke of Württemberg (1754–1816), later king of his territorial state, embarked on refurbishing his residence in 1799, he took the opportunity of closing the gaps in his ancestral portrait gallery. All pictures already there were made the same size and framed identically. The added pieces depict ideal heads deriving from a prototype.[17] Intended to represent his family and demonstrate its uninterrupted reign and not as authentic likenesses, the function of this refurbished gallery as revealed in the choice of such a series of pictures could hardly be more obvious. After all, the status value of the individual painting has been rendered in unmistakable visual terms by the significance accruing to it as part of an overarching context.

A remarkable contemporary phenomenon was the portrait collection amassed by the Munich bookseller Johann Baptist Strobl (1748–1805). The son of a master cooper from Aichach, Strobl had studied theology in Ingolstadt and had taught for a while in Straubing and at a Munich higher secondary school. From 1777 he was engaged in the profession of selling historical, ecclesiastical and agricultural writings as well as children's books and schoolbooks in the Bavar-

88 Josef Hauber, Die Ga-
lerie des Münchener
Buchhändlers Johann
Baptist Strobl, Detail,
um 1795/1800, Ger-
manisches National-
museum, Nürnberg

Josef Hauber, The Gallery
of the Munich Bookseller
Johann Baptist Strobl,
detail, c. 1795/1800,
Germanisches National-
museum, Nuremberg

Porträts man hier auf ein Mal übersehen kann.«[18] »Diese ganze
Sammlung, die so zu sagen eine wahre lebende Kronik unserer Zeit
dem Blick darstellt«, vereinte Porträts von Staatsmännern, Dichtern
und Naturforschern mit einer beachtlichen Reihe von Bildnissen
einfacher Leute, so beispielsweise von Lehrern und Handwerkern,
etwa des Gürtlers und Matrosen Heinrich Zimmermann, des
94 Jahre alten Joseph Babenstuber, eines Tagwerkersohnes aus Thal-
kirchen, oder der 90-jährigen Anna Ertl, Tochter eines Kürschners
in der Au, die ihr Leben lang hart gearbeitet hatte.

ian capital. An educationalist and philanthropist,
Strobl was styled the "Bavarian Robespierre" for the
unabashedly republican leanings he displayed during
the Napoleonic era. In the late 18th century, he was
the most celebrated art collector in Munich. He
bought mainly portraits of contemporaries and he
ordered portraits in oils of compatriots who seemed
significant to him, particularly from the Munich
court painter Johann Georg Edlinger (1741–1819).

In his "Statistische Aufschlüsse über das Her-
zogthum Baiern", Joseph Hazzi (1768–1845) made
the following observations in 1803 on the Strobl col-
lection, which are relevant in the present connexion:
"one encountered there a picture room of a kind nev-
er found in a gallery, of more than 200 portraits of
scholars, remarkable men who have deserved well of
Bavaria, most of them painted by the celebrated court
painter Etlinger. The sight of so many men so differ-
ent in their character traits is astonishing, whose aptly
caught portraits can be viewed here all at once."[18]
"This entire collection, which, so to speak, presents
to view a true, living chronicle of our time," united
portraits of statesmen, poets and natural scientists
with a considerable number of likenesses of men from
the commonalty, such as teachers and craftsmen,
including the brass-founder and mariner Heinrich
Zimmermann, 94-year-old Joseph Babenstuber, who
was the son of a day labourer from Thalkirchen, and
90-year-old Anna Ertl, daughter of a furrier in the
Au, who had worked hard her whole life.

A painting executed by Josef Haubers (1766–
1834) shortly before 1800, which is now distributed
in two parts between the Munich Stadtmuseum and
the Germanisches Nationalmuseum in Nuremberg,
depicts Strobl in his gallery. The old man is seated on
a stool and is surrounded by children, to whom he is
explaining the portrait of the 94-year-old woodcutter
Graf which has been set up on a table, while Strobl's
son, Michael Friedrich, is showing other little visitors
the likeness of a bearded man hung on the gallery
wall (fig. 4).[19] Attentive contemporaries of Strobl's
noted with approval the interest he showed in the
countenance of the "common man" and people of the
lowest estate apart from all those portraits of distin-
guished Bavarians who had served the state and

251

Ein kurz vor 1800 entstandenes Gemälde Josef Haubers (1766–1834), das heute in zwei Teile zertrennt im Münchner Stadtmuseum und im Germanischen Nationalmuseum in Nürnberg aufbewahrt wird, zeigt Strobl in der Galerie. Der Greis sitzt auf einem Schemel und ist von Kindern umringt, denen er das auf einem Tisch aufgestellte Bildnis des 94-jährigen Holzhauers Graf erklärt; sein Sohn Michael Friedrich weist indessen anderen kleinen Besuchern des Bildersaals das an der Wand aufgehängte Konterfei eines Bärtigen (Abb. 88).[19] Aufmerksame Zeitgenossen registrierten Strobls über die Porträts um Staat und Wissenschaft verdienter Bayern hinausgehendes Interesse am Antlitz des gemeinen Mannes, am Menschen des einfachen Standes, durchaus positiv. Andere sahen darin ein seltenes Kuriosum. Übelwollende Menschen, wie der Polizeispitzel Johann Michael Armbruster, hingegen deuteten dieses »Pantheon der kleinen Leute« eher als ikonographische Demagogie und Ausdruck verwerflicher demokratischer Gesinnung.

Sämtlichen dieser Betrachtungsweisen wohnte Zutreffendes inne. Immerhin hatte sich ein Kleinbürger mit der Anlage einer Galerie einer bisher fast ausschließlich dem Hof beziehungsweise dem Adel vorbehaltenen Gepflogenheit bemächtigt. Das Ölgemälde, eine Standespersonen reservierte, hochoffizielle, feierliche Darstellungsform, wurde hier auf ungewöhnliche Weise als Medium zur Abbildung von jedermann benutzt. Außerdem vereinte die Sammlung die Stände ohne allen Unterschied und jede Hierarchie, stellte also ein kaum vergleichbares »Retabel einer egalitären Menschlichkeit« dar.[20]

Strobls Ziel war eine umfassende Galerie des Verdienstes. Dabei verstand er unter diesem Kriterium nicht nur Höchstleistung auf den Gebieten der Wissenschaft, der Politik und der Künste. Im Sinne der Aufklärung war die rechtschaffene, nützliche und der allgemeinen Achtung würdige Tätigkeit des einfachen Mannes, des Kleinbürgers, Bauern und Tagelöhners darin einbegriffen. Die Bildwürdigkeit einer Person bestimmte ihre Merkwürdigkeit im wörtlichen Sinn, worunter auch hohes Lebensalter, seltsame Lebensumstände und langwährende rechtschaffene Tätigkeit zählten. Der Sammler verwirklichte in seinem Kabinett offensichtlich jenen Respekt vor dem gemeinen Manne, der damals als »zentrale Schuldigkeit einer reformwilligen Gesellschaft« galt. Um diesen Gedanken noch weitgreifender zu publizieren, hatte er eine Stichsammlung »denk- und merkwürdiger Baiern« geplant, die vom Wiener Kupferstecher Friedrich John (1769–1843) ab 1792 in Angriff genommen wurde, aber erst mit der 1807 von Ernst August Fleischmann herausgegebenen »Gallerie denkwürdiger Baiern« ihren Abschluss fand. Nach dem Tode Strobls löste man die Sammlung auf, die Gemälde wurden versteigert. Somit ging der sozialreformerische Sinn dieser

science. Others simply viewed this as eccentric. Ill-disposed contemporaries, such as the police informer Johann Michael Armbruster, on the other hand interpreted this "Pantheon of the common people" as iconographic demagogy and the expression of an utterly reprehensible democratic mindset.

There is something apt in all those viewpoints. After all, in setting up a gallery, a petit bourgeois had appropriated a custom previously reserved almost exclusively for the court or the nobility. The oil painting, the preserve of a person of rank as an entirely official, stately form of representation, was in Strobl's gallery used as medium for representing "the common man". Moreover, since the collection united the estates without distinguishing between the classes and was devoid of hierarchic relationships, it represented an incomparable "retable of egalitarian humanity".[20]

Strobl's objective was a comprehensive gallery based on merit. He did not regard this criterion as subsuming only the supreme achievements of science, statesmanship and the arts. In the Enlightenment sense, the honest, useful work of the "common" man, the petit bourgeois, the peasant and the day labourer, that was worthy of universal respect, was included in the term. His or her remarkable qualities in the literal sense of the term were what made a person worthy of portrayal. These qualities included great age, an unusual lifestyle and long years of honest hard work. In his cabinet, the collector overtly displayed the respect for the commons which was then regarded as the "central obligation of a society willing to reform". In order to promulgate this idea with even more far-reaching implications, Strobl had planned a collection of engravings of "memorable and remarkable Bavarians", which the Viennese copperplate engraver Friedrich John (1769–1843) began in 1792. However, this "Gallery of Memorable Bavarians" would not be completed until 1807, when it was published by Ernst August Fleischmann. After Strobl's death, his collection was disbanded and the paintings sold at auction. Thus the unusual idea of uniting impulses for social reform in an assemblage of this kind was lost and the individual elements of the series were often downgraded to the status of portraits of unknown subjects or mere genre scenes.

F. VON. MVFFIANA

H. VON. GRVINIOLON

H. VON. MOMMONGNON

AIN TARTER. SO DER FVRST. VŌ SIBENBVRGER
MIT. MER ANDERE . GEFANGEN .HAT.

F. VON. LABRIANA

H. VON. MAVTZION

89 Domenicus Custos,
 Serie von »Tataren-Bild-
 nissen«, um 1596, Zen-
 tralbibliothek, Graphi-
 sche Sammlung, Zürich

*Domenicus Custos,
series of "Tatar Portraits",
c. 1596, Zentral-
bibliothek, Graphische
Sammlung, Zurich*

ungewöhnlichen Zusammenstellung verloren und die Einzelteile
der Serie gerieten vielfach zu Porträts Unbekannter oder bloßen
Genreszenen.

In dieser Hinsicht teilte die ungewöhnliche Reihung von Bild-
nissen das Schicksal der Messerschmidt'schen Köpfe. Wie diesen war
auch Wesen, intendierter Sinn und Botschaft der Galerie letzten
Endes nur ihrer Erscheinung als Serie dezidiert abzulesen. Allein die
Möglichkeit der gleichzeitigen Gesamtsicht aller, vornehmlich von

In this respect, the unusual array of portraits shares
the fate of Messerschmidt's Heads. As with them, the
essence, the intended meaning of, and the message
conveyed by, the Strobl gallery could ultimately only
be clearly read when the individual works appeared
collectively as a series. The possibility alone of being
able to look in one place at all the portraits as a
whole, most of them painted by Edlinger, is what
made legible the aim as stated, above and beyond the
skill with which the individual likeness had been cap-
tured and the remarkable qualities of the individuals
portrayed. It goes without saying that Strobl's "Pan-
theon", comprising as it does so many portraits, differs
greatly from the series of "Character Heads" developed
from a single pictorial type. Synchronicity and a com-
parable strategy for illustrating an intellectual phe-
nomenon with a sequence of heads are what relates
them to one another.

Series of portraits or heads are, according to
Michael Krapf, in any case among the many sources
of inspiration that might have been brought to bear
on Messerschmidt.[21] Since the Renaissance such series
had circulated widely, been known to artists and been
popular as study material. Treatises on the study of
physiognomy were particularly lavishly illustrated in
this respect, as is shown by the following compendia:
the compendium of Barthelemi della Rocca
(1467–1504); the "Chiromantia" compiled in 1534 by
Ioannes ab de Indagine (1467–1537), which is illus-
trated with woodcuts by Hans Wechtlin (1480/85-
after 1526), and the "De Humana Physiognomia" of
Giovanni Battista della Porta (c. 1535–1615), which
was first published in 1570 and was frequently
reprinted.[22]

Among the most influential pictorial works of
this kind are the "Grotesque Heads" of Leonardo,
which for a long time were misinterpreted as early
records in the history of Western caricature because in
them the human countenance is so monstrously
deformed.[23] Giorgio Vasari reported the artist was
unusually interested in faces from the street, especial-
ly if they were particularly abnormal in configuration.
The Leonardo drawings, executed between 1490 and
1503, represent busts, most of them shown in profile
or half profile, with distinctive facial features, some of

Edlinger gemalten Porträts eröffnete die Lesbarkeit des gesetzten Anspruchs über die Kunstfertigkeit des einzelnen Bildnisses und die Merkwürdigkeit der einzelnen dargestellten Personen hinaus. Freilich unterscheidet sich das aus zahlreichen Porträts bestehende »Pantheon« Strobls deutlich von der aus einem Bildtyp entwickelten Reihe der »Charakterköpfe«. Seine Gleichzeitigkeit und die vergleichbare Strategie, ein geistiges Phänomen mit einer Folge von Köpfen zu veranschaulichen, macht sie verwandt.

Serien von Bildnissen beziehungsweise Köpfen zählen, so Michael Krapf, auf jeden Fall zu den vielfältigen Anregungen, die inspirierend auf Messerschmidt gewirkt haben könnten.[21] Seit der Renaissance waren solche Reihen vielfach verbreitet, bei Künstlern bekannt und als Studienmaterial beliebt. Diesbezüglich besonders umfangreiche Illustrationen enthielten physiognomische Traktate, so jenes Kompendium von Barthelemi della Rocca (1467–1504), die von Ioannes ab de Indagine (1467–1537) im Jahr 1534 edierte »Chiromantia«, die mit Holzschnitten Hans Wechtlins (1480/85– nach 1526) bebildert ist, oder das 1570 erschienene und wiederholt aufgelegte Werk »De Humana Physiognomia« Giovanni Battista della Portas (um 1535–1615).[22]

Zu den wirkmächtigsten Bildern dieser Art zählen jedoch die »Grotesken Köpfe« von Leonardo, die aufgrund der monströsen Deformation des menschlichen Antlitzes lange Zeit zu Unrecht als Zeugnisse der Frühgeschichte abendländischer Karikatur missdeutet wurden.[23] Giorgio Vasari berichtete, der Künstler habe den Gesichtern der Straße, sonderlich abnorm gebildeten, ein ungewöhnliches Interesse entgegengebracht. Die zwischen 1490 und 1503 entstandenen Zeichnungen geben meist ins Profil oder Halbprofil gewendete Büsten mit markanten, teilweise auch grimassierenden Gesichtszügen, der außergewöhnlichen Ausprägung einzelner Partien oder auch anatomischen Missbildungen wieder, so dass in der Zusammenschau der Blätter der Eindruck vom Menschen als einem bizarren Wesen entsteht. In dieser Tradition, allerdings mit tatsächlich karikierender Intention schufen der Kupferstecher Martino Rota (1520–1583) in Wien die »Heidnischen Götter«, Antonio Tempesta (1555–1630) seine Grotesken römischer Heroen und Heroinen, skurrile Darstellungen von Halbfiguren im Profil mit monströsen und debilen Gesichtspartien, die samt ihren spöttischen Bildunterschriften das antike Heldentum verhöhnen,[24] oder Domenicus Custos (1559/60–1615) eine Folge von »Tatarenbüsten«, die im Auftrag der Fugger für die Sammlung Kaiser Rudolfs II. entstanden und ein kurioses Bildkompendium des exotischen Volkes darstellen sollte (Abb. 89).[25]

Daneben erfuhr Leonardos Serie bizarrer Köpfe in mehrfacher Weise Reproduktion, so von seinem Schüler Francesco Melzi

them even grimacing. They represent such extraordinary configurations of individual parts or anatomical deformities that, viewed as a whole, these drawings create an impression of man as a bizarre being. The following are in this tradition, albeit really with the intention of caricature: the copperplate engraver Martino Rota (1520–1583) in Vienna with the "Pagan Gods"; Antonio Tempesta (1555–1630) with his grotesque Roman demigods and their female counterparts, bizarre half-figure representations in profile with monstrous and even moronic facial features, which, along with their mocking captions, make fun of the deities of Antiquity[24] and Domenicus Custos (1559/60–1615) with a series of "Tatar busts", which were commissioned by the Fuggers for the collection of the Emperor Rudolf II and were intended to make up an odd pictorial compendium devoted to that exotic people (fig. 89).[25]

Concomitantly, Leonardo's series of bizarre heads was reproduced in various ways by his pupil Francesco Melzi (c. 1493–c. 1570), the Prague copperplate engraver Wenzel Hollar (1607–1677) and the French art theorist and etcher Anne Claude Philippe Comte de Caylus (1692–1765) among others.[26] The grand-ducal art collection at the castle in Schwerin possessed a series of 50 small-scale grotesque heads and busts in the form of ivory reliefs. Not carved until the second third of the 18th century, after the Caylus etchings, they attest to the translation of their famous antecedents into three-dimensional art (fig. 90).[27] The size and character of this group indicate that they were conceived as a compendium intended to capture the entire imaginable range of exotic and peculiar, undoubtedly extraordinary, ways the human head might look. In any case, it may be supposed that they represent an endeavour to register as complete a survey of eccentric countenances as possible, based on the authority of the model. In an unmediated and peculiar way, it also reflects a facet of the lively interest shown in the human physiognomy that was being increasingly fuelled by the contemporaneous philosophical and artistic debate, which would culminate in the "craze for the study of physiognomy" sparked off in the mid-1770s by Johann Caspar Lavater's "Physiognomische Fragmente."

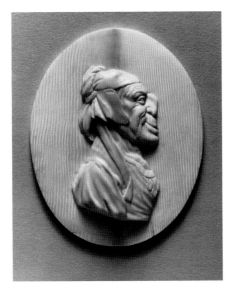 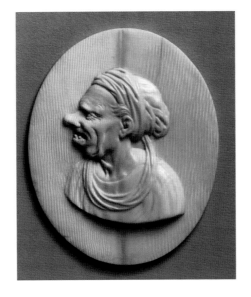 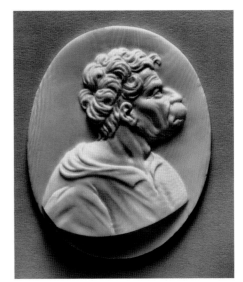

90 Norddeutscher Elfen-
beinschnitzer, Drei Gro-
teskenköpfe aus einer 50
Stücke umfassenden
Serie, 2. Drittel 18. Jahr-
hundert, Staatliches
Museum, Schwerin

*North German ivory
carver, Three Grotesque
Heads from a series com-
prising 50 pieces, 2nd
third 18th century,
Staatliches Museum,
Schwerin*

(um 1493–um 1570), dem Prager Kupferstecher Wenzel Hollar
(1607–1677) sowie dem französischen Kunsttheoretiker und Radie-
rer Anne Claude Philippe Comte de Caylus (1692–1765).[26] Die
Großherzogliche Kunstsammlung des Schweriner Schlosses beher-
bergte eine fünfzig kleinformatige Elfenbeinreliefs umfassende Serie
grotesker Köpfe beziehungsweise Brustbilder, die nach den Vorlagen
von Caylus erst im zweiten Drittel des 18. Jahrhunderts geschnitzt
worden ist und die Übertragung der berühmten Vorbilder in die
dreidimensionale Kunst belegt (Abb. 90).[27] Schon der beachtliche
Umfang dieses Beispiels bezeugt den kompendienartigen Charakter,
der solchen Anlagen intendiert ist, um das gesamte vorstellbare
Spektrum exotischer und kurioser, zweifellos außergewöhnlicher Er-
scheinungen des menschlichen Hauptes einzufangen. Auf jeden Fall
lässt sich das auf die Autorität der Vorlage gestützte Streben nach
größtmöglicher Vollkommenheit exzentrischer Antlitzbildungen
vermuten. Mittelbar und auf eigentümliche Weise spiegelt es außer-
dem eine Facette des ausgeprägten Interesses an der menschlichen
Physiognomie, das von den zeitgenössischen philosophischen und
künstlerischen Diskussionen immer stärker befeuert wurde und das
mit der »Physiognomikmode«, die Johann Caspar Lavaters (1741–
1801) »Physiognomische Fragmente« ab Mitte der siebziger Jahre
auslösten, einen Höhepunkt erreichen sollte.

In connection with training at art academies, numer-
ous series of engravings were produced in the 18th
century based on the sequence of schema drawings
done in 1668 by Charles Le Brun (1619–1690).
Painter to the French court and director of the Paris
Academy, Le Brun had striven to create a "method of
construction" for investigating the emotions on the
basis of art theory and had accordingly drawn up a
canon of such representations.[28] Works of this kind
are known by numerous French artists, including
Gérard Audran (1640–1703), Henri Testelin
(1616–1695), Sébastien Le Clerc (1637–1714) and
Bernard Picart (1673–1733). In most of them, Le
Brun's mimetic "exempla" are arranged in 19 groups of
three.[29] German artists and art theorists also devoted
themselves intensively to the subject. Christian
Ludolph Reinhold (1739–1791) added a comprehen-
sive chapter "Von dem Ausdrukke der Leiden-
schaften" ["On the Expression of the Passions"] to his
System der zeichnenden Künste..., published in 1784,
and illustrated the work with numerous plates, each
of which show six heads and thus focus on the mani-

Im Zusammenhang der akademischen Ausbildung entstanden im 18. Jahrhundert zahlreiche Stichserien, die auf der 1668 geschaffenen Folge von Schema-Zeichnungen Charles Le Bruns (1619–1690) fußen. Der Pariser Hofmaler und Akademiedirektor hatte sich die kunsttheoretische Ergründung und entsprechende Kanonisierung der Affekte beziehungsweise die Schaffung eines ihrer Abbildung dienenden »Konstruktionsverfahrens« zum Ziel gesetzt.[28] Von zahlreichen französischen Künstlern, so Gérard Audran (1640–1703), Henri Testelin (1616–1695), Sébastien Le Clerc (1637–1714) oder Bernard Picart (1673–1733), sind entsprechende Werke überliefert, in denen die mimischen Exempla Le Bruns meist zu 19 Dreiergruppen zusammengestellt sind.[29] Aber auch deutsche Künstler und Kunsttheoretiker widmeten sich dem Thema eingehend. Christian Ludolph Reinhold (1739–1791) gab seinem 1784 veröffentlichten »System der zeichnenden Künste …« ein ausführliches Kapitel »Von dem Ausdrukke der Leidenschaften« bei und illustrierte es mit zahlreichen Tafeln, die jeweils sechs Köpfe tragen und so den Fokus auf die vielfältige Erscheinungsform des menschlichen Hauptes richten, jedoch keinen darüber hinausreichenden Zusammenhang anstreben. Die Titulierung des Werkes als System freilich signalisiert seinen Anspruch auf innere Vollständigkeit zweifellos.[30] Schließlich entstanden in jener Zeit vielfach graphische Folgen von Ausdrucks- und Charakterstudien, wie die »Teste di carattere« von Johann Baptist Lampi d. Ä. (1751–1830) oder die »Weiblichen Charakterköpfe« von Jakob Plazidius Altmüller (1780–1819), die kleine Kompendien menschlicher Gefühlsäußerungen darstellen wollen, ohne jedoch einen Anspruch auf Vollständigkeit auf diesem Gebiet zu erheben.[31]

Messerschmidts Büsten unterscheiden sich von solchen Folgen ganz wesentlich durch die Verkörperung einer Idee, die mittels Variierung eines Bildtyps in der Wiederholung artikuliert wird. Eben diesem Prinzip ist zumindest eine Reihe von zwölf »Charakterköpfen« Martin Johann Schmidts (1718–1801) verpflichtet, die aus »melancholische[n] und versonnene[n] Selbstbildnissen« des als Kremser Schmidt bekannten Malers besteht, aber auch die dreißig Ansichten des Mienenspiels von Voltaire, die der Genfer Maler und Graphiker Jean Huber (1721–1786) schuf.[32] Offenbar war der außergewöhnliche Bildhauer also nicht der einzige Künstler, der dieses Prinzip seinerzeit anwandte. Skulpturale Beispiele lassen sich sogar früher bezeugen.

Zu den bedeutendsten Reihen dieser Art in der Kunst des 18. Jahrhunderts im deutschen Sprachraum zählen die das Chorgestühl der Stiftskirche Heiligenkreuz bei Wien bekrönenden Büsten von Giovanni Giuliani (1664–1744). Der aus Venedig stammende, 1711 als Laienbruder in den Konvent der Zisterzienser eingetretene Künstler schuf sie wie das gesamte prächtige Gestühl

fold ways the human head may be configured but that was the only linkage aimed at here. However, the term "system" in the title of the work undoubtedly signals that inner coherence and completeness were the objective.[30] Finally, many sequences of prints as studies of expression and character appeared at the time, including the Teste di carattere of Johann Baptist Lampi the Elder (1751–1830) and the "Weibliche Charakterköpfe" (Female Character Heads) of Jakob Plazidius Altmüller (1780–1819), which were intended as small compendia depicting the expression of emotions without any claim to exhausting the possibilities in this field.[31]

Messerschmidt's busts differ in essentials from such sequences in that they embody an idea which is articulated in the repetition of a pictorial type through variations on it. This same principle informs at least an set of twelve "Character Heads" by the painter Martin Johann Schmidt (1718–1801), known as "Schmidt from Krems". These Character Heads are "melancholy and pensive self-portraits". The same idea also informs the thirty views of expressions assumed by Voltaire's countenance as depicted by the Geneva painter and printmaker Jean Huber (1721–1786).[32] Evidently the extraordinary sculptor Messerschmidt was not the only artist to apply this principle in his day. Further, there is evidence of sculpture based on it that antedates Messerschmidt.

Among the best-known sets of this type in 18th-century are the busts surmounting the choir stalls in the Heiligenkreuz monastery church near Vienna. They are the work of Giovanni Giuliani (1664 bis 1744), a native of Venice, who entered the Cistercian monastery as a lay brother in 1711. Giuliani, probably supported by his workshop, created the entire magnificent set of stalls between 1707 and 1708 (fig. 91). In connection with the busts on the stalls, the monastery annals of the day mention canonised popes, cardinals, archbishops and bishops, princes, learned doctors and monks, hermits, nobles and knights who belonged to the order or supported it.[33]

Although the more than 30 busts are distinguished by superior conception and workmanship, the movement in them evoked by the tilt and turn of

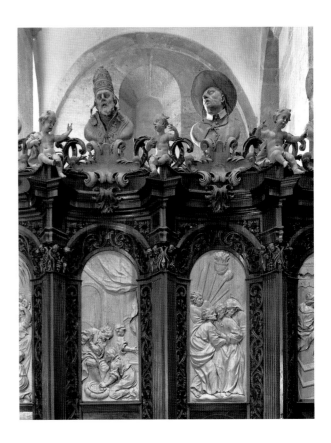

91 Giovanni Giuliani, Chorgestühl der Stiftskirche Heiligenkreuz, 1707/08, Lindenholz, Kloster Heiligenkreuz bei Wien
Giovanni Giuliani, choir stalls, 1707/08, limewood, Heiligenkreuz Monastery near Vienna

wohl mit Unterstützung seiner Werkstatt in den Jahren 1707 und 1708 (Abb. 91). In den zeitgenössischen klösterlichen Annalen wird hinsichtlich der Darstellungen von kanonisierten Päpsten, Kardinälen, Erzbischöfen und Bischöfen, Fürsten, Doktoren und Mönchen, Einsiedlern, Adligen und Rittern gesprochen, die dem Orden angehörten oder ihn unterstützten.[33]

Trotz hoher künstlerischer und handwerklicher Qualität in der Ausführung der über dreißig Bildwerke, ihrer mittels Kopfwendungen evozierten Bewegtheit und der spannungsreichen Akzentuierung der Reihe durch dramatische Wendungen ist nicht zu übersehen, dass die Häupter einem anatomischen Grundtypus genügen, den starke Nase, breite Backenknochen und fliehende Stirn ausmachen. Aufgrund der Verbindung der Grundgestalt mit natürlichen Zügen, unterschiedlichen Frisuren und eigentümlichen Trachtenaccessoires gelang dem Bildschnitzer die nuancenreiche Variierung der vielfach wiederholten »Musterform«. So stellen sich die heiligen Krieger als bärtige Landsknechte mit Hakennasen und von Anstrengungen gezeichneten Gesichtern dar, die Herzöge als Träger glatter, zart geformter Antlitze. Die Asketen tragen ihre von Entbehrung gezeichneten Wangen zur Schau und richten ekstatische Blicke gen Himmel, die kirchlichen Würdenträger geben sich vornehm, pathetisch, vergeistigt.

the heads and the exciting enhancement of the set by touches that lend them a dramatic twist, the fact cannot be ignored that these heads are based on a single anatomical type, featuring a prominent nose, broad cheek bones and a receding forehead. The carver has succeeded in subtly varying the "sample form" by linking the basic type with naturalistically rendered features, varying the hair styles and adding distinctive dress and accessories. The Crusaders are represented as bearded lansquenets with hooked noses and faces marred by strain whereas the dukes are represented with smooth, delicately formed countenances. The ascetics, cheeks emaciated from abstinence, gaze rapturously into the sky while the Church dignitaries are pictured as elegant, wallowing in pathos, yet spiritual.

Different as these busts may seem at first glance, the aesthetic principle informing them is uniformity of formal conception. "The use of types in relation to the representation of content and expression," as Elfriede Baum stated years ago, "guarantees the unity of the whole."[34] The individual figures, which could originally be precisely identified by the

257

92 Andreas Schlüter, Vier
 Masken »Sterbender
 Krieger«, 1696/97,
 Zeughaus, Berlin
 Andreas Schlüter, Four
 Masks, "Dying Warrior",
 1696/97, Zeughaus,
 Berlin

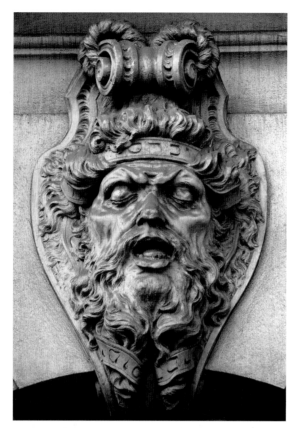
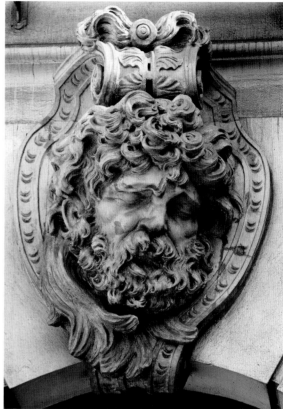
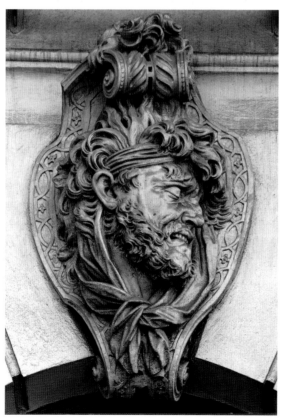
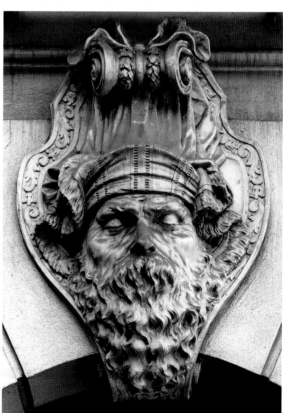

So unterschiedlich die Büsten auf den ersten Blick vielleicht erscheinen mögen, prägend ist ihre Gleichgestaltigkeit. »Die Typisierung in Bezug auf den Darstellungsinhalt und Ausdruck«, meinte schon Elfriede Baum, »gewährleistet die Einheitlichkeit des Ganzen«.[34] Die Figuren, die mittels der einst von den von beigeordneten Putten gehaltenen Attributen exakter identifiziert werden konnten, sind schon aufgrund ihrer Anordnung zunächst Glieder einer zusammengehörigen Gruppe. Als »ordensspezifischer« Zweig der im Himmel schon wirklichen Civitas Dei, der Ecclesia triumphans, repräsentiert sie offenbar die Ewigkeit. Gemeinsam mit dem während der Gottesdienste in den Stallen anwesenden Konvent, dem noch in der »irdischen Fremde« pilgernden Teil der Kirche, der Ecclesia militans, hilft sie das seit dem patristischen Zeitalter geläufige spirituell-mystische Verständnis der Himmel und Erde vereinenden Kirche abzubilden, deren vorzügliche Aufgabe der Lobpreis des Schöpfers ist.[35]

Schon kurz zuvor, an der Wende zum 18. Jahrhundert war in der preußischen Residenzstadt Berlin ein aufgrund seines profanen Inhalts vollkommen anders gearteter, hinsichtlich des der Messerschmidt'schen Serie intendierten Prinzips aber bemerkenswert verwandter Zirkel von Häuptern entstanden. Andreas Schlüter (1659–1714) stattete damals seinen unweit des Schlosses errichteten Neubau des Zeughauses mit bemerkenswert umfangreicher plastischer Zier aus. Unter anderem versah er sämtliche Schlusssteine der etwa 100 rundbogigen Fenster und Tore des Sockelgeschosses mit einer prächtigen skulpturalen Gestaltung. Als die hinsichtlich künstlerischer Ausdruckskraft und technischer Vollkommenheit der Ausführung erlesensten Stücke gelten darunter jene 22 überlebensgroßen Masken im quadratischen Innenhof des Gebäudes, die weitgehend in den Jahren 1696 und 1697 vom Meister selbst und nach seinen Modellen von seinem Mitarbeiter Georg Gottfried Weyhenmeyer (1666–1715) ausgeführt wurden. Darstellung fanden Häupter erschlagener Krieger, die als Trophäen auf kartuschenartig angelegte Schilde gehängt sind (Abb. 92).[36]

Im Wesentlichen mittels eines physiognomischen Typus gestaltete Schlüter eine Reihe von Köpfen, die vom straffen, bartlosen Gesicht des Jünglings über das kurzbärtige, mit markanten Zügen ausgestattete Antlitz des Mannes bis zum zerfurchten, knochigen, von Haaren umwallten Haupt des Alten die wesentlichen Altersstufen repräsentieren. In der ergreifenden Todesphysiognomie dieser Masken, die ein Spektrum entfalten, das »von dem verbissenen Sterben bis zur verklärten Ruhe, von der grausigen Starre des Leichnams, dem keine Freundeshand den letzten Dienst erwies, bis zum heldisch jugendlichen Charakterkopf, den ein letzter Impuls noch mit dem Leben zu verbinden scheint«, schuf der Bildhauerarchitekt

attributes once held by the putti assigned them, belong together as members of a group, which is, first of all, indicated by the overall arrangement. As a branch "specific to the Order" of the Civitas Dei, which has already been realised in Heaven, of the Ecclesia triumphans, the Church Triumphant, the group obviously represents eternity. Together with the congregation of monks present in the stalls during divine service, the section of the Church who are still pilgrims in the "earthly sphere", the Church Militant (Ecclesisa militans), this group of figures helps to illustrate the spiritual and mystical idea of the Church as uniting Heaven and earth that had become widespread since the age of the Church Fathers and whose prime task is praising the Creator.[35]

Not long before that, at the turn of the 17th to the 18th century, a circle of heads was created in the Prussian capital Berlin. Its profane content made it entirely different in kind but, with respect to the principle informing the Messerschmidt series, nonetheless remarkably close to the Character Heads. Andreas Schlüter (1659–1714) embellished the new armoury built near the Schloss at that time with remarkably plentiful sculptural decoration. One of the things Schlüter did was to decorate all the keystones of a total of approximately 100 round-arched windows and doors of the ground floor with magnificent sculpture. These choice pieces, notable for their expressive powers and consummate workmanship, are those 22 larger than life-sized masks in the quadrangle, most of which were executed between 1696 and 1697 by Schlüter himself and his employee, Georg Gottfried Weyhenmeyer (1666–1715), after the master's models. They are representations of the heads of fallen warriors, hung up as trophies on cartouche-like shields (fig. 92).[36]

Drawing essentially on a type for the face, Schlüter created a row of heads representing the important ages of man, ranging from the firm, beardless face of a youth through that of a man in the prime of life depicted with distinctive features and a short beard to the head of an old man with a furrowed, bony face framed by billowing hair. In his shattering depiction of death and dying in these masks, Schlüter has attempted to show all the forms

93 Franz Xaver Nissl,
Zwei Relieftafeln mit
anatomischen Modellen,
2. Hälfte 18. Jahrhun-
dert, Holz, farbig ge-
fasst, Grassi Museum für
Angewandte Kunst,
Leipzig. Erworben mit
Unterstützung der
Sächsischen Landes-
stelle für Museumswesen
aus Mitteln des
Freistaates Sachsen,
Inv. 2005.178–179

Franz Xaver Nissl,
Two relief panels with
anatomical models,
2nd half of 18th century,
wood in coloured frame,
Grassi Museum für Ange-
wandte Kunst, Leipzig,
acquired with the help of
the Sächsische Landes-
stelle für Museumswesen
with funds from the
State of Saxony,
Inv. 2005.178–179

ein Hauptwerk europäischer Barockskulptur und zugleich ein unge-
wöhnliches Sinnbild für den bezwungenen Feind schlechthin.[37]

Vermutlich war die Idee von den für das Abendland eben erst
siegreich beendeten Türkenkriegen, entsprechenden Berichten und
Realien, inspiriert. Kurfürst Friedrich Wilhelm von Brandenburg
(1620–1688) hatte Kaiser Leopold I. (1640–1705) im Jahr 1686
7000 Mann Fußvolk und 1200 Reiter zum Entsatz von Ofen
gesandt und nach der Erstürmung der Stadt auch zahlreiche Beute-
stücke erhalten. Darüber hinaus gelangten damals militärische
Requisiten und sogar Leichenteile auf den Kuriositätenmarkt. Auf
der Leipziger Neujahrsmesse 1684 boten Wiener Kaufleute Fässer
voller Türkenköpfe, »somtheils grausame Gesichter theils unge-
wöhnliche Bärte und vielerley Haupt-Haar hatten«, an und setzten

they can take "from a fierce struggle with death to
transfigured calm, from the horrors of rigor mortis in
the corpse to whom no friend's hand has rendered the
last service to the heroically youthful Character Head,
who seems to be still linked with life by a final stir-
ring." Both sculptor and architect, Schlüter has here
created a major work of European Baroque sculpture
that is also an unusual and exemplary symbol of the
foe vanquished.[37]

Presumably the idea was inspired by accounts of,
and battle trophies from, the wars against the Turks,
which had just ended in victory for the West. In 1686
Frederick William, Elector of Brandenburg
(1620–1688), had dispatched 7,000 infantrymen and
1,200 cavalry to relieve Emperor Leopold I (1640–
1705) at the siege of Ofen, and after the city was
entered, had received a great deal of loot. Moreover,
military trophies and even body-parts were offered for
sale on the curiosities market. At the 1684 Leipzig New
Year's Fair, Viennese merchants were touting casks full
of Turks' heads, "some of them had cruel faces, some
had unusual beards and a great deal of hair on their
heads" and presumably did a brisk trade in them, not
least for decorating Kunstkammer and libraries.[38]

Significantly, in the 18th century, both the
variety of expressions depicted in the Schlüter masks
and the quality of comprehensive portrayal of the
emotions in them were praised on several occasions.
In a description of Berlin compiled in 1756, those
are the very aspects singled out for praise: "The key-
stone Heads in the quadrangle, made by the cele-
brated Schlüter with his own hand, as a remarkable
work of art admired by everyone because they
express all human passions to the life."[39] Adolf
Traugott von Gersdorf, a landed aristocrat from the
march of Brandenburg, who visited the Armoury in
1793, was impressed by the variations of the death
agony depicted in the Heads and while not seeing
all the emotions in them, at least found "the various
emotions of dying persons very well expressed".[40] As
his contemporaries had done with Messerschmidt's
Character Heads, those who saw the Schlüter Heads
interpreted them first and foremost as the artistic
articulation of the expression of feelings on the sur-
face of the face.

sie wohl auch bestens ab, nicht zuletzt zur Ausstattung von Kunstkammern und Bibliotheken.[38]

Bezeichnenderweise wurde im 18. Jahrhundert mehrfach vor allem die Vielgestaltigkeit des Ausdrucks der Masken gerühmt, aber auch ihre Qualität umfassender Schilderung der menschlichen Affekte gelobt. In einer 1756 edierten Beschreibung Berlins wird genau dies nämlich besonders gepriesen: Dass, »die auf dem Hofe befindlichen Schlusssteinköpfe, so der berühmte Schlüter mit eigener Hand verfertigt, als ein sonderbares Kunststück von jedermann bewundert werde, indem sie alle Leidenschaften des Menschen nach dem Leben ausdrücken.«[39] Der märkische Gutsbesitzer Adolf Traugott von Gersdorf, der das Zeughaus 1793 besuchte, zeigte sich ob der von den Häuptern geschilderten Spielarten der Agonie beeindruckt und sah in ihnen zwar nicht alle, zumindest aber »die verschiedenen Affekte sterbender Personen sehr gut ausgedrückt«.[40] Wie die Zeitgenossen in Messerschmidts Köpfen deutete man auch hier zunächst die künstlerische Artikulation menschlicher Gefühlsäußerungen auf der Oberfläche des Gesichtes.

Die Zurschaustellung von Schädeln Getöteter signalisierte mit der Ausnahme des Reliquienkultes prinzipiell die Demonstration erbarmungslosen Machtwillens, vernichtenden Hohns und überragenden Sieges. Bezeichnenderweise stellt die Kernaussage der Serie, der weder narrative Züge noch eine linear lesbare Anordnung im Baugefüge innewohnen, jedoch nicht den militärischen Triumph in den Vordergrund. Mit der beispiellosen Reihe von Toten thematisierte Schlüter vielmehr Schrecken und Grausamkeit des gewaltsamen Todes. Indem er das Sujet also mit humanen Gefühlen auflud, wandte er die triumphale Konnotation des Bildes in souveräner wie überwältigender und elementar faszinierender Weise ins Existentiell-Menschliche. Die aus einem Bildtyp heraus entwickelte Serie ermöglicht die »Abfolge von Köpfen, die bei aller Stilisierung so rücksichtslos einer einzigen, und zwar der äussersten Erscheinung des menschlichen Daseins nachforschen«.[41]

Nach diesem charakteristischen Prinzip funktionierten im 18. Jahrhundert auch Reihen von Bildern, die über Köpfe und Büsten hinaus den gesamten menschlichen Körper zum Inhalt hatten. Von dem Tiroler Bildschnitzer Franz Xaver Nissl (1731–1804), der seine Ausbildung zunächst bei Gregor Fritz (1693–1774) in Hall, schließlich in der Werkstatt des Münchner Hofbildhauers Johann Baptist Straub (1704–1784) absolvierte und bis zu seiner Selbständigkeit 1756 in Fügen dort auch als Mitarbeiter wirkte, sind Serien anatomischer Modelle überliefert (Abb. 93). Im Wesentlichen besteht das Œuvre des Rokoko und Klassizismus auf eigenartige Weise verbindenden Meisters in der Ausstattung Tiroler Kirchen mit Altarfiguren und skulpturalen Bestandteilen von Gestühlen.[42]

Unlike the cult of relics, displaying the skulls of men who had been killed signalled in principle a demonstration of a merciless drive for power, destructive contempt and triumph at a decisive victory. Significantly, the core statement made in the Schlüter series, which is informed neither by narrative features nor a legible linear arrangement in the architectural context, does not give priority to the military triumph. On the contrary, with this matchless array of the dead, Schlüter has focused on the horrors and cruelty of a violent death. By charging his subject matter with humane feelings, he has transformed the triumphal connotations of the picture in an overwhelmingly assured and elementally fascinating way into something existential and quintessentially humane. This series developed from a pictorial type makes it possible "to investigate in this sequence of heads, which, as stylised as they are, as ruthlessly as the individual is dealt with, the ultimate phenomenon of human existence."[41]

Series of heads focusing on the entire human body and not just as detached heads or busts, also functioned on this characteristic principle in the 18th century. The Tyrolese carver Franz Xaver Nissl (1731–1804) trained at first under Gregor Fritz (1693–1774) in Hall before going on to serve an apprenticeship in the workshop of the Munich court sculptor Johann Baptist Straub (1704–1784), working there until he set up on his own in Fügen in 1756. Nissl made series of anatomical heads (fig. 93). Eccentrically uniting Rococo and Classicism, the œuvre of this master consists primarily in the appointments of Tyrolese churches: altar figures and the sculptural embellishment of pews.[42] In addition, small relief panels, some of them signed, with anatomical pictures. One series of this kind, consisting of ten pieces, is owned by the Landhut sculptor Fritz Koenig (* 1924), who has installed them in his workshop to fulfil what was presumably their original function. Just 40 cm high, each of these little panels depicts a human figure viewed from different angles and skeletonised to a varying degree. Frontal, side and rear views are reproduced as a skeleton or écorché or intermediate states, occasionally also with macabre dangling pieces of skin. Arms and legs, head and hands

Daneben sind kleine, teilweise signierte Relieftafeln mit anatomischen Bildern bekannt. Eine solche aus zehn Stücken bestehende Serie befindet sich im Besitz des Landshuter Bildhauers Fritz Koenig (*1924), der sie gemäß der ihr vielleicht einst zugedachten Funktion in seiner Werkstatt installiert hat. Die knapp 40 cm hohen Brettchen zeigen eine menschliche Gestalt in jeweils variierenden Ansichten und Stadien der Skelettierung. Vorder-, Seiten- und Rückansichten sind als Gerippe oder Ecorché beziehungsweise entsprechende Zwischenstufen, gelegentlich auch mit makaber herabhängenden Hautpartien, wiedergegeben. Arme und Beine, Haupt und Hände geben sich in verschiedenen Posen, so dass vielfältige Muskelanspannungen und Gelenkausrichtungen deutlich vor Augen treten und die Serie ein verblüffend ganzheitliches Bild des menschlichen Körpers darbietet. Wasserschlagartige Vorsprünge, auf denen die Figuren zu stehen scheinen, tragen neben der Signatur des Bildschnitzers eine Nummerierung.[43] Zwei etwa gleichgroße Stücke einer weiteren Serie, die sich nicht nur durch die Absenz der Nummerierung und die Anlage naturnachahmender Standflächen der Skelette, sondern auch durch höhere handwerkliche Qualität und spannungsvollere Komposition auszeichnet, beherbergte die Kunstkammer Georg Laue in München.[44]

Nissl benutzte für seine Serien Kupferstiche des Bologneser Graphikers Domenico Maria Bonaveri (1640–nach 1703), die dieser in den 1670er Jahren nach älteren Vorbildern geschaffen und als Liber anatomicus herausgegeben hat.[45] Ob seine Relieftafelreihen anatomischen Lehrzwecken oder aber künstlerischer Orientierung dienten, gegebenenfalls vielleicht sogar von Anfang an in Kunstkabinetten verwahrt worden sind, ist nicht gänzlich sicher. Ihr Anspruch aber ist zweifellos als systematischer zu bezeichnen, da er in der Vermittlung eines vollständigen Bildes der menschlichen Anatomie durch einzelne, mit Hilfe eines Figurentyps geformter Sequenzen besteht. Insbesondere die Landshuter Serie, deren intendierte Reihenfolge von der Nummerierung angegeben wird, ermöglicht sowohl durch additives Sehen der einzelnen Teile als auch gleichzeitige Betrachtung der ganzen Reihe eine koordinierte Gesamtschau von Knochen- und Muskelapparat des Menschen. Gleichwohl bleibt eigentlich ohne Bedeutung, an welcher Stelle man die Serie zu lesen beginnt.

Verschiedener könnte das Sujet von dem der »Charakterköpfe« sicherlich kaum sein. Dennoch verbindet beide Serien Prinzipielles, das bereits an den genannten Werken von Schlüter und Giuliani beobachtet werden konnte. Dezidierter als ältere oder auch gleichzeitige, einander zu Gruppen ergänzende Bildreihungen – dies verdeutlichen die oben aufgeführten Beispiele – folgen sie weder einem Handlungszusammenhang noch besitzen sie illustrierendes

are presented in different poses so that numerous muscular contractions and joint positions are clearly demonstrated. Taken as a whole, the series provides an astonishingly holistic view of the human body. Projections, on which the figures appear to be standing, bear numbering as well as the carver's signature.[43] Two pieces of roughly similar size from another series are distinguished not only by the absence of numbering and the addition of plinths emulating nature for the skeletons to stand on as well as workmanship of a higher quality and more taut handling of the composition, are in the Kunstkammer Georg Laue in Munich.[44]

For his series, Nissl used copperplates by the engraver Domenico Maria Bonaveri (1640–after 1703) of Bologna, which Bonaveri had executed in the 1670s after earlier models and published as a Liber anatomicus.[45] Whether Nissl's series of relief panels was intended to be used for teaching anatomy or art or whether they were originally made to be placed in an art cabinet cannot be ascertained. It can, however, undoubtedly lay claim to being more systematic since it conveys a complete image of human anatomy in individual sequences formed with the aid of a figure type. The Landshut series especially, with its numbering indicating the intended sequence, makes it possible, either through paratactic study of the individual panels or synchronous viewing or both, to obtain a co-ordinated survey of the human skeleton and muscles. It does not matter actually where one begins to read the series.

The subject matter is certainly as remote from that of the Messerschmidt "Character Heads" as it could possibly be. Still a principle links the two series, the same principle observed in the above mentioned works by Schlüter and Giuliani. It is more obvious that the "Character Heads", like the Landshut series, follow neither a narrative nor an illustrative structure – this is shown in the examples cited above – but are rather composed of thematic or type variants of expressions. They also represent a constellation that is timeless and must be viewed as a whole for the statement they make to be readable. The crucial element is the reiteration of a structure. Each of the pictures constructed in this way is related to an equal degree to every other picture in the same series

Gepräge, setzen sich aber offenbar aus Ausdrucksvarianten eines Themas oder Typs zusammen, fixieren eine zeitenthobene Konstellation und vertreten hinsichtlich der Aussage den Anspruch auf Totalität. Wesentliches Element ist dabei die Wiederholung einer Struktur; jedes der so konstruierten Bilder steht mit jedem anderen derselben Serie in gleichwertiger Beziehung und ist dem gleichen Ziel verpflichtet, gibt ihm aber jeweils neuen Ausdruck. Die Serie, deren Glieder auf diese Weise miteinander verbunden sind, funktioniert demnach als ein künstlerisches Kommunikationsmittel, das die spezifische Aufgabe besitzt, etwas eigentlich unfassbar Ganzes zu beschreiben.

Für die Schaffung eines »Systems« bot sich dieses Mittel zwangsläufig an. Und Messerschmidt griff darauf zurück, wie andere Künstler seit der Wende vom 17. zum 18. Jahrhundert. Akademische Ausbildung, weitreichende kunsttheoretische Kenntnisse, Studienmaterial, einschließlich Serien graphischer Vorlageblätter, Traktate und Lehrbücher mit Reihen anatomischer und physiognomischer Abbildungen dürften die Basis gebildet haben, auf der dieses eigentümliche Serienphänomen entwickelt worden ist. Dass zahlreiche tradierte Motivreihen und Bildfolgen, wie oben dargelegt, im 18. Jahrhundert vielfach eine unter anderem der Verdeutlichungsabsicht geschuldete quantitative Ausweitung erfahren hatten, begünstigte die Entfaltung wohl zusätzlich. Schließlich zeichnete sich das Säkulum grundsätzlich durch das Bestreben aus, alles Wissen über Mensch, Natur und Gesellschaft zu quantifizieren, um es schließlich qualifizieren zu können.[46] Die Aussagen der prosperierenden Wissenschaften zielten stärker als je zuvor auf das Ganze der menschlichen Existenz.[47] Die Medizin beispielsweise fragte nach dem Körper als funktionaler Einheit von Organen, in der sich das Ganze ausdrückt. Ein Sammler zeitgenössischer Porträts wie Strobl war am gesamten Spektrum der Individuen einer Gesellschaft interessiert, und auch die Physiognomik als Kunst- und Morallehre zielte auf die Totalität des menschlichen Seins.[48] Nicht zuletzt war selbst den Dichtern des Sturm und Drang daran gelegen, die vermeintlich verlorene Ganzheit des Menschen wiederzugewinnen.[49] Messerschmidts Projekt einer Serie von Kunstwerken, deren Aussagegehalt durch den Reihencharakter mit einem Totalitätsanspruch verknüpft ist, findet darin ihren natürlichen Kontext.

Schließlich hatte das »Mimesisgebot«, ein Resultat der im 18. Jahrhundert geführten Debatten über die Nachahmung der Natur, dem Künstler das Recht auf eigenwilligen Ausdruck seiner Beobachtungen und Erfahrungen zuerkannt. Somit kamen seinem Werk »Erkenntnis- und Gestaltungsaufgaben« zu und ihm wurde »die Fähigkeit zugesprochen, aus der individuellen und subjektiven Erfahrung heraus eine Welt herzustellen«.[50] Franz Xaver Messer-

and is committed to the same objective but each gives it a new expression. The series whose various members are thus linked functions, therefore, as an artistic means of communication which possesses the specific purpose of describing what is actually an incomprehensible whole.

These were the only means available for creating a "system". And Messerschmidt, like other academicians since the late 17th and early 18th centuries, resorted to them perforce. Academic training, a wide-ranging knowledge of art theory, study materials including series of prints as models, treatises and books of instruction with series of pictures reproducing anatomy and facial features must have been the foundation on which this phenomenally unusual series was built. Another factor that probably facilitated the development of the Character Heads was that the numerous sets of motifs and sequences of pictures which had come down to the 18th century, were often, as has been outlined above, then enlarged in the quantitative sense, partly at least to make a more pointed and less equivocal statement. Finally, the 18th century was essentially distinguished by a striving to quantify all knowledge of man, nature and society so that it might ultimately be improved in quality.[46] Statements made about the flourishing state of the sciences were addressed to an unprecedented extent to the whole of human existence.[47] Medicine, for instance, researched into the body as the functional unity of organs in which the whole was expressed. A collector of portraits of his contemporaries such as Strobl was interested in the entire spectrum of individuals making up society. Even the study of physiognomy as a body of teachings relevant to both aesthetic and moral doctrine was directed at the whole of human existence.[48] Finally, the "Sturm und Drang" poets were concerned with regaining the wholeness of man, which they perceived as having been lost.[49] That is the natural context of Messerschmidt's project of a series of art works whose statement content was linked via its serial character with a holistic objective.

After all, the "law of mimesis", a result of the debate conducted in the 18th century on the replication of nature, entitled the artist to his own distinctive way of expressing his observations and experi-

schmidts Köpfe bilden solch eine Welt im Sinn einer Ganzheit. Dass die Büstenreihe von ihrem analytischen Charakter wie konstruktiven Anliegen deutlich als kreativer Beitrag zu den intellektuellen Kontroversen der Aufklärung über das Wesen des Menschen gekennzeichnet wird, braucht nicht eigens betont zu werden.[51] Und dass sich der Meister für sein Werk souverän einer informationsträchtigen Form der Serie bediente, die zu den Bewegungsprinzipien der Moderne avancieren sollte,[52] macht es nur um so interessanter. Wenngleich er nicht als »Erfinder« dieses Serienphänomens gelten darf, stellt es eine wesentliche Facette der aus Traditionsbindung und Innovation gleichermaßen gespeisten Komplexität seiner einzigartigen »Köpf-Stückhe« dar.

1 Siehe dazu Nicolai Reprint 1994 sowie die Abschrift des Textes im Anhang S. 313–323.

2 Hansmann / Kriss-Rettenbeck 1977, S. 250–253; Eibl-Eibesfeldt / Sütterlin 1992, S. 283–361.

3 Zitiert nach Pötzl-Malíková 1982, S. 146–147; Nicolai Reprint 1994, S. 413.

4 Zu diesem Problem siehe den Beitrag »Die Charakterköpfe – Formen, Namen und Zahlen« von Maraike Bückling in diesem Katalog.

5 Zitiert nach Pötzl-Malíková 1982, S. 148–149.

6 Nicolai Reprint 1994, S. 419–420.

7 Zedler 1744, Sp. 1209.

8 Gampp 1998, S. 33.

9 Gampp 1998, S. 33.

10 Gampp 1998, S. 34.

11 Boehm 1988, S. 17–24.

12 Poche / Koøán 2003, S. 93–126.

13 Wunderlich 2001, S. 64–72.

14 Ausst.-Kat. Tanz der Toten 1998, S. 246–248; Wunderlich 2001, S. 89; Laue 2001, S. 174–175.

15 Winterschmidt 1764.

16 Siehe Pommeranz-Liedtke 1956.

17 Fleischhauer 1967, S. 25–26.

18 Hazzi 1803, Bd. 3, 1. Abt., S. 379.

19 Bezold 1909, S. 144; Huber 1997, S. 23–25.

20 Bauer 1997, S. 15.

21 Krapf, Charakterköpfe 2002, S. 53.

22 Reißer 1997, S. 61–73; Campe 1990a, S. 416–418.

23 Gombrich 1954, S. 199–219; Kwakkelstein 1994; Forcione 2003, S. 203–224, 451–461.

24 Ausst.-Kat. Beredsamkeit 1992, S. 107.

25 Solar 1973, S. 32–35.

26 Caylus 1730; Kirchner 1991, S. 190–229.

27 Möller 2000, Nr. 163–212.

28 Kirchner 1991, S. 29–50.

29 Montagu 1994, S. 176.

30 Reinhold 1784.

31 Krapf, Charakterköpfe 2002, S. 55.

32 Feuchtmüller 1989, S. 566; Krapf, Charakterköpfe 2002, S. 55.

33 Frey 1926, S. 117; Niemetz 1965, S. 7; Ausst.-Kat. Giovanni Giuliani 2005, S. 310–317.

ences. Consequently, his work had "knowledge and design-related tasks" to perform and it was "credited with the ability of creating a world from individual, subjective experience".[50] Franz Xaver Messerschmidt's Character Heads form a world of that kind in the sense that they are a whole. There is no need to emphasise that this series of busts has been authoritatively designated a creative contribution to the intellectual controversies shaping the Enlightenment on the nature of man.[51] And that the master made adroit use of a form of series that conveyed a maximum of information, which would become one of the principles driving Modernism,[52] makes it all the more interesting. Even though Messerschmidt cannot be regarded as the "inventor" of the serial phenomenon, it does represent a quintessential facet of the complexity arising in the linkage of tradition and innovation informing his unique "Head Pieces".

1 See Nicolai Reprint 1994 as well as the text as reproduced in the appendix pp. 313–323.

2 Hansmann / Kriss-Rettenbeck 1977, pp. 250–253; Eibl-Eibesfeldt / Sütterlin 1992, pp. 283–361.

3 Quoted in Pötzl-Malíková 1982, pp. 146–147; Nicolai Reprint 1994, p. 413.

4 On this problem see the essay "The Character Heads – Forms, Names and Numbers" by Maraike Bückling in the present catalogue.

5 Quoted in Pötzl-Malíková 1982, pp. 148f.

6 Nicolai Reprint 1994, pp. 419f.

7 Zedler 1744, col. 1209.

8 Gampp 1998, p. 33.

9 Loc. cit.

10 Ibid., p. 34.

11 Boehm 1988, pp. 17–24.

12 Poche / Koøán 2003, pp. 93–126.

13 Wunderlich 2001, pp. 64–72.

14 Exhib. cat. Tanz der Toten 1998, pp. 246–248; Wunderlich 2001, p. 89; Laue 2001, pp. 174f.

15 Winterschmidt 1764.

16 See Pommeranz-Liedtke 1956.

17 Fleischhauer 1967, pp. 25f.

18 Hazzi 1803, Vol. 3, 1. Abt. [section 1], p. 379.

19 Bezold 1909, p. 144; Huber 1997, pp. 23–25.

20 Bauer 1997, p. 15.

21 Krapf, Charakterköpfe 2002, p. 53.

22 Reißer 1997, pp. 61–73; Campe 1990a, pp. 416–418.

23 Gombrich 1954, pp. 199–219; Kwakkelstein 1994; Forcione 2003, pp. 203–224, pp. 451–461.

24 Exhib. cat. Beredsamkeit 1992, p. 107.

25 Solar 1973, pp. 32–35.

34 Baum 1964, S. 30–31.

35 Wiedenhofer 1992, S. 55–70.

36 Dohme 1878; Benkard 1925, S. 7–9, Taf. 14–25; Ladendorf 1935,
 S. 12–14; Dautel 2001, S. 41–140.

37 Benkard 1925, S. 8.

38 Zedler 1754, Sp. 1701; Kammel 2001, S. 516–517.

39 Kuester / Müller 1756, Sp. 159.

40 Hoppe 1993, S. 20.

41 Benkard 1925, S. 7.

42 Feulner 1929, S. 53; Hölzel 1977.

43 Stölzl 2004, Abb. 138, 139, S. 172, 173, 320, Nr. 138, 139.

44 Laue 2001, S. 114–115; Ausst.-Kat. Quick 1997, S. 41.

45 Vorbildhaft waren die Holzschnitte der 1543 erstmals unter dem Titel »De
 humani corporis fabrica« veröffentlichten Anatomie des Brüsseler Arztes
 Andreas Vesalius (1514–1564); Ausst.-Kat. Pygmalions Werkstatt 2001,
 S. 226–229.

46 Lepenies 1976, S. 21–24.

47 Campe 1994, S. 162–186.

48 Schmölders 1994, S. 243–244.

49 Campe 1990b, S. 68–83.

50 Gebauer / Wulf 1992, S. 227.

51 Vgl. Bückling 1999b und Bückling 2002.

52 Boehm 1988, S. 24.

26 Caylus 1730; Kirchner 1991, pp. 190–229.

27 Möller 2000, nos. 163–212.

28 Kirchner 1991, pp. 29–50.

29 Montagu 1994, p. 176.

30 Reinhold 1784.

31 Krapf, Charakterköpfe 2002, p. 55.

32 Feuchtmüller 1989, p. 566; Krapf, Charakterköpfe 2002,
 p. 55.

33 Frey 1926, p. 117; Niemetz 1965, p. 7; exhib. cat.
 Giovanni Giuliani 2005, pp. 310–317.

34 Baum 1964, pp. 30f.

35 Wiedenhofer 1992, pp. 55–70.

36 Dohme 1878; Benkard 1925, pp. 7–9, pls. 14–25;
 Ladendorf 1935, pp. 12–14; Dautel 2001, pp. 41–140.

37 Benkard 1925, p. 8.

38 Zedler 1754, col. 1701; Kammel 2001, pp. 516f.

39 Kuester / Müller 1756, col. 159.

40 Hoppe 1993, p. 20.

41 Benkard 1925, p. 7.

42 Feulner 1929, p. 53; Hölzel 1977.

43 Stölzl 2004, figs. 138, 139, pp. 172, 173, 320, nos. 138, 139.

44 Laue 2001, pp. 114f.; exhib. cat. Quick 1997, p. 41.

45 The models were the woodcuts in the "De humani cor-
 poris fabrica", first published in 1543 under that title by
 the Brussels physician Andreas Vesalius (1514–1564);
 exhib. cat. Pygmalions Werkstatt 2001, pp. 226–229.

46 Lepenies 1976, pp. 21–24.

47 Campe 1994, pp. 162–186.

48 Schmölders 1994, pp. 243–244.

49 Campe 1990b, pp. 68–83.

50 Gebauer / Wulf 1992, p. 227.

51 Cf. Bückling 1999b and Bückling 2002.

52 Boehm 1988, p. 24.

Thomas Kirchner

Franz Xaver Messerschmidt und die Konstruktion des Ausdrucks

Vom Werk Franz Xaver Messerschmidts geht eine eigenartige Faszination aus, doch entzieht es sich nicht selten eines Zugriffs. Insbesondere die berühmten, etwa ab 1770 entstandenen Charakterköpfe wollen sich nicht einer Klassifikation, wie sie die Kunstgeschichte entwickelt hat, fügen. Ungeachtet der zahlreichen wichtigen Erkenntnisse, die in den letzten Jahren gewonnen wurden,[1] verschließen sich die Köpfe noch immer über weite Strecken. Die Quellen, vor allem Friedrich Nicolais Bericht von seinem Besuch bei dem Künstler im Jahre 1781,[2] helfen nur wenig, die zahlreichen offenen Fragen zu beantworten. Und auch die von Ernst Kris' zentraler Studie ausgehenden Versuche, die Werke mit einer psychischen Erkrankung des Künstlers zu erklären,[3] brachten nicht mehr Licht in das Dunkel. Die Irritation der Forschung ist verständlich. Messerschmidt hatte soeben erfolgreich den Schritt zum Neoklassizismus vollzogen, um sich den Charakterköpfen zuzuwenden, die sich so gar nicht den Vorstellungen von dem neuen Stil fügen wollen. Die Köpfe sind singulär, doch sie sind so voraussetzungslos nicht, wie man es mitunter glaubte. Sie sind vielmehr in einen kulturgeschichtlichen Kontext der Aufklärung eingebunden,[4] auch gehören sie in den künstlerischen Kontext des Neo-

Franz Xaver Messerschmidt and the Construction of Expression

Franz Xaver Messerschmidt's work exerts an unusual fascination yet it has quite frequently eluded explanation. The celebrated Character Heads especially, which were begun in about 1770, resist classification of the sort developed by art historians. Regardless of the numerous additions made to our knowledge of the Character Heads in recent years,[1] they are still to a great extent a closed book. The sources, especially Friedrich Nicolai's account of a visit to the artist in 1781,[2] are not all that helpful in answering all the many questions that remain to be resolved. Nor have the attempts based on Ernst Kris's pivotal study to explain the works as the result of the artist being beset by mental illness[3] shed more light. That scholars feel frustrated is understandable. Messerschmidt had just successfully managed the step to Neo-Classicism when he turned around to devote himself to the Character Heads, which certainly do not conform to notions of the new style. The heads are singular yet they are not as without antecedents as has sometimes been assumed. On the contrary, they are contextually associated with the cultural history of the Enlightenment;[4] they also belong to the artistic context of Neo-Classicism. They are anchored in tradition, both in art and art theory. And on closer scrutiny, they are revealed as the consistent outcome of several lines of development.

The first aspect to be examined is the physiognomy debate that raged in Europe during the 1770s. The Character Heads are contemporaneous with the publication of the theologian Johann Caspar Lavater's work in four volumes "Physiognomische Fragmente, zur Beförderung der Menschenkenntniß und Menschenliebe" (1775–1778), after he had already set the parameters of the subject in two smaller treatises published in 1772. The work was enormously successful; the author quite obviously had his finger on the pulse of the times. Lavater linked up with earlier writings,

klassizismus, zugleich stehen sie in einer künstlerischen und kunsttheoretischen Tradition. Und bei genauerer Betrachtung erscheinen sie als das konsequente Ergebnis, das am Ende einer Reihe von Entwicklungslinien steht.

An erster Stelle ist die Physiognomiedebatte zu nennen, die in Europa ab den 1770er Jahren ausgetragen wurde. Zeitgleich mit der Entstehung der Charakterköpfe erschien Johann Caspar Lavaters vierbändiges Werk »Physiognomische Fragmente, zur Beförderung der Menschenkenntniß und Menschenliebe« (1775–1778), nachdem der Theologe bereits 1772 das Thema in zwei kleineren Schriften abgesteckt hatte. Das Werk war ein großer Erfolg, der Autor hatte ganz offensichtlich den Nerv seiner Zeit getroffen. Er knüpfte an ältere Schriften an, insbesondere an Giovanni Battista della Portas »De Humana Physiognomonia« (1586). Die Physiognomik versprach die Lösung eines zentralen Problems der frühneuzeitlichen Philosophie, die Offenlegung des Verhältnisses von Leib und Seele. Der Charakter eines Menschen schien an seinem Gesicht oder an seinem Kopf ablesbar, eine feste Korrelation zwischen den Formen einzelner Gesichtsteile und einzelnen Charaktereigenschaften wurde behauptet. Jedoch stieß Lavaters Versuch, die Physiognomik als eigenständige Wissenschaft zu etablieren, – obwohl selbst einem aufgeklärten Anspruch entsprungen – gerade in aufgeklärten Kreisen auf regen Widerspruch. Johann Wolfgang von Goethe in Weimar, anfangs selbst Mitarbeiter der »Physiognomischen Fragmente«, Georg Christoph Lichtenberg in Göttingen und in Berlin Friedrich Nicolai, der Messerschmidt in Preßburg besuchte, waren die berühmtesten Kritiker.[5] Lavater wurde sein religiöser Impetus vorgeworfen, der dem höchsten menschlichen Wesen die höchste ästhetische Form zuwies und nur dem schönen Menschen auch eine moralische hohe Stellung zubilligte. Aber die Disziplin wurde auch grundsätzlich in Frage gestellt. So sprach Lichtenberg in seiner Entgegnung »Über Physiognomik wider die Physiognomen. Zu Beförderung der Menschenliebe und Menschenkenntniß« (1778) der Physiognomik jeglichen Erkenntniswert ab, lediglich die Pathognomik, die nicht die festen, sondern die durch Gemütsbewegungen veränderlichen Gesichtsformen untersucht, könne Auskunft über den Charakter einer Person geben. Außerdem geriet die Physiognomik in Konflikt mit einer Disziplin, die wie kaum eine andere aufgeklärte Prinzipien verfolgte, mit der Pädagogik. Deren Ziel, den Menschen zum Besseren zu verändern, ließ sich nur schwerlich vereinbaren mit der Grundthese der Physiognomik, dass der Charakter eines Menschen untrennbar mit seinen nicht veränderbaren festen Kopfformen verbunden sei.

Messerschmidts Köpfe müssen als Teil dieser Debatte betrachtet werden, über die er mit Sicherheit informiert war.[6] Der Bild-

notably Giovanni Battista della Porta's "De Humana Physiognomonia" (1586). The study of physiognomy promised to resolve a central problem troubling philosophers at the dawn of the Modern Age: how to demonstrate the relationship between body and soul. A person's character seemed to be legible in his face or from the shape of his head. A constant correlation between the forms of individual parts of the face and individual character traits was posited. However, Lavater's attempt to establish physiognomy as a science in its own right – even though it was premised on enlightened claims – encountered vociferous dissent in Enlightenment circles. Johann Wolfgang von Goethe in Weimar, who had himself initially collaborated on "Physiognomische Fragmente", Georg Christoph Lichtenberg in Göttingen and Friedrich Nicolai in Berlin, who visited Messerschmidt in Bratislava, were the most celebrated critics.[5] Lavater was accused of being driven by religion to ascribe the highest aesthetic form to the most superior human being and concede the moral high ground only to beautiful people. However, the fundamentals of the discipline were also called into question. In his rebuttal of Lavater, "Über Physiognomik wider die Physiognomen. Zu Beförderung der Menschenliebe und Menschenkenntniss" (1778), Lichtenberg denied the value of physiognomy as a study. Only the study of pathognomy, examining the changes in facial form induced by the various emotions, might impart information on a person's character. In addition, the study of physiognomy ran counter to a discipline which, more than any other, pursued the principles of the Enlightenment: pedagogy or education. Its stated aim to improve people by changing them could scarcely be reconciled with the basic tenet of physiognomy that a person's character was indissolubly linked with his unalterable head form.

Messerschmidt's Heads must be viewed as part of that debate, on which he was certainly informed.[6] The sculptor made use of the methodology developed for the study of physiognomy. Distinctive head forms, emphasis on the forehead, nose, mouth and chin areas, which were especially taken into account by the discipline, the emphasis laid on particular parts of the face are pivotal features of the Character

94 Charles Le Brun, Le ris, um 1668, schwarze Kreide, Feder in Schwarz auf weißgelbem Papier, Musée du Louvre, Paris, Inv.-Nr. G.M. 6469
Charles Le Brun, Laughter, c.1668, black chalk and ink on cream paper, Musée du Louvre, Paris, Inv. no. G.M. 6469

hauer benutzte das Instrumentarium, das die Physiognomik entwickelt hatte. Ausgeprägte Kopfformen, Betonung der von der Disziplin besonders berücksichtigten Stirn-, Nasen-, Mund- und Kinnpartien, Pointierung einzelner Gesichtspartien sind zentrale Merkmale der Charakterköpfe. Trotzdem entziehen diese sich einer eindeutigen Lesbarkeit, wie sie die Physiognomik anstrebte. Sie geben keine präzise Auskunft über das Wesen der Dargestellten. Die Behauptung der Physiognomen, dass das Äußere eines Kopfes Aufschluss über den Charakter gibt, lässt sich an den Köpfen Messerschmidts nicht realisieren. Ein Charakter im Lavater'schen Sinne mag angedeutet sein, aber viel erfährt der Betrachter nicht über die dargestellten Personen. Und ebenfalls der Pathognomik entzog sich Messerschmidt. Zwar verwendete er auch deren Ausdrucksformen, diese sind jedoch genauso wenig eindeutig zu lesen wie die Kopfformen. Einen Einblick in den Charakter der Personen erlauben auch sie nicht.

In diesem Zusammenhang sei die Beobachtung eines Details vermerkt, das nicht nur bei den Charakterköpfen, sondern bereits vorher bei den Porträtköpfen auffällt: die Augen. Gerade die Bildhauer widmeten ihnen eine große Aufmerksamkeit, um das tote Material, mit dem sie arbeiteten, zu beleben und um den Nachteil, nicht Farben hinzuziehen zu können, auszugleichen. Und auch Messerschmidt ist dieser Tradition gefolgt und hat den Augen durch die Gestaltung von Iris und Pupille Leben eingehaucht. Diese Gestaltungsweise gab er, von wenigen Ausnahmen abgesehen, ab etwa 1769, also noch vor den Charakterköpfen, auf, was mit dem von der Forschung konstatierten etwa gleichzeitig anzusetzenden Übergang zu einer neoklassizistischen Formensprache zusammengehangen haben mag. In unserem Kontext hat dieser Schritt indes noch eine andere Dimension, er betrifft auch die Möglichkeit, vom Äußeren

Heads. Nevertheless, they elude unequivocal readings of the kind aimed at by adherents of the study of physiognomy. The Character Heads do not impart precise information on the essence of those represented. The claim made by adherents of physiognomy that the outside of the head allowed conclusions to be drawn on character are not substantiated in Messerschmidt's Heads. Character as Lavater understood it may be suggested but the viewer does not learn much about the persons depicted. And Messerschmidt also eluded the snares of pathognomy. He did use the pathognomic modes of expression but they, too, cannot be read any more unequivocally than the head forms. Nor do they permit insights into the character of the persons represented.

In this connexion, the observation of a detail which attracts our attention both in the Character Heads and even more so in the Messerschmidt portrait heads that preceded them is noteworthy: the eyes. Sculptors especially tended to devote a great deal of attention to them in order to animate the dead material with which they worked and to compensate for the disadvantage of not being able to add colour. And Messerschmidt, too, followed this tradition and breathed life into the eyes by the way he handled the iris and the pupil. With a few notable exceptions, he had abandoned his early way of handling these features by c. 1769, that is, even before he embarked on the Character Heads, which may coincide with his adopting a Neo-Classical formal language, confirmed by scholars as having set in at about the same time. In our context, however, this step has still another dimension; it also concerns the possibility of gaining insight into a person's soul through his external appearance. After all, according to notions entertained since Antiquity, the eye was the window of the soul. Messerschmidt shut that window. We are not to learn anything about those he represents through their eyes.

Another point of reference for the Character Heads is the classical doctrine of the emotions. It was supposed to yield information on the emotional state of a given person yet not probe his character as the study of pathognomy purported to do. Messerschmidt exploited the doctrine of the emotions to the

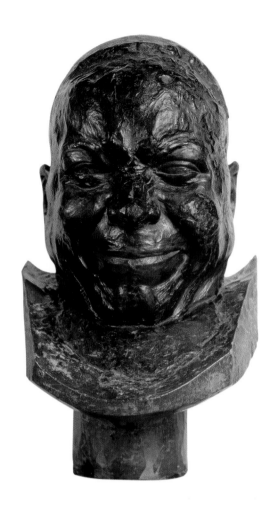

95 Franz Xaver Messer-
schmidt, Ein alter fröh-
licher Lächler, nach
1770, Lindenholz mit
Wachsauflage, Österrei-
chische Galerie Belvede-
re, Wien, Inv.-Nr. 2286
*Franz Xaver Messer-
schmidt, An Old Cheer-
ful Smiler, after 1770,
limewood with wax
appliqué, Österreichische
Galerie Belvedere, Vien-
na, Inv. no. 2286*

des Menschen Einblick in dessen Seele zu erhalten. Denn nach bis auf die Antike zurückreichenden Vorstellungen war das Auge das Fenster der Seele. Messerschmidt verschloss nun dieses Fenster. Durch die Augen erfahren wir nichts über die Dargestellten.

Ein weiterer Bezugspunkt der Charakterköpfe ist die klassische Affektlehre. Sie wollte über die emotionale Befindlichkeit einer Person Auskunft geben, nicht aber deren Charakter ergründen wie die Pathognomik. Messerschmidt bediente sich intensivst des Vokabulars der Affektlehre, seine Charakterköpfe sind voll von Hinweisen auf emotionale Bewegungen, sie werden in einem hohen Maße von diesen geprägt. Zweifellos kannte er die Affektlehre des Pariser Akademiedirektors und Hofmalers Ludwigs XIV., Charles Le Brun (Abb. 94, 95).[7] Dieser hatte 1668 ausgehend von René Descartes' für die Entwicklung der Psychologie zentralen Studie »Les passions de l'âme« (1649) eine Systematik des Affektausdruckes entwickelt, die nach seinem Tod erstmals 1698 veröffentlicht wurde. Descartes' Studie war für die bildende Kunst von herausragender Bedeutung, ging der Philosoph doch davon aus, dass eine emotionale Bewegung immer mit einer auf dem Gesicht ablesbaren körperlichen Bewegung einhergehe. Handelte es sich um einen einfachen Affekt, so war dessen Ausdruck einfach, war der Affekt zusammengesetzt, so

utmost. His Character Heads are full of clues as to what emotions are stirring the subjects depicted; the Heads are, in fact, shaped to a great degree by them. Undoubtedly he would have been familiar the teachings on the emotions promulgated by Charles Le Brun (figs. 94, 95), director of the Paris Academy and painter to the court of Louis XIV.[7] In 1668, taking as his starting point René Descartes' "Les passions de l'âme" (1649), Le Brun developed a – posthumously published (1698) – methodology pivotal to the systematic study of emotions through expression. Descartes' study was of paramount importance to the visual arts since the philosopher based it on the premise that stirrings of the emotion were always readable through concomitant facial action. If the emotion concerned were a simple one, the composition of the corresponding facial expression would also be. This made it seem possible to represent the emotions in visual terms.

Soon Le Brun's system no longer sufficed because it only gave broad outlines. Art was increasingly

96 Peter Paul Rubens,
Die Geburt des
Dauphins, 1622–1625,
Öl auf Leinwand,
Musée du Louvre, Paris,
Inv.-Nr. 1776
*Peter Paul Rubens, The
Birth of the Dauphin,
1622–1625, oil on can-
vas, Musée du Louvre,
Paris, Inv. no. 1776*

expected to reproduce complex emotional states. It had to prove itself by being capable of expressing different, even contradictory, emotions simultaneously. Two reasons for this should be mentioned. On the one hand, art could in this way reproduce a multi-strand narrative and in so doing assert itself against literature. On the other – more importantly in the present connection – emotion as simple and unalloyed hardly seemed by then to correspond to the realities of emotional life. It continued to be experienced as increasingly complex and sophisticated so that a simple, unalloyed emotion might at best be considered part of a complex whole but not as a stirring of the emotions as it existed in reality.[8] Peter Paul Rubens' (fig. 96) "The Birth of the Dauphin" has been frequently cited since the early 18th century as a prime example of this. Writers discovered in the face of Queen Maria de' Medici, who had just given birth, a link between the joy she is experiencing at the birth of the Dauphin and physical pain she is feeling from the act of parturition, that is, two simultaneously felt emotions which might seem to be conflicting. In the 1760s Jean-Baptiste Greuze (1725–1805) was regarded as the painter most capable of representing a highly complex state of the emotions. The encyclopaedist and art critic Denis Diderot rejoiced at this very aspect of the scenes Greuze set so convincingly in bourgeois everyday life (fig. 97). Greuze enjoyed a formidable reputation throughout Europe and his works were widely disseminated via prints after them.

Messerschmidt made use of the doctrine of the emotions. His Character Head project began – if one believes a contemporary – with it. An anonymous writer reports that the sculptor began with a number of quite small heads, executed at first in wax and later worked in other materials, and with drawings of the emotions. He also mentions character studies.[9] And, moreover, he adopted the thinking on the mixed, conflicting passions. His Character Heads reveal a linkage of all sorts of forms of expression. On closer scrutiny, however, these various forms of expression turn out to be just as impossible to read as the head forms. In the Character Heads, the sculptor did not pursue a decodable language of facial expression, a new doctrine of expression as a further development

war auch sein Ausdruck zusammengesetzt. Damit schienen Emotionen darstellbar.

Bald genügte das Le Brun'sche System nicht mehr, es war zu grob. Von der Kunst wurde zunehmend die Wiedergabe differenzierter emotionaler Bewegungen erwartet. Sie hatte sich darin zu beweisen, unterschiedliche, auch entgegengesetzte Affekte gleichzeitig auszudrücken. Zwei Gründe sind hierfür anzuführen. Zum einen konnte sie auf diesem Wege eine vielschichtige Narration wiedergeben und sich damit gegenüber der Literatur behaupten. Zum anderen erschien – für unseren Zusammenhang von größerer Bedeutung – der einfache, unvermischte Affekt kaum noch dem realen Emotionsleben zu entsprechen. Dieses wurde als immer komplexer und komplizierter erfahren, so dass die einfachen, unvermischten Affekte allenfalls als Teil einer Gemengelage verstanden werden konnten, nicht aber als eine emotionale Bewegung, die in der Wirklichkeit existierte.[8] Als herausragendes Beispiel wurde seit dem frühen 18. Jahrhundert immer wieder »Die Geburt des Dauphins« von Peter Paul Rubens (Abb. 96) angeführt. In dem Gesicht der soeben niedergekommenen Königin Maria de' Medici entdeckten die Autoren eine Verbindung von Freude angesichts der Geburt des Dauphins und Schmerz der Geburt, von zwei Empfindungen also, die eigentlich im Widerspruch zueinander zu stehen scheinen. In den 1760er Jahren galt insbesondere Jean-Baptiste Greuze (1725–1805)

97 Jean-Baptiste Greuze,
Die vielgeliebte Mutter,
1769, Öl auf Leinwand,
Sammlung Comte de la
Viñaza, Madrid

Jean-Baptiste Greuze,
The Beloved Mother,
1769, oil on canvas,
Comte de la Viñaza
Collection, Madrid

of, or even rivalling, the Le Brun system, which had been so often called for and which Messerschmidt presumably had intended with his first project. He linked up with existing doctrines but here, too, deviated in a crucial point. Greuze and Diderot had been concerned with approaching reality as close as possible. However, art had to learn that the complexity of emotional reality could not always be captured with the means available to a doctrine of the emotions, no matter how sophisticated it might be. Messerschmidt, too, had presumably realised this from his studies. And so he extrapolated abstraction from a reality that could only be extrinsically experienced. The forms he invented for the emotions are often exaggerated. Nuances are often suppressed; moreover, the linkage of emotions he shows cannot, generally speaking, be found in actual reality on a face. The facial muscles are incapable of performing simultaneously the divergent actions shown on so many of the Heads. The faces reveal constructs for semantic markers of expression which do not result in any facial expression encountered in reality. In fact, these constructs overcharge the capacity for expression inherent in a real face.

In the Character Heads, Messerschmidt kept resorting to his own countenance for reference. As Nicolai reported, he also worked from his image in the mirror in order to study facial expression and then transpose it to a head.[10] This procedure should, however, not be interpreted as a sort of self-questioning of the kind encountered in Rembrandt or van Gogh. His own countenance instead provided the material with which Messerschmidt worked. He was better able to experiment on and with himself in trying out the expressions resulting from emotions than he would have been from a model. He could repeat expressions, construct something which did not exist in reality. In applying this procedure, Messerschmidt was adopting one that was frequently recommended in 18th-century writing on art. There the discussion had long raged on how human passions might best be captured by art. Study from nature could not produce satisfactory results since the expression of a passion was too fleeting to be easily caught. The classical method of working from life, from a model, failed as

als der Künstler, der ein höchst differenziertes Stimmungsgefüge dazustellen verstand. Der Enzyklopädist und Kunstkritiker Denis Diderot bejubelte gerade diesen Punkt seiner im bürgerlichen Alltag angesiedelten Szenen (Abb. 97). Die Werke von Greuze genossen in ganz Europa ein großes Ansehen und waren durch die Reproduktionsgraphik weit verbreitet.

Messerschmidt bediente sich bei der Affektlehre, sein Projekt der Charakterköpfe hat – will man einem Zeitgenossen glauben – von dieser ihren Ausgang genommen. Der Anonymus berichtet, dass der Bildhauer mit einer Reihe von kleineren, anfangs in Wachs, dann auch in anderen Materialien gearbeiteten plastischen Köpfen und mit Zeichnungen von Affekten begann, auch ist von Charakterstudien die Rede.[9] Und ebenfalls die Überlegungen zu den gemischten, miteinander kontrastierenden Leidenschaften hat er offensichtlich aufgegriffen. Seine Köpfe zeigen eine Verbindung unterschiedlichster Ausdrucksformen. Bei genauerer Betrachtung erweisen sich jedoch diese Ausdrucksformen ebenso wenig eindeutig lesbar wie die Kopfformen. Eine dechiffrierbare Sprache des Gesichtsausdrucks, eine neue Ausdruckslehre in Weiterentwicklung oder auch in Konkurrenz zu dem Le Brun'schen System, wie sie immer wieder gefordert wurde und wie sie Messerschmidt vermut-

98 Albrecht Dürer, Propor-
tionsstudie eines Kopfes,
Holzschnitt, in: Albrecht
Dürer, »Vier Bücher von
der menschlichen Pro-
portion«, 1528
*Albrecht Dürer, Propor-
tion study of a Head,
woodcut, in: Albrecht
Dürer, "Four Books on
Human Proportion",
1528*

well. A model could assume a particular pose and
hold it but she or he could not persist in an artificial-
ly induced emotional state over any length of time.
Instead, artists were urged to study the great models
of their calling, especially the work of Raphael. In
addition, they were frequently admonished to look to
themselves. They were supposed to experience the
emotions themselves and have recourse to a mirror to
study the expression of the emotions from their own
faces.[11] Gérard de Lairesse even went a step further in
his "Groot schilderboek" (1707). After recommending
to artists that they should execute drawings after their
own image as seen in the mirror in various states of
emotion, he suggested they should make a series of
plaster casts of one modelled head and work these

lich mit seinem ersten Projekt beabsichtigt hatte, verfolgte der Bild-
hauer nicht. Er knüpfte an die bestehenden Lehren an, wich aber
auch hier in einem entscheidenden Punkt ab. Greuze und Diderot
war es um eine möglichst große Wirklichkeitsnähe gegangen, jedoch
musste die Kunst erfahren, dass die Komplexität der emotionalen
Wirklichkeit sich nicht immer mit den Mitteln selbst einer noch so
differenziert vorgehenden Affektlehre einfangen ließ. Dies hatte ver-
mutlich auch Messerschmidt bei seinen Studien erkannt. Und so
abstrahierte er von einer äußerlich erfahrbaren Wirklichkeit. Die
Ausdrucksformen seiner Affekte sind häufig übertrieben, Nuancen
mitunter überdeckt, zudem sind die gezeigten Verbindungen im All-
gemeinen in Wirklichkeit auf einem Gesicht nicht zu finden. Die
Gesichtsmuskeln können die in vielen Köpfen gezeigten Bewegun-
gen unterschiedlicher Richtungen nicht gleichzeitig leisten. Die
Gesichter zeigen Konstruktionen von Ausdrucksmerkmalen, die
keinen in der Wirklichkeit anzutreffenden Gesichtsausdruck erge-
ben, ja die Ausdrucksmöglichkeiten eines Gesichtes überfordern.

Messerschmidt ging bei den Charakterköpfen immer wieder
von seiner eigenen Physiognomie aus. Auch arbeitete er, wie Nicolai
berichtete, nach seinem Spiegelbild, um den Gesichtsausdruck zu
studieren und dann auf einen Kopf zu übertragen.[10] Man hat dieses
Vorgehen jedoch nicht als eine Art Selbstbefragung zu verstehen,
wie sie uns etwa bei Rembrandt oder van Gogh begegnet. Die eige-
ne Physiognomie ist vielmehr Material, mit dem Messerschmidt

99 Pier Leone Ghezzi, Der
Altsänger Antonio Maria
Bernacchi, 1731, Zeich-
nung, Biblioteca Apos-
tolica Vaticana, Rom,
Ottob. Lat. 3116
*Pier Leone Ghezzi,
The Alto Antonio Maria
Bernacchi, 1731, draw-
ing, Biblioteca Apostolica
Vaticana, Rome,
Ottob. Lat. 3116*

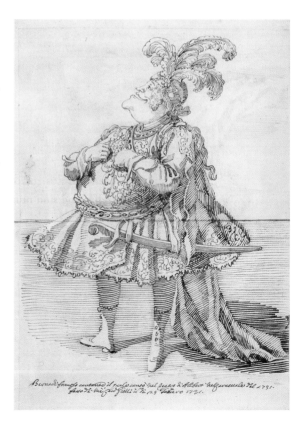

arbeitete. Besser als mit einem Modell konnte er an und mit sich selbst experimentieren, konnte Gemütsausdrücke ausprobieren, sie wiederholen, konnte auch etwas konstruieren, was in der Wirklichkeit nicht vorzufinden war. Mit der Vorgehensweise griff er ein in der Kunstliteratur des 18. Jahrhunderts immer wieder vorgeschlagenes Verfahren auf. Dort entspann sich seit längerem eine Diskussion, wie die menschlichen Leidenschaften am besten künstlerisch erfasst werden könnten. Ein Naturstudium brachte keine zufriedenstellenden Ergebnisse, war der Ausdruck einer Leidenschaft doch zu flüchtig, als dass er leicht eingefangen werden konnte. Auch versagte das klassische Verfahren, nach einem Modell zu arbeiten. Ein Modell konnte eine bestimmte Stellung einnehmen, aber es konnte sich nicht künstlich über einen längeren Zeitraum in einen Affekt begeben. Stattdessen wurde den Künstlern das Studium der großen Vorbilder, insbesondere der Werke Raffaels, nahegelegt, außerdem wurden sie immer wieder auf sich selbst verwiesen. Sie sollten die Affekte selbst erleben und einen Spiegel hinzuziehen, um deren Ausdruck an ihrem eigenen Gesicht zu studieren.[11] Gérard de Lairesse ging in seinem »Groot schilderboek« (1707) noch einen Schritt weiter. Nachdem er dem Künstler empfohlen hatte, Zeichnungen nach dem eigenen Spiegelbild in unterschiedlichen Affekten anzufertigen, empfahl er, von einem plastischen Kopf eine Reihe von Abgüssen herzustellen und diese – sei es nach dem eigenen Spiegelbild, sei es nach anderen Personen – zu bearbeiten und mit den Ausdrucksmerkmalen der unterschiedlichen Affekte zu versehen. Die Köpfe ergäben eine Sammlung, auf die der Künstler bei seiner weiteren Arbeit zurückgreifen könne.[12]

Messerschmidt übernahm diese Vorgehensweise. Und auch hier entfernte er sich von seinem Ausgangspunkt. Seine Köpfe sind nicht mehr Hilfsmittel zur Bewältigung einer zentralen künstlerischen, indes äußerst schwierigen Aufgabe, zur Wiedergabe menschlicher Emotionen in einem bildnerischen Zusammenhang, wie es Lairesse und verschiedene Kunsttheoretiker vorgesehen hatten. Sie haben sich verselbständigt und sind nun eigentliches Ziel des künstlerischen Schaffens.

Ein weiterer Bezugspunkt ist zu benennen, der in der Messerschmidt'schen Welt von Bedeutung ist. Seine Köpfe sind in einem hohen Maße konstruiert, sie scheinen einem geometrischen Prinzip zu unterliegen. Auch hierbei folgte der Künstler den in der Kunstliteratur entwickelten Methoden. Die Proportionslehren setzen die einzelnen Teile des menschlichen Körpers in ein Maßverhältnis zueinander. Albrecht Dürer vermaß als erster systematisch den Menschen und legte ein differenziertes Proportionssystem vor. Sein empirischer Zugriff umfasste auch den Kopf (Abb. 98). Und Charles Le Brun benutzte für einen Teil seiner Affektstudien ebenfalls ein

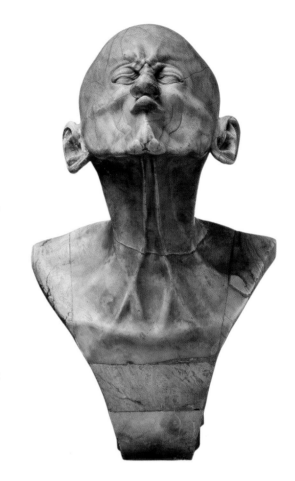

100 Franz Xaver Messerschmidt, Zweiter Schnabelkopf, vor 1781, Alabaster, Österreichische Galerie Belvedere, Wien, Inv.-Nr. 5640

Franz Xaver Messerschmidt, Second Beaked Head, before 1781, alabaster, Österreichische Galerie Belvedere, Vienna, Inv. no. 5640

over – either after their own image in the mirror or that of someone else – to lend them the qualities of expression proper to the various emotions. Such heads would make a collection which the artist might draw on in his subsequent work.[12]

Messerschmidt adopted this procedure. And here, too, he distanced himself from his starting point. His heads are no longer aids to dealing with an artistic task of paramount importance that was also extremely difficult, to reproducing human emotions in a sculptural context as Lairesse and various other art theorists had intended. Messerschmidt's Heads

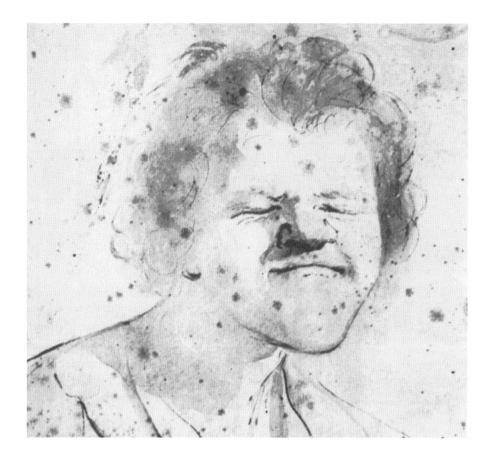

101 Giovanni Francesco
 Barbieri, gen. Guercino,
 Karikatur, um 1650,
 Musée du Louvre, Paris,
 Inv.-Nr. 6924
 Giovanni Francesco
 Barbieri, called Guercino,
 caricature, c.1650,
 Musée du Louvre, Paris,
 Inv. no. 6924

geometrisches System, dem er die einzelnen Gesichtsteile einschrieb (Abb. 94). Dieses Verfahren erlaubte eine planmäßige Erfassung des Gesichtes und seiner Bewegungen. Ganz ähnlich scheint Messerschmidt von einer geometrischen Vermessung des Gesichtes ausgegangen zu sein, um sich auch von diesem System zu entfernen. Die Konstruktion der Köpfe mit Hilfe geometrischer Gesetze führte bei ihm nicht zu einer Annäherung an die Natur, zu einer Ergründung von deren Gesetzmäßigkeiten, wie dies die Proportionslehren verfolgten, sondern eher zu einer Abkehr von der Natur, zu deren Abstraktion.

All die angeführten, von Messerschmidt herangezogenen Bereiche wurden von derselben Idee geleitet. Physiognomik, Pathognomik, Affektlehre und Proportionslehre verfolgten das Ziel, dem Künstler den Zugriff auf die Wirklichkeit zu erleichtern. Sie suchten nach den Gesetzmäßigkeiten der Natur. Insbesondere eine auf eine Idealisierung abhebende akademische Kunst benötigte die Kenntnis dieser Gesetzmäßigkeiten für die Ausbildung und für die künstlerische Praxis. Die Befolgung der der Natur zugrunde liegenden göttlichen Idee sollte den unmittelbaren Zugriff auf die Wirklichkeit erleichtern, wenn nicht sogar ersetzen.

became an autonomous entity in their own right and as such they became the actual aim of his creative activity.

Another point of reference should be mentioned which is important in Messerschmidt's world. His Heads are constructed to such an extent that they seem to be based on an underlying geometric principle. In this, too, the artist was following methods developed in writings on art. The various doctrines of proportion placed the individual parts of the human body in a ratio to one another. Albrecht Dürer was the first to measure man systematically and publish a sophisticated system of proportions. His empirical approach also included the head (fig. 98). And as part of his study of the emotions, Charles Le Brun also used a geometric system to which he allotted the individual parts of the face (fig. 94). This method made it possible to study systematically the face and its actions. Messerschmidt seems to have started from geometric measurement of the face on very similar

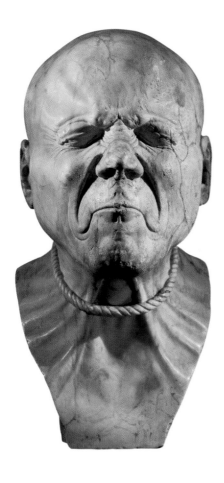

102 Franz Xaver Messer-
 schmidt, Ein Erhängter,
 nach 1770, Alabaster,
 Österreichische Galerie
 Belvedere, Wien,
 Inv.-Nr. 5637
 Franz Xaver Messer-
 schmidt, A Hanged Man,
 after 1770, alabaster,
 Österreichische Galerie
 Belvedere, Vienna,
 Inv. no. 5637

Bei Messerschmidt diente keines dieser Hilfsmittel mehr zur Reali-
sierung der mit ihnen ursprünglich verbundenen Idee. Das, was
eigentlich zur Erfassung der Natur führen sollte, führte de facto zu
einer Entfernung von dieser Natur. Die Kopfformen verweisen
nicht auf einen Charakter, die Ausdrucksformen tragen nicht zum
Verständnis der emotionalen Befindlichkeit der Personen bei, die
Vermessung der Köpfe hat keine realistische Kopfform zum Ergeb-
nis. Stattdessen haben wir es mit einer extremen Stilisierung zu tun.
Die Köpfe sind – entgegen jeglicher Wirklichkeitserfahrung – sym-
metrisch aufgebaut, die die Ausdrucksformen und Kopfbewegungen
markierenden Falten und Muskeln sind stilisiert, und auch die Haa-
re und Augenbrauen sind nicht realistisch gestaltet, sondern folgen
einem ornamentalen Schema.

 Nicolai berichtet, der Künstler habe bei seinen Köpfen ein
kompliziertes und dem Autor offensichtlich nicht völlig verständ-
liches Proportionssystem verfolgt, das einzelne Partien des Kopfes
mit unterschiedlichen Körperteilen in Beziehung setze.[13] Über die-
ses System ist viel spekuliert worden, insbesondere da Messer-
schmidt den Proportionen einen feindlichen Geist zuwies, mit dem
er ringen musste. Einigen Autoren galten diese Erläuterungen Nico-

lines, only, however, to distance himself from this sys-
tem as well. The construction of heads with the aid of
the laws of geometry did not lead him to approach
nature more closely, to plumbing natural laws, which
was the aim pursued in the doctrines of proportion.
Instead, it lead him away from nature and towards an
abstract treatment of it.

 All the fields cited which Messerschmidt drew
on were informed by the same idea. The study of
physiognomy, pathognomy, the doctrine of the emo-
tions and the doctrine of proportion all pursued the
objective of making it easier for an artist to access
reality. They sought to discover the laws of nature.
Academic art, grounded as it was in idealisation,
needed the knowledge of these laws both for training
purposes and for artistic praxis. Following the divine
idea subsumed in nature was supposed to make access
to reality easier and even possibly replace reality.

 In Messerschmidt, none of these aids served to
realise the idea originally linked with them. What was
supposed to lead to understanding of nature in fact
led away from that same nature. Head forms do not
indicate character; forms of expression do not con-
tribute to understanding the emotional state of the
persons involved. Measuring heads does not result in
a realistic head form. Instead, we are confronted here
with extreme stylisation. The Messerschmidt Heads
are – against all empirical experience of reality – sym-
metrically constructed. The wrinkles and muscles
marking forms of expression and Head movements

275

103 Leonardo da Vinci, Gruppe von fünf grotesken Köpfen, um 1490, Federzeichnung, The Royal Collection, H. M. Queen, Elisabeth II, Windsor Castle, Inv.-Nr. RL 12495

Leonardo da Vinci, group of five grotesque heads, c. 1490, pen-and-ink drawing, The Royal Collection, H. M. Queen Elizabeth II, Windsor Castle, Inv. no. RL 12495

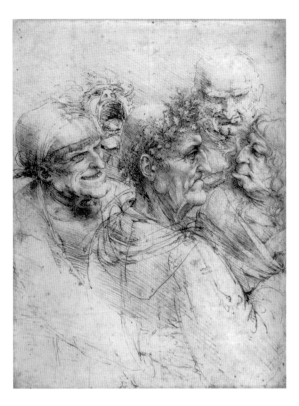

are stylised. Not even the hair and eyebrows are realistically handled but instead follow an ornamental schema.

Nicolai reports the artist followed a complicated and evidently, as far as the writer was concerned, not entirely comprehensible system of proportions, which related individual parts of the Head with various parts of the body.[13] Much has been conjectured about that system since Messerschmidt allocated to the proportions an inimical spirit with which he had to wrestle. Some writers have regarded these explanations of Nicolai's as final proof that the artist suffered from a mental disorder. However, the idea of a connexion between individual parts of the head and the body does not seem all that abstruse; it is reminiscent of Chinese medicine, which had been introduced to Europe by Jesuit missionaries. And the artist's wrestling with the Spirit of Proportion can be interpreted rather as a metaphorical description of struggling with an aesthetic system which was not nature-oriented but was presumably grounded in mathematics, one which was, in any case, abstract, which the artist wanted to work through by overcoming the unmediated reproduction of nature.[14]

Let us turn to one last point. Messerschmidt's works are of a markedly private character. He did show them – when he was in the right mood – to visitors but he neither created them on commission nor did he have any intention of selling them.[15] "[…] he worked for himself and for no one else […]," thus the Frankfurt collector and art-writer Heinrich Sebastian Hüssgen quotes the artist, who justified his refusal to allow the traveller to view his works on those grounds late in 1780.[16] The artist was not always so unforthcoming; nonetheless, it is obvious that he created those works for himself. He was trying something out in them, developing a language of forms that allowed for no compromises of the sort demanded by the market. The price for this uncompromising stance was that the works were only intelligible to a limited degree, a problem with which we are still struggling today.

Art history knows another area in which artists worked privately on similar lines and eluded a commitment to reality to the same extent: caricature. This

lais als endgültiger Beleg für die geistige Verwirrtheit des Künstlers. Jedoch scheint die Idee eines Zusammenhanges einzelner Kopfpartien und Körperteile so abstrus nicht, sie lässt an die chinesische Medizin denken, die im 18. Jahrhundert insbesondere durch die jesuitischen Missionare in Europa bekannt wurde. Und das Ringen des Künstlers mit dem Geist der Proportion kann verstanden werden als eine etwas verbrämte Beschreibung des Ringens nicht mit einem an der Natur orientierten, sondern mit einem vermutlich mathematisch begründeten, auf jeden Fall aber abstrakten ästhetischen System, das sich der Künstler in Überwindung der unmittelbaren Naturwiedergabe erarbeiten wollte.[14]

Wenden wir uns einem letzten Punkt zu. Messerschmidts Werke haben einen dezidiert privaten Charakter. Zwar zeigte er sie – wenn er bei Laune war – auch seinen Besuchern, aber er fertigte sie weder im Auftrag an, noch dachte er daran, sie zu veräußern.[15] » […] er arbeite für sich, und für sonst niemand […] «, so zitiert der Frankfurter Sammler und Kunstschriftsteller Heinrich Sebastian Hüssgen den Künstler, der dem Reisenden mit dieser Begründung Ende 1780 die Besichtigung seiner Werke verweigerte.[16] Nun war der Künstler nicht immer so abweisend, deutlich ist jedoch, dass er die Werke für sich schuf. Er probierte in ihnen etwas aus, entwickelte eine künstlerische Formensprache, die keine Kompromisse erlaubte, wie sie ein Markt verlangte. Der Preis für dieses kompro-

104 Francis Grose, Karikatur-
studien, in: Francis Grose,
»Rules for Drawing
Caricaturas«, 1788
*Francis Grose, caricature
studies, in: Francis Grose,
"Rules for Drawing
Caricaturas", 1788*

missloses Vorgehen war die nur bedingte Verständlichkeit der Werke, mit der wir noch heute zu kämpfen haben.

Die Kunstgeschichte kennt einen anderen Bereich, in dem Künstler ähnlich privat gearbeitet haben und der sich gleichermaßen einer Wirklichkeitsverpflichtung entzog: die Karikatur. Die Gattung, die insbesondere in Rom am päpstlichen Hofe gepflegt wurde, verweigerte sich einer idealistischen Ästhetik, sie entwarf geradezu deren Gegenbild. So wie das idealisierende Bild einen Kopf verschönert, so weicht die Karikatur ins Hässliche ab.[17] Johann Joachim Winckelmann lieferte wenige Jahre vor der Entstehung von Messerschmidts Charakterköpfen eine Rechtfertigung der Karikatur, als er in seinem »Sendschreiben über die Gedanken von der Nachahmung der griechischen Werke in der Malerey und Bildhauerkunst« (1756) bemerkte: »Der Verfasser [gemeint ist Winckelmann in den ›Gedanken über die Nachahmung der griechischen Werke in der Malerey und Bildhauerkunst‹] giebt es als einen Vor-

genre, which was cultivated in Rome at the papal court especially, refused to commit to an idealistic aesthetic; it created the very reverse. Just as an idealising image makes a head look more beautiful, caricature branches off into ugliness.[17] A few years before Messerschmidt's Character Heads came into being, Johann Joachim Winckelmann provided a justification of caricature when he remarked in "Sendschreiben über die Gedanken von der Nachahmung der griechischen Werke in der Malerey und Bildhauerkunst" (1756): "The author [i.e. Winckelmann] mentions it as an advantage in the artists of antiquity that they transcended the bounds of common nature: do not our masters of caricature do just this?"[18] Published anonymously, the "Sendschreiben" (that is to say, Circular or Newsletter) was conceived and

zug bey den Künstlern des Alterthums an, daß sie über die Grenzen der gemeinen Natur gegangen sind: thun unsere Meister in Caricaturen nicht eben dieses?«[18] Das anonym publizierte »Sendschreiben« war von Winckelmann als taktisch platzierte Kritik an seiner idealistischen Programmschrift »Gedanken über die Nachahmung der griechischen Werke in der Malerey und Bildhauerkunst« (1755) konzipiert worden, um es dann in seiner »Erläuterung der Gedanken von der Nachahmung der griechischen Werke in der Malerey und Bildhauerkunst; und Beantwortung des Sendschreibens über diese Gedanken« (1756) zu widerlegen und die Positionen der »Gedanken über die Nachahmung« noch einmal zu unterstreichen. Erstaunlicherweise bleibt diese Passage jedoch in der »Erläuterung« unwidersprochen. Winckelmann akzeptierte somit die Karikatur als Gegenentwurf zur idealistischen Hochkunst, nicht um diese zu entkräften, sondern um nach deren künstlerischen Prinzipien zu forschen.[19] Und so war die Karikatur eine Kunstform, die von prominenten Künstlern gepflegt wurde, die in der Hochkunst anerkannt waren und die sich nicht selten dem Neoklassizismus angeschlossen hatten.[20]

Messerschmidt griff diese Überlegung in seinen Charakterköpfen auf. Nicht nur übernahm er etwa in dem berühmten »Schnabelkopf« von der Karikatur das Mittel der Übertreibung einzelner markanter Gesichtspartien (Abb. 99, 100), sondern er entlehnte ihr auch mimische Ausdrucksformen, wie die häufiger anzutreffende Verbindung von zusammengekniffenem Mund und geschlossenen Augen (Abb. 101, 102). Messerschmidt wird die Überlegungen Winckelmanns wie auch die Gattung der Karikatur spätestens während seines Rom-Aufenthaltes im Jahre 1765 kennen gelernt haben.

Auch wenn es sich bei den Köpfen von Messerschmidt nicht um Karikaturen handelt, so ist der Hinweis auf die Gattung doch hilfreich. Denn die Karikatur bediente sich wie unser Bildhauer des Vokabulars der Physiognomik und der Pathognomik. Dies konnte so weit gehen, dass mitunter, wie etwa bei Leonardo da Vincis physiognomischen Studien (Abb. 103), eine klare Unterscheidung schwer fällt. Und selbst für die Karikatur wurde überlegt, das menschliche Gesicht zu vermessen. So arbeitete Francis Grose in seinen »Rules for Drawing Caricaturas: with an Essay on Comic Painting« (1788) mit Konstruktionslinien, ähnlich wie dies Albrecht Dürer und Charles Le Brun für ihre Untersuchungen getan hatten (Abb. 104, vgl. Abb. 94, 98). Grose griff also auf ein Verfahren zurück, das zur Wirklichkeitserfassung entwickelt worden war, um eine künstliche Zeichensprache für die Karikatur zu entwickeln. Messerschmidts Vorgehensweise ist vergleichbar. Auch er hatte mit seinen konstruierten Köpfen eine künstliche Zeichensprache vor Augen. Die Kunst – dies hatten spätestens die Diskussionen um Physiogno-

launched for tactical reasons by Winckelmann as criticism of the idealistic agenda he had set out in his "Gedanken über die Nachahmung der griechischen Werke in der Malerey und Bildhauerkunst" (1755), only to rebut it in "Erläuterung der Gedanken von der Nachahmung der griechischen Werke in der Malerey und Bildhauerkunst; und Beantwortung des Sendschreibens über diese Gedanken" (1756) and to re-affirm the stances he had adopted in "Gedanken über die Nachahmung". Surprisingly, however, the above passage remained unrefuted in "Erläuterung". This means that Winckelmann accepted caricature as diametrically opposed to idealist high art, not, however, to repudiate it but rather as a tool for researching into its artistic agenda.[19] And caricature was, therefore, an art form that was cultivated by distinguished artists who had achieved recognition in high art and not infrequently had become adherents of Neo-Classicism.[20]

Messerschmidt took up this thinking in his Character Heads. Not only did he adopt from caricature in his celebrated "Beaked Head" the devices for the exaggeration of pronounced individual facial features (figs. 99, 100) but also borrowed its mimetic forms of expression such as the frequently occurring combination of lips pressed tightly together and closed eyes (fig. 101, 102). Messerschmidt probably became familiar with Winckelmann's thinking as well as with caricature as a genre during his stay in Rome in 1765 at the latest.

Even though Messerschmidt's Heads are not caricatures, it is nonetheless helpful to invoke that genre in connection with them. Like caricaturists, our sculptor used the vocabulary developed in the study of physiognomy and pathognomy. This vocabulary might be implemented to such an extent, as, for instance, in Leonardo da Vinci's physiognomic studies (fig. 103), that it is difficult to distinguish between what is caricature and what is not. And measuring the human face was even mooted for caricature. Francis Grose, for one, in his "Rules for Drawing Caricaturas: with an Essay on Comic Painting" (1788) worked with construction lines much as Albrecht Dürer and Charles Le Brun had done in their studies (fig. 104; cf figs. 94, 98). Grose, therefore, reverted to a

Frontispice.

105 Jean-Jacques Lequeu,
Frontispiz zu: Jean-
Jacques Lequeu, »Nou-
velle méthode appliquée
aux principes élémen-
taires de dessin«, 1792

*Jean-Jacques Lequeu,
Frontispiece of: Jean-
Jacques Lequeu, "Nou-
velle méthode appliquée
aux principes élémentaires
de dessin", 1792*

method that had been developed for capturing reality in order to create an artificial language of signs for caricature. Messerschmidt's approach is similar. He, too, had an artistic language of signs before him in the shape of his constructed Heads.

Art – this had been shown at the latest by the debates about the study of physiognomy and pathognomy as well as the academic doctrine of emotions – had reached the limits of its expressive capabilities. As an artist who was primarily concerned with the human countenance, Messerschmdit must also have experienced this deficit. His portraits from the late 1760s and early 1770s show he was trying to go beyond mere reproduction and even that he did not always entirely succeed in uniting portraiture and the doctrine of expression, as is the case with the marble bust of Gerard van Swieten (cat. no. 1). The crisis that overtook Messerschmidt in his late Viennese years must certainly have been triggered off by his disappointment at not achieving recognition and being rejected as a candidate for a chair at the Viennese Academy;[21] however, it was also art-related. Whether he came to terms with this crisis and, if he did, how he managed to do so are largely beyond the state of our knowledge even though there are numerous indications that he had to struggle with that crisis for the rest of his life. However, he could only come to terms with it through an approach to art that abandoned the classical requirement of commitment to reality. He could no longer experience the head as a whole but rather only in its several parts. Not unlike Jean-Jacques Lequeu a few years later in the frontispiece to his instructions on drawing (1792, fig. 105), Messerschmidt dissected the head into its components and then re-assembled it. The link with reality was lost in the process but the expressive capacity of his art was thus considerably enhanced. The Heads are a pure art form; in them art observes only the laws governing them. Without being obliged to make a cogent and coherent statement about the body-soul relationship, the sculptor could try out forms of expression, even resort to the most extreme handling of them. In their rejection of reality and their ornamental conception, Messerschmidt's Character Heads should not be reduced to a specific emotion or a specific character

mik und Pathognomik, aber auch um die akademische Affektlehre gezeigt – war an die Grenzen ihrer Ausdrucksfähigkeit gestoßen. Als Künstler, der sich vornehmlich mit dem menschlichen Antlitz beschäftigte, musste dies Messerschmidt ebenfalls erfahren haben. Seine Porträts in den späten sechziger und frühen siebziger Jahren zeigen, wie er über das bloße Abbilden hinauszugehen versuchte, auch wie es ihm etwa in der Marmorbüste von Gerard van Swieten (Kat.-Nr. 1) nicht immer völlig gelang, Porträt und Ausdruckslehre miteinander zu verbinden. Die Krise, in die er in den späten Wiener Jahren geriet, wurde sicherlich durch die Enttäuschung über die fehlende Anerkennung und schließlich über die Verweigerung einer Professur an der Wiener Kunstakademie ausgelöst,[21] sie war aber auch künstlerischer Natur. Wie und ob er diese Krise menschlich bewältigte, entzieht sich weitgehend unserer Kenntnisse, auch wenn es zahlreiche Hinweise gibt, dass er bis zum Ende seines Lebens mit ihr zu kämpfen hatte. Aber künstlerisch konnte er die Krise nur durch eine Kunst überwinden, die die klassische Anforderung einer Wirklichkeitsverpflichtung aufgab. Der Kopf war ihm nicht mehr als Ganzes erfahrbar, sondern nur noch in seinen Teilen. Nicht unähnlich wie wenige Jahre später Jean-Jacques Lequeu im Frontispiz seiner Zeichenlehre (1792, Abb. 105) zerlegte Messerschmidt den Kopf in seine Bestandteile und fügte diese dann wieder zusammen. Der Wirklichkeitsbezug ging dabei verloren, aber die Ausdrucksfähigkeit seiner Kunst stieg beträchtlich. Die Köpfe sind reine Kunstform, die Kunst gehorcht in ihnen nur noch ihren eigenen Gesetzen. Ohne die Verpflichtung, eine schlüssige Aussage über das Leib-Seele-Verhältnis machen zu müssen, konnte der Bildhauer Ausdrucksformen, auch in einer extremen Gestaltung, ausprobieren. Die Charakterköpfe Messerschmidts mit ihrer Abkehr von der Wirklichkeit und ihrer ornamentalen Gestaltung wollen nicht im Sinne der Descartes'schen Ausdruckslehre auf einen konkreten Affekt oder im Sinne der Physiognomik oder Pathognomik auf einen Charakter zurückgeführt werden, sondern sie müssen ähnlich wie die Karikaturen als ein Versuch verstanden werden, die Kunst auf ihre Ausdrucksfähigkeit hin zu untersuchen.

Messerschmidt stand mit seinem Vorgehen nicht allein. Überall in Europa machte sich bemerkbar, dass eine auf die Wiedergabe einer äußeren Wirklichkeit verpflichtete Kunst an ihre Grenzen stieß. Der Konflikt zwischen Naturverpflichtung und künstlerischem Anspruch war dem Neoklassizismus eingeschrieben.[22] Vielleicht hat Messerschmidt den Konflikt nicht so wie andere Künstler reflektiert, aber er hat ihn mit Sicherheit empfunden. Und bei seiner Untersuchung der Ausdrucksfähigkeit der künstlerischen Mittel fand er Lösungen, die in ihrer Radikalität weit über das hinausgingen, was die Zeit akzeptieren konnte.

as called for in the study of physiognomy or pathognomy. Instead, they must, like caricature, be interpreted as an attempt at investigating the potential for expression that art might attain.

Messerschmidt was not alone in his approach. Throughout Europe it was becoming apparent that art committed to reproducing reality in the extreme was fast reaching its limits. The conflict between a commitment to nature and the claims of art was written into Neo-Classicism.[22] Messerschmidt may not, perhaps, have reflected on the conflict in the same way as other artists but he certainly must have felt it. And, in his investigation of the capacity for expression of the means available to art, he came up with solutions which were so radical that they went well beyond what his time was willing to accept.

1 In addition to the work by Pötzl-Malíková 1982 (on the Character Heads see pp. 68–83, 241–266), three publications dealing with Messerschmidt and the Character Heads in particular are recommended as representative: Behr / Grohmann / Hagedorn 1983; exhib. cat. Messerschmidt 2002; Pfarr 2006; on this see auch Heike Höcherl, "At once Configurations of Madness and Works of Art" in the present catalogue, p. 89–104.

2 Nicolai Reprint 1994, pp. 401–420; also see the reproduction appended to the present catalogue, p. 313–323.

3 Kris 1932.

4 See Bückling 2002 and Krapf, Auftraggeber und Freundeskreis 2002.

5 See Kirchner 1997 in particular for the criticism voiced in Berlin Enlightenment circles.

6 There is evidence that Lavater knew and appreciated Messerschmidt's work through the Freemason and Rosicrucian Joseph Podmanicky as an intermediary; see Pötzl-Malíková 1982, p. 79.

7 See for instance Biedermann 1978, especially pp. 30f.; see Montagu 1994 for Le Brun's doctrine of emotions.

8 See Kirchner 2001.

9 Anon. 1794, p. 21; see also Krapf, Leben und Werk 2002, p. 26.

10 Nicolai Reprint 1994, p. 413.

11 See Kirchner 1991, pp. 239–244 and Kirchner 2004, pp. 365–368.

12 "Neemd dan een plaister-tronie en giet een vorm van twee stukken op dezelve, van loot of eenige andere harde stoffe, om'er daar na zo veel als men wil van potaard in af te drukken, welke afdrukzels gy na gemelde teekening als dan, met de vingers of boetzeerstokjens, tot uw genoegen, kund veranderen, hier wat opgezet, daar wat afgenomen, en gins wat aangezet, zonder het generaal echter te veranderen: dus zullen u dezelve in plaats van het leeven kon-

1 Hingewiesen sei hier neben dem Werk von Pötzl-Malíková 1982 (zu den Charakterköpfen siehe S. 68–83, 241–266) stellvertretend auf drei Publikationen, die sich mit Messerschmidt und insbesondere mit den Charakterköpfen beschäftigen: Behr/Grohmann/Hagedorn 1983; Ausst. Kat. Messerschmidt 2002; Pfarr 2006; dazu siehe auch Heike Höcherl, »Wahngebilde und Kunstwerke zugleich« in diesem Katalog, S. 89–104.

2 Nicolai Reprint 1994, S. 401–420; siehe dazu auch die Abschrift im Anhang dieses Kataloges, S. 313–323.

3 Kris 1932.

4 Siehe Bückling 2002 und Krapf, Auftraggeber und Freundeskreis 2002.

5 Siehe hierzu, insbesondere auch zu der in Berliner Aufklärerkreisen geübten Kritik, Kirchner 1997.

6 Belegt ist, dass Lavater das Werk Messerschmidts durch Vermittlung des Freimaurers und Rosenkreuzers Joseph Podmanicky kannte und schätzte; siehe Pötzl-Malíková 1982, S. 79.

7 Siehe etwa Biedermann 1978, besonders S. 30–31; zu Le Bruns Affektlehre siehe Montagu 1994.

8 Siehe Kirchner 2001.

9 Anonymus 1794, S. 21; siehe auch Krapf, Leben und Werk 2002, S. 26.

10 Nicolai Reprint 1994, S. 413.

11 Siehe hierzu Kirchner 1991, S. 239–244, und Kirchner 2004, S. 365–368.

12 »Neemd dan een plaister-tronie en giet een vorm van twee stukken op dezelve, van loot of eenige andere harde stoffe, om'er daar na zo veel als men wil van potaard in af te drukken, welke afdrukzels gy na gemelde teekening als dan, met de vingers of boetzeerstokjens, tot uw genoegen, kund veranderen, hier wat opgezet, daar wat afgenomen, en gins wat aangezet, zonder het generaal echter te veranderen: dus zullen u dezelve in plaats van het leeven konnen dienen, inzonderheid wanneer de tronie, waar op gy uw vorm gemaakt heb, na uwe tekening komt te gelyken, op dat gy by verandering ook zien kund hoe veel de trekkeningen desgelyks veranderen.« Lairessse 1740, T.1, S. 63.

13 Nicolai Reprint 1994, S. 410–413.

14 Die Suche nach dem Titel des italienischen Buches zu den Proportionen, das Nicolai in der Wohnung Messerschmidts sah, scheint vor diesem Hintergrund wenig sinnvoll. Pötzl-Malíková (1982, S. 79–80) vermutet ein okkultes Werk hinter dem Hinweis Nicolais.

15 Es wird berichtet, dass ein ungarischer Graf und möglicherweise auch Herzog Albert von Sachsen-Teschen die Serie erwerben wollte, beide blieben ohne Erfolg; siehe Pötzl-Malíková 1982, S. 214.

16 Hüssgen 1782, S. 43.

17 Siehe Hofmann 1956, passim.

18 Winckelmann Reprint 1962, S. 73.

19 Ich danke Werner Busch für den freundlichen Hinweis auf diesen Zusammenhang; siehe auch Busch 1981b.

20 Siehe Busch 1993, S. 458.

21 Zu konstatieren ist in diesem Zusammenhang sicherlich auch die von Behr/Grohmann/Hagedorn 1983 angenommene Bleivergiftung des Künstlers.

22 Siehe dazu Busch 1981 und Busch 1993, passim.

nen dienen, inzonderheid wanneer de tronie, waar op gy uw vorm gemaakt heb, na uwe tekening komt te gelyken, op dat gy by verandering ook zien kund hoe veel de trekkeningen desgelyks veranderen.« Lairessse 1740, T. 1, p. 63.

13 Nicolai Reprint 1994, pp. 410–413.

14 Against this background, trying to discover the title of the Italian book on proportion which Nicolai saw in Messerschmidt's house would seem to make little sense. Pötzl-Malíková (1982, pp. 79f.) conjectures an occultist work behind Nicolai's hint.

15 A Hungarian count and possibly also Albert, Duke of Saxe-Teschen, are reported to have wanted to acquire the set but both were unsuccessful; see Pötzl-Malíková 1982, p. 214.

16 Hüssgen 1782, p. 43.

17 See Hofmann 1956 passim.

18 Winckelmann Reprint 1962, p. 73.

19 I am indebted to Werner Busch for kindly pointing out this connexion; see also Busch 1981b.

20 See Busch 1993, p. 458.

21 In this connexion, the suggestion made in Behr/Grohmann/Hagedorn 1983 that the artist suffered from lead poisoning should also be mentioned as probably correct.

22 See Busch 1981 and Busch 1993, passim.

Axel Christoph Gampp

Kunst als Läuterungsprozess

Die Charakterköpfe des
Franz Xaver Messerschmidt
im Kontext
des ästhetischen und arkanen
Wissens seiner Zeit

Während seiner Wiener Jahre verkehrte Messerschmidt mit einer
Reihe herausragender Persönlichkeiten. Dazu gehörten auf der einen
Seite ein Kreis um Franz Anton Mesmer, den Vertreter des Magne-
tismus, wo Ideen der Aufklärung in freimaurerischer Ausprägung
gepaart wurden mit einem hermetischen Denken und dem Versuch,
in arkane Zusammenhänge einzudringen. Hier stand ein angebliches
Wissen der alten Ägypter hoch im Kurs.[1] Auf der anderen Seite muss
es ein Umfeld gegeben haben, dessen Zentrum Franz von Scheyb
bildete, der in Wien in ästhetischen Fragen als Koriphäe galt.[2]

Es mischen sich deswegen in Messerschmidts Person ganz ver-
schiedene Strömungen, die zwar untereinander in Verbindung ste-
hen, die aber gleichwohl analytisch voneinander zu trennen sind:
– »Geheimes Wissen«, freimauerisch eingefärbt und deswegen
durchaus der Aufklärung verpflichtet,
– Aegyptophilie oder vielleicht besser: eine Ägyptosophie,
– ästhetische Aspekte der Aufklärung.
Diese Punkt sind zu trennen und doch auch wieder zusammenzu-
führen. Denn wie gleich zu zeigen sein wird, steht der Betrachter für
die ästhetischen Forderungen der Aufklärung im Zentrum. Er ent-
scheidet als zentrale Instanz über Erfolg oder Misserfolg des Kunst-
werkes. Ihn gilt es zu »affizieren«, seine Emotionen zu wecken, ihn
innerlich zu berühren und in die Stimmung des Kunstwerkes zu
versetzen.[3] Fließen nun die beiden Punkte, geheimes Wissen und
Ägyptosophie, ins Kunstwerk ein, so muss auch dann das Ziel darin

Art as a
Cathartic Process

Franz Xaver Messerschmidt's
Character Heads
in the context
of the aesthetic and
the arcane knowledge of his time

During his Vienna years, Messerschmidt associated
with a number of distinguished people. On the one
hand, they included the circle of Franz Anton Mes-
mer, the exponent of magnetism, where Enlighten-
ment ideas as shaped by Freemasonry were coupled
with hermetic thinking and an attempt to penetrate
to recondite contexts. There what passed for knowl-
edge of the ancient Egyptians was on the agenda.[1] On
the other hand, there must have been an environment
centred on Franz von Scheyb, who was regarded in
Vienna as the expert on aesthetics.[2]

As a result, two entirely different tendencies
fused in Messerschmidt. Although they were linked in
his understanding, they must, however be distin-
guished from one another for the purpose of analysis:
– "arcane knowledge", tinged by Freemasonry and,
therefore, definitely committed to the Enlightenment,
– Aegyptophilia or perhaps more apposite:
Aegyptosophy,
– aesthetic aspects of the Enlightenment.
The above points must be looked at severally
before they can be viewed collectively. After all, as is
about to be shown, the viewer was at the centre of
Enlightenment aesthetic aims. It is the viewer who
decides, as the crucial authority, on the success or
failure of an art work. The viewer must be "affected";
his emotions must aroused, he must be moved and
made to empathise with the mood of the art work.[3]
Although both aspects, arcana and Aegyptosophy, go
into the work of art, another goal must consist in
conveying a message about the third aspect in such a
way in the work of art that the viewer cannot elude
the impact made by the work and the knowledge to
be gained from it. It is in this charged field that what
are known as the Character Heads of Franz Xaver

bestehen, im Kunstwerk dem Betrachter von jenem anderen so Mitteilung zu machen, dass er sich der Wirkung und damit der Erkenntnis nicht entziehen kann. In diesem Spannungsraum sind die so genannten Charakterköpfe des Franz Xaver Messerschmidt anzusiedeln, und es stellt sich die Frage, was in ihre Produktion an Wissen eingeflossen und was sie in ihrer Rezeption vermitteln sollen. Dazu freilich ist zunächst nach dem Anteil zu fragen, den Messerschmidt an den verschiedenen Aspekten aufklärerischen Gedankengutes selbst hatte.

Franz Xaver Messerschmidt und die Aufklärung [4]

Messerschmidt hatte in Wien erfolglos versucht, an der kaiserlichen Akademie Karriere zu machen. Der Versuch war von höchster Stelle, nämlich vom Staatskanzler Fürst Wenzel von Kaunitz-Rietberg, vereitelt worden, wohl aufgrund akademieinterner Querelen und Intrigen gegen den Künstler.[5] Messerschmidt verließ daraufhin Wien und zog nach Preßburg. Der Wegzug enthielt zwei wesentliche Elemente des modernen Künstlers: Messerschmidt machte in Wien eine Verkaufsausstellung seiner im Atelier befindlichen Werke, er arbeitete also im wahrsten Sinne des Wortes als Ausstellungskünstler, und er gedachte darüber hinaus in Preßburg von den Früchten seiner Arbeit und von keiner anderen Unterstützung mehr zu leben.[6]

Wie wir aus verschiedenen Quellen wissen, intensivierte er in Preßburg die Arbeiten an einer in Wien begonnenen Serie von Selbstporträts,[7] die als »Charakterköpfe« in die Kunstgeschichte eingegangen sind.

Was nun an Gedankengut bei ihrer Produktion eine Rolle spielte, darüber sind wir vor allem aus einer Quelle bestens unterrichtet. Der Berliner Aufklärer Friedrich Nicolai suchte Messerschmidt 1781 im Preßburger Atelier auf, sah ihm bei der Arbeit zu und befragte ihn eingehend.[8] Messerschmidt, der als kräftiger Mann von geringer Bildung, aber einer großen Neugierde an arkanen Dingen charakterisiert wird, schildert, wie er von einem »Geist der Proportion« gequält werde und zwar nur deswegen, weil er schon tief in geheime Erkenntnisse und Zusammenhänge eingedrungen sei. Es sei ihm nämlich offenkundig, dass »alle Dinge in der Welt ihre bestimmten Verhältnisse haben und daß alle Wirkungen ihren Ursachen entsprechen. [...] Es werde alles in der Welt durch die Proportionen regiert, und wer diejenigen Proportionen an sich erwecke, welche der Proportion des andern entsprächen oder ihr überlegen wären, müsse Wirkungen hervorbringen, welche der Wirkung des andern entsprechen, oder ihr überlegen seyn müßten.«[9] Dieser Zusammenhang habe sich ihm vor allem vermittels

Messerschmidt must be placed. The question also arises of what background knowledge went into their making and what they were intended to convey to respondents. The first thing, of course, is to ascertain what share Messerschmidt himself had in the various aspects of Enlightenment thinking.

Franz Xaver Messerschmidt and the Enlightenment[4]

Messerschmidt had tried in vain to make a career at the Imperial Viennese Academy. His attempt was thwarted from the very top, namely Chancellor Prince Wenzel von Kaunitz-Rietberg, probably as a result of internal Academy quarrels and intrigues against the artist.[5] Messerschmidt then left Vienna and moved to Bratislava. His departure contains two essential elements of the modern artist: Messerschmidt mounted an exhibition of works in his Vienna studio and sold them. This means he was working to exhibit his work in the literal sense and, moreover, he intended to live in Bratislava from the fruits of his labour and receive no other financial support.[6]

As we know from various sources, at Bratislava Messerschmidt began to work harder on the project he had begun in Vienna, a series of self-portraits[7] which have been written into the annals of art history as the "Character Heads".

We are well informed from one source especially on what thinking played a role in their production. In 1781 the Berlin exponent of the Enlightenment, Friedrich Nicolai, sought out Messerschmidt in his Bratislava studio, watched him at work and questioned him extensively.[8] Messerschmidt, who is characterised as a robust man of little formal education but driven by devouring curiosity about arcane matters, describes how he has been tormented by a "Spirit of Proportion", solely because he has delved so deep into recondite knowledge and contexts. To Messerschmidt, as he says, it is obvious that "all things in the world have their particular proportions and that all effects corresponded to their causes. [...] Everything in the world is governed by proportions and anyone who rouses in himself the proportions which correspond to the proportion of another or are superior to it must evoke effects which correspond to the propor-

einer im Zimmer aufgehängten Zeichnung enthüllt, die eine ägyptische Statue ohne Arme zeigte. Nicolai hielt sie allerdings nicht für eine Zeichnung nach einem existierenden Modell, sondern für das Resultat der Vermessung verschiedener ägyptischer Statuen, mithin für eine Kompilation jener Proportionen. Weil sich ihm – so Messerschmidt weiter – der Zusammenhang der Proportionen gerade durch dieses Blatt so sehr erhellt habe, habe ein Geist der Proportion, der auf das große Wissen neidisch geworden sei, begonnen, ihn zu malträtieren: »Da er von einem festen Charakter war, so faßte er Muth, um diesen vermeintlich boshaften Geist zu überwinden. Er ging darauf aus, in die Tiefe der Verhältnisse immer fester einzudringen, damit er endlich über den Geist Macht bekomme, und nicht mehr der Geist über ihn. Er ging in dieser unsinnigen Theorie endlich praktisch so weit, daß er sich einbildete, wenn er sich an verschiedenen Theilen des Körpers, besonders an die rechte Seite unter die Rippen griffe, und damit eine Grimasse des Gesichts verbände, welche mit dem Kneipen des Rippenfleisches das jedesmalige erforderliche ägyptische Verhältniß habe, so sey die höchste Vollkommenheit in dieser Sache erreicht.«[10] Die Grundlage dieser Selbstkasteiung ist allerdings nicht nur das apotropäische Vorgehen gegen den Geist, sondern es verbindet sich damit noch eine andere Überlegung: »Er bildete sich gleichfalls ein: das nämliche Verhältniß was sich am Haupte eines Menschen finde, sey auch über den ganzen Körper einzeln ausgebreitet. Dieß war nun freilich halb wahr und halb falsch […]. Verhältniß in allen Theilen eines jeden gegebenen menschlichen Körpers ist allerdings gewiß da, so gewiß als Ursache und Wirkung immer in Verhältniß steht. Hierauf beruhet die Physiognomik eines jeden wirklich vorhandenen menschlichen Körpers. Eben so ist ein gewisses allgemeines Verhältniß des menschlichen Körpers überhaupt anzunehmen. Hierauf beruhen alle bildende Künste, und das Ideal der Schönheit und der Zeichnung.«[11] Die Vorstellung Messerschmidts ging also dahin, dass ein an entfernteren Teilen des Körpers verspürter Schmerz in einer Korrelation zu einem spezifischen Gesichtsausdruck stehe, sich gleichsam im Gesicht abbilde.[12]

In diesen wenigen hier wiedergegebenen Passagen wird deutlich, wie vieles vom weiter oben Konstatierten hier zusammenfließt:

a) Messerschmidt glaubt an geheimes Wissen, das er einerseits ergründet, dessen Enthüllung aber der Geist der Proportion verhindern möchte.

b) Das geheime Wissen hat Wurzeln in einer Ägyptosophie, durch die Aussagen über Proportionen oder vielmehr: über die Korrelation der verschiedenen Teile des Körpers gemacht werden können, die ganz offensichtlich in einem übergeordneten, makrokosmischen Korrelationssystem aufgehen.

tion of the other or must be superior to it."[9] This connexion had been disclosed to Messerschmidt primarily in a drawing hung up in the room, which depicts an armless Egyptian statue.

Nicolai, however, did not regard it as a drawing from an existing model but rather as the sum of the measurements of various Egyptian statues, indeed for a compilation of those very proportions. Because – Messerschmidt goes on to add – this particular drawing had shed light for him on the interrelationship of the proportions, the Spirit of Proportion, which had become envious of his profound knowledge, had begun to abuse him: "Since he was of a staunch character, he summoned up the courage to subdue this presumedly malicious spirit. He took as his point of departure delving ever deeper into the depths of relations so that he might ultimately have dominion over the Spirit and the Spirit no longer over him. He finally went so far in this nonsensical theory that he imagined, if he pinched himself in various parts of his body, especially on the right side below the ribs, and linked a facial grimace with this which had the requisite Egyptian proportion in each instance with pinching the flesh on his ribs, the utmost perfection would be attained in this matter."[10]

The basis of this self-chastisement is not, however, just apotropaic pre-emptive action against the Spirit. Another consideration is also bound up with it: "He also imagined: the very proportion which is found on the head of a man, also extends severally to the whole body. This was, of course, half true and half erroneous [...]. There is, however, certainly proportion in all parts of any given human body as certainly as cause and effect are always in proportion to each other. The physiognomy of any really existing human body rests on this. Also a certain general proportion of the human body should be assumed. All fine arts rest on this, likewise the ideal of beauty and drawing."[11] Messerschmidt's idea amounted to this, therefore: that a pain felt in more distant parts of the body correlated with a specific facial expression, that it was, as it were, reproduced in the face.[12]

In these few passages quoted above, it becomes apparent how they represent the fusion of much of what has been affirmed above:

c) Es besteht ein Verhältnis zwischen der Produktion, wo bestimmte Schmerzerfahrungen Eingang finden und sich in Porträtbüsten niederschlagen, und der Rezeption, das heißt der Wirkung dieser Erfahrungen auf einen Betrachter.

Was hier für die Analyse getrennt wird, vereinigt sich aber in einem Kunstwerk, dessen Entstehung nur im Zeitalter der Aufklärung und unter Prämissen eines neuen Kunstverständnisses möglich ist. Als Stichwort sei das sentimentalische Bild genannt, dessen maßgebliche Qualität – wie bereits erwähnt – in der Affizierung des Betrachters besteht.[13] Im weiteren Verlauf soll auf diesen Punkt spezifisch eingegangen werden, bevor in einer Conclusio auch die anderen Fäden wieder zusammengezogen werden.

Die ägyptische Genealogie und die Rolle Thubalkains

In der jüngeren Forschung zu Messerschmidt wird immer wieder auf die ägyptischen Götter rekurriert.[14] Dabei wird ein Zusammenhang hergestellt zu Hermes Trismegistos beziehungsweise zu dessen ägyptischem Äquivalent Thot. Der Hinweis war gegeben durch Nicolai selbst, der in der Beschreibung seines Besuches in Messerschmidts Atelier von einem Hermes spricht. Er tut dies dort freilich in einem ganz allgemeinen Sinne und ohne einen direkten Zusammenhang zum Künstler selbst herzustellen.[15] Von Messerschmidt heißt es bloß, er kehre ebenfalls seine Augen nach Ägypten.[16] Nun gibt die hermetische Literatur der Zeit allerdings eine höchst interessante Genealogie preis, die auf abenteuerliche Weise die alttestamentarische Genealogie mit jener der ägyptischen und griechisch-römischen Götter vereint. Diese Genealogie ist unten schematisch dargestellt.[17]

Hermes wäre also der Sohn des Cham, wie aber auch Misraim. Dieser Misraim ist niemand anders als Thubalkain.[18] Für uns ist diese Genealogie entscheidend, weil sie alttestamentarische Personen umwandelt in altägyptische beziehungsweise in solche der klassischen Antike. Die Grenzen zeitlich fernerer Epochen verschmelzen hier zu einem großen Konglomerat, in dem der alttestamentarische Thubalkain ebenso seinen Platz hat wie der altägyptische Thot oder der griechische Hermes. Die Genealogie wirft also ein befremdliches Licht auf jene konstatierte Ägyptosophie, die auch Messerschmidt

a) Messerschmidt believes in recondite knowledge, which he, on the one hand, is investigating but the disclosure of which the Spirit of Proportion seeks to prevent.

b) The recondite knowledge is rooted in Aegyptosophy through statements which can be made on proportions or rather on the correlation between the various parts of the body, which are manifestly subsumed in an overarching, macrocosmic system of correlations.

c) There is a relationship between production, which entails specific experiences of pain that are distilled into portrait busts, and reception, in other words, the effect these experiences have on a viewer.

What has been here rendered into discrete units for the sake of analysis, is, however, united in a work of art, whose genesis is only possible in the age of Enlightenment and is premised on a new idea of art. The keyword invoked is the "sentimental" picture, whose paramount quality – as mentioned above – consists in affecting the viewer.[13] In the following, this point is to be focused on and, finally, other threads are to be drawn together in the conclusion.

The Egyptian genealogy and the role of Tubalkain

Recent Messerschmidt scholarship repeatedly invokes the Egyptian gods.[14] A link is established with Hermes Trismegistus and his Egyptian equivalent, Thoth. Nicolai himself made the point when he spoke of a Hermes in his description of his visit to Messerschmidt's studio. He did this, of course, in an entirely general sense and without relating it directly to the artist himself.[15] All that is said of Messerschmidt in this connexion is that he also turned his eyes towards Egypt.[16] The hermetic writings of the day, however, reveal an extremely interesting genealogy, which boldly unites the Old Testament genealogy with that of the Egyptian and Greco-Roman pantheon. This genealogy looks as follows:[17]

Seth – Noah ——————— **Sem**
oder / or **Cham**
Saturn (auch genannt / also called Jupiter oder / or Japhet)

Chus oder / or Junger Saturn ——— **Osiris**
Misraim oder / or Vulcanus ——— **Isis**
Put oder / or Phaeton
Canaan oder / or Hermes / Tautus / Toyth / Mercurius

erfasst hat, und die mit moderner Ägyptologie nur partielle Berührungspunkte kennt.

Für Messerschmidt dürfte aber die Genealogie und insbesondere die Stellung von Thubalkain nicht ohne Interesse gewesen sein, und er hätte auch verschiedentlich Gelegenheit gehabt, auf diese Figur zu stoßen. Thubalkain gilt nach Genesis 4,22 als der erste Schmied und ganz generell als der Erfinder der Kunst in Erz. Als Bruder des Jubal hatte er ein langes Fortleben, weil beide gemeinsam auch als Erfinder der Musik angesehen wurden. In dieser Rolle war Thubalkain noch im 17. und 18. Jahrhundert auf Orgelprospekten Süddeutschlands, dem Herkunftsgebiet Messerschmidts, präsent.[19]

Zum anderen wird gerade mit ihm (und nicht mit Hermes oder Thot) ein frühes Wissen um die richtigen, nämlich aus der Bibel ableitbaren Maße verbunden.[20] In Wien waren drei Freimaurerlogen aktiv, die sich zum Orden der Ritter und Brüder des Lichts, auch genannt »Asiatische Brüder«, bekannten.[21] In deren Aufnahmeritual steht Thubalkain (Tubalkain) für jenen, der in den Geheimnissen des Buches des Menschen (das heißt des Alten Testamentes) seine Seligkeit suchte. Christus als sein Nachfolger wird jene Geheimnisse teilweise enthüllen. Im Zusammenhang mit dieser Ausprägung der freimaurerischen Bewegung tritt Hermes Trismegistos hingegen nirgends auf.

Für unseren Zusammenhang ist Thubalkain deswegen besonders wertvoll, weil verschiedene Bemühungen Messerschmidts in ihm zusammenlaufen: ägyptische Geheimwissenschaft, das Suchen nach den richtigen Proportionen und die Kenntnis jenes Materials, aus dem Messerschmidt einen Großteil seiner Charakterköpfe geschaffen hat. Wenn Messerschmidt also in Metall arbeitet und dabei ein Proportionssystem anwendet, kommt er Thubalkain besonders nahe, der – so muss man an dieser Stelle nochmals betonen – selbst Teil des ägyptosophischen Personals war. Insofern Messerschmidt also als Plastiker arbeitet, dürfte er in ihm ein Vorbild gefunden haben. Dabei ist freilich zu betonen, dass es sich bei der ägyptischen Darstellung auf Messerschmidts Zeichnung mit Sicherheit nicht um eine Darstellung Thubalkains gehandelt hat,[22] sondern wohl tatsächlich um eine Studie nach ägyptischen Statuen. Doch die besondere Betonung auf Maße und Proportionen sind ein Erbe des Thubalkain.

Messerschmidt hat jedoch nicht nur als Plastiker in Erz gearbeitet, sondern auch als Bildhauer in Stein. Beide Materialien, Erz wie Stein, wurden für die Charakterköpfe verwendet. Auch die Arbeit in Stein spielt in der genannten Ausformung der Freimaurerei eine große Rolle. Im Aufnahmeritual zum fünften Grade des Ordens der Ritter und Brüder des Lichts wird der Kandidat nach den Qualitäten des »Großen Füllsteines« befragt, des Sinnbildes des

Misraim, the son of Ham. This Misraim is none other than Tubalkain.[18] In the present connection, this genealogy is crucial because it converts Old Testament characters into ancient Egyptian as well as members of the Greco-Roman pantheon. The boundaries between ages far in the past are here blurred into a vast conglomerate in which the Tubalkain of the Old Testament, like the Egyptian Thoth and the Greek Hermes, has his place. The genealogy, therefore, sheds a rather disconcerting light on the Aegyptosophy of which Messerschmidt was also an adherent and which has very little in common with modern Egyptology.

The genealogy and especially the position of Tubalkain in it must have been of considerable interest to Messerschmidt and he would have had several opportunities of encountering this figure. Tubalkain is, according to Genesis 4:22, the first blacksmith and generally viewed as the inventor of artefacts in bronze. As Jubal's brother, Tubalkain lived a long time in cultural history because the two of them are also regarded as the inventors of music. In this role Tubalkain was still present in the 17th and 18th centuries on south German organ screens, and Messerschmidt was from south Germany.[19]

On the other hand, early knowledge of what was right, namely proportions derived from the Bible, were linked with Tubalkain (and not with Hermes or Thoth).[20] In Vienna there were three active Freemasons' lodges who professed allegiance to the Order of Knights and the Brethren of Light, also known as the "Asian Brethren".[21] In their initiation rites, Tubalkain stands for anyone who is seeking eternal bliss in the secrets of the Book of Man (that means the Old Testament). Christ as the successor to Tubalkain will reveal some of his secrets. Hermes Trismegistus is never linked with this particular form of Freemasonry.

Tubalkain is particularly important in the present connection because various endeavours of Messerschmidt's converge in him: Egyptian arcana, the search for just proportion and knowledge of the material from which Messerschmidt made most of his Character Heads. Since Messerschmidt worked in metal and applied a system of proportions to what he was doing, he comes particularly close to Tubalkain, who - it must be emphasised again at this juncture -

Ordens. Er muss bekennen, dass der Füllstein nicht nur Gesundheit verleihe, sondern den menschlichen Elementarkörper von unreinen Trieben befreie, die menschliche Seele mit dem Licht vereine und den Geist so reinige, dass er durch das Band der Geschöpfe bis in seinen Ursprung wirken kann. Schließlich vermag er dadurch die Hilfe der Lichtgeschöpfe zu fordern und die Bewohner der Finsternis zum Gehorsam zu zwingen.[23]

In diesen Vorstellungen von Plastik und Bildhauerei fließen somit neuerlich Elemente zusammen, die direkte Auswirkungen auf die Produktion der Charakterköpfe haben: hermetisches Wissen um das Material und Läuterung durch dasselbe. Von hier aus führt eine Linie direkt zu den Umständen der Produktion der Messerschmidt'schen Charakterköpfe wie auch zu einer Materialikonologie.

Bedingungen der Produktion

Zu erkennen war das Handlungsmotiv, aus dem heraus Messerschmidt seine Charakterköpfe schuf: Geheimes ägyptosophisches Wissen, das er »ins Bild setzen« möchte und durch das zugleich der böse Geist der Proportion ferngehalten werden kann. Dieses in der Produktion eingeflossene Wissen soll allerdings auch in der Rezeption wieder zutage treten, er setzt also Produktion und Rezeption in ein Verhältnis zueinander.

Damit sind die Bedingungen der Produktion nie unabhängig von jenen der Rezeption. Als Produktionselemente können im Prinzip zwei namhaft gemacht werden:

a) Die Affekte

a.1.) Affekte als apotropäisches Mittel

In seiner Schilderung teilt Messerschmidt viel über die purgierende Wirkung seiner Arbeit mit. Denn durch seine Selbstkasteiung hält er den neidischen Geist der Proportion fern. Der Geist der Proportion ist dabei – im Gegensatz zum im 18. Jahrhundert häufigen Verständnis der Geister als Gespenster[24] – keine Erscheinung, sondern geistiger Natur. Der Geist ist beinahe allegorisch zu verstehen, als Verkörperung der Proportion an sich. Ein purgierender Prozess spielt im Rahmen der erwähnten Orden der Ritter und Brüder des Lichts, auch genannt »Asiatische Brüder«, eine gewichtige Rolle. Er führt auch dort zu höheren Formen von Erkenntnis und Einsicht.

a.2.) Affekte als Ausdruck proportionaler Korrelationen

Die in Messerschmidts Charakterköpfen zum Ausdruck gebrachte Verzerrung oder Grimasse steht in einem Korrelat zu anderen Teilen des Körpers. Dort zugefügte Schmerzen hinterlassen ihre Spuren im Gesicht, wie umgekehrt nach der Messerschmidt'schen Vorstellung aus den Grimassen des Gesichtes fernere Teile des Körpers affiziert werden können. Damit teilt Messerschmidt etwas über die Korrelation der Körperteile untereinander mit. Setzt man – wie in jeder

himself was part of the Aegyptosophical personnel. Since Messerschmidt worked as a sculptor, he must have taken Tubalkain as his role model. Nonetheless it must be emphasised that the drawing in Messerschmidt's room was certainly not a representation of Tubalkain[22] but probably really a study after Egyptian statues. However, the particular emphasis laid on scale and proportion are Tubalkain's legacy.

Messerschmidt, however, worked in stone as well as bronze. Both materials, bronze and stone, were used for the Character Heads. Work in stone also plays an important role in the school of Freemasonry described above. The initiation rites to the fifth degree of the Order of Knights and the Brethren of Light require the candidate to be questioned on the properties of the "Great Keystone", the symbol of the Order. The candidate must profess that the Keystone not only confers good health but also frees the elementary particles of the human body from impure urges, unites the human soul with the Light and purifies the spirit so that it can work through the band of beings to its wellspring. Finally, it can through it request the aid of the Light Beings in compelling the dwellers in darkness to obedience.[23]

New elements, therefore, fuse in these ideas of sculpture and sculpting, ideas which have a direct effect on the production of the Character Heads: hermetic knowledge of the material and purification through it. From here a line can be traced directly to the conditions under which Messerschmidt produced his Character Heads and to an iconology of materials.

Conditions of production

The motive that induced Messerschmidt to create his Character Heads has been recognised: Aegyptosophical arcana that he wanted "to put into the picture" and through which the evil Spirit of Proportion can be warded off. This knowledge that has gone into the product is, however, to resurface in the reception of the work so he places production and reception in a relationship to each other.

The conditions of production are, therefore, never independent of those of reception. Two elements of production can be listed:

hermetischen Tradition üblich – den Körper als Mikrokosmos, so ließe sich die Korrelation der Einzelteile zu einem Ganzen natürlich auch auf den Makrokosmos als Ganzes extrapolieren.

b) Die verwendeten Materialien

Ein Großteil der Charakterköpfe wurde in Zinn oder Blei oder einer Zinn-Blei-Legierung verfertigt.[25] Zweifelsfrei sind das – verglichen etwa mit der Bronze – eher preiswerte Materialien. Sie scheinen aber eine Rolle zu spielen innerhalb des eben genannten Purgierungsprozesses.[26] In den Aufnahmeformeln zum vierten Grad der Erkenntnis im erwähnten Ritterorden spielt der rohe Stein eine Rolle, aber auch eine Reinigung durch Ausglühen, Auflösen und Abwaschen.[27] Die Köpfe aus Stein dürften vor diesem Hintergrund als Verfeinerungsprozess gewertet werden, jene aus gegossenem Blei oder Zinn als Resultate eines Verfahrens, das mit Ausglühen und Auflösen arbeitet, um zum Ziel zu kommen.

Beim Besuch Messerschmidts nennt Nicolai die Titel einiger hermetischer Bücher, wobei nicht bekannt ist, ob Messerschmidt diese wirklich gelesen hat oder ob hier persönliche Assoziationen Nicolais zum Tragen kommen. Auf jeden Fall fällt darunter auch jenes von Adam Michael Birkholz (1746–1818), »Die sieben heiligen Grundsäulen der Ewigkeit und der Zeit«, Leipzig 1783. Inwieweit es davon frühere Ausgaben gab, ist hier nicht zu eruieren. In diesem Werk findet sich ein eigens ausgeschiedener Abschnitt mit dem Titel »Brunnen der Weisheit und Erkenntnis der Natur. Von einem unvergleichlichen Philosophen gegraben und geöfnet durch Anonymum Von Schwarzfuss«. Beschrieben wird ein von Gott gespiesener Brunnen, der sein Wasser emanistisch in von Gott fernere Bereiche des Lebens strömen lässt. Unter anderem wird der »Brunn der Weisen« darin auch zu Zinn (im 10. Kapitel) und zu Blei (im 11. Kapitel).[28] Materialikonologisch ist das Zinn ein unreines Element, weil es nach dem Brunnen der Weisen zuviel weißen, unreinen Schwefel enthält.[29] Dieser kann jedoch durch den weißen sophischen Schwefel bezwungen werden, der dann alle »Unreinigkeit und Krudität« des Zinns verschlingt.[30] Im Zinn spielt sich als Material also in nuce das Gleiche ab, was Messerschmidt durch die Form auch vollbringen will: ein Purgationseffekt. Parallel dazu verhält es sich mit dem Blei, das als saturnisches Element bezeichnet wird und in dem ebenfalls durch Verschmelzung gegenläufiger Elemente ein reines Element entsteht.[31]

Dass nun Messerschmidt für seine Charakterköpfe weißlichen, jedoch gelb-rötlich fleckigen Alabaster wählt, mag neuerlich mit dem Preis des Materials zu tun haben. Sicherlich war er günstiger als hochweißer Marmor, mit dem Messerschmidt zeitgleich etwa das Bildnis des Herzogs von Sachsen-Teschen verfertigte (Wien, Albertina). Freilich legt der Alabaster gerade durch seine Flecken auch

a) The emotions

a.1.) Emotions as an apotropaic device

In Nicolai's description, Messerschmidt has a lot to say on the cathartic effects of his work. After all, through self-chastisement he wards off the envious Spirit of Proportion. The Spirit of Proportion is - unlike the widespread 18th-century notion that spirits were spectres[24] - not an apparition but is of a spiritual or intellectual nature. The Spirit should be viewed almost allegorically, as the embodiment of true proportion. A purification process plays an important role in the above mentioned Order of Knights and Brethren of Light, also known as the "Asian Brethren". There, too, it leads to higher forms of knowledge and insight.

a.2.) Emotions as the expression of correlating proportions

The contortions or grimaces expressed in Messerschmidt's Character Heads correlate with other parts of the body. Pain induced there leaves its mark on the face and, conversely; as Messerschmidt saw it, remote parts of the body can be affected by facial grimaces. In this Messerschmidt is imparting something about the correlation between the parts of the body. If the body – as is usual in any hermetic tradition – is a microcosm, the correlation between the individual parts and the whole can also, of course, be extrapolated from it to the macrocosm as the whole.

b) The materials used

Most of the Character Heads were made in pewter or lead or in an alloy of tin and lead.[25] Undoubtedly those were inexpensive materials, compared with bronze. However, they seem to have played a role in the above-mentioned purification process.[26] Rough stone as well as purification through cauterization, dissolution and lustral bathing play a role in the initiation rights for admission to the Order of Knights mentioned above.[27] The Character Heads made of stone may be evaluated against this background whereas those of cast lead or pewter must be viewed as the result of a process (the lost-wax process of casting) that works with heating and melting to attain its objective.

On his visit to Messerschmidt, Nicolai mentions the titles of hermetic books but it is not known

von einem Verschmelzungs- und damit Purifizierungsprozess Zeugnis ab, indem nach hermetischem Verständnis nämlich die Sonne die Erdstoffe sublimiere und durch Kochen das Irdische in einen unverbrennbaren roten Schwefel umwandle, der schließlich seine Feuchtigkeit verliere und sich in beständiges Gold transformiere.[32] Gerade der rötlich-gelb gefleckte Alabaster legt für den, der es zu lesen versteht, sichtbar von diesem Prozess Zeugnis ab.

Ganz offensichtlich geht Messerschmidts Theorie dahin, kongenial sowohl in Form wie Materie den Läuterungsprozess zu versinnbildlichen. Einerseits tut er das um seiner selbst willen, denn damit einher geht die Befreiung vom schmerzhaften Einfluss des Geistes der Proportion. Doch nach der oben wiedergegebenen Passage aus Nicolai, wonach alle Wirkungen ihren Ursachen entsprächen und Wirkungen (gezielt) gezeitigt werden können, ist es dem Eingeweihten möglich, Wirkungen hervorzubringen, die der Wirkung des anderen entsprächen oder ihr überlegen seien. Damit wird auf eine Wechselwirkung zwischen Produzenten und Rezipienten angespielt, die ihre Entsprechung in der zeitgenössischen Ästhetik und zwar im unmittelbaren Umfeld Messerschmidts findet. Dieses Umfeld ist zwar nicht zwingend identisch mit jenem anderen, eingangs geschilderten, das sich mit Freimaurerei und hermetischen Problemen abgibt. Doch in Messerschmidts Person und Biographie kommen die beiden Zirkel zusammen.

Bedingungen der Rezeption

Im Zentrum jenes anderen Zirkels, der sich mit ästhetischen Fragen beschäftigt, steht Franz von Scheyb (Abb. 106).[33] Dessen Büste von der Hand Messerschmidts gilt als früheste klassizistische Büste Wiens (Abb. 9,18). Zu fragen wäre, ob hier auch noch stilistisch ein »Läuterungsprozess« zum Ausdruck gebracht wird, der sich ebenfalls in Messerschmidts Charakterköpfen fortsetzt und der formal das Porträt von jedem überflüssigen Zierrat befreit.

Franz von Scheyb hat als Kunstliterat Messerschmidt ein Denkmal gesetzt, indem er ihn als wahren Wegweiser der Bildhauerei preist und ihn einen deutschen Quesnoy (das ist François Duquesnoy) nennt, der danach strebe, den Mut, das Werkzeug und die Hand des Phidias zu erlangen.[34]

Von Scheyb ist in Vielem kein sonderlich origineller, sondern vielmehr ein kompilatorischer Schriftsteller. Deswegen rückt er auch ein Element sehr ins Zentrum, nämlich die Wirkung des Kunstwerkes auf seinen Betrachter, jene Affizierung, von der weiter oben schon die Rede war und die zweifelsfrei als Ausdruck der neuen, aufklärerischen und in letzter Instanz bürgerlichen Ästhetik zu werten ist.[35] In seiner Abhandlung von der Bildhauerkunst kommt von Scheyb, nachdem er das Verfahren zur Bearbeitung des Steines und zur Her-

whether Messerschmidt really read them or whether Nicolai's personal associations are here being projected on to his subject. In any case, there is an allusion to the "Seven Holy Pillars of Eternity and Time", Leipzig 1783, by Adam Michael Birkholz (1746–1818). This is not the place for speculating on whether there were earlier editions. In this work there is a special section entitled "The Fountain of Wisdom and Knowledge of Nature. Interred by an Incomparable Philosopher and Opened by Anonymus von Schwarzfuss". What is described in it is a fountain fed by God, who makes his waters as His emanation flow into areas of life quite remote from Him. In it, the "Fountain of the Wise" becomes, *inter alia*, tin (in the 10th chapter) and lead (in the 11th chapter).[28] In the iconological sense, tin is an impure element because, according to the Fountain of the Wise, it contains too much white, impure sulphur.[29] It can, however, be purified by white, "sophic" sulphur, which swallows up all the "impurities and crudity" of the tin.[30] In pewter as a material, therefore, the same thing occurs *in nuce* that Messerschmidt wants to accomplish through casting: a lustral effect. This is paralleled by lead, which is designated a saturnine element and in which a pure element emerges from the melting away of countervailing elements.[31]

That Messerschmidt chose alabaster of a primarily white cast yet marked with yellowish and reddish flecks may have had something to do with the going prices for materials. Alabaster was certainly cheaper than the gleaming white marble from which Messerschmidt executed the portrait of the Duke of Saxe-Teschen (Vienna, Albertina) at about the same time. Then again, alabaster also bears witness, through the blotches on it, to a melting process and, therefore, to a purification process. According to hermetic doctrine, the sun sublimated earthly substances and, by heating them to the boiling point, transmuted them into incombustible red sulphur, which, ultimately becoming anhydrous, was transmuted into solid gold.[32] Alabaster with reddish yellow spots, therefore, attests visibly to him who can read and understand, to this process.

Messerschmidt's theory evidently aimed at symbolising the purification process in the analogy

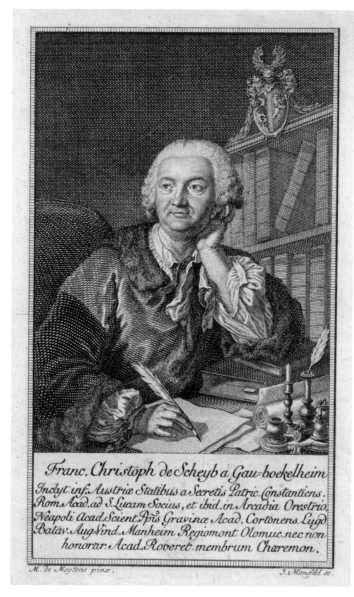

Franc. Christoph de Scheyb a Gau-boekelheim

Inclyt.inf.Austriæ Statibus a Secretis Patric.Constantiens. Rom.Acad.ad S.Lucam Socius, et ibid.in Arcadia Orestrio. Neapoli Acad.Scient.Epis Gravinæ Acad.Cortônens.Lugd Batav.Aug.Vind.Manheim Regiomont Olomuc.nec non honorar.Acad.Roveret.membrum Charemon.

M. de Meytens pinx. J.x.Mansfeld sc.

106 Johann Ernst Mansfeld, Porträt des Franc. Christoph de Scheyb, bez. u. l.: »M. de Meytens pinx.«, u. r.: J. Mansfeld sc., Kupferstich, Wien, Museum, Wien, Inv.-Nr. 103.513

Johann Ernst Mansfeld, portrait of Franc. Christoph de Scheyb, signed bottom left: "M. de Meytens pinx.", bottom right: "J. Mansfeld sc.", copperplate engraving, Wien Museum, Vienna, Inv. no. 103.513

between form and material. On the one hand, he was doing all this for his own sake since it would result in his being freed of the tormenting influence of the Spirit of Proportion. However, according to the passage from Nicolai quoted above, which says that all effects correspond to their causes and effects can be (deliberately) induced, the initiate can elicit effects which correspond to the effects of the other or are superior to it. This alludes to the interrelationship of producer and respondent, which corresponds to the aesthetic of the time and, more importantly, to Messerschmidt's immediate social and cultural environment. This environment need not be identical with that described at the beginning, which dabbled in Freemasonry and issues related to hermetic teachings. However, the two circles intersect in Messerschmidt's personality and biography.

Conditions of reception

Franz von Scheyb (fig. 106) is at the centre of the other circle, the one that dealt with aesthetic issues.[33] Messerschmidt's bust of von Scheyb is thought to have been the first Neo-Classical bust in Vienna (fig. 9, 18). The question arises of whether here, too, a "purification process" has been expressed, one which also continues in Messerschmidt's Character Heads and frees the portrait of all extraneous decorative elements.

As an art theorist, Franz von Scheyb erected a monument to Messerschmidt by praising him as a true pioneer of sculpture and calling him a German Quesnoy (meaning François Duquesnoy), one who strove to match the courage, the skill and the hand of Phidias.[34]

In many respects von Scheyb is a compiler rather than an original writer. That is why he focuses on a particular element, in other words, the effect of the work of art on the viewer, on how it affects him, which was discussed above, and how it must undoubtedly be evaluated as an expression of the new Enlightenment aesthetic, which is ultimately a bourgeois one.[35]

In his treatise on sculpture, von Scheyb, after precisely describing the process of working the stone and bringing forth a sculpture from it, moves on to the chapter entitled "On the Necessity of Expression".

ausarbeitung der Skulptur genau beschrieben hat, zum Kapitel mit der Überschrift »Von der Nothwendigkeit des Ausdrucks«. Dort schreibt er: »So oft die menschliche Natur in eine Bewegung geräth, so lässet sie durch ausdrückliche äußerliche Zeichen auch ihre innerliche Empfindung wahrnehmen. [...] Daher scheine es, daß alle Theile des belebten Körpers einander so zu sagen die Hand bieten, das Anliegen des Herzens sich zu offenbaren. Ueberhaupt aber kann man das Gesicht nicht anders als einen Spiegel betrachten, worinn eine solche Empfindung deutlich angezeigt wird.«[36] Im späteren Werk »Orestrio« nimmt sich von Scheyb des Themas nochmals an und vertieft es.[37] Die Macht der Kunst (in diesem Falle der Malerei) äußert sich besonders eindrücklich, »[...] wenn sie durch verschiedene Farben und gewisse Regungen die Leidenschaften und Empfindungen der Seele ausdrücken, sie auch sogar auf eine gewisse Art sichtbar machen kann. Alsdann scheint es, der Beobachter komme nicht nur zu hören, und zu fühlen, sondern auch mitzureden, zu sprechen, und an dem Schmerz, an der Furcht, Freude, oder am Schrecken Theil zu nehmen.«[38]

Denkt man an das eben nochmals in Erinnerung gerufene Zitat Messerschmidts bei Nicolai, wonach es dem Künstler möglich sein müsse, Wirkungen hervorzubringen, so ist eine solche Äußerung gar nicht möglich ohne einen Hintergrund, wie er durch von Scheyb formuliert wird. Nur wo Produktion und Rezeption in einem unmittelbaren Abhängigkeitsverhältnis stehen, wo die Rezeption der Absicht der Produktion zu entsprechen und umgekehrt die Produktion sich auf die Bedürfnisse der Rezeption einzustellen hat und wo schließlich die Affizierung des Betrachters gleichzeitig zum ästhetischen Qualitätsmerkmal von Kunst wird, nur in diesem Rahmen kann sich eine Idee wie jene von Messerschmidt und seinen Charakterköpfen konkretisieren.

Freilich ist die letzte Absicht von Scheybs doch eine andere, denn er kennt drei »Hauptleidenschaften«: Zorn, Begierde und Vernunft. Der Zorn würde sich in einem vernunftlosen, ungehemmten Ausdruck zeigen, die Vernunft hingegen in einer würdigen Strenge. Die Begierde verstellt sich mit einem fröhlichen Angesicht, um zum Ziel ihrer Wünsche zu gelangen.[39] Eine Differenzierung von Messerschmidts Charakterköpfen nach diesen drei Gesichtspunkten ist nicht möglich, es kann sich folglich nicht um jene Kategorien handeln, die zu einer Einteilung tauglich wären.

Überhaupt ist Messerschmidt kaum an jenem Katalog von Affekten interessiert, der sich im 17. und 18. Jahrhundert formiert, ausgehend von den Überlegungen des französischen Hofmalers Charles Le Brun.[40] Von Scheyb beschreibt die derart vorgegebenen Elemente der Affekte,[41] aber höher stufte er doch das Studium nach der Natur ein.[42] In der Tat arbeitet Messerschmidt in der Schilde-

There he writes: "Whenever human nature is moved, it also makes perceptible its inner feeling through explicit external signs. [...] Hence it would appear that all parts of the animated body hold out a hand to each other, as it were, to reveal the concerns of the heart to themselves. However, one cannot regard the face other than as a mirror in which such feeling is clearly shown."[36] In a later work, "Orestrio", von Scheyb reverts to the subject and goes into it in more depth.[37] The power of art (in this case painting) is expressed particularly vividly "when it can express the passions of the soul through different colours and certain stimuli, can even in a certain manner render them [the passions] visible. Then it appears the viewer not only comes to hear and to feel but also to engage in conversation with, to speak and to partake of the pain, the fear, joy or terror."[38]

If one returns to the Messerschmidt quotation in Nicolai of which one is reminded above, according to which it must be possible for the artist to produce effects, a statement like that is not even possible without an intellectual background as formulated by von Scheyb. Only where production and reception are directly interdependent, where reception corresponds to the intention of production and, conversely, production must adjust to the needs of reception and where, finally, the viewer's being affected at the same time becomes a standard for the aesthetic quality of a work of art, only in this frame of reference can an idea such as that informing Messerschmidt and his Character Heads assume concrete form.

Of course, von Scheyb's intention is a different one for he knows of three "governing passions": anger, lust and reason. Anger would be revealed in uninhibited expression without benefit of reason. Reason, on the other hand, would be revealed in dignified austerity. Lust is disguised by a cheerful countenance in order to arrive at the goal it desires.[39] It is not possible to group Messerschmidt's Character Heads by those three criteria. Consequently, they cannot be the categories that would be suitable for classification.

Indeed Messerschmidt is scarcely interested at all in the catalogue of emotions that was developed in the 17th and 18th centuries, beginning with the thoughts expressed on the subject by the French court

rung Nicolais unmittelbar nach der Natur, denn er kneift sich und versucht den dadurch entstandenen Ausdruck vor einem Spiegel zu sehen und ins Kunstwerk zu übertragen.[43] Dazu ist er auch verpflichtet, denn es geht ihm nicht um die Mitteilung über Grundformen der Affekte, sondern es geht ihm letztlich um eine purgierende und apotropäische Wirkung der Kunst, ihm als Produzenten gegenüber, aber auch gegenüber dem Betrachter. Das »System«, von dem er spricht, tendiert wohl eher in diese Richtung, als dass es entweder einen vollständigen Abriss möglicher Affekte vorstellen oder aber eine weitgehende Erkenntnis proportionaler Abhängigkeiten deutlich machen wollte.

Die Absicht Messerschmidts muss also dahin gegangen sein, durch die Werke von Bildhauerei und Plastik sich selbst zu läutern, im ausgeprägten Affekt derselben aber jenen Läuterungsprozess auch beim Betrachter in Gang zu setzen. Dieser Läuterungsprozess ist freilich nun an keine bestimmte Pathognomie gebunden, sondern wirkt durch das – nach Messerschmidt im Werk hervortretende – Korrespondenzsystem und die damit einhergehende Affizierung des Betrachters. Der Gesichtsausdruck reinigt in der Anschauung also noch ganz andere Teile des Körpers.

Fazit

Es scheint, als sei die Läuterung der rote Faden, der sich durch Produktion und Rezeption hindurch zieht. Davon legt Messerschmidts Schilderung gegenüber Nicolai Zeugnis ab, davon sprechen aber im kulturgeschichtlichen Hintergrund schon die Reinigungsrituale in freimaurerischem Ambiente, zu dem Messerschmidt Zugang hatte. Darüber gibt aber auch das Material ikonologisch Auskunft, indem Zinn und Blei selbst den Läuterungsprozess dokumentieren und auch der gefleckte Alabaster dafür zum Sinnbild werden dürfte.

Aus dem freimaurerischen Ambiente hätte Messerschmidt leicht Kenntnis vom ersten Plastiker in Erz, Thubalkain, erlangen können, der nicht nur auf die geheimen ägyptischen Wissenschaften verwies, sondern auch für eine hermetische Kenntnis von Maßen und Proportionen stand.

Doch erst die Einbettung in eine aufklärerische Ästhetik, wie sie von Scheyb dem Messerschmidt'schen Wissen beigesteuert haben wird, macht den Versuch Messerschmidts sinnvoll. Denn erst durch die Maxime, dass jedes Kunstwerk den Betrachter auch affizieren und emotional berühren solle, kann eine Serie wie die Charakterköpfe jene didaktische Wirkung übernehmen und entfalten, die Messerschmidt ihnen ohne Zweifel zugedacht hatte.

Die Produktion läutert den Künstler, die Rezeption den Betrachter. Von dieser Vorstellung war Messerschmidt geprägt und

painter Charles Le Brun.[40] Von Scheyb does describe the elements of the emotions thus set out[41] but rates study from nature higher.[42] Indeed, in Nicolai's description, Messerschmidt is working directly from life because he pinches himself and tries to translate the expression thus induced and viewed in the mirror to a work of art.[43] He is obliged to do so because he is not concerned with imparting the basic forms of the emotions revealed but ultimately with the cathartic and apotropaic effect of art, both *qua* producer and with respect to the viewer. That is what the "system" Messerschmidt speaks of probably applies to instead of representing a complete outline of the emotions possible or even elucidating a far-reaching knowledge of the interrelationship of proportions.

Messerschmidt, therefore must have intended to purify himself through works of sculpture in the emotion expressed in them while also inducing the cathartic process in the viewer. This cathartic process is, of course, not linked with any particular pathognomy. Instead it operates through the system of correspondences – according to Messerschmidt, emerging in the work – and the viewer's being concomitantly affected by it. The facial expression, therefore, in being viewed, purifies entirely different parts of the body.

Summary

It would seem as if purification or catharsis is the red thread of the discourse that runs through production and reception. This is attested to by the description Messerschmidt gives Nicolai. The lustral rituals in Freemasonry in the background as viewed from the standpoint of cultural history, however, also argue for this conclusion and Messerschmidt had access to them. The materials he used also add iconological information since tin and lead themselves document the purification process and even the blotchy alabaster might be a symbol of that process.

From an environment steeped in Freemasonry, Messerschmidt may easily have gained knowledge of that first sculptor in bronze, Tubalkain, who not only represented a reference to ancient Egyptian arcana but also stood for the hermetic knowledge of scale and proportion.

davon sprechen die Charakterköpfe formal und materialikonologisch. Einer bekannten Ikonographie konnte sich Messerschmidt verschließen, weil es bei der Rezeption nicht um Qualitäten der Kennerschaft, sondern um Qualitäten des Erlebens ging. Je intensiver dieses Erlebnis ausfiel, umso wirkungsvoller – so darf man wohl die Messerschmidt'schen Intentionen bestimmen – fiel die Läuterung aus. Ihr Ziel kann auch benannt werden: Es ist jene Überwindung fleischlicher Triebe, die auch die Prämisse höherer Erkenntnisse bei den Freimaurern war. Von diesen Trieben hat sich Messerschmidt in der Produktion befreien wollen, von ihnen sollen auch wir durch die Betrachtung befreit werden. In dieser intendierten Katharsis geht Messerschmidt freilich über die Absichten seiner Zeit hinaus, vielleicht auch ein wenig hinter die aktuellsten Bestrebungen zurück. Denn diesen war die Vermittlung eines wie auch immer gearteten Inhaltes gar nicht mehr so wichtig. Zwar ist die moralische Bildung ganz zweifelsfrei Bestandteil des sentimentalischen Bildes, die Zielrichtung ist aber so klar nicht gegeben. Das Erlebnis des Affektes allein, des menschlichen Berührtwerdens, war in der Regel Wirkung genug, denn dadurch wurde der Betrachter jeglicher sozialer Rolle entkleidet und auf Grundnormen des menschlichen Daseins zurückgeworfen. Und auf der anderen Seite tritt zunehmend eine Genie-Konzeption auf, die keinerlei Einschränkungen des ingeniösen Arbeitens und im Prinzip auch keinerlei Zugeständnisse an das Publikum dulden möchte.[44] Messerschmidt sucht den Kontakt zum Publikum auch nicht explizit, aber nach allem, was festgehalten werden konnte, ist doch die Wirkungsabsicht auf ein ideales Publikum relativ klar zu umreißen. Er will nicht nur die Erkenntnis menschlicher Kondition verschaffen, sondern ganz offensichtlich läuternd wirken. Darin liegt eine der Besonderheiten der Charakterköpfe, die sie aus dem Kreis zeitgleicher Werke deutlich hervorhebt. Das Künstler-Genie, das sich in seiner Autonomie im Zuge der späten Aufklärung erst deutlich herauszukristallisieren beginnt, ist nur zum Teil Messerschmidts Sache. Zwar ist die Serie der Charakterköpfe nicht belehrend, um eine zentrale Kategorie der älteren Kunstliteratur zu bemühen. Vielmehr sind sie läuternd und zwar einerseits auf der Ebene der direkten Anschauung, andererseits auf der arkaneren Ebene der Materialikonologie.

Der insgesamt arkane Anteil von Messerschmidts Bemühen hat freilich der Wirkung nur sehr partiell zum Durchbruch verholfen. Bereits die früh erfolgte Betitelung der einzelnen Köpfe legt von dieser Ignoranz sprechend Zeugnis ab. Die Köpfe werden dadurch in einen indiviuell-narrativen Zusammenhang gestellt (durch Epiteta wie »Ein mit Verstopfung Behafteter«, Kat.-Nr. 13, »Innerlich verschlossener Gram«, Kat.-Nr. 14, oder »Ein aus dem Wasser Geretteter«). Das war nie Messerschmidts Absicht.

Messerschmidt's undertaking does not make sense until it has been embedded in an Enlightenment aesthetic of the kind von Scheyb would have contributed to the sculptor's background knowledge. For only through the maxim that every art work should also affect and emotionally move the viewer can a series such as the Character Heads assume the didactic function and elicit the effect that Messerschmidt undoubtedly intended.

Production purifies the artist; reception is cathartic for the viewer. Messerschmidt was imbued with this idea and the Character Heads attest to this in respect of both form and the iconology of materials. Messerschmidt could disregard any known iconography because he was concerned, in respect of reception, with the quality of experience elicited rather than the quality of knowledge to be gained. The more intensive the experience of viewing, the more effective the catharsis would be – this is how one might describe Messerschmidt's intention. Its objective can also be ascertained: it was the sublimation of carnal urges, on which the higher knowledge of Freemasonry was also premised. Messerschmidt wanted to free himself of such urges in production but we, too, are supposed to be freed of them in viewing his work. In this intended catharsis, Messerschmidt does, of course, go well beyond what was intended in his day, although perhaps he lags somewhat behind the most current endeavours. For to them, imparting a content of whatever kind was no longer of prime importance. Moral edification is undoubtedly an element of the sentimental picture; however, the aim is not so clearly stated. Experiencing emotion, being moved, usually sufficed as the intended effect since through it the viewer is divested of any social role and thrown back on the basic norms of human existence. And, on the other hand, a conception of genius emerges, which tolerates neither limitations on the work of genius nor, on principle, compromises made to the public.[44] Nor does Messerschmidt explicitly seek contact to the public. However, according to all that can be ascertained, the intention of eliciting an effect in an ideal public can be traced relatively clearly. Messerschmidt not only wants to elicit knowledge of the human condition; he evidently also wants to

effect this cathartically. This is one of the qualities peculiar to the Character Heads which makes them stand out so clearly from other works of the time. The concept of the artist as genius, which only begins to show up in all its autonomy over the course of the late Enlightenment, is only in part Messerschmidt's concern. The series of the Character Heads is not didactic in intent, just to mention a pivotal category of earlier art historical writing. On the contrary, the Character Heads are cathartic, on the one hand, on the plane of empirical observation and, on the more recondite plane represented by the iconology of materials.

The arcane aspect of Messerschmidt's undertaking, was, however, only partly effective in inducing the effect he intended. The titles given quite early on to the individual Character Heads attest eloquently to respondents' ignorance of it. The naming of the Heads has placed them in an individualising narrative context (through such attributive epithets as "Afflicted with Constipation", cat. no. 13, "Grief Locked Up Inside", cat. no. 14, and "Just Rescued from Drowning"). That was never Messerschmidt's intention.

1 Siehe Ilg 1885, Vorwort. Zu den Mitgliedern der Wiener Loge siehe Bückling 2002, S. 83 und Anm. 51.

2 Franz von Scheyb hat seine ästhetischen Vorstellungen in zwei Werken festgehalten: Köremons Ehrenmitgliedes der Akademie von St. Lucas in Rom, auch verschiedener andrer Akademien in Italien und Deutschland, Natur und Kunst in Gemälden, Bildhauereyen, Gebäuden und Kupferstichen zum Unterricht der Schüler, und Vergnügen der Kenner, 2 Bde, Leipzig / Wien 1770 (Scheyb 1770); sowie: Orestrio von den drey Künsten der Zeichnung. Mit einem Anhang von der Art und Weise, Abdrücke in Schwefel, Gyps, und Glas zu verfertigen auch in Edelsteine zu graben. Herausgegeben von Franz Christoph von Scheyb in Gauböckelheim, 2 Bde, Wien 1774 (Scheyb 1774).

3 Vgl. dazu Sulzer 1792–1794, Bd. 2, S. 57, hier zitiert nach Büttner 1999, S. 343: » […] das eigentliche Geschäfft der schönen Künste ist, Empfindungen zu wecken«.

4 Auf die Wiedergabe der Biographie wird hier verzichtet, siehe dazu vor allem das Standardwerk zu Messerschmidt: Pötzl-Malíková 1982. Siehe auch den Beitrag von Heike Höcherl, Der »Hogarth der Plastik«, in diesem Katalog.

5 Siehe zur Wiener Karriere Pötzl-Malíková 1982, S. 17–49. Zu den Umständen seiner Entlassung siehe Gampp 1998, S. 20.

6 Gampp 1998, S. 21.

7 Michael Krapf verweist auf den neuesten Stand der Forschung, die mehrere Modelle in den Charakterköpfen erkennen will, darunter auch den Bruder Messerschmidts, Johann Adam; siehe Krapf, Schnabelköpfe 2002, S. 87 und Anm. 2. Davon, dass mehrere Personen als Modell gedient hätten, ist nach den Quellen nichts bekannt. Aufgrund der grimassierenden Verzerrungen der Physiognomie muss es auch schwer fallen, die jeweiligen Modelle zu eruieren.

8 Friedrich Nicolai, Beschreibung einer Reise durch Deutschland und die Schweiz im Jahre 1781. Nebst Bemerkungen über Gelehrsamkeit, Industrie, Religion und Sitten, von Friedrich Nicolai, Berlin / Stettin 1783–1785, hier Bd. 6, S. 401–420.

9 Nicolai 1785, S. 410.

10 Nicolai 1785, S. 412–413.

11 Nicolai 1785, S. 411.

12 Deswegen muss angesichts von Messerschmidts Büsten auch nicht (wie Nicolai selbst es fälschlicherweise an einer Stelle tut) von Physiognomie gesprochen werden, sondern von Pathognomie. Lavater (1778, S. 120) definiert den Unterschied wie folgt: Während die Physiognomie die »Wissenschaft der Zeichen der Kräfte« sei, sei die Pathognomie die »Wissenschaft der Zeichen der Leidenschaft«. Die Physiognomik zeige, was der Mensch überhaupt sei, die Pathognomik aber, was er im gegenwärtigen Moment sei, denn ihr gehe es um die Darstellung der Bewegungen und Beweglichkeiten, mithin des Leidenschaftlichen eines Gesichtes.

13 Siehe Busch 1993. Dass Kunstwerke den Betrachter affizieren sollen, ist seit Alberti ein Gemeinplatz der Kunsttheorie (siehe Alberti 2002, § 41). Die Neuheit besteht darin, dass nunmehr fast ausschließlich auf dieses Kriterium rekurriert wird. Davon mehr im weiteren Verlauf des Artikels.

14 Siehe dazu Krapf, Schnabelköpfe 2002, S. 87–96, sowie Krapf 1995.

15 Nicolai 1785, S. 411: »Man weiß, wie viel Aufhebens die Schwärmer von mancherley Art aus den Naturkenntnissen machen, welche der sogenannte ägyptische Hermes (der aber leider! nie in der Welt existirt hat) besessen haben soll.«

16 Nicolai 1785, S. 411.

17 Siehe dazu: Hermetis Trismegisti Erkaentnuess der Natur und des darin sich offenbahrenden Grossen Gottes […]. Verfertigt von Alethophilo,

1 See Ilg 1885, Preface. On the members of the Vienna lodge, see Bückling 2002, p. 83 and n. 51.

2 Franz von Scheyb expounded his conception of aesthetics in two works: "Köremons Ehrenmitgliedes der Akademie von St. Lucas in Rom, auch verschiedener andrer Akademien in Italien und Deutschland, Natur und Kunst in Gemälden, Bildhauereyen, Gebäuden und Kupferstichen zum Unterricht der Schüler, und Vergnügen der Kenner", 2 vols, Leipzig / Vienna 1770 (Scheyb 1770) and "Orestrio von den drey Künsten der Zeichnung. Mit einem Anhang von der Art und Weise, Abdrücke in Schwefel, Gyps, und Glas zu verfertigen auch in Edelsteine zu graben. Herausgegeben von Franz Christoph von Scheyb in Gauböckelheim", 2 vols, Vienna 1774 (Scheyb 1774).

3 Cf Sulzer 1792–1794, Vol. 2, p. 57, quoted here from Büttner 1999, p. 343: "[...] The actual business of the fine arts is to arouse emotions."

4 The biography is not detailed here; for it, see especially the standard work on Messerschmidt: Pötzl-Malíková 1982. Also see the essay by Heike Höcherl, "The Hogarth of Sculpture" in the present catalogue.

5 On his career in Vienna, see Pötzl-Malíková 1982, pp. 17–49. For the conditions leading to his dismissal, Gampp 1998, p. 20.

6 Gampp 1998, p. 21.

7 Michael Krapf points out the most recent state of research, which proposes to view several models in the Character Heads, including Johann Adam, Messerschmidt's

Hamburg 1706. Die nachfolgende Genealogie im Schema in der unpaginierten Vorrede. Von diesem Werk erschien eine Neufassung 1786 (siehe Krapf 1995, S. 50, Anm. 37). Diese Ausgabe war dem Verfasser nicht zugänglich.

18 Siehe zur Identifikation: Zedler Reprint 1961, Bd. 43, Sp. 1797–1798.

19 Messerschmidt stammt aus Wiesensteig im schwäbischen Raum. Zur Ikonographie des Thubalkain siehe Erffa 1989, Bd. 1, S. 397–400. Zur Verwendung auf Orgelprospekten siehe Weiermann 1956, S. 89f.

20 Benito Arias Montano (1527–1598), Thubalcain: sive De mensuris sacris liber; eingebunden in: Ders.: Biblia sacra, Antwerpen 1572, Bd. 7 (ohne durchgehende Paginierung). Beschrieben werden darin, auf Stellen des Alten Testamentes basierend, jene Maße, denen Körperteile zugrunde liegen (Finger, Fuß etc.), die gängigen Gewichte und Maße zum Bemessen von Flüssigem und Festem. Von den Proportionen innerhalb dieser Maße oder gar der Proportionen des Körpers selbst wird nicht verhandelt, nur von der Tauglichkeit des Körpers als Messinstrument.

21 Siehe dazu Frick 1973, S. 456 und 464. Mitglied war unter anderen der mit Messerschmidt unmittelbar bekannte Graf Karl Pállfy.

22 Zur Ikonographie des Thubalkain siehe Erffa 1989 sowie – als ein besonders prominentes Beispiel – die Reliefs nach Vorlagen Giottos am Campanile von Florenz (Braunfels 1947/48, S. 205f. mit Verweis auf die mittelalterliche Ikonographie).

23 Braunfels 1947/48, S. 471.

24 Siehe dazu Axel Christoph Gampp, Born out of the Spirit of Proportion: Franz Xaver Messerschmidt and his »Charakterköpfe«; in: Intersection, Vol. 9, Spirits Unseen: The Representation of Subtle Bodies in Early Modern Europe Culture (im Druck).

25 Ein Kopf (Nro. 48 der ehemaligen Serie mit dem nachträglich verliehenen Titel »Ein alter fröhlicher Lächler«) fällt aus der Reihe, indem er aus Lindenholz mit Wachsauflage gemacht wurde. Inwieweit es sich hier um ein Modell für einen späteren Guss handelt, ist offen; siehe dazu Krapf, Katalog 2002, S. 266.

26 Es lässt sich an dieser Stelle keine Hierarchie innerhalb der Köpfe erkennen, denen eine Differenz des Materials zugrunde läge, noch eine andere Einteilung, die auf den verwendeten Materialien basieren würde.

27 Siehe Frick 1973, S. 467.

28 Adam Michael Birkholz, Die sieben heiligen Grundsäulen der Ewigkeit und der Zeit; Leipzig 1783. Darin: »Brunnen der Weisheit und Erkenntnis der Natur. Von einem unvergleichlichen Philosophen gegraben und geöfnet durch Anonymum Von Schwarzfuss«, S. 67 bzw. S. 69. Übrigens wird von Nicolai noch ein zweites Buch dem Titel nach genannt, nämlich Johann Conrad Dippel (1673–1734), Microcosmische Vorspiele des neuen Himmels und der Erde: wie dem Menschen, als dem Bilde Gottes, von Gott zugelassen […]. Von einem Liebhaber göttlicher und natürlicher Geheimnisse, Amsterdam (eigentlich: Berlin) 1733. Bei Dippel wird – weniger ausführlich – ebenfalls

brother; See Krapf, Schnabelköpfe 2002, p. 87 and n. 2. From the sources nothing is known about several people having served as models. The grimacing distortions of the countenance must also make it difficult to discover any individual models.

8 Friedrich Nicolai, "Beschreibung einer Reise durch Deutschland und die Schweiz im Jahre 1781. Nebst Bemerkungen über Gelehrsamkeit, Industrie, Religion und Sitten", Berlin/Stettin 1783–1785; here Vol. 6, pp. 401–420.

9 Nicolai 1785, p. 410.

10 Ibid., pp. 412f.

11 Ibid., p. 411.

12 Consequently, the term physiognomy must not be applied to Messerschmidt's busts (as Nicolai does erroneously in one passage); instead the applicable term is pathognomy. Lavater (1778, p. 120) defines the difference between the two as follows: whereas physiognomy is the "science of the powers", pathognomy is the "science of the signs of passion". Physiognomy shows what man really is but pathognomy what he is at the present instant since pathognomy is concerned with representing the movements and actions, particularly the passionate ones, of a face.

13 See Busch 1993. That art works affect the viewer has been a commonplace of art theory since Alberti (see Alberti 2002, § 41). What is new about this is that this criterion is now taken for virtually the sole one. More on this in the following.

14 See especially Krapf, Schnabelköpfe 2002, pp. 87–96 and Krapf 1995.

15 Nicolai 1785, p. 411: "One knows how much fuss and bother the Enthusiasts of various sorts make of knowledge of Nature which the so-called Egyptian Hermes (who, unfortunately! never existed in this world) is supposed to have possessed."

16 Loc. cit.

17 See: "Hermetis Trismegisti Erkaentnuess der Natur und des darin sich offenbahrenden Grossen Gottes […]. Verfertigt von Alethophilo", Hamburg 1706. The genealogy in the diagram is taken from the unpaginated prologue. A new edition of this work was published in 1786 (see Krapf 1995, p. 50, n. 37). This edition was not available to the present author.

18 See for the identification: Zedler Reprint 1961, Vol. 43, col. 1797f.

19 Messerschmidt came from Wiesensteig in Swabia. On the iconography of Tubalkain, see Erffa 1989, Vol. 1, pp. 397–400. On the use of organ screens, see Weiermann 1956, p. 89f.

20 Benito Arias Montano (1527–1598), "Thubalcain: sive De mensuris sacris liber"; bound in Montano, Biblia Sacra, Antwerp 1572, Vol. 7 (without continuous pagination). What is described in it, based on Old Testament passages, are the basic proportions of the human body (the fingers, the foot, etc) and the common weights and measurements for measuring liquids and solids. Nothing is said about the proportions within these dimensions or even about the proportions of the body itself; all that is discussed is the suitability of the body as an instrument for measuring.

21 See Frick 1973, pp. 456, 464. One member was Count Karl Pállfy, with whom Messerschmidt was personally acquainted.

22 For the iconography of Tubalkain see Erffa 1989 and – as a particularly distinguished example – the reliefs after Giotto in the Florence Campanile (Braunfels 1947/48, p. 205f. with references to the medieval iconography).

23 Braunfels 1947/48, p. 471.

24 See Axel Christoph Gampp, Born out of the Spirit of Proportion: Franz Xaver Messerschmidt and his "Charakterköpfe"; in: Intersection, Vol. 9, Spirits Unseen: The Representation of Subtle Bodies in Early Modern European Culture (in press).

25 One Head (No. 48 of the former series, later entitled "An Old Cheerful Smiler") differs from the others in being made of limewood with wax

vom Purgierungsprozess bei den Metallen gesprochen (S. 115).

29 Birkholz 1783, S. 67–68.

30 Wahrscheinlich verbirgt sich dahinter ebenfalls ein im Orden der Ritter und Brüder des Lichts, auch genannt »Asiatische Brüder«, verhandelter Aspekt des Initiationsritus. Frick (1973, S. 470) schildert im Aufnahmeritual zum fünften Grad, wie der solarische und der lunarische Schwefel mit weiteren Elementen vereint ein unvergängliches Wesen zeugen.

31 Birkholz 1783, S. 71 und 73.

32 Birkholz 1783, S. 55.

33 Zum Verhältnis von Messerschmidt zu von Scheyb siehe Gampp 1998, S. 27.

34 Scheyb 1770, Bd. 2, S. 94–95.

35 Neben dem Verweis auf Buschs fundamentales Werk (Busch 1993) sei im Zusammenhang von Messerschmidt und von Scheyb auch auf Gampp 1998 verwiesen.

36 Scheyb 1770, Bd. 2, S. 77–78.

37 Scheyb 1774, Bd. 1, S. 183: »Wir haben in der Natur und Kunst unsers Köremons von den Leidenschaften zwar viel gehört. Seine Beobachtungen aber zeigen mehr die Anordnung, und Zeichnung des Gemäldes, als was ich hier zu weiterm Unterricht und Nutzen des Malers vortragen will […].«

38 Scheyb 1774, Bd. 1, S. 185.

39 Scheyb 1770, Bd. 2, S. 78.

40 Siehe dazu vor allem Kirchner 1991.

41 Scheyb 1774, Bd. I, S. 185–186: »Viele Schriftsteller haben allerhand Zufälle bestimmt, welche nach verschiedenen Affecten äusserlich erscheinen, und in den Muskeln des Angesichts sich deutlich offenbaren; und dieses ist, was eine gewisse stille Sprache des Gemüthes zu erkennen giebt.«

42 Scheyb 1774, Bd. 1, S. 185: »Dem Maler ist es nützlich, wenn er dergleichen, und andere solche Sachen in Büchern gelesen hat; unendlich mehr Vortheil aber wird er haben, wenn er sie in der Natur selbst beobachtet, und studiret […].«

43 Nicolai 1785, S. 413: »Nun ging er wirklich hiernach zu Werke; er kniff sich, er schnitt Grimassen vor dem Spiegel, und glaubte die bewunderungswürdigsten Wirkungen von seiner Herrschaft über die Geister zu erfahren.«

44 Siehe dazu Büttner 1999, S. 348, mit Verweis auf Karl Philipp Moritz.

appliqué. Whether this was a model to be cast later is a moot question: see Krapf, Katalog 2002, p. 266.

26 No hierarchy of Heads can be established on the basis of material differences nor can any other grouping be based on the materials used.

27 See Frick 1973, p. 467.

28 Adam Michael Birkholz, Die sieben heiligen Grundsäulen der Ewigkeit und der Zeit; Leipzig 1783. In it: "Brunnen der Weisheit und Erkenntnis der Natur. Von einem unvergleichlichen Philosophen gegraben und geöfnet durch Anonymum Von Schwarzfuss", pp. 67, 69. Incidentally, Nicolai mentions the title of a second book: Johann Conrad Dippel (1673–1734), Microcosmische Vorspiele des neuen Himmels und der Erde: wie dem Menschen, als dem Bilde Gottes, von Gott zugelassen [...]. Von einem Liebhaber göttlicher und natürlicher Geheimnisse, Amsterdam (actually Berlin) 1733. Dippel speaks – less extensively – of the purification process in metallurgy (p. 115).

29 Birkholz 1783, pp. 67f.

30 Behind this was probably another aspect of the initiation rite used in the Order of Knights and the Brethen of Light, also called the Asian Brethren. Frick (1973, p. 470) describes in the initiation rites for admission to the fifth degree how solar and lunar sulphur united with other elements to create an imperishable entity.

31 Birkholz 1783, pp. 71, 73.

32 Ibid. 1783, p. 55.

33 For Messerschmidt's relationship to Scheyb, see Gampp 1998, p. 27.

34 Scheyb 1770, Vol. 2, pp. 94f.

35 Apart from Busch's standard work (Busch 1993), the reader is referred to Gampp 1998 for the link between Messerschmidt and von Scheyb.

36 Scheyb 1770, Vol. 2, pp. 77f.

37 Scheyb 1774, Vol. 1, p. 183: "We have in the nature and art of our Köremon heard much of the passions. His observations, however, show rather more of the composition and draughtsmanship of a painting than I wish to expound for the further instruction and use of the painter [...]"

38 Ibid., p. 185.

39 Scheyb 1770, Vol. 2, p. 78.

40 See especially Kirchner 1991.

41 Scheyb 1774, Vol. 1, pp. 185f.: "Many writers have ascertained all sorts of coincidences which appear according to the various emotions and are clearly revealed in the facial muscles; and this is what discloses a certain tacit language of the soul."

42 Loc. cit.: "It is useful for the painter if he has read similar and other such things in books; he will, however, have infinitely more advantage if he observes them in nature himself and studies them [...]."

43 Nicolai 1785, p. 413: "Now he really went to work on this; he pinched himself, made faces before the looking-glass and believed he was experiencing the most remarkable things about his dominion over the spirits."

44 See Büttner 1999, p. 348, with reference to Karl Philipp Moritz.

Ulrich Pfarr

Messerschmidts Köpfe und ihre imaginären Betrachter: Die Krise des Ausdrucks

Meinem Vater Alois

Gemischte Gefühle

Man stelle sich vor: am Stadtrand von Preßburg, in einem, so wollen es manche Biographen, verrufenen Bezirk unterhalb der Burg,[1] kommt man zu Besuch zu einem einst gefeierten Künstler, der nun als »Geisterseher« von sich reden macht. In einem Haus über der Donau arbeitet er an sagenhaften »Egyptischen Köpfen«,[2] die mancher Neugierige jedoch niemals zu Gesicht bekam. Den frappanten und affizierenden Anblick, den die geballte Präsentation der Serie teils heftig grimassierender und sich frontal entgegenreckender Büsten dem eintretenden Besucher geboten haben mag, kann man im Zeitalter medialer Dauerschocks wohl kaum nachvollziehen. Verschiedentlich wurde es in Ausstellungen unternommen, eine größere Anzahl der Köpfe auf einer einzigen Stellage zu versammeln; allerdings ohne dass dies der unheimlichen Atmosphäre der verdichteten Aufstellung in einem bequem möblierten Wohnraum nahegekommen sein wird.[3] Dem Atelierbesuch des Berliner Aufklärers Friedrich Nicolai, der in Preßburg letzte Gefährdungen der bürgerlichen Vernunft ausleuchten wollte, ist immerhin eine ausführliche Betrachtung des »Falls Messerschmidt« zu verdanken. Freilich bietet sie weder verlässliche Fakten noch einen subjektiven Erfahrungsbe-

Messerschmidt's Heads and the Implied Observer: Crisis of Expression

Mixed feelings

Just imagine: on the outskirts of Bratislava, in a shady district, as some biographers call it, below the castle,[1] you are visiting a once celebrated artist, who is now the talk of the town as "the man who sees spirits". In a house above the Danube, he is working on fabulous "Egyptian Heads",[2] which some curious visitors, however, have never actually seen. In an age of media overload with its incessant shocks, it is virtually impossible to grasp how striking and affecting the concentrated presentation of the series of busts, some of them making fierce faces and arrayed frontally towards the entering visitor, really was. Attempts have variously been made to assemble a fairly large number of these Heads in one place at exhibitions – without however approaching anything like the eerie atmosphere created when they were set up at close quarters in a comfortably furnished sitting-room.[3] Nevertheless, we are indebted to the studio visit of that man of the Enlightenment from Berlin, Friedrich Nicolai, who wanted to illumine the last benighted threats to bourgeois reason in Bratislava, for an extensive observation of the "Messerschmidt case". Of course, it provides neither reliable facts nor even a subjective account of an experience.[4] Only indirectly, in his enormous exertions to rationalise, which, above and beyond the journalistic aim underlying his account of his journey, document a profound uneasiness caused by his encounter with Messerschmidt, does Nicolai record something of that experience. Nicolai only involved himself with the Heads to a limited extent, in the sense of the aesthetic of "mixed feelings" that had been redefined by his friend Moses Mendelssohn.[5] On the contrary, Nicolai's defensive strategy induced him to subdivide the Heads he saw into categories, which attest to the success and failure of this attitude of response to them. After all, of the

richt.[4] Nur indirekt, in seinen eminenten Rationalisierungsbemü- hungen, die über den publizistischen Zweck seiner Reisebeschrei- bung hinaus eine tiefe Beunruhigung durch das Zusammentreffen mit Messerschmidt dokumentieren, überliefert Nicolai etwas von diesem Erlebnis. Auf die Köpfe hat sich Nicolai nur begrenzt im Sinne der von seinem Freund Moses Mendelssohn neuformulierten Ästhetik des »gemischten Gefühls«[5] eingelassen. Seine Abwehrstra- tegie führte ihn vielmehr zur Einteilung der gesehenen Köpfe in Kategorien, die vom Gelingen und Scheitern dieser Rezeptionshal- tung zeugen. Denn von den angeblich 60 vollendeten Exemplaren weiß er letztlich nur vier »der Natur gemäße« zu würdigen, nament- lich das lachende Selbstbildnis (Nro. 1, Kat.-Nr. 4) und jenes mit aufgesperrtem Mund, »so dass man die Zunge bis an ihre Wurzeln sehen konnte« (Nro. 5, Kat.-Nr. 12), sowie zwei »ganz ernsthafte im antiken Stile« (etwa Nro. 22, Kat.-Nr. 18).[6] Gesteht er den beiden letztgenannten Köpfen Schönheit zu, so erfordern die beiden erstge- nannten einen Beitrag des Betrachters, nämlich Nicolais Bewunde- rung ihrer unerhörten Naturwahrheit. Für die beiden »Schnabel- köpfe« und die übrigen 54 Büsten zieht er die zunächst allen Köpfen gezollte Bewunderung ihrer Vollendung als Kunstwerke wie- der zurück, indem er ihre »scheußlichen Konvulsionen« verurteilt und mit fraglichen Äußerungen des Künstlers auf dessen Geister- theorie bezieht. In den Köpfen erkennt Nicolai daher keinen Bei- trag zur zeitgenössischen Debatte zwischen der »Physiognomik« Johann Caspar Lavaters und der »Pathognomik« Georg Christoph Lichtenbergs. Denn die Wirkungsabsicht der mimischen Verzerrun- gen würde demzufolge nicht auf das reale Publikum der Köpfe zie- len, sondern auf das Geisterreich. Auf diese Weise kann Nicolai ein bizarres mimisches Element vieler Köpfe erklären, das Messer- schmidt dann nicht als Ausdrucks-, sondern als Würdeformel in die späten Porträts integriert hätte: Der Mensch solle das Rot der Lip- pen einziehen, damit er wie die Tiere, die das Rot nicht zeigten, bes- ser die Geister erkennen könne.[7] Es herrscht hier keine Symmetrie zwischen mutmaßlich dargestellten und tatsächlich ausgelösten Gefühlen. Doch »Ausdruck« als Korrelat der emotionalen Wirkung ist eine Forderung, die beispielsweise Johann Georg Sulzer in seiner Theorie der schönen Künste mehrfach formuliert.[8] Ähnliche Äuße- rungen, in der Tradition der Traktate Albertis und Leonardos, finden sich in den Schriften Franz von Scheybs, deren Einfluss auf Messer- schmidt in der Thematik seiner 1774 ausgestellten Kleinplastiken noch deutlich greifbar ist.[9] Indem Ernst Kris 1932 von seiner Erfah- rung scheiternder Einfühlung auf den scheiternden Ausdruck der Köpfe schloss, legte er ein expressionistisches Einfühlungskonzept zugrunde.[10] Dass Werke der Kunst Gefühle wecken, dass man sei- nem Gegenüber »Ausdruck« zuspricht, ist freilich kein Spezifikum

60 pieces alleged to have been finished, Nicolai only honours four that are "according to nature" with his appreciation, that is, the laughing self-portrait (no. 1, cat. no. 4) and the head with the mouth so wide open "that one could see the tongue down to its roots" (no. 5, cat. no. 12) as well as two "very serious ones in the style of Antiquity" (probably no. 22, cat. no. 18).[6] Although Nicolai concedes that the two last Heads are handsome, the two listed first required a contri- bution from the viewer, in fact Nicolai's admiration of their unprecedented truth to nature. As for the two "Beaked Heads" and the remaining 54 busts, Nicolai retracts the admiration he had felt for them as con- summate works of art by condemning their "horrific convulsions" and relates them, on the grounds of questionable remarks made by the artist, to the lat- ter's theory of spirits. Consequently, Nicolai did not see the Heads as a contribution to the debate then raging between adherents of Johann Caspar Lavater's "physiognomics" and Georg Christoph Lichtenberg's "pathognomics'. The impact the mimetic contortions was intended to make was, accordingly, not addressed to a real public as viewers of the Heads, but instead to the realm of spirits. In this way Nicolai can explain a bizarre mimetic element found in many of the Heads, which Messerschmidt would have integrated in the late portraits as a dignity formula rather than a for- mula of expression: man should draw in the red of the lips so that he, like animals, who do not show the red, might better recognise the spirits.[7] Here no sym- metry reigns between what may be conjectured to have been represented and feelings actually triggered. However, "expression" as correlating with emotional impact is a requirement which Johann Georg Sulzer, for instance, formulated in several passages of his the- ory of the visual arts.[8] Similar statements, in the tra- dition of the treatises of Alberti and Leonardo, occur in the writings of Franz von Scheyb, whose influence on Messerschmidt is still clearly palpable in the themes represented in the small-scale sculpture dis- played in 1774.[9] In concluding from his experience of failed empathy in 1932 that the expressions of the Heads represented failure, Ernst Kris was basing his observations on an Expressionist conception of empa- thy.[10] That works of art arouse feelings, that one

107 Vladimír Kordoš,
 Hommage an
 Messerschmidt,
 Videoperformance,
 1989
 Vladimír Kordoš,
 Homage to Messer-
 schmidt, video per-
 formance, 1989

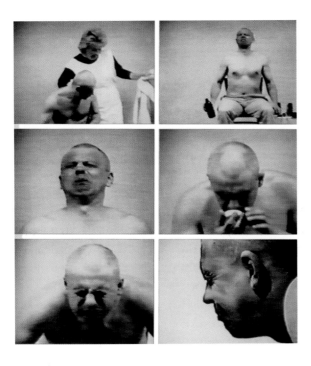

von Gesichtsdarstellungen, sondern gilt ebenso für Landschaftsmalerei oder Architektur. Ob die Köpfe Messerschmidts überhaupt Emotionen zur Darstellung bringen, steht zunächst in Frage.

Dichotomie der Deutungen

In der frühesten Nachricht, in Meusels Künstlerlexikon von 1778, heißt es zu den ersten Köpfen: »In München hat er unter anderem vier Köpfe gearbeitet, die verschiedene Leidenschaften ausdrücken und sein Bildnis vorstellen.«[11] Mit Kris ist anzunehmen, dass der Bildhauer in der Tat Anregungen der Traktate Le Bruns und Parsons' verarbeitete und das Spiegelexperiment nutzte, um über die immer wieder als grimassenhaft kritisierten graphischen Vorlagen hinaus zu authentischen Aufzeichnungen der Leidenschaften zu gelangen. Das Selbstexperiment des Erweckens von Gefühlen, um im Augenblick des Affekts vor den Spiegel zu treten und das eigene Gesicht zu studieren, sollte die vieldiskutierte »Unfähigkeit des Modells«[12] überwinden. In der Videoperformance »Hommage an Messerschmidt« führte der slowakische Künstler Vladimír Kordoš 1989 solche Manipulationen vor (Abb. 107), jedoch in einer Bildinszenierung, die auch Assoziationen an einen psychiatrischen Kontext oder eine mögliche Verhörsituation zulässt.[13] Gerade die Analogie des Videoauges zum von der Inquisition eingeführten »Geheimen Gebärdenprotokoll«[14] kann dann die Funktion zur Aufzeichnung unwillkürlichen Ausdrucksverhaltens verdeutlichen. Zugleich ruft diese

attributes "expression" to one's respondent, is, of course, not specific to representations of faces but indeed applies equally to landscape painting and architecture. It is, first, questionable whether Messerschmidt's Heads are representations of emotions at all.

The dichotomy of interpretations

In the earliest account, in "Meusel's Künstlerlexikon" of 1778, it is said of the first Heads: "In Munich he worked inter alia four Heads, which express different passions and represent his likeness."[11] In agreement with Kris it should be assumed that the sculptor did indeed assimilate inspiration from the treatises of Le Brun and Parsons and used the experiment in front of the mirror to go beyond the graphic models that had been frequently criticised as grimaces to achieve authentic records of the passions. The experiment Messerschmidt conducted on himself of arousing feelings in order to go before the mirror and study his own face in the instant of emotion was intended to overcome the much debated "inadequacy of the model".[12] In a 1989 video Performance, "Homage to Messerschmidt" the Slovak artist Vladimír Kordoš demonstrated manipulations of that kind (fig. 107), albeit in a pictorial mise-en-scène, which also allows associations with a psychiatric context or possibly a cross-examination situation.[13] The analogy of the video eye and the "confidential gesture protocol" introduced by the Inquisition[14] is particularly good at making clear the function of recording involuntary expressive behaviour. At the same time, this work invokes a dilemma fundamental to experimentation on oneself: the artist must act at the same time as a subjective "experiencer" and an objective observer.

The Heads lend themselves particularly well to classification according to Lavater's physiognomics because so many of them are bald and the noses are emphasised; the Swiss theologian saw the infallible signatures of the soul only in the raised features, primarily in skull forms and nasal profiles. The physiognomic quest for a transparent inner life, however, is taken *ad absurdum* by Messerschmidt's seemingly arbitrary combinations of various parts of the face, necks and wig-like hair.[15] Consequently, all arguments would seem to speak for Lichtenberg's posi-

Arbeit ein grundlegendes Dilemma des Selbstexperiments auf: Der Künstler muss zur gleichen Zeit als subjektiv erlebende und als objektiv beobachtende Instanz agieren.

Der Physiognomik Lavaters kommen die Köpfe insbesondere durch ihre häufige Glatzköpfigkeit und die Hervorhebung der Nasen entgegen, denn die untrüglichen Signaturen der Seele sah der Schweizer Theologe nur in den stehenden Zügen, vorwiegend in Schädelformen und Nasenprofilen. Durch Messerschmidts scheinbar willkürliche Kombinatorik unterschiedlicher Gesichtsteile, Hälse und perückenhafter Haare[15] wird die physiognomische Suche nach einem durchschaubaren Innern allerdings ad absurdum geführt. Soweit sprechen alle Argumente für die Position Lichtenbergs, der »Pathognomik« in Abgrenzung von Lavater als eine universale Sprache spontaner, nicht simulierbarer Ausdrucksbewegungen definierte.[16]

Doch bis in die neueste Forschungsliteratur reicht der Widerspruch zwischen den Auffassungen, den Köpfen wohne ein »Maximum an Ausdruck« inne,[17] oder sie zeigten lediglich »künstliche Anspannungen des Gesichts«,[18] also eine Artistik der Gesichtsmuskulatur[19] ohne psychischen Gehalt. Unentschieden bleiben in dieser Hinsicht die traditionellen Spottnamen, die den Köpfen 1793 von einem anonymen Autor angehängt wurden, um sie für die Wahrnehmung in den vorgeprägten Schablonen der seinerzeit populären Physiognomik herzurichten.[20] Demzufolge zeigten einige Köpfe vorherrschende Leidenschaften wie »Spottsucht« oder »Weinerlichkeit«, die die Dargestellten moralisch qualifizieren: als »Narren«, »Bösewichter« oder eben auch »Edelmütige«. In den meisten Fällen ist jedoch von bloßen Reflexen oder körperlichen Malheuren die Rede: von Geruchswahrnehmungen, Gähnen, Schlaf, schmerzhafter Verwundung oder Verstopfung. Einen anderen Akzent setzte das 1785 erschienene Epitaph auf den zwei Jahre zuvor verstorbenen Messerschmidt, das identifizierbare Köpfe nennt und diese als Selbstdarstellungen des Künstlers apostrophiert: angesprochen werden Lachen, Wut, Zähneblecken, Gähnen und Schlaf.[21] Damit übereinstimmend hatte die Wiener Zeitung am 27. August 1783 gemeldet, die »Egyptischen Köpfe« drückten »alle Arten der Leidenschaften und Rührungen« aus, ein auch 1793 in der »Merkwürdigen Lebensgeschichte« noch erwähntes Projekt, das sich mit Sulzer begründen ließe. Dieser hatte vorgeschlagen, »ein Mann von Genie« solle zu einer Sammlung von Gesichtsbildungen und Gebärden beitragen und diese nach dem Vorbild der Naturkunde ordnen.[22] Verwirklicht sein dürfte dies allerdings eher im Kunstkabinett Lavaters, der nicht nur Porträts und Schattenrisse, sondern auch Studien einzelner Gesichtsteile und Körpergebärden sammelte und einem scheinbar rationalen Ordnungsprinzip unterwarf.[23]

tion; in differentiating himself from Lavater, Lichtenberg defined "pathognomics" as a universal language of spontaneous expressive actions that could not be simulated.[16]

However, the contradiction between views that the Heads are informed by a "maximum of expression"[17] or, alternatively, that all they show is an "artificial straining of the face",[18] that is, facial-muscle acrobatics[19] without psychological content, has persisted down to the most recent research. In this respect, the traditional derisory names which were given to the Heads by an anonymous author in 1793 to make them conveniently fit into the received stereotypes of the phsyiognomics popular in his day remain in dispute.[20] According to what the names indicate, some of the Heads show dominant passions such as "addiction to mockery" or "lachrymosity", which qualify the persons represented by moral category: as "fools", "villains" or, on the other hand, as "magnanimous". In most cases, however, all that is talked of are mere reflexes or physical ills: the perception of odours, yawning, sleep, being painfully wounded or suffering from constipation. The 1785 epitaph on Messerschmidt, who had died two years previously, shifts the emphasis in mentioning identifiable Heads and in claiming they are self-portraits of the artist: what is addressed is laughing, anger, clenching the teeth, yawning and sleep.[21] Concurring, the "Wiener Zeitung" of 27 August 1783 reported that the "Egyptian Heads" expressed "all sorts of emotions", a project also mentioned in 1793 in the "Merkwürdige Lebensgeschichte", which could be based on Sulzer. He had proposed "a man of genius" should contribute to a collection of facial formations and gestures and arrange them after the model of natural history.[22] If realised at all, this must, however, have been in Lavater's Kunstkabinett; Lavater not only collected portraits and silhouettes but also studies of individual facial features, body poses and gestures and subjected them to what was seemingly a rational ordering principle.[23]

Legibility and temporality of the emotions

Lichtenberg and Lavater are very close to one another in their bourgeois urge to demystify the artificial sign

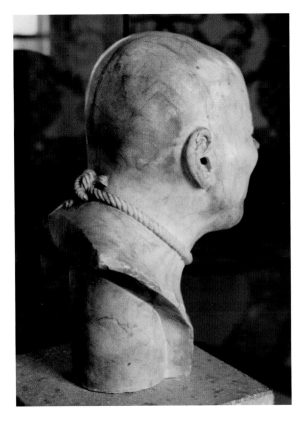

108 Franz Xaver Messer-
schmidt, Kopf Nro. 25
(Ein Erhängter),
Rückansicht, nach 1770,
Alabaster, Österreichi-
sche Galerie Belvedere,
Wien, Inv.-Nr. 5637
*Franz Xaver Messer-
schmidt, Head no. 25
(A Hanged Man),
rear view, after 1770,
alabaster, Österreichische
Galerie Belvedere,
Vienna, Inv. no. 5637*

Lesbarkeit und Zeitlichkeit der Emotionen

Lichtenberg und Lavater sind in ihrem bürgerlichen Impetus, die künstlichen Zeichensysteme der höfischen Gesellschaft durch den Rekurs auf die Natur zu entzaubern, eng verbunden. Wenn uns die Köpfe vor eine radikal physiognomische Situation stellen, in der das Wissen über den Gegenüber nur am Körper zu finden ist, hat dies auch Konsequenzen für die Lesbarkeit des emotionalen Ausdrucks. An Lessings Beitrag zum Laokoon-Streit hat Gunter Gebauer diffe-renzierte Überlegungen zur Semiotik der Künste angeschlossen.[24] Zwar zeigt der Kopf des Laokoon prägnante Ausdrucksmomente und hat über Jahrhunderte für mimische Darstellungen des Leidens als renommiertestes Modell gedient, »Ausdruck« nimmt Gebauer aber vor allem am Rumpf der Hauptfigur wahr. Er unterscheidet eine direkte Zuweisung von Emotionen an das Gegenüber, die eine in der Kunst nur von der Malerei hervorgerufene »Zwischenkörper-lichkeit« voraussetze, und eine indirekte Zuweisung, die in der körperlich von uns abgeschiedenen Skulptur den »fruchtbaren Moment« erfordert. Durch dieses Konzept rege das Werk zur Pro-duktion der Erzählungen an, die Emotionen erst erzeugen. Bemer-kenswert am Beitrag Gebauers ist, dass er damit zugleich den Raum für die Einbettung emotionalen Geschehens in Episoden entfaltet. Jede Emotion enthält eine Beziehungsstruktur, sie interpretiert ein

systems of court society by having recourse to nature. If the Heads confront us with an acute physiognomic situation, in which knowledge of our respondent can only be sought in the body, this also has conse-quences for the legibility of the emotion expressed. Gunter Gebauer has added sophisticated thoughts on the semiotics of the arts to Lessing's contribution to the Laocoön controversy.[24] Although the head of Laocoön demonstrates significant aspects of expres-sion and for centuries has served as the most re-nowned model for mimetic representations of suffer-ing, Gebauer perceives "expression" primarily in the torso of the main figure. He distinguishes between directly allotting emotions to the viewer as respon-dent, which is premised on an "intercorporeality" that in art is only evoked by painting and, on the other hand, indirectly allotting emotions, which requires the "fertile moment" in the sculpture as it is physically separate from us. Through this concept, thus Gebauer, the work inspires the production of narra-tives, which are what generate emotions. What is so remarkable about Gebauer's contribution is that he thus develops the space for embedding emotional happenings in episodes. Every emotion contains a referential structure; it interprets a happening and formulates a wish relating to an object.[25] In painting and the performing arts, such moments, *inter alia*, make an impact through spatial relationships, which, on the other hand, influence individual viewers of a piece of sculpture through their own presence. Nevertheless, the Laocoön group provides narration to an especially high degree since the attack of the deadly serpents and their victims' desperate struggle to ward them off are subjected to extremely detailed description.

Messerschmidt's Heads are represented as far more reduced: here the story can only arise in the minds of the men and women looking at them, since even anecdotal elements, such as the Hanged Man's rope (fig. 108), the fur cap worn by the "The Artist as He imagined Himself Laughing" (cat. no 4), the stringy hair of "Just Rescued from Drowning" and the "Capuchin's" tonsure (cat. no 3) are ironic signs without any meaning that remains constant. Annoy-ing as the traditional derisory names may be today,

Geschehen und formuliert einen Wunsch bezüglich eines Objektes.[25] In der Malerei und den darstellenden Künsten gelangen solche Momente unter anderem durch räumliche Verhältnisse zur Wirkung, die individuelle Betrachter einer Skulptur hingegen durch ihre eigene Präsenz beeinflussen. Immerhin bietet aber gerade die Laokoon-Gruppe ein hohes Maß an Narration auf, wird doch der Angriff der tödlichen Schlangen und der Abwehrkampf ihrer Opfer äußerst detailreich geschildert.

Weit reduzierter bieten sich die Köpfe Messerschmidts dar: Hier kann die Geschichte nur noch im Kopf der Betrachterinnen und Betrachter entstehen, denn selbst anekdotische Elemente, wie der Strick des »Erhängten« (Abb. 108), die Pelzmütze des »lachenden Selbstporträts« (Kat.-Nr. 4), das strähnige Haar des »aus dem Wasser Geretteten«, die Tonsur des »Kapuziners« (Kat.-Nr. 3) sind ironische Zeichen ohne stabile Bedeutung. So ärgerlich die traditionellen Spottnamen heute sind, da sie unsere Wahrnehmung in unzulässiger Weise schematisieren: In den verschiedenen Auflagen der »Merkwürdigen Lebensgeschichte« (von 1793 bis 1858) und im Feuilleton des 19. Jahrhunderts wird nicht nur versucht, die Spottnamen in ihren unterschiedlichen Redaktionen plausibel zu machen; stets erfinden die Autoren hierzu Geschichten, wie wir sie auch selbst phantasieren müssen, wenn die Köpfe für uns lebendig und emotional bedeutend werden sollen. Welche Büste könnte dies besser verdeutlichen als der als »schlafend« titulierte, ausweislich seiner Haare »liegend« vorzustellende Kopf Nro. 8 (Kat.-Nr. 9)? »Sanft und ruhig« ist der Schlaf des Dargestellten keineswegs, die Anspannung der zusammengezogenen Brauen und der nur im Anflug eines Lächelns gezeigten, leicht zusammengepressten Lippen lassen vielmehr an einen lebhaften, von vielerlei Affekten geleiteten Traum denken. Anders als dies ein Werk der Zeichnung oder Malerei vermöchte, verrät uns diese Plastik nichts vom Inhalt des Traums: Wir können nur unsere eigenen Imaginationen an seine Stelle setzen.

Dies verweist auf eine weitere Position im Laokoon-Diskurs des 18. Jahrhunderts, die Wilhelm Vosskamp hervorgehoben hat. Bei Goethe kommt auch der Skulptur eine zeitliche Dimension zu, denn auch sie ist Sprache, und die Intermedialität des geschriebenen Textes vermag den Prozess der Betrachtung aufzunehmen.[26] In der Tat ist die emotionale Wirkung der originalen »Egyptischen Köpfe« wesentlich von zeitlichen Verläufen abhängig, so dass den widersprechenden Deutungen unterschiedliche Betrachtungszyklen entsprechen: (1) Bei der ersten Begegnung lösen die Köpfe meist spontanes Lachen aus; man lässt sich gern mit ihnen photographieren. (2) In der zweiten Phase, beim längeren Verweilen entsteht der Eindruck mimischer Starre und emotionaler Leere. (3) Langfristige Betrachtung führt in eine dritte Phase, in der neue emotionale Pro-

since they stereotype our perception in an impermissible way, in the various editions of the "Merkwürdige Lebensgeschichte" (from 1793 to 1858) and in 19th-century newspaper articles, not only is an attempt made to demonstrate the plausibility of the derisory names in their various redactions, but the authors invariably invent stories about them, just as we ourselves must dream up if the Heads are to remain alive and emotionally significant for us. Which of the busts could demonstrate this more clearly to us than head No. 8 (cat. no 9), which is given the title "Quiet Peaceful Sleep" and, on the grounds of the figure's hair, is to be imagined as "reclining"? The sleep of the figure represented is certainly not at all "gentle and quiet"; on the contrary, the tensions revealed in the contracted brows and in the lips, which are lightly pressed together with a hint of a smile make one think of a lively dream accompanied by many different emotions. Unlike a drawing or painting, this sculpture reveals nothing of the content of the dream to us: we can only replace it with our own imaginings.

This leads yet another position adopted in the 18th-century Laocoön discourse, which Wilhelm Vosskamp has pointed out. In Goethe, sculpture is also given a temporal dimension, for it too is language and the intermediality of the written text can assimilate the beholding process.[26] The emotional impact made by the original "Egyptian Heads" is indeed dependent on the temporal context of their viewing, so that the contradictory interpretations correspond to differing viewing cycles. (1) At first encounter, these Heads tend to induce spontaneous bursts of laughter; one enjoys being photographed with them. (2) In the second phase, after one has lingered a while with them, an impression arises of mimetic rigidity and emotional emptiness. (3) Long-term viewing leads to a third phase, to new emotional projections, which can stem from scholarly reflexions on them or private fantasising and in turn animate the Heads to an extraordinary degree. This is not the place to attempt a psychoanalytically grounded interpretation of these processes. But still, the time spent with works of sculpture can inform further thoughts on them.

jektionen, die aus fachlichen Reflexionen oder privaten Phantasien herrühren können, die Köpfe wiederum außerordentlich beleben. An dieser Stelle soll keine psychoanalytisch informierte Deutung dieser Vorgänge versucht werden, doch die Frage nach der Zeitlichkeit der Betrachtung plastischer Kunst kann weitere Überlegungen leiten.

Mimische Systeme

Wenn zeitgenössische Quellen nur widersprüchlich Auskunft geben, gilt es, die Köpfe selbst nach ihrem affektiven Gehalt zu befragen. Vorausgesetzt wird im Folgenden die Untersuchung ihrer mimischen Ausdrucksmomente mit Hilfe eines Instruments der klinischen Emotionsforschung, des Facial Action Coding Systems, das die tausendfachen Möglichkeiten menschlicher Gesichtsbewegungen auf anatomischer Grundlage in 44 Bewegungseinheiten auflöst.[27] Damit verbunden sind Regeln für deren Auftreten in Kombinationen und das Erkennen ihrer dabei und je nach Intensität veränderten Erscheinungsweise. Im ersten Schritt liefert bereits die Anwendung dieses Verfahrens Aufschlüsse über den Realismus der sichtbaren Gesichtsbewegungen und deren Übereinstimmung mit der natürlichen Logik der menschlichen Mimik. Grundsätzlich zeigen die Köpfe nur anatomisch identifizierbare und miteinander kombinierbare Bewegungen. Dies jedoch bedeutet nicht, dass den Köpfen zugleich der dokumentarische Status photographischer Momentaufnahmen eingeräumt werden könnte. Denn in der plastischen Formfindung verdichten sich ausgedehnte Vorgänge des Objektstudiums, künstlerische Traditionen und persönliche Ideosynkrasien. Erst der zweite Schritt, die Interpretation, erweist vor dem Hintergrund der Traktate Le Bruns und Parsons' sowie antiker Vorbilder den Bruch Messerschmidts mit konventionellen Ausdrucksformeln. In Verbindung mit den Spuren wissenschaftlich-exakter Beobachtungen belegt dies nachdrücklich das Selbstexperiment vor dem Spiegel, oder als theoretische Möglichkeit, das Studium eines kongenialen Modells.

Einerseits reduziert Messerschmidt die Bewegungen des Stirnmuskels übereinstimmend mit Parsons, der die vielfach gebrochenen Brauenbewegungen bei Le Brun kritisierte und stattdessen behauptete, der Occipito frontalis könne nur insgesamt innerviert werden.[28] Dies führt bei den Köpfen zur Abschaffung der »Laokoon-Formel«: Niemals verwendet Messerschmidt noch zur Stirnmitte gehobene, kontrahierte Brauen. Die Bewegung des Zusammenziehens und Senkens der Brauen, an der andere Muskeln beteiligt sind, bewirkt aber gemeinsam mit Anspannungen der Nase und der Augenlider bei etlichen Köpfen außen herabgezogene Brauen und schräge, nach außen abfallende Augenschlitze, die extremen Ausprägungen der Laokoon-Formel gleichen. Andererseits präsentiert Messerschmidt sehr variationsreich die besondere Plastizität

Mimetic systems

Even though contemporary sources only impart contradictory information, the Heads themselves must be examined in respect of their affective content. In the following, the examination is premised on their mimetic aspects of expression with the aid of an instrument used in clinical emotional research, the Facial Action Coding System (FACS), which covers the thousands of possibilities of human facial actions on the anatomical basis of 44 facial action units.[27] Linked with this system are rules for the incidence of these facial action units in combinations and recognition of the changes that may occur in them depending on the intensity of the emotion thereby expressed. Applying the first step of this procedure already provides insights into the realism of the visible facial actions and their correspondence to the natural logic of human facial expression. Essentially, the Heads only depict actions that can be anatomically identified and combined. This does not, however, mean that the Heads could be allowed the documentary status of photographic snapshots. Extensive processes of studying the object, artistic tradition and personal idiosyncrasies are distilled into the invention of sculptural form. It is the second step, interpretation, that reveals, against the background of Le Brun's and Parsons' treatises, Messerschmidt's break with the formulaic conventions for expression, as well as models from Greco-Roman Antiquity. In connection with the clues observed in scientifically precise observation, this furnishes compelling proof of the artist's experiments on himself in front of the mirror or, as a theoretical possibility, his study of an affirmative model.

On the one hand, Messerschmidt has reduced the actions of the frontalis muscle in concurrence with Parsons, who criticised the many fragmentary eyebrow actions in Le Brun and instead maintained that the cccipito frontalis could only be innervated as a whole.[28] This has led in the Heads to the abolition of the "Laocoön formula": Messerschmidt never uses brows raised and contracted towards the centre of the forehead. The action of contracting and lowering the brows, which involves muscles other than the frontalis, however, causes, in conjunction with the tensions in the nose and eyelids observable in quite a few of

der unteren Gesichtshälfte, zu der horizontale, vertikale und diagonale Komponenten sowie die komplexen Bewegungen des ringförmigen Mundmuskels beitragen. Eine »Codierung« ist wegen des Fehlens eines unbewegten Urmodells dieser Abänderungen nur unter methodischen Vorbehalten möglich, erfordert aber keine Plausibilität aus Sicht der Alltagserfahrung.

Zuweilen wird die Mimik der Köpfe als »unrealistisch« beschrieben; dies übersieht möglicherweise, dass dort extreme und antagonistische, in der Kunst nie zuvor dargestellte Muskelanspannungen erscheinen. Vielmehr bedingt die Übertragung von Beobachtungen am Menschen in artifizielle plastische Formen stets die Entscheidung für bestimmte »plastische Codes« mit niedriger oder höherer Beschreibungsdichte, die den ästhetischen Eindruck zwischen den Polen »Idealität« und »Verismus« bestimmen. Obwohl Messerschmidt in vielen Details offenkundig eine hochgradig realistische Wirkung anstrebte, hat er größere Formen zugleich rigoros stilisiert. So erscheinen die beim starken Herabziehen der Mundwinkel und gleichzeitigen Hochschieben der Unterlippe um die Mundwinkel entstehenden Taschen zwar stets mit rücksichtsloser Präzision geschildert, sind aber bei Kopf Nro. 43 (Kat.-Nr. 15) organisch modelliert und bei Kopf Nro. 30 (Kat.-Nr. 13) vertieft und geometrisch verhärtet.[29] Einen Sonderfall bilden die Nasen, auch wenn dies in einer nasenärztlichen Dissertation[30] nicht vermerkt wurde. Gerümpfte Nasen, bei dreißig von 49 »Charakterköpfen« anzutreffen, sind stets kürzer als unbewegte Nasen; will man annehmen, dass zumindest einigen Büsten jeweils der selbe Kopftyp zugrunde liegt, dann wird die gesamte Nase durch die Rümpfbewegung nach oben gezogen, als sei sie nicht durch Nasenbein und Knorpel verankert. Messerschmidts System der Ausdehnung und Kontraktion überschreitet hier die menschliche Anatomie, bleibt aber in sich logisch: wie alle übrigen Gesichtsteile verändert auch die Nase durch mimische Bewegungen ihre Proportion.

Entschlüsselt man den affektiven Gehalt der gezeigten Bewegungskombinationen mit Hilfe kunsthistorischer Muster und klinischer Modelle, gelangt man zu einem irritierenden Ergebnis. Nur die Zeichen von Ärger und Wut erscheinen, in verschiedenen Abstufungen und Regulierungen, rein und unvermischt an etlichen Köpfen, so an Nro. 22 (Kat.-Nr. 18) und Nro. 38 (Kat.-Nr. 7). Sie gehen bei Nro. 22 mit einer Konstellation im Mundbereich einher, die im Unterschied zu anderen Köpfen keine objektive Unterscheidung zwischen dauerhaften Formen und vorübergehenden Bewegungsspuren mehr erlaubt. Insofern liefert sie Hinweise auf die unter anderen von Parsons und Lavater vertretene, von Lichtenberg jedoch kritisierte Habitualisierungsthese. Die Lesbarkeit eindeutiger Emotionen wird aber zusätzlich dadurch erschwert, dass die Merk-

the Heads, the brows to be lowered on the outside, and the slanting eye-slits to droop outwards in a manner similar to an extreme application of the Laocoön formula. On the other hand, Messerschmidt presents a rich array of variations on the plasticity peculiar to the lower half of the face, to which horizontal, vertical and diagonal components as well as the complex action of the orbicularis (the muscle ringing the mouth) contribute. "Coding" is only possible with methodological reservations because an immobile prototype model of these changes is lacking but it does not require any substantiation of its plausibility from the standpoint of everyday experience.

The facial expression of these Heads has occasionally been described as "unrealistic"; this interpretation may possibly overlook the circumstance that in them extreme and antagonistic muscle contractions have been depicted that had never before been represented in the visual arts. On the contrary, the translation of observation made on human beings into artificial sculptural forms always presupposes a decision to use particular "sculptural codes" with greater or lesser descriptive density, which determine the aesthetic impression on the continuum between the extremes of "idealism" and "verism'. Although Messerschmidt evidently strove for a high degree of realistic effect in many details, he nonetheless rigorously stylised larger forms. Consequently, the sacs appearing around the corners of the mouth when the latter are emphatically depressed while at the same time the lower lip is raised are always represented with ruthless precision, but in head no. 43 (cat. no 15) they are organically modelled yet in head no. 30 (cat. no 13) deepened and geometrically hardened.[29] The noses are a special case, even though this was not noticed in a rhinological dissertation.[30] Wrinkled noses, occurring in 30 of the 49 Character Heads, are always shorter than noses that are motionless. Should one wish to assume that at least several of the busts derived from the same head type, the whole nose is pulled upwards by the action of wrinkling, as if it were not anchored by the nasal bone and cartilage. Messerschmidt's system of relaxation and contraction here infringes human anatomy, yet nonetheless remains coherent: like all other parts of the face,

male weiterer Affekte wie Überraschung, Angst und Verachtung nur in der oberen oder unteren Gesichtshälfte erscheinen. Freude und Ekel wiederum sind entweder mit Ärger vermischt oder in eine große Zahl weiterer Bewegungen eingebunden.

An dem stets als »lachendes Selbstporträt« angesprochenen Kopf Nro.1 (Kat.-Nr. 4) finden sich alle Kennzeichen des Lachens und spontanen Lächelns. Gehobene Wangen lassen mit äußerster Penetranz dargestellte Krähenfüße entstehen, auf eine zusätzliche Anspannung des Unterlids deutet freilich die von Faltengraten durchfurchte Augenpartie hin. Nicht mit Freude oder befreitem Lachen zu vereinbaren ist das Zusammenziehen und Senken der Brauen. Von entscheidender Bedeutung für das von Kris bemerkte mutmaßlich psychotische Moment, das Fehlen einer emotionaler Schwingung,[31] erweist sich jedoch die Hebung der Mundwinkel im Verhältnis zur Verformung von Wangen und Nasolabialfalten. Zwar ist die Oberlippe insgesamt weit angehoben, die Mundwinkel biegen jedoch nach unten. Nun muss man einräumen, dass es der Kunstgeschichte an Beispielen wenig geglückten Lachens nicht mangelt, und simuliertes Lachen lässt sich wohl kaum für Studienzwecke still stellen.[32] Doch für solche Dissonanzen ist man in einer Zeit obligatorischen Lächelns auf Wahlplakaten und Titelblättern wohl weniger sensibilisiert als im ausgehenden 18. Jahrhundert. Im Lachen der Büste Messerschmidts manifestieren sich Symptome der gegenläufigen, die Mundwinkel abwärts ziehenden Aktion des Triangularis – jenes Muskels, den Kabarettisten gewöhnlich einsetzen, um den mimischen Habitus der derzeitigen Bundeskanzlerin zu parodieren. Morphologisch kommt aufgrund der Brauenkomponente nur eine Beimengung von Wut oder Ärger in Frage, das Lachen erhält somit eine hämische Note. Gleichwohl dieses aggressive Moment an den implizierten Betrachter adressiert ist, bleibt es versteckt und ist in einem Abguss der Büste sogar »entschärft« worden.[33] Statt dessen lässt die veränderte Synchronisierung von Mund, Wangen und Augen zuallererst auf die Performanz, die vorgeführte Intentionalität dieses Lachens schließen. Damit rückt es in die Tradition von Philosophen- und Künstlerporträts in der Rolle des lachenden Demokrit, die etwa auch für das berühmte Altersselbstbildnis Rembrandts in Köln erwogen worden ist. In engerer Beziehung zu den »Egyptischen Köpfen« stehen Werke des 1770 sehr wahrscheinlich mit Messerschmidt zusammengetroffenen Malers Joseph Ducreux (1735–1802).[34] Dieser schuf ab 1780 mehrere lachende Selbstbildnisse, die den demokritischen Spott nicht nur mit traditionellen gestischen Mitteln, sondern auch durch betont aggressives Zähnezeigen verdeutlichen (Abb. 109).

Während das »lachende Selbstporträt« eine Überblendung zweier kohärenter, obere und untere Gesichtshälfte erfassender

the nose, too, changes its proportions through mimetic action.

If one decodes the affective content of the facial action combinations shown by means of art-historical patterns and clinical models, one arrives at a disturbing conclusion. Only the signs of annoyance and anger appear pure and unadulterated in various degrees of intensity and control in some Heads, such as no. 22 (cat. no 18) and no. 38 (cat. no 7). In no. 22 they coincide with a constellation in the mouth area which, unlike that of other Heads, does not allow for an objective distinction to be made between permanent forms and traces of fleeting action. In so far, this constellation points *inter alia* to the habitualisation theory advocated by Parsons and Lavater but criticised by Lichtenberg. However, reading emotions as unequivocal is made even more difficult because the semantic markers of other emotions such as surprise, anxiety and contempt only appear in either the upper or lower half of the face. Joy and disgust, on the other hand, are either mingled with annoyance or tied into a large number of other facial actions.

All the marks of laughter and spontaneous smiling occur in head no. 1, which is always designated "The Artist as He Imagined Himself Laughing" (cat. no 4). Raised cheeks can cause crow's feet to appear with extreme immediacy. Admittedly, the orbicular zone being furrowed with raised wrinkles suggests additional contraction of the lower eyelid. The contraction and lowering of the brows are not reconcilable with joy or liberating laughter. However, the lifting of the corners of the mouth correlated with the deformation of the cheeks and nasolabial folds proves to be of crucial importance for the aspect noted by Kris and presumed psychotic.[31] The upper lip is, on the whole, raised high but the corners of the mouth now droop. Now it must be conceded that there is no lack of successfully represented laughter in art and simulated laughter can hardly stand still for the purpose of study.[32] However, in an era of compulsory smiling on election posters and magazine covers, the public is probably less sensitised to such dissonances than it was in the late 18th century. In the laughter depicted in Messerschmidt's busts, symptoms appear in the countervailing action by the triangularis of

109 Joseph Ducreux,
Selbstbildnis als
Demokrit, nach 1780,
Öl auf Leinwand,
Musée du Louvre, Paris,
Inv.-Nr. RF 2261
Joseph Ducreux,
Self-Portrait as Demo-
critus, after 1780,
oil on canvas,
Musée du Louvre, Paris,
Inv. no. RF 2261

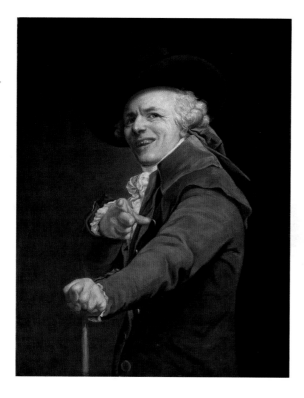

depressing the corners of the mouth – the triangularis is the muscle usually set in motion by present-day German cabaret artistes to parody the facial habits of the incumbent lady Chancellor. Morphologically speaking, the only possible emotion is an admixture of anger or annoyance, which lends the smile overtones of malice. Although this aggressive aspect is addressed to the implied viewer, it remains latent and has even been "defused".[33] Instead the thus altered synchronisation of mouth, cheeks and eyes allows conclusions to be drawn on the performance character, the voluntary character, displayed in this smile. This places it in the tradition of the philosopher and artist portraits in the role of the laughing Democritus, which has also been mooted for the celebrated self-portrait of Rembrandt at an advanced age in Cologne. Works by Joseph Ducreux (1735–1802), who is highly likely to have encountered Messerschmidt in 1770, are probably more closely related to the "Egyptian Heads".[34] Ducreux executed several laughing self-portraits from 1780, which not only illustrate the derision of Democritus with the traditional gestural devices but also by means of an aggressive show of clenched teeth (fig. 109).

Whereas the Messerschmidt "The Artist as He Imagined Himself Laughing" reveals the overlapping of two emotions in the coherent interplay of the upper and lower halves of the face, most of the other Heads are notable for the expressive discrepancy between the two halves of the face. One might ascribe surprise or fear to heads nos. 16 (cat. no. 19) and 26 (cat. no. 20), with brows raised inside and out and eyes wide open – but not to head no. 9 (cat. no. 17), in which only the lower eyelid is contracted. In Head no. 16 these components contrast with a constellation of the lips which is identical with the historical patterns for grief and despair as well as the clinical paradigm for the anger in in Le Brun's "Le Désespoir" (fig. 110). The same vertical facial actions affect the mouth of no. 26, yet here the lips are not parted and everted but rather compressed and funnelled inward. This suggests annoyance above all. In a further sequence, the "open" upper half of the face in no. 12 (fig. 111) has been replaced by a "closed" variant, which is morphologically identical to the upper halves of no. 34

Affekte aufweist, kommt es bei der Mehrzahl der Köpfe zu expressiven Brüchen zwischen den Gesichtshälften. Den Köpfen Nro. 16 (Kat.-Nr. 19) und 26 (Kat.-Nr. 20) mit innen und außen gehobenen Brauen und aufgerissenen Augen – nicht aber dem Kopf Nro. 9 (Kat.-Nr. 17), bei dem nur das untere Augenlid angespannt ist – könnte man Überraschung oder Angst zuschreiben. Bei Nro. 16 steht diesen Komponenten aber eine Lippenkonstellation gegenüber, die den historischen Mustern für Trauer und Verzweiflung, aber auch dem klinischen Paradigma für die in Le Bruns »Le Désespoir« (Abb. 110) enthaltene Wut gleichen. Auf den Mund von Nro. 26 wirken die gleichen vertikalen Aktionen ein, doch hier sind die Lippen nicht geöffnet und nach außen gestülpt, sondern zusammengepresst und einwärts gerollt. Dies deutet vor allem auf Ärger hin. In einer weiteren Folge ist die »offene« obere Gesichtshälfte bei Nro. 12 (Abb. 111) durch eine »geschlossene« Variante ersetzt, die morphologisch den oberen Hälften von Nro. 34 (Kat.-Nr. 21) und weiteren Köpfen gleicht. Gemeinsam mit der Nasenbewegung entsteht dort jeweils eine Kombination heftiger Muskelanspannungen, die keine eindeutige Decodierung erlaubt. Symptome verschiedener negativer Affekte sind hier verdichtet, und die in unterschiedlichen Graden angewinkelten Augenschlitze bilden Merkmale der Laokoon-Formel nach. Einzig die Nasenbewegung könnte wegen ihres bereits im 18. Jahrhundert bemerkten Auftretens beim Lachen,[35] mehr noch

110 Jean Audran (nach Charles Le Brun), Le Désespoir, Kupferstich, 1727
Jean Audran (after Charles Le Brun), Despair, copperplate engraving, 1727

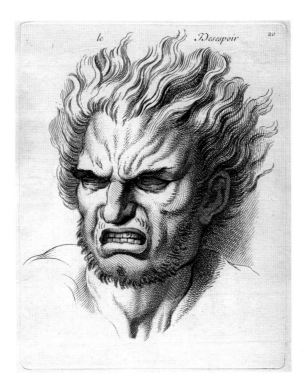

aber wegen ihres Vorkommens bei einem Großteil der Köpfe womöglich ganz anders verstanden werden: etwa im Sinne eines universalen Begehrens oder aber einer übernatürlichen, nach innen gerichteten Sinneswahrnehmung.

Sehr häufig treten an den Köpfen Kontrollbewegungen auf, die Affekte dämpfen und unterdrücken (wie bei Nro. 38, Kat.-Nr. 7) oder verbergen sollen. Dem Hochschieben der Unterlippe und dem von Nicolai umgedeuteten Einziehen der Lippen begegnet man heute in den Medienbildern öffentlicher Personen; dass solche Photographien meist im Zusammenhang mit Rücktritten oder der Aufdeckung von Haushaltsdefiziten und Fehlmanagement erscheinen, dürfte auch einer bestimmten Bildpolitik geschuldet sein. Resümierend ließe sich sagen, dass die »Egyptischen Köpfe« das Innere ebenso zeigen, wie sie es verbergen. Wollte Nicolai den verborgenen Spieler der Kempelen'schen Schachmaschine ans Licht der Öffentlichkeit bringen, so ging es Messerschmidt, darin keinesfalls im Widerspruch zu Lichtenberg, um die Abgrenzung eines Bereichs privater Innerlichkeit. Mit Vosskamp kann man von einem »Trug der Skulptur« sprechen,[36] der im psychoanalytischen Bildbegriff Jacques Lacans so formuliert wird: »Generell ist das Verhältnis des Blicks zu dem, was man sehen möchte, ein Verhältnis des Trugs. Das Subjekt stellt sich als etwas anderes dar, als es ist, und was man ihm zu sehen gibt, ist nicht, was es zu sehen wünscht.«[37]

(cat. no 21) and other Heads. Together with the nasal action, a combination of strong muscular contractions arises there, which does not permit unequivocal coding. Symptoms of various negative emotions are here condensed and the eyes, reduced to slits to varying degrees, replicate semantic markers of the Laocoön formula. Only the nasal action might possibly be entirely differently interpreted because it has already emerged in connexion with laughter in the 18th century[35] but even more so because it occurs in the majority of Messerschmidt Heads: rather in the sense of universal desire or, alternatively, of an inward-directed sensory perception of the supernatural.

Controlling actions occur very frequently in the Heads, which subdue or suppress emotions (as in no. 38, cat. no. 7) or even conceal them. The upward thrust of the lower lip and the retraction of the lips re-interpreted by Nicolai are still encountered today in media images of people in public life. That such photographs are usually published in connexion with resignations or the revelation of budget deficits and mismanagement could well also be due to a particular pictorial policy. To sum up, it might be said that the "Egyptian Heads" both reveal and conceal what is going on inside. Nicolai wanted to bring the Kempelen chess automaton out in the open whereas Messerschmidt, and in this he does not at all oppose Lichtenberg, was concerned with demarcating a sphere of inner privacy. With Vosskamp, one can speak of "sculpture as deception", [36] which is formulated as follows in Jacques Lacan's psychoanalytical definition of the image: "In general the relationship of the image to what one would like to see is a deceptive relationship. The subject represents himself as something other than he is and what one thinks one is seeing in it is not what one wants to see."[37]

Body and soul

Even though the face has become the sole field of expression for the psyche, reduction to the head should not just be interpreted in the sense of psychological realism. This reduction cannot mean the same as dissociation of body and mind since the altered psychological topography, the transposition of the functions of "breast" and "heart" to the mind, broke

111 Franz Xaver Messer-
schmidt, Kopf Nro. 12
(Der Nieser), Original
nach 1770, Gipsabguss,
Österreichische Galerie
Belvedere, Wien,
Inv.-Nr. 5683
*Franz Xaver Messer-
schmidt, Head no. 12
(The Sneezer), original
after 1770, plaster cast,
Österreichische Galerie
Belvedere, Vienna,
Inv. no. 5683*

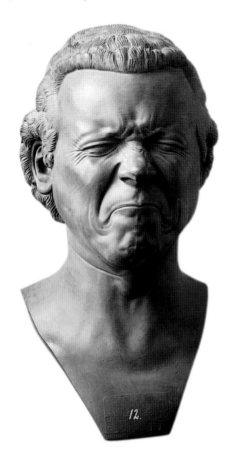

Leib und Seele

Wenn das Gesicht zum exklusiven Ausdrucksfeld des Seelischen
wird, sollte die Reduktion auf den Kopf nicht nur im Sinne eines
psychologischen Realismus verstanden werden. Sie kann nicht mit
einer Trennung von Körper und Geist gleichbedeutend sein, denn
die veränderte Topographie des Seelischen, die Verlagerung der
Funktionen von »Brust« und »Herz« in das Gehirn bereitete dessen
materialistische Durchleuchtung durch die Phrenologen[38] vor und
leistete pseudowissenschaftlichen Rückschlüssen im Un-Geist der
Schädellehre Lavaters Vorschub. Obwohl die heutige Neurowissen-
schaft in manchen Auslassungen zum »freien Willen« bezüglich des
Leib-Seele-Problems zum Diskussionsstand des 17. Jahrhunderts
zurückzukehren scheint, stellte bereits das Denken der Spätaufklä-
rung den Cartesianischen Dualismus in Frage. Für die Köpfe Mes-
serschmidts gilt dies umso mehr, wenn der vermeintlich abgeschnit-
tene oder, wie Berninis Büsten der »Anima Beata« und der »Anima
Dannata« (Abb. 74), zum Seelenporträt entmaterialisierte Leib über
den Schmerz und über die Emotion des Ekels in aufdringlicher
Weise zurückkehrt und geradezu über-präsent wird. In dieser Per-
spektive macht das von Nicolai beschriebene System des Rippen-

the ground for the materialist study of the mind by
the phrenologists[38] and promoted pseudo-scientific
conclusions to be drawn in the unsavoury spirit of
Lavater's teachings on the skull. Although the neurol-
ogy of today to be returning to the state of 17th-cen-
tury discourse in some outpourings on "free will" in
connexion with the body-soul problem, the thinking
of the late Enlightenment already questioned Carte-
sian dualism. This holds all the more for Messer-
schmidt's Heads if the apparently cut-off body or, like
the Bernini busts of the "Anima Beata" and the "Anima
Dannata" (fig. 74), a body dematerialised to being a
portrait of the soul obtrusively returns via pain and
the emotion of disgust and becomes what can only be
termed excessively present. Viewed thus, Messer-
schmidt's system of pinching the ribs and thighs to
evoke a certain "proportion" in the face, as described
by Nicolai, certainly makes sense. Unspeakable pain
and unspeakable lust – both have been perceived in
these Heads. Indeed heads nos. 30 (cat. no. 13), 33
(cat. no. 10), 34 (cat. no. 21) and 5 (cat. no. 12), in
that order, do reveal some empirically observed and
sequentially emerging components of facial action
demonstrating pain.[39]

In the majority of the Heads, the action most
characteristic of disgust, wrinkling the nose, is imme-
diately apparent. No matter whether this addresses
the sense of smell, which, as the opposite of visually-
oriented enlightenment, allows no detachment, or
whether intellectualised, even moralising, disgust is
meant, perception of the body and not least demarca-
tion from a rejected "other" by means of bodily
metaphors invariably play a role. How strongly the
busts address even a subconscious physical aspect is
shown in the ascription of "Constipation" to head
no. 30 (cat. no. 13): the mouth itself is stopped up by
a rectangular object that does not belong there. In
heads no. 18[40] and no. 47 (cat. no. 14), even this
object – which is definitely not a Mesmer magnet[41] –
is demonstratively concealed. Even the author of the
derisory names had projected the blockage on to the
mind in those Heads and thought of a "morose" dis-
position or "resentment buried deep". Now there can
be no doubt that subconscious, subjectively inaccessi-
ble emotions can in turn produce somatic symptoms.

und Schenkelkneifens, um jeweils eine gewisse »Proportion« im Gesicht hervorzurufen, durchaus Sinn. Unsagbaren Schmerz und unsagbare Lust – beides hat man an den Köpfen schon wahrgenommen. Tatsächlich weisen etwa die Köpfe Nro. 30 (Kat.-Nr. 13), 33 (Kat.-Nr. 10), 34 (Kat.-Nr. 21) und 5 (Kat.-Nr. 12), in dieser Reihung, einige empirische, sequentiell auftretende Komponenten mimischen Schmerzverhaltens auf.[39]

Bei der Mehrzahl der Köpfe fällt die charakteristischste Aktion des Ekels, das Naserümpfen, sofort ins Auge. Ob dies auf den Geruchssinn zielt, der als Widerpart zur visuell orientierten Aufklärung keine Distanz erlaubt, oder intellektualisierter, auch moralischer Ekel gemeint ist, stets spielt Körperwahrnehmung und nicht zuletzt die Abgrenzung von einem abgelehnten Anderen durch körperliche Metaphern eine Rolle. Wie sehr die Büsten auch an unbewusst Körperliches appellieren, zeigt etwa die Zuweisung einer »Verstopfung« an den Kopf Nro. 30 (Kat.-Nr. 13): Von einem rechteckigen Fremdkörper verstopft ist hier ja der Mund. Bei den Köpfen Nro. 18[40] und Nro. 47 (Kat.-Nr. 14) wird selbst dieser Gegenstand – sicherlich kein mesmeristischer Magnet[41] – augenscheinlich verbogen. Immerhin hat der Autor der Spottnamen die Blockade in diesen Fällen mentalisiert und an ein »finsteres« Gemüt beziehungsweise »tief verschlossenen Gram« gedacht. Nun besteht kein Zweifel, dass unbewusste, subjektiv unzugängliche Emotionen wiederum somatische Symptome hervorbringen können. In letzter Konsequenz ist zwar wenig wahrscheinlich, dass der Urheber der Köpfe den Materialismus eines La Mettrie teilte; sein kaum zu bestreitender Geisterglaube setzt vielmehr dualistische Vorstellungen wie jene Emmanuel Swedenborgs voraus, wonach jeder Mensch im Innern ein Geist sei. Gehören die aus Selbstbeobachtungen bekannten Phänomene des Unbewussten jedoch einer dunklen Natur an, die sich immer wieder entzieht, so genügen bereits Vorstellungen des Mesmerismus, um die strikte Trennung zwischen geistigem Bewusstsein und körperlicher Dingwelt aufzuheben.

Clowneske Momente

Zur humoristischen Wirkung einiger Köpfe trägt ein clowneskes Moment zweifellos bei. Gewöhnlich gehen die mimischen Signale des Clowns nicht von natürlichen Gesichtsbewegungen aus; Augenumrahmungen, breit gezogene Nasolabiallinien und nach oben gebogene Mundwinkel sind vielmehr breit aufgeschminkt. Die feineren Zeichen der Augen und Lippen, Spuren der Person unter der Maske, vermag die Maskerade jedoch nicht völlig zu überdecken. Gerät die Illusion ins Wanken, in Momenten der Krise, bricht diese Spannung hervor. Vergleichbare expressive Überlagerungen kennzeichnen nicht erst die bekannten Photoübermalungen Arnulf Rai-

Ultimately, however, it is not likely that the creator of the Heads shared the materialism of a La Mettrie. On the contrary, Messerschmidt's undeniable belief in spirits presupposes dualistic ideas such as those of Emmanuel Swedenborg, according to which every person is a spirit within. Should, however, subconscious phenomena known from observations of the self be of a darker nature, which always evades detection, even notions of Mesmerism suffice to cancel out the strict demarcation between spiritual awareness and a physical, bodily world.

Clownish aspects

A clownish aspect undoubtedly contributes to the comical impression made by some of the Heads. Usually the mimetic signals of the clown do not emanate from natural facial actions. Instead, framing of the eyes, broadly drawn nasolabial lines and drawn-up corners of the mouth are rendered in coarse make-up. Even so, the masquerade does not entirely conceal the finer signs of eyes and lips, traces of the person beneath the mask. Should the illusion start to waver, in critical moments, this tension is exposed. Arnulf Rainer's well-known overpaintings of photos are not the first comparable examples of expressive overlayering – they have been prefigured, especially in the Heads designated "A Know-it-All Quibbling Quipster" (no. 3), "Wags" (nos. 35 and 37, figs. 62, 63) and "The Satirist" (no. 26, cat. no. 20), which have attracted interpretations of malice or schadenfreude (no. 33, cat. no. 10) or create the subjective impression of a sly smile[42] (no. 33, cat. no. 10). As in a clown, the natural contours of the lips are invisible and between the horizontally stretched nasolabial folds and the mouth reduced to a line by the lips being sucked in and compressed, a discrepancy is created which is even enhanced by the little dimples and folds created around the mouth by countervailing facial actions. If the upper half of the face is added, the plausibly and coherently represented symptoms of controlled joy in the case of heads no. 44 and no. 33 (cat. no. 10) are counteracted by being correlated with disgust, annoyance, disdain and possibly grief. Not until one submits to the implicit stage-direction of the lowered head of no. 33 and kneels down to

ners – bereits zu eigen sind sie insbesondere jenen Köpfen, die als »Spötter« (Nro. 3), »Schalksnarren« (Nro. 35 und 37, Abb. 62, 63) oder »Satirikus« (Nro. 26, Kat.-Nr. 20) bezeichnet wurden, die Zuschreibung von Bosheit (Nro. 33, Kat.-Nr. 10) oder Schadenfreude auf sich gezogen haben oder subjektiv den Eindruck eines verschmitzten Lächelns[42] (Nro. 33, Kat.-Nr. 10) erwecken. Wie beim Clown sind die natürlichen Konturen der Lippen unsichtbar, und zwischen horizontal gedehnten Nasolabialfalten und dem durch Einrollen und Zusammenpressen der Lippen auf einen Strich reduzierten Mund entsteht eine Diskrepanz, die durch kleine Grübchen und Wülste, die infolge antagonistischer Bewegungen um den Mund herum entstehen, noch verstärkt wird. Zieht man die obere Gesichtshälfte hinzu, so werden die plausibel und kohärent dargestellten Symptome kontrollierter Freude im Fall der Köpfe Nro. 44 und Nro. 33 (Kat.- Nr. 10) durch Korrelate von Ekel, Ärger, Verachtung und möglicherweise Trauer konterkariert. Erst wer sich auf die implizite Regieanweisung des gesenkten Kopfs Nro. 33 einlässt und in die Knie geht, um das Gesicht frontal zu betrachten, ist dieser negativen Emotionalität vollständig ausgesetzt.

Es ist ihre Unbestimmtheit, die in der Brüchigkeit mimischer Zeichen kondensierte Ambiguität der Clownsfigur, die sie für postmoderne Künstlerinnen und Künstler von Cindy Sherman und Jeff Wall bis Ugo Rondinone attraktiv macht. Das im 20. Jahrhundert vorherrschend gewordene Paradigma des Ausdrucks als Brechung vorgefundener Codes lässt die Köpfe Messerschmidts seit vielen Jahrzehnten als zeitgenössisch erscheinen, so dass auch die aufgerissene Oberfläche des unvollendeten Stuttgarter Kopfes (Kat.-Nr. 11) nun an expressive Notate inneren Erlebens und die Verarbeitung extremer Erfahrungen denken lässt.[43] Aus einer Krise des Ausdrucks wäre somit ein Symbol existentieller Krisenerfahrung entstanden.

observe the face frontally, is one entirely exposed to this negative blast of emotion.

It is the indeterminate character of the clown figure, its ambiguity condensed in fragmentary mimetic signs, that have made it so appealing to Postmodern artists from Cindy Sherman and Jeff Wall to Ugo Rondinone. The paradigm of expression as breaking existing codes that became prevalent in the 20th century has for decades now made Messerschmidt's Heads appear contemporary. As a result, the roughened surface of the unfinished Stuttgart Head (cat. no 11) makes one think of an expressive notation of the inner life and the working through of extreme experiences.[43] A symbol of existential experience of crisis would thus have arisen from a crisis of expression.

1 Zur Topographie siehe Keleti 2002, S. 100.

2 Während Messerschmidt in den Briefen der Jahre 1776–1777 nur von Köpfen oder Kopf-Stücken spricht (Pötzl-Malíková 1982, S. 133–134, Dokumente XXII und XXIV), ist in zwei 1783 erschienenen Quellen von »Egyptischen Köpfen« die Rede. Dies kann stilistisch auf die ägyptisierende strenge Achsensymmetrie der Köpfe und inhaltlich auf ihre den Hieroglyphen gleichende Rätselhaftigkeit bezogen werden.

3 Zur Auffindung nach dem Tod des Künstlers siehe das Nachlassverzeichnis bei Pötzl-Malíková 1996, S. 220–222, hier 220–221. (Wiederabdruck in Ausst.-Kat. Messerschmidt 2002, S. 291).

4 Siehe Pötzl-Malíková 1996, S. 215–217; zur Begegnung mit Nicolai siehe Pfarr 2006, S. 47–99.

5 Siehe Gampp 1998, besonders S. 22–26, 34.

6 Die 49 im 19. Jahrhundert als »Charakterköpfe« ausgestellten Büsten werden hier nach ihrer im Werkkatalog (Pötzl-Malíková 1982) rekonstruierten Nummerierung zitiert, die auf der »Merkwürdigen Lebensgeschichte« (Anonymus 1794) beruht. Nur die Metallbüsten tragen rechts am Sockel

1 On the topography see Keleti 2002, p. 100.

2 Whereas Messerschmidt only speaks of Heads or head pieces in his letters of 1776–1777 (Pötzl-Malíková 1982, pp. 133-134, Documents XXII and XXIV), two sources from 1783 speak of "Egyptian Heads". This can refer stylistically to the Egyptianising, astringent axial symmetry of the Heads and, respecting content, to the enigmatic quality that makes them like hieroglyphs.

3 On its discovery after the artist's death, see the estate inventory in Pötzl-Malíková 1996, pp. 220ff. (reproduced in exhib. cat. Messerschmidt 2002, p. 291).

4 See Pötzl-Malíková 1996, pp. 215ff.; on Messerschmidt's encounter with Nicolai, see Pfarr 2006, pp. 47–99.

5 See Gampp 1998, especially pp. 22–26, 34.

6 The 49 busts exhibited in the 19th century as "Character Heads" are here quoted after the numbering reconstructed in the catalogue of works (Pötzl-Malíková 1982), which is based on the "Merkwürdige Lebensgeschichte" (Anon. 1794). Only the metal busts bear numerals hewn into the bases on the right. It is not known whether Messerschmidt himself numbered the Heads.

7 Nicolai Reprint 1994, p. 414.

8 Sulzer 1771, p. 105: "[…] mere shadows are transformed through the magic of expression into thinking and feeling beings. Without this artifice a painted and carved image is a dreary form [...]; through it it becomes an acting being, with which we share our hearts."

9 See Pfarr 2006, pp. 327–338. Unfortunately, the relevant Messerschmidt works have been lost.

10 Kris 1932, pp. 189–192, 206; see Pfarr 2006, p. 46.

11 Meusel 1778. Although, as attested by Messerschmidt's letters, at least six new Heads were produced, Meusel reveals himself to be well informed in the matter by mentioning the "religion" busts.

12 Scheyb, who borrowed this aspect from French art theory, saw two solutions here: in "Köremon" (Scheyb 1770,

eingeschlagene Ziffern. Ob Messerschmidt selbst die Köpfe schon nummeriert hat, ist nicht bekannt.

7 Nicolai Reprint 1994, S. 414.

8 Sulzer 1771, S. 105: »[...] bloße Schatten werden durch die Zauberey des Ausdruks in denkende und empfindende Wesen verwandelt. Ohne diese Kunst ist ein gemahltes und geschnitztes Bild eine öde Form [...]; durch sie wird es zu einem handelnden Wesen, mit dem wir unser Herz theilen.«

9 Siehe Pfarr 2006, S. 327–338. Leider sind die betreffenden Werke Messerschmidts verschollen.

10 Kris 1932, besonders S. 189–192, 206; siehe Pfarr 2006, S. 46.

11 Meusel 1778. Zwar sind in München ausweislich der Briefe Messerschmidts mindestens sechs neue Köpfe entstanden, mit der Erwähnung der Büste der »Religion« zeigt sich Meusel aber sachlich gut informiert.

12 Scheyb, der diesen Aspekt der französischen Kunsttheorie entnahm, sah hier zwei Auswege vor: im »Köremon« (Scheyb 1770, Bd. 2, S. 123) rät er, bei antiken Vorbildern Zuflucht zu nehmen, im »Orestrio« (Scheyb 1774, Bd. 1, S. 181, 186) empfiehlt er, die Affekte in der Natur zu beobachten. Siehe auch Kirchner 1991, besonders S. 242–243.

13 Das 1989 beim Transart Communication Festival in Nové Zámky aufgezeichnete Video zeigt Kordoš' Vortrag über Messerschmidt, die Diaprojektion von Werken, die Vorbereitung der Performance und Kordoš' »Live-Interpretation« der Köpfe.

14 Siehe Schneider 1993.

15 Dies wurde schon öfters beschrieben, siehe etwa Bücherl 1989.

16 Lichtenberg 1778/1986; siehe Košenina 1995, besonders S. 94–116.

17 Gampp 1998, S. 24; Bückling 1999a, S. 74; Kammel 2004, S. 139.

18 Grevers 1997.

19 Behr / Grohmann / Hagedorn 1983.

20 Anonymus 1794, S. 42–69.

21 Tekusch 1785.

22 Sulzer 1771, S. 427–430.

23 Siehe Mraz/Schlögl 1999.

24 Gebauer 2003, S. 239–242; siehe Pfarr 2003b, S. 32.

25 Siehe Frijda 1996.

26 Vosskamp 2003.

27 Siehe allgemein Ekman 1988; Ekman 2004, S. 19–20, 50–51.

28 Parsons 1747, S. ii, 62.

29 Zu den Hintergründen der hier wirksamen aggressiven Impulse siehe Pfarr 2004, S. 9–15.

30 Siehe Grevers 1997.

31 Kris 1932, S. 192.

32 Daran lassen die Theorien des 18. Jahrhunderts kaum Zweifel; siehe Pfarr 2006, S. 161–165.

33 Siehe Pfarr 2006, S. 187.

34 Dazu siehe Denk 1998, S. 197–199.

35 Parsons 1747, S. 73.

36 Vosskamp 2003, S. 163: »Goethe se dérobe par la littérature au 'leurre' de la sculpture, pourrait-on dire, selon la formule de Jacques Lacan.«

37 Lacan 1964, Seminar 4. März 1964, S. 111.

38 Siehe etwa Krapf, Leben und Werk 2002, S. 19.

39 Siehe Pfarr 2006, S. 279–282.

40 Siehe Scherf 2005.

41 Mesmers Auftritt vor der Akademie in München setzte voraus, dass er sich bereits Anfang 1775 wieder von den seit 1774 eingesetzten Heilmagneten distanzierte; siehe Pfarr 2006, S. 70.

42 Bückling 1999b, S. 116.

43 Siehe Zoege von Manteuffel 1984, S. 456–457; Pfarr 2006, S. 365–381.

Vol. 2, p. 123) he advises resorting to ancient models; in "Orestrio" (Scheyb 1774, Vol. 1, p. 181, p. 186) he recommends observing the emotions from nature. See also Kirchner 1991, especially pp. 242f.

13 The video, recorded in 1989 at the Transart Communication Festival in Nové Zámky, shows Kordoš's lecture on Messerschmidt, the slide show of works, the preparation for the Performance and Kordoš's "live interpretation" of the Heads.

14 See Schneider 1993.

15 This has often been described; see for instance Bücherl 1989.

16 Lichtenberg 1778/1986; see Košenina 1995, especially pp. 94–116.

17 Gampp 1998, p. 24; Bückling 1999a, p. 74; Kammel 2004, p. 139.

18 Grevers 1997.

19 Behr / Grohmann / Hagedorn 1983.

20 Anon. 1794, pp. 42–69.

21 Tekusch 1785.

22 Sulzer 1771, pp. 427–430.

23 See Mraz/Schlögl 1999.

24 Gebauer 2003, pp. 239–242; see Pfarr 2003b, p. 32.

25 See Frijda 1996.

26 Vosskamp 2003.

27 See in general Ekman 1988; Ekman 2004, pp. 19f., 50f.

28 Parsons 1747, p. ii, 62.

29 On the background of the aggressive urges that come into play here, see Pfarr 2004, pp. 9–15.

30 See Grevers 1997.

31 Kris 1932, p. 192.

32 The 18th-century theories leave hardly any doubts about that; see Pfarr 2006, pp. 161–165.

33 See Pfarr 2006, p. 187.

34 See Denk 1998, pp. 197ff.

35 Parsons 1747, p. 73.

36 Vosskamp 2003, p. 163: "Goethe se dérobe par la littérature au "leurre" de la sculpture, pourrait-on dire, selon la formule de Jacques Lacan." ["Goethe evades via letters the "lure" of sculpture, one might say, according to the formula of Jacques Lacan."]

37 Lacan 1964, Seminar 4 March 1964, p. 111.

38 See for instance Krapf, Leben und Werk 2002, p. 19.

39 See Pfarr 2006, pp. 279–282.

40 See Scherf 2005.

41 Mesmer's appearing at the Munich Academy presupposes that he had by early 1775 again rid himself of the therapeutic magnets used since 1774; see Pfarr 2006, p. 70.

42 Bückling 1999b, p. 116.

43 See Zoege von Manteuffel 1984, pp. 456f.; Pfarr 2006, pp. 365–381.

Anhang
Appendix

Friedrich Nicolai

Beschreibung einer Reise durch Deutschland und die Schweiz im Jahre 1781

Nebst Bemerkungen über Gelehrsamkeit,
Industrie, Religion und Sitten, von Friedrich Nicolai.
Mit Röm. Kaiserl. und Königl. Preuß. Churbrandenb.
allergnädigsten Freiheiten.
Berlin und Stettin 1785
Sechster Band, Kleine Nebenreise nach Ungarn

Unter den bildenden Künstlern sind drey Kupferstecher, Joh. Mich. Landerer, J. S. Paczko, und M. Weinmann. Der merkwürdigste Künstler war ganz unstreitig der nachher, im Auguste 1783, im 51ten Jahre seines Alters verstorbene Bildhauer Franz Xaver Messerschmidt[1], aus Wiesensteig in Schwaben unweit Dillingen gebürtig. Dieser Mann ist als Künstler und als Mensch gleich merkwürdig. Er war ein Mann von ungemeiner Stärke des Geistes und des Leibes. In seiner Kunst ein außerordentliches Genie; im gemeinen Leben ein wenig zur Sonderbarkeit geneigt, welches hauptsächlich aus seiner Liebe zur Unabhängigkeit entstand. Er wollte wenige Bedürfnisse haben, liebte nichts außer seiner Kunst, und hatte in derselben alles sich selbst zu danken. Er besaß eine sehr lebhafte Imagination, und eine sehr leichte Hand (faire), mit der er alles sehr behende ausführte, was er dachte. So studirte er bloß die Natur, fast ohne einige Anweisung; und, nachdem er sich in verschiedenen Städten des südlichen Deutschlandes herumgetrieben hatte, ging er in seinem 33ten Jahre (1765) nach Rom, wo er, wie ich von Künstlern weiß, die mit ihm zu gleicher Zeit daselbst waren, die Aufmerksamkeit aller dort studirenden Artisten erregte und die Freundschaft der vorzüglichsten unter ihnen sich erwarb. Seine Sonderbarkeit verließ

Description of a Journey through Germany and Switzerland in the Year 1781

With Observations on Learning, Industriousness, Religion and Mores, by Friedrich Nicolai
With freedoms graciously granted by His Roman Imperial Majesty and His Royal Prussian Majesty the Elector of Brandenburg. Berlin and Stettin 1785
Volume six, A Short Diversion to Hungary

Among the artisans are three copperplate engravers, Joh. Mich. Landerer, J. S. Paczko, and M. Weinmann. The most remarkable artist was, undeniably, the sculptor Franz Xaver Messerschmidt, who afterwards died in August 1783, in the fifty-first year of his life,[1] a native of Wiesensteig near Dillingen in Swabia. This man was equally remarkable as an artist and a person. He was a man of unusual strength of intellect and body. In his art an extraordinary genius, in common life rather inclining to eccentricity, which came about mainly from his love of independence. He claimed to have few needs, loved nothing apart from his art and in that owed everything to himself. He possessed a very lively imagination and a very deft hand, with which he executed everything he thought very rapidly. Consequently, he studied nature only, virtually without any instruction; and, after roaming about in various cities of southern Germany, went in his thirty-third year (1765) to Rome, where he attracted the attention of all artists studying there and acquired the friendship of the best among them. His eccentricity, however, did not leave him even there. The young painters and sculptors in Rome, especially those who

1 Er hat einen Bruder, der auch ein Bildhauer ist, und gleichfalls in Presburg lebt, der aber mit ihm nicht verwechselt werden muß. Der Verstorbene sagte mir selbst, sein Bruder sey als Künstler nur sehr mittelmäßig. Dieser Bruder erbte die Kunstarbeiten des oben beschriebenen, und besitzt sie noch.

1 He has a brother, who is also a sculptor and also lives in Pressburg, but must not, however, be confused with him. The late artist himself told me his brother was only a very mediocre artist. This brother inherited the art works of the man described above and still possesses them.

ihn daselbst auch nicht. Die jungen Maler und Bildhauer in Rom, sonderlich die, welche Pensionen von großen Höfen genießen, spielen zum Theil den Petitmäter; und viele der andern machen ihre Studien bey den antiken Bildsäulen mit einem Apparat, mit einer Umständlichkeit, die nicht selten mit ihrem Talente in umgekehrtem Verhältnisse stehet. Messerschmidt fiel gerade in das entgegengesetzte Extrem. Aeußerlich lebte er wie der gemeinste Mensch, und war auch so gekleidet. Als er seine Studien in Rom anfing, kaufte er einen Kloben Lindenholz, nahm ihn auf die Schulter, kam so in den Farnesischen Pallast, und legte sein Holz vor dem Herkules nieder. Zwey spanische Bildhauer vom Hofe pensionirt, im modischen Morgennelige, die wechselweise mit großen Tasterzirkeln maßen und an ihren thönernen Modellen bossirten, – sahen den deutschen Fremdling, der im schlechten Wammes mit kurz abgeschnittenen Haaren ankam, als einen Tagelöhner über die Achsel an. Messerschmidt ohne große Anstalten, und ohne zu messen, fing an mit ein Paar Schnitzmessern in die kreuz und die queer ins Holz zu schneiden. Die übrigen Künstler sahen ihm verwundernd zu, und die Spanier besonders zuckten die Achseln, und glaubten, daß auf diese Art nichts kluges herauskommen könnte. Aber ihr Spott verwandelte sich in Erstaunen, als sie nach einigen Tagen aus dem unförmlichen Holze einen herrlichen Herkules entstehen sahen. Die Spanier, welche auf diese Art von ihren Meistern nicht waren unterwiesen worden, glaubten, dies müsse durch Hülfe des bösen Geistes geschehen seyn; und einer ließ etwas davon merken. Messerschmidt, immer kurz angebunden, schlug den Advokaten des Teufels, der ohnedieß von den übrigen jungen Künstlern nicht geliebt war, wegen dieser Beschuldigung ins Gesicht, und behauptete seinen Platz mit Ehren, den man ihm vorher kaum gegönnet hatte.

Er kam ohngefähr 1768 nach Wien, wo er bey der Akademie als Lehrer der Bildhauerkunst angestellet ward. Alle Akademien sind Sammelplätze der Zänkereyen und kleinen Intriguen. Zu Wien es außerdem von jeher Mode gewesen, daß die Künstler und die angesetzten Lehrer sich vor den Direktoren und dem akademischen Rathe[2], tief hatten bücken und ganz von denselben abhängen müssen. Dieß war nun freylich keine Sache für einen Mann wie Messerschmidt, der keinen Künstler weiter als nach dem Grade seiner Geschicklichkeit schätzte. Er beklagte sich gegen mich sehr über viele Chikanen und Ungerechtigkeiten, die man ihm bewiesen hätte. Ich lasse dies dahin gestellt seyn. Genug Messerschmidt verkaufte nach einiger Zeit alle seine Kunstsachen, Zeichnungen, Kupferstiche, Bücher, und andere Habseligkeiten; und zog nach Presburg,

enjoyed stipends from large courts, played in part the little master ; and many of the others accomplished their studies of the ancient pictured columns with paraphernalia, with a fuss and bother which was not seldom incommensurate with their talent. Messerschmidt went to the very opposite extreme. As far as externals went, he lived like the most common man and also dressed accordingly. When he began his studies in Rome, he bought a cudgel of limewood, bore it on his shoulder, went into the Farnese Palace like that and laid his wood down before the Hercules. Two Spanish sculptors paid stipends by the court, in fashionable morning dress, who were alternately measuring with large callipers and modelling on their clay models – looked over their shoulders at the German stranger, who arrived in a poor jerkin with hair shorn short, as if at a day labourer. Messerschmidt without further ado and without measuring, began with a couple of chisels to cut this way and that into the wood. The other artists looked at him in amazement, and the Spaniards especially shrugged their shoulders and thought that nothing clever might come of it in this manner. But their scorn turned to amazement when, after only a few days, they saw a splendid Hercules emerge from the misshapen wood. The Spaniards, who had not been instructed by their masters in this way, believed this must have happened with the aid of an evil spirit; and one of them gave an indication of what he thought. Messerschmidt, always a man of few words, struck the Devil's advocate in the face, who in any case was not popular with the other young artists, because of this accusation and asserted his place in all honour, which he had hardly been grudged before.

He went to Vienna about 1768, where he was hired at the Academy as an instructor of sculpture. All academies are hotbeds of dispute and petty intrigues. In Vienna, it had also been from time immemorial the fashion that artists and employed teachers had to bow low before the directors and the academic Council[2] and were entirely dependent on them. This of course was not the thing for a man like Messerschmidt, who admired no artist except accord-

wo er sich in der Vorstadt Zuckermandl³ ein kleines Haus dicht an der Donau kaufte. Hier lebte er meistens von gemeinen Arbeiten⁴, die bey ihm bestellt wurden, sehr sparsam, aber unabhängig und sehr vergnügt. Ich fand ihn in diesem einsamen Häuschen, stark an Leibeskräften und bey heiterm Gemüthe. Er hatte etwas sehr freymüthiges und ungezwungenes in seinem Wesen, und wir wurden bald ziemlich vertraut, besonders da ich eine Empfehlung von einem Künstler brachte, den er in Rom gut gekannt hatte. Sein ganzes Hausgeräth bestand aus einem Bette, einer Flöte, einer Tabackspfeife, einem Wasserkruge, und einem alten italiänischen Buche von den Verhältnissen des menschlichen Körpers. Dies war alles, was er von den Sachen, die er ehemals besaß, hatte behalten wollen. Außerdem hing am Fenster auf einem halben Bogen die Zeichnung einer ägyptischen Statue ohne Arme, die er nie ohne Bewunderung und Ehrfurcht ansah. Dies bezog sich auf eine specifike Thorheit Messerschmidts, die er bis zu einer erstaunlichen Höhe trieb, und darinn auf eine Art ausdauerte, die unglaublich seyn würde; wenn nicht schon aus mehrern Beyspielen erhellete, was ein fester Charakter, was Fleiß vereint mit Fanatismus und mit Liebe zur Einsamkeit, endlich hervorbringen kann.

Messerschmidt war ein Mann von feurigen Leidenschaften, und hatte dabey einen großen Hang zur Einsamkeit. Er war unfähig jemanden unrecht zu thun, aber erlittenes Unrecht empfand er sehr tief. Dadurch ward sein Charakter versauert, ob er sich gleich sonst in seinem fröhlichen Muthe nicht stören ließ. Er lebte ganz für seine Kunst. Er war in allen Kenntnissen, die nicht zu derselben gehören, sehr unwissend, ob er gleich Fähigkeit hatte mehrere Kenntnisse zu erlangen und sehr lehrbegierig war. Er gerieth in Wien unter eine Gesellschaft von Leuten, die sich geheimer Kenntnisse, des Umgangs mit den unsichtbaren Geistern, und der Herrschaft über die Kräfte der Natur rühmten. Diese Art von Leuten ist in ganz Europa und besonders in Deutschland sehr zahlreich; sie verkrüp-

ing to the degree of his skill. He complained bitterly to me about very many vexations and injustices which had been done to him. I shall leave it at that. It suffices to say after the lapse of some time, Messerschmidt sold all his art paraphernalia, drawings, copperplate engravings, books and other personal effects; and moved to Pressburg, where he bought a small house right on the Danube in the suburb of Zuckermandl.³ There he mainly lived from common works⁴ which were commissioned from him, very thriftily but independently and hugely content. I found him in that lonely little house, in robust health and in a cheerful frame of mind. He had something very candid and unaffected about him and we were soon on quite familiar terms, especially since I brought with me a recommendation from an artist whom he had known well in Rome. His household goods consisted solely in a bed, a flute, a tobacco pipe, a water jug and an old Italian book on the proportions of the human body. That was all he had wanted to keep of the things he had once possessed. In addition, a drawing of an Egyptian statue without arms, which he never glanced at without admiration and awe, hung at a window on half a sheet of paper. This was related to a specific foolishness of Messerschmidt's, which he carried to an astonishing extreme and persisted in it in a way that would be unbelievable if several other examples did not shed light on what a firm character, what industriousness united with fanaticism and a love of solitude can ultimately bring forth.

3 Diese Vorstadt gehört dem Grafen Palffy, liegt im Grunde des Schlosses, und hat verschiedene Freyheiten.
4 Ich habe schon gesagt, daß Messerschmidt ein sehr excentrischer Mensch war. Er erzählte mir unter andern: ein ungarischer Bauer habe bey ihm ein Krucifix, oder wie es der katholische gemeine Mann nennet, ein Herrgott bestellt. Der Künstler fragte: „Wollt ihr einen ungarischen Herrgott, oder einen andern?" Der Bauer voll Vaterlandsliebe antwortete: „Allerdings, einen ungarischen Herrgott!" M. machte also ein Krucifix ganz in ungarischer Tracht mit einer Filzmütze. Der Bauer erschrak als er dies sah. M. sagte: Er habe es gemacht, wie es verlangt worden. Der Bauer versetzte sehr naiv: „Ich will keinen besondern Herrgott haben; der aller Leute Herrgott ist halt recht gut ungarisch!" M. welcher wohl wußte, daß mit der Geistlichkeit nicht gut zu spaßen ist, verschloß seinen ungarischen Herrgott in den Schrank, und machte dem Bauern ein gewöhnliches Krucifix.

3 This suburb belongs to Count Palffy, lies in the grounds of the castle and has various freedoms.
4 I have already said that Messerschmidt was a very eccentric man. He told me, among other things: a Hungarian peasant had ordered a Crucifix from him, or, as the Catholic common man calls it, a Lord God. The artist asked: 'Do you want a Hungarian Lord God or a different one?' The peasant, full of patriotism, answered: 'Certainly, a Hungarian Lord God!' M. therefore made a Crucifix entirely in Hungarian costume with a felt cap. The peasant was horrified when he saw it. M. said he had made it as required. The peasant replied very naively: 'I do not wish to have a special Lord God; that of all men is after all quite Hungarian!' M., who was probably well aware that there is no joking with the clergy, shut his Hungarian Lord God away in the cupboard and made a Crucifix of the usual kind for the peasant.

peln den Verstand unsäglich vieler Menschen, und haben auf die-
selben einen Einfluß, welcher dem Willen der unbekannten, durch
welche die ganze Maschine regiert wird, nur allzugemäß ist. An
einer Menge von eingeschränkten Köpfen, die sich unter ihnen
befinden, ist nicht viel zu verderben, und es wird durch Pflegung
natürlicher Dummheit nichts anders als künstliche Stupidität her-
vorgebracht. So entsteht von natürlichen Dummköpfen, durch
geheime Weisheit noch dummer gemacht, nichts als geheimes dum-
mes Geschwätz, und höchstdumme schwärmerische Bücher, wie
etwa: Die sieben heiligen Grundsäulen der Zeit und Ewigkeit;
Mikrokosmische Vorspiele des neuen Himmels und der neuen Erde,
und wie eine neue vom Himmel gesegnete Erde quintessentialisch
herauszubringen; Berichte vom sichtbaren Gluten- und Flammen-
feuer der uralten Weisen; und andere Bücher dieser Art, welche
denn nichts als dumm sind, und bloß noch wegen der allgemeinen
geheimen Verkrüppelung des Verstandes, die von vielen sehr neuen
uralten Weisen jetzt so fleißig betrieben wird, noch etwas dummere
Leser finden als ihre Verfasser sind. Aber wenn diese unsinnigen
Ideen auf einen guten Kopf würken, der ihre groteske Anlagen mit
seiner natürlichen Scharfsinnigkeit ausbildet, so kommen oft die
sonderbarsten fructus ingenii in umbra sapientiae ludentis heraus,
wovon ich mehrere auffallende Beyspiele anführen könnte.

 Messerschmidt war ein Mann von sehr feuriger Imagination,
dabey blutreich und von starken körperlichen Kräften, lebte fast
beständig einsam, und von seiner ersten Jugend an sehr keusch.
Diesen letzten Umstand betheuerte er selbst gegen mich, und führte
ihn als einen Beweis an, daß er wirklich Geister sähe[5] und nicht
bloß Einbildungen habe; mir hingegen war dies gerade ein Beweis
des Gegentheils. Seine ausschweifende Thorheit hatte wirklich einen
sehr edlen Ursprung. Ein so gefundener Mann, der beständig sehr
enthaltsam lebte, beständig seine Einbildungskraft anstrengte,
beständig sitzend arbeitete, und fast beständig einsam war, mußte
nothwendig Unordnungen im Körper, Folgen des stockenden Bluts,
ängstliches Pochen des Herzens, empfinden; und seine lebhafte Ein-
bildungskraft, vereint mit seinen Lieblingsvorurtheilen, bildete sich
sehr bald allerley geistige Gestalten, welche vermeintlich diese Wir-
kungen, deren Ursachen doch in ihm selbst lagen, außer ihm her-
vorbringen sollten.

 Die allermeisten Menschen, wenn sie einen Mann in Messer-
schmidts Lage sehen, halten ihn entweder für einen außerordent-

5 Bekanntlich pflegen die Schwärmer vorzuspiegeln, es werde eine große
 Reinigkeit des Lebens erfordert, wenn man würdig werden solle, Umgang
 mit den Geistern zu haben. Sie wissen sich dieses Umstandes meisterlich zu
 bedienen, um die verständigsten Leute trübsinnig und so zu ihren Absich-
 ten bequem zu machen.

Messerschmidt was a man of fiery passions yet had for
all that a strong inclination to solitude. He was inca-
pable of doing injustice to anyone yet suffered pro-
foundly from injustice done to him. Thus his charac-
ter was embittered although he otherwise did not let
himself be perturbed in his cheerfulness. He lived
entirely for his art. In all fields of knowledge that
were unrelated to it, he was very ignorant although he
had the aptitude to attain knowledge of several things
and was very eager to learn. In Vienna he found him-
self in the society of people who boasted of arcane
knowledge, of dealings with invisible spirits and mas-
tery over the forces of nature. This sort of person is
very numerous throughout Europe and especially in
Germany; they cripple the understanding of an
unspeakably large number of men and have an influ-
ence on them which is only too much in conformity
with the will of the unknown through which the
whole apparatus is governed. There is not much to be
spoilt in many of these limited understandings occur-
ring among them and, through the cultivation of nat-
ural obtuseness, nothing is brought forth other than
the stupidity of artifice. Thus there arises from dunces
by nature, rendered even more obtuse by arcane wis-
dom, nothing but recondite obtuse babble and very
obtuse books for enthusiasts, as for instance: the Sev-
en Holy Pillars of Time and Eternity; Microcosmic
Preludes to the New Heaven and the New Earth and
how to bring forth a new Earth quintessentially
blessed by Heaven; accounts of visible coals and
flames of fire from the Wise Men of yore; and other
books of this kind, which, after all, are nothing but
stupid and not merely because of the general recon-
dite crippling of reason, which is now being carried
on so industriously by many very recent Wise Men of
yore, who find readers even a trifle more block-head-
ed than their authors. But should these nonsensical
ideas work on a good head, which schools its
grotesque inclinations with its natural acuteness, the
most unusual fructus ingenii in umbra sapientiae
ludentis [fruits of genius into the shade of a playful
wisdom] emerge, of which I could mention several
noteworthy examples.

 Messerschmidt was a man of very fiery imagina-
tion, sanguine withal and of great bodily strength,

lichen Menschen, oder erklären ihn geradezu für einen Narren, der keiner weitern Aufmerksamkeit werth sey. Ich aber glaube, es sey mit den Krankheiten des Geistes, wie mit den Krankheiten des Körpers: daß nemlich durch derselben genaue Kenntniß die wahre Beschaffenheit der Kräfte, die im Menschen liegen, und ihre eigentliche Wirkungen gar sehr erörtert werden können. Ich pflege also, wenn ich solche seltsame Menschen sehe, weder geradezu zu bewundern noch zu verachten, sondern so viel mir möglich ist, zu untersuchen, auf welche Art wohl solche Leute auf ihre Lieblingsideen gekommen seyn möchten. Geschähe dieß mehr, so würde sich deutlich zeigen, daß das, was man am meisten für wunderbar hält, sehr natürlich ist.

Ich versuchte also auch von dem guten Messerschmidt zu erforschen, wie die Ideen in seinem Kopfe eigentlich zusammen hingen. Er drückte sich zwar etwas zurückhaltend und nicht ganz deutlich aus, wie er denn auch von dem was er dabei dachte, meistens sehr undeutliche Begriffe haben mochte. Indessen brachte ich ohngefähr folgendes heraus. Daß es Geister[6] wären, die ihn besonders des Nachts so sehr schreckten und plagten, setzte er als ein unumstößliches Axiom voraus; und den würde er für seinen Feind gehalten haben, der es in seiner Gegenwart im geringsten hätte bezweifeln wollen. Nun setzte er hinzu: Er habe lange nicht begreifen können, wie es zugehe, daß er, der beständig so keusch gelebt, von den Geistern so viel Peinigung hätte erdulden müssen,[7] da sie doch der schwärmerischen Theorie zufolge, eben deswegen einen sehr angenehmen Umgang mit ihm hätten pflegen sollen. Mit einemal aber sey es ihm eingefallen, und nun habe er der Sache nachgedacht, und das ganze System in aller Vollkommenheit erfunden, wie er, und schlechterdings jedermann, Herr über die Geister werden könnte. Der gute Mann kam auf den sehr wahren Satz: daß alle Dinge in der Welt ihre bestimmten Verhältnisse haben und daß

lived almost always alone and was very chaste from earliest youth. This last circumstance he even insisted on to me and used it as proof that he really did see spirits[5] and not just figments of the imagination; to me, on the hand, this was proof of the opposite. His rampant foolishness really had a very noble origin. A man of this sort, who persisted in living very abstinently, continually laboured his imagination, continually worked seated and was almost invariably alone, would of necessity feel disorders of the body, the result of the flow of blood being blocked, anxious beating of the heart; and his lively imagination, united with his favourite prejudices, very soon assumed all sorts of intellectual forms which presumably brought forth from him those effects, the causes of which after all lay in himself.

The vast majority of men, when they see a fellow in Messerschmidt's position, regard him either as an exceptional person or declare him a fool unworthy of further notice. I, however, believe it is as true of disorders of the intellect as it is of diseases of the body; viz. that they can be even clearly explained through the same precise knowledge of the real quality of the powers that lie in men and their actual effects. I am accustomed, therefore, when I see such a curious person, neither to admire excessively nor to despise but, as far as is possible for me, to study in what way such persons may have arrived at their favourite ideas. Were that to happen more, it would be clearly shown that that which is regarded as most wondrous is very natural.

6 Die kahle Philosophie der finstern Jahrhunderte, welche die Wirkung aller unbekannten Ursachen gewissen Geistern zuschrieb, wurmt jetzt wieder gewaltig in vielen unphilosophischen Köpfen, und wirkt bey ihnen oft Zutrauen und oft Bekümmerniß, wo keines von beiden hingehört. Wollten sie sich doch erst nur selbst einen Begriff von dem machen, was sie unter einem Geiste verstehen; so würden sie sehen, wie armselig ihre ganze Theorie ist, – wenn anders die schlauen Demagogen, welche den Verstand ihrer Schüler verkrüppeln, um sie besser zu ihren Absichten zu brauchen, dies zugeben wollten.

7 Welche traurige Folgen ununterbrochene Enthaltsamkeit haben kann, wenn sie mit schwärmerischer Anstrengung der Imagination verknüpft ist, kann man aus einem kleinen aber in seiner Art wichtigen Traktate sehen: Nachricht von einer höchstmerkwürdigen Krankheit, welche Hr. Blanchet Pfarrer zu Cours bey Reolle in Guienne sich durch unverbrüchliche Enthaltsamkeit zugezogen hat. 1780. 8. Eben so war es auch mit Messerschmidt beschaffen.

5 It is well known that enthusiasts pretend a great purity of life is required if one wishes to be worthy of consorting with spirits. They are past-masters at using this circumstance adroitly in order to make the most rational men melancholy and, therefore, receptive to their intentions.

6 The bald-faced philosophy of the unenlightened centuries, which attributed the effect of all unknown causes to certain spirits, now once again rankles powerfully in many unphilosophical heads and in some cases causes in them credulousness and again in others affliction, although neither belongs there. Should they themselves, however, obtain some notion of what they mean by a spirit, they would see how contemptible their entire theory is – even though the sly demagogues who cripple the understanding of their pupils in order to better use them for the ends they intend, might admit this differently.

alle Wirkungen ihren Ursachen entsprechen. Er trug ihn nur etwas unbestimmt und schielend etwa folgendermaßen vor: Es werde alles in der Welt durch die Proportionen regiert, und wer diejenigen Proportionen an sich erwecke, welche der Proportion des anderen entsprächen oder ihr überlegen wären, müsse Wirkungen hervorbringen, welche der Wirkung des andern entsprechen, oder ihr überlegen seyn müßten. Aus diesem halbverstandenen Satze, vermischt mit seinen thörichten Ideen von Geistern und mit seinen Kunstkenntnissen, brachte er ein scharfsinnig scheinendes System voll Unsinns mit Methode verknüpft zu Stande, welches er nach Art aller Leute, bey denen die Einbildungskraft mit dem Verstande davon läuft, für untrüglich hielt. Man weiß, wie viel Aufhebens die Schwärmer von mancherley Art aus den Naturkenntnissen machen, welche der sogenannte ägyptische Hermes (der aber leider! nie in der Welt existirt hat) besessen haben soll. Also kehrte auch M. seine Augen nach Aegypten; und, da er ein Künstler war, so ließ er sich träumen, das rechte Geheimnis der Verhältnisse läge eigentlich in den Verhältnissen der Glieder der ägyptischen Statuen, besonders in der Zeichnung, die er an seinem Fenster aufgehängt hatte, und die vermuthlich das Resultat der Messung verschiedener Theile von verschiedenen Statuen war. Er wähnte, die Verhältnisse, die sich in dieser Zeichnung fanden, wären die Norm der Verhältnisse die sich überhaupt an dem menschlichen Körper finden. Er bildete sich gleichfalls ein: das nämliche Verhältniß was sich am Haupte eines Menschen finde, sey auch über den ganzen Körper einzeln ausgebreitet. Dieß war nun freilich halb wahr und halb falsch, so wie es immer gehet, wenn eine Wahrheit nicht gründlich untersucht wird. Verhältniß in allen Theilen eines jeden gegebenen menschlichen Körpers ist allerdings gewiß da, so gewiß als Ursache und Wirkung immer in Verhältniß steht. Hierauf beruhet die Physiognomik eines jeden wirklich vorhandenen menschlichen Körpers. Eben so ist ein gewisses allgemeines Verhältniß des menschlichen Körpers überhaupt anzunehmen. Hierauf beruhen alle bildende Künste, und das Ideal der Schönheit und der Zeichnung. Aber sehr ungereimt ist es; zu wähnen, daß man dieses Verhältniß, welches unter so mannichfaltigen Kollisionen sich so sehr verbirgt, mit leichter Mühe erkennen könne. Wenn man hier nicht eine geprüfte Erfahrung mit einer wohlüberdachten Theorie verknüpft, so macht man die ungereimtesten Trugschlüsse. M. war in diesem Falle. Wenn er in seinem Unterleibe oder an seinen Schenkeln Schmerzen empfand (wie dieß jedem Menschen, besonders dem der eine sitzende Lebensart führt, sehr leicht geschehen kann); so bildete er sich ein, dieß käme daher, daß er an einem marmornen oder bleyernen Bilde gerade an einer Stelle des Gesichtes arbeitete, welche mit einer gewissen Stelle der unteren Theile des Körpers analog wäre. Er bildete sich ein, Bemer-

I endeavoured, therefore, to ascertain in the worthy Messerschmidt also how the ideas in his head were actually related. He expressed himself somewhat reticently and not quite clearly, just as he also usually employed very imprecise terms for what he was thinking. Nonetheless, I managed to bring out approximately what follows. That it was spirits[6] which so frightened and plagued him at night, he supposed an incontrovertible axiom; and he would have regarded as his enemy anyone who in his presence would have doubted this in the least. Now he added: he had long been unable to grasp how it came about that he, who had always lived so chastely, should have to endure so much torment from the spirits[7] since they, according to the enthusiasts' theory, should for that very reason have cultivated a very pleasant treatment of him. However, it had suddenly occurred to him and now he had thought over the matter and found the whole system in all its perfection, how he, and in fact anyone at all, might become master of the spirits. The worthy fellow hit upon the very true sentence: that all things in the world have their just proportions and that all effects correspond to their causes. Only he recited it rather uncertainly and squinting as follows: everything in the world was governed by proportions and whoever invoked those proportion in himself which corresponded to the proportion of others or were superior to them, would of necessity bring forth effects which would correspond to the effect of the other or would of necessity be superior to it. From this half-understood sentence, mingled with his foolish notions of spirits and with his knowledge of art, he achieved a system that, seemingly acute, was full of madness with method, which he, in the manner of all men in whom the imagination runs away with their reason, considered infallible. It is well known how

7 What sad consequences uninterrupted abstinence can have if it is coupled with enthusiastic exertion of the imagination, can be seen in a brief, but of its kind important, treatise: Nachricht von einer höchstmerkwürdigen Krankheit, welche Hr. Blanchet Pfarrer zu Cours bey Reolle in Guienne sich durch unverbrüchliche Enthaltsamkeit zugezogen hat. 1780. 8. [Report of a most strange illness which M. Blanchet, curate of Cours near Reolle in Guienne, contracted through unshakable abstinence] Just so did it happen with Messerschmidt.

kungen über diese Verhältnisse gemacht zu haben, und zog aus falschen Erfahrungen falsche Schlüsse. Er dichtete sich, weil seine Phantasie mit Geistern angefüllt war, einen besonderen Geist der Proportion. Weil ihm seine Eitelkeit einbildete, er habe über die Proportionen und deren Wirkungen ganz unerhörte neue Entdeckungen gemacht, und weil er mitten unter diesen Entdeckungen (vermuthlich wegen vielen anhaltenden Sitzens) im Unterleibe Schmerzen fühlte; so ließ er sich träumen, der Geist der Proportion sey neidisch auf ihn, daß er der Vollkommenheit der Kenntniß der Proportionen so nahe käme, und verursache ihm daher diese Schmerzen. Da er von einem festen Charakter war, so faßte er Muth, um diesen vermeintlich boshaften Geist zu überwinden. Er ging darauf aus, in die Tiefe der Verhältnisse immer fester einzudringen, damit er endlich über den Geist Macht bekomme, und nicht mehr der Geist über ihn. Er ging in dieser unsinnigen Theorie endlich praktisch so weit, daß er sich einbildete, wenn er sich an verschiedenen Theilen des Körpers, besonders in die rechte Seite unter die Rippen griffe, und damit eine Grimasse des Gesichts verbände, welche mit dem Kneipen des Rippenfleisches das jedesmalige erforderliche ägyptische Verhältniß habe, so sey die höchste Vollkommenheit in dieser Sache erreicht. In dieser Tollheit bestätigte ihn ein Engländer, der ihn besuchte, und welchen M. für den einzigen hielt, der auch dieß System verstanden hatte. Er fragte: der Engländer habe, weil er nicht deutsch verstanden, an seinem eigenen Körper die Stelle des Schenkels entblößt gezeigt, welche der Stelle des Kopfes entspräche, die M. eben damals an einem Kopfe bearbeitete; und dieß, setzte er hinzu, habe ihn mit völliger Ueberzeugung durchdrungen, daß sein System ganz unumstößlich richtig wäre.

Nun ging er wirklich hiernach zu Werke: er kniff sich, er schnitt Grimassen vor dem Spiegel, und glaubte die bewunderungswürdigsten Wirkungen von seiner Herrschaft über die Geister zu erfahren. Er freuete sich seines Systems, und beschloß, es durch Abbildung dieser grimassirenden Verhältnisse festzusetzen und auf die Nachwelt zu bringen. Seiner Meinung nach waren es 64 verschiedene Abänderungen der Grimassen. Er hatte, als ich bey ihm war, schon sechzig verschiedene Köpfe, theils von Marmor theils aus einer Masse von Zinn und Bley, meist in Lebensgröße, vollendet; und ganzer eilf Jahre durch hatte er mit einer ausdauernden Geduld über die man erstaunen muß, sich mit dieser unseligen Arbeit ununterbrochen beschäftigt. Alle diese Köpfe waren sein Bildniß. Ich sah ihn am ein und sechzigsten Kopfe arbeiten. Er sah dabey jede halbe Minute in den Spiegel, und machte mit größter Genauigkeit die Grimasse, die er brauchte. Als Kunstwerke, besonders diejenigen Köpfe die natürliche Stellungen haben, sind

much fuss enthusiasts of various kinds make about the natural science which the so-called Egyptian Hermes (who, however, unfortunately! never existed in this world) is supposed to have possessed. Accordingly, M. also turned his eyes towards Egypt and, since he was an artist, allowed himself to dream that the true mystery of proportions actually lay in the proportions of the limbs of the Egyptian statues, especially in the drawing which he had hung at his window, and which was presumably the result of measurements of various parts of different statues. He entertained the notion the proportions which were present in that drawing might be the norm of the proportions that actually occur in the human body. He also imagined: the specific proportions occurring in the head of a man also applied severally to the entire body. This was, of course, half true and half erroneous as is always the case when a truth is not subjected to thorough study. Proportion is nevertheless definitely in all parts of any given human body just as certainly as cause and effect are always related. The physiognomy of any really existing human body rests on that. Equally, a certain general proportion of the human body must indeed be assumed. This is the foundation of all arts and the ideal of beauty and of drawing. But it is highly inconsistent to entertain the notion that one can easily with little effort discern this proportion, which is so hidden beneath so manifold contradictions. If one does not here link tried and tested experience with well-grounded theory, one draws the most inconsistent fallacious conclusions. M. was in this pitfall. When he felt pains in his belly or in his thighs (as can very easily happen to any man, especially to him who leads a sedentary life), he imagined that this came from his working on a marble or lead portrait bust at exactly the place on the face which corresponded by analogy to a particular place in the lower part of his own body. He imagined he had made observations about these correspondences and drew erroneous conclusions from fallacious experiences. He rhymed together for himself, because his imagination was filled with spirits, a particular Spirit of Proportion. Because his vanity induced him to imagine he had made startling new discoveries about proportions and their effects and because he

wahre Meisterstücke, die man ohne Bewunderung nicht betrachten kann. Indessen, da die meisten mit ganz zusammen gekniffenen Lippen und in so seltsamen Konvulsionen erscheinen; so würde ich immer noch in großer Verlegenheit gewesen seyn, einigermaßen die Veränlassung dieser Art von Uebertreibungen zu errathen, wenn nicht eine vermeinte Grundregel, die Messerschmidt gesprächsweise und mit Vertraulichkeit mir eröfnete, mir einen Blick in die Methode seines Unsinnes gegeben hätte. Er sagte nämlich: der Mensch müsse billig das Rothe der Lippen ganz einziehen, weil es kein Thier zeige. Ein sehr seltsamer Grund! Ich machte ihm den Einwurf, daß ein Mensch kein Thier sey; er hatte aber gleich eine Antwort fertig. Er sagte, die Thiere hätten große Vorzüge vor den Menschen; sie könnten viele Sachen in der Natur erkennen und empfinden, die dem Menschen verborgen blieben. Wenn jemand einmal Thorheiten vertheidigen will, so ist ihm jeder Trugschluß willkommen, und wenn er noch so albern wäre. Daß die Thiere öfters feinere Sinne haben und durch schärfern Geruch oder Gehör Dinge empfinden, welche der Mensch noch nicht empfindet, war dem guten M. eine viel zu simple Erklärung. Weil sein Gehirn voll seltsamen Ideen von Geistern war, weil er, wie viele Leute von schwacher Beurteilungskraft, jede unbekannte Wirkung durch die Wirkung eines Geistes (causa occulta) erklären zu müssen vermeinte; so bildete er sich ein, die Thiere könnten besser als die Menschen die Geister erkennen, und wollte dieß, Gott weiß durch welchen seltsamen Sprung der Ideen dadurch erklären, daß die Thiere keine Lippen zeigten. Aus dieser ungereimten Meinung ward dann einigermaßen deutlich, warum diejenigen unter seinen Köpfen, welche ihm bey dem thörichten System die wichtigsten waren, solche gespannte und gräßlich verstellte konvulsivische Figuren hatten.

Eigentlich waren alle Kunstwerke, die er zu diesem Zwecke gearbeitet hatte, von dreyerley Art:

1) Die simpeln der Natur gemäßen Köpfe. Diese waren wahrhaftig bewunderungswürdige Meisterstücke, die einen Künstler der ersten Größe zeigten. Er hatte sich einmal lachend sehr schön, und dann auch den Mund ganz aufsperrend, gebildet, so daß man Zähne, Gaumen und die Zunge bis an ihre Wurzel sehen konnte; Gegenstände die vielleicht noch nie von einem Bildhauer sind vorgestellet worden. Dieß war mit einer bewunderungswürdigen Richtigkeit und Wahrheit gearbeitet. Besonders aber waren zwey Köpfe ganz vortrefflich, wo er sich ganz ernsthaft in antikem Stile vorgestellet hatte. Ich konnte mich nicht satt daran sehen; er aber blickte auf diese Köpfe mit einer Art von Verachtung. Diese Gestalten waren die natürlichen veredelten Gestalten des Menschen. Daher hielt sie der verstimmte Sinn des armen M. für etwas ganz gemeines, und träumte sich hingegen, durch zusammengekniffene Lippen und

felt pains in the midst of these discoveries, he allowed himself to dream the Spirit of Proportion was envious of him because he came so close to perfecting his knowledge of proportions and for this reason was causing him those pains. Since he was of a sturdy character, he took courage that he would subdue that presumably evil spirit. He assumed he would delve ever deeper into the depths of proportions so that he would ultimately have power over the spirit and the spirit would no longer have power over him. He finally went virtually so far in this nonsensical theory as to imagine if he pinched himself in various parts of his body, especially on his right side amid the ribs and linked this with a grimace on his face which would have the same Egyptian proportion required in each instance with the pinching of the rib flesh, the height of perfection would be attained in this matter. In this foolishness he was confirmed by an Englishman, who visited him and whom M. regarded as the only other man to have understood this system. He wondered: the Englishman, because he did not understand German, had indicated on his own body the place on the thigh which corresponded with the place on the head which M. at that time was working; and this, he added, had thoroughly convinced him that his system was incontrovertibly right.

After that he really set about things: he would pinch himself, he made faces in front of the looking-glass and believed he was experiencing the most remarkable effects of his mastery over the spirits. He was pleased with his system and resolved to capture it by reproducing these grimacing proportions and bequeathing them to posterity. In his opinion, there were sixty-four variations on the grimaces. He already had, by the time I was at his house, completed sixty different heads, some of marble, some of a composition of pewter and lead, most of them life-sized; and he had occupied himself unceasingly with this wretched labour full eleven years with an enduring patience which must astonish one. All those heads were his own likeness. I saw him working on the sixty-first head. He glanced into the looking-glass every half minute and made the face he needed with the utmost precision. As works of art, especially those heads that have natural poses, they are genuine mas-

scheußliche Konvulsionen eine übernatürliche Geisteskraft hervorzubringen. Eben so verachtet der trübsinnige Pietist die großen und edlen Kräfte, welche Gott in die Natur gelegt hat, und setzt sein ganzes Vertrauen in eine erträumte Wiedergeburt, welche Gottes edelstes Geschöpf verstümmelt. Eine eben so traurige Wiedergeburt menschlicher Formen waren denn

2) die 54 Köpfe, welche, um dem übernatürlichen Sinne der Thiere nachzuahmen, mit zusammengekniffenen Lippen und in angespannten Konvulsionen vorgestellet waren. Man sah an denselben wirklich, welche Armseeligkeiten die menschliche Kunst hervorbringt, wenn sie etwas übernatürliches will entstehen lassen. M. blickte indeß diese verzerrten übernatürlichen Gestalten mit einem solchen Wohlgefallen an, mit welchem ich kaum seine edlen natürlichen Köpfe betrachten konnte. Ich versuchte umsonst, von ihm die Ursachen einiger ganz seltsamen Grimassen zu erfahren; er drückte sich immer zurückhaltend aus. – Nun standen im Winkel des Zimmers

3) noch zwey Köpfe von einer ganz seltsamen schwer zu beschreibenden Gestalt. Man stelle sich vor, daß alle Knochen und Muskeln eines menschlichen Gesichts so zusammen gedrückt und vorwärts gezogen wären, daß die äusserste Spitze der Nase mit der höchsten Spitze der zurückgeschobenen Stirn und der äußersten Spitze des hervorgedrückten Kinnknochens einen Winkel von 20 Grad macht, daß also das Gesicht beynahe in die Form eines Schnabels gezogen ist, obgleich doch immer die menschliche Gestalt bleibt. Da ich merkte, daß M. diese Bilder nur kurz mit starren Augen betrachtete, und gleich das Gesicht abwandte, so fragte ich mit der größten Behutsamkeit, was diese vorstellen sollten. M. schien ungern die Erklärung geben zu wollen, und seine sonst lebhaften Augen wurden ganz gläsern, indem er mit abgebrochenen Worten antwortete. Er sagte: „Jener (nemlich der Geist) habe ihn gezwickt, und er habe ihn wieder gezwickt, bis die Figuren herausgekommen wären. Er habe gedacht: Ich will dich doch endlich wohl zwingen; aber er wäre beynahe darüber des Todes gewesen." Ich merkte aus allem, daß diese Karikaturen menschlicher Gesichter eigentlich die Gestalten waren, unter denen die betrogene Phantasie des armen M. sich die Geister der Verhältnisse vorstellte, die ihn vermeintlich deshalb quälten, weil er, wie es ihm seine betrogene Eitelkeit vorbildete, so tief in die Geheimnisse der Verhältnisse, wodurch die Geister könnten gezwungen werden, eingedrungen wäre. Wenn man bedenkt, daß der arme Tropf sich vor diesen vermeinten Geistern fürchtete, daß er einsam war, und in dieser Einsamkeit seine verdrehte Phantasie aufs äusserste anspannte, um diese ihm so fürchterlichen Gestalten recht lebhaft vorzustellen und sie sogar in Marmor nachzubilden; so läßt sich leicht begreifen, daß er in der That vor Angst

terpieces, which one cannot view without admiration. However, since most of them appear with lips pressed tightly together and in such strange convulsions, I would still be greatly at a loss to guess to any extent what had occasioned this sort of exaggeration had Messerschmidt not allowed me a glimpse into the method of his madness by confiding to me in conversation and very privately, what he took for a basic rule. He said, namely: man must simply pull in the red of the lips entirely because no animal shows it. A very strange reason! I objected to him that man is not an animal; but he had a ready answer. He said animals had great advantages over men; they could recognise and feel many things in nature that remain concealed to men. When someone wants to defend foolishness, every fallacious conclusion is welcome, no matter how silly it might be. That animals often have more acute senses and feel things by dint of a more acute sense of smell or hearing which man cannot feel was much too simple an explanation for the worthy M. Because his brain was full of peculiar notions about spirits, because he, like so many persons of weak judgement, believed he had to explain every unknown effect as the effect of a spirit (causa occulta), he imagined animals could recognise spirits better than men can and wanted to explain this, God knows by what peculiar leap of the imagination, by the fact that animals do not show lips. From this absurd opinion, it became somewhat clear why those of his heads which were the most important to him according to his foolish system were those that had strained and hideously disfigured convulsed features.

In fact, all the works of art he had created for this purpose were of three kinds:

1) Simple heads conforming with nature. These were truly admirable masterpieces, which revealed an artist of the highest abilities. He had portrayed himself once very pleasantly laughing and opening up his mouth so wide that teeth, palate and the tounge down to its root were visible; objects which perhaps had never before been represented by a sculptor. That was worked with an admirable justness and truth. Two heads in particular, however, were utterly excellent, in which he had represented himself as very serious in the ancient style. I could not gaze on it enough; he,

beynahe des Todes hat seyn können. Aber toll genug ist es, daß ein Bildhauer, der von den reinsten antiken Verhältnissen der menschlichen Gestalt ausging, durch eine verdorbene Einbildungskraft und durch unsinnige Hypothesen verleitet, sich endlich den Geist des Verhältnisses selbst, unter einem Bilde des abscheulichsten Unverhältnisses, dessen eine menschliche Einbildungskraft nur fähig ist, vorstellen konnte.

Ein kleiner und beynahe lächerlicher Umstand erklärte mir übrigens, wie Unordnung des Körpers auf die Phantasie würkt, und wie ein verstörter Verstand wundersame Ursachen der Dinge außer sich sucht, wenn ganz natürliche im Körper selbst liegen. M. sagte mir, gleichsam im Vertrauen, ganz sachte: „Als er voll Todesangst den Geist so oft und dieser ihn wieder gezwickt habe, sey der Geist, zum guten Glücke, plötzlich aufgesprungen, habe einen h–Wind fahren lassen, und sey verschwunden. Wäre dieß nicht geschehen, so hätte er des Todes seyn müssen." – Der Teufel ist seit langer Zeit im Besitzstande, mit großem Gestanke zu verschwinden. Diese kleine Geschichte erläutert, wie dieß gemeiniglich mag zugegangen seyn; denn es ist wohl kein Zweifel, daß was der arme M. dem Geiste zuschrieb, von ihm selbst herkam, zumahl da er sich so fleißig in die rechte Seite zwickte; und, daß der Geist verschwand, so bald keine Beängstigung mehr da war, ist auch sehr natürlich. Die Dinge, welche für die wunderbarsten ausgegeben werden, sind gemeiniglich von der allergemeinsten Art; und es ist nicht das erstemal, daß trübsinnige Schwärmer ihre Blähungen, nachdem es kommt, für teuflische Anfechtungen, oder für göttliche Eingebungen hielten.

Messerschmidt ward in der Folge mit verschiedenen Leuten bekannt, deren Kopf auch durch vermeinte Geistererscheinungen verrückt war. Sie verdrehten dem guten Manne vollends den Verstand, über welche Vorfälle ich die Decke ziehen will. Er ward ein trauriges Beyspiel, daß die unordentliche Anstrengung und Verrückung des Geistes endlich auch auf den Körper wirkt; und starb viel früher, als er vermuthlich sonst nach seiner natürlich gesunden Konstitution gestorben seyn würde.

Seine Köpfe sind, wie oben gedacht, bey seinem Bruder in Presburg geblieben. Sie verdienen sehr, daß sie jeder Fremder, der nach Presburg kommt, aufmerksam betrachtet. Der Verstorbene sagte mir selbst, ein ungarischer Graf habe ihn für dieselben 8000 Fl. gebothen, er wolle sie aber nicht unter 10,000 Fl. lassen. In solchem Falle wolle er die ganze Folge noch einmal und besser machen; nur die beiden Schnabelköpfe ausgenommen, welche er nicht zum zweytenmal hervor bringen könne.

Messerschmidt machte mein Bildniß in Alabaster in halberhobener Arbeit, welches ich noch zum Andenken dieses seltsamen Mannes und wirklich großen Künstlers aufbewahre.

on the other hand, looked down on these heads with a sort of contempt. These figures were the naturally ennobled figures of man. Hence poor M.'s discordant senses regarding them as something entirely commonplace and dreaming, on the other hand, of summoning forth a supernatural power of the spirit by means of pressed lips and horrible convulsions. Even so does the melancholy Pietist despise the great and noble powers which God has put into nature and places his entire faith in an imagined rebirth which disfigures God's noblest creation. Such a sad rebirth of human forms were then

2) the fifty-four heads which, to imitate the supernatural senses of animals, were represented with tightly pressed lips and in tense convulsions. One saw in them really what wretchedness human art brings forth when it seeks to create something supernatural. M., however, viewed these distorted supernatural figures with such a satisfaction as I hardly ever saw him look at his noble natural heads. I attempted in vain to learn from him the causes of some very peculiar grimaces; he always expressed himself with reticence. – Now there were standing in a corner of the room

3) two more heads, of so strange appearance that it is difficult to describe. Imagine to yourself that all the bones and muscles of a human countenance were so compacted and drawn forwards that the extreme tip of the nose forms an angle of 20 degrees with the uttermost tip of the receding forehead and the extreme tip of the jutting chin bone, that, therefore, the face is almost in the form of a bird's beak although the human appearance remains. As I noticed that M. only briefly glared with staring eyes at those likenesses and then immediately turned his head aside, I asked him with the greatest tact what they were intended to represent. M. seemed unwilling to give an explanation and his otherwise animated eyes became entirely glassy while he answered in choppy words. He said: 'He (viz., the spirit) had pinched him and he pinched him in turn until the figures came out. He had thought: I want finally to force you; but it might nearly have been the death of me.' I noticed from all this that these caricatures of human faces were actually the figures which the deluded imaginings of poor M. conceived as the Spir-

its of Proportions, which presumably tortured him because, as his deluded vanity imagined, he had delved so deep into the mysteries of proportion that this could subdue the spirits. When one bears in mind that the poor soul feared these imaginary spirits, that he was lonely and in this loneliness his twisted imagination strained to the utmost to represent quite true to life those figures that were so frightening to him and even reproduce their likeness in marble, it is easy to understand that he may have indeed been almost frightened to death. But it is madness itself that a sculptor who started from the purest proportions of Antiquity should have been induced by a vitiated imagination and irrational hypotheses to imagine ultimately the Spirit of Proportion itself as being reflected in the most hideous lack of proportion of which a human imagination is capable.

A minor and almost risible circumstance incidentally explained to me how disorders of the body affect the imagination and how a disturbed mind seeks wondrous causes of things outside itself when entirely natural ones lie in the body itself. M. said to me, confidentially as it were, entirely soberly: 'When, filled with the fear of death, he pinched the Spirit so often and it pinched him in turn, the Spirit, fortunately, suddenly sprang up, broke a wind and vanished. Had this not happened, he would have been dead.' – The Devil has long since been capable of vanishing with a great stink. This anecdote explains how this must have in general occurred; for there is probably no doubt that poor M. ascribed to the spirit what came from himself, especially since he was so industriously pinching his right side; and that, as soon as the spirit vanished, there was no longer any cause for fear, is also very natural. The things which are explained as the most miraculous are generally of the most commonplace sort; and it not the first time that melancholy enthusiasts have taken their flatulence in retrospect for devilish assaults or for divine inspiration.

Messerschmidt subsequently became familiar with various persons whose brains had also been addled by what they took for the apparition of spirits. They entirely robbed the good man of his reason, but I prefer to draw a veil over such incidents. He was a sad example of how disordered endeavour and intellectual derangement ultimately affect the body; and he died much younger than he presumably would have with his naturally sound constitution.

His heads have, as mentioned above, remained with his brother in Pressburg. They very much deserve to be attentively viewed by every stranger who comes to Pressburg. The late artist himself told me a Hungarian count had offered him 8,000 florins for them but he had not wanted to part with them for less than 10,000 fl. In such cases he wanted to redo the entire sequence and improve on it; except for the two beaked heads, which he would not be able to reproduce a second time.

Messerschmidt took my likeness in alabaster in half-length, a work I still keep in memory of that strange man and really great artist.

Wiedergegeben nach / *Reprinted*
Nicolai 1785
Friedrich Nicolai, Beschreibung einer Reise durch Deutschland und die Schweiz im Jahre 1781, Bd. 6, Berlin / Stettin 1785, S. 401–420

Literaturverzeichnis / *Bibliography*

Abafi 1891
Ludwig Abafi, Geschichte der Freimaurerei in Oesterreich-Ungarn, Bd. 2, Budapest 1891

Alberti 2002
Leon Battista Alberti, Della Pittura. Über die Malkunst, hg. von Oskar Bätschmann und Sandra Gianfreda, Darmstadt 2002

Andreae 1995
Bernard Andreae (Hg.), Museo Chiaramonti, Teilbände 1–3, Berlin / New York 1995

Androssov 1994
Sergey Androssov, Unknown Works of Orazio Marinali, in: La scultura, 1994, NF H. 48–51, S. 71–76

Anonymus /Anon. 1794
Anonymus, Merkwürdige Lebensgeschichte des Franz Xaver Messerschmidt, k. k. öffentlichen Lehrer der Bildhauerkunst, hg. von dem Verfasser der freimüthigen Briefe über Böhmens und Oestreichs Schaafzucht, Wien 1794

Arburg 1999
Hans-Georg von Arburg, Johann Caspar Lavaters Physiognomik. Geschichte – Methodik – Wirkung, in: Gerda Mraz / Uwe Schlögl (Hg.), Das Kunstkabinett des Johann Caspar Lavater, Wien 1999, S. 40–59

Assmann 2005
Jan Assmann, Die Zauberflöte. Oper und Mysterium, München / Wien 2005

Balet / Gerhard 1979
Leo Balet / E. Gerhard [Eberhard Rebling], Die Verbürgerlichung der deutschen Kunst, Literatur und Musik im 18. Jahrhundert, hg. und eingeleitet von Gert Mattenklott, Frankfurt am Main / Berlin / Wien 1979

Baltrušaitis 1989
Jurgis Baltrušaitis, Tierphysiognomik der Menschenseele, in: Ausst.-Kat. Wunderblock 1989, S. 181–189

Barkhoff 1994
Jürgen Barkhoff, Fiktionale Geisterwelten. Mesmerismus und Literatur als Medien der Transzendenzsuche, in: Zeitschrift für Parapsychologie und Grenzgebiete der Psychologie 36, 1994, S. 72–91

Bauer 1995
Eberhard Bauer, Spiritismus und Okkultismus, in: Ausst.-Kat. Okkultismus und Avantgarde. Von Munch bis Mondrian, 1900–1915, hg. von Veit Loers, Schirn Kunsthalle, Frankfurt am Main 1995, S. 60–80

Bauer 1997
Richard Bauer, Um Licht und Gerechtigkeit. Konturen der bayerischen Geschichte 1777–1805, in: Huber 1997, S. 7–17

Baum 1964
Elfriede Baum, Giovanni Giuliani, Wien / München 1964

Baum 1980
Elfriede Baum, Katalog des Österreichischen Barockmuseums im Unteren Belvedere, 2 Bde., Wien / München 1980

Beck 1985
Herbert Beck, Liebieghaus – Museum alter Plastik. Führer durch die Sammlungen. Bildwerke des Klassizismus, Frankfurt am Main 1985

Beck 1989
Herbert Beck, Das Opfer der Sinnlichkeit. Ein Rückblick auf den »Kunstverderber« Bernini, in: Antikenrezeption im Hochbarock, hg. von Herbert Beck / Sabine Schulze (= Schriften des Liebieghauses, Frankfurt am Main), Berlin 1989, S. 205–220

Behr / Grohmann / Hagedorn 1983
Hans-Georg Behr / Herbert Grohmann / Bernd-Olaf Hagedorn, Charakter-Köpfe. Der Fall F. X. Messerschmidt: Wie verrückt darf Kunst sein?, Weinheim / Basel 1983

Benkard 1925
Ernst Benkard, Andreas Schlüter, Frankfurt am Main 1925

Bezold 1909
Gustav von Bezold (Hg.), Katalog der Gemälde-Sammlung des Germanischen Nationalmuseums in Nürnberg, 4. Aufl., Nürnberg 1909

Biedermann 1978
Gottfried Biedermann, Franz Xaver Messerschmidt – zu den sog. »Charakterköpfen«, in: Alte und moderne Kunst 23, 1978, H. 159, S. 26–31

Birkholz 1783
Adam Michael Birkholz, Die sieben heiligen Grundsäulen der Ewigkeit und der Zeit in deutschen Sinnbilder, zum Besten aller Weisheit Suchenden. Nebst dem Brunnen der Weisheit und Erkenntniß der Natur, Anonymum von Schwarzfuss, Leipzig 1783

Boehm 1988
Gottfried Boehm, Werk und Serie – Probleme des modernen Bildbegriffs seit Monet, in: Kreativität und Werkerfahrung. Festschrift für Ilse Krahl zum 65. Geburtstag, hg. von Daniel Hees / Gundolf Winter, Duisburg 1988, S. 17–24

Böhme 1995
Gernot Böhme, Über die Physiognomie des Sokrates und Physiognomik überhaupt, in: Ders., Atmosphäre, Frankfurt am Main 1995, S. 101–126

Boehn 1969
Max von Boehn, Die Mode. Eine Kulturgeschichte vom Barock bis zum Jugendstil, München 1969

Boehringer 1933
Erich Boehringer, Der Caesar von Acireale, Stuttgart 1933

Bol 2004
Peter C. Bol (Hg.), Die Geschichte der antiken Bildhauerkunst II: Klassische Plastik (Tafelband), Mainz 2004

Born 1784
I. v. B. M. v. St. (= Ignaz von Born Meister vom Stuhl), Ueber die Mysterien der Aegyptier, in: Journal für Freymaurer 1, Wien 5784 [=1784], S. 15–132

Borrmann 1994
Norbert Borrmann, Kunst und Physiognomik. Menschendeutung und Menschendarstellung im Abendland, Köln 1994

Braunfels 1947 / 48
Werner Braunfels, Giottos Campanile, in: Das Münster, 1947 / 48, H. 1, S. 193–210

Bücherl 1989
Barbara Bücherl, Franz Xaver Messerschmidt. Charakterköpfe, in: Ausst.-Kat. Wunderblock 1989, S. 55–67

Bückling 1989
Maraike Bückling, Erwerbungsbericht: Franz Xaver Messerschmidt, Wien, um 1770–72, Büste eines bärtigen, alten Mannes, in: Städel-Jahrbuch NF 12, 1989, S. 328–330

Bückling 1996
Maraike Bückling, Skulpturen, in: Meisterwerke der Sammlungen des Fürsten von Liechtenstein. Skulpturen - Kunsthandwerk - Waffen, hg. von Uwe Wieczorek, Bern 1996, S. 15–93

Bückling 1999a
Maraike Bückling, Hauch und Windstöße der Aufklärung. Die Teilnahme der bildenden Kunst an der kunsttheoretischen Diskussion um 1770, in: Das achtzehnte Jahrhundert. Zeitschrift der Deutschen Gesellschaft für die Erforschung des achtzehnten Jahrhunderts 23, 1999, H. 1, S. 59–78

Bückling 1999b
Maraike Bückling, Wien. Der Bildhauer Franz Xaver Messerschmidt. Ein exemplarisches Künstlerœuvre der Umbruchzeit, in: Ausst.-Kat. Mehr Licht 1999, S. 100–119

Bückling 2002
Maraike Bückling, »Cognosce et dignosce« – »Erkenne und differenziere«. Messerschmidt – ein Künstler der Aufklärung, in: Ausst.-Kat. Messerschmidt 2002, S. 77–85

Bückling 2006
Maraike Bückling, Die »Frileuse«. Ein Bildwerk von Jean-Antoine Houdon, in: Pygmalions Aufklärung. Europäische Skulptur im 18. Jahrhundert, hg. von Roland Kanz / Hans Körner, München / Berlin 2006, S. 165–183

Busch 1981a
Werner Busch, Akademie und Autonomie. Asmus Jacob Carstens' Auseinandersetzung mit der Berliner Akademie, in: Ausst.-Kat. Berlin zwischen 1789 und 1848. Facetten einer Epoche, Akademie der Künste, Berlin 1981, S. 81–92

Busch 1981b
Werner Busch, Die klassizistische Karikatur in Deutschland – Begriff und Gattung, in: Kunstchronik 34, 1981, S. 17–18

Busch 1993
Werner Busch, Das sentimentalische Bild. Die Krise der Kunst im 18. Jahrhundert und die Geburt der Moderne, München 1993

Busch 1998
Werner Busch, Das Einfigurenhistorienbild und der Sensibilitätskult des 18. Jahrhunderts, in: Ausst.-Kat. Kauffmann 1998, S. 40–46

Büttner 1999
Frank Büttner, Der Betrachter im Schein des Bildes. Positionen der Wirkungsästhetik im 18. Jahrhundert, in: Ausst.-Kat. Mehr Licht 1999, S. 341–349

Campe 1990a
Rüdiger Campe, Affekt und Ausdruck. Zur Umwandlung der literarischen Rede im 17. und 18. Jahrhundert, Tübingen 1990

Campe 1990b
Rüdiger Campe, Rhetorik und Physiognomik oder Die Zeichen der Literatur, in: Rhetorik und Strukturalismus 9, 1990, S. 68–83

Campe 1994
Rüdiger Campe, Bezeichnen, Lokalisieren, Berechnen, in: Schings 1994, S. 162–186

Caròla-Perrotti 2001
Angela Caròla-Perrotti, Die neapolitanischen Porzellanmanufakturen Capodimonte und Real Fabbrica Ferdinandea, in: Ausst.-Kat. Commedia dell'arte, Schloss Charlottenburg, Berlin 2001, S. 244–254

Caylus 1730
Recueil de Testes de caractères & de charges dessinées, par Léonard de Vinci Florentin & gravées par M. le C., Paris 1730

Cilleßen 1995
Wolfgang Cilleßen, Mode, in: Lexikon der Aufklärung. Deutschland und Europa, hg. von Werner Schneiders, München 1995, S. 272–273

Chapman 1990
H. Perry Chapman, Rembrandt's Self-Portraits. A Study in Seventeenth-Century Identity, Princeton / New Jersey 1990

Crüwell 2006
Konstanze Crüwell, Auf der Suche nach einem verschollenen Kopf, in: Frankfurter Allgemeine Zeitung, 21. August 2006

Darnton 1986
Robert Darnton, Der Mesmerismus und das Ende der Aufklärung in Frankreich, Frankfurt am Main / Berlin 1986

Dautel 2001
Isolde Dautel, Andreas Schlüter und das Zeughaus in Berlin, Diss. Tübingen 1999, Petersberg 2001

Delbrueck 1912
Richard Delbrueck, Antike Porträts, Bonn 1912

Denk 1998
Claudia Denk, Artiste, Citoyen & Philosophe. Der Künstler und sein Bildnis im Zeitalter der französischen Aufklärung, München 1998

Diderot / Seznec 1957–1967
Denis Diderot, Les Salons 1759–1781, hg. von Jean Seznec, Oxford 1957–1967

Dohme 1878
Robert Dohme, Die Masken der sterbenden Krieger im Lichthofe des Königlichen Zeughauses zu Berlin von Andreas Schlüter, Berlin 1878

Ebeling 2005
Florian Ebeling, Das Geheimnis des Hermes Trismegistos. Geschichte des Hermetismus, München 2005

Ego 1991
Anneliese Ego, Animalischer Magnetismus oder Aufklärung. Eine mentalitätsgeschichtliche Studie zum Konflikt um ein Heilkonzept im 18. Jahrhundert, Würzburg 1991

Eibl-Eibesfeldt / Sütterlin 1992
Irenäus Eibl-Eibesfeldt / Christa Sütterlin, Im Banne der Angst. Zur Natur- und Kunstgeschichte menschlicher Abwehrsymbolik, München / Zürich 1992

Ekman 1988
Paul Ekman, Gesichtsausdruck und Gefühl, hg. und übers. von Maria von Salisch, Paderborn 1988

Ekman 2004
Paul Ekman, Gefühle lesen. Wie Sie Emotionen erkennen und richtig interpretieren, München 2004 (= Emotions revealed. Understanding Faces and Feelings, London 2003, aus dem Englischen übers. von Susanne Kuhlmann-Krieg)

Erffa 1989
Hans Martin von Erffa, Ikonologie der Genesis. Die christlichen Bildthemen aus dem Alten Testament und ihre Quellen, Bd. 1, München 1989, S. 397–400

Fanta 2002
Renate Fanta, Ein unbewusster Schritt in die Moderne. Messerschmidt als Fall der Psychoanalyse, in: Ausst.-Kat. Messerschmidt 2002, S. 129–138

Feuchtmüller 1989
Rupert Feuchtmüller, Der Kremser Schmidt. 1781–1801, Innsbruck / Wien 1989

Feulner 1929
Adolf Feulner, Skulptur und Malerei des 18. Jahrhunderts in Deutschland, Potsdam 1929

Fidler 1984
Petr Fidler, Bemerkungen zur Preßburger Plastik des 16.–18. Jahrhunderts anhand einer Publikation, in: Alte und moderne Kunst 29, 1984, S. 52–53

Fleischhauer 1967
Werner Fleischhauer, Schlossmuseum Ludwigsburg, Stuttgart / Berlin / Köln / Mainz 1967

Forcione 2003
Varena Forcione, Leonardo's Grotesques. Original and Copy, in: Ausst.-Kat. Leonardo da Vinci: Master Draftsman, hg. von Carmen C. Bambach, The Metropolitan Museum of Art New York, New Haven / London 2003, S. 203–224, 451–461

Frey 1926
Österreichische Kunsttopographie. Bd. 19: Die Denkmale des Stiftes Heiligenkreuz, bearb. von Dagobert Frey, Wien 1926

Frick 1973
Karl R. H. Frick, Die Erleuchteten. Gnostisch-theosophische und alchemistisch-rosenkreuzerische Geheimgesellschaften bis zum Ende des 18. Jahrhunderts – ein Beitrag zur Geistesgeschichte der Neuzeit, Graz 1973

Friedel 1785
Johann Friedel, Briefe aus Wien verschiedenen Inhalts an einen Freund in Berlin, Leipzig / Berlin 1785

Frijda 1996
Nico H. Frijda, Gesetze der Emotionen, in: Zeitschrift für psychosomatische Medizin und Psychoanalyse 42, 1996, S. 195–305

Frimmel 1914
Theodor von Frimmel, Feuilleton. Mälzels Kunstkabinett, in: Wiener Zeitung, 26. Juli 1914 (Nr. 172)

Füssli 1779
Hans Rudolph Füssli, Allgemeines Künstlerlexikon, oder: Kurze Nachricht von dem Leben und den Werken der Maler, Bildhauer, Baumeister, Kupferstecher, Kunstgießer, Stahlschneider etc. etc., Erster Theil, Zürich 1779

Füeßli 1802
Hans Rudolph Füeßli, Annalen der bildenden Künste für die österreichischen Staaten, Zweyter Theil, Wien 1802

Gampp 1998
Axel Christoph Gampp, »Als Kunstwerke wahre Meisterwerke«. Die Selbstporträts des Franz Xaver Messerschmidt als Ausdruck einer aufgeklärt-bürgerlichen Ästhetik, in: Image de l'artiste – Künstlerbilder, Colloque du Comité International d'Histoire de l'Art, Université de Lausanne, 9.–12. Juni 1994, Neue Berner Schriften zur Kunst, Bd. 4, Bern u. a. 1998, S. 19–34

Gebauer / Wulf 1992
Gunter Gebauer / Christoph Wulf, Mimesis. Kultur – Kunst – Gesellschaft, Reinbek bei Hamburg 1992

Gebauer 2003
Gunter Gebauer, Le corps du Laocoon, in: Le Laocoon: histoire et réception. Revue Germanique International 19, 2003, S. 237–250

Geyer-Kordesch 1985
Johanna Geyer-Kordesch, Die Nachtseite der Naturwissenschaft: Die ›okkulte‹ Vorgeschichte zu Franz Anton Mesmer, in: Heinz Schott (Hg.), Franz Anton Mesmer und die Geschichte des Mesmerismus. Beiträge zum Internationalen wissenschaftlichen Symposium anlässlich des 250. Geburtstages von Mesmer, 10.–13. Mai 1984 in Meersburg, Stuttgart 1985, S. 13–30

Giuliani 1996
Luca Giuliani, Das älteste Sokrates-Bildnis. Ein physiognomisches Porträt wider die Physiognomiker, in: Der exzentrische Blick: Gespräch über Physiognomik, hg. von Claudia Schmölders, Berlin 1996, S. 19–42

Glandien 1981
Otto Glandien, Franz Xaver Messerschmidt (1726–1783) – Ausdrucksstudien und Charakterköpfe, in: Arbeiten der Forschungsstelle des Instituts für Geschichte der Medizin der Universität zu Köln, Bd. 20, Köln 1981

Goeckingk 1820
Leopold Friedrich Guenther von Goeckingk, Friedrich Nicolai's Leben und literarischer Nachlaß, Berlin 1820

Goethe HA 1996
Goethes Werke, Hamburger Ausgabe, hg. von Erich Trunz, Bd. 3, München 1996

Gombrich 1954
Ernst H. Gombrich, Leonardo's Grotesque Heads. Prolegomena to their Study, in: Leonardo. Saggi e Ricerchi, Rom 1954, S. 199–219

Gorsen 1997
Peter Gorsen, Kunst und Wahn. Triumph und Konflikt des Menschen in der Kunst der Neuzeit, in: Ausst.-Kat. Kunst & Wahn, hg. von Ingried Brugger / Peter Gorsen / Klaus Albrecht Schröder, Kunstforum Wien 1997, S. 59–77

Gorsen 2002
Peter Gorsen, Selbstversuche: Die Grimassen Messerschmidts, in: Frankfurter Allgemeine Zeitung, 31. Dezember 2002

Gräffer 1867
Franz Gräffer, »Der Hogarth der Plastik«, in: Wiener Dosenstücke, 2. Teil, Wien 1867

Grevers 1997
Joana Grevers, Gesichter und ihre Nasen in Kunsttheorie und Kunstwerken, München 1997

Grimm 1991
Claus Grimm, Rembrandt selbst. Eine Neubewertung seiner Porträtkunst, Stuttgart / Zürich 1991

Hàmori 1992
Katalin Hàmori, Wirkungen der Aufklärung auf die Skulptur von Franz Xaver Messerschmidt, in: L'Art et les Révolutions, hg. von Robert Rosenblum, Straßburg 1992, S. 233–245

Hàmori 1994
Katalin Hàmori, Collection of Baroque Sculptures, Museum of Fine Arts, Budapest 1994

Hansmann / Kriss-Rettenbeck 1977
Liselotte Hansmann / Lenz Kriss-Rettenbeck, Amulett und Talisman. Erscheinungsform und Geschichte, München 1977

Hazzi 1803
Joseph von Hazzi, Statistische Aufschlüsse über das Herzogthum Baiern. Aus ächten Quellen geschöpft; ein allgemeiner Beitrag zur Länder- und Menschenkunde, Bd. 3, Nürnberg 1803

Heintze 1961
Helga von Heintze, Römische Porträt-Plastik, Stuttgart 1961

Helmus 1999
Liesbeth M. Helmus, De verzamelingen van het Centraal Museum Utrecht. Schilderkunst tot 1850, Utrecht 1999

Herding 1989
Klaus Herding, Im Zeichen der Aufklärung. Studien zur Moderne, Frankfurt am Main 1989

Hevesi 1909
Ludwig Hevesi, F. X. Messerschmidt's Werke, hg. von J. Wlha, Wien 1909

Hölzel 1977
Gerda Hölzel, Franz Xaver Nissl (1731–1804), Diss. Innsbruck 1977

Hofmann 1956
Werner Hofmann, Die Karikatur von Leonardo bis Picasso, Wien 1956

Hoppe 1993
Günther Hoppe, Berlin im Jahre 1793. Das Tagebuch Adolf Traugott von Gersdorfs, in: Der Bär von Berlin. Jahrbuch des Vereins für Geschichte Berlins 42, 1993, S. 7–47

Huber 1997
Brigitte Huber, Ein Pantheon der kleinen Leute. Die Bildergalerie des Münchner Buchhändlers Johann Baptist Strobl (1748–1805), Eurasburg 1997

Hüssgen 1782
Heinrich-Sebastian Hüssgen, Kurzes Verzeichniß einiger verstorbenen und noch lebenden Künstler, welche in dem neuen Lexikon des Hrn. Füeßli, in Folio, theils gänzlich fehlen, theils nöthige Zusätze erhalten, in: Johann Georg Meusel (Hg.), Miscellaneen artistischen Innhalts, 3, 1782, H. 13, S. 32–50

Ilg 1885
Albert Ilg, Franz Xaver Messerschmidt's Leben und Werke, Wien / Leipzig 1885

Jäger 1975
Hella Jäger, Naivität. Eine kritisch-utopische Kategorie in der bürgerlichen Literatur und Ästhetik des 18. Jahrhunderts, Kronberg / Taunus 1975

Jedding-Gesterling / Brutscher 1988
Maria Jedding-Gesterling / Georg Brutscher (Hg.), Die Frisur. Eine Kulturgeschichte der Haarmode von der Antike bis zur Gegenwart, Hamburg 1988

Kammel 2001
Frank Matthias Kammel, Gefährliche Heiden und gezähmte Exoten. Bemerkungen zum europäischen Türkenbild im 17. und frühen 18. Jahrhundert, in: Frieden und Krieg in der Frühen Neuzeit. Die europäische Staatsordnung und die außereuropäische Welt, hg. von Ronald G. Asch / Wulf Eckart Voß / Martin Wrede, München 2001, S. 503–525

Kammel 2004
Frank Matthias Kammel, Ein mit Verstopfung Behafteter – Der Satirikus, in: Ausst.-Kat. Faszination Meisterwerk 2004, S. 139–143

Karner 2001
Regine Karner (Hg.), Mode: von Kopf bis Fuß 1750–2001, Katalog zur 273. Sonderausstellung des Historischen Museums der Stadt Wien, Wien 2001

Keleti 2002
Magda Keleti, Im Königreich Ungarn. Die späten Jahre in Pressburg, in: Ausst.-Kat. Messerschmidt 2002, S. 97–105

Keller 1971
Harald Keller, Die Kunst des 18. Jahrhunderts, Propyläen Kunstgeschichte, Bd. 10, Berlin 1971

Kemp 1975
Wolfgang Kemp, Die Beredsamkeit des Leibes. Körpersprache als künstlerisches und gesellschaftliches Problem der bürgerlichen Emanzipation, in: Städel-Jahrbuch NF 5, 22, 1975, S. 111–134

Kemp 2002
Wolfgang Kemp, Wie normal ist verrückt? Verformt und verschlossen. Wien zeigt die Zerrköpfe des Barockkünstlers Franz Xaver Messerschmidt, in: Die Zeit, 28. November 2002

Kirchner 1991
Thomas Kirchner, L'expression des passions. Ausdruck als Darstellungsproblem in der französischen Kunst und Kunsttheorie des 17. und 18. Jahrhunderts, Mainz 1991

Kirchner 1997
Thomas Kirchner, Chodowiecki, Lavater und die Physiognomiedebatte in Berlin, in: Ernst Hinrichs / Klaus Zernack (Hg.), Daniel Chodowiecki (1726–1801). Kupferstecher. Illustrator. Kaufmann, Wolfenbütteler Studien zur Aufklärung, Bd. 22, Tübingen 1997, S. 101–142

Kirchner 2001
Thomas Kirchner, »Observons le monde«. La réalité sociale dans la peinture française du XVIIIe siècle, in: Thomas W. Gaehtgens / Christian Michel / Daniel Rabreau / Martin Schieder (Hg.), L'art et les normes sociales au XVIIIe siècle, Passages / Passagen, Bd. 2, Paris 2001, S. 357–381

Kirchner 2004
Thomas Kirchner, »De l'usage des passions«. Die Emotionen bei Künstler und Kunstwerk und Betrachter, in: Klaus Herding / Bernhard Stumpfhaus (Hg.), Pathos, Affekt und Gefühl. Die Emotionen in den Künsten, Berlin / New York 2004, S. 357–377

Klára 1974
Garas Klára, Franz Anton Maulbertsch és kora, Budapest 1974

Kleinert 1995
Annemarie Kleinert, Perücke / Zopf, in: Lexikon der Aufklärung. Deutschland und Europa, hg. von Werner Schneiders, München 1995, S. 300–302

Košenina 1995
Alexander Košenina, Anthropologie und Schauspielkunst. Studien zur »eloquentia corporis« im 18. Jahrhundert, Tübingen 1995

Krapf 1995
Michael Krapf, Franz Xaver Messerschmidt: Er nannte sie seine Schnabelköpfe, in: Belvedere. Zeitschrift für bildende Kunst 1, 1995, H. 1, S. 44–55

Krapf, Leben und Werk 2002
Michael Krapf, Franz Xaver Messerschmidts Leben und Werk. Der Werdegang eines Schwierigen, in: Ausst.-Kat. Messerschmidt 2002, S. 13–30

Krapf, Charakterköpfe 2002
Michael Krapf, Die Charakterköpfe. Von den »simplen der Natur gemäßen Köpfen« zu den konvulsivischen Arbeiten, in: Ausst.-Kat. Messerschmidt 2002, S. 49–64

Krapf, Auftraggeber und Freundeskreis 2002
Michael Krapf, Die Auftraggeber und der Freundeskreis unter besonderer Berücksichtigung der Rolle des Magnetiseurs F. A. Mesmer, in: Ausst.-Kat. Messerschmidt 2002, S. 65–76

Krapf, Schnabelköpfe 2002
Michael Krapf, Er nannte sie seine »Schnabelköpfe«. Der Kampf gegen den Geist der Proportion, in: Ausst.-Kat. Messerschmidt 2002, S. 87–96

Krapf, Musealisierung 2002
Michael Krapf, Die Musealisierung der »Charakterköpfe«. Messerschmidt-Rezeption im 19. Jahrhundert, in: Ausst.-Kat. Messerschmidt 2002, S. 107–115

Krapf, Katalog 2002
Michael Krapf, Katalog der ausgestellten Werke, in: Ausst.-Kat. Messerschmidt 2002, S. 139–281

Krauß 1986
Paul Krauß, Die Charakterköpfe des Franz Xaver Messerschmidt aus psychiatrischer Sicht, in: Hohenstaufen. Veröffentlichungen des Geschichts- und Altertumvereins Göppingen 13, 1986, S. 114–134

Kris 1932

Ernst Kris, Die Charakterköpfe des Franz Xaver Messerschmidt. Versuch einer historischen und psychologischen Deutung, in: Jahrbuch der Kunsthistorischen Sammlungen in Wien NF 6, 1932, S. 169–228

Kris 1933

Ernst Kris, Ein geisteskranker Bildhauer (Die Charakterköpfe des Franz Xaver Messerschmidt), in: Imago, Zeitschrift für psychoanalytische Psychologie, ihre Grenzgebiete und Anwendungen 19, 1933, S. 384–411 (Reprint 1969)

Kuéss / Scheichelbauer 1959

G. Kuéss / B. Scheichelbauer, 200 Jahre Freimaurerei in Österreich, Wien 1959

Kuester / Müller 1756

Georg Gottfried Kuester / Johann Christoph Müller, Des Alten und Neuen Berlin dritte Abtheilung, Berlin 1756

Kwakkelstein 1994

Michael Willem Kwakkelstein, Leonardo da Vinci as a Physiognomist – Theory and Drawing Practice, Leiden 1994

Kybalion 1997

Kybalion, Eine Studie über die hermetische Philosophie des alten Ägyptens und Griechenlands, Geleitwort von Hermann E. Helmrich, Sauerlach 1997

Lacan 1964

Jacques Lacan, Die vier Grundbegriffe der Psychoanalyse, Textherstellung durch Jacques-Alain Miller, übers. von Norbert Haas, 1964, 4. Aufl., Weinheim 1996

Ladendorf 1935

Heinz Ladendorf, Der Bildhauer und Baumeister Andreas Schlüter, Berlin 1935

Lairesse 1740

Gérard de Lairesse, Groot schilderboek, waar in de schilderkonst in al haar deelen grondig werd onderweezen, ook door redeneeringen en prentverbeeldingen verklaard, Haarlem 1740

Laue 2001

Georg Laue (Hg.), Memento mori. Kunstkammer Georg Laue, Bd. 3, München 2001

Lavater 1778

Johann Caspar Lavater, Physiognomische Fragmente, Bd. 4, Leipzig / Winterthur 1778

Lehmann 1997

Leonhard Lehmann, Franziskaner (Konventualen, Kapuziner) und Klarissen, in: Peter Dinzelbacher / James Lester Hogg (Hg.), Kulturgeschichte der christlichen Orden in Einzeldarstellungen, Stuttgart 1997, S. 143–192

Lehner-Jobst 2002

Claudia Lehner-Jobst, Franz Xaver Messerschmidt. Eine Ausstellung im Barockmuseum der Österreichischen Galerie Belvedere, in: Parnass 22, 2002, H. 4, S. 94–100

Lepenies 1976

Wolf Lepenies, Das Ende der Naturgeschichte. Wandel kultureller Selbstverständlichkeiten in den Wissenschaften des 18. und 19. Jahrhunderts, München 1976

Lesky 1973

Erna Lesky, Gerard van Swieten. Auftrag und Erfüllung, in: Gerard van Swieten und seine Zeit, hg. von Erna Lesky / A. Wandruszka, Wien / Köln / Graz 1973, S. 11–62

Lichtenberg 1778 / 1986

Georg Christian Lichtenberg, Über Physiognomik; wider die Physiognomen (1778), in: Ders., Schriften und Briefe, hg. von Wolfgang Promies, Bd. 3, München 1967, S. 256–295

Loschek 2005

Ingrid Loschek, Reclams Mode- und Kostümlexikon, Stuttgart 2005

Ignaz de Luca 1778

Ignaz de Luca, Das gelehrte Oesterreich. Ein Versuch. Des ersten Bandes zweytes Stück, Wien 1778

Lyon 1958

Georgette Lyon, Joseph Ducreux. Premier Peintre de Marie-Antoinette (1735–1802). Sa vie – son œuvre, Paris 1958

Maaz 2001

Bernhard Maaz, Die Crux der Subjektivität. Die Bildnisbüste im Zeitalter ihrer Popularisierung, in: Bärbel Stephan / Astrid Nielsen / Antje Scherner (Hg.), Hauptsache Köpfe. Plastische Porträts von der Renaissance bis zur Gegenwart aus der Skulpturensammlung, Staatliche Kunstsammlungen, Dresden 2001, S. 26–32

Malíková 1965

Maria Malíková, Die Porträtplastik von Franz Xaver Messerschmidt, in: Mitteilungen der Österreichischen Galerie 9, 1965, H. 53, S. 11–30, Abb. 4–31

Marandel 1987

J. Patrice Marandel (Einleitung), Europe in the Age of Enlightenment and Revolution, hg. von The Metropolitan Museum of Art, New York 1987

Maek-Gérard 1982

Eva Maek-Gérard, Die Antike in der Kunsttheorie des 18. Jahrhunderts, in: Forschungen zur Villa Albani. Antike Kunst und die Epoche der Aufklärung, hg. von Herbert Beck / Peter C. Bol, Berlin 1982, S. 1–58

Maué 2005

Claudia Maué, Die Bildwerke des 17. und 18. Jahrhunderts im Germanischen Nationalmuseum, Teil 2: Bayern, Österreich, Italien, Spanien, Mainz 2005

Meusel 1778

Johann Georg Meusel, Teutsches Künstlerlexikon oder Verzeichnis der jetzt lebenden teutschen Künstler, Bd. 1, Lemgo 1778, S. 88–89

Meusel 1781

Johann Georg Meusel, Ideal und Nachahmung, in: Miscellaneen artistischen Innhalts, 1781, H. 6, S. 3–14

Mikoletzky 1982

Nikolaus Mikoletzky, Kris, Ernst, in: Neue Deutsche Biographie, Bd. 13, Berlin 1982, S. 48–50

Möller 1974

Horst Möller, Aufklärung in Preußen. Der Verleger, Publizist und Geschichtsschreiber Friedrich Nicolai, Berlin 1974

Möller 2000

Karin Annette Möller, Elfenbein. Kunstwerke des Barock. Bestandskatalog Staatliches Museum Schwerin, Schwerin 2000

Möller / Domnick 1986

Heinz Möller / Walter Domnick, Stilkunde Frisurenkunde. Berufsgeschichte, Hamburg 1986

Montagu 1994

Jennifer Montagu, The Expression of the Passions. The Origin and Influence of Charles Le Brun's »Conférence sur l'expression générale et particulière«, New Haven / London 1994

Mraz / Schlögl 1999

Gerda Mraz / Uwe Schlögl (Hg.), Das Kunstkabinett des Johann Caspar Lavater, Wien 1999

Müller 1986
Lothar G. Müller, Mikroskopie der Seele – Zur Entstehung der Psychologie aus dem Geist der Beobachtungskunst im 18. Jahrhundert, in: Die Geschichtlichkeit des Seelischen. Der historische Zugang zum Gegenstand der Psychologie, hg. von Gerd Jüttemann, Weinheim/Basel 1986, S. 185–208

Neumann 1988
Gerhard Neumann, »Rede, damit ich dich sehe«. Das neuzeitliche Ich und der physiognomische Blick, in: Ulrich Fülleborn/Manfred Engel (Hg.), Das neuzeitliche Ich in der Literatur des 18. und 20. Jahrhunderts. Zur Dialektik der Moderne, München 1988, S. 71–108

Nicolai 1785
Friedrich Nicolai, Beschreibung einer Reise durch Deutschland und die Schweiz im Jahre 1781, Bd. 6, Berlin/Stettin 1785, S. 401–420

Nicolai Reprint 1994
Friedrich Nicolai, Beschreibung einer Reise durch Deutschland und die Schweiz im Jahre 1781, Bd. 6, Berlin/Stettin 1785. Neudruck: Friedrich Nicolai, Gesammelte Werke, hg. von Bernhard Fabian/Marie-Luise Spieckermann, Bd. 17, Hildesheim/Zürich/New York 1994, S. 401–420

Niemetz 1965
P. Paulus Niemetz, Das Heiligenkreuzer Chorgestühl von Giovanni Giuliani, Heiligenkreuz/Wien 1965

Oberhaidacher 1984
Jörg Oberhaidacher, Kunstgeschichte oder Psychologie? Zu den Charakterköpfen des Franz Xaver Messerschmidt, in: Österreichische Zeitschrift für Kunst und Denkmalpflege 38, 1984, H. 1/2, S. 25–42

Obermeit 1980
Werner Obermeit, »Das unsichtbare Ding, das Seele heißt«. Die Entdeckung der Psyche im bürgerlichen Zeitalter, Frankfurt am Main 1980

Ohage 1990
August Ohage, Lichtenberg als Beiträger zu Lavaters »Physiognomischen Fragmenten«, in: Lichtenberg-Jahrbuch 3, 1990, S. 28–51

Pakosta 1976
Florentina Pakosta, Mein Bekenntnis zur Franz Xaver Messerschmidt, in: Tendenzen 17, 1976, S. 41–44

Parsons 1747
James Parsons, Human Physiognomy Explain'd: in the Crounian Lectures on Muscular Motion. For the Year 1746. Read before the Royal Society, in: Philosophical Transactions 1747, Bd. 44, Teil 1, London 1747

Paulys Realencyclopädie 1912
Paulys Realencyclopädie der classischen Altertumswissenschaft, hg. von Wilhelm Kroll, 14. Halbband, Stuttgart 1912

Perreau 2004
Stephan Perreau, Hyacinthe Rigaud. 1659–1743. Le peintre des rois, Montpellier 2004

Pfarr 1999
Ulrich Pfarr, Lasst alles raus! Medizin, Physiognomik und »Erfahrungsseelenkunde« in den Charakterköpfen von Franz Xaver Messerschmidt, in: Frankfurter Allgemeine Zeitung, 27. Oktober 1999

Pfarr 2001
Ulrich Pfarr, Ernst Kris on F. X. Messerschmidt – A Valuable Stimulus for New Research?, in: American Imago, Studies in Psychoanalysis and Culture 58, 2001, S. 445–461

Pfarr 2003a
Ulrich Pfarr, Franz Xaver Messerschmidt (1736–1783). Wien, Österreichische Galerie Belvedere, 11. Oktober 2002–9. Februar 2003 (Ausstellungsrezension), in: Kunstchronik 56, 2003, H. 1, S. 9–14

Pfarr 2003b
Ulrich Pfarr, Franz Xaver Messerschmidts mehrfach kodierte Köpfe – das Gesicht als Spiegel der Seele?, in: Psychoanalyse im Widerspruch, hg. vom Institut für Psychoanalyse und Psychotherapie Heidelberg-Mannheim 15, 2003, H. 29, S. 25–41

Pfarr 2004
Ulrich Pfarr, Destruktion des Ideals oder Aggression gegen sich selbst? Spannungen in der Kunst F. X. Messerschmidts, in: Psychoanalyse – Texte zur Sozialforschung, hg. von Oliver Decker 8, 2004, H. 1 (Gewalt und Kunst), S. 7–19

Pfarr 2006
Ulrich Pfarr, Franz Xaver Messerschmidt. Menschenbild und Selbstwahrnehmung (= Neue Frankfurter Forschungen zur Kunst, Bd. 2, hg. vom Kunstgeschichtlichen Institut der Johann Wolfgang-Goethe-Universität Frankfurt am Main), Berlin 2006

Philipe 1994
Julien Philipe, Charles Le Brun. L'Expression des passions & autres conférences. Correspondance, o. O. 1994

Poche/Koøán 2003
Emanuel Poche/Ivo Koøán, Matthias Bernhard Braun. Der Meister des Böhmischen Barock und seine Werkstatt, Innsbruck 2003

Pötzl-Malíková 1982
Maria Pötzl-Malíková, Franz Xaver Messerschmidt, Wien/München 1982

Pötzl-Malíková 1984a
Maria Pötzl-Malíková, Das Grabmal Gerard van Swietens in der Augustinerkirche in Wien, in: Alte und moderne Kunst 29, 1984, S. 25–28

Pötzl-Malíková 1984b
Maria Pötzl-Malíková, Franz Xaver Messerschmidt (1736–1783), in: Johann Baptist Straub (1704–1784). Franz Xaver Messerschmidt (1736–1783). Bildhauer aus Wiesensteig, hg. von Walter Ziegler, Weißenhorn 1984, S. 45–63

Pötzl-Malíková 1987
Maria Pötzl-Malíková, Zur Beziehung Franz Anton Mesmer – Franz Xaver Messerschmidt. Eine wiedergefundene Büste des berühmten Magnetiseurs, in: Wiener Jahrbuch für Kunstgeschichte 40, 1987, S. 257–267, Abb. S. 395–398

Pötzl-Malíková 1996
Maria Pötzl-Malíková, Zwei unbekannte Dokumente zum Leben und Werk Franz Xaver Messerschmidts, in: Ars, 1996, H. 1–3, S. 215–224

Pötzl-Malíková 2003
Maria Pötzl-Malíková, Zur aktuellen Situation in der Messerschmidt-Forschung. Anmerkungen zu einer Präsentation, in: Österreichische Zeitschrift für Kunst und Denkmalpflege 57, 2003, H. 2, S. 253–264

Pötzl-Malíková 2004
Maria Pötzl-Malíková, F. X. Messerschmidt a záhada jeho charakterováčh hláv, Bratislava 2004

Pötzsch 1993
Regine Pötzsch (Hg.), Schlaf in der Kunst, Basel 1993

Pommeranz-Liedtke
Gerhard Pommeranz-Liedtke, Der graphische Zyklus von Max Klinger bis zur Gegenwart, Berlin 1956

Poulet 1992
Anne Poulet, Les années romaines de Clodion, in: Ausst.-Kat. Clodion 1992, S. 15–34

Presler 1996
Gerd Presler, Im Gesicht zeigt sich der wahre Teufel, in: Art, 1996, H. 2, S. 74–81

Promies 1992
Wolfgang Promies, Lichtenbergs »Italiänische Reise«, in: Ausst.-Kat. Georg Christoph Lichtenberg 1742–1799, Wagnis der Aufklärung, Mathildenhöhe Darmstadt, Niedersächsische Staats- und Universitätsbibliothek Göttingen, 1992, S. 307–311

Réau 1964
Louis Réau, Houdon. Sa vie et son œuvre, Paris 1964

Reinhold 1784
Christian Ludolph Reinhold, System der Zeichnenden Künste. Nebst einer Anleitung zu den Antiken, Hieroglyphen und modernen allegorischen Attributen, Münster / Osnabrück 1784

Reißer 1997
Ulrich Reißer, Physiognomik und Ausdruckstheorie der Renaissance. Der Einfluss charakterologischer Lehren auf Kunst und Kunsttheorie des 15. und 16. Jahrhunderts, München 1997

Ricœur 1974
Paul Ricœur, Die Interpretation. Ein Versuch über Freud, Frankfurt am Main 1974

Richter 1965
Gisela M. A. Richter, The Portraits of the Greeks, 3 Bde., Leicester 1965

Riedl-Dorn 1990
Christa Riedl-Dorn, Die Naturwissenschaften zur Zeit Mozarts in Wien, in: Ausst.-Kat. Zaubertöne. Mozart in Wien, Historisches Museum der Stadt Wien, Wien 1990, S. 66–70

Ronzoni 1982
Luigi A. Ronzoni, Zwischen Rokoko, Klassizismus und »Geisteskrankheit«, in: Weltkunst 52, 1982, H. 18, S. 2485–2487

Ronzoni 1997
Luigi A. Ronzoni, Diagnose: Portreen. Zum Rätsel der Charakterköpfe Franz Xaver Messerschmidts, in: Parnass 17, 1997, Sonderheft 13, S. 36–44

Ronzoni 2004
Luigi A. Ronzoni, Karl Georg Merville (1751–1798). Ein später Vollender der Wiener Skulpturentradition. Zum Medium der weißen Komposition, München 2004

Ronzoni 2005
Luigi A. Ronzoni, Giovanni Giuliani (1664–1744) (= Ausst.-Kat. Giovanni Giuliani 2005)

Sauerländer 1963
Willibald Sauerländer, Jean-Antoine Houdon. Voltaire, Stuttgart 1963

Sauerländer 1989
Willibald Sauerländer, Überlegungen zu dem Thema Lavater und die Kunstgeschichte, in: Idea. Jahrbuch der Hamburger Kunsthalle 8, 1989, S. 15–30

Sauerländer 2002
Willibald Sauerländer, Ein Versuch über die Gesichter Houdons, München / Berlin 2002

Sauerländer 2003
Willibald Sauerländer, Bartlos und am liebsten kahlschädelig. Eine Wiener Ausstellung zeigt die grotesken Charakterköpfe Franz Xaver Messerschmidts, in: Süddeutsche Zeitung, 14. Januar 2003

Scheidel 1867
Sebastian Alexander Scheidel, Geschichte der Dr. Senckenberg'schen Stiftshäuser, Frankfurt am Main 1867

Scherf 1992
Guilhem Scherf, Catalogue I. Le premier séjour italien, in: Ausst.-Kat. Clodion 1992, S. 77–121

Scherf 2005
Guilhem Scherf, Une Tête de caractère de Messerschmidt au Louvre, in: La Revue des Musées de France – Revue du Louvre, 2005, H. 2, S. 15–16

Scheyb 1770
Franz Christoph von Scheyb (Pseudonym: Köremon), Natur und Kunst in Gemälden, Bildhauereyen, Gebäuden und Kupferstichen, zum Unterricht der Schüler, und Vergnügen der Kenner, 2 Bde., Leipzig / Wien 1770

Scheyb 1774
Franz Christoph von Scheyb (Pseudonym: Orestrio), Von den drey Künsten der Zeichnung. Mit einem Anhang von der Art und Weise, Abdrücke in Schwefel, Gyps, und Glas zu verfertigen auch in Edelsteine zu graben, 2 Bde., Wien 1774

Schings 1994
Hans-Jürgen Schings (Hg.), Der ganze Mensch. Anthropologie und Literatur im 18. Jahrhundert, Stuttgart / Weimar 1994

Schmid 2004
Theodor Schmid, 49 Köpfe. Die Grimassen-Serie des Franz Xaver Messerschmidt, Zürich 2004

Schmölders 1994
Claudia Schmölders, Das Profil im Schatten. Zu einem physiognomischen »Ganzen« im 18. Jahrhundert, in: Schings 1994, S. 242–259

Schnapp 1998
Alain Schnapp, De Montfaucon à Caylus: le nouvel horizon de l'Antiquité, in: Ausst.-Kat. La Fascination de l'Antique 1998, S. 142–148

Schneider 1993
Manfred Schneider, Die Inquisition der Oberfläche. Kleist und die juristische Kodifikation des Unbewussten, in: Leib-Zeichen. Körperbilder, Rhetorik und Anthropologie im 18. Jahrhundert, hg. von Rudolf Behrens / Roland Galle, Würzburg 1993, S. 23–39

Schweitzer 1948
Bernhard Schweitzer, Die Bildniskunst der römischen Republik, Leipzig 1948

Seipp 1793
Christoph Ludwig Seipp, Reisen von Preßburg durch Mähren, beyde Schlesien und Ungarn nach Siebenbürgen und von dort zurück nach Preßburg, Frankfurt / Leipzig 1793

Sichelschmidt 1971
Gustav Sichelschmidt, Friedrich Nicolai. Geschichte seines Lebens, Berlin 1971

Sloan 2003
Kim Sloan (Hg.), Enlightenment. Discovering the World in the Eighteenth Century, London 2003

Solar 1973
Gustav Solar, Eine unbekannte Folge deutscher Kupferstich-Karikaturen aus der Zeit vor 1600, in: Pantheon 31, 1973, S. 32–39

Sotheby's 2005
Auktionskatalog Sotheby's, European Sculpture & Works of Art, London, 8. Juli 2005, S. 94–101, Lot 81

Städtler 2003
Thomas Städtler, Lexikon der Psychologie, Wörterbuch, Handbuch, Studienbuch, Stuttgart 2003

Stastny 2003
Philipp Stastny, Die »Dämonen« Messerschmidts. Neue Erkenntnisse zu den Charakterköpfen, in: Belvedere. Zeitschrift für bildende Kunst 9, 2003, H. 2, S. 48–59

Stölz 2004
Christoph Stölz, Fitz König. Meine Arche Noah, Müchen 2004

Strauss / Röder 1983
Herbert A. Strauss / Werner Röder (Hg.), International Biographical Dictionary of Central European Emigrés 1933–1945, Bd. 2, Teil 1 (A-K), The Arts, Sciences, and Literature, München / New York / London / Paris 1983

Sulzer 1771
Johann Georg Sulzer, Allgemeine Theorie der schönen Künste, Leipzig 1771

Sulzer 1792–1794
Johann Georg Sulzer, Allgemeine Theorie der Schönen Künste, Leipzig 1792–1794

Suthor 1999
Nicola Suthor, Denis Diderot: Das Paradox des Porträtmalers (1767), in: Porträt, hg. von Hannah Baader / Rudolf Preimesberger / Nicola Suthor, Berlin 1999, S. 369–377

Tekusch 1785
Preßburger Musenalmanach auf das Jahr 1785. Gesammelt von M. Tekusch, Preßburg, S. 105f.

Thieme-Becker
Ulrich Thieme / Felix Becker, Allgemeines Lexikon der bildenden Künstler von der Antike bis zur Gegenwart, Leipzig 1907 ff.

Thiessen 2006
Hillard von Thiessen, Die besseren Seelsorger? – Die Kapuziner in Freiburg, in: Ausst.-Kat. Eine Stadt braucht Klöster, Augustinermuseum Freiburg, Lindenberg im Allgäu, Freiburg i. Br. 2006, S. 82–84

Tietze-Conrat 1920
Erika Tietze-Conrat, Österreichische Barockplastik, Wien 1920

Tietze-Conrat 1921
Erika Tietze-Conrat, Ein unbekanntes Bildnis des Gerhard van Swieten, in: Oud Holland 39, 1921, S. 49–51

Vosskamp 2003
Wilhelm Vosskamp, Goethe et le »Laocoon«. L'inscription de la perception dans la durée, in: Le Laocoon: histoire et réception, hg. von Elisabeth Decultot / Jacques le Rider / François Queyrel, Revue Germanique International 19, 2003, S. 159–166

Wagner 1967
Walter Wagner, Die Geschichte der Akademie der bildenden Künste in Wien, Wien 1967

Weiermann 1956
W. Weiermann, Der süddeutsche Orgelprospekt im 17. und 18. Jahrhundert, Diss. München 1956

Weinberger 1930
Martin Weinberger, Bildnisbüsten von Guido Mazzoni, in: Pantheon 5, 1930, S. 191–194

Weisbach 1928
Werner Weisbach, Der sogenannte Geograph von Velazquez und die Darstellungen des Demokrit und Heraklit, in: Jahrbuch der preußischen Kunstsammlungen 49, 1928, S. 141–158

Weiss 1924
Gabriele Weiss, Franz Xaver Messerschmit. Ein Bildhauer des 18. Jahrhunderts, Diss. Wien (Manuskript) 1924

West 1933
Robert West, Römische Porträt-Plastik, München 1933

Wiedenhofer 1992
Siegfried Wiedenhofer, Das katholische Kirchenverständnis. Ein Lehrbuch der Ecclesiologie, Graz / Wien / Köln 1992

Wilhelm 1976
Gustav Wilhelm, Die Fürsten von Liechtenstein und ihre Beziehungen zu Kunst und Wissenschaft, in: Jahrbuch der Liechtensteinischen Kunstgesellschaft 1, 1976, S. 11–179

Winckelmann 1755
Johann Joachim Winckelmann, Gedancken über die Nachahmung, Dresden 1755

Winckelmann Reprint 1962
Johann Joachim Winckelmann, Sendschreiben über die Gedanken von der Nachahmung der griechischen Werke in der Malerey und Bildhauerkunst, in: Ders., Kunsttheoretische Schriften, Bd. 1, Baden-Baden / Straßburg 1962, S. 46–89

Winterschmidt 1764
Adam Wolfgang Winterschmidt, Der Tugend- und lasterhafte Studente poetisch und moralisch entworfen, Frankfurth / Leipzig 1764

Wittkower 1963
Rudolf und Margot Wittkower, Born under Saturn. The Character and Conduct of Artists: A documented History from Antiquity to the French Revolution, London 1963

Wittkower 1965
Rudolf und Margot Wittkower, Künstler – Außenseiter der Gesellschaft, Berlin / Köln / Mainz 1965

Wöbkemeier 1990
Rita Wöbkemeier, Erzählte Krankheit. Medizinische und literarische Phantasien um 1800, Stuttgart 1990

Wolf 1952
Georg Wolf, Geschichte der Frisur in allen Zeiten, Darmstadt 1952

Wunderlich 2001
Uli Wunderlich, Der Tanz in den Tod. Totentänze vom Mittelalter bis zur Gegenwart, Freiburg i. Br. 2001

Wurzbach
Constant von Wurzbach, Biographisches Lexikon des Kaiserthums Österreich, Wien 1856ff.

Yonan 2003
Michael E. Yonan, The Two Messerschmidts, in: Eighteenth-Century Studies 36, 2003, S. 558–576

Zedler 1731
Johann Heinrich Zedler: Grosses Vollständiges Universal-Lexikon aller Wissenschaften und Künste, Bd. 43, 1745

Zedler 1744
Grosses vollständiges Universallexikon aller Wissenschaften und Künste, verlegt von Johann Heinrich Zedler, Leipzig / Halle, Bd. 41, 1744

Zedler 1745
Johann Heinrich Zedler, Grosses vollständiges Universallexikon aller Wissenschaften und Künste, verlegt von Johann Heinrich Zedler, Bd. 45, Leipzig / Halle 1745

Zelle 1987
Carsten Zelle, Angenehmes Grauen. Literaturhistorische Beiträge zur Ästhetik des Schrecklichen im achtzehnten Jahrhundert (= Studien zum achtzehnten Jahrhundert, hg. von der Deutschen Gesellschaft zur Erforschung des achtzehnten Jahrhunderts, Bd. 10), Hamburg 1987

Zelle 1989
 Carsten Zelle, Physiognomie des Schreckens im achtzehnten Jahrhundert. Zu Johann Caspar Lavater und Charles Lebrun, in: Lessing Yearbook 21, 1989, S. 89–102

Zoege von Manteuffel 1984
 C. Zoege von Manteuffel, Zwei kleine Alabasterbüsten von Franz Xaver Messerschmidt, in: Zusammenhang – Festschrift für Marielene Putscher, hg. von Otto Baur / Otto Glandien, Köln 1984, S. 451–469

Ausstellungskataloge / *Exhibition Catalogues*

Ausst.-Kat. Ägyptomanie 1994
 Ägyptomanie. Ägypten in der europäischen Kunst 1730–1930, hg. von Wilfried Seipel, Kunsthistorisches Museum Wien, Mailand 1994

Ausst.-Kat. Art in Rome 2000
 Art in Rome in the Eighteenth Century, hg. von Edgar Peters Bowron / Joseph J. Rishel, Philadelphia Museum of Art, Philadelphia 2000

Ausst.-Kat. Beredsamkeit 1992
 Die Beredsamkeit des Leibes. Zur Körpersprache in der Kunst, hg. von Ilsebill Barta-Fliedl / Christoph Geismar-Brandi, Graphische Sammlung Albertina Wien, Salzburg / Wien 1992

Ausst.-Kat. Clodion 1992
 Guilhem Scherf / Anne Poulet, Clodion 1738–1814, Musée du Louvre, Paris 1992

Ausst.-Kat. Donner 1993
 Georg Raphael Donner 1693–1741, hg. von der Österreichischen Galerie Belvedere Wien, Bad Vöslau 1993

Ausst.-Kat. Elfenbein 2001
 Elfenbein. Einblicke in die Sammlung Reiner Winkler, bearb. von Jutta Kappel, Deutsches Elfenbeinmuseum Erbach, Staatliche Kunstsammlungen Dresden (Grünes Gewölbe), Städtische Galerie Liebieghaus – Museum alter Plastik Frankfurt am Main, München 2001

Ausst.-Kat. face to face 1994
 face to face. Three Centuries of Artists' Self-portraiture, hg. von Xanthe Brooke, Walker Art Gallery, Liverpool 1994

Ausst.-Kat. Faszination Meisterwerk 2004
 Faszination Meisterwerk. Dürer – Rembrandt – Riemenschneider, hg. von Ulrich Großmann, Germanisches Nationalmuseum, Nürnberg 2004

Ausst.-Kat. Furienmeister 2006
 Der Furienmeister, hg. von Herbert Beck / Peter C. Bol / Maraike Bückling / Max Hollein, Liebieghaus – Museum alter Plastik Frankfurt am Main, Petersberg 2006

Ausst.-Kat. Giovanni Giuliani 2005
 Giovanni Giuliani (1664–1744), hg. von Johann Kräftner, bearb. von Luigi A. Ronzoni, Liechtenstein Museum Wien, 2 Bde., München / Berlin / London / New York 2005

Ausst.-Kat. Große Kunst in kleinem Format 2004
 Große Kunst in kleinem Format, bearb. von Fritz Fischer, Württembergisches Landesmuseum Stuttgart, Ulm 2004

Ausst.-Kat. Hauptsache Köpfe 2001
 Hauptsache Köpfe. Plastische Porträts von der Renaissance bis zur Gegenwart aus der Skulpturensammlung, Staatliche Kunstsammlungen, Dresden 2001

Ausst.-Kat. Hogarth 1998
 Mariage A-la-Mode. Hogarth und seine deutschen Bewunderer, hg. von Martina Dillmann / Claude Keisch, Alte Nationalgalerie, Staatliche Museen zu Berlin, Städelsches Kunstinstitut und Städtische Galerie Frankfurt am Main, Berlin 1998

Ausst.-Kat. Houdon 2003
 Jean-Antoine Houdon, Sculptor of the Enlightenment, hg. von Anne L. Poulet, National Gallery of Art, Washington 2003

Ausst.-Kat. Joseph Wenzel von Liechtenstein 1990
 Joseph Wenzel von Liechtenstein. Fürst und Diplomat im Europa des 18. Jahrhunderts, hg. von Reinhold Baumstark, Sammlungen des Fürsten von Liechtenstein, Einsiedeln 1990

Ausst.-Kat. Kauffmann 1998
 Angelika Kauffmann Retrospektive, hg. von Bettina Baumgärtel, Kunstmuseum Düsseldorf, Haus der Kunst München, Ostfildern-Ruit 1998

Ausst.-Kat. Klassizismus und Biedermeier 2004
 Klassizismus und Biedermeier, hg. von Johann Kräftner, Lichtenstein Museum Wien, München 2004

Ausst.-Kat. Kunst lebt 2006
 Kunst lebt. Die Welt mit anderen Augen sehen, hg. von Tilman Osterwold, Kunstgebäude Stuttgart, Köln 2006

Ausst.-Kat. La Fascination de l'Antique 1998
 La Fascination de l'Antique 1700–1770. Rome découverte, Rome inventée, hg. von François de Polginac / Joselita Raspi Serra, Musée de la civilisation gallo-romaine, Lyon 1998

Ausst.-Kat. L'âme au corps 1993
 L'âme au corps. Arts et sciences 1793–1993, hg. von Jean Clair, Galeries nationales du Grand Palais, Paris 1993

Ausst.-Kat. Lockenpracht 2006
 Lockenpracht und Herrschermacht.
 Perücken als Statussymbol und modi-
 sches Accessoire, hg. von Jochen Luck-
 hardt / Regine Marth, Herzog Anton
 Ulrich-Museum Braunschweig, Freiburg
 i. Br. 2006
Ausst.-Kat. Louise Bourgeois 1998
 Jean Clair, Five Notes on the Work of
 Louise Bourgeois, Cheim & Read,
 New York 1998
Ausst.-Kat. Mehr Licht 1999
 Mehr Licht. Europa um 1770. Die bil-
 dende Kunst der Aufklärung, hg. von
 Herbert Beck / Peter C. Bol / Maraike
 Bückling, Städelsches Kunstinstitut und
 Städtische Galerie Frankfurt am Main,
 München 1999
Ausst.-Kat. Melancholie 2005
 Melancholie. Melancholie und Wahnsinn
 in der Kunst, hg. von Jean Clair, Galeries
 nationales du Grand Palais, Paris, Neue
 Nationalgalerie, Staatliche Museen zu
 Berlin, Ostfildern-Ruit 2005
Ausst.-Kat. Messerschmidt 2002
 Franz Xaver Messerschmidt 1736–1783,
 hg. von Michael Krapf, Österreichische
 Galerie Belvedere Wien, Ostfildern-Ruit
 2002
Ausst.-Kat. Messerschmidt Têtes de caractères
 1993
 Franz Xaver Messerschmidt, Sculpteur
 baroque (1736–1783) «Têtes de caractè-
 res», Musée d'Art et d'Histoire, Palais
 Masséna, Nizza 1993

Ausst.-Kat. Natur und Antike 1985
 Natur und Antike in der Renaissance,
 hg. von Herbert Beck / Peter C. Bol,
 Liebieghaus – Museum alter Plastik,
 Frankfurt am Main 1985
Ausst.-Kat. Pygmalions Werkstatt 2001
 Pygmalions Werkstatt. Die Erschaffung
 des Menschen im Atelier von der Renais-
 sance bis zum Surrealismus, hg. von Hel-
 mut Friedel, bearb. von Barbara Eschen-
 burg, Lenbachhaus München, Köln 2001
Ausst.-Kat. Quick 1997
 The Quick and the Death. Artist and
 Anatomy, Hayward Gallery, London 1997
Ausst.-Kat. Tanz der Toten 1998
 Tanz der Toten – Todestanz. Der monu-
 mentale Totentanz im deutschsprachigen
 Raum, Museum für Sepulkralkultur
 Kassel, Dettelbach 1998
Ausst.-Kat. Wunderblock 1989
 Wunderblock. Eine Geschichte der
 modernen Seele, hg. von Jean Clair /
 Cathrin Pichler / Wolfgang Pircher, Reit-
 halle in den ehemaligen Hofstallungen,
 Messepalast, Wien 1989

Bildnachweis / *Illustration Credits*

Accademia Nazionale di San Luca, Rom /
Rome: Abb. 19

Ägyptisches Museum, Kairo / *Cairo*: Abb. 55

Albertina, Wien / *Vienna*: Abb. 61

Ambasciata di Spagna, Rom / *Rome*: Abb. 74

Archiv des Autors: Abb. 94, 96, 97, 98, 99, 101,
103, 104, 105

Bayerisches Nationalmuseum, München /
Munich: Abb. 24, 25, 32, 71; Kat.-Nr.
7 a–e (Walter Haberland)

Klaus G. Beyer, Weimar : Abb. 92

Bibliothèque nationale, Paris: Abb. 7

bpk / RMN / Musée du Louvre, D. A.G.:
Abb. 48, 67, 68, 82, 109 (Madeleine
Coursaget), Abb. 41, 42 (Jean-Gilles
Berizzi)

Robert Braunmüller, München / *Munich*:
Abb. 38

Maraike Bückling, Frankfurt am Main: Kat.-
Nr. 9 b–d, 12 d–f, 19 b, e

Bundesdenkmalamt Wien / *Vienna*: Abb. 91

Centraal Museum, Utrecht: Abb. 47

Photostudio Fritz Simak: Abb. 13, 14, 76

City Gallery of Bratislava, Collection: Kat.-Nr.
3 a–d

Norbert Eschbach, Gießen: Kat.-Nr. 13 b, e,
20 b–c

Germanisches Nationalmuseum, Nürnberg /
Nuremberg: Abb. 86, 87, 88; Kat.-Nr.
13 a–c, 20 a, d, e

Vladimír Kordoš: Abb. 107

Kunsthistorisches Museum mit MVK und
ÖTM, Wissenschaftliche Anstalt
öffentlichen Rechts, Wien / *Vienna* 2006:
Abb. 8, 77; Kat.-Nr. 1 a–c

Kunstkammer Georg Laue, München / *Munich*:
Abb. 85, 93

Landesmuseum Württemberg, Stuttgart: Kat.-
Nr. 11 a–c, 14 a–c, 22 a, 22 / 23 a, 23 a
(Photo: Peter Frankenstein / Hendrik
Zwietasch)

Liebieghaus Skulpturensammlung, Frankfurt
am Main: Abb. 46; Kat.-Nr. 5a (Photo:
Werner Neumeister), 5 b–c (Photo: Frank
Kunert)

Musée d'art et d'histoire, Genf / *Geneva*:
Abb. 75

Musée du Louvre, Département des Sculp-
tures: Abb. 59, 60 (Photo: Pierre Phi-
libert)

Museo Chiaramonti, Vatikan / *Vatican*:
Abb. 27, 72, 73

Museo Archeologico Nazionale, Neapel /
Naples: Abb. 54

ÖNB / Wien-Bildarchiv: Abb. 1 (NB 501.617-
C), 29 (NB 508.163 B), 37 (WH 1680
E), 43 (NB 901.817-A / B), 111 (WH
3.762-E)

Umberto Orlandini, Modena: Abb. 79

Österreichische Galerie Belvedere, Wien / *Vien-
na*: Umschlag vorne / *Front Cover,* Abb. 16,
28, 34, 35, 45, 56, 58, 62, 63, Kat.-Nr. 6
a–c, 10 a–b, 18 a–b; Abb. 3, 10, 21, 52, 65,
66, 80, 102, Kat.-Nr. 21 a–b (Photo: Pho-
tostudio Otto); Abb. 2, 15 (Photo: Photo-
studio Otto 1996); Abb. 39, 83, 100 (Pho-
to: Photostudio Otto 1997); Abb. 36, 95
(Photo: Photostudio Otto 2000); Abb. 33
(Photo: Photostudio Otto 2006); Abb. 64
(Photo: Photostudio Pfeifer)

Ulrich Pfarr: 108, 110

Privatbesitz / *Private Collection*: Abb. 69, 84;
Kat.-Nr. 4 a–d, 6 b–c, 8 a–b, 15 a–d,
16 a–d

Sammlungen des Fürsten von und zu Liechten-
stein, Vaduz-Wien / *Vienna*: Abb. 30, 31;
Kat.-Nr. 2 a–d

Dr. Senckenbergische Stiftung, Frankfurt am
Main: Abb. 6, 17 (Photo: David Hall)

Skulpturensammlung, Staatliche Kunstsamm-
lungen Dresden: Abb. 51 (Photo: Estel /
Klut 2003)

St. Stephan, Wien: Abb. 4, 5 (Photo: Elfriede
Mejchar)

Staatliche Museen zu Berlin, Skulpturen-
sammlung und Museum für byzantinische
Kunst: Abb. 22, 23 (Photo: A. Vogt /
2005); Eigentum des Kaiser-Friedrich-
Museums-Vereins: Abb. 40 (J. P. Anders
1987), 49, 53 (Photo: A. Vogt / 2005)

Staatliches Museum, Schwerin: Abb. 90

Städel Museum, Frankfurt am Main: Abb. 50,
57, 70 (Photo: Ursula Edelmann –
Artothek)

Szépmüvészeti Múzeum, Budapest: Umschlag
hinten / *Back Cover*; Abb. 12; Kat.-Nr. 9 a,
e, f, 12 a–c, g, 19 a–c, g (Jòzsa Dènes
2006), Abb. 26

Wiener Stadt- und Landesarchiv, Wien /
Vienna: Abb. 11

Wien Museum, Wien / *Vienna*: Abb. 9, 18, 20,
44, 106; Kat.-Nr. 17a–c

Zisterzienserabtei Stift Heiligenkreuz: Abb. 78
(Photo: Fritz Simak, Wien / *Vienna*)

Leihgeber / *Lenders*

Unser Dank gilt den Sammlern und Museen, die sich bereit erklärt haben, uns die für die Dauer der Ausstellung zusammengeführten Werke zur Verfügung zu stellen/ *Our thanks to all the collectors and museums who have been prepared to place their works at our disposal for the duration of the exhibition:*

Galéria mesta Bratislavy, Bratislava
Dr. Ivan Jančár, Direktor / *Director*
Dr. Želmíra Grajciarova

Szépmüvészeti Múzeum, Budapest
Dr. László Baán, Generaldirektor / *General Director*
Dr. Miriam Szöks
Dr. Maria Verö

Bayerisches Nationalmuseum, München / *Munich*
Dr. Renate Eikelmann, Generaldirektorin / *General Director*
Dr. Astrid Scherp

Germanisches Nationalmuseum, Nürnberg / *Nuremberg*
Prof. Dr. G. Ulrich Großmann, Generaldirektor / *General Director*
Dr. Frank Matthias Kammel
Dr. Hermann Maué
Anja Löchner

Landesmuseum Württemberg, Stuttgart
Prof. Dr. Cornelia Ewigleben, Direktorin / *Director*
Dr. Fritz Fischer
Peter Heinrich
Chris Gebel

Kunsthistorisches Museum Wien / *Vienna, Kunstkammer*
Hofrat Dr. Wilfried Seipel, Generaldirektor / *General Director*
Hofrat Dr. Helmut Trnek, Direktor / *Director*
Dr. Sabine Haag, Stellvertretende Direktorin / *Deputy Director*
Ilse Jung
Sieglinde Kunst

Österreichische Galerie Belvedere, Wien / *Vienna*
Hofrat Dr. Gerbert Frodl, Direktor / *Director*
Hofrat Dr. Michael Krapf
Mag. Bernhard Andergassen
Susanna Hiegesberger

Sammlungen des Fürsten von und zu Liechtenstein, Vaduz-Wien / *Vienna*
Lichtenstein Museum. Die Fürstlichen Sammlungen, Wien / *Vienna*
Dr. Johann Kräftner, Direktor / *Director*
Mag. Michael Schweller

Wien Museum, Wien / *Vienna*
Dr. Wolfgang Kos, Direktor / *Director*
Mag. Lisa Wögenstein
Mag. Katrin Sippel
Helmut Selzer

Sowie Privatleihgeber, die nicht genannt werden möchten. / *Along with private lenders who do not wish to be named.*

Der Katalog erscheint anlässlich der Ausstellung
»Die phantastischen Köpfe des Franz Xaver Messerschmidt«,
Liebieghaus Skulpturensammlung, Frankfurt am Main
15. November 2006 bis 11. März 2007
This catalogue is published on the occasion of the exhibition "The Fantastic Heads of Franz Xaver Messerschmidt", Liebieghaus Skulpturensammlung, Frankfurt am Main, 15 November 2006 until 11 March 2007

Direktor / *Director*
Max Hollein

Ausstellung und Katalog / *Exhibition and Catalogue*
Maraike Bückling

Ausstellungsassistenz / *Exhibition Assistance*
Heike Höcherl

Ausstellungsorganisation / *Exhibition Management*
Katja Hilbig (Leitung /*Head*), Mirga Nekvedavicius

Restauratorische Betreuung / *Conservation*
Cordula Kähler

Ausstellungsarchitektur / *Exhibition Architecture*
Nikolaus Hirsch, Michel Müller
Daniel Dolder (Assistenz / *Assistance*)

Graphische Gestaltung / *Graphic Design*
Heine / Lenz / Zizka, Frankfurt/Berlin

Sponsoring / *Sponsoring*
Inka Drögemüller mit / *with* Katharina Simon

Marketing / *Marketing*
Melanie Damm mit / *with* Bernadette Seidler

Presse / PR / *Press / PR*
Dorothea Apovnik mit / *with* Eva Ehninger

Budget und Verwaltung / *Budget and Administration*
Heinz-Jürgen Bokler (Leitung / Head)

Bildung / *Education*
Maraike Bückling, Caroline Gabbert, Anne Sulzbach

Photoredaktion / *Picture Editing*
Heike Höcherl, Mirga Nekvedavicius mit / *with* Stefanie Adam,
Susanne Katzer, Hanna Martin

Technik / *Technique*
Milorad Petrovic, Alfons Pfeiffer, Peter Pludra, Heinz Urban

Sekretariat / *Secretariat*
Adelheid Felsing, Brigitte Gaebe, Ursula Körner, Doris Rösch-Becker

Katalogredaktion / *Catalogue Editing*
Maraike Bückling, Heike Höcherl

Übersetzungen / *German-English Translations*
Arne Laub, Castallack

Lektorat Deutsch / *Copy-Editing German*
Ines Dickmann, Köln

Lektorat Englisch / *Copy-Editing English*
Michael Scuffil, Köln

Projektmanagement / *Project management*
Kerstin Ludolph, Karen Angne

Umschlaggestaltung und Gestaltungskonzept / *Catalogue Cover Design and Design Concept*
Heine / Lenz / Zizka, Frankfurt / Berlin

Layout und Satz / *Layout and Typesetting*
Sabine Golde / André Grau, Leipzig

Lithographie / *Lithography*
Reproline Genceller, München

Druck und Bindung / *Imprint and binding*
Printer Trento S.r.l., Trento

© 2006 Liebieghaus Skulpturensammlung Frankfurt am Main,
Autoren / *Authors* und / *and* Hirmer Verlag GmbH, München

Bibliografische Infomation der Deutschen Nationalbibliothek
Die Deutsche Nationalbibliothek verzeichnet diese Publikation in der Deutschen Nationalbibliografie; detaillierte bibliografische Daten sind im Internet über http://dnb.d-nb.de abrufbar.
Bibliographic Information published by the Deutsche Nationalbibliothek The Deutsche Nationalbibliothek lists this publication in the Deutsche Nationalbibliographie; detailed bibliographic data are available in the Internet at http://dnb.d-nb.de.

ISBN-10 3-7774-3365-9
ISBN-13 978-3-7774-3365-3

Printed and bound in Italy

Alle Rechte vorbehalten

Umschlagabbildungen / *Cover Illustrations*
Vorderseite / *Front Cover*
Franz Xaver Messerschmidt, Der Erzbösewicht, nach 1770,
Österreichische Galerie Belvedere, Wien (Kat.-Nr. 10)
Franz Xaver Messerschmidt, An Arch Rascal, after 1770, Österreichische Galerie Belvedere, Vienna (cat. no. 10)
Rückseite / *Back Cover*
Franz Xaver Messerschmidt, Der Gähner
Szépmüvészeti Múzeum, Budapest (Kat.-Nr. 12)
Franz Xaver Messerschmidt, The Yawner Szépmüvészeti Múzeum, Budapest (cat. no. 12)

Fontispiz / *Frontispiece*
Franz Xaver Messerschmidt, Ein düstrer finsterer Mann
Österreichische Galerie Belvedere, Wien (Kat.-Nr. 21)
Franz Xaver Messerschmidt, A Dismal and Sinister Man Österreichische Galerie Belvedere, Vienna (cat. no. 21)